THE ILLUSTRATED
Ramayana
THE TIMELESS EPIC OF DUTY, LOVE, AND REDEMPTION

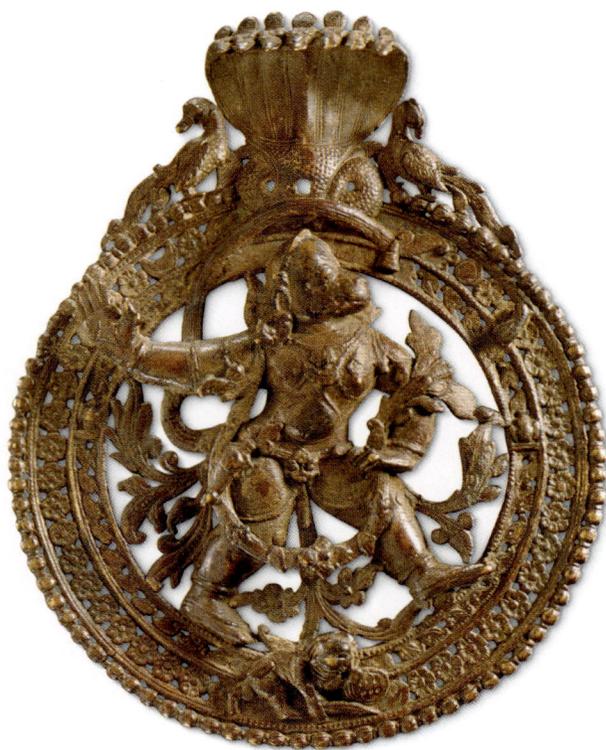

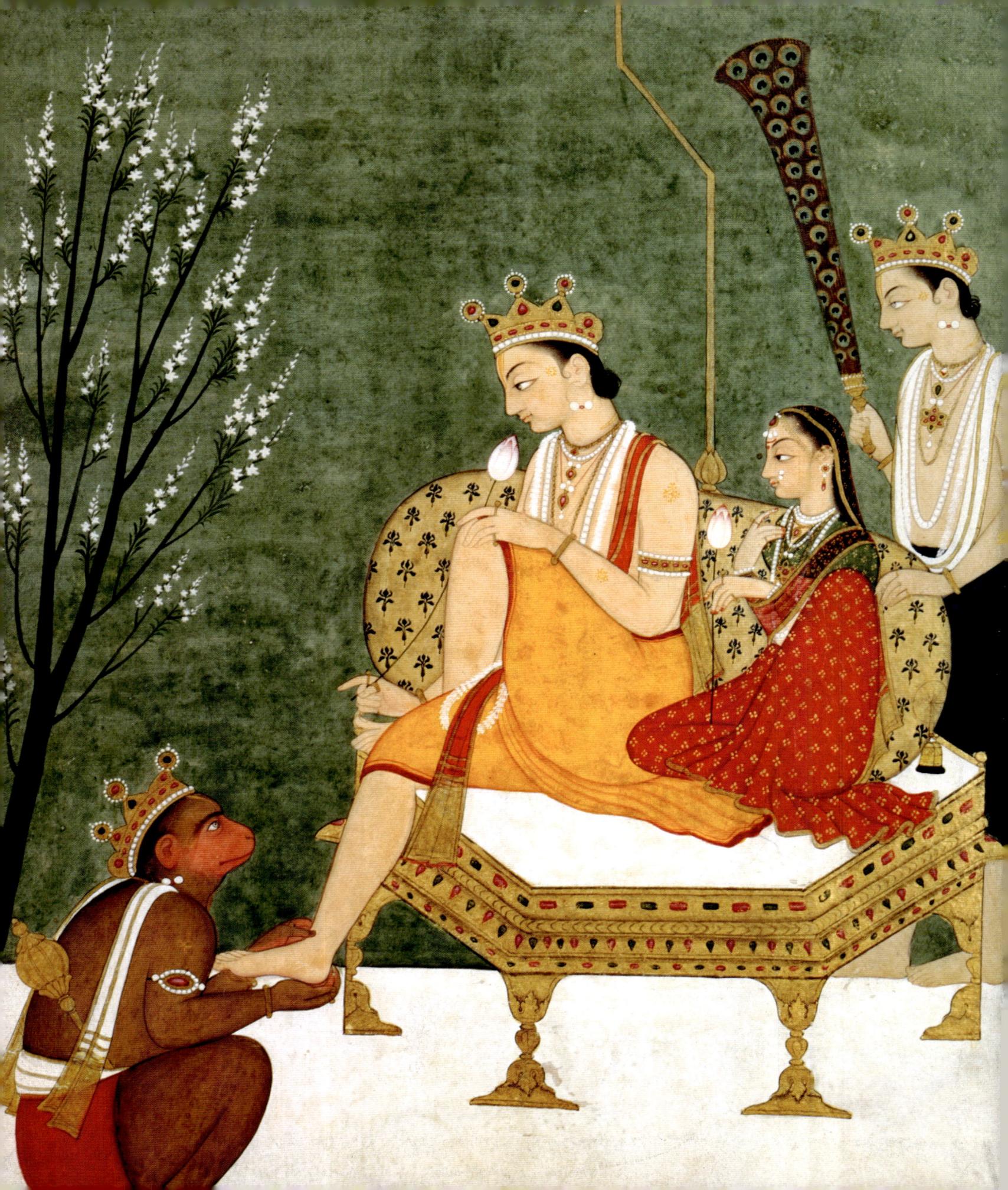

THE ILLUSTRATED
Ramayana

THE TIMELESS EPIC OF DUTY, LOVE, AND REDEMPTION

DK

DK | Penguin Random House

Editorial Team Hina Jain, Mark Silas, Beverly Smart, Ayushi Thapliyal, Vatsal Verma

Design Team Devika Awasthi, Bhavika Mathur

Proofreader Dipali Singh

Jacket Designer Neha Ahuja Chowdhry
Senior Picture Researcher Sumedha Chopra
DTP Designers Narender Kumar, Mohd Rizwan, Nand Kishore Acharya

Pre-Production Manager Sunil Sharma
Production Manager Pankaj Sharma
Picture Research Manager Taiyaba Khatoon
Managing Editor Chitra Subramanyam
Managing Art Editor Neha Ahuja Chowdhry
Managing Director, India Aparna Sharma

Consultant Bibek Debroy

Writer and Researcher Tarinee Awasthi

The contents of this book are based on
The Valmiki Ramayana, translated by Bibek Debroy,
published by Penguin Random House, 2017

First published in Great Britain in 2021 by
Dorling Kindersley Limited
DK, One Embassy Gardens, 8 Viaduct Gardens,
London, SW11 7BW

The authorised representative in the EEA is
Dorling Kindersley Verlag GmbH. Arnulfstr. 124,
80636 Munich, Germany

A CIP catalogue record for this book
is available from the British Library.

ISBN: 978-0-2414-7376-4

Printed and bound in China

For the curious
www.dk.com

This book was made with Forest Stewardship
Council ™ certified paper – one small step in
DK's commitment to a sustainable future.

For more information go to
www.dk.com/our-green-pledge

MIX
Paper from
responsible sources
FSC™ C018179

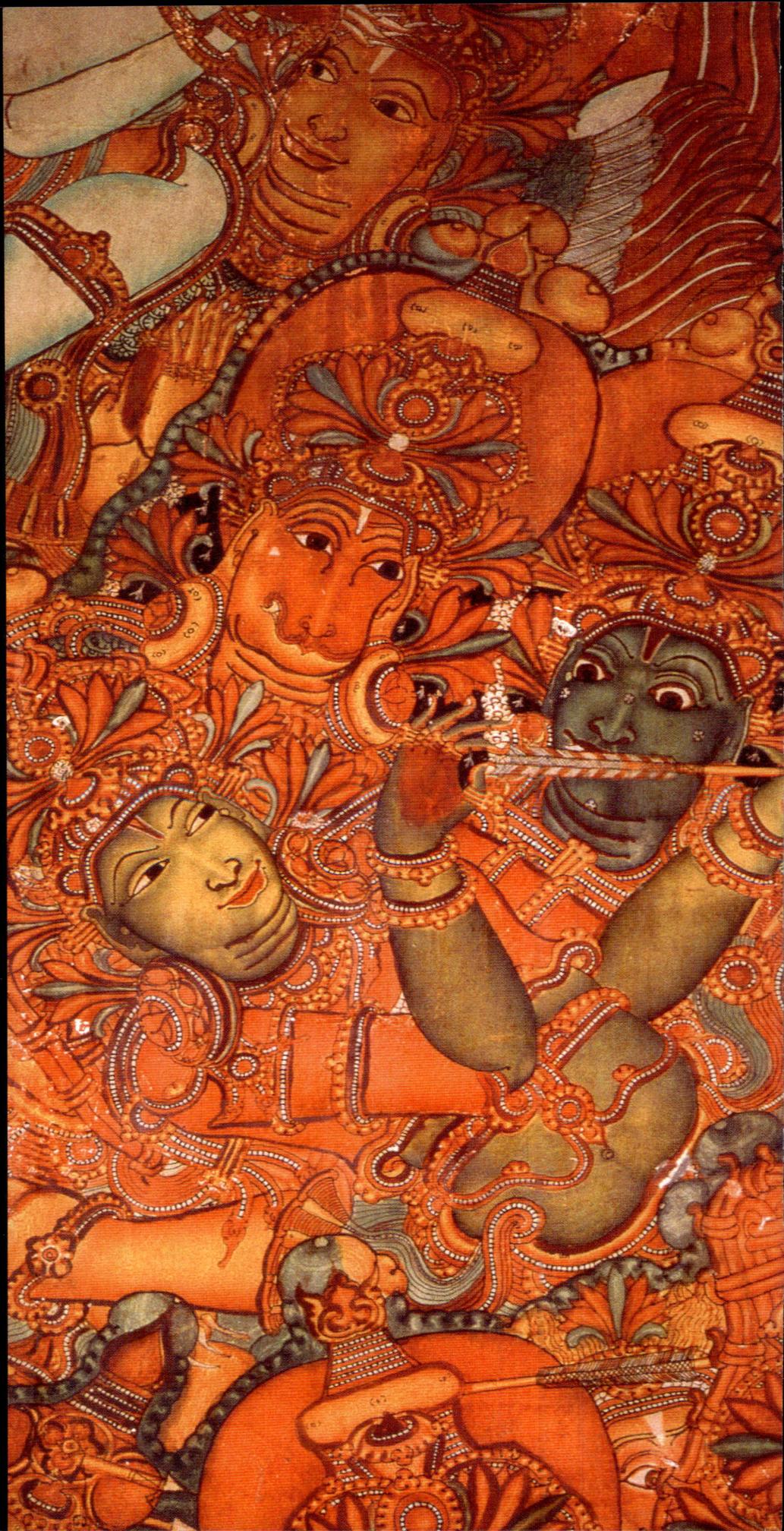

CONTENTS

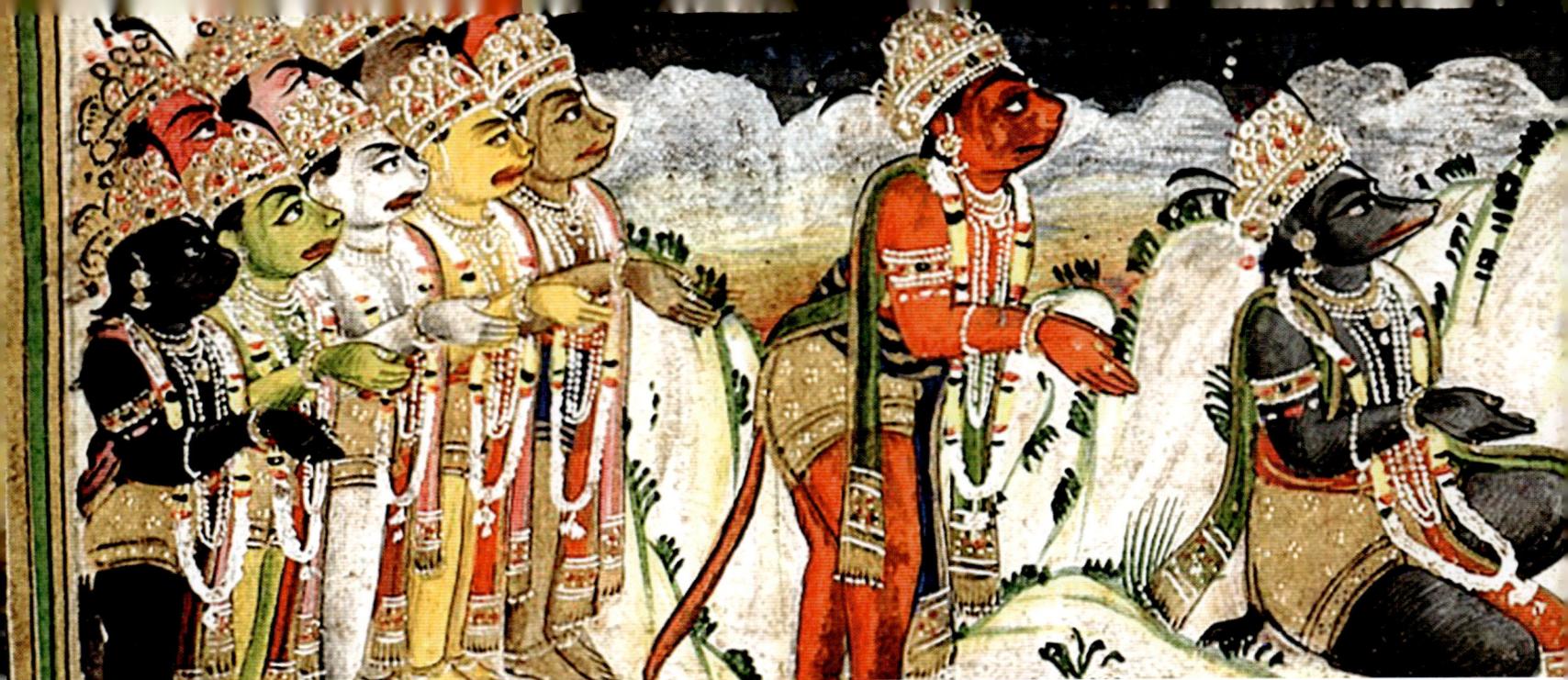

3

4

5

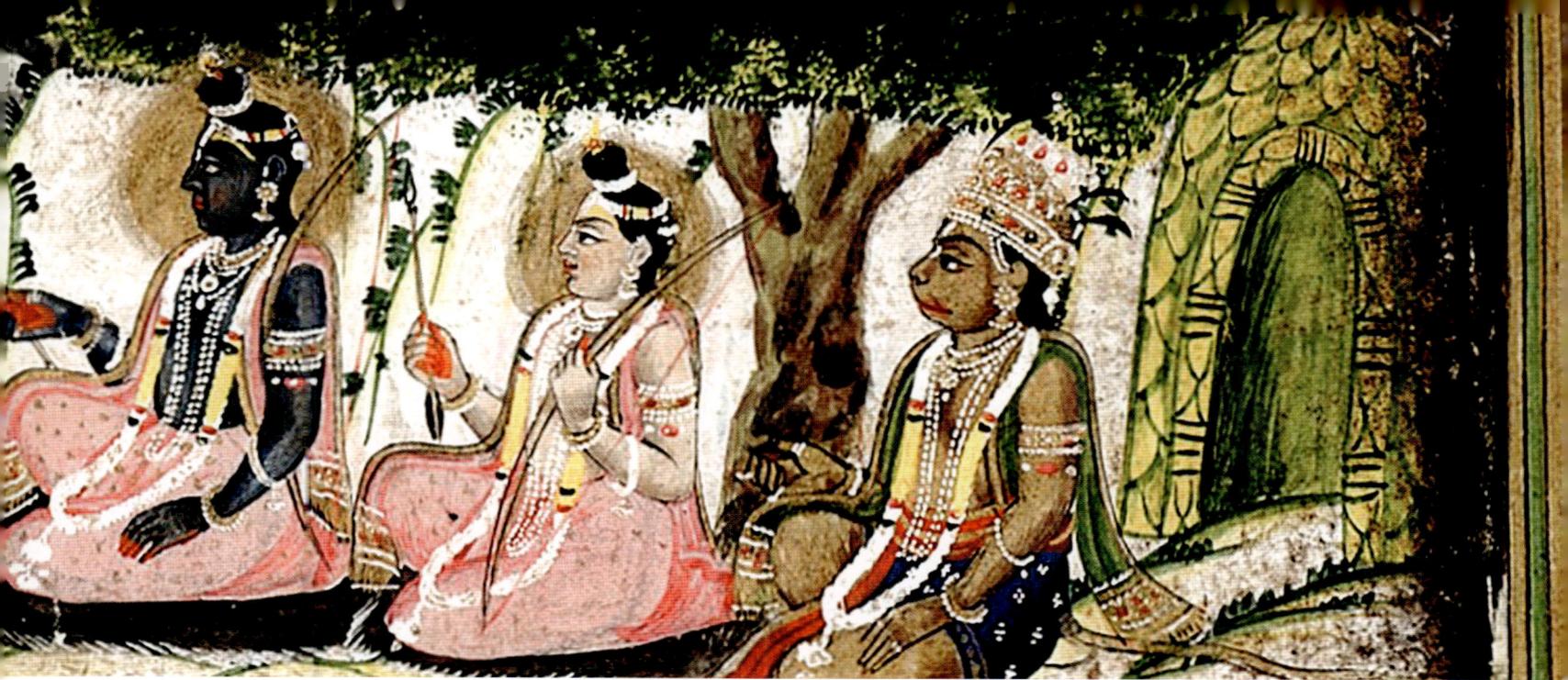

6

7

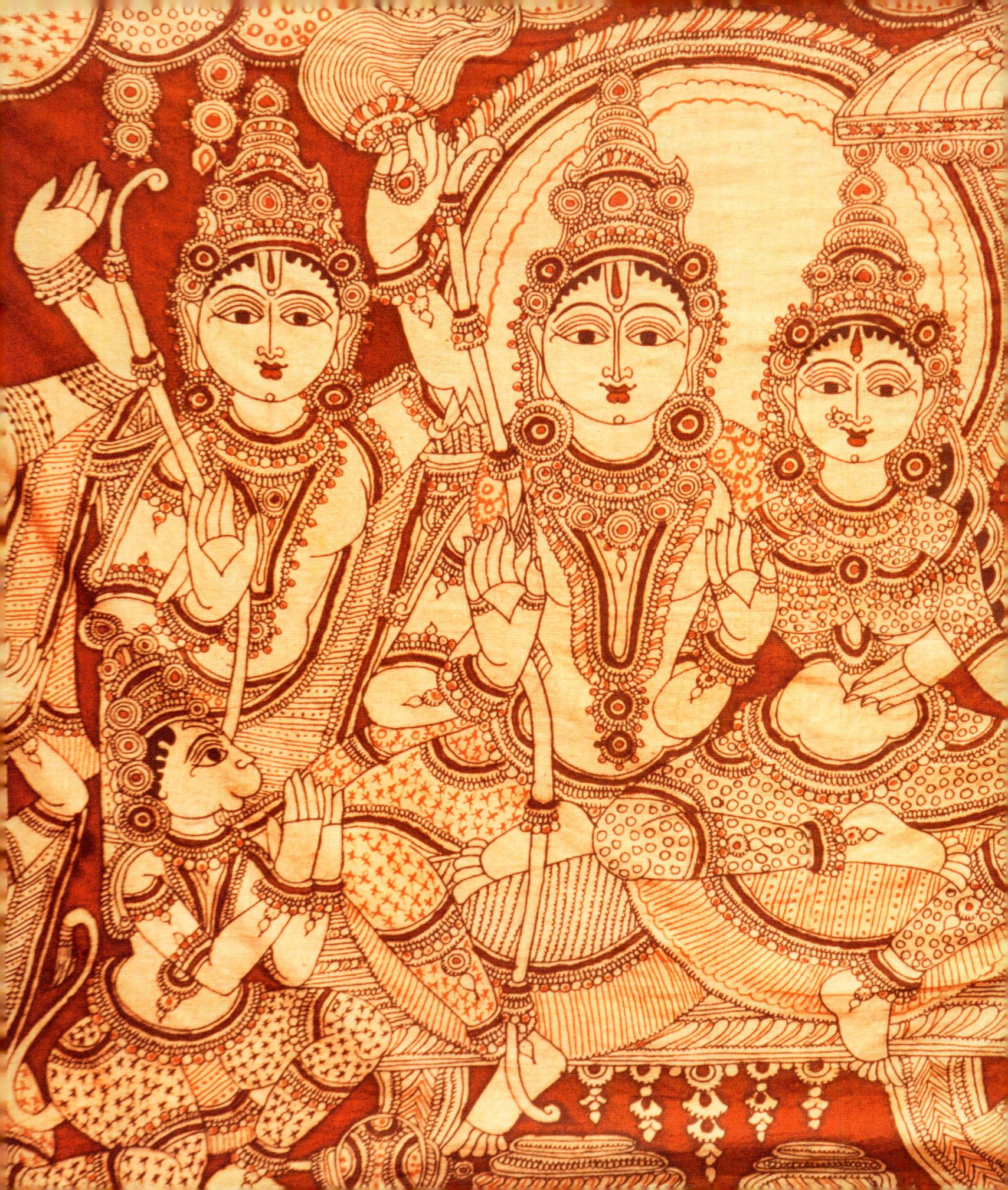

Foreword

In parts of India, people say, "Rama! Rama!" "Ra" is the 27th letter in the Sanskrit alphabet, "Aa" the 2nd, and "Ma" the 25th. Thus, Rama Rama = Ra+Aa+Ma+Ra+Aa+Ma= 27+2+25+27+2+25=108, a sacred number. Whether this numerological argument has any historical basis is irrelevant. Such arguments illustrate the pervasive influence Rama, *Ramayana*, and the protagonists from the *Ramayana* story have left on India's consciousness. The word "Ramayana" means Rama's progress. Therefore, unlike *Mahabharata*, *Ramayana* is centred on Rama, though people have often had takes on other protagonists. *Ramayana* is the story of the solar dynasty (*surya vamsha*), while *Mahabharata* is the story of the lunar dynasty (*chandra vamsha*). The solar dynasty started with Ikshvaku and effectively ended with Brihadbala (killed during the Kurukshetra War), though the tale dragged on till Sumitra (ousted by Mahapadma Nanda). There were famous kings in this lineage. Rama's story covers only one part of this lineage's history. The rest is found in the Puranas.

It is not the case that Rama's story occurs only in Sanskrit texts. Non-Sanskrit renderings (like *Ramcharitmanas*) have done much to shape perceptions about Rama and a strength of this volume, though based on *Valmiki Ramayana*, is cross-referencing to such texts. Stories about Rama also feature in Jain and Buddhist accounts and in other countries. For example, Hanuman metamorphosed into China's famous white monkey.

In Sanskrit, Rama's story is found in *Valmiki Ramayana*, *Adhyatma Ramayana*, *Yogavasishtha Ramayana*, Mahabharata's *Vana Parva*, Kalidasa's *Raghuvamsham*, Bhavabhuti's *Uttararamacharita* and *Bhattikavya*. Though based on Valmiki's *Ramayana*, this volume also cross-references those other versions, with a wealth of wonderful illustrations and pictures.

Valmiki's *Ramayana* comes alive.

Bibek Debroy

An economist by profession, Bibek Debroy is currently Chairman of the Economic Advisory Council to the Prime Minister of India. He has authored several books, including a translation of the Critical Edition of Valmiki's *Ramayana*.

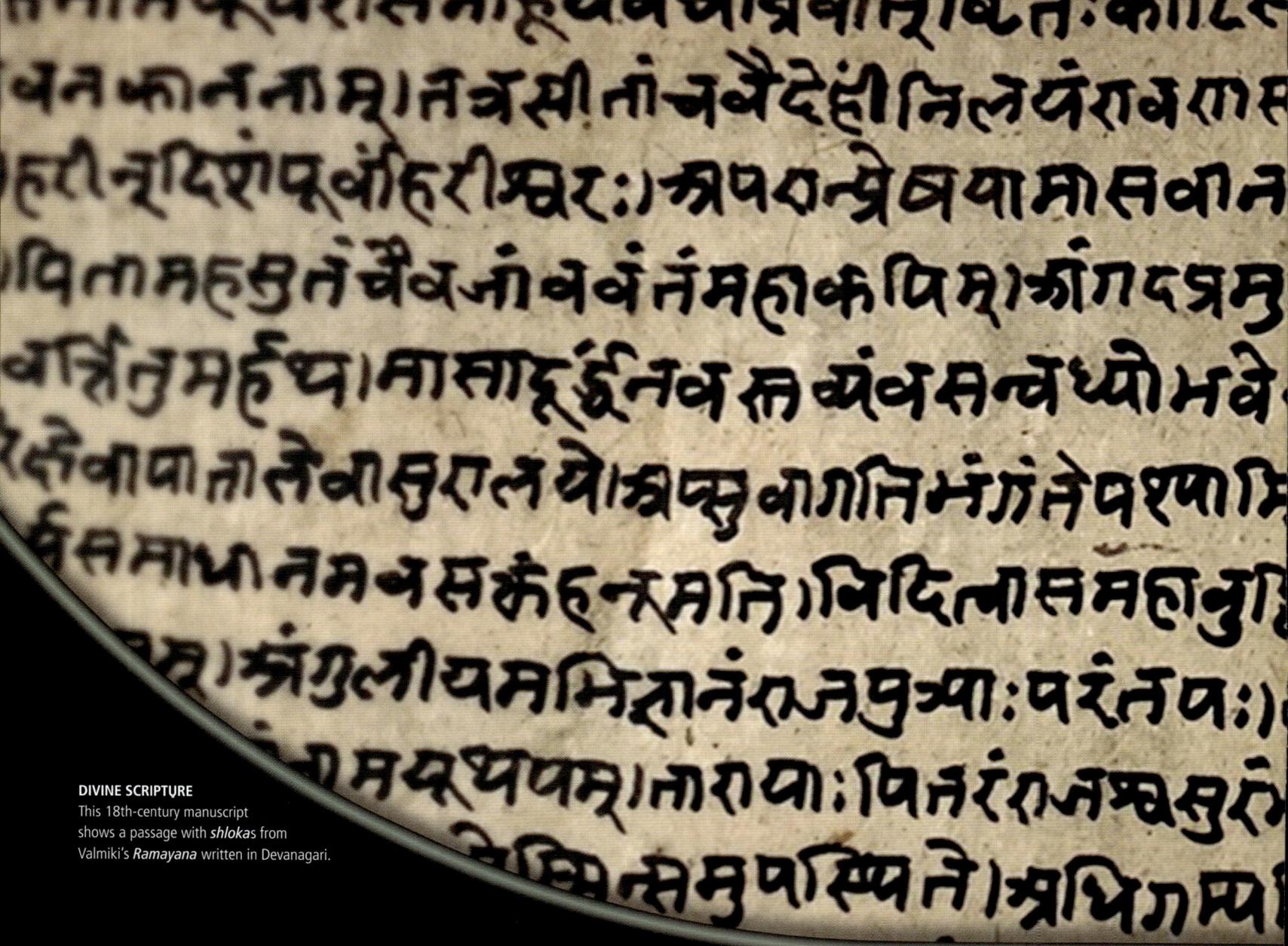

INTRODUCTION:
THE STORY OF RAMA

Ramayana is one of the two most treasured epics composed in ancient India. Along with the *Mahabharata*,
it imbues the minds and hearts of millions of Hindus as a sacred text, a particular way of relating to the past,
and as poetry, shaping (and, in turn being shaped by) the community in crucial ways. *Ramayana* narrates the
life of Rama, the legendary warrior prince of Ayodhya, as he walks the path that destiny has paved for him.
Valmiki's *Ramayana* gives us insights into the paradigm of righteousness, wisdom, and good conduct that is
Rama, the protagonist of this timeless tale.

"**O Rama**! O one for whom valour is the **truth**! Hear the truth. You are the god **Narayana**... the one who has vanquished his enemies in the past and will in the future. You are **without decay**. You are the **brahman**. O Raghava! You are the truth in the middle and at the **end**."

The *Ramayana* of Valmiki

The *Ramayana*, or the path or journey of Rama as a narrative cycle has captured the imagination of people in India and across the world for centuries. Devotees revere it, scholars study it, and storytellers and readers find joy in the text.

The *Ramayana*, at its simplest, is about the exile of a righteous prince who performs deeds of spectacular valour. At its most exalted, it stands for the moment at which the Divine, in His play and grace, manifests Himself in the earthly realm, and a complex spiritual imaginary is part of this understanding.

The structure

While there are endless *Ramayana*s (See pp 14–17), one of the earliest extant versions, also the most influential (though maybe not the best-known in its detail) within India, is Valmiki's *Ramayana*.

Composed in Sanskrit, it comprises seven parts called *kanda*s, or chapters. These are the Bala Kanda (childhood), Ayodhya Kanda (after the city of Ayodhya), Aranya Kanda (forest), Kishkindha Kanda (after the Vanara realm, Kishkindha), Sundara Kanda (beautiful), Yuddha Kanda (war), and Uttara Kanda (concluding or latter).

Each chapter is subdivided into sections or *sarga*s. The text suggests that it has 500 such subsections,

> "I pay homage to the **sweet Valmiki-koel**, who, having perched on the **branch of poetry**, coos the **sweet sounds 'Rama, Rama.'**"
>
> POPULAR SANSKRIT VERSE OFTEN USED TO PAY HOMAGE TO VALMIKI

but that may be more of a notional figure. The first part tells the story of Rama's birth, early battles, and marriage. The second deals with his exile. The third describes the years of exile up to the abduction of Rama's wife, Sita, by the Rakshasa, Ravana. In the fourth chapter, Rama meets a key ally, Sugriva, and helps him regain his kingdom. In the

Sundara Kanda, Sugriva's adviser, Hanuman, who later becomes Rama's follower, brings news of Sita. The next chapter describes the great war between Rama and Ravana. The last deals with

THE KNOWLEDGEABLE SEER
One of the oldest existing versions, Valmiki's *Ramayana* is unique as it has the author also featuring as a key part of the story.

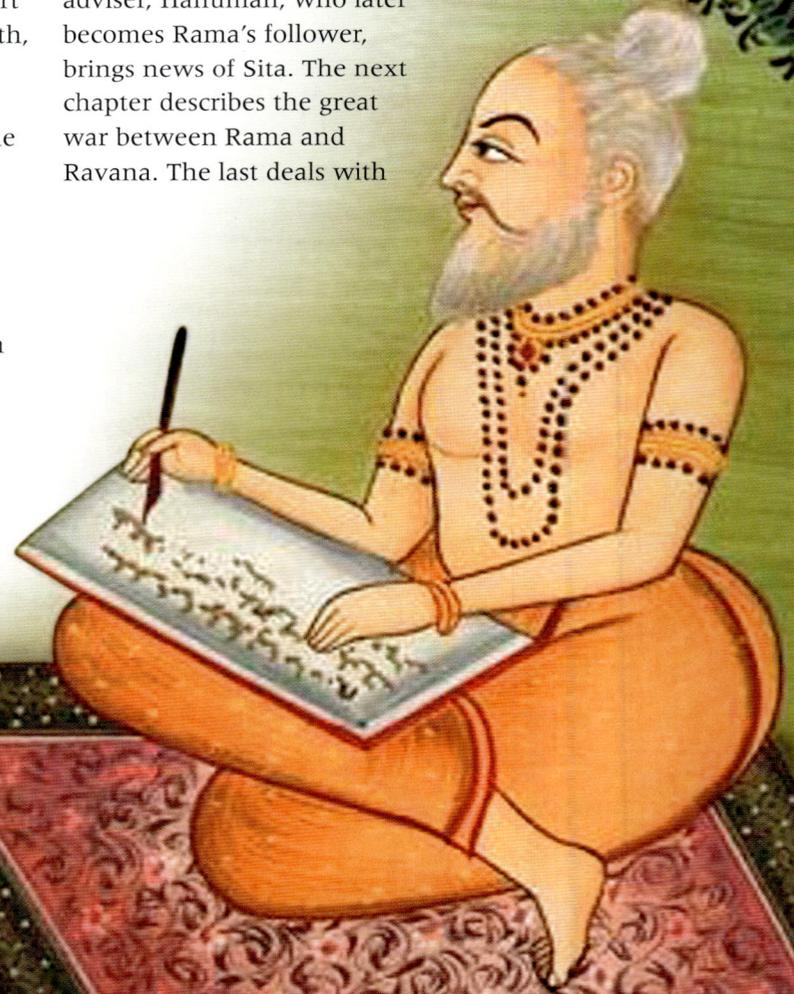

events that take place after Rama's consecration as king.

Dating the epic

The dating of this text has been a contentious issue, particularly because the seer, who is credited with its composition, features in the story. So, to date Valmiki and the *Ramayana* is also, for some people, to date Rama.

The traditional dating relies on the understanding of the four yugas (ages for humankind), and places the *Ramayana* sometime in the second yuga, which is several 100,000 years ago (Indian author Ramaswami Sastri places it at 867,102 BCE). There have also been some attempts to date the *Ramayana* on the basis of astronomical information that may be available in the text, which are later than yuga-based dating.

Historians generally do not regard the *Ramayana* as an epic composed by a single author at a particular point in time, but rather, propose a process whereby it came to be recorded in the form that we have now. The dates that

they propose are usually much later than the traditional view. Historians often consider that the earliest parts were composed around the 5th or 6th century CE, and some take the revisions up to an approximation of our present versions to as late as the 1st–3rd century CE.

Both these methods accept history as a mode, that is, they recognize that events happen in a datable fashion – whether the events of the *Ramayana,* which are taken as historical fact, or as the act of its composition.

However, there is a third perspective, where the notion of history itself is put to the test by the understanding of Rama's eternal play (See pp 14–15), and the status of Valmiki, as the rishi – the seer of the *Ramayana* accords him a spiritual status that transcends the act of having composed the text.

A MANUSCRIPT from the *Ramcharitmanas*

The Critical Edition

From a textual or text-historical perspective, the *Ramayana* exists in recensions, preserved across India.

In the period between 1951 and 1975, the Oriental Institute in Baroda (Vadodara), Gujarat, under the aegis of the Maharaja Sayajirao University of Baroda, worked to produce the "Critical Edition" of the Valmiki *Ramayana*.

In this, various manuscripts were consulted to agree upon a common basis for them, with the alternative versions recorded alongside.

The Illustrated Ramayana primarily uses economist and scholar Bibek Debroy's translation of the Critical Edition for the "narrative" elements of the text.

Occasionally, a verse or so has been included, which did not make it into the text of the Critical Edition.

However, if there is the need to refer to something that has a bearing on the plot, or an alternative narrative for part of a text, it has been recorded separately. Within Valmiki's *Ramayana*, there have been no attempts

RAMAYANA AND MAHABHARATA

The relationship between the *Ramayana* and *Mahabharata* has long been the subject of scholarly inquiry. Interestingly, the *Mahabharata* records the story of Rama in a narrative called the *Ramopakhyana*, or the Rama episode. The context is that one of the heroes of the *Mahabharata*, Yudhishthira, is depressed because of his wife's abduction. At this point, Sage Markandeya tells him Rama's story. Some scholars believe that this narration reflects an earlier point in the development of the Rama story.

A DIGITAL ILLUSTRATION of *Mahabharata's* Yudhishthira

to distinguish between what are considered historically later or earlier versions by historians, but rather, the received text has been treated as a whole.

Similarly, we have referred repeatedly to "Valmiki" as the author of the *Ramayana*; the reader is free to think of it as the Sage Valmiki or as a collective shorthand for the composers of the *Ramayana*.

> "In **beautiful *padas***, the broad-minded and illustrious one composed **the account of the illustrious Rama's conduct**."

ON VALMIKI COMPOSING THE *RAMAYANA*, *SARGA* (2), BALA KANDA

The *Ramayana* **Universe**

The story of Rama surpasses time, regions, and cultures. It has taken on multiple forms and has a myriad versions and recensions, each just as relevant and inspiring as the other.

Valmiki's *Ramayana* is undeniably central to the literate Rama tradition and one of the earliest extant versions of the story. However, Ramayana, the narrative of Rama's deeds, manifests in endless literary, visual, and performative pursuits across India, the subcontinent, and parts of Asia.

The range is expansive, encompassing the breadth of rich traditions. It is, of course, impossible to list or explore all of them, as it is also universe-like in the way that it continues to grow.

Earliest retellings

One kind of reworking includes the Buddhist and Jain retellings of the story of Rama.

The earliest Buddhist narration is the *Dasharatha Jataka*, which is considered early enough for some scholars to contend that its composition predated Valmiki. The earliest Jain retelling is the *Paumacariya* of Sage Vimalasuri, which dates the 1st century. There have been further retellings within these religious traditions, while the Buddhist retellings include those outside India.

Poetic renditions

The *Ramayana* calls itself *kavya*, a term used for poetic compositions (but not necessarily in verse). It also means that it emerges from a *kavi*, which means poet or composer, but often has the connotations of a more seer-like quality. It is unsurprising for a text that styles itself as a poetic composition to inspire innumerable reworkings in the form of literary compositions.

Early on was the popular Sanskrit author Kalidasa (circa 5th century), who wrote a long poem called *Raghuvarsha*, or the lineage of the Raghus, beginning before Rama and continuing after his passing. Some of his other work may also have been in engagement with some aspects of the *Ramayana*.

Following Kalidasa, innumerable playwrights and poets used the material of the *Ramayana* for their creations.

RAMAYANA ACROSS BORDERS
This bas-relief carving at the temple complex of Wat Xieng Thong in Laos depicts a war sequence from the *Ramayana*. The story of Rama has traversed far and wide and is quite popular in other Asian countries, such as Indonesia, Thailand, and Laos.

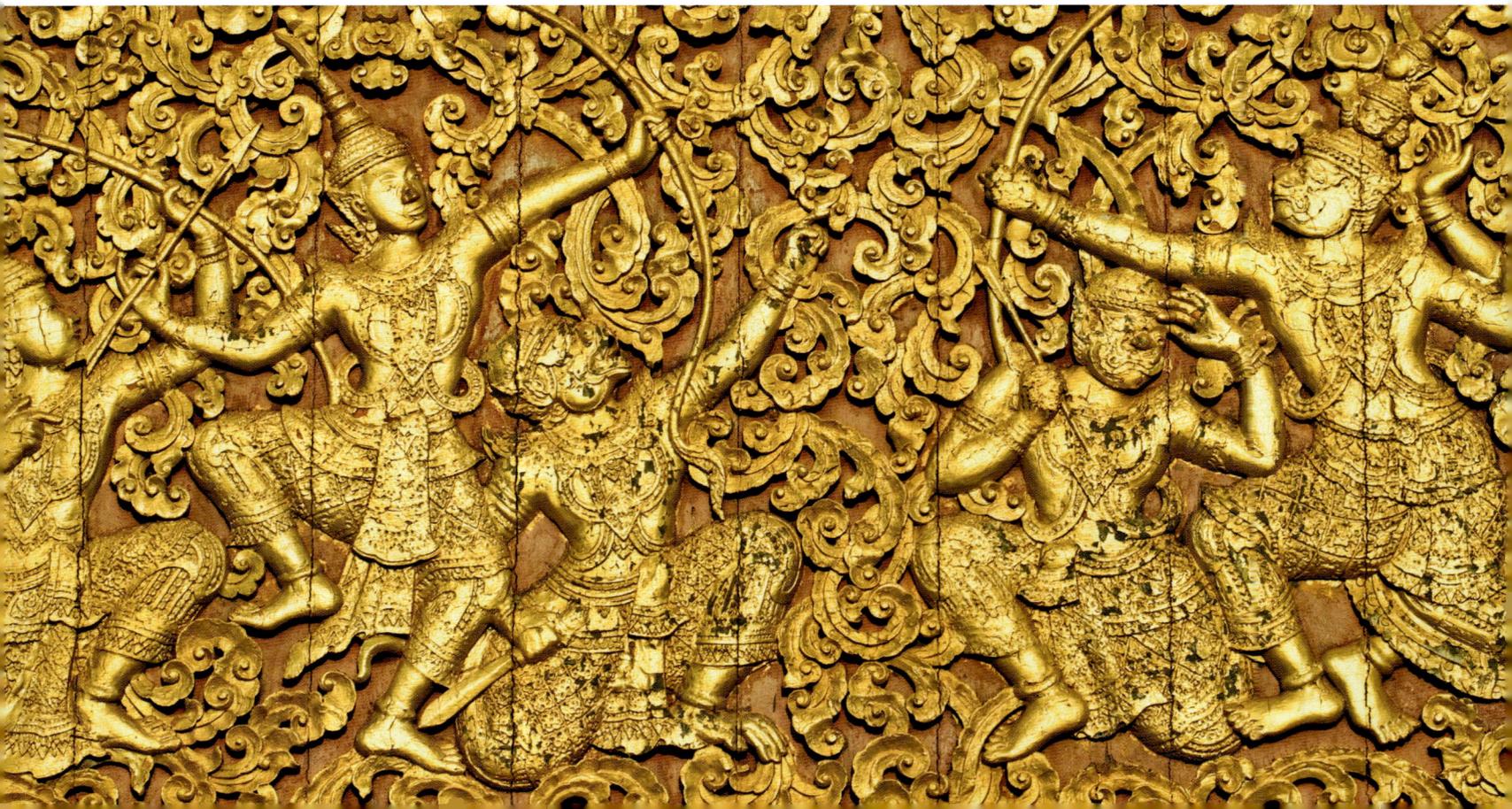

" 'As long as **there are mountains** and as long as **there are rivers** on this earth, **till such a time**, this **Ramayana account will circulate** in the worlds. As long as Rama's account, composed by you, **circulates**, till that time, you will reside in the upper regions, the nether regions and even in my world.' Having spoken these words, the **illustrious Brahma** vanished."

BRAHMA TO VALMIKI, *SARGA* (2), BALA KANDA

This included compositions in various genres, including plays, long poems in verse, mixed verse and prose, and "pun" poetry (where reading the verses in different ways yields different narratives). This continues through the second millennium and was as prolific as it was involved.

Various approaches

Writers had the option of taking one of several strategies towards the plot of the *Ramayana*. They could choose to cover the entire period that Valmiki did.

They could pick out an episode, or a section, and compose it with a reasonable degree of adherence to Valmiki.

They could also take up virtually the entire plot, but leave out some things (like many choose to end with Rama's consecration), or they could rework parts of the plot they chose to focus on.

This reworking could be to make the plot fit better with their view of the story or the format of the play. In fact, there are some characters whose roles are transformed consistently through a genre. More significantly, some authors, such as 8th-century playwright Bhavabhuti, make

a radical and self-conscious move to change the plot so it fits their view of Rama better. It is not only authors of poetic texts, but also those of texts on poetics, who often regard the *Ramayana* as the first and prototypical poetic composition.

Sanskrit retellings form another kind of engagement with Rama's story, and these do not see themselves as poetic compositions. Some are attributed to Valmiki himself, such as the Sanskrit text *Adbhuta-Ramayana*, or the *Yoga-vasishtha-maharamayana*, where the frame story sometimes includes a disciple of Valmiki asking him to narrate more of Rama's story.

In the *Adbhuta-Ramayana*, Valmiki indicates the multiplicity of the stories of Rama. Much of this text deals with exploring the divine nature of Rama and Sita.

Another important text of this kind is the medieval Sanskrit text *Adhyatma Ramayana*, which is a dialogue between Shiva and Parvati, with Shiva explaining Rama's divine nature.

Sanskrit commentaries in the second millennium also explored the Ramayana tradition. The worship of

Rama has also been recorded in various Sanskrit texts, whether as the central theme or as one among various kinds of spiritual orientations.

In vernaculars

In the second millennium, there was a blossoming of Rama stories in languages other than Sanskrit. The best-known of these include the Tamil *Ramavataram*, composed by Kamba in the 12th century, and often simply called the *Kambaramayanam*; the Assamese *Saptakanda Ramayana* (14th century); the Bengali *Sri-Rama-Panchali*; or the *Krittibasi Ramayana*, composed by Krittibas Ojha (14–15th century); the Odia rendition by poet Balarama Das (15–16th century); Saint Ekanatha's Marathi *Bhavartha-Ramayana*; and Tulsidas's 16th-century *Ramcharitmanas*.

These are parts of patterns in a much larger tapestry, whose influence can hardly be overstated.

The name "Rama", moreover (See pp 258–59) comprehends and transcends the Rama story, being invoked by saint-poets through much of the second millennium. When the *Ramayana* is being

read as a part of personal spiritual practice, it is as likely to be a vernacular rendition as Valmiki's is.

Neither the vernacular nor the Sanskrit writing around Rama, moreover, was limited to full-length texts of the kind referred to here. There is an abundance of Sanskrit *stotra*s, or

»

PARASHURAMI

In Valmiki's *Ramayana*, Rama encounters Parashurama after his wedding and subdues him. However, in some versions, Parashurama and Lakshmana have an extensive, often highly charged and sarcastic, conversation. This dialogue, also called *Parashurami*, is sometimes performed independently of the *Ramlila* in parts of north India. This is an interesting example of the complex interaction between Valmiki, the vernacular, and the local community.

A PALM LEAF MANUSCRIPT of an 18th-century Odia version of the *Ramayana*.

praise-hymns, which focus on Rama, as well as vernacular compositions addressed to both forms of Rama – the divine incarnate, and the formless divine.

A large number of these, such as the Telugu and Sanskrit compositions of composer and Rama devotee, Thyagaraja (18–19th century) hold a central position within the world of south Indian classical music.

In addition, there is a robust oral tradition of recalling Rama and Sita, along with other figures from the *Ramayana*. These include compositions that recall specific events from the story, such as Rama's exile or songs associated with his birth or marriage rituals, often sung, at people's own birth and marriage ceremonies.

In performance arts

The performative tradition around the *Ramayana* manifests in different ways. One aspect of this is the *katha* (story or narrative), which occurs in different ways across South Asia. This is when a speaker tells the story of Rama with an interwoven commentary.

Another is the *Ramlila*, which is a re-enactment of the events of the *Ramayana* that often attaches itself to a vernacular version (only to quickly overtake it with improvisation). Sometimes, particular parts of the Rama story can take on a life of their own.

There are abundant examples of the story flourishing outside India as well. For example, scholar of Buddhism Frank E Reynolds draws attention to the Southeast Asian Laotian *Phra Lak/Phra Lam* (Lakshmana and Rama), or the Thai *Ramakien* tradition, as well as the general significance of Rama's story in Thailand. Poet and scholar of Indian literature, AK Ramanujan, famously said about the *Ramayana* and *Mahabharata* that nobody in India hears them for the first time. He also said that these narratives form the "pool of signifiers", covering key plots, characters, relationships, and geography.

Following the advent of colonial modernity, far from dropping out, the *Ramayana* narratives continued to serve this function.

It has been used as a way to articulate dissent either by casting Rama in the role of fighting the injustice of Ravana, or by making him stand in for the existing, entrenched social order and raising another character up as the fighter for justice. There are two kinds of

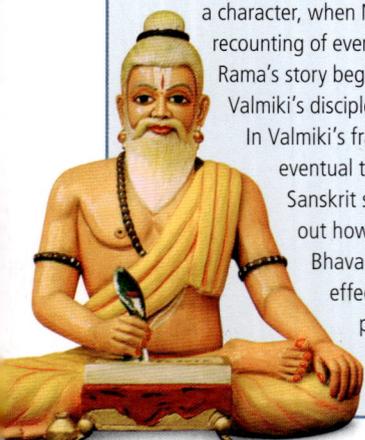

ACROSS THE AGES
An elaborate fair and a drama performance often characterize the Hindu festival of Dussehra. This image, dated 1834, shows one such performance before the Raja of Benaras (Vanarasi).

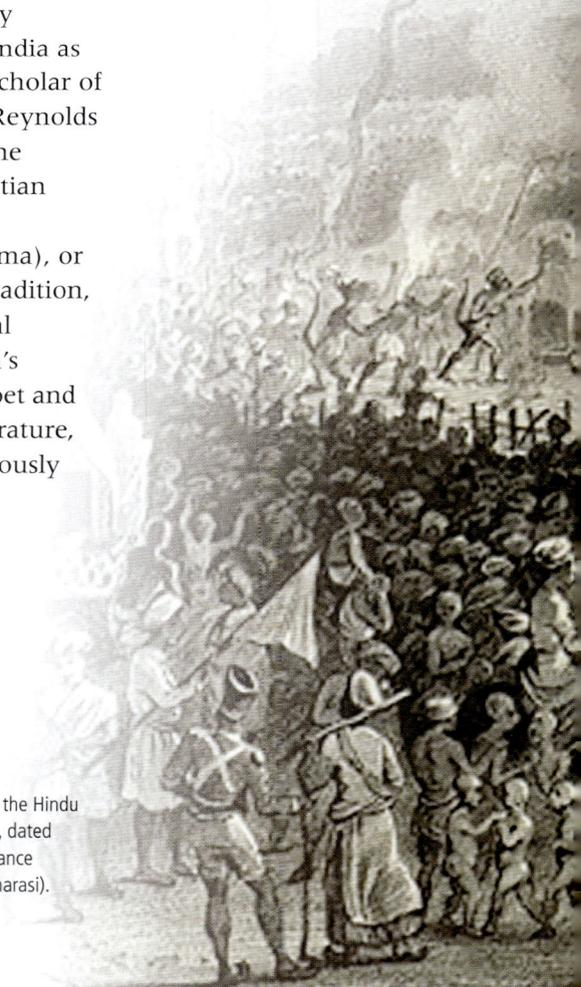

narratives in this regard – those which focus on a particular character, other than Rama, but still regard him with reverence as the protagonist and often the divine, whereas others seek to cast him in negative light. In the 20th century, the Rama narrative has also travelled, in the form of translations and over the internet. There have also been several television series, and live-action and animated films that have retold the story of Rama. The *Ramayana* famously proclaims that the story of Rama shall circulate in the worlds so long as the mountains stand and rivers flow on the earth. The broader *Ramayana* tradition (rather self-conscious itself) often refers to how there are a 1,000 million *Ramayana*s, or a 1,000 million extensions of Rama's story. Hyperbole or not, the Ramayana is a narrative that has been circulating for over two millennia and is not losing its momentum, touching ever more lives and moving ever more people.

"My composition is **devoid of all virtues**, it has only **one world renowned virtue**... in it is contained **the great name of the Raghu lord**."

IN PRAISE OF RAMA, *RAMCHARITMANAS* BY TULSIDAS

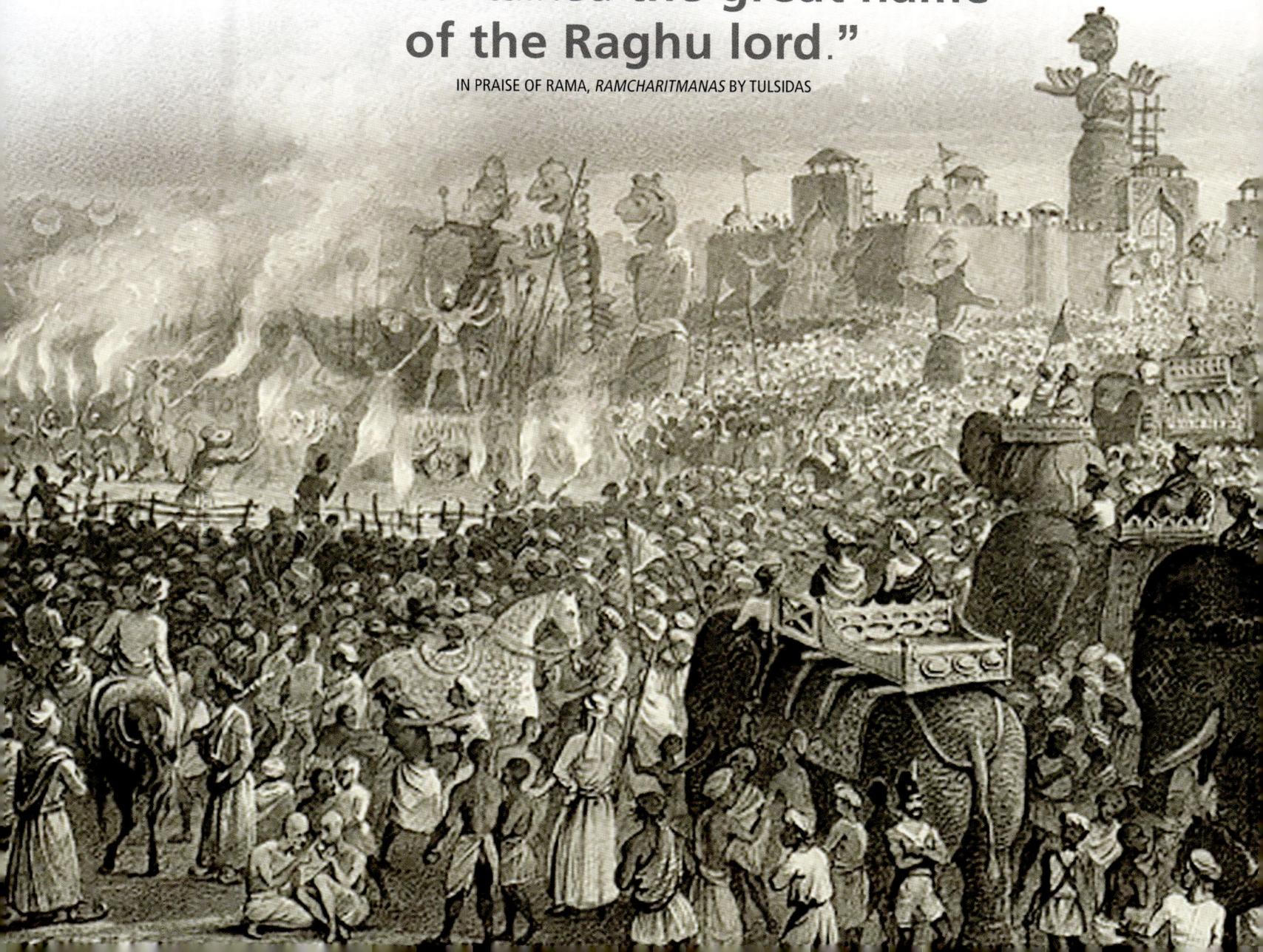

DHARMA, ARTHA, KAMA, AND MOKSHA

Human Pursuits

"Rama is the **personification of dharma**. He is **virtuous.** Truth is his valour. He is the **king of all the worlds**, like Vasava among the gods."

MARICHA TO RAVANA, *SARGA* (35), ARANYA KANDA

Out of all the schemes that shape Hindu thought, one of the more important ones is referred to as *purushartha*. The word is a compound made of *purusha* (man) and *artha*. *Artha* is a rather multivalent term, but is best understood here as that which is sought. *Purushartha* might be referred to as those which man pursues, or should pursue. In later tradition, these are determined to be – dharma, *artha, kama,* and moksha.

THE FOUR DISCIPLINES

Dharma is a term that has many referents and hence, is often relegated to the class of the almost mystically untranslatable phrases. While it is true that dharma can hold several ideas at once, and some of those ideas are nearly impossible to translate into another language, the real issue is its multivalence. Much like *artha,* each time one comes across the term, one has to figure out which dharma it is. Certain kinds of contemporary usage in modern Indian languages occasionally reduces it to religion or a religious group; however, the term is usually not used in that sense.

For the present context, as one of the four *purushartha*s, dharma has the sense of virtue and righteousness, sometimes imbued with the idea of ritual obligation and the pursuit of heaven. *Artha* can mean that which is pursued. However, when included in the list of *purushartha*s, it refers to political and economic concerns. To that extent, it is particularly important for rulers. *Kama* is the pursuit of pleasure or desire, often connected with sensory pleasure. Moksha is the liberation from the cycle of rebirth.

While moksha is one of the four, it isn't hard to find perspectives where it is to be pursued even at the cost of all of the remaining three.

ALTERNATIVE ACCOUNT

ADHYATMA RAMAYANA

The frame narrative of the 13–15th century *Adhyatma Ramayana* involves Shiva, the Destroyer, and his consort, Parvati. Parvati asks the questions that prompt Shiva to narrate Rama's story. He tells her of a conversation between Sita, Rama, and Hanuman.

After Rama's coronation, the Vanara sits before him, seeking knowledge. Rama asks Sita to instruct him, and then himself explains the unity between the self and the Supreme Being, the realization of which destroys all bondage.

Here, Rama is the preceptor, his teaching shows the path to liberation, and as the Supreme Being, he is also that which is attained *as* liberation.

A 19TH-CENTURY artwork of Shiva and Parvati

PURSUIT OF DHARMA

Even from a cursory glance through the *Ramayana*, it becomes clear that the narrative hinges around dharma.

In each chapter, there are several questions of dharma, whether it is the issue of committing violence as an ascetic, or preserving the truth of one's father's words even against his express wishes. Rama states in the Ayodhya Kanda that like seers, he is firm on dharma alone, and one could argue that he privileges dharma over *artha* or *kama* in this instance. Advice to rulers, whether it is Bharata, Ravana, or Sugriva, is usually to the effect that *kama* must be subordinated to *artha* and dharma, and that the pursuit of *artha*, too, must be in accordance with dharma.

The choices that Rama faces are rarely between dharma and adharma – virtue and vice, righteousness and evil.

Most often, it is the choice between two kinds of dharma: the dharma of a person as they are simultaneously cast in two roles, or as they choose between one or more axes of dharma. Further, it is not always the case that Rama simply decides on a course of action alone and that is that. Not only does he have to determine the course of action in accordance with dharma, he is often questioned (perhaps most famously by Sugriva).

These questions are not meant merely as a foil for Rama's decision, but are serious questions and objections and Valmiki does not always seem to take one side or the other.

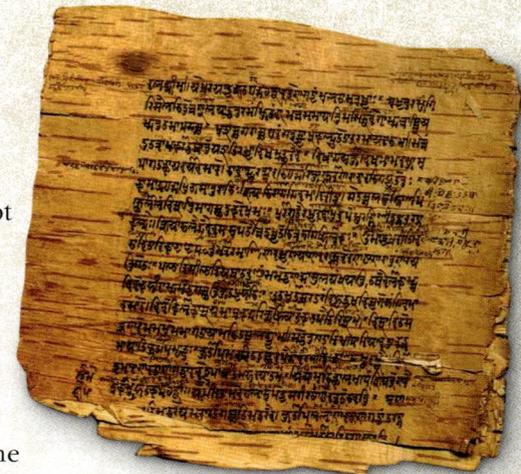

A MANUSCRIPT of the *Utpattiprakarana Mokshopaya*

RAMA AND MOKSHA

While the emphasis in the *Ramayana* is overwhelmingly on dharma, *artha* and *kama* still feature. Moksha, however, does not seem nearly as important to Valmiki. Historically, it is considered a later addition to this group of pursuits. However, it is a concept of fundamental importance, not only within Hinduism, but also in other adjacent traditions. To that extent, it would have been surprising if moksha had not made an appearance in Rama's broader world at all.

There are at least two or three obvious ways in which Rama is related to moksha.

Although moksha is not what Rama seeks in Valmiki's *Ramayana*, he is an important figure in *Mokshopaya* ("the means to moksha"; the precursor of the *Yogavasishtha*), and it is to him that Sage Vasishtha delivers the discourse on liberation.

Secondly, Rama himself is the means to and grantor of, or the sole constituent of the state of moksha (as well as the grantor of the other three *purushartha*s). While there are entire systems centred around this, it is interesting to see the way commentaries on Valmiki incorporate this idea. In one of the verses in the Yuddha Kanda, Rama proclaims that he grants fearlessness to anybody who surrenders before him saying "I am yours." (See pp 130–31)

The 16th-century commentator Govindaraja reads fearlessness in two ways, "Fearlessness is moksha itself, because we hear as the result of *brahmavidya* 'thus he comes to have attained fearlessness, one who knows the bliss of brahman [the supreme being] does not fear anything' (*Taittiriya Upanishad*). The entreaty for a particular result, 'I am yours,' is in accordance with this view. On a different view, it is the analogous implication of the other three results as well, because he is the grantor of all results."

Finally, some devotees see devotion to Rama to be better than all human pursuits and their results. So, in the 16th-century *Ramcharitmanas*, Bharata says, "I have no attachment to *artha*, dharma, or *kama*; nor do I desire the state of liberation. I only want the boon that I have love for Rama's feet in life after life."

Even to desire liberation is to contaminate one's love for Rama, whereas if one possesses true devotion, liberation follows one around!

In Rama's Footsteps

The *Ramayana* is as much about Rama's journey – the path he took in his youth, while in exile, and later as he searched for Sita. Often regarded in different and sometimes overlapping ways, the physical spaces described attract both contention and deep affection.

Besides a pilgrimage to places mentioned in the *Ramayana*, there is also a tradition of tracing the path that Rama took, performing the same journey that he did – making it a process of both seeking and realizing Rama.

This is not an attempt to historically pin down what might have happened where, but an attempt to bring up some locations associated with the story in order to get a sense of its spread across the Indian subcontinent.

It is possible that the same place could be identified with more than one spot, and the devotee is likely to say with a smile, "Well, the lord incarnates in each cosmic cycle." There have, however, been serious premodern and contemporary attempts to identify exactly which of these places Rama visited.

The beginning and the end

Perhaps the most important of the places associated with the *Ramayana* is Ayodhya. It is generally identified with a city in the north-central Indian state of Uttar Pradesh. The city is considered the birthplace of Rama as well as the place where he grew up, ruled after his exile, and ascended to heaven from, and is naturally an important place of pilgrimage.

The realm of Ayodhya is also sometimes called "Saketa", and there is the notion of an eternal Saketa (a place where god resides) where Rama is ever in a state of divine play. Rama's realm is also sometimes called "Avadha".

The River Sarayu is significant as Rama steps in these waters before ascending to heaven, and takes with him whoever else steps into its waters. Indeed, Sanskrit poet and dramatist Kalidasa, in the *Raghuvansha*, describes it as a *tirtha* (a ford). Those who stepped into it crossed over the ocean of existence.

About 20 km (12.5 miles) from Ayodhya is the spot identified as Nandigram, where Bharata lived during the years of Rama's exile.

Land of Sita

The next significant place in Rama's journey is Mithila, which is where Sita grew up. Scholar Aditya Chaturvedi cites textual references to identify this region as flanked by the rivers Kaushiki and Gandaki in the east and west, and the Himalayas and Ganga in the north and south, about 300 and 200 km (186 and 125 miles) respectively.

The expanse of Mithila would include parts of the present-day Indian states of Bihar and Jharkhand and would extend to parts of Nepal. The people of Avadha and Mithila usually regard Rama and Sita with a familiar affection – which does not take away in any way from the spectacular divinity but rather makes it sweeter.

Places of exile

After leaving Ayodhya for exile, Rama, Sita, and Lakshmana meet King Dasharatha's friend, Guha, at Shringaverapura (See pp 98–99). The region is said to be close to Prayagraj, the city of the confluence of the rivers Ganga and Yamuna, in Uttar Pradesh. Prayagraj, and in it the hermitage of Sage Bharadwaja, are still important spots of pilgrimage.

From there Rama went to Chitrakoot, which is considered to be near the border of the states of Uttar Pradesh and Madhya Pradesh, and it is here that Bharata comes to see Rama. One often gets the impression that Chitrakoot was already a sacred spot before Rama came here, and was frequented by sages and adepts. Panchavati is usually identified as being near Aurangabad in Maharashtra. The place where Rama promised to kill Rakshasas is 500 km (310 miles) northeast of it, while Kishkindha is said to be near Hampi in Karnataka in the south-western part of India, as is the Lake Pampa.

CLOUD MESSENGER

In *Meghadoota* ("Cloud Messenger"), a 100-verse poem, Kalidasa tells of a Yaksha who is separated for a year from his beloved, and sends a cloud with his message. Much of the poem describes the path the cloud should take, but the very first verse contains a reference to the waters which were made sacred by Sita's bathing in them.

A 20TH-CENTURY illustration of Kalidasa writing the *Meghadoota*

MANDORE

It is believed that Mandodari (See p 343), the wife of Ravana, the king of Lanka, belonged to Mandore, the ancient capital of the kingdom of Marwar and a town near Jodhpur, Rajasthan, in present-day India. Ravana and Mandodari, the daughter of the Daitya Maya and his consort Hema, it is said, were married in a pavilion in the town, a structure that can still be seen.

The Vindhya mountains cover the central part of India. However, there is also a tradition that Rama spent at least part of his exile in the state of Chhattisgarh, and the place where he met Shabari is sometimes believed to be Shivrinarayana, located there.

Finally, Rameswaram in Tamil Nadu, from where Rama crossed the ocean, is marked by a massive temple dedicated to Shiva, associated with Rama, even though the Valmiki version does not contain a reference to the worship of Shiva.

The land of India, for believers, is a land consecrated by various sacred circuits, and the path of Rama, to be walked in pursuit of Rama, holds a deep significance in the spiritual map of Indians.

THE PATH OF RAMA
A representation of a map of early India identifying some of the key places that, it is believed, Rama visited.

HIMALAYA

KURU
PANCHALA
MARU
Ganga
Sarayu
Gandaki
Mithila

MATSYA
Yamuna
Ayodhya
Nandigram
KOSALA
KASHI
MITHILA

Shringaverapura
Chitrakoot
Prayagraj
Ganga

AVANTI
Son
MAGADHA

SURASHTRA

VINDHYA
Narmada
Shivrinarayana
DASARNA

VIDARBHA
UTKALA

Panchavati
KALINGA

Godavari
Godavari

RSIKA

SAHYA
Krishana
ANDHRA

KUNTALA

Kishkindha
Lake Pampa

Kaveri
MAHENDRA
COLA
MALAYA
KERALA
Rameswaram

LANKA

"**Sarayu**, with the **sacred waters**, flowed in a westward direction... Brahma... arrived at the spot where Kakutstha had presented himself at **the gate to heaven**."

AS RAMA REACHED SARAYU, *SARGA* (100), UTTARA KANDA

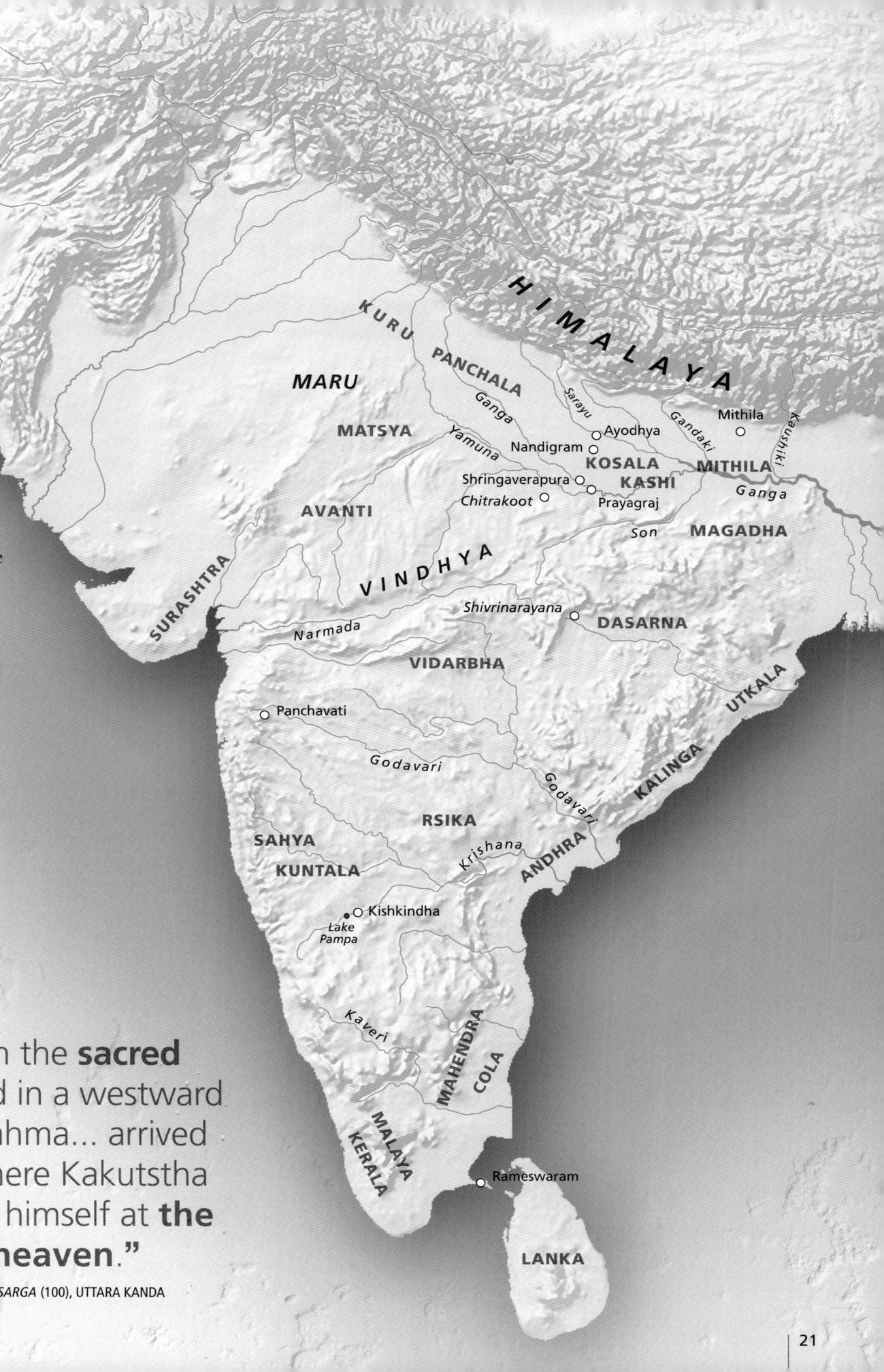

The **Gods** in the *Ramayana*

The story of Rama, told through the *Ramayana*, features a vast pantheon of deities, gods, and demigods that play integral roles throughout the narrative. They act as divine overseers, bestowing upon Rama celestial weapons, and guiding him throughout his journey, to help him fulfil the purpose for which he came to the earth.

T he *Ramayana* is structured around the coming together of the human and divine realms, both tormented by a single Rakshasa, Ravana, and his cohorts. Ravana's boon makes it so that he cannot be killed by a god or a divine being, and most humans, it appears, do not have the capacity to defeat him. Thus, the gods approach Vishnu, the Preserver of the universe, and ask him to take a human form and be born as Rama, so that he might kill Ravana. The pantheon, as represented in the *Ramayana*, is composed

of three gods who stand apart from the rest, four deities who have certain capacities as the regents of the directions, and various others.

The first triad includes Brahma, Shiva, and Vishnu. They are rarely described together in this way. In the *Ramayana*, they are not really assigned the division of labour that is commonly seen, where Brahma creates, Vishnu preserves, and Shiva destroys in preparation for a new cycle of creation. However, the three of them certainly have a distinct position compared to the rest of the deities.

Brahma, the Grandfather
Brahma, in his message to Rama in the Uttara Kanda, tells him that it was Rama, who, in an earlier state, created Brahma and charged him with the task of progeneration. The latter, in turn, approached that divine being who created him and sought that he protect the world. That being became Vishnu, intent upon the preservation of creatures – a task which compelled him to take on the form of Rama

THE SUPREME BEINGS
This early 19th-century artwork shows the triad of Brahma (left), Vishnu (centre), and Shiva (right).

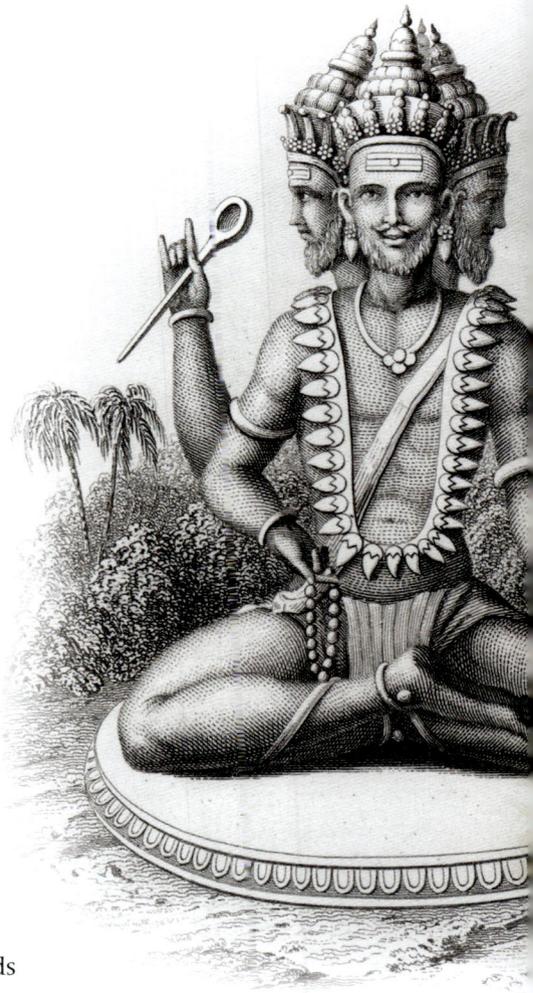

in the first place. Brahma is also the one who, at the end of the Yuddha Kanda, reveals Rama's divine nature to him, referring to his deeds and magnificence in his various aspects as Vishnu.

Brahma, in the *Ramayana*, is sometimes referred to as "Grandfather", alluding to the fact that all beings descend from him. He is the one who usually grants blessings to various figures, and whom the gods usually go to for refuge, before he determines the future course of action.

Shiva, the Destroyer
Shiva, in the *Ramayana*, does not play a part in the actual story the way Brahma does, but he does come up several times. His relationship with Uma, his consort and daughter of the mountain Himalaya; his burning up of

the god of love; his bearing of the Ganga – all central to the general understanding of the Shiva – are featured in the *Ramayana*. He, too, from time to time grants boons, and is one of those who addresses Rama after Ravana's defeat.

Of the triad's consorts, Uma is seen in the story of her anger (See p 50) and in her granting a boon to Ila (See p 365). The goddess of speech and learning, Sarasvati, often associated with Brahma, makes a brief appearance where she acts to help out the gods. Lakshmi, Vishnu's consort, is Sita herself, and Sita is explicitly identified as such when Brahma reminds Rama of their identity.

ALTERNATIVE ACCOUNT

A DIVINE FRIENDSHIP

Shiva and Rama are often portrayed as having a relationship of deep love, each honouring the other. Some narratives have Rama offer worship to Shiva at the shore of the ocean. He, in turn, is frequently the one to reveal the mystical truths about Rama, often to Parvati or Uma, his consort. Sometimes, Shiva is described as the foremost among Rama's devotees, and the 16th-century Awadhi poet Tulsidas emphasizes that devotion for one to the exclusion of the other is futile.

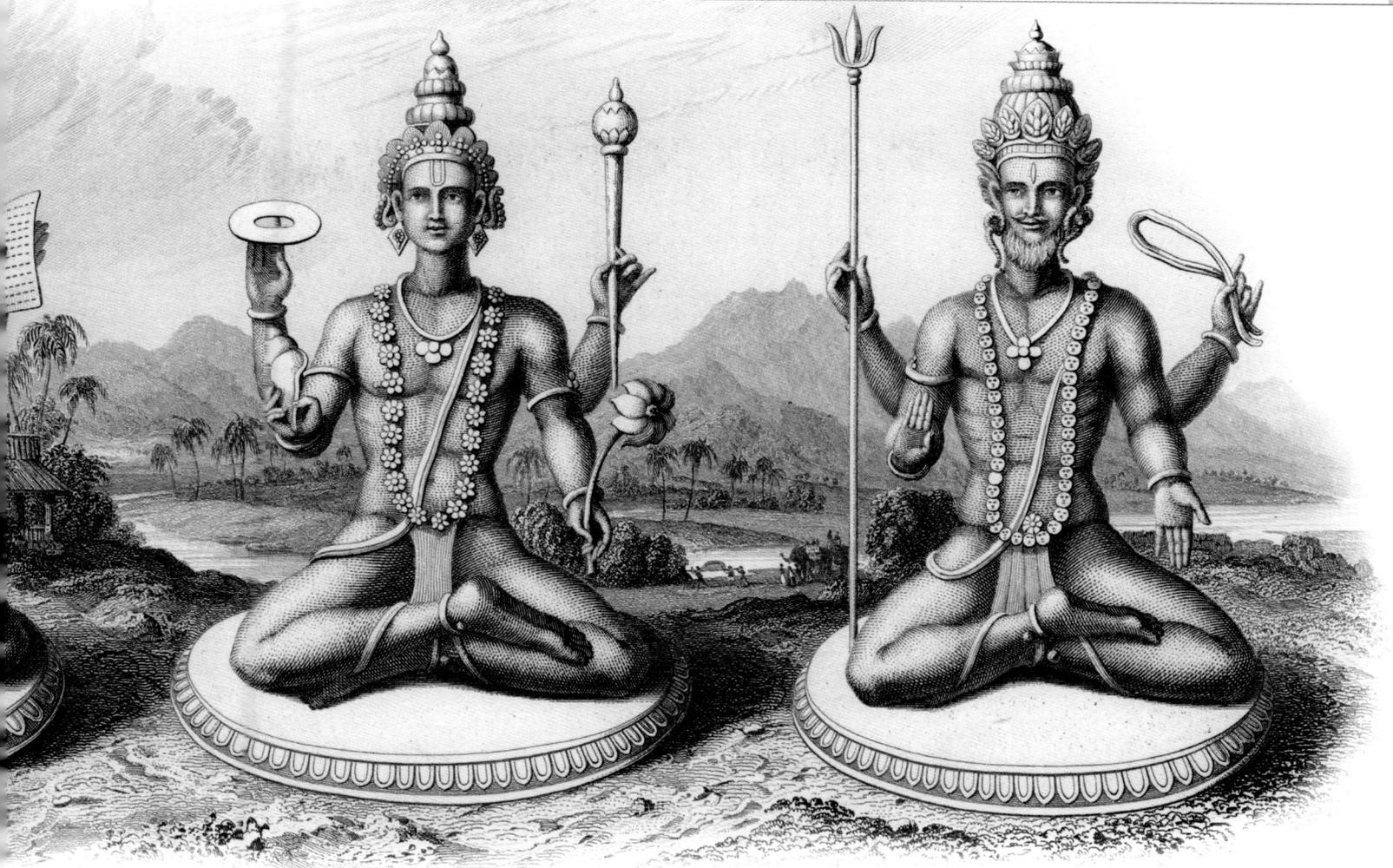

The lords of the directions

There are gods who are guardians of the directions, including Indra, Yama, Varuna, and Kubera, the son of Vishrava (See p 342).

Indra is the king of the gods, and wields a weapon called the Vajra. He is often invoked as a point of comparison for acts of valour, in particular his defeat of Vritra, the serpentine creature associated with drought. In the narrative of the *Ramayana*, however, Indra is more often than not defeated by Asuras and Rakshasas and seeks refuge.

Varuna is an important deity from the Vedic context, but rarely plays an independent role in the narrative of the *Ramayana*, often being associated with the waters. Yama is the deity who is associated with the spirits of the dead. Kubera, the god of wealth, is also Ravana's half-brother.

Agni, the deity of fire, plays an important role, as it is he who returns Sita to Rama (See pp 326–27). He is often invoked and revered as the witness and as the bearer of oblations. Vayu, the god of wind, features prominently in stories about Hanuman, the Vanara. The Ashvins, the twin gods of medicine with an affinity for horses, normally come up as the fathers of certain Vanaras. Apart from these, there are references to Maruts, gods associated with the winds, the story of whose origin is recounted in the *Ramayana* (See p 53), and to the Adityas, who do not have an independent role here, but are a class of solar deities.

> " ... The **Rakshasa named Ravana** is using his valour to **obstruct us** in every possible way... The **wind god** cannot blow against his flanks. On seeing him, the **god of the ocean,** with his turbulent waves, cannot make him tremble. "

THE ASSEMBLY OF THE GODS TO BRAHMA, *SARGA* (14), BALA KANDA

23

THE MANY FORMS OF VISHNU

Dashavatara

"... all the gods replied to the **undecaying Vishnu**. Assume a **human form** and slay Ravana in a battle…"

GODS TO VISHNU, *SARGA* (15), BALA KANDA

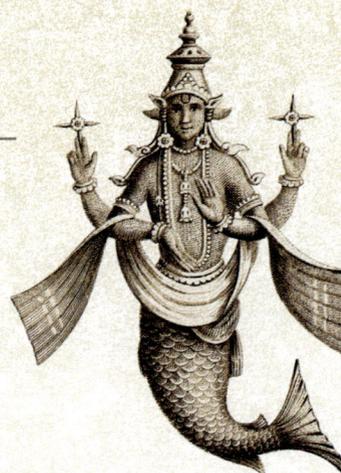

MATSYA, or the fish

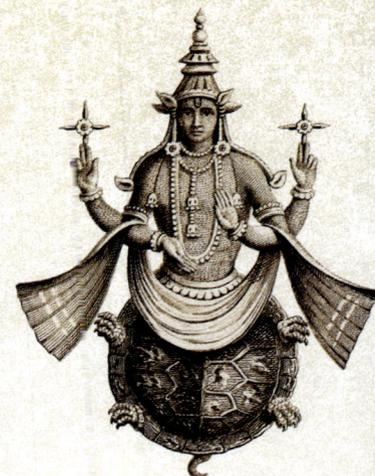

KURMA, or the tortoise

The term *avatara* literally means descent and is perhaps most commonly used to refer to the forms Vishnu, the Preserver of the universe, took. In the early narrations of Vishnu's *avatara*s, the causes are cosmic. Gods find themselves troubled, or there is a great calamity, and Vishnu takes on various forms. The lists sometimes vary, and the incarnations are not always numbered at 10. The reasons for the incarnation of Vishnu also vary. Some systems, for example, hold that the incarnation of Vishnu in human or animal form is occasioned by cosmic crises. Others intensify the aspect of love for devotees in his decision to incarnate. In any case, there is a list that has become more or less standard, and is commonly known as *Dashavatara*.

MATSYA, KURMA, AND VARAHA

In the first incarnation of Matsya, or the fish, the great Manu, son of the sun, found a fish that possessed a horn. It warned him of an impending flood, urging him to tie a boat with the seeds of creation to its horn. In this incarnation, Vishnu is also said to have killed the Asura Hayagriva, thus saving the Vedas or the ancient Hindu scriptures.

The second incarnation is said to be Kurma, or the tortoise. In this, the gods, defeated by their nemeses, approached Vishnu, who told them to form an alliance with the Asuras and churn the ocean of milk for nectar (See pp 52–53). He assured the gods that they would get nectar, and not the Asuras. Vishnu took on the form of a tortoise and bore the mighty Mount

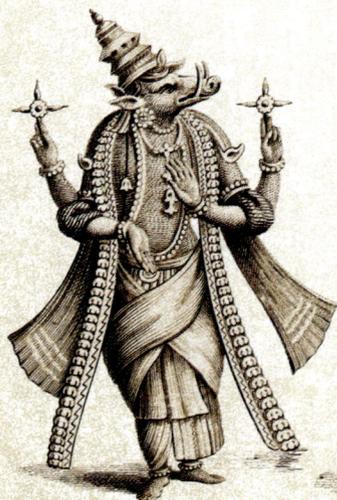

VARAHA, or the great boar

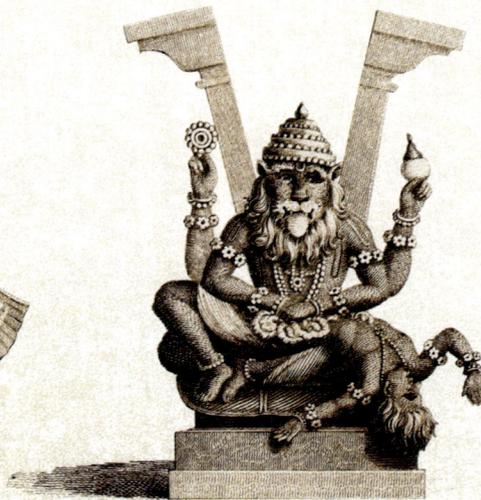

NARASIMHA, or the man-lion

VAMANA, or the dwarf

PARASHURAMA, or Rama with an axe

Mandara, which was used for churning. When the nectar emerged, Vishnu took on the form of a beautiful woman and deluded the Asuras so that most of them could not get nectar.

The third incarnation, Varaha, or the boar, was at the appeal of the gods, tormented by the Asura Hiranyaksha. As Varaha, Vishnu lifted the earth up on his tusks from where it was submerged in the waters.

THE MAN-LION

The Narasimha, or man-lion incarnation, is associated with the son of Hiranyaksha's brother, Hiranyakashipu, who had a particularly devout son

VAMANA AND PARASHURAMA

The fifth incarnation, Vamana, or the dwarf, took place after the righteous Daitya king Bali defeated the gods. Vishnu took the form of a dwarf and asked Bali for as much land as

Prahlada, a Vishnu devotee. Hiranyakashipu tormented the gods, but was killed when Vishnu appeared as Narasimha to protect Prahlada. The Asura had been granted a boon,

he could cover in three steps. Bali agreed. Taking on his immense form, Vishnu covered the earth, netherworlds, and heaven in three steps. The sixth incarnation is Parashurama, or Rama of the axe, the

which set a series of conditions for his death, which also meant that weapons could not affect him. Narasimha, therefore, killed him with his fierce talons.

son of sage Jamadagni and Renuka. He killed a Kshatriya called Kartavirya Arjuna, and is said to have wiped all the Kshatriyas off the face of the earth 21 times, giving it away to his teacher, Kashyapa.

RAMA

KRISHNA

BUDDHA

KALKI

RAMA, KRISHNA, BUDDHA, AND KALKI

The seventh incarnation was Rama, who was born to end the torment that Ravana caused the gods, whose story is recounted, among other places, in the *Ramayana*. The eighth incarnation of Vishnu is Krishna, the son of Vasudeva and Devaki of the Yadava clan, who killed his uncle Kamsa. He is worshipped and praised both as the young child and youth, and as the companion of the five heroes of the *Mahabharata*, who delivered the message of the *Bhagavad*

Gita in the middle of a battlefield. In some versions of the list, Krishna is replaced by Balarama, his older brother, while Krishna becomes the Supreme Lord, who incarnated as all the other *avatara*s.

The ninth incarnation is the Buddha, who is included in different ways. Sometimes, it is said that Vishnu took the form of Buddha to delude the evil, whereas later he came to be regarded as a benevolent incarnation, who embodied compassion. The 10th incarnation, Kalki, is yet to come.

> "That which is your **supreme form**, nobody knows it. The form which is in the **incarnations** is the one the **gods worship**."
>
> GODS TO VISHNU, *SARGA* (15), BALA KANDA

ANALYSIS

AVATARAS IN VALMIKI'S *RAMAYANA*

In the *Ramayana*, one finds a somewhat different scheme of *avatara*s, even though some from the standard list make an appearance, apart from Rama himself. As the Indologist Horst Brinkhaus has summarized, the Critical Edition of the *Ramayana* is quite thin on the *avatara*s that are mentioned. Some incarnations in the early part of the *Ramayana* have been determined as being later and only exist in some recensions of the text. Vishnu's exploits as Varaha are mentioned, but attributed to Brahma instead. A more complex picture appears in the Yuddha Kanda, when Brahma informs Rama of his divinity. Further, the word *avatara* does not have the same weight in Valmiki's *Ramayana* as it comes to have in later textual traditions.

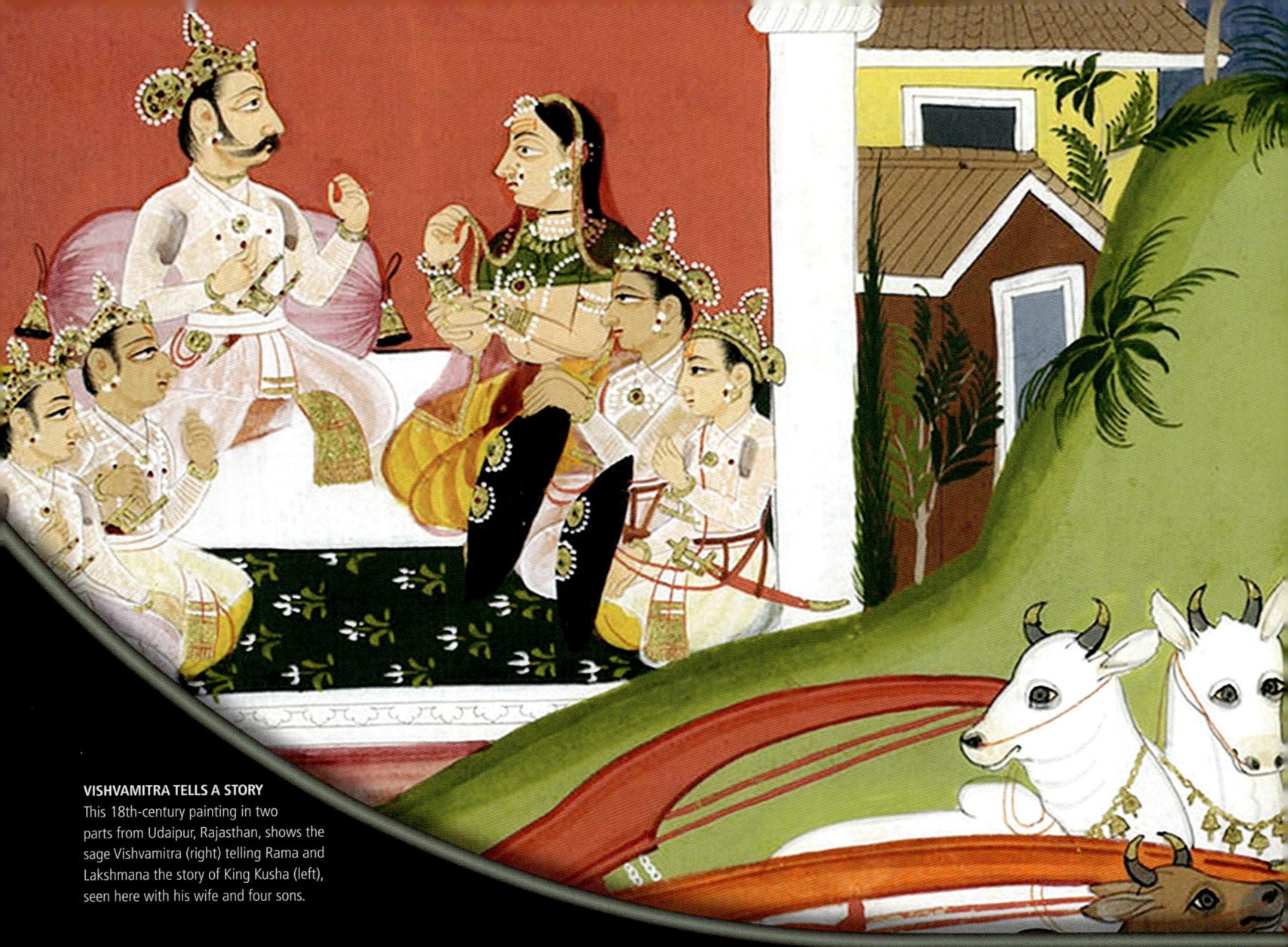

VISHVAMITRA TELLS A STORY
This 18th-century painting in two parts from Udaipur, Rajasthan, shows the sage Vishvamitra (right) telling Rama and Lakshmana the story of King Kusha (left), seen here with his wife and four sons.

1 BALA KANDA:
DAYS OF YOUTH

The first Kanda of Valmiki's *Ramayana*, the Bala Kanda is a prime exemplar of ancient literary art that depicts divine intervention in the affairs of the mortals. It is an account of the parallel tales of King Dasharatha's plight after being deprived of an heir, and the gods looking for a solution to the terrible atrocities that Ravana, the lord of the Rakshasas, is inflicting upon the world. It is at the crossroads at which these two narratives collide that gives us the birth of Rama, the future king of Ayodhya and the saviour of the gods and the earth.

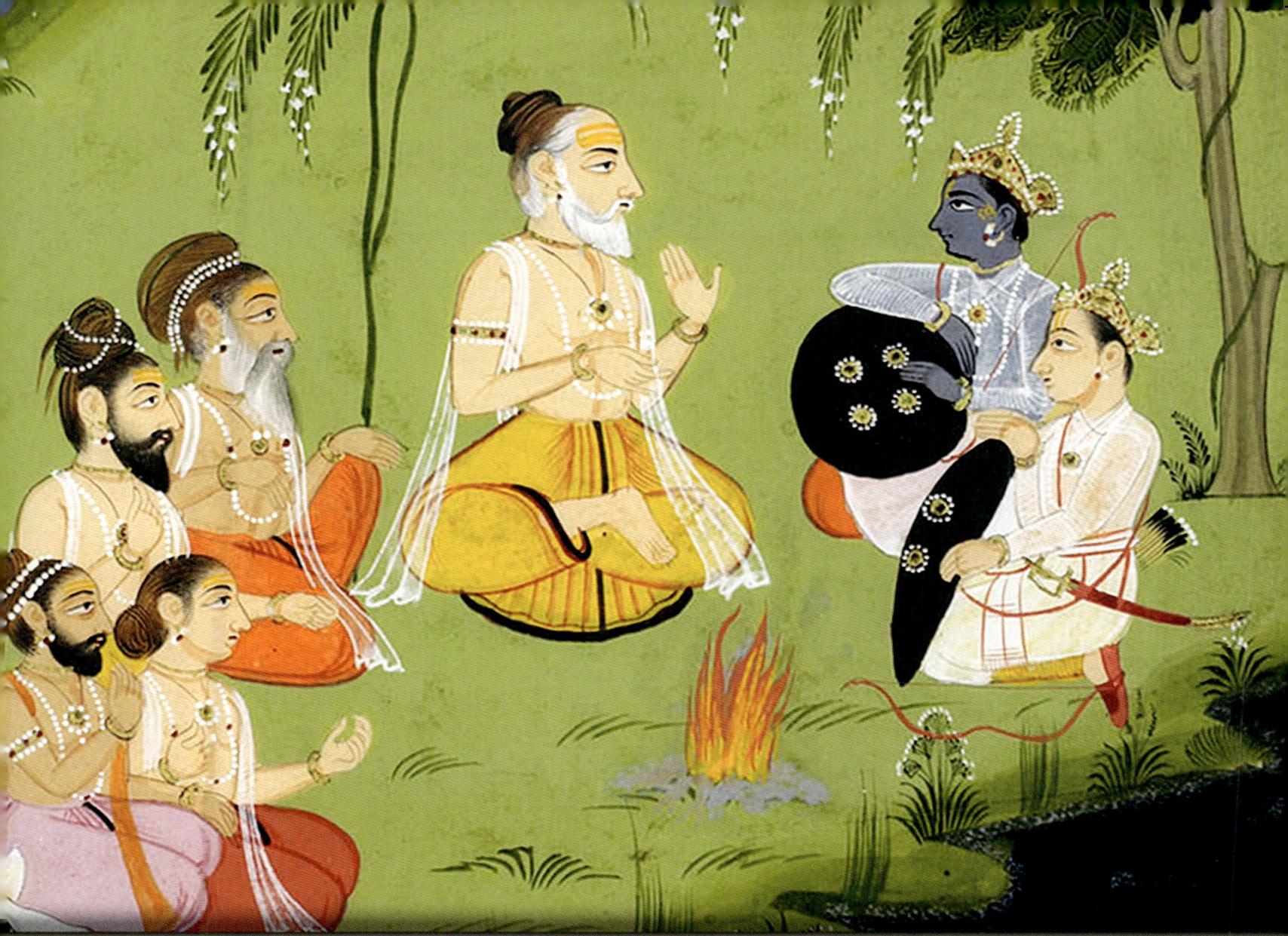

" ... for the sake of **sons** and for the sake of **heaven**... lord of the earth will have his desires satisfied... He will have four sons, infinite in valour. **They will establish lineages** and will be famous in **all the worlds**."

SAGE RISHYASHRINGA RECOUNTING LORD SANATKUMARA'S PROPHETIC WORDS FOR KING DASHARATHA. *SARGA* (10), BALA KANDA

Valmiki Learns of Rama

Even before the story of Rama, it is the story of the *Ramayana* that is told. Valmiki, the celebrated "author" of the *Ramayana*, was not its first narrator, but rather its first recorded audience. Many factors conspired to bring about its composition in verse, but it began as most stories do – with a question.

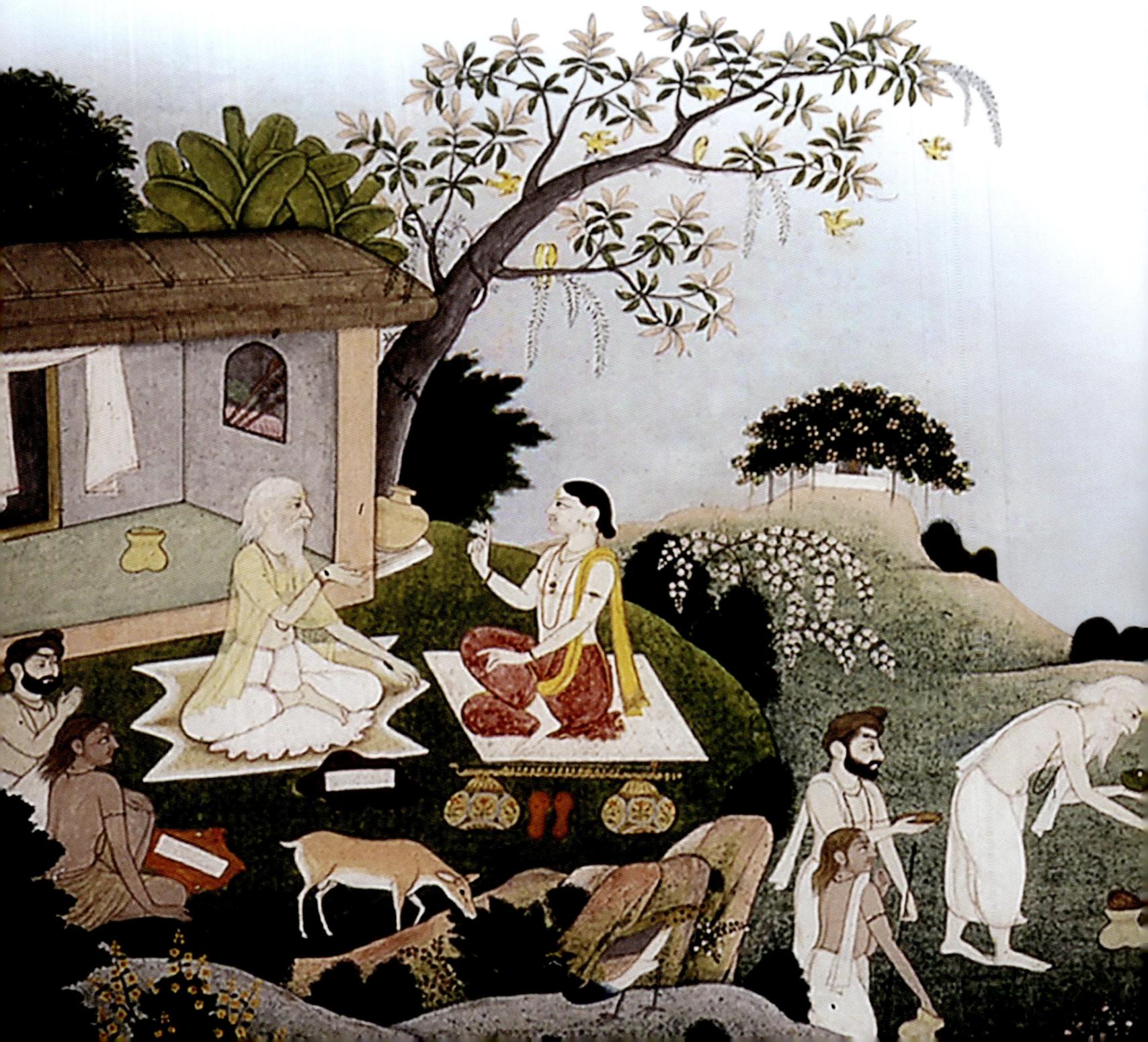

> "This is a **sacred account** and **destroys all sins**.
> It is **auspicious** and in **conformity** with the
> **Vedas**. If a person reads about this conduct,
> he is **cleansed of all sins**."

NARADA TO VALMIKI, *SARGA* (1), BALA KANDA

The ever-wandering celestial sage, Narada, renowned for his storytelling skills and knowledge of the three worlds, visited the great ascetic, Valmiki, at his hermitage on the banks of the River Tamasa.

The sage was pleased to see him. He had been struggling with a question for some time, and thought that if there was anyone who would know the answer, it would be Narada.

THE WANDERING SAGE
This late 18th-century painting from Kangra, Himachal Pradesh, created with paint and gold on paper, has three sections that depict Valmiki worshipping Narada on his arrival (below), Narada recounting Rama's story (extreme left), and his departure (top right).

So, he asked, "Who in this world is endowed with all exceptional qualities? Who knows dharma, the path of righteousness, and is truthful? Who is firm and has a good character? Who is so fierce that when he is angered in battle, even the gods fear him? And who, even being so, has conquered his anger? Who is wise and a benefactor of all beings? Who is both supremely capable and beautiful?"

Valmiki was not asking about historical figures or celestial beings. The object of his inquiry was a person who walked the earth as he spoke – "now, in this world".

In praise of Rama
Pleased with the question, Narada replied, "The qualities you list are rare, but I know of such a man. He is Rama, born to the Ikshvaku lineage." He began recounting Rama's qualities and they were even more spectacular than the ones Valmiki had asked for. Rama, the son of Kaushalya and Dasharatha, equalled the ocean in depth, the Himalayas in firmness, Vishnu in valour, the moon in beauty, the fire of death itself in anger, the earth in forbearance, and Kubera, the god of wealth, in charity. He was like dharma personified in matters of truth. He was intelligent, just, eloquent, glorious, and a destroyer of enemies. He was beautiful, and had a pleasing complexion, large eyes, a beautiful forehead, broad chest, deep collarbones, and long arms that went down to his knees. He knew the essence of the Vedas and subsidiary disciplines. He was the protector of all beings and of dharma.

Narada tells the story
The sage told Valmiki of King Dasharatha and his wish to install his eldest son, Rama, as the crown prince. He told him of Rama's 14-year exile in the forest and his great battle with Ravana, the Rakshasa king.

He narrated the details of Rama's return, still speaking of past events. Finally, Narada described how Rama's perfect reign would be, talking of the past, present, and then the future.

After ruling for 11,000 years, Narada said, Rama would go to Brahma's realm. He ended his account by saying, "This is a sacred account. Reading it

»

CHARACTER PROFILE
NARADA

Born to Brahma, the Creator of the universe, through his mental powers and not by conjugation, Narada is also associated with Vishnu, the Preserver. He is often depicted as travelling to various realms, singing and chanting the name and stories of his beloved Vishnu. Known for his inability to stay in a place for too long, he conveys vital information to the gods and other beings and is key to the transmission of narratives.

In an important parallel to this part of the *Ramayana*, Narada has a significant conversation with the sage, Vyasa, at the beginning of the *Bhagavata Purana* and emphasizes the importance of devotion. It is after this that the sage composes the Puranas, a key part of sacred Hindu literature.

will cleanse sins, bring good luck, and greatness." So saying, the celestial sage finished reciting Rama's story.

Valmiki and his disciples paid their respects, and Narada left soon after, making his way back to heaven.

By the river

Some time later, Valmiki decided to visit the banks of the River Tamasa with his disciple, Bharadwaja. A tributary of the mighty and sacred River Jahnavee (Ganga), Tamasa flowed close to the hermitage.

KEY CONCEPT

SHLOKA IN SANSKRIT POETRY

Valmiki is widely revered as the first poet, and the *Ramayana* is often regarded as the archetypical poem. The origin of poetry in Sanskritic literary tradition is inextricably intertwined with the recognition of the pain of separation (in another). So, Sanskrit poetry emerges from versified grief or *shoka*.

The term *shloka*, commonly used to mean a verse in Sanskrit, consists of several Vedic metres, one of which is called *anushtubh*. A *shloka* has eight syllables in each quarter. Most syllables in the *shloka* metre can be either long or short, in terms of how long it takes to pronounce them, but the fifth, sixth, and seventh are relatively fixed. Most of the *Ramayana* is composed in this metre.

ANCIENT PARCHMENTS

On reaching its banks, Valmiki found himself drawn to the beauty of its waters, which were crystal clear with not even a trace of mud.

He turned towards his disciple, Bharadwaja, and said, "O son! This *tirtha* (pilgrimage), beautiful and clear, is like the mind of a righteous person, one who is devoid of any impurities, has goodness in his heart, and follows the prescribed principles."

He instructed his disciple to bring him a pot of water and his garment made of bark. Bharadwaja, always attentive and willing, handed him the garment and pot.

A cruel act

As Valmiki walked towards the water, he glanced at the dense forest and noticed a pair of curlews. Devoted to each other, they seemed oblivious to the sage. As they made love, they were so engrossed in each other that they did not notice the Nishada (hunter) nearby.

As the great sage looked at the birds, the Nishada struck the male with an arrow. It fell to the ground, trembling and

soaked in its blood. Seeing her dying mate, the female cried out in pathetic tones. Valmiki saw the struggling bird, desperate for life, and heard the cries of separation of the female.

The first *shloka*

Shocked at this cruel interruption of love, Valmiki, overwhelmed with grief, reacted with deep compassion and pain. He spoke:

> *maa nishaada pratishtha tvam/ agamah shashvateeh samah//*
> *yat-kraunca-mithunad-ekam/ avadhih kama-mohitam //*

("O Nishada! This couple of curlews was in the throes of passion and you killed one of them. Therefore, you will possess ill repute for an eternal number of years.")

Astonished that he had spoken these words aloud, Valmiki wondered, "What are these words that I have uttered while overcome with sorrow?"

Grief, in verse

Valmiki turned to Bharadwaja and said, "While overcome by pain, I spoke these words. This rhythmic statement, with quarters of equal syllables that I uttered, while afflicted with *shoka* (grief), must be *shloka*."

In that moment, poetry emerged from the experience of the pain of another.

Later, as they walked back, Valmiki could not get the *shloka* out of his mind, and wondered about its significance.

At the hermitage, Valmiki's disciples repeated the newly minted verse, and grief – crystallized in the verse – completed its journey to poetry, through their participation and repetition.

"It was **chanted** by the great sage in **four** *padas*, with an **equal number of** *aksharas* in each. Because of **repeated recitation** and because it **emerged from sorrow**, it came to be known as a *shloka*."

ON THE RECITAL OF THE *SHLOKA* BY VALMIKI'S DISCIPLES, *SARGA* (2), BALA KANDA

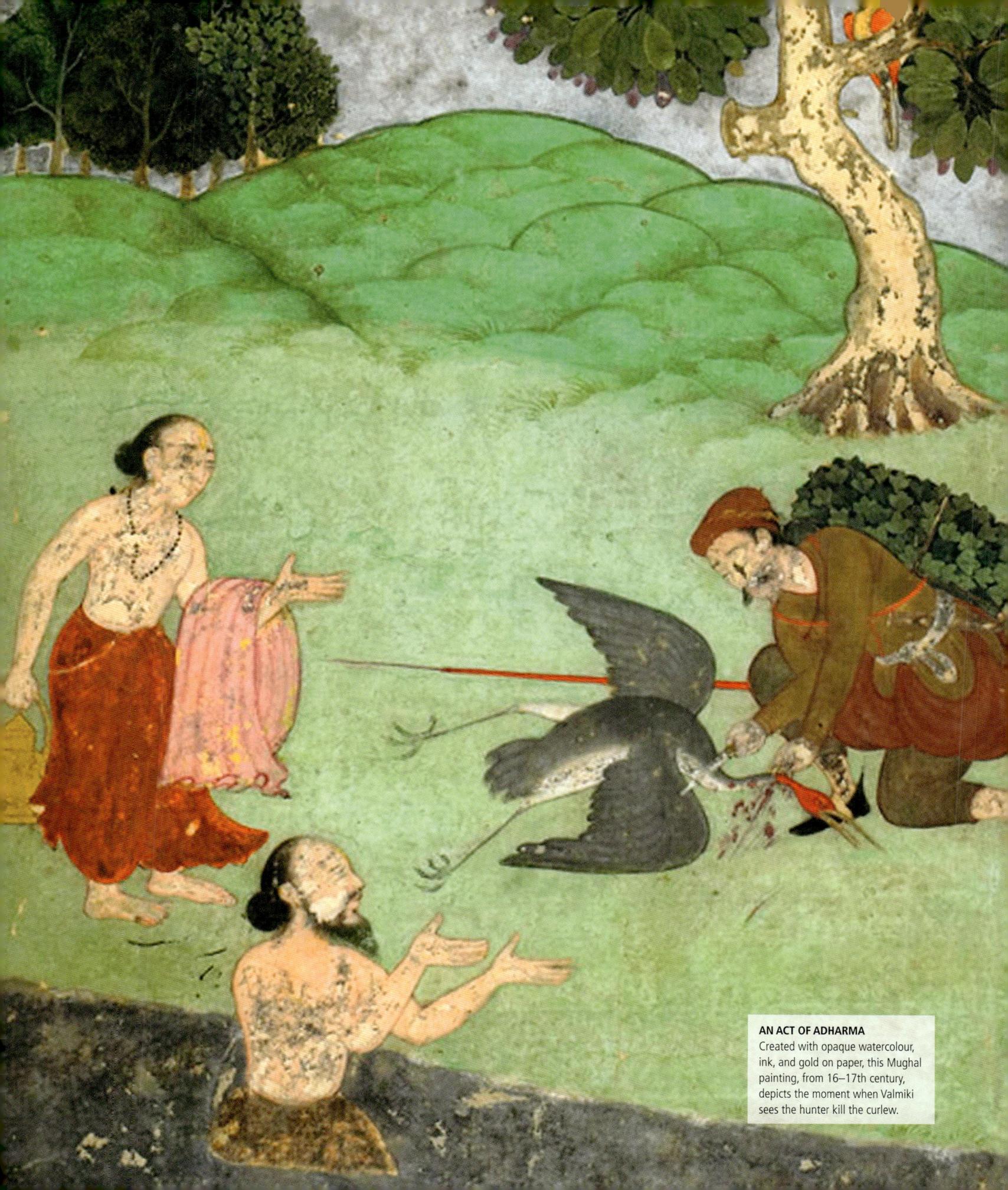

THE CREATOR OF THE UNIVERSE
A 19th-century gouache painting depicts Brahma.
He has four faces that point towards the north, east,
south, and west. His faces, it is believed, symbolize the
four Vedas, the four yugas (ages for humankind), and
the four varnas (traditional social classes).

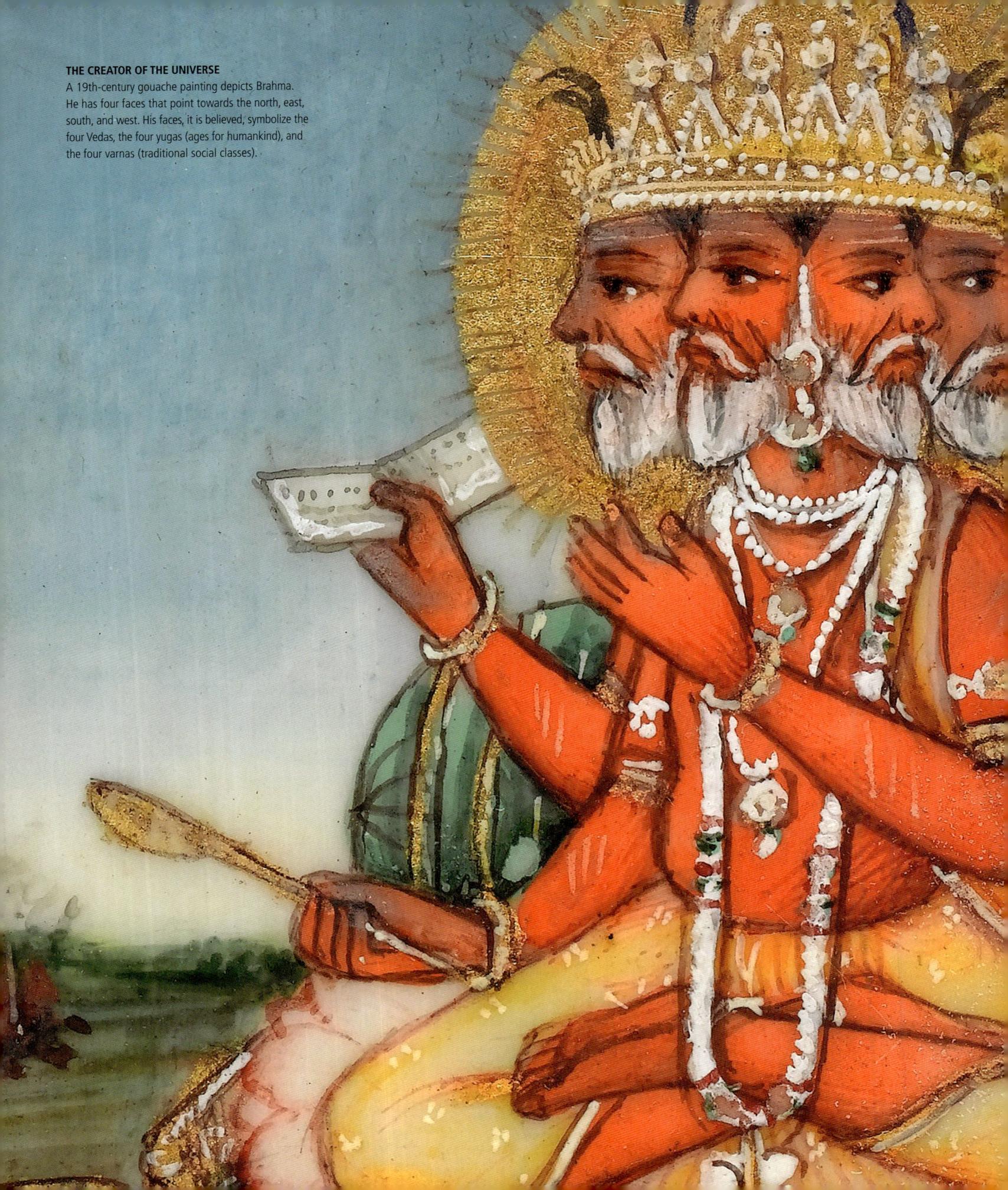

Ramayana's Composition

Valmiki sat meditating, unable to forget the curlews or his own peculiar verse, composed in a moment of grief. At that moment, a celestial guest appeared and set his mind at ease.

Valmiki sat meditating when Brahma, the Creator of the universe, appeared before him. Astonished, Valmiki prostrated and greeted him with folded hands.

He then paid Brahma his respects and offered him *padya* (water to wash his feet), *arghya* (a gift), and *asana* (a seat).

Valmiki sat down but, despite being in front of the great lord, was unable to forget the curlews and the cruelty of the hunter's act. Overcome by grief, he uttered the verse again.

Seeing Valmiki's dilemma, and perhaps delighted at the fruition of his plan, Brahma said with a smile, "Do not think about this any more. You have composed a structured *shloka*. The metre and speech were born because I willed it so.

"Best of seers, now use this beautiful structure to compose a complete account of Rama's conduct as you heard it from Narada.

"Nothing of the acts of Rama, Sita, or Lakshmana shall remain hidden from you. You shall have full knowledge of all they did, in public or private. Not a word of what you say in this composition shall ever be rendered false."

Thus, according Valmiki supernatural insight, Brahma vanished.

> **"** As long as there are **mountains… rivers** on this earth, till such a time, this ***Ramayana* account** will circulate in the worlds. **"**
>
> BRAHMA TO VALMIKI, *SARGA* (2), BALA KANDA

Singing Rama's Story

Poetry only fulfils its purpose when it is recited well. This is true even more so for Rama's story. After all, hadn't Brahma himself gone through such trouble to find the perfect narrator? So, Valmiki wondered who could carry this exceptional composition forward.

Valmiki sat in deep thought, wondering who was skilled enough to recite Rama's story. At that moment, his disciples, Lava and Kusha, arrived and touched his feet, interrupting his thoughts.

The perfect storytellers

Born at the hermitage, Lava and Kusha were princes in the garb of ascetics and well versed in the Vedas and dharma. They were virtuous, intelligent, and beautiful. Indeed, they were Rama's mirror image.

Blessed with pleasing voices, they possessed an accurate sense of pitch, pause, tune, rhythm, and all the skills and knowledge of the Gandharvas, who served as musicians in the palace of the gods. They were perfect to tell Rama's story to the world.

The *Ramayana*

It was a lovely composition, meant to be sung in pleasant tones, categorized into three scales and seven notes. It was perfect for singing as it could be adjusted to suit any instrument. It had all the rasas, or flavours, which poems should possess. The narrative itself was extraordinary, nothing like what the world had witnessed before.

Telling Rama's story

The two brothers memorized the *kavya* or epic poem, learning every word to ensure that they would not make mistakes. They learnt of Rama's commitment to dharma, his brother, Lakshmana's devotion, the greatness of Sita's character, and the prowess of Hanuman.

With unmatched singing skills, they recited the poems with great precision and

THE GREAT EPIC
This 18th-century painting from Kangra, Himachal Pradesh, depicts Valmiki reciting the *Ramayana* to Lava and Kusha. Valmiki was a celebrated poet, who did not just pen the epic, but was also an integral part of the story.

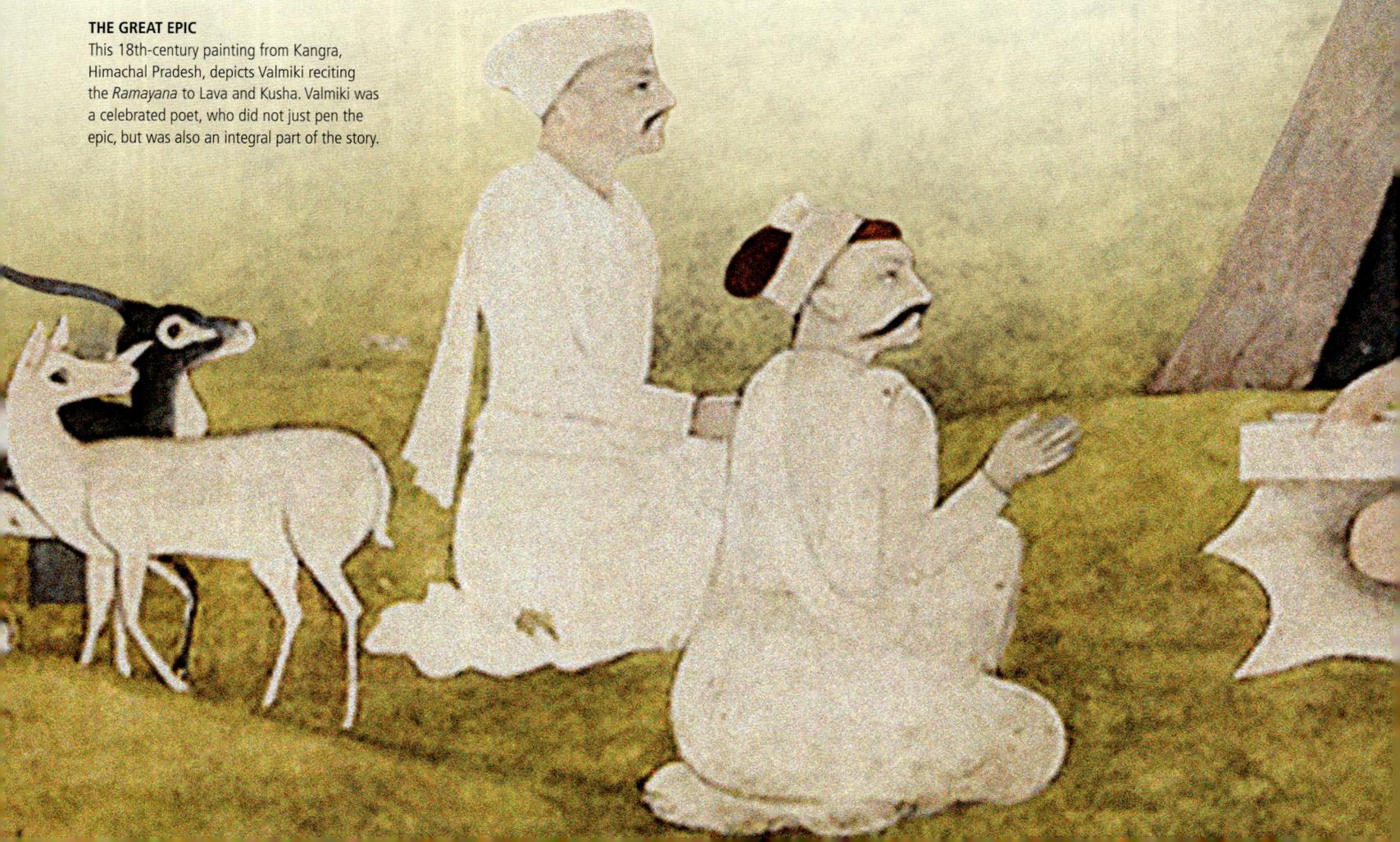

> "Those **two immersed themselves** in it... Accomplished in a **wealth of** *svaras*, they sang together, **melodiously** and with **affection**."

SAGES IN PRAISE OF LAVA AND KUSHA'S RECITAL OF THE *RAMAYANA*, *SARGA* (4), BALA KANDA

KEY CONCEPT
RASAS

The idea of the rasa is central to parts of the Indian aesthetic tradition. The Sanskrit term means flavour or juice and there are eight or nine rasas. These include, the erotic or romantic, heroic, grotesque, furious, mirthful, terrible, piteous, wonderful, and pacific. Valmiki's *Ramayana* is sometimes classified as the piteous, because of the ultimate separation of Rama and Sita. Playwright Bhavabhuti considers this rasa central to his narrative too, the others only relating to it as whirlpools relate to water. Rama, though, is sometimes seen as an embodiment of all the rasas at different points in the narrative.

A BHARATANATYAM DANCER portraying the *veera* or heroic rasa

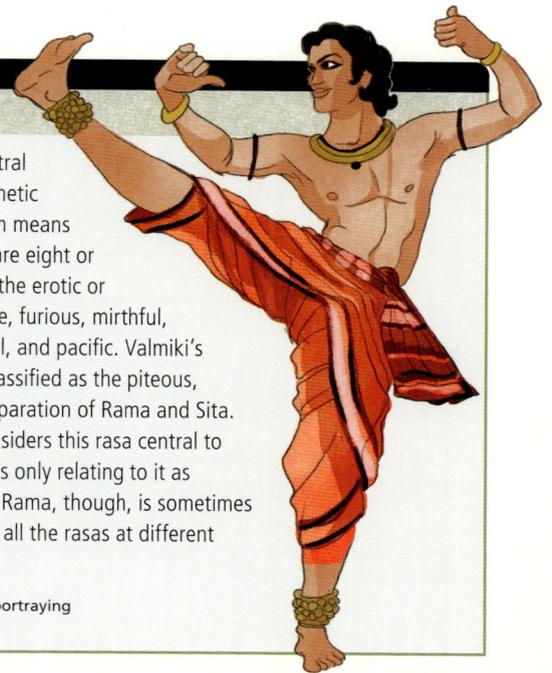

emotion just the way Valmiki taught them. So powerful was the combined effect of Valmiki's composition and their recitation that their ascetic audiences often had tears in their eyes.

In one such gathering, the sages were so overwhelmed that they exclaimed, with tears in their eyes, "The singing is so sweet as is the *shloka*. It is almost as if these events, which happened a long time ago, are taking place before our very eyes!" Pleased, they presented the young brothers with a water pot, an honour fit for ascetics.

Rama hears of the brothers
Lava and Kusha travelled the lands telling Rama's story. Once, while singing on the royal road, Rama happened to see them and was so moved by what he had heard that he took them to his palace. He honoured them and requested them to retell the account.

Sitting on his divine golden throne, surrounded by his brothers and ministers, Rama said, "Listen to the story that these young men sing. Look, they are dressed as ascetics, but they bear all the marks of kings. Their splendour seems to rival that of the gods themselves. It is said that the story that they tell is remarkable, both in its words and meanings. It brings prosperity, even unto me."

The brothers began singing in their melodious voices. Their recitation had a wondrous effect on the listeners, allowing them to experience the events in an exceptionally vivid way.

Rama, the perfectly poised king who had lived these events, found himself overwhelmed. He watched Lava and Kusha's performance and was soon immersed in the story.

THE EUPHONIOUS ONES

Lava and Kusha

"Those two brothers had **melodious** voices and looked like Gandharvas... Having **emerged** from **Rama's body**, they were like two **mirror images of him**."

DESCRIPTION OF LAVA AND KUSHA, *SARGA* (4), BALA KANDA

In Valmiki's *Ramayana*, Lava and Kusha are, paradoxically, both omnipresent as well as rarely seen. Indeed, one could argue that we know more about Rama's relationship with Bharata and Lakshmana's sons than we do about his own – even after they have ostensibly moved in with him following Sita's departure.

Narrating their own story

Lava and Kusha make their presence known right at the beginning of the narrative. In fact, they are the ones narrating Rama's detailed story, with Rama himself as the audience. It is the king of Ayodhya himself, who finds these two singers and brings them to the palace so that they may render the narrative in the assembly.

Since Valmiki is granted divine sight in order to be able to compose the *Ramayana*, he is able to see the twins' future as well as Rama's, and can, therefore, have them narrate it.

It is then that Lava and Kusha tell the story of how they are born to Sita while she lived under Sage Valmiki's protection, and while Shatrughna was present in the hermitage.

We are told of how the sage names them Lava and Kusha. Valmiki teaches them the story of the *Ramayana*, and their skill and prowess as singers are emphasized repeatedly, as is the efficacy of their narration.

Their activity in the narrative is virtually limited to their narration of the tale in the Uttara

THE SONS OF RAMA AND SITA
A watercolour painting of Lava (right) and his twin brother Kusha (left), adorned with jewels and wielding weapons.

Kanda, and thereby, setting into motion Sita's final departure.

Rama's heirs

After that, we hear of Rama arranging for Bharata's and Lakshmana's sons receiving realms of their own to reign over, likely because Shatrughna's and Rama's children would receive their respective kingdoms. It is interesting to note that while Dasharatha

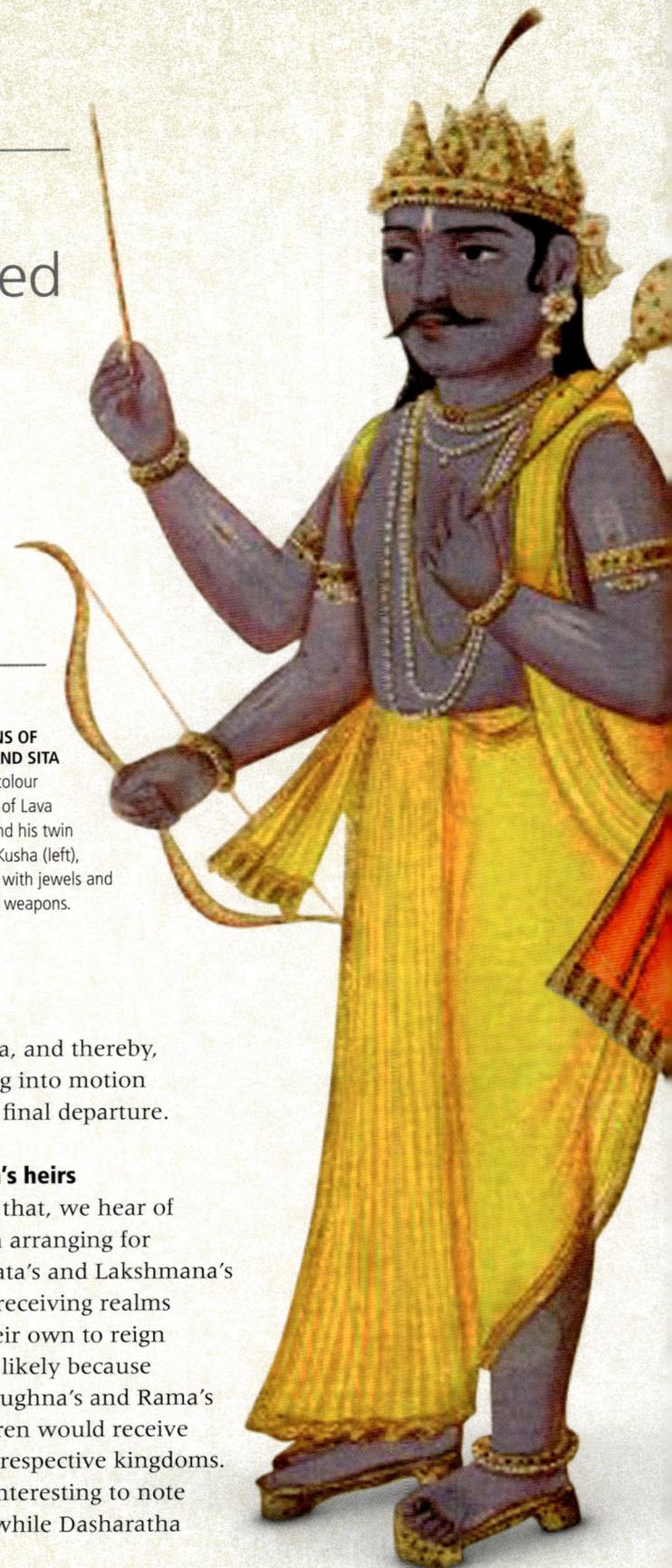

never thought of dividing his kingdom, Rama ensures that all eight of their children have independent realms.

Encountering the twins

The twins begin to have the specifics of their characters filled in by later writers.

The 8th-century Sanskrit playwright Bhavabhuti gives the readers one of the most moving descriptions of the discoveries of the brothers in the *Uttararamacharita*. Janaka, Kaushalya, and Vasishtha's wife Arundhati spot Lava at Valmiki's hermitage and he demonstrates a familiarity with Rama's story. Over the course of the next couple of acts, people who know Rama and Sita encounter young Lava, and, instinctively, respond with affection or respect.

In Arundhati's case, Lava leaves with his friends while Valmiki tells them, rather mysteriously, that all shall be revealed in due course.

Chandraketu, Lakshmana's son, meets Lava in battle as the latter seeks to lead away the sacrificial horse he is supposed to protect. He does this despite a feeling of deep affection for Lava. Sumantra, the charioteer, looks at Lava and is reminded of Rama. The conversation veers towards Rama and Lava's irreverence angers Chandraketu.

Indeed, this point in the play contains an unbridled criticism of the kind Bhavabhuti rarely indulges in, in *Uttararamacharita*. Generally, even as Rama is criticized for abandoning Sita, it is usually tempered by the description of his terrible state, or blunted by his own comments about how cruel his act was.

Lava, however, knows of Rama only through his story and finds no reason to be sympathetic. He challenges Rama's earlier exploits, which constituted the legend. When Rama actually sees the two young men, however, and lovingly embraces him, Lava's earlier opposition disappears. Instead, he asks Rama to disregard his childish insolence, and Rama responds by saying that it is an ornament of heroes.

Following a complex series of events, including a play within a play, Rama is reunited not only with his sons, but also Sita.

In later narratives

While Bhavabhuti's version is imbued with a certain warmth, other versions where the twins try to acquire the sacrificial horse, often culminate in a confrontation.

In these, each of Rama's brothers face the twins in battle and are defeated at their hands. Rama then enters the battlefield and, sometimes, actually succumbs, temporarily, to death at his sons' hands.

Most of these, however, remain about Rama and his reunion with Sita and his sons. Sanskrit poet and dramatist Kalidasa, in the *Raghuvansha* ("The Raghu Lineage"), describes how Rama's younger brother and cousins regard Kusha with affectionate respect, as is the norm in their family.

He talks about Kusha's resettlement of Ayodhya, and his transfer of Kushavati, the region Rama had assigned him before the latter's ascent, to sages. He also talks of how the jewels that Sage Agastya once bestowed upon Kusha fell into the River Sarayu, leading, eventually, to Kusha marrying a Naga woman called Kumudvati. The two later have a son named Atithi, through whom the Raghu lineage lived.

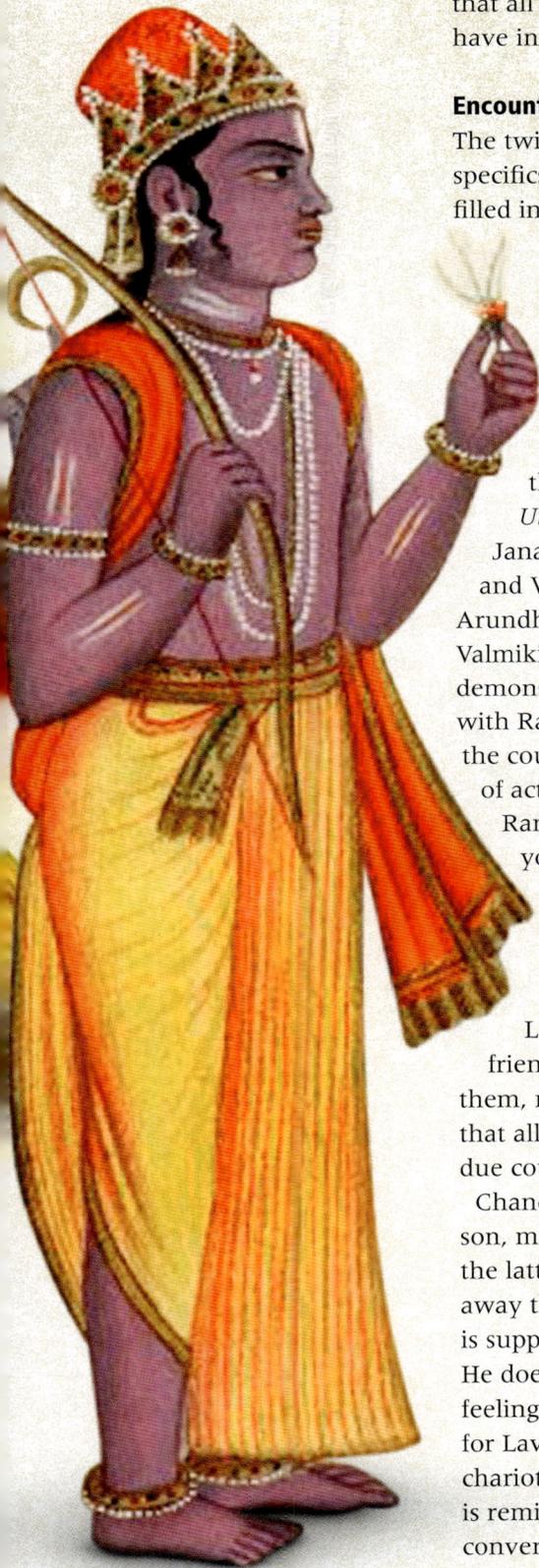

37

For the **Want** of a **Son**

Desperate for an heir, the great king Dasharatha prayed to the gods and conducted an elaborate sacrifice. Meanwhile, tormented by the powerful Rakshasa Ravana, the gods begged Vishnu for deliverance. Indeed, many things had to come together for the birth of Rama and his brothers.

The story of Rama began in the famed city of Ayodhya, the capital of Kosala, on the banks of the River Sarayu. Dasharatha, born to the Ikshvaku lineage, ruled the vast kingdom from this glorious city.

An accomplished warrior and a just ruler, he devoted himself to the pursuit of dharma, the path of righteousness and truth. His kingdom was a place of scholarship and valour, whose citizens performed their social and religious duties. His counsellors were competent and his teachers, the great sages, Vasishtha and Vamadeva, were the very standards of wisdom. The king was like the sun, bright and illuminated, and seemed to want for nothing.

However, haunted by the absence of an heir, the king often wondered who would take his lineage forward.

An ancient account

One day, driven by the desire for an heir, the king decided to appease the gods and conduct a special horse sacrifice. Dasharatha asked Sumantra, his trusted advisor and charioteer, to summon the priests so that they could begin preparations.

Sumantra, however, had heard that the birth of Rama had been preordained. He told the king of an ancient account, when the sage Sanatkumara informed an assembly that Dasharatha would request the sage Rishyashringa (See box) to perform a sacrifice. The king would then father four sons.

> "O Vishnu! **Divide** yourself into **four parts** and **become their sons**... **Defeat Ravana** in a battle... **Save** the **ascetics**..."

THE GODS TO LORD VISHNU, *SARGA* (15), BALA KANDA

Dasharatha immediately set off for the kingdom of Anga, where Rishyashringa lived. There, he requested the sage's presence at the sacrifice. The sage agreed and accompanied the king to Ayodhya, where the citizens welcomed them with the blowing of conch shells and the deep beats of drums.

The sacrifice

Rishyashringa performed the rites and, a year later, sacrificed the horse as a part of the ritual. This merely cleansed the king of his sins. The sage began the second sacrifice that would help Dasharatha get children. The gods gathered in the heavens, as he recited the mantras.

The assembly of gods

The gods, Gandharvas (magical beings), and sages gathered to observe the rituals. They saw Brahma, the Creator of the universe, and pleaded, "The Rakshasa king, Ravana, whom you had once granted a boon, torments us. We cannot perform our duties. The wind cannot blow near him, the ocean does not dare disturb him, and the sun is too afraid to scorch him. Help us."

Seeing them despair, Brahma offered them a way out. He told them that though Ravana had listed several beings at whose hands he could not be killed, he had not included humans. "He does not respect humans, and it shall be a man who brings about his death," he said.

Vishnu decides to be reborn

Vishnu, the Preserver of the universe, arrived just then. His radiance cast a light around him. The gods begged him to defeat Ravana. "He is so fierce in his energy that he makes virtuous ascetics scream in fear," they said.

STORY FROM THE *RAMAYANA*

A SAGE HELPS

Once, the kingdom of Anga faced a long period of drought, because of a transgression that King Romapada committed. The priests told the king that only the sage Rishyashringa could bring relief to the kingdom. They suggested that the king send courtesans to invite the sage as he knew nothing of women. His arrival in Anga brought rain, eventually ending the drought. The king then honoured him and gave his daughter, Shanta, to him in marriage.

A SCULPTURE OF RISHYASHRINGA outside the Hazara Rama temple in Hampi, Karnataka

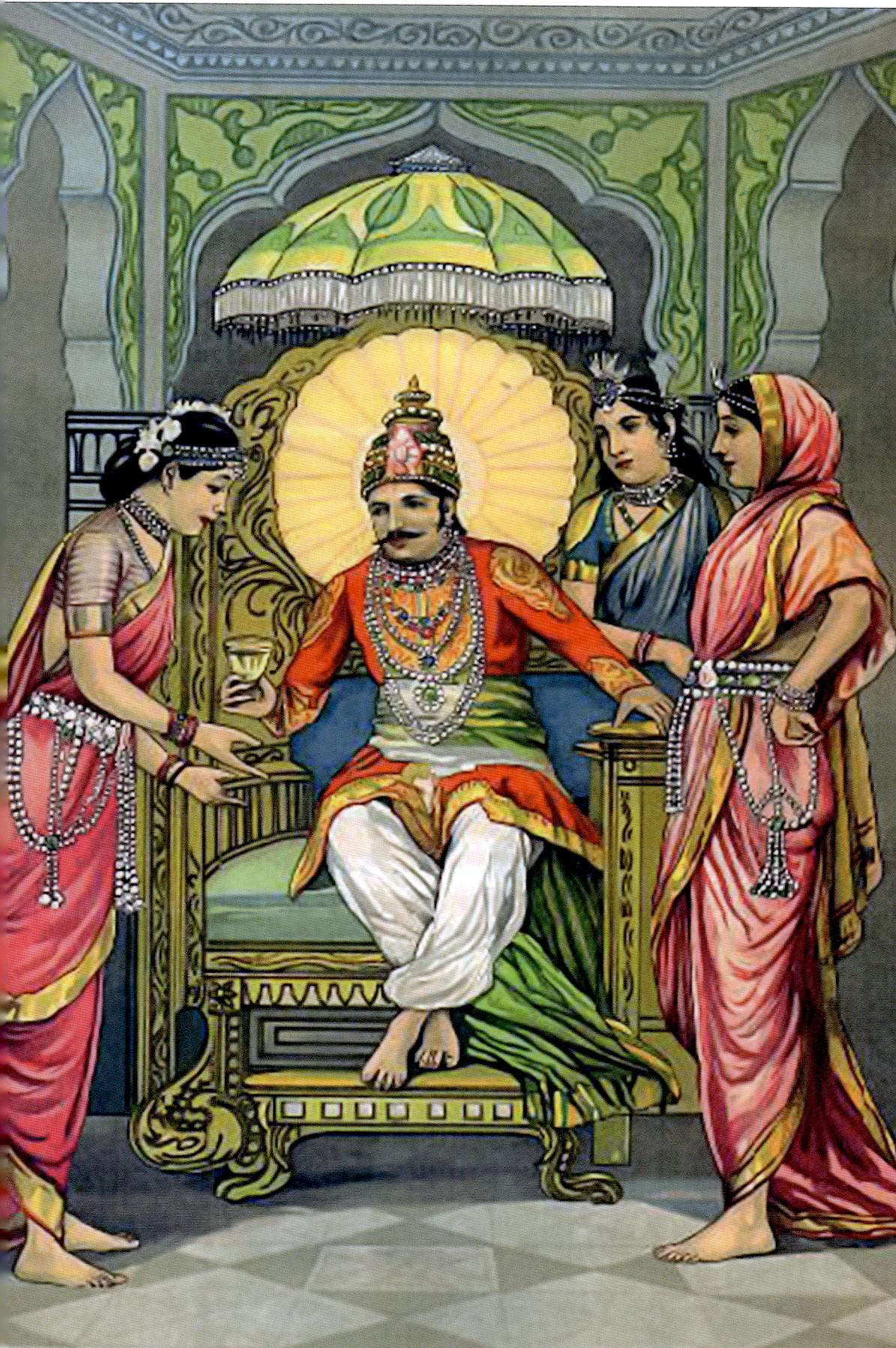

They pointed at the virtuous Dasharatha and his wives and said, "O Vishnu! Divide yourself into four parts and become their sons. Defeat Ravana."

Vishnu asked in a gentle voice, "How would I slay the lord of the Rakshasas?" "Assume a human form," they pleaded. "Only a human can kill Ravana." The compassionate Vishnu agreed to their request.

It was an opportune moment, for Dasharatha was in the middle of the sacrifice for a son.

A divine gift

As Dasharatha performed the rituals, a resplendent figure emerged from the holy fire, holding a celestial dish made of molten gold. He was as tall as a mountain and blazed like the sun. He said, "O king. Take this *payasam* (rice pudding) that the gods have prepared."

He asked the king to give the pudding to his wives and they would be blessed with sons. The king accepted it and rushed to the palace inner quarters and to his three queens.

DIVINE GIFT
An oleograph by celebrated artist Raja Ravi Varma depicts Dasharatha offering the divine *payasam*, or rice pudding, to his three wives.

Rama is Born

The events to effect the birth of Rama were now set in motion. As the king prepared to welcome his sons, the gods readied an army, waiting for the moment Rama would wage a war against Ravana.

Dasharatha divided the *payasam* (rice pudding) and offered the first half to Kaushalya, the eldest queen. He divided the rest and offered half of it to Sumitra. Of the quarter that remained, he gave one half to Kaikeyi and the other to Sumitra once again.

In the heavens, Brahma knew Vishnu would need allies during his time on the earth. So, he instructed the other gods to have sons, who would have the bodies of monkeys and possess magical powers. The gods went forth and produced powerful progeny with women – earthly and semi-celestial. They were 10 million such beings with immense strength and intelligence who, in turn, fathered more. The Vanaras, as they came to be called became Rama's future army.

At an auspicious moment on the ninth day of the spring month of Chaitra, Kaushalya gave birth to Rama, who possessed all the divine markers of Lord Vishnu. She was radiant, almost like Aditi, the mother of the gods. Kaikeyi gave birth to Bharata, the one imbued with truth. Sumitra bore two sons, for she had received two portions of the pudding. They were named Lakshmana and Shatrughna.

On the twelfth day after their birth, in a grand naming ceremony, the sage Vasishtha gave the four princes their names. They would be well versed in the Vedas, upholders of dharma, and devoted to the welfare of all creatures.

In heaven, the gods rejoiced, for they knew that Ravana's end was near.

" ... **Kaushalya** gave birth to the immensely fortunate **Rama**... who possessed all the divine signs. With the infinitely **energetic son**, Kaushalya was radiant."

KAUSHALYA, AFTER THE BIRTH OF RAMA, *SARGA* (17), BALA KANDA

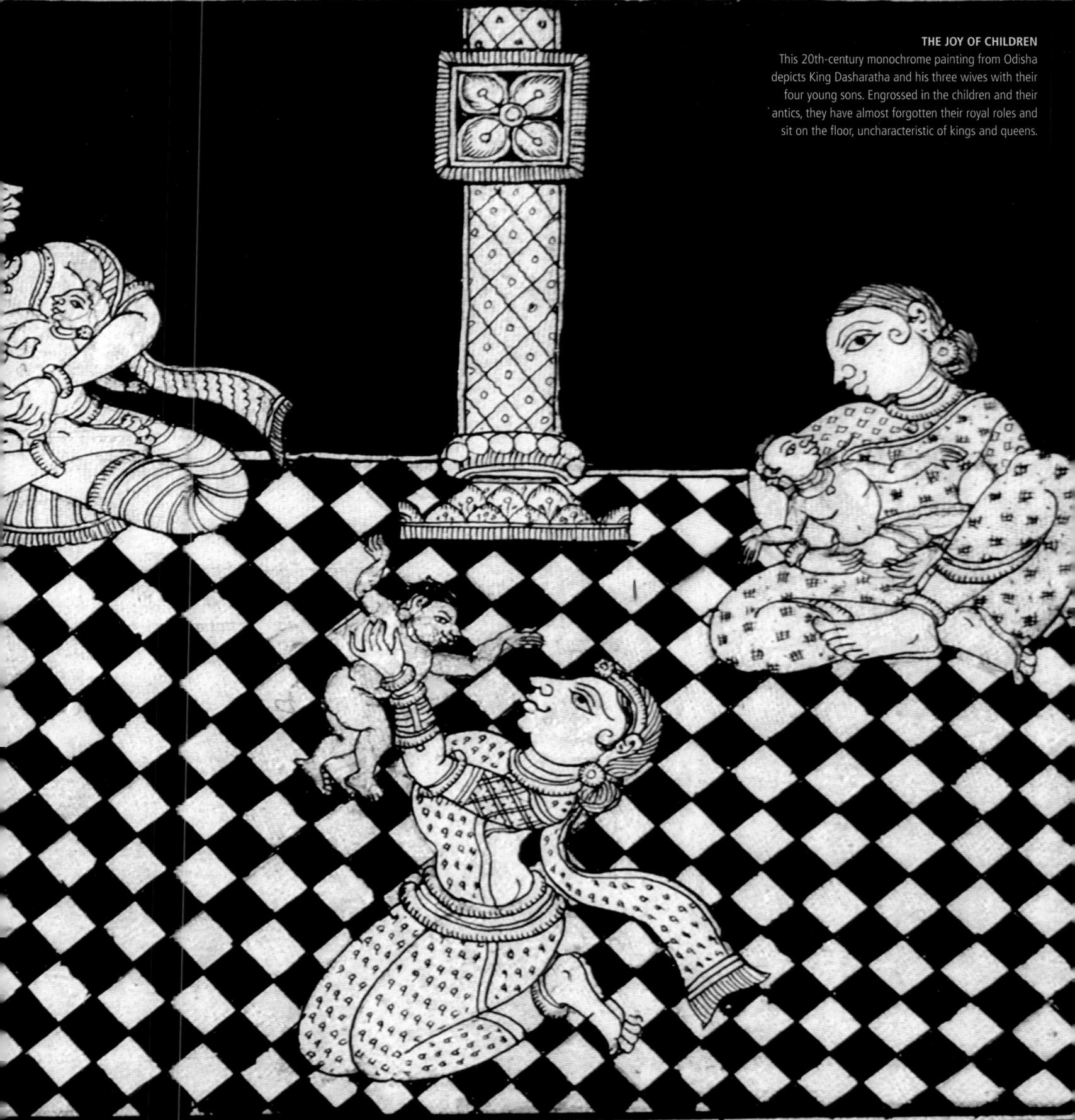

Vishvamitra's Request

The princes grew up to become remarkable young men, loved and respected by all. As Dasharatha contemplated arranging marriages for them, a guest arrived bearing an unexpected request. It set in motion a series of events and ensured that Rama would fulfil his destiny.

Dasharatha's sons had exceptional qualities. Even so, Rama was particularly dear to his father. Of the brothers, Lakshmana was especially attached to Rama, who loved him as well. He would scarcely eat or sleep unless Lakshmana was there with him. Similarly, Bharata and Shatrughna were deeply attached to each other. The princes grew into brilliant young men, trained in all the arts and engaged in the good of all beings.

ANALYSIS

YOGAVASISHTHA

The *Yogavasishtha* is a text from the early second millennium that teaches non-dualism. The primary part of the text inserts itself into the *Ramayana* at the moment of Vishvamitra's arrival and constitutes a dialogue between Vasishtha and Rama.

When Rama was summoned, on Vishvamitra's arrival, his attendant reported that the prince seemed to have lost interest in all activities. The sage said that the apparent despondence was neither due to attachment nor difficult circumstances. It was, instead, imbued with discriminatory wisdom and detachment. He must, therefore, be brought in immediately, so that Vasishtha may address him.

> "The **drums of the gods** were sounded and a great **shower of flowers** rained down... With **quivers and bows** in their hands, they illuminated the **ten directions**."
>
> WHEN RAMA AND LAKSHMANA LEFT AYODHYA WITH VISHVAMITRA, *SARGA* (21), BALA KANDA

A request

One day, the great sage, Vishvamitra arrived at Dasharatha's palace. Delighted, the king rushed out to welcome him, and invited him into the palace. After offering the radiant sage a seat, the king said, "O great sage! Your arrival is like receiving the nectar of life, or seeing rain in a barren desert. I beseech you, tell me what would please you."

Pleased with the welcome and the king's words, rich in expression and intent, Vishvamitra told the king of a sacrifice that he was conducting, which was nearing completion. However, the Rakshasas Maricha and Subahu had disrupted the rituals and desecrated the sacrificial altar with flesh and blood. "I cannot unleash my anger at them due to the vows involved in the sacrifice," he said. "I have come to ask you to grant me your oldest son, Rama. Only he can defeat them." The sage looked at the king and sensed his hesitation.

"Do not let fatherly love weaken you, O king," he said. "I will protect Rama, and his own prowess is unmatched. I will bestow him with all manner of beneficial objects. He will become famous across the three worlds. For both dharma and glory, you should give me Rama."

The king's dilemma

Dasharatha lost his composure on hearing Vishvamitra's words and cried, "O great sage! My lotus-eyed Rama isn't even 16 years of age." The king volunteered to accompany the sage instead, along with his army. He implored the great sage to tell him about the Rakshasas, their strength and their protector.

Vishvamitra told Dasharatha about Ravana, the powerful lord of the Rakshasas, and how he had urged Maricha and Subahu to obstruct the sages and their sacrifices.

The king, overwhelmed by fear for his son's life, begged the sage to reconsider. "The enemies you describe are fierce and skilled, and Rama is a child," he said. Maricha and Subahu were impossible to defeat, he said. Even he, as the king of Ayodhya with the might of his army, would only be able to battle one demon at a time. "I cannot give Rama to you," he said.

Vishvamitra looked at the king who had, but a short while ago, pledged to give him whatever he had wanted. Anger laced his words, as the sage reminded the king that he came from the exalted Ikshvaku lineage.

"You are like the god of dharma yourself. If you break your pledge you will destroy the fruits of all the sacrifices that were performed in the past. So, do not resort to adharma," he thundered.

So intense was Vishvamitra's rage that the earth shook and the gods trembled. Sage Vasishtha quickly intervened and convinced Dasharatha

that Vishvamitra was an ideal guardian and would protect Rama. The king finally acceded to the sages' wishes.

The brothers set forth

As Rama and Lakshmana left Ayodhya, flowers rained down from heaven. They walked half a yojana (about 6.5 km or 4 miles), until they reached the southern banks of the River Sarayu.

Vishvamitra asked them to partake of water from the river and receive the divine powers, Bala and Atibala. With this, he said, Rama would not face hunger or thirst, and have incomparable strength.

The next morning, they walked to the confluence of the rivers Ganga and Sarayu, where they came upon Anga, home to a group of fierce sages who were disciples of Shiva, the god of Destruction. The princes and Vishvamitra decided they would spend the night here.

THE PRECEPTOR AND HIS DISCIPLES
This painting from 1898 by Indian artist Raja Ravi Varma shows Vishvamitra training Rama with a bow and an arrow as his younger brother, Lakshmana, looks on.

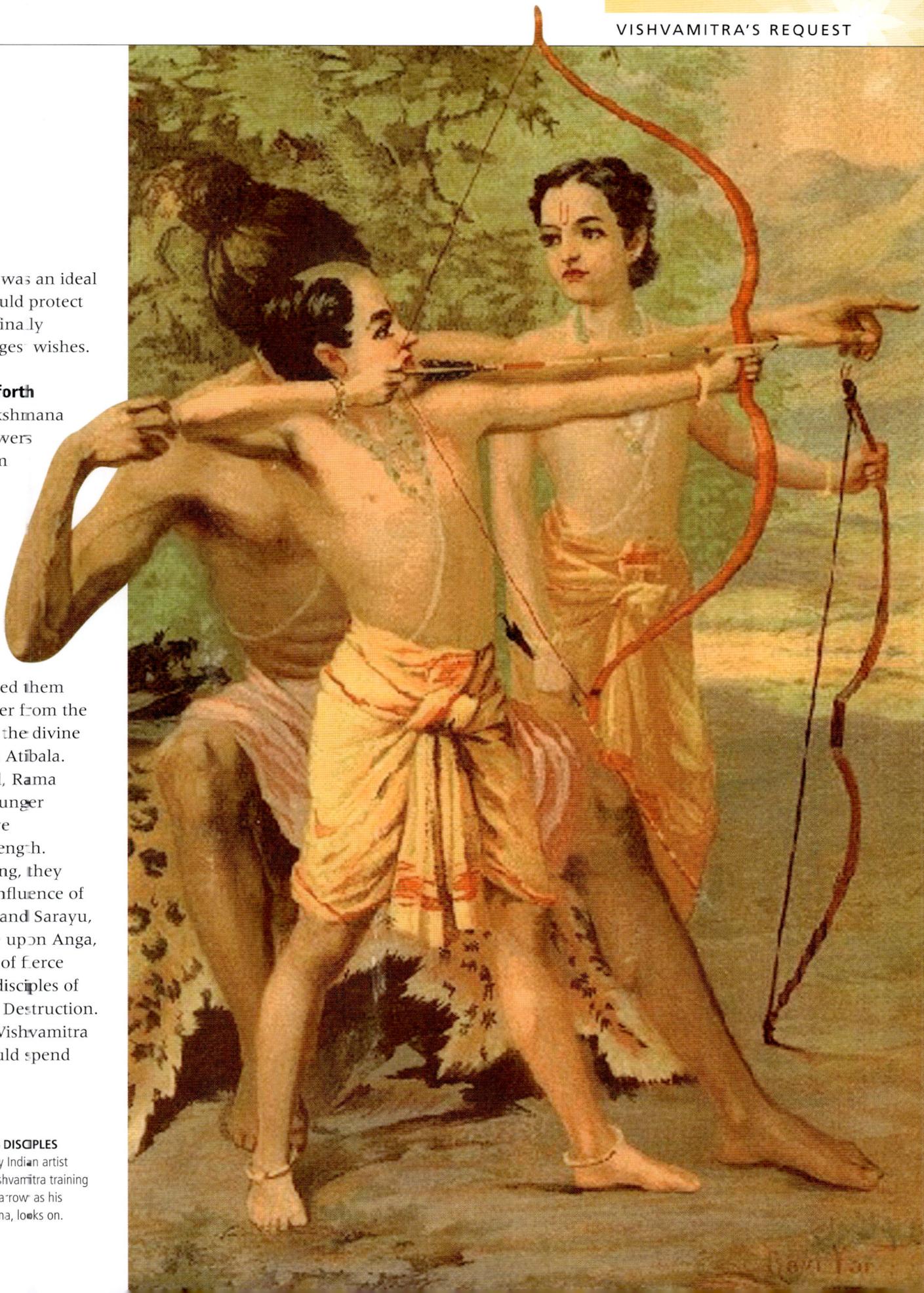

The Battle with Tataka

The three men spent the night in Anga and, the next day, continued their journey along the River Sarayu. Near a dense forest, they came to face to face with the cursed creature, Tataka, a sworn enemy of the sages. Vishvamitra urged Rama to kill her and rid the world of her wickedness. The prince, however, hesitated.

> "She descended with **great force** and **valour**, like a **bolt of thunder**... he **pierced her body** and she fell down, **dead**. Her form was **terrible**."
>
> RAMA'S ENCOUNTER WITH TATAKA, *SARGA* (25), BALA KANDA

Vishvamitra and the two princes spent the night at Anga. It was here that Shiva, the god of Destruction, scorched the body of Kama, the god of love. This place, where he lost his body (*anga*), is known as Anga and the god of love became Ananga (without body).

The next morning, the three men continued their journey. As they crossed the River Sarayu in a boat, Rama heard a fierce sound and asked Vishvamitra about it.

The great sage told them how the Sarayu originated from a lake named Manasa, made by Brahma, the Creator of the universe. The thunderous clap was the Sarayu meeting the River Ganga. Hearing this, the brothers bowed their heads to honour the rivers.

At the southern bank, Rama and Lakshmana saw a dreadful, impenetrable forest before them. They could hear the roars and shrieks of horrific creatures. "What a terrible forest!" Rama exclaimed.

Vishvamitra told them that the region encompassed the countries of Malada and Karusha. Once, Indra, the king of gods, committed the sin of killing a Brahmana named Vritra. When the gods bathed Indra to cleanse him of the sin, these two countries bore the filth that was released from his body. Pleased, Indra granted them the boon of prosperity. The region remained blessed, until the arrival of Tataka (See box).

Rama's dilemma

Tataka could change her form at will and had the strength of a thousand elephants, Vishvamitra told them. "Slay her. If you do not, she will continue to wreak havoc. Make this sacred region, which Indra himself proclaimed so, habitable once again," he commanded.

Rama, who knew the Vedas and followed dharma, the path of righteousness, found himself in a dilemma. Tataka, for whatever ruin she may have brought upon that land, was a woman. Vishvamitra, sensed his hesitation. "Do not have any qualms of killing her because she is a woman," he said. "You bear the burden of kingship and are obliged to act in a way that benefits the four orders of society. You must act for the good of society as a whole and in the interest of dharma. Indra and Vishnu, the Preserver of the universe, faced similar dilemmas and acted for the good of the world. They even destroyed women who threatened it."

Rama, heard these words and stated his own resolve, "In Ayodhya, my father commanded that I follow your orders without deliberation. Your commands have the force of one who knows the supreme reality. I shall do as you say in the interest of cows, Brahmanas, and this region."

Tataka is killed

So saying, Rama raised his mighty bow and pulled at its string. The sharp twang echoed through the forest, and reached Tataka.

ALTERNATIVE ACCOUNT

BHARATA'S TEST

In Bengali medieval poet Krittibas Ojha's version of Rama's story, Dasharatha sent Bharata and Shatrughna with Vishvamitra, hoping the sage would not notice. The sage set forth and at a stop, told them that there were two ways to their destination – a short one, involving an encounter with Tataka, and a longer one that would avoid her. Bharata opted for the latter, raising the sage's hackles. His anger, it seemed, would burn Ayodhya, until Rama calmed him down. Vishvamitra gave Rama and Lakshmana the same choice. Rama chose the shorter path. For once, Vishvamitra was afraid, but Rama assured him that he would kill Tataka with a single arrow.

Overcome with anger at this impudence, she found the three men. Rama, though he had resolved to kill her, was still unwilling, and turned to Lakshmana.

"Look at the fierce body of this female Yaksha," he said. She has the strength of illusory powers. I shall turn her back, wounding her nose-tip and ears. She is a woman and is therefore protected. I do not want to kill her. Rather, I shall hinder her strength and movement." As he spoke, though, she hurled herself towards him like a thunderbolt. Rama shot an arrow into her chest and she fell dead.

A gift of divine weapons

The next day, pleased by Rama's valour, Vishvamitra gave Rama divine gifts – mantras that when chanted would present the young prince with weapons of every nature. He received the Dandachakra (a magical staff), the vajra, which belonged to Shiva, the Dharmachakra and Kalachakra, staffs that keep dharma and time intact, and weapons that the Asuras, Gandharvas (magical beings), and the Pishachas (demons) wielded. Rama folded his hands and accepted the gifts.

TATAKA'S DEATH
This 19th-century *pata* or scroll painting from Murshidabad, West Bengal, shows the scene where Rama kills the Rakshasi Tataka.

STORY FROM THE *RAMAYANA*

TATAKA, THE ANGRY YAKSHA

Desirous of progeny, Suketu, a Yaksha (magical being), performed a penance to please Brahma who blessed him with a daughter named Tataka. She had the strength of a thousand elephants and grew into a beautiful young woman. She married Sunda, the son of a Rakshasa named Jambha, and gave birth to a son named Maricha. One day, the sage Agastya cursed Sunda who died. Tataka and her son swore to take revenge and attacked the sage, who cursed them, turning Maricha into a Rakshasa and Tataka into a maneater. Senseless with anger, she ravaged Malada and Karusha, where Agastya lived.

Protecting Siddhashrama

The three men emerged from the dreaded forest and saw a radiant grove in the distance. This was Siddhashrama, Vishvamitra's hermitage, and it is here that Rama would face his first great challenge. As the great sage prepared to conduct an important sacrifice, the two princes of Ayodhya stood guard, awaiting Maricha and Subahu's next attack.

Rama saw the beautiful grove, so radiant that it glowed even from a distance. "What is this place? To whom does this hermitage belong?" he wondered. This was Siddhashrama, Vishvamitra said, and their destination.

Vishnu's Siddhashrama

Vishvamitra told the princes that Siddhashrama once belonged to Vishnu, the Preserver of the universe. The sage told them of a time when the Asura king Bali conquered the three worlds.

Seeking help, the gods went to the hermitage, where Vishnu was meditating, and requested him to intervene. Lord Vishnu then took the Vamana or dwarf form (See pp 24–25) and defeated Bali.

"I dwell here because of my devotion to Vishnu," said Vishvamitra. "It is here that the Rakshasas trouble us and obstruct all observances."

The sacrifice begins

The sages of Siddhashrama saw the three men and greeted them with great respect and affection.

After resting, Rama and Lakshmana requested Vishvamitra to prepare for the main ritual.

The next morning, they asked Vishvamitra, "When do these Rakshasas arrive to torment you? When should we begin guarding the hermitage?" The other sages spoke on Vishvamitra's behalf as he had taken a vow of silence. "Protect this spot for the next six days," they said.

For five days and nights, Rama and Lakshmana guarded Vishvamitra. They did not sleep or rest, and patrolled the ashrama, but everything was peaceful.

Rakshasas attack

On the sixth day, the sages started up the fires on the sacrificial altar. Rama warned Lakshmana to stay alert. Anything could happen.

The atmosphere resounded with the chanting of mantras, oblations were poured into the sacred fires and the sacrifice began. Suddenly, the sky turned dark as if the monsoon had arrived earlier than usual. A horrifying noise echoed across the skies.

The Rakshasas Maricha and Subahu, ghastly in form and violent in nature, approached the enclosure with their followers. They showered blood on the sages and tried to disrupt the sacrifice.

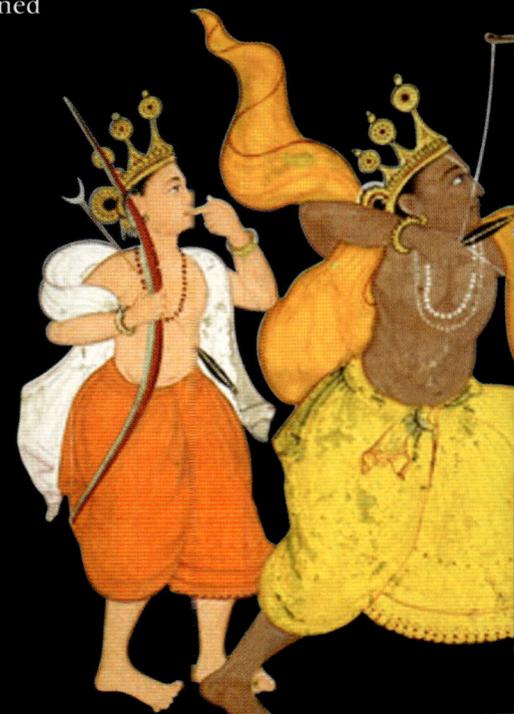

Rama turned to Lakshmana and told him that he would use Manava (the weapon of the Gandharvas). "It will drive away the Rakshasas, the way the wind scatters the densest of clouds," he said. Rama hurled the weapon at Maricha. It struck him and

MARICHA AND SUBAHU
Rama and Lakshmana confront the brothers, Maricha and Subahu, in this early 17th-century Mughal painting. The Rakshasas are typically depicted as grotesque creatures with sharp teeth, horns, and long claws.

STORY FROM THE *RAMAYANA*

KING KUSHANABHA'S DHARMA

Vishvamitra's ancestor and Brahma's son, Kusha, had four sons – Kushamba, Kushanabha, Adhurtarajas, and Vasu, each of whom founded cities. Kushanabha created the city of Mahodaya and had 100 daughters, all as beautiful as the stars.

Vayu, the god of wind, saw them and grew besotted. He asked them to leave their human forms and marry him. They refused and said they would follow only their father's bidding. Furious, Vayu disfigured their limbs.

Kushanabha learnt what had transpired and asked his daughters to forgive Vayu. "Forgiveness is the true ornament. It is dharma," he said.

He married his daughters to King Brahmadatta and when the king touched them, their deformities disappeared.

Kushanabha later had a son named Gadhi. He had a son named Vishvamitra and a daughter, Satyavati, who married the great sage, Richika. She followed her husband to heaven in her physical body and also came to be known as the River Koushiki.

> **"The descendant of the Raghu lineage slew all the Rakshasas… He was worshipped by the rishis, as the victorious Indra was in earlier times…"**

ON RAMA'S TRIUMPH AGAINST MARICHA AND SUBAHU, *SARGA* (29), BALA KANDA

flung him 100 yojanas (about 1,260 km or 900 miles) away, into the middle of the ocean. Rama told Lakshmana, "This weapon, inseparable from righteousness and imbued with dharma, banished the enemy, but did not kill him. But, I do wish to destroy these other wicked ones."

Rama struck Subahu with the Agneya (the weapon of fire). It found its mark easily and the Rakshasa fell dead. He then reached for Vayavya (the weapon of wind) to kill the remaining Rakshasa. The sages celebrated Rama's victory even as Vishvamitra completed the sacrifice without any interruption. He said, "Rama! My purpose is achieved. You have done as I asked. You have truly rendered this siddhashrama (a hermitage of accomplishment)."

To Mithila

The next morning, Rama and Lakshmana greeted the sages and presented themselves to Vishvamitra. In gentle tones, they asked, "We stand before you as servants, command us!" Vishvamitra and the other sages replied almost in unison, "We will go to Mithila, ruled by the great King Janaka."

The king, they said, had organized a magnificent sacrifice. He also had in his possession, Shiva's bow, which no being had been able to string. "You should see it. So, you shall accompany us there," Vishvamitra said. The two princes happily agreed.

THE ARSENAL OF THE GODS

Celestial Weapons

"With these, you will be able to **pacify, subjugate,** and **defeat** large numbers of **gods**, Asuras, Gandharvas, serpents, and **enemies**... I will bestow all those **divine weapons** on you.**"**

VISHVAMITRA TO RAMA, *SARGA* (26), BALA KANDA

Various readings and interpretations have been put forth over the decades about what it means for a warrior to possess a celestial weapon. In the *Ramayana* and subsequent traditions, we find a certain sense of what these weapons are, what they do, and how they are transmitted, but it is not always clear what their mechanics are. These weapons appear to require invocation before their launch, and have rather spectacular effects.

What a weapon can counter depends on the deity it is connected to. There also seems to be a certain sense of responsibility attached to the use of such weapons. Some embody sentient or semi-sentient spirits or beings, and others are associated with particular deities. There are weapons that are built for specific purposes for deities as well.

ALTERNATIVE ACCOUNT
CELESTIAL WEAPONS AS IDENTIFIERS

Building upon this notion of transmission, in Bhavabhuti's *Uttararamacharita*, Rama blesses Lava and Kusha with these weapons before Sita is sent into the forest, while they are still in her womb. When they grow up, they do, in fact, possess them, and that is crucial in identifying them. This is because, it is clarified, these particular weapons only function in a lineage of transmission.

IN OTHER CULTURES
A spectacular battle scene from the *Ramakien*, the Thai version of the *Ramayana*, plays itself out in the form of the Khon, one of the most dramatic dance-drama genres of Thailand.

TRANSMISSION OF WEAPONS

What distinguishes these weapons is the fact that they need to be received in a certain way. One cannot simply decide to learn how Brahma's weapon is wielded, or create a physical form of the weapon. More often than not, a god or a person in possession of these weapons has to bestow these weapons upon the receiver. Further, simply possessing the weapon does not mean that one can pass it on as one wills. There are degrees of eligibility as to what one can do with them. For instance, some are granted weapons with the ability to pass them along as they will, some cannot pass them on, but can keep them for as long as they like, while others can only use them once before the weapon returns to the deity to whom it belongs. Although this transmission of weapons appears explicitly occasionally, it is in the background for many events within the *Ramayana*. Occasionally, they are used as a plot point by later authors (See box).

The first occasion at which the reader sees such a transmission occur is in the Bala Kanda, when Vishvamitra bestows a series of weapons upon Rama. This moment reveals several aspects of the process of transmission and the nature of these weapons.

Vishavamitra does not grant them the weapons as soon as they leave Ayodhya. He waits until Rama has killed Tataka (See p 45), and the gods ask him to give weapons to Rama, who is a fitting receptacle.

This transmission consists of the passing on of the formulae of invocation and withdrawal, which are received after ritual purification, and these weapons can be called forth and dismissed. Many weapons are associated with various gods, such as Shiva, Vishnu, Agni, or Vayu – there are some projectiles of various kinds, and others whose particular divine associations are not made clear. Some are associated with Gandharvas (magical beings) and Vidyadharas (semi-divine beings). Yet others are described through their particular function, such as their ability to cause the enemy to sleep.

When Vishvamitra begins to chant, these weapons appear before Rama, recognizing him as the one who controls them, and express their willingness to serve him.

At this point, Rama asks Vishvamitra how the weapons are withdrawn – one explanation offered seems to be that if only half the process is known, the weapons do not return to one after they have been used.

USE OF THE POWER

Perhaps the most spectacular display during the war in Lanka is Rama's use of the Gandharva weapon that he uses to defeat an entire army all by himself. Indrajit's use of divine weapons and the way he came to possess them is also described in detail. His weapons are displayed in the war, as well as when Hanuman arrives in Lanka the first time. This is also one of the few occasions that discuss the actual mechanics of the use of these weapons, as Indrajit frets over Hanuman's fetters having been undone (See p 230).

However, one of the things that seems to distinguish Rama from his enemies is that he dissuades of Lakshmana from using the Brahma weapon (See p 297). The powers these weapons bestow imply a certain amount of responsibility. One cannot use a destructive weapon only to serve an immediate purpose in battle.

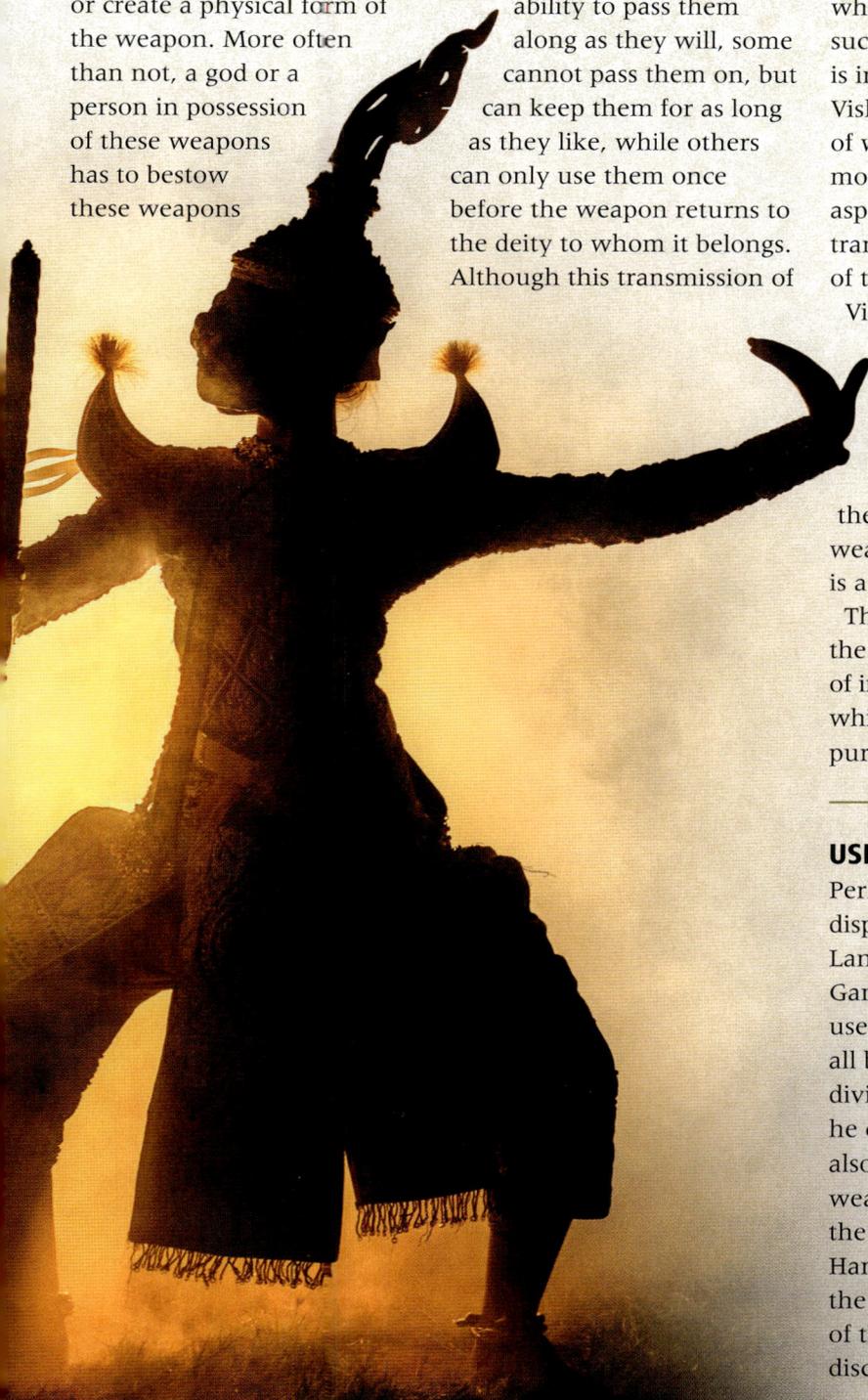

STORY FROM THE *RAMAYANA*

The Descent of Ganga

After spending the night along the banks of the River Shona, Vishvamitra and the two princes continued their journey to Mithila. Along the way, Rama asked the great sage to tell him the story of Ganga, the sacred river that flowed through the three worlds.

Himavat, the best of mountains, had two daughters, Ganga and Uma. Once, the gods asked Himavat for Ganga. Following dharma and for the sake of purifying the worlds, he accepted and Ganga left for heaven. There, for the sake of the three worlds, she started flowing, as she willed.

It was one of Rama's ancestors who finally brought Ganga back to the earth.

The stolen horse

King Sagara had two queens, Keshini and Sumati. Desiring a son, he performed immense austerities until Bhrigu, a sage, blessed him. One of the wives, he said, would have 60,000 sons, but they would not have any offspring. The other wife would have one son, who would carry the lineage forward.

Sumati chose to have 60,000 sons, while Keshini gave birth to one, named Asamanja. He grew up cruel and was banished from the city for his many offences. His son, Anshuman, however, was loved by all.

Once, Sagara undertook a horse sacrifice. At a crucial moment, Indra, in the guise of a Rakshasa, stole the horse. The king sent his 60,000 sons in search of the horse, but could not find it.

Sagara insisted that they keep looking. "Dig up the earth, if you have to," he commanded. So, the sons started digging. They used terrible ploughs and spears, which were like a *vajra* – as powerful as a diamond and a thunderbolt. The earth shrieked at the assault as the serpents, Asuras, Rakshasas, and other beings that lived within the earth were slaughtered. The sons dug for 60,000 yojanas until they reached Rasatala, one of the nether regions. Sagara commanded that they dig further, and so they did.

The Gandharvas, gods, Asuras, and serpents rushed to Lord Brahma, the Creator of the universe, begging for help. He assured them that Vishnu, the Preserver of the universe, would stop Sagara's sons.

Kapila's wrath

The sons dug so deep that they reached the four *diggaja*s, the elephants that hold up the earth. Finally, in the south-eastern corner, they saw Vishnu, in the form of sage Kapila (See box) and the stolen sacrificial horse grazing nearby. They spoke to the sage with great irreverence, as if he were a mere thief. Kapila, with a mighty "Hum," reduced them to ashes.

Sagara grew worried as his sons had not returned, and sent Anshuman in search of them. The young prince found his uncles' ashes and the horse. Realizing they were dead, he tried to offer water for their souls, according to the ritual, when Garuda, the great bird, stopped him. "Your uncles were burnt by the wrath of Kapila himself. Only the waters of the celestial River Ganga can deliver them to heaven," he said.

Ganga comes to the earth

Anshuman returned with the horse and in time became the king. But, neither he nor his son, Dilipa, could bring Ganga to the earth.

Dilipa's son, Bhagiratha, desired sons and performed great austerities to please Brahma. The Creator, duly propitiated, asked him for a

STORY FROM THE *RAMAYANA*

KARTIKEYA'S BIRTH

Uma, the younger daughter of Himavat, performed great austerities and married Shiva. Once, when Shiva approached Uma with desire, the gods were terrified, for his seed was too powerful to bear for the world. They requested him to desist and he agreed, but the seed had to be disposed. It was decided that the earth would bear it. So, Agni (fire) and Vayu (wind) turned it into a white mountain and a clump of reeds. Furious, Uma cursed the gods that they may never have sons, and earth that she may never find the love of a son.

Soon, the gods needed a general. They asked Brahma, who told them that Uma's curse could not be violated, but that she may accept a son born of Agni and her sister, Ganga. This boy, raised by celestial women, collectively called Krittikas, was named Kartikeya. This story is called "Kumarasambhava", or "The Birth of Kumara".

STATUE OF Lord Murugan or Kartikeya in Gombak, Selangor, Malaysia

"The **supreme descent** of Ganga was **extraordinary**... It was as if flashes of **lightning** were **streaked** throughout the sky... **Devoid** of all **taints**, the **sparkling** water **roamed freely**."

GANGA'S DESCENT TO EARTH, *SARGA* (42), BALA KANDA

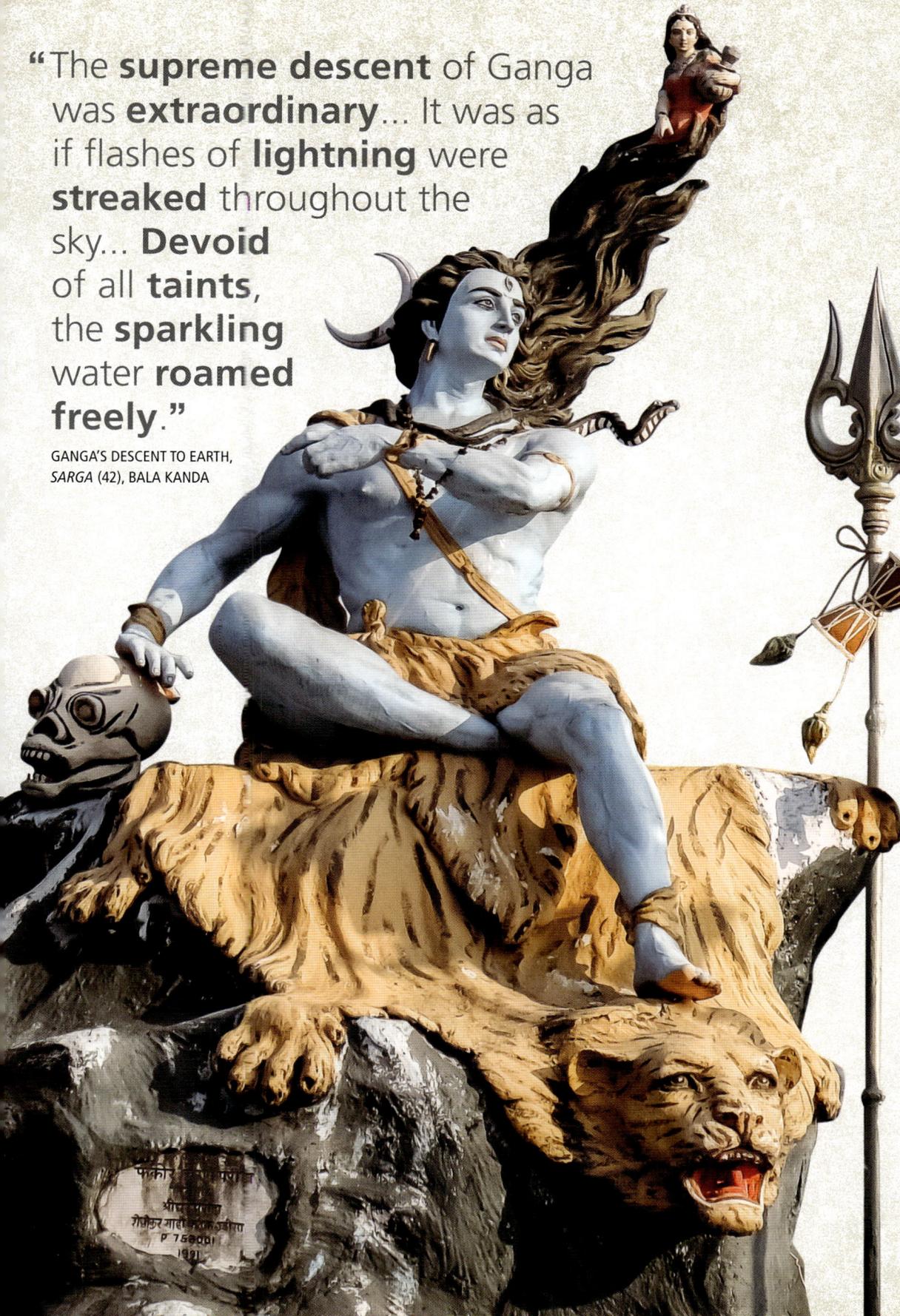

boon and Bhagiratha replied, "Let the sons of Sagara, my forefathers, receive the due offerings and let my lineage never end." Brahma granted him his boon, but said, "The earth will not be able to withstand the sheer force with which Ganga will descend. Only Shiva can wield that burden." Bhagiratha immersed himself in further austerities to please Shiva, who finally agreed to help.

The gods, rishis, and Gandharvas gathered to witness the incredible sight, as Ganga descended from the heavens. Foam streaked through the sky, as if thousands of swans were swimming in the heavens. In some places, she was furious and fast, and in others slow, meandering, and almost meditative.

Shiva caught her in his matted locks and Ganga lost her way for many years. When she found a way out, she roared to the earth, the all-purifying waters now even more sacred after their contact with Shiva's head.

Whoever touched the waters was cleansed of all sin. Bhagiratha sprinkled his ancestors' ashes in the Ganga and Sagara's sons finally ascended to heaven.

THE ORIGINS OF GANGA
The story of Ganga and Shiva is a frequent element in Hindu iconography. Seen here is a statue of Shiva on the banks of the Ganga in Rishikesh, Uttarakhand. The river is shown as wrapped in his hair.

STORY FROM THE *RAMAYANA*

In **Search** of **Immortality**

Vishvamitra and the princes crossed the Ganga and reached Vishala. "Great sage, whose city is this?" Rama asked, curious about the beautiful, sprawling city before him. So, the sage recounted the glorious events that took place in Vishala during the Golden Age.

In the Krita Yuga or the Golden Age, Diti and Aditi, daughters of Daksha – one of the sons of Brahma – married the sage Kashyapa and had powerful sons. While Diti's sons were the Daityas or the demons, Aditi's sons were the Adityas or the gods.

Churning of the ocean

The Daityas and the Adityas, wanted to transcend old age and disease, and decided to churn the ocean of milk to get amrita, the nectar that would help them attain immortality. But, they needed help. So, they requested Vasuki, the many-headed king of serpents, to become the rope, and used the mountain Mandara as a churning stick.

The brave sons of Diti and Aditi began churning and soon a variety of magical objects and beings appeared. Dhanvantari – the physician of the gods – emerged as did 600 million apsaras, beautiful celestial maidens who were created during the churning. The Daityas and the Adityas did not accept them and so they came to belong to everyone. Next to emerge was Varuni, the goddess of liquor, and the gods claimed her. This is why the Daityas are also known as Asuras or those without liquor, and the gods as Suras. The incomparable horse, Uchchaishrava, and the gem, Koustubha emerged too.

The churning continued until finally, the supreme nectar emerged. A fierce battle began between the Suras and the Asuras. In the end, Diti's sons were slayed and Indra, the king of gods, ruled over the three worlds.

Indra's act

When Diti heard of the death of her sons, she was furious. The grieving mother told her husband, Kashyapa, "O blessed one! Your sons have killed mine in battle. I want a son who will kill Indra. I will acquire such a son through austerity." Kashyapa told her that she would achieve what she wished for only if she remained in a state of purity for 1,000 years. "Then, you will give birth to my son, who will destroy the three worlds," he said.

Hearing his words, a delighted Diti began performing her austerities. While engaged in penance, her stepson, Indra, served

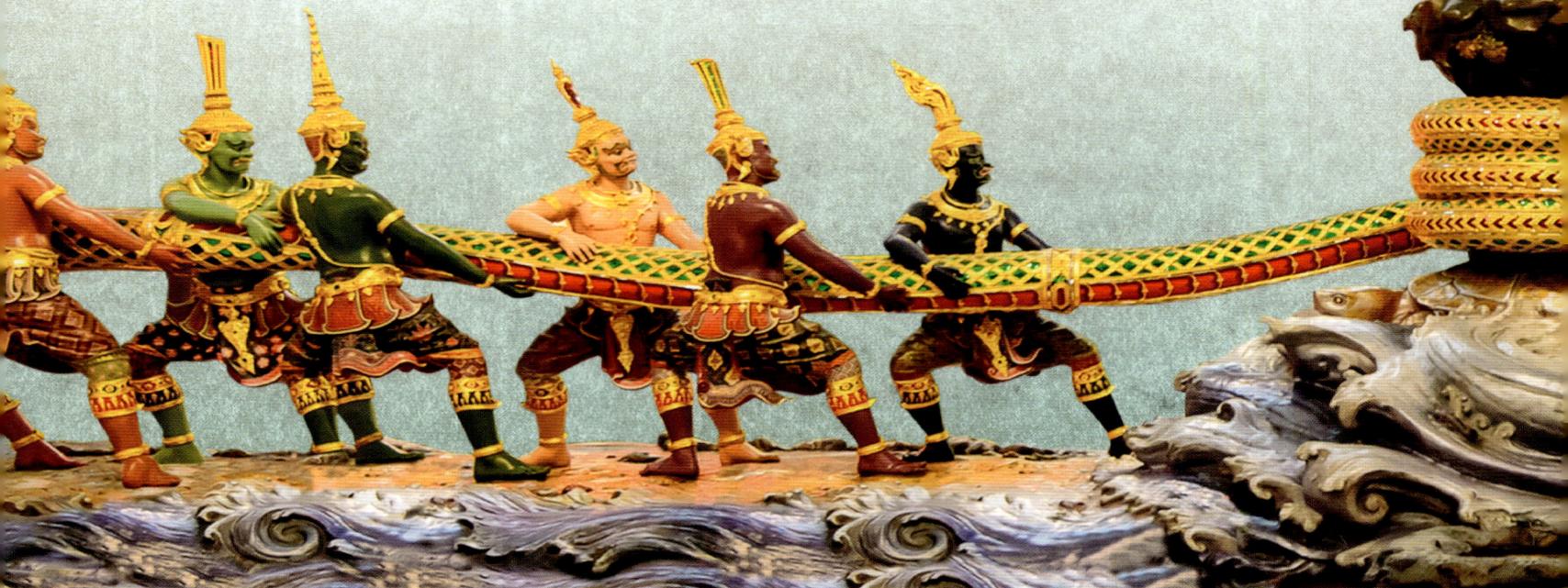

"Those **great-souled ones** began to think about how they might be **immortal**, about how they might be **without old age** and **without disease**."

ON GODS AND ASURAS, *SARGA* (44), BALA KANDA

her and brought her whatever she needed. Over time, Diti, pleased with his service, calmed down.

Soon, 990 years passed. She told Indra, "Son, only 10 years remain. You shall soon see your brother, but do not worry. I will resolve his desire to defeat you. He will conquer the three worlds and you shall enjoy victory at his side."

That afternoon, Diti fell from her state of purity as she had slept with her head where her feet were supposed to be.

A delighted Indra used this weakness to enter her womb and divided the embryo into seven parts.

The embryo wept and Diti woke up hearing its cries. "Don't kill it!" she cried. Out of respect for his mother's words, Indra desisted and exited her womb. He said, "Forgive me! I entered your womb while you were lying in a state of impurity and cut up the one who was to defeat me." Diti, though distressed, said, "I was at fault because of my state of impurity. Please let the seven parts of my embryo become the seven guardians of wind."

This is how the seven *Maruts*, or storm deities and Indra's companions, came to be.

The city of Vishala

This incident took place in the region of Vishala. The son of Ikshvaku, Vishala, founded the city itself, which was subsequently ruled by his descendants, including Sumati.

Vishvamitra ended the tale and then accepted the hospitality of the king, Sumati, for one night.

The next morning, they would leave for Mithila to meet King Janaka and see Shiva's bow.

ALTERNATIVE ACCOUNT

ELEMENTS IN THE STORY

The story of the churning of the ocean, often referred to as *Samudra-manthana*, is significant and appears in several texts, including the *Mahabharata*. There are, naturally, some variations, even within the Valmiki *Ramayana* textual history. Some popular elements, such as Vishnu forming the base for the churning or Shiva consuming the deadly poison at Vishnu's suggestions, are not included in the Critical Edition, but are drawn from the other versions of the *Ramayana*.

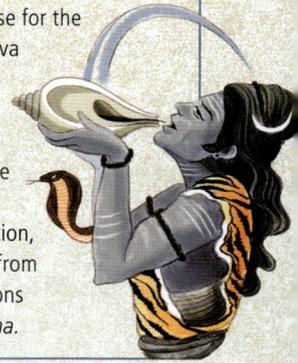

CHURNING OF THE OCEAN
This sculpture, depicting the churning of the ocean can be seen at the Suvarnabhumi Airport in Bangkok, Thailand. The Asuras can be seen on the left and the gods are on the right.

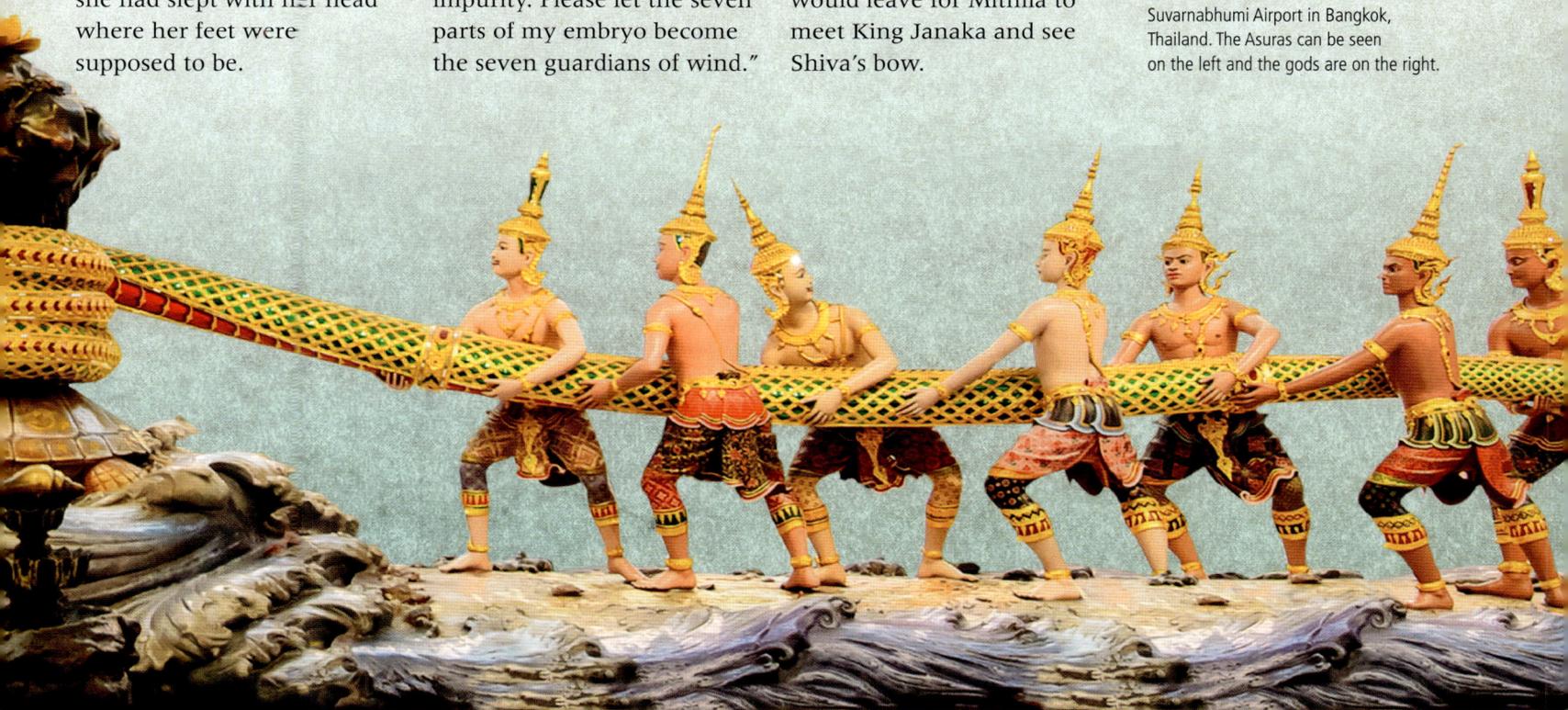

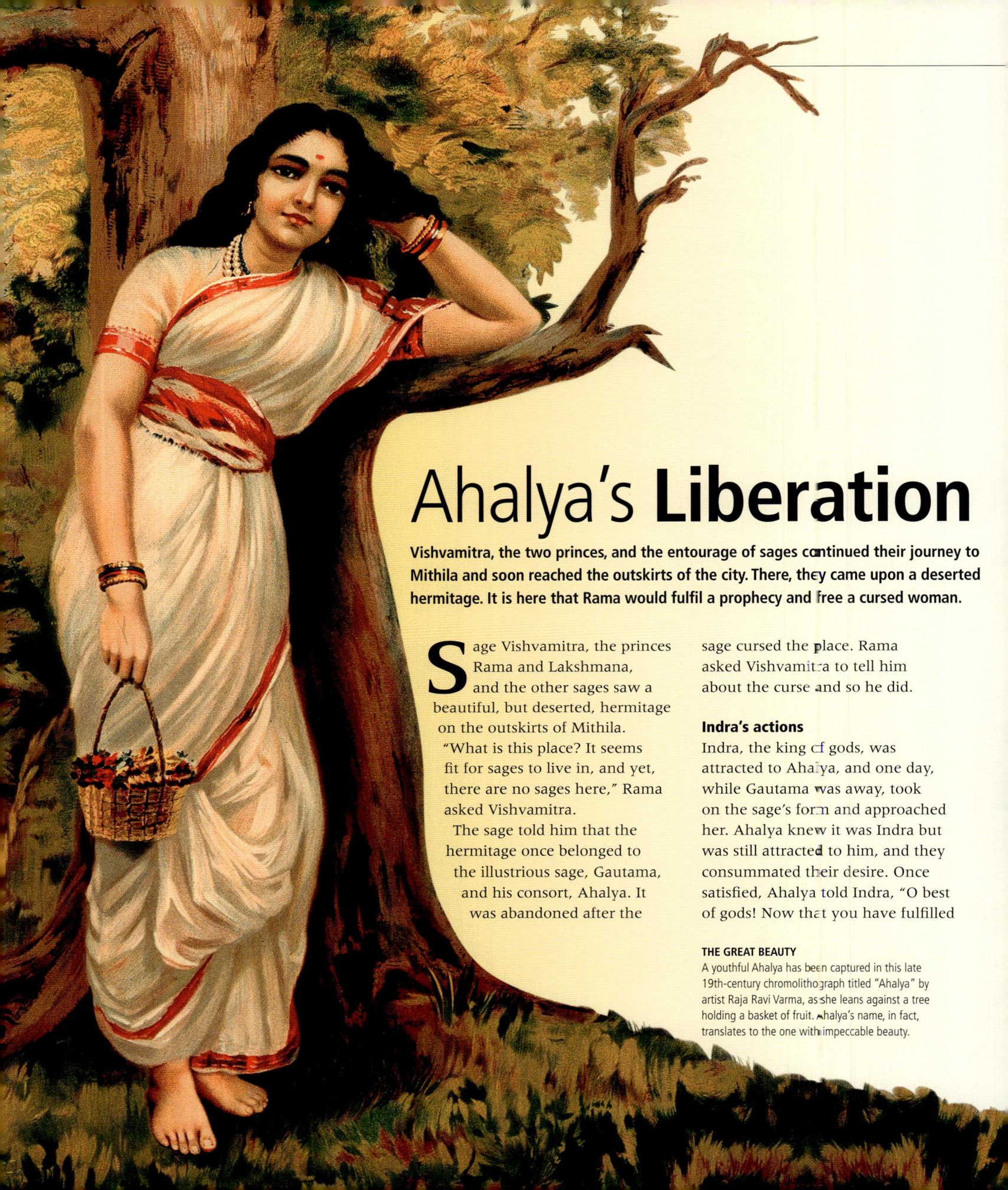

Ahalya's **Liberation**

Vishvamitra, the two princes, and the entourage of sages continued their journey to Mithila and soon reached the outskirts of the city. There, they came upon a deserted hermitage. It is here that Rama would fulfil a prophecy and free a cursed woman.

Sage Vishvamitra, the princes Rama and Lakshmana, and the other sages saw a beautiful, but deserted, hermitage on the outskirts of Mithila. "What is this place? It seems fit for sages to live in, and yet, there are no sages here," Rama asked Vishvamitra.

The sage told him that the hermitage once belonged to the illustrious sage, Gautama, and his consort, Ahalya. It was abandoned after the sage cursed the place. Rama asked Vishvamitra to tell him about the curse and so he did.

Indra's actions

Indra, the king of gods, was attracted to Ahalya, and one day, while Gautama was away, took on the sage's form and approached her. Ahalya knew it was Indra but was still attracted to him, and they consummated their desire. Once satisfied, Ahalya told Indra, "O best of gods! Now that you have fulfilled

THE GREAT BEAUTY

A youthful Ahalya has been captured in this late 19th-century chromolithograph titled "Ahalya" by artist Raja Ravi Varma, as she leans against a tree holding a basket of fruit. Ahalya's name, in fact, translates to the one with impeccable beauty.

"She was like a **cloud covered in snowy mist**, with a **radiance** like that of the **full moon**."

ON AHALYA'S FORM, *SARGA* (48), BALA KANDA

your desire, leave quickly. Protect yourself and me." Indra turned to leave, worried that the all-powerful sage would see him.

Gautama walked in at that very moment, dripping with the sacred waters he had bathed in, and blazing like the sacred fire itself. Indra was terrified. The sage saw the god disguised as him, and knew what had happened.

Gautama's curse

Enraged, he first cursed the god with infertility and then turned to Ahalya.

He said, "You shall dwell here for thousands of years, performing austerities, living on air, sleeping on ashes, and unseen by any being – human or divine. You will be purified only when Rama, the son of Dasharatha, comes here. You will be rendered devoid of avarice or delusion when you extend hospitality

to him. You will then regain your own form and join me."

So saying, Gautama left the hermitage, once frequented by gods, and retreated to the Himalayas. The gods, later, helped Indra regain his fertility after they offered the testicles of a ram to the ancestors, as a sacrifice.

Vishvamitra completed the story, turned to Rama and said, "Come. Enter this hermitage of the virtuous, and free the goddess-like Ahalya."

Ahalya freed

The princes entered the hermitage and saw Ahalya. Her form glowed because of her penance. The curse had made her invisible to all beings, but she became visible the moment she saw Rama. The princes touched her feet and she offered them *padya* (water to wash their feet) and *arghya* (a gift). The gods arrived and showered them

with flowers. They praised Ahalya, now purified by her penance, even as Gautama, now reunited with his wife, honoured Rama.

Arrival in Mithila

After completing the prophecy, the princes and Vishvamitra made their way to Mithila.

Janaka, the king of Mithila, heard of the sage's arrival and rushed to meet him. His priest, Shatananda, who was Ahalya and Gautama's son, accompanied him as well. They welcomed Vishvamitra with great reverence. Overjoyed, Janaka said, "My sacrificial offerings have borne fruit for you have graced me with your presence!" Then, he saw Rama and Lakshmana and asked, "Who are these lotus-eyed young men bearing swords, bows, and quivers, resembling gods descended from heaven of their own accord? They seem to light up this place like the sun and moon illuminate the sky. What brings them here, and who is their father?"

Vishvamitra introduced the princes of Ayodhya and recounted their experiences and victories. He then told Janaka about their desire to learn more about Shiva's sacred bow, which was in the king's possession.

A MINIATURE PAINTING of Ahalya (right) and Rama (in blue)

"Have you freed my mother?"

Shatananda, upon hearing Vishvamitra's account, cried, "O great sage! Did you show my honourable mother to the prince? Did she offer unto Rama, who deserves the worship of all beings, appropriate worship? Did you tell Rama that ancient story of my mother's glory and the evil designs of the god? Was my mother united with my father after seeing Rama?"

Vishvamitra reassured him. "Do not worry," he said. "Your parents are reunited." Hearing this, Shatananda was deeply pleased.

STORY FROM THE *RAMAYANA*

The **Making** of a *Brahmarshi*

When Shatananda heard of Rama's encounter with his mother Ahalya, he was immensely grateful to Vishvamitra for bringing it about. In the presence of all the sages and King Janaka, he told Rama the story of Vishvamitra, who was once a great king with dharma in his soul, and his transformation into a powerful sage.

V ishvamitra was born into a family of rulers and was a virtuous king. Once, he travelled the earth, visiting great kingdoms across mighty rivers until he arrived at sage Vasishtha's hermitage.

> " ... **infinite** in his **splendour** and **austerities** ... **immensely energetic**... there is no one on earth who is more blessed than he is."

SHATANANDA TO RAMA, *SARGA* (50), BALA KANDA

Vishvamitra's demand

Vasishtha welcomed him and after talking to him, offered hospitality to the king and his army. The king, though honoured by the offer, refused, but the sage insisted.

Vishvamitra watched in wonder as Vasishtha called upon Shabala, the magical cow, to produce food and drink for the entire army. Amazed, the king, with some pride, decided that such

a marvellous cow could only belong to someone as powerful as him. He asked Vasishtha to give Shabala to him in return for a 100,000 cows, but the learned sage refused.

"King! I cannot give her to you for any amount of cows or silver. My ritual offerings, ancestral offerings, my divine mantras, my life – all depend on her. How can I abandon her?" he said. The king persisted and offered him everything, from 14,000 elephants with gold necklaces to 8,000 golden chariots with four white horses, but the sage refused. He said, "She is my life. I will not give her to you."

The fight for Shabala

Angry, Vishvamitra tried to drag Shabala away. She broke free and implored Vasishtha to call on his energies. She used the sage's strength to unleash an army of warriors, armed with blazing swords and long javelins. A great battle took place and Vishvamitra lost many sons.

Distraught, he crowned his surviving son as the king and left for the Himalayas. He performed severe austerities and obtained boons from Shiva, the god of destruction.

He returned with renewed strength and destroyed the hermitage. Vasishtha, now truly angered, raised his staff and dared Vishvamitra to attack him. The king hurled weapon after weapon at the sage, but a mere staff countered them all. This

was a turning point in the king's life. Trained to be a ruler and a warrior, he realized his achievements were meagre in comparison to Vasishtha's spiritual strength as a sage. He decided that he would become a *Brahmarshi* (holy sage) as well.

A king's struggle

Vishvamitra became an ascetic and performed so many austerities that he impressed Brahma, the Creator. The god gave him the title of a *Rajarshi*, a royal sage, but Vishvamitra remained dissatisfied and continued his penance.

One day, Trishanku, a king and former disciple of Vasishtha, approached him. He wanted to ascend to heaven in his physical form, but Vasishtha had refused to

A RARE FEAT
Vishvamitra is likely the only person to have attained the status of a *Brahmarshi* through sheer will. The austere sage is seen with Menaka in this painting by Raja Ravi Varma.

help. Vishvamitra offered refuge and, eventually, got the gods to allow Trishanku into heaven. He also saved the life of sage Shunashepa, who had been abandoned by his parents, to be sacrificed in an offering made by a king.

Vishvamitra persevered, performing many austerities for a long time and became a rishi, but was not content. His focus and determination never wavered until he met Menaka, a celestial maiden, and he succumbed to desire.

Soon, 10 years passed. When he realized this, Vishvamitra decided to conquer desire. Pleased by his efforts, Brahma addressed him as *Maharshi*, but told him that he had not yet conquered his senses. Only then, the god said, would he receive the title of *Brahmarshi*.

Vishvamitra turned to more severe practices, such that even Indra, the king of gods, feared his determination. He sent Rambha, another celestial maiden, to distract the sage. Vishvamitra merely glanced at her, but desire and anger entered his mind in quick succession and that destroyed the accumulated product of his austerity. He remained silent for 1,000 years, in the face of all the distractions that the gods sent his way.

By the end of it, the sage was like a log. His fierce radiance rendered the lustre of all celestial beings dull and terrified them. They ran to Brahma and said, "We have tested Vishvamitra and there isn't even the subtlest maculae in him. He could burn up all of existence with his power. Grant him what he wills, before he turns his mind to destruction!"

Fruits of hard labour
Brahma blessed Vishvamitra, "*Brahmarshi*! Arise! We are pleased by your austerities. I grant you a long life!" The sage bowed and said, "If you have granted me the status I desired, then let the divine syllables reveal themselves to me, and let Vasishtha himself address me as *Brahmarshi*."

The gods asked Vasishtha, who accepted him as a friend and peer. Vishvamitra, in turn, worshipped him with great reverence.

Rama in **Mithila**

The sun set by the time the priest, Shatananda, finished recounting Vishvamitra's story. The following morning, King Janaka invited the sage, Rama, and Lakshmana to the palace. Here, he told them about Shiva's supreme bow and of Sita's birth.

King Janaka was deeply honoured that Vishvamitra and the princes Rama and Lakshmana had arrived at his palace. He greeted them and then addressed the sage, "O blessed one! What might I do for you? Command me, for I am fit to be commanded by you."

A request

Vishvamitra introduced the two princes as the sons of Dasharatha, the valiant king of Ayodhya. He said, "They are skilled in the art of war, and are famous for their greatness across the world. They wish to see the best of bows that is in your possession. They will return once they have seen it."

So addressed, Janaka said, "Great sage! Please listen to the story of the supreme bow and why it remains in my possession."

Shiva's bow

So saying, Janaka told them the story of Daksha, the son of Brahma, the Creator of the universe, who undertook a great sacrifice. He invited all the gods, except for Shiva, the Destroyer of the universe. Enraged at the oversight, he destroyed Daksha's sacrifice. He stood there with his bow

SHIVA AND DAKSHA
This early 19th-century painting portrays Daksha (right) standing next to a form of Shiva called Veerabhadra. Most motifs associated with Shiva, including Ganga emerging from his locks, can be seen here.

LOCATION

MITHILA

Mithila is usually identified with the present-day east Indian state of Bihar and some parts of Nepal. While Valmiki's description of it is minimal, the vast *Ramayana* tradition sees it as crucial, since it is Sita's land.

In the *Vishnu Purana*, Mithila is named after King Mithi, whose father, Nimi, was cursed by Vasishtha into abandoning his physical form. The gods churned his body and that gave rise to his son, Mithi. Because Mithi was born in this unusual way, he and his successors were known as Janaka (self-born ones).

Other *Ramayana*s are more extensive in their description of Mithila and often emphasize that the Goddess Lakshmi, consort to Vishnu, the Preserver of the universe, chose to dwell here. In PS Sundaram's *Kamba Ramayana*, Kamba, the poet, for instance, says, "That fortressed city ... seemed to welcome with open arms the prince with the lotus eyes. It was as if it was keen that he should hurry up to meet the goddess who had left the spotless flower to make Mithila her residence – a big boon that the kingdom got as a result of rigorous penance."

> "Having been **raised from the surface of the ground**, she was reared as **my daughter**... **not born from a womb**... will be bestowed as *viryashulka*."

JANAKA ON SITA'S BIRTH, *SARGA* (65), BALA KANDA

SEEING SITA

Many versions of the *Ramayana* describe Rama and Lakshmana walking through Mithila in deeply evocative ways. Residents of the city drop whatever they are doing so that they may glance at Rama. They are often so struck by him that they wish the king would give up his vow and marry Sita to Rama right away.

In *Kamba Ramayana*, Rama and Sita see each other, and in other versions, they happen to meet in a garden. In *Krittivasi Ramayan* and the *Ramcharitmanas*, Sita prays to various gods, in particular the Divine Mother. In both, she receives divine reassurance that she shall be married to Rama.

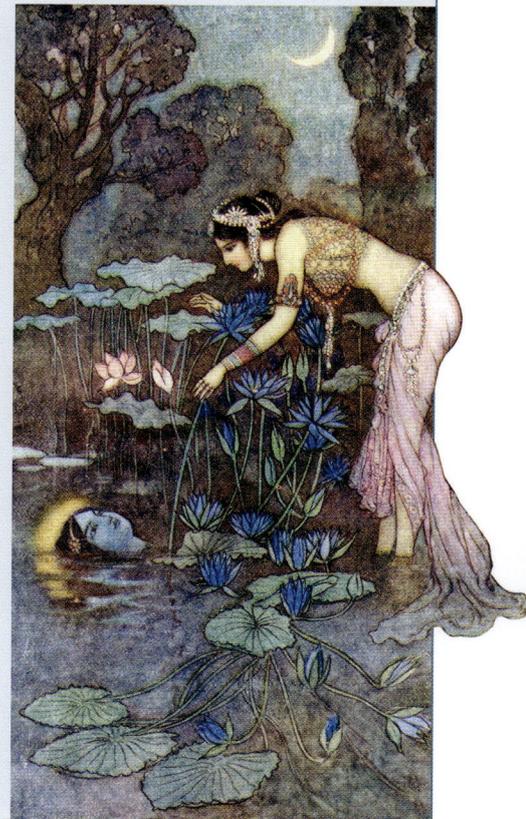

ILLUSTRATION OF SITA reaching out to Rama by artist Warwick Goble

and threatened to cut off the gods' heads. When they propitiated him, he granted this bow to them. Later, Shiva entrusted this great bow to Devarata, Janaka's ancestor. It had been passed on to the various rulers of Mithila ever since.

Sita's marriage

Janaka then told Rama and Lakshmana about his daughter, Sita, whom he found as a baby, while ploughing a field. "Not born from a womb, she is the one who became famous by the name of Sita. I declared her to be *viryashulka*," he said, "as I have placed valour as the price to wed her." Sita had many suitors, Janaka said, but he refrained from marrying her to them. "Kings came to Mithila to seek her hand and wanted to exhibit their strength. I showed them Shiva's bow, but none of them could even lift it," he said.

Realizing that their valour was under doubt, the kings laid siege on Mithila for a year. Janaka turned to the gods and asked them to help. They granted him a powerful army of chariots, foot soldiers, elephants, and horses. The king of Mithila defeated all of them. Some died, while others fled, he said.

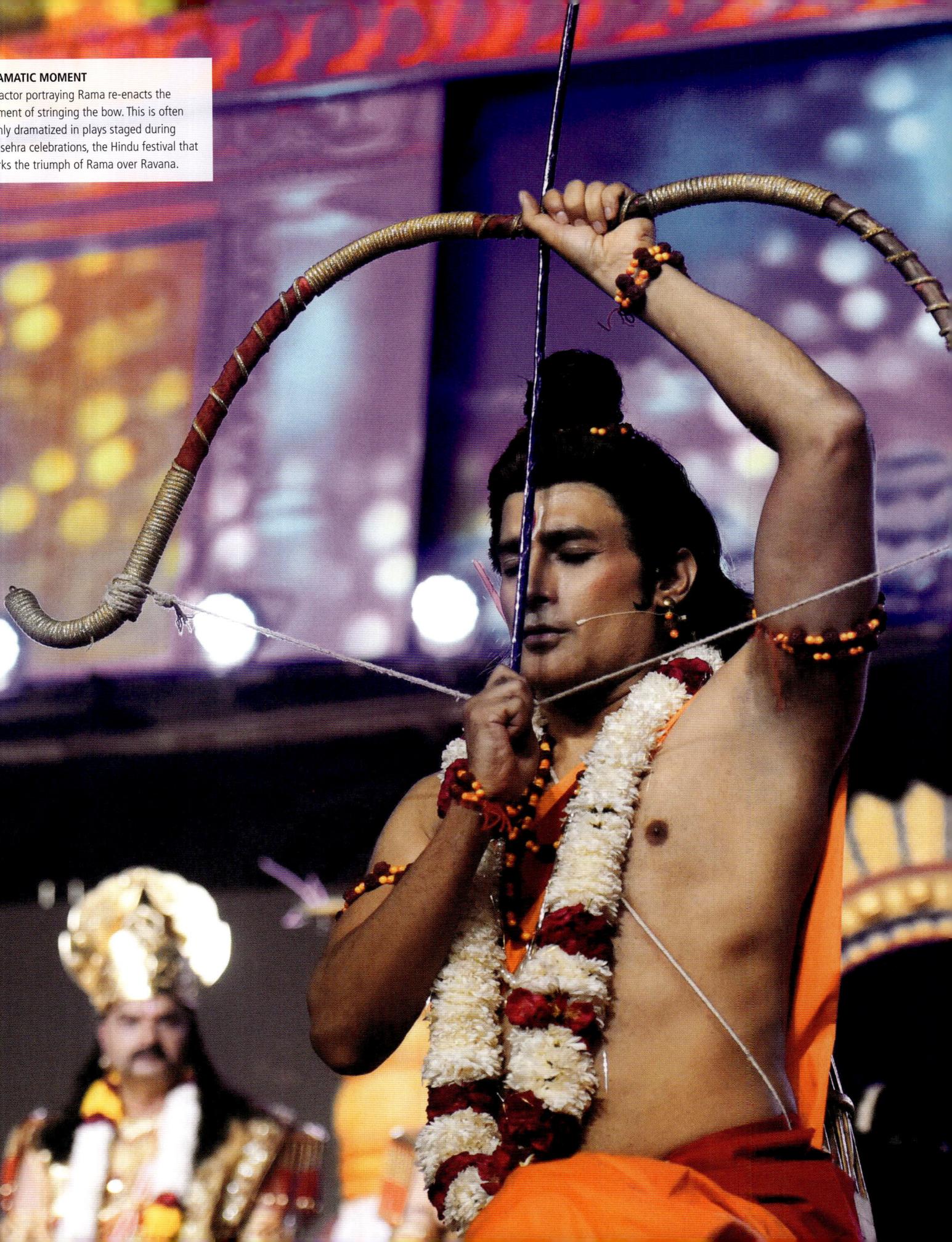

DRAMATIC MOMENT
An actor portraying Rama re-enacts the moment of stringing the bow. This is often highly dramatized in plays staged during Dussehra celebrations, the Hindu festival that marks the triumph of Rama over Ravana.

Stringing
Shiva's **Bow**

In a noteworthy display of strength, Rama lifted Shiva's supreme bow, took aim, and proved his mettle. Pleased, Janaka offered him Sita's hand in marriage.

Janaka looked at Vishvamitra and said, "If Rama were to string this bow, I shall grant him my daughter, Sita." On Vishvamitra's behest, the king ordered for the bow to be brought forth.

Five thousand tall men emerged, pulling an iron casket with eight wheels. The best among all bows lay on the casket, decorated with garlands. Janaka turned to Vishvamitra and said, "This is the bow, which the Janakas have worshipped. Gods, Rakshasas, and semi-celestial beings of various kinds, have all tried and failed to string it – what of humans! Show it to the princes."

Rama, in accordance with Vishvamitra's commands, opened the casket and reached for the bow. With great reverence, he said, "Sir! I shall touch this bow with my hand, and try to lift and string it."

He lifted the bow as if in play, strung it, and took aim. Such was his speed and felicity that the bow snapped at the middle.

As it broke into two, a terrible sound filled the earth and the ground shook. No one remained standing except the king, sage Vishvamitra, and the two princes. The king said, "I have witnessed Rama's valour." So saying, he offered him Sita's hand in marriage.

"While many thousands of men looked on, the descendant of the Raghu lineage... playfully strung the bow and took aim. The bow snapped at the middle. A great sound arose, like the roar of a storm."

AS RAMA STRUNG SHIVA'S BOW, *SARGA* (66), BALA KANDA

Recounting the **Lineages**

Delighted at the prospect of Sita's marriage to Rama, Janaka invited Dasharatha to Mithila, where, as was customary, representatives from each side recounted the great lineages of the Ikshvakus and the Videhas. Finally, not one but four matrimonial alliances were forged between the two sides.

Once Janaka decided to give Sita's hand in marriage to Rama, he looked towards Vishvamitra for advice. He said, "Should you permit it, I will send my counsellors to Ayodhya so that they may inform King Dasharatha of what has transpired here. They shall humbly invite the king here." The sage agreed and Janaka immediately sent the messengers. It took them three nights to reach the great city of Ayodhya.

In Ayodhya

At the palace, they saw King Dasharatha, aged in appearance, yet god-like in his brilliance. They addressed him with reverence, "Janaka, the king of Mithila, asks after your well-being with great affection. Seeking repeated assurance of your well-being in all ways, the lord of Mithila has conveyed a message, which bears sage Vishvamitra's stamp of approval."

They read out Janaka's message: "I had vowed that my daughter is *viryashulka* and turned away many kings, finding their valour lacking. That daughter of mine has been won by your son, who broke the divine bow cleanly in two. I wish to give him my daughter in marriage, so I may complete my vow. Please come to Mithila soon."

Delighted, Dasharatha wasted no time and began preparations to depart. An immense army and the great

> "Let these **two excellent lineages**, auspicious in deeds, yours and that of the **Ikshvakus**, be closely tied to each other **through an alliance**."
>
> VISHVAMITRA TO JANAKA, *SARGA* (71), BALA KANDA

RAMA'S LINEAGE
This 18th-century painting from Udaipur, Rajasthan, depicts the entire lineage of the Ikshvakus, starting from Brahma.

sages Vasishtha, Vamadeva, Katyayana, and Markandeya accompanied the wedding party. They arrived in Mithila four days later.

The two kings meet

Janaka, glad to see the lord of Ayodhya, addressed him with great affection. "It is my great fortune that you have arrived. It is fortunate that all obstacles have been removed and that my lineage is exalted by this relationship with the heroic descendants

of Raghu," he said. Then, he asked Dasharatha, if the wedding could take place the next day. Dasharatha replied, "O King, I heard once that it is the giver who decides the conditions of the gift. We shall do as you say."

Ikshvakus and Videhas

The next morning, Janaka invited his brother, Kushadhvaja, Dasharatha, his sons, and the counsellors. They began the ritual introductions after everyone seated themselves. The great sages presented the lineage of the Ikshvaku and Videha dynasties, as is customary before a wedding.

Dasharatha then spoke up, "Sage Vasishtha is like the family deity of the Ikshvakus. With the consent of Vishvamitra and other sages, he shall state my lineage."

Vasishtha addressed Janaka and his priest, "Brahma, whose origin is unexpressed, is eternal. His son was Marichi. Marichi's son was Kashyapa, whose son was Vivasvan, and his, in turn, was Manu. Manu's son was Ikshvaku, the first king of Ayodhya. From Ikshvaku, through Vikukshi, Bana, Anaranya, Prithu, Trishanku (See p 56), Dhundumara, Yuvanashva, Mandhata, Susandhi, Dhruvasandhi, Bharata, Asita, Sagara (See p 50), Asamanja,

Anshuman, Dilipa, Bhagiratha (See p 50), and Kakutstha, descended Raghu. From Raghu's son, Kalmashapada, was born Shankhana, and from him Sudarshana, and in this way, through Agnivarna, Sheeghraga, Maru, Prashushruka, Ambareesha, Nahusha, Yayati, Nabhaga, and Aja, Dasharatha is descended. Rama and Lakshmana are the sons of Dasharatha. For Rama and Lakshmana, born in this lineage, I ask for your two daughters. Grant them unto these well-suited young men."

Janaka replied, "Great sage! At the time of giving away a daughter, the entire lineage should be recited. The deeply virtuous Nimi is well known. His son was Mithi, whose son was the first Janaka (See p 58). From him, through Udavasu, Nandivardhana, Suketu, Devarata, Brihadratha,

Mahaveera, Sudhriti, Dhrishtaketu, Haryashava, Maru, Prativandhaka, Kirtiratha, Devamidha, Maheedhraka, Keertirata, Maharoma, Svarnaroma, and Hrasvaroma, are descended my younger brother, Kushadhvaja, and I. Kushadhvaja is the king of Samkashya."

"I give as brides Sita and Urmila to Rama and Lakshmana."

Vishvamitra, with Vasishtha's support, said, "Your lineages are exalted. This is a well-suited relationship. Your brother, Kushadhvaja, is a virtuous king and has two daughters. We seek them in marriage for the other sons of Dasharatha, Bharata and Shatrughna."

Pleased, Janaka replied, "Very well. Let the four princes take the hands of the four princesses in marriage on the same day."

CHARACTER PROFILE

JANAKA

Sita's father is remembered as Janaka, a title given to all the kings of Videha or Mithila lineage (See p 58). However, in the broader Indic universe, he is also known as a great royal sage who mastered the secret of detachment. He appears in the *Brihadaranyaka Upanishad* and texts teaching non-dualism, such as *Ashtavakra Gita* and *Yogavasishtha* (See p 42). In later *Ramayana*s, this sometimes comes into play when Janaka first sees Rama — the heart and mind of even one as restrained as Janaka, is moved at the sight, for Rama is the Supreme Being himself.

JANAKA'S (SHOWN HERE) given name was Seeradhwaja

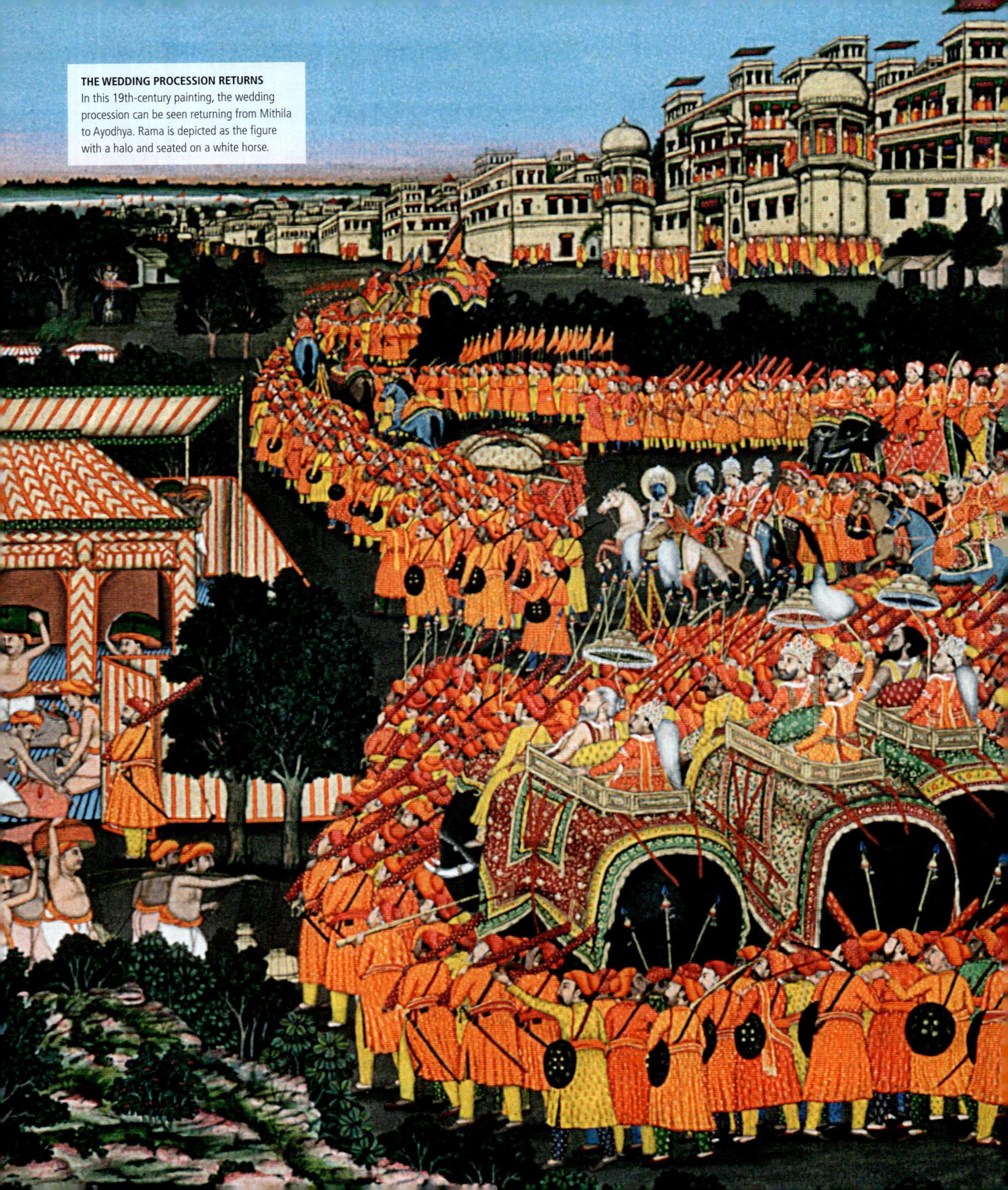

THE WEDDING PROCESSION RETURNS
In this 19th-century painting, the wedding procession can be seen returning from Mithila to Ayodhya. Rama is depicted as the figure with a halo and seated on a white horse.

The Wedding and After

The marriage ceremonies were performed in the month of Magha, on Uttaraphalguni, when Bhaga – the god of marital bliss – was the presiding lord. Soon after, the wedding procession returned to Ayodhya. Their journey back home, however, wasn't devoid of obstructions.

Now that matters were settled, Dasharatha left for his accommodation to perform ritual observances. The next morning, he gave away thousands of cows and other riches to Brahmanas in the name of his sons. Meanwhile, Yudhajit, Bharata's maternal uncle, arrived as well

At the wedding altar

After performing all the rituals as was prescribed, Dasharatha arrived at the sacrificial enclosure. He was accompanied by his sons, who were adorned with ornaments and had donned auspicious attire for the wedding. Placing the sages ahead of them, the four princes performed the pre-wedding rituals.

Vasishtha then addressed Janaka, "King Dasharatha, accompanied by his sons, has completed the sacred rituals and awaits the brides. Perform your duties, O king, and begin the wedding ceremony."

Janaka, who knew dharma, the path of righteousness, responded with the ceremonial questions: "Who stands guard at the door? Whose command do you await? This is your house – why do you stand on ceremony? This kingdom is all yours. My daughters are seated by the altar, as resplendent as the flames of the holy fire. I, too, am seated and await you. Do not delay, please enter." On hearing Janaka's words, Dasharatha, his sons, and the sages entered the wedding area.

The hands of the four brides were placed in the hands of the grooms, and the couples circumambulated the fire and the elders thrice. All customary and Vedic ceremonies were performed.

As the rituals concluded, flowers rained from the sky. Divine drums played and the sounds of singing and divine musical instruments were heard. The Gandharvas sang and celestial maidens danced as they witnessed this spectacle from the sky.

The return to Ayodhya

Vishvamitra departed for the northern mountains the next day. Janaka, after giving his daughters many gifts, took Dasharatha's leave and returned to his own residence.

The wedding party started the journey back to Ayodhya, with Dasharatha, his sons, their wives, the royal sages, and the armies.

As they travelled, they experienced a strange mixture of omens. The birds were agitated, but the animals seemed to show favourable signs. The sages told Dasharatha that this meant a great terror would approach, but would eventually be resolved. As they spoke, a wind rose. »

CULTURE

WEDDING SONGS

In many regions across India, songs on Rama and Sita are sung to mark wedding rituals. It both sacralizes the bride and groom and brings Rama and Sita closer to the community, making them part of intimate circles of affection. In this example from the Mithila region in eastern India, Rama is encouraged to fill Sita's hair parting with vermilion (referred to as *sendur-daan* here) by surrounding relatives:

*Carefully lift the golden vermilion,
bridegroom, O Dasharatha's boy!
Slowly apply it to our daughter,
O Dasharatha's boy!
Don't be shy, hold your heart,
O Dasharatha's boy!
Quickly perform the sendur-daan,
O Dasharatha's boy!
Steady your trembling hand,
O Dasharatha's boy!
Hold our daughter to your heart,
O Dasharatha's boy!*

SENDUR FORMS AN IMPORTANT part of Hindu marriage ceremonies

"This is my **daughter, Sita** and she will perform every act of **dharma** with you. O fortunate one! If you also **desire her, accept her hand** with your hand."

JANAKA TO RAMA, *SARGA* (72), BALA KANDA

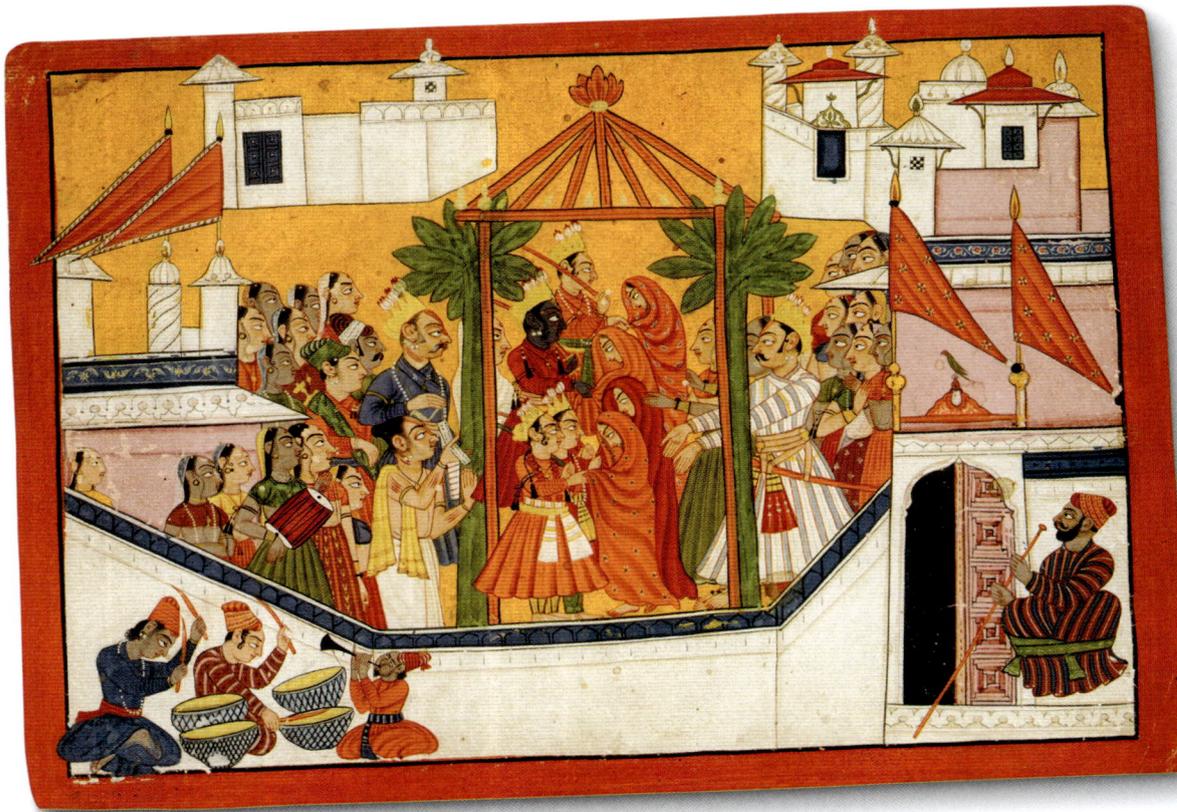

HAND IN HAND
In accordance with the rituals and to symbolize unification, the four brothers grasped the hands of their prospective wives. This 18th-century Basohli painting portrays the performance of that ritual.

In the storm that followed, the earth trembled, trees toppled over, and darkness took over the entire sky. The procession, covered in ashes, saw a terrible figure approaching. He had matted locks and seemed insurmountable like the mountain Kailasa, and difficult to bear like death's own fires. He bore a battleaxe, a bow, and arrows.

Parashurama's challenge

Knowing him to be Parashurama, all the sages offered him due honour. He then turned to Rama and said, "O brave son of Dasharatha! I have heard a great deal about your valour and heroism. I have also heard of how you broke the great bow. Now, take this other great bow and string it. I shall grant you the honour of a duel after examining your strength in the stringing of this bow."

Dasharatha tried to calm Parashurama and compel him to desist, but he ignored the king. Instead, Parashurama addressed Rama, "These two mighty bows were made by Vishvakarma. The gods gave one to Shiva, the Destroyer – that's the one you broke. This other, they gave to Vishnu, the Preserver of the universe, who entrusted it to Richika, my grandfather. My father, Jamadagni, received it from him. Place this mighty arrow onto the bow, and I shall engage you in a duel."

Rama's reaction

Restrained in the presence of his elders, but still radiant with strength, Rama said, "I have heard of your battles with the Kshatriyas, and I respect your actions because you were performing your duties towards your father. However, you disregard me as if I were devoid of the qualities of a warrior. You shall see my valour for yourself today."

Rama grasped the bow and with great joy, placed the arrow. He told Parashurama, "You are a Brahmana and related to Vishvamitra. I cannot aim this arrow at you. However, this is the great arrow of Vishnu, and does not return to the quiver unshot. I can aim it at your supernatural abilities to travel, or the realms you have gathered through austerities."

As he held up the great bow of Vishnu, rishis and gods gathered to witness the wonderful sight. Dimmed by Rama's splendour, Parashurama spoke softly, "Rama! I gifted the earth to my guru Kashyapa after

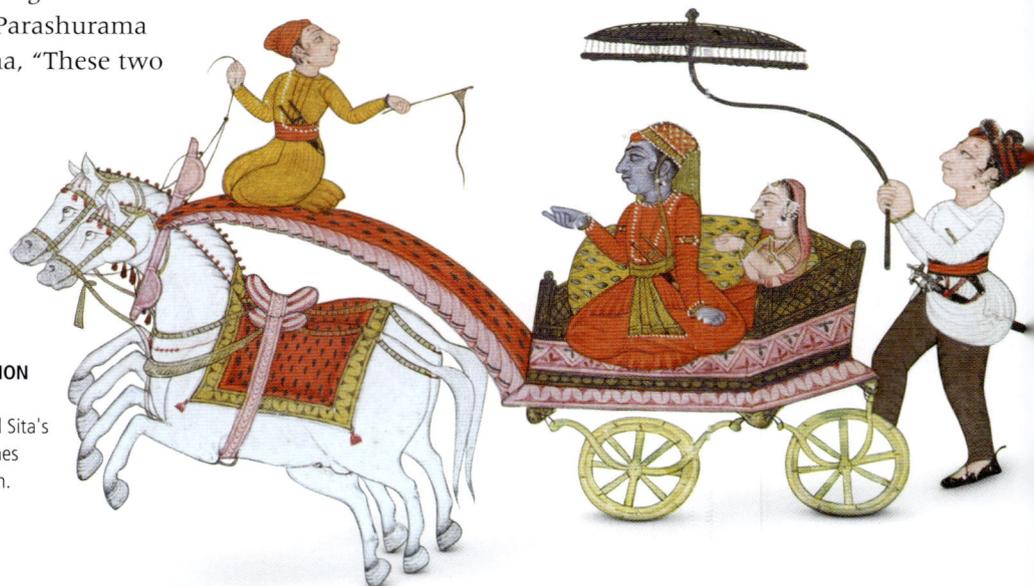

A NORTHERN DEPICTION
This mid-18th century depiction of Rama and Sita's return to Ayodhya comes from Himachal Pradesh.

"The **spirited** one was devoted to her... Whatever was in the **innermost portions** of their hearts became **manifest** to each other."

ON RAMA AND SITA'S DEVOTION TO EACH OTHER, *SARGA* (76), BALA KANDA

PARASHURAMA
This idol of Parashurama is carved on the inner wall of Rani ki Vav, a stepwell in the Patan region of Gujarat. The structure incorporates sculptures of many forms of Vishnu.

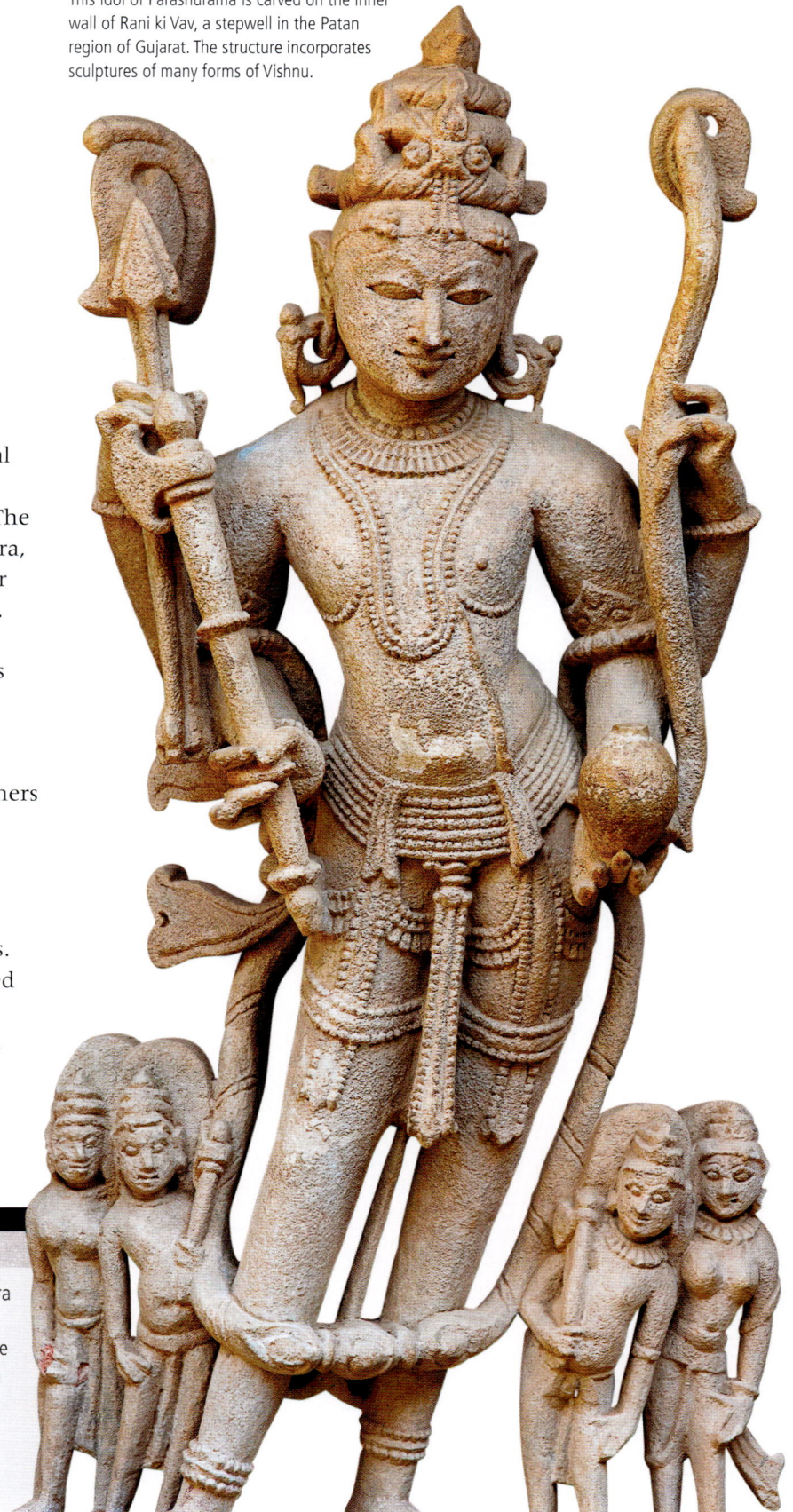

conquering it. At his command, I will not spend the night here. Leave my abilities to travel as they are, so I may return to my abode at Mount Mahendra. But do not delay in destroying those realms. I am not embarrassed at having met defeat at your hands, for you are the lord of the three realms."

Rama released the arrow and the sage departed, having paid Rama due honour. Rama handed the supreme bow and arrow to Varuna, the god of the water, and the procession continued towards Ayodhya.

The married life

Ayodhya was adorned for the occasion and its streets strewn with flowers.

The citizens played musical instruments as the princes entered the royal palace. The queens, Kaushalya, Sumitra, and Kaikeyi, received their daughters-in-law with joy. The customary rituals welcoming the newlyweds were performed and the couples entered the royal household in perfectly auspicious ways. The brothers lived with their consorts, serving their father.

Rama, whose deeds were unmatched, lived this way for many seasons. He was completely devoted to Sita, who in turn, was twice as devoted to Rama. They lived together, as Vishnu did with his consort, Lakshmi.

RASIKA SPIRITUAL PRACTICES

Ramayana scholar, Philip Lutgendorf, in his essay "The Secret Life of Ramcandra of Ayodhya" offers an interesting perspective. He explores how the time that Rama spent in Ayodhya with Sita after his return from Mithila is the focus of the spiritual practices of a particular branch of Rama worship. In this, "Saketa" – a name for Ayodhya in some contexts and the locus of Rama's divine play – is approached as transcendental. Initiates in the *Rasika* branch of the Hindu sect of Ramanandis receive a further initiation, which allows access into transcendental Saketa as the servant, elder, lover, or companion of the lord.

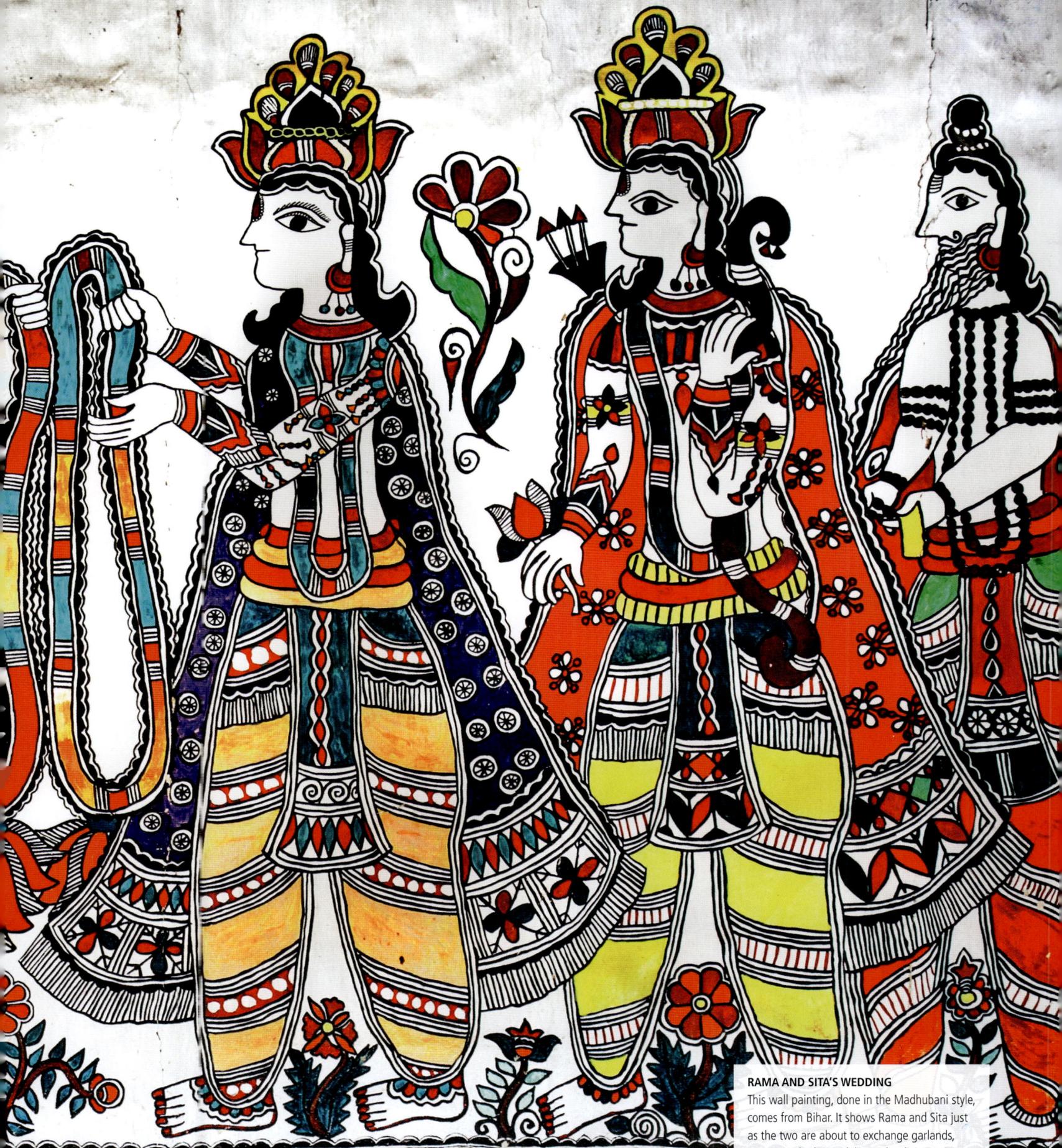

RAMA AND SITA'S WEDDING
This wall painting, done in the Madhubani style, comes from Bihar. It shows Rama and Sita just as the two are about to exchange garlands, even as onlookers celebrate the divine union.

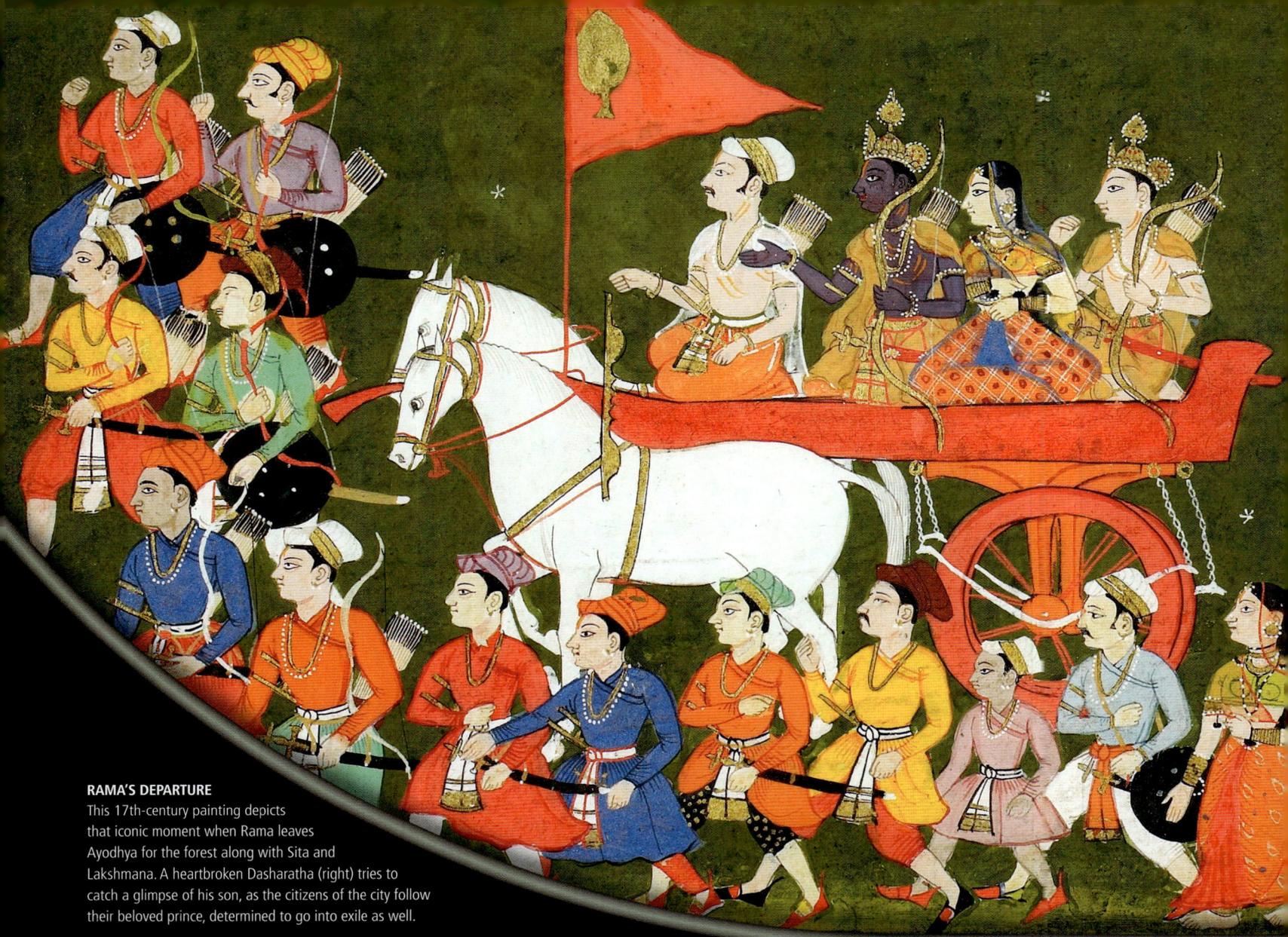

RAMA'S DEPARTURE
This 17th-century painting depicts that iconic moment when Rama leaves Ayodhya for the forest along with Sita and Lakshmana. A heartbroken Dasharatha (right) tries to catch a glimpse of his son, as the citizens of the city follow their beloved prince, determined to go into exile as well.

2 AYODHYA KANDA:
THE ETERNAL CITY

Rama is chosen as heir apparent to the throne of Ayodhya, but the wheel of destiny spins the other way. Forced to keep the sacred vow made to his wife Kaikeyi, Dasharatha exiles Rama, so that Bharata can be crowned king. Rama's wilful acceptance of his father's decree and the calm self-control with which he conducts himself after hearing the news, characterizes him throughout the story as an ideal son, worthy of kingship. The chapter ends with an exploration of brotherly devotion and the beginning of a long journey.

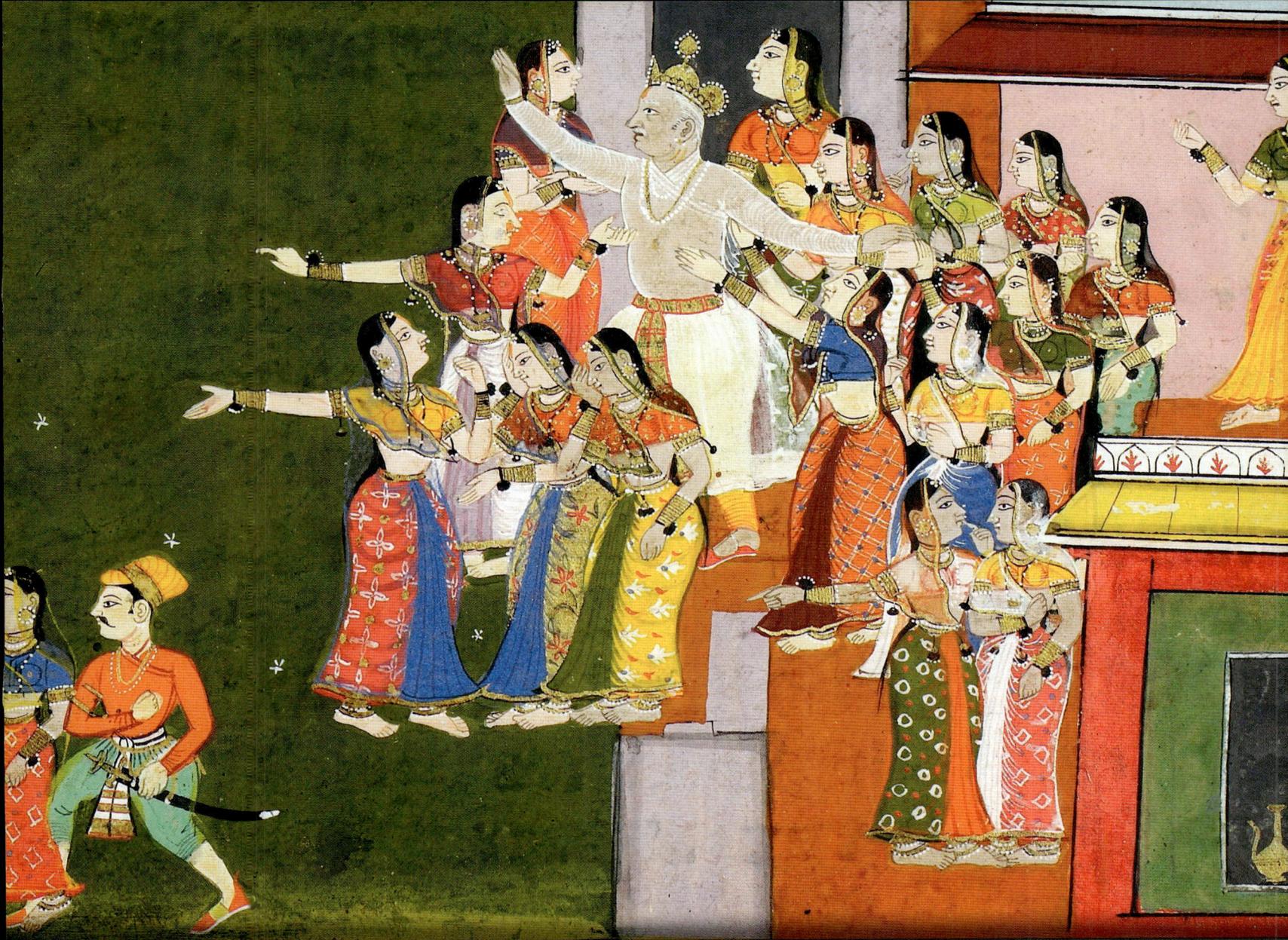

"Right now, I will quickly dispatch **Rama** to the **forest**. I will swiftly instate **Bharata** as the **heir apparent**. O Manthara! Now think of a means whereby Bharata, and not Rama, gets the **kingdom**."

KAIKEYI TO MANTHARA, *SARGA* (9), AYODHYA KANDA

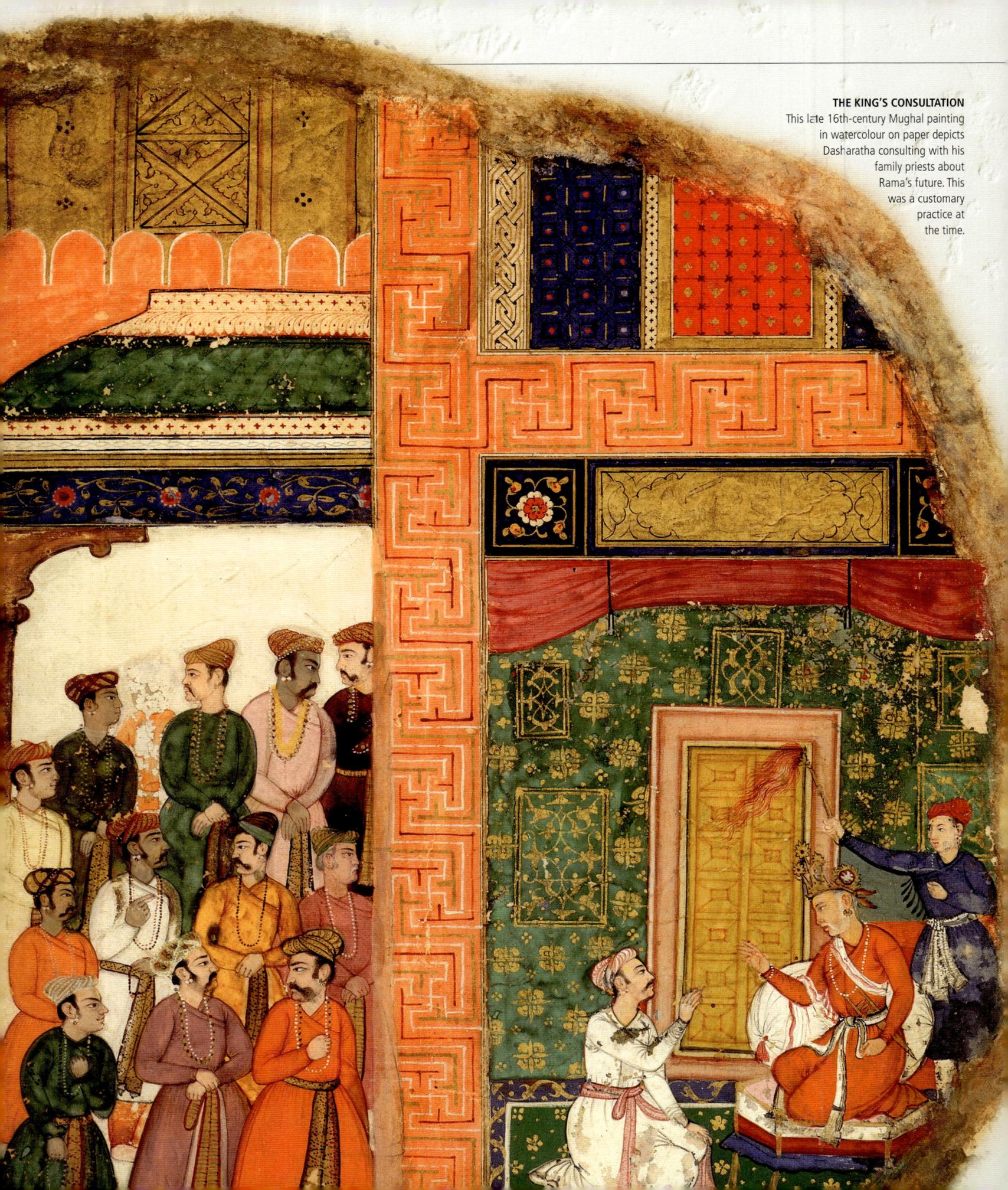

Who Will Be **King?**

Time passed after the return of Rama and soon Bharata and Shatrughna prepared to visit the kingdom of Kekaya. King Dasharatha thought this was an ideal time to make an important announcement. Unknown to him, this decision became a catalyst to future events in his children's lives.

One day, Dasharatha called Bharata and told him that his uncle, Yudhajit, had arrived to take Shatrughna and him to the kingdom of Kekaya to visit their grandfather. The brothers took their father's blessings and left. Their grandfather was delighted to see them and the brothers enjoyed their stay there. But, they would often think of their aged father, Dasharatha.

The glory of Rama

Dasharatha loved his sons as if they were his own limbs. Rama gave him the most joy for he performed all his duties towards the people, his mothers, father, and teachers, to perfection. The Brahmanas and citizens were pleased with him. Calm and peaceful, he never responded with harsh words. He was not arrogant or wrathful. Rama knew weaponry, his obligations, and the minds of his people. He was unassailable in battle even for angered gods and demons.

Dasharatha's decision

Seeing Rama, Dasharatha wondered when he would see him consecrated. "He is dearer to people than I am, as beloved as the god of rain," he thought.

Convinced that the time was right, he invited the sages and the nobility to his court. He told them that he wanted to step down as the king. "This world was protected by the Ikshvakus who came before me. I, too, followed in their footsteps and have sought to protect the people to the best of my ability. However, this body has become old and I would like to rest awhile."

He suggested that Rama take his place. "Rama is like Indra himself in valour and the best of those who bear dharma. He is a fitting lord for you – for the three realms would find a lord in him."

The gathered nobility agreed immediately, recounting the prince's virtues with enthusiasm. They wished to see Rama as crown prince.

Dasharatha wasted no time and called Rama to the assembly and informed him of his intent. He spoke to the counsellors too, and decided to hold the consecration the following day.

The king speaks to Rama

Dasharatha retreated to his royal chamber and asked Sumantra, his charioteer, to bring Rama to him once again.

When the lotus-eyed one entered the room, Dasharatha confessed that he was worried and fearful. "All manner of ill omens afflict me. Spend tonight in austerity. I think this is best done in Bharata's absence. He is righteous and follows you, and would never oppose you. Yet, it is best that he finds out later, as the minds of men are unpredictable."

A mother celebrates

When Rama gave his mother, Kaushalya the news she was overjoyed. "May you live long, and your enemies be destroyed," she said tearfully.

Rama turned to Lakshmana and said, "You shall partake in this glory with me, beloved brother! You are my own other self. This kingdom, and indeed, life itself, I only seek for your sake."

So saying, he left with Sita to perform austerities through the night, even as the city rejoiced at the news of his consecration.

An observation

Manthara, Kaikeyi's handmaiden and confidante, who had been with her since birth, saw the city bustling with festivities. She asked a maid standing nearby, "Why is Rama's mother giving away such riches? Why is there such joy among the people?"

The maid replied with great excitement, "Tomorrow, at an auspicious time, Dasharatha will consecrate Rama as the crown prince."

ANALYSIS
DIVINE DISCONTENT

While this part of the *Ramayana* reads like palace intrigue, it fits into the cosmic scheme, which Rama's birth was part of. If Rama was consecrated and lived happily in Ayodhya, Ravana's reign would have continued and the purpose of the gods would not have been fulfilled. In the *Adhyatma Ramayana*, Brahma, the Creator of the universe, sends Narada, the sage to remind Rama of his purpose. After Rama greets him, Narada praises him and Sita as the Supreme Being, and conveys Brahma's message. Rama responds, "Listen, sage! There is nothing that I do not know. I shall soon go to the forest and live there for 14 years, destroying Ravana under the pretext of Sita's abduction."

> **"O king!** Your son possesses many **auspicious** qualities. Rama has truth for his valour. Invested with **divine** qualities, he is like **Shakra**… He is superior to all those in the **Ikshvaku lineage**."
>
> A CITIZEN OF AYODHYA DESCRIBING RAMA'S QUALITIES TO DASHARATHA, *SARGA* (2), AYODHYA KANDA

Manthara's
Intrigue

**Dasharatha's decision made Manthara furious.
What she did next changed many destinies forever.**

Angered at the maid's words, Manthara rushed to Kaikeyi's chambers and woke her up. "Fool! Wake up! Do you not see yourself drowning? While you sleep, great misery is about to befall you," she said in a scathing tone.

Puzzled, Kaikeyi asked, "What has happened? What has become of my good fortune?"

Manthara, who only had Kaikeyi's interest at heart, told her of Dasharatha's plan. "I am full of grief. Your mind is pure, so you do not see that the king, though he speaks of righteousness, is a cheat. He has sent your son away and is trying to pass the kingdom to Rama. This will destroy you and your lineage. Act fast and save yourself and your son!"

"You've brought wonderful news!" Kaikeyi exclaimed in delight and gifted Manthara jewels. "I see no difference between Rama and Bharata. I am satisfied if the king consecrates Rama."

Manthara persisted, "What is this untimely joy? Don't you understand that you are in the middle of an ocean of sorrow? Kaushalya is fortunate. Her son is being consecrated. You will stand by her like a servant."

Kaikeyi, in response, extolled Rama's virtues and assured her maid that Rama would treat his elders well. "Once Rama has ruled for 100 years, Bharata shall have his turn. Rama serves me with greater care than he does Kaushalya," she said.

"You are a fool," Manthara said, "If Rama gains the kingdom, he could banish your son or even kill him. So, think of a way to make your Bharata the crown prince, and exile Rama."

"I have come here for the **sake of your welfare**... My **misery** has become **greater** because of **your misery**."

MANTHARA TO KAIKEYI, *SARGA* (8), AYODHYA KANDA

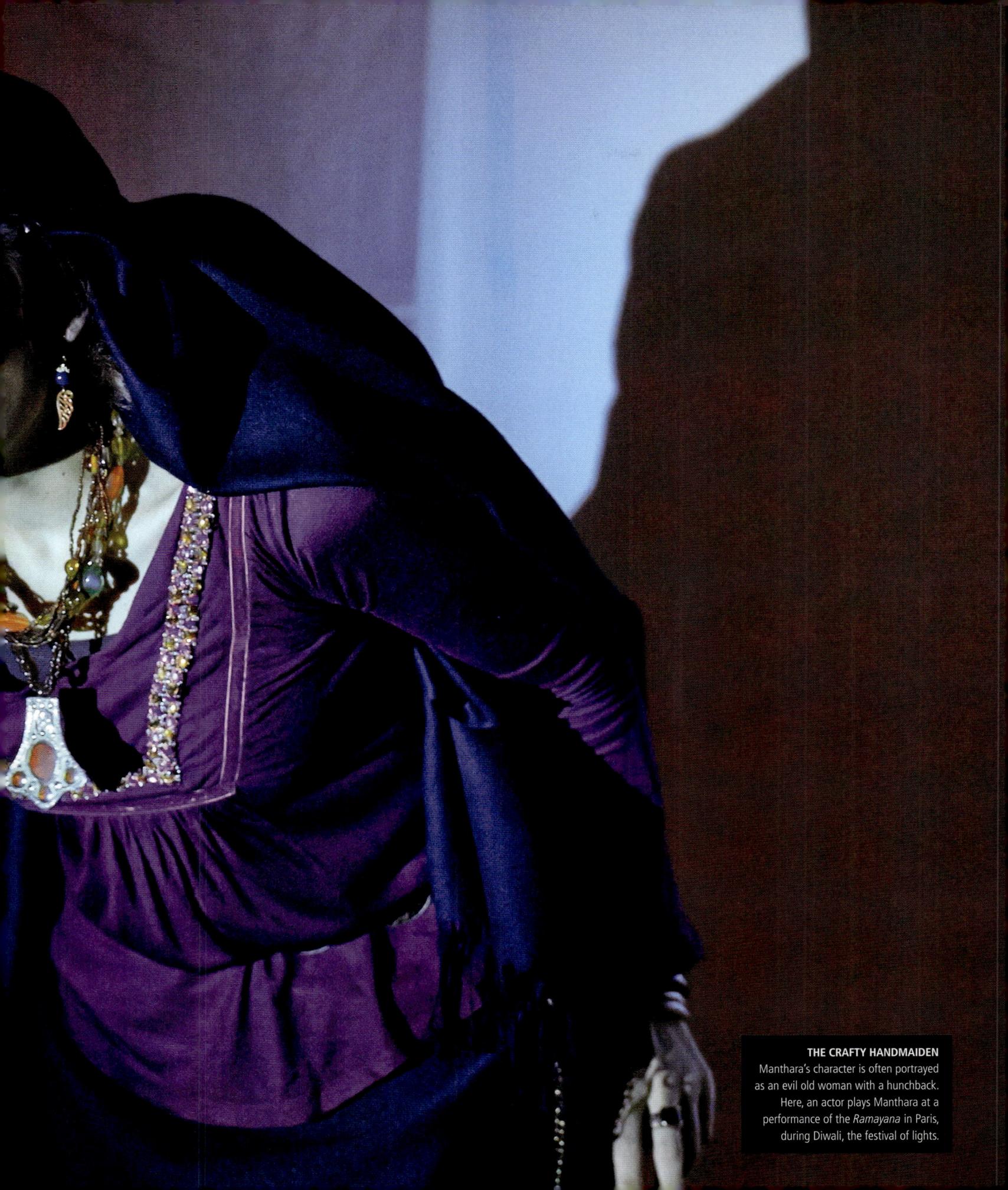

THE CRAFTY HANDMAIDEN
Manthara's character is often portrayed as an evil old woman with a hunchback. Here, an actor plays Manthara at a performance of the *Ramayana* in Paris, during Diwali, the festival of lights.

DHARMA OF A KING'S DUTY TOWARDS HIS SUBJECTS

Inheritance and **Kingship**

"The king must **protect** all those who reside inside **his kingdom**... I hope you devote your time **equally** to *artha*, dharma and *kama*."

RAMA TO BHARATA, *SARGA* (94), AYODHYA KANDA

Two distinct, but coexistent, attitudes towards kingship exist in the *Ramayana*. One view holds that kingship is a set of duties performed in the interest and protection of the subjects, a yoke to be borne. In this view, the protection of the realm and its control are desirable, and the king is not expected to live an austere life, but the chief purpose of kingship is not personal enjoyment. In the other view, the realm facilitates the pleasure of the ruler himself – this view is only ever brought up to be censured. This is explained in terms of the interrelationship of dharma, *artha* (purpose or meaning), and *kama* (pursuit of pleasure or desire) (See pp 18–19).

For the first kind of king, *kama* is regulated by *artha*, and they are both regulated by dharma, whereas in the latter's case there is an indiscriminate indulgence in *kama*. However, a king is not expected to block *artha* with dharma under normal circumstances, and is usually expected to pursue all three.

A KING'S DUTY
Once consecrated, a dutiful king is expected to follow the path of righteousness and pursue *artha* or *kama* only when appropriate.

PURSUITS OF A KING

Two distinct views emerge in the Yuddha Kanda. Ravana is chastised often for his indulgence in pleasures without paying attention to issues of policy. The two positions are exhibited in a conversation between Kumbhakarna and Mahodara.

The former emphasizes the employment of policy in consultation with wise advisers, and argues the need to pursue dharma, *artha*, and *kama* at appropriate times. If a king refuses to accord dharma the final authority, even when he knows that it should be so, his learning is futile. Mahodara, however, focusses on actions and their results, and argues that adherence or non-adherence may result in good or bad results. Since actions are for favourable outcomes in this life and in the next, even one who indulges in *kama* might at least have a favourable outcome in the here and now.

Lakshmana's tirade against dharma – perhaps the result of the news of Sita's death (See p 299) – presents a sophisticated account of why dharma is inefficacious. The crux is that if Rama, always acting in accordance with dharma, could suffer in this way, of what use could dharma be? Instead of privileging *kama*, however, Lakshmana privileges *artha*, which he suggests, Rama disregards in agreeing to Kaikeyi's demands and is the cause of his current predicament. These views are presented as serious alternatives, and are not weak arguments.

KINGSHIP AS A YOKE

When Dasharatha announces his decision to pass the kingship on to Rama, he says that he has followed the path of the Ikshvakus in protecting his realm and subjects. He adds that his body has become frail in the process of ensuring the welfare of the people for so many years, bearing diligently the heavy yoke of dharma. He had, of course, indulged in all possible pleasures as well in those years, but that was not the purpose of his kingship.

In a way, Rama and his brothers can be contrasted with Ravana in terms of how they view kingship.

Ravana insists on privileging *kama*, but control over his realm and the extension of that control is important as well. He seeks to take over the realms of the gods and defeat all kings. He even takes over Lanka, which belonged to his older half-brother, Kubera (See p 343). On the other hand, when Rama contemplates the Rajasuya, a royal sacrifice, Bharata dissuades him because of the destruction it would bring about, and Rama is immediately convinced.

Rama's renunciation of Sita (See p 355), purely out of concern for what people would say, is sometimes understood in terms of satisfying his subjects.

A METAL STATUE of Kubera, the god of wealth

THE LAW OF INHERITANCE

It seems that the norm, in the *Ramayana*, is for the older son to inherit the kingdom, Rama and Vali being the chosen successors of their fathers. However, Rama and his brothers are ever willing to reject the kingdom in the pursuit of a higher ideal.

In the Ayodhya Kanda, while Rama and Bharata are willing to reject the right to the kingdom, neither shies away from the responsibility. Bharata lives as an ascetic on the outskirts of the city, but runs the kingdom efficiently on Rama's behalf. Rama, in the Kishkindha Kanda, claims that he acts as Bharata's representative.

When Rama grieves over leaving Ayodhya, not leaving and fighting for the kingdom is not an option. Lakshmana rejects Rama's suggestion that he become the crown prince, and Shatrughna is reluctant to leave Rama to live in the kingdom that has been given to him (See p 362).

In fact, none of Rama's brothers are willing to even live on, let alone rule, after him. The deeper distinction that becomes manifest, as the two kinds of positions on kingship and inheritance, is of how one places oneself with reference to other beings.

In one view, in accordance with dharma, the harshest set of rules is for oneself (or those close to oneself – Rama ends up renouncing the two people who were closest to him). One's personal pain and pleasure, while it may be suffered and enjoyed, is not a factor in decision-making.

According to the other view, decisions are foremost made keeping one's own desires in mind.

DASHARATHA'S ADVISERS

Within Valmiki's *Ramayana*, there is a mention of Dasharatha's eight advisers who were devoted to him. They are identified as Dhrishti, Jayanta, Vijaya, Siddhartha, Arthasadhaka, Ashoka, Mantrapala, and Sumantra. Described as skilled administrators, who had been tested for their loyalty and transparency, they often used spies for an insight into the happenings within the kingdom and perhaps the mood of the people. They offer an interesting insight into the nature of governance in Dasharatha's kingdom.

The Queen's Displeasure

Manthara convinced Kaikeyi that Rama's consecration was equivalent to Bharata's destruction. Then, she hatched an evil plan. She reminded Kaikeyi of the boons the king had promised her a long time ago, and told her how she could seek those from him now.

Manthara's wicked words made Kaikeyi burn with anger. "I shall swiftly exile Rama to the forest and have Bharata consecrated as the heir apparent," she said, flying into a rage. "O Manthara! Think of how we can ensure that Bharata acquires the kingdom."

Manthara's plan

With malice towards Rama, Manthara made a plan. She reminded the queen of the great battle between the gods and the Asuras.

The king – Dasharatha – had gone to help Indra, the king of gods, taking Kaikeyi with him.

He advanced to the city of Vaijayanta, ruled by the Asura, Timidhvaja, who was well versed in the power of illusion. A fierce battle ensued, which destroyed the army of the gods and left

> **"… her face was only enveloped in anger… she was distracted… like a star in the sky, enveloped in darkness."**
>
> KAIKEYI'S STATE, *SARGA* (9), AYODHYA KANDA

Dasharatha wounded. Kaikeyi removed him from the battlefield and saved his life.

Manthara looked at the queen and reminded her how the king, pleased with Kaikeyi, offered her two boons. She said, "You told him that you would ask for those promises at the right time, and he agreed. Make use of his promise. Ask him to grant you Bharata's consecration and a 14-year exile to the forest for Rama. If Rama stays away for 14 years, Bharata's reign will have become firm and stable."

Manthara then told the queen how to achieve her wishes, "Go to the chamber of anger. There, abandon all your ornaments and lie on the ground. When the king comes to see you, do not look

at him. He has immense love for you and can neither bear to make you angry, nor look at you when you are angry. The king cannot transgress your wishes. You need to understand your strength. Reject anything else that the king offers and remind him of his promises."

The king is summoned

Kaikeyi, accompanied by the crooked handmaiden, rushed to her special chamber. She discarded all her ornaments, lay on the ground, and said,

"Manthara, tell the king that either I shall die, or Rama will go to the forest and Bharata will acquire the kingdom."

The king, meanwhile, having ordered Rama's consecration, went looking for his beloved Kaikeyi to tell her the good news.

Dasharatha's reassurance

The king, who loved his youthful wife more than life itself, saw her lying on the ground. Alarmed, he touched her with affection, "I do not know of any anger you

ALTERNATIVE ACCOUNT

MANTHARA'S MOTIVATIONS

Although in some versions of the *Ramayana*, the gods intervene to make Manthara have Rama banished, in Valmiki's version, she is simply acting out of concern for Kaikeyi. There is no evidence that she has any personal animus for Rama. However, in the *Adhyatma Ramayana*, she is described as somebody who is his enemy for no reason.

Interestingly, in medieval Tamil poet Kamba's version, large parts of whose composition are devotional, Manthara tempers Kaikey's praise of Rama, reminding her that he killed Tataka, a female Yaksha. Kamba also says that she remembered the time Rama slung mud balls at her as a child. In his *Sri Ramayana Darshanam*, Kannada poet and playwright, KV Puttappa, also known as "Kuvempu", uses this to explore the idea of karma as a decisive factor. And yet, Kamba also writes that had Manthara not been so heartless, driven by fate, how would we have received a taste of Rama's fame?

BEJEWELLED KAIKEYI
This 17th-century Madurai painting from the Vishnu temple in the Azhagar (Alagar) Kovil region in Tamil Nadu portrays Kaikeyi adorned with beautiful ornaments from head to toe.

may have towards me. Did somebody disrespect you or rebuke you? Are you unwell? Tell me, shall I kill somebody who should not be killed? Or save a life that should be taken? Shall I make a rich person poor? Or endow a poor man with riches? I, along with all that is mine, am yours to command. Tell me your heart's desire."

Reassured, Kaikeyi spoke, "I have not been offended or disrespected. There is something I seek from you. If you wish to grant my wish, give me your word and I shall tell you."

The king smiled, "O proud one! Do you not know that there is nothing dearer to me than you, other than the lion among men, Rama? Pull my heart out and look at it, if you will, and tell me what you desire. I swear by my good deeds that I shall do what pleases you."

Kaikeyi's Boon

Kaikeyi spoke up, making use of the two boons Dasharatha had given her in exchange for saving his life. Her words left the king shattered.

Dasharatha's words pleased Kaikeyi who was keen to express her terrible desire. What had been brewing in her mind was not just unpleasant, but wicked, equal only to the news of sudden death.

Acting upon Manthara's words and firm in her resolve, Kaikeyi said, "I want you to swear and give me a boon – let the gods led by Indra, the sun and moon, the sky and planets, the day and night, the directions, this earth, the semi-divine beings and Rakshasas, the family deities, and all beings, bear witness to this. Let the gods hear that this king, who is known to be truthful, brilliant, controlled, and who knows dharma, is granting me his word. King, there were two boons you had granted me in the past. I seek to realize them today."

Then, she stated her demands, "By the very preparations you have made for Rama's consecration shall my son Bharata be made the heir apparent. So that his reign is smooth and devoid of any obstacles, Rama should be exiled to the Dandakaranya forest right away. He will live there as an ascetic for 14 years, with matted hair and clad in antelope skin and rags. This very day, Bharata will acquire the kingdom, and this very day, I will see Rama departed to the forest."

> **"Bereft of any thorns, Bharata must be made the heir apparent. Right now, I wish to see Raghava leave for the forest."**
>
> KAIKEYI TO DASHARATHA, *SARGA* (10), AYODHYA KANDA

INSIDE THE CHAMBER OF ANGER
This oil painting from 1890 by artist Raja Ravi Varma depicts Kaikeyi lying on the floor in a manner that did not befit a queen, as Dasharatha tries to pacify her. The queen is seen here without her ornaments and royal garb. At the time, in accordance with tradition, only widows or destitute women were seen without jewellery.

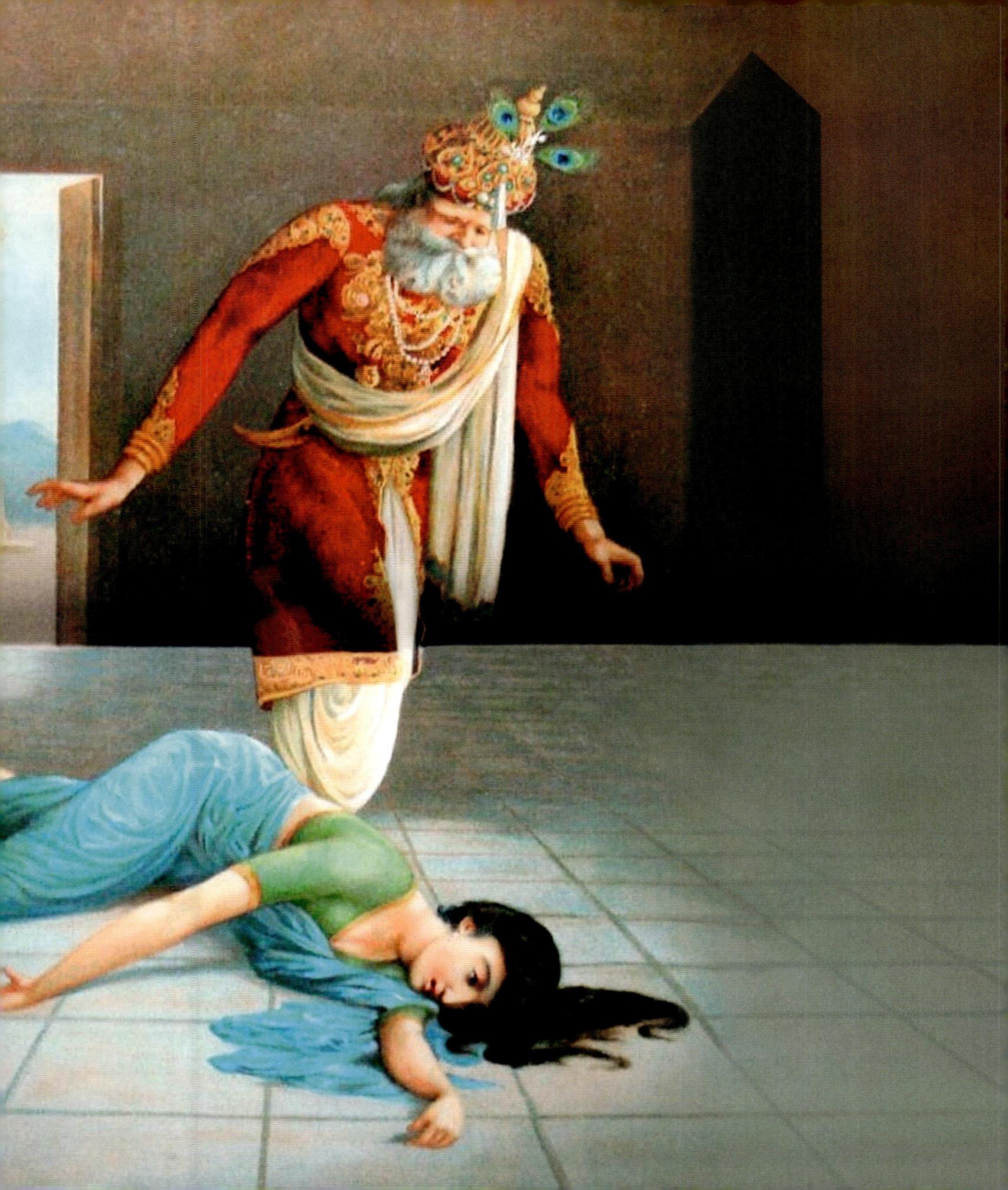

THE KING OF AYODHYA AND HIS CONSORTS

Dasharatha and the Queens

" He knows about **dharma** and is talked about. His **energy** is like that of a *Maharshi*. His **three wives** are virtuous, prosperous, and famous.**"**

THE GODS TO VISHNU ABOUT DASHARATHA, *SARGA* (15), BALA KANDA

Dasharatha, the son of Aja and the ruler of Ayodhya, is portrayed as a valorous ruler. His reign over Ayodhya is prosperous and it is clear that he and his subjects want for nothing. With Vasishtha as his priest, it is likely he is the envy of the land. Perhaps his most distinguishing feature is his immense love for Rama.

A father's love

His sons, born when he is quite old, are immeasurably precious to him. Of them, Rama, the oldest one, is held in special regard.

Dasharatha's love for his son is often understood in the broader context of Rama's divinity. It is clear that Rama has a certain effect on Dasharatha. In fact, Rama says that his father, even if previously angry, calms down in his presence. In Valmiki's *Ramayana*, Dasharatha is chosen to be Rama's father

because he is an illustrious king and desired a son. The motivation is much richer in other narratives.

In one version, Dasharatha and Kaushalya, in their previous lives, pray to the Supreme Being that He be born as their son, or that they have a son equal to Him. It is for this reason that they are attached to Rama. Further, both of them seek

A FAMILY PORTRAIT
This painting from the 1800s shows Dasharatha sitting with his three wives and four sons. It is possible that the son on his lap is Rama.

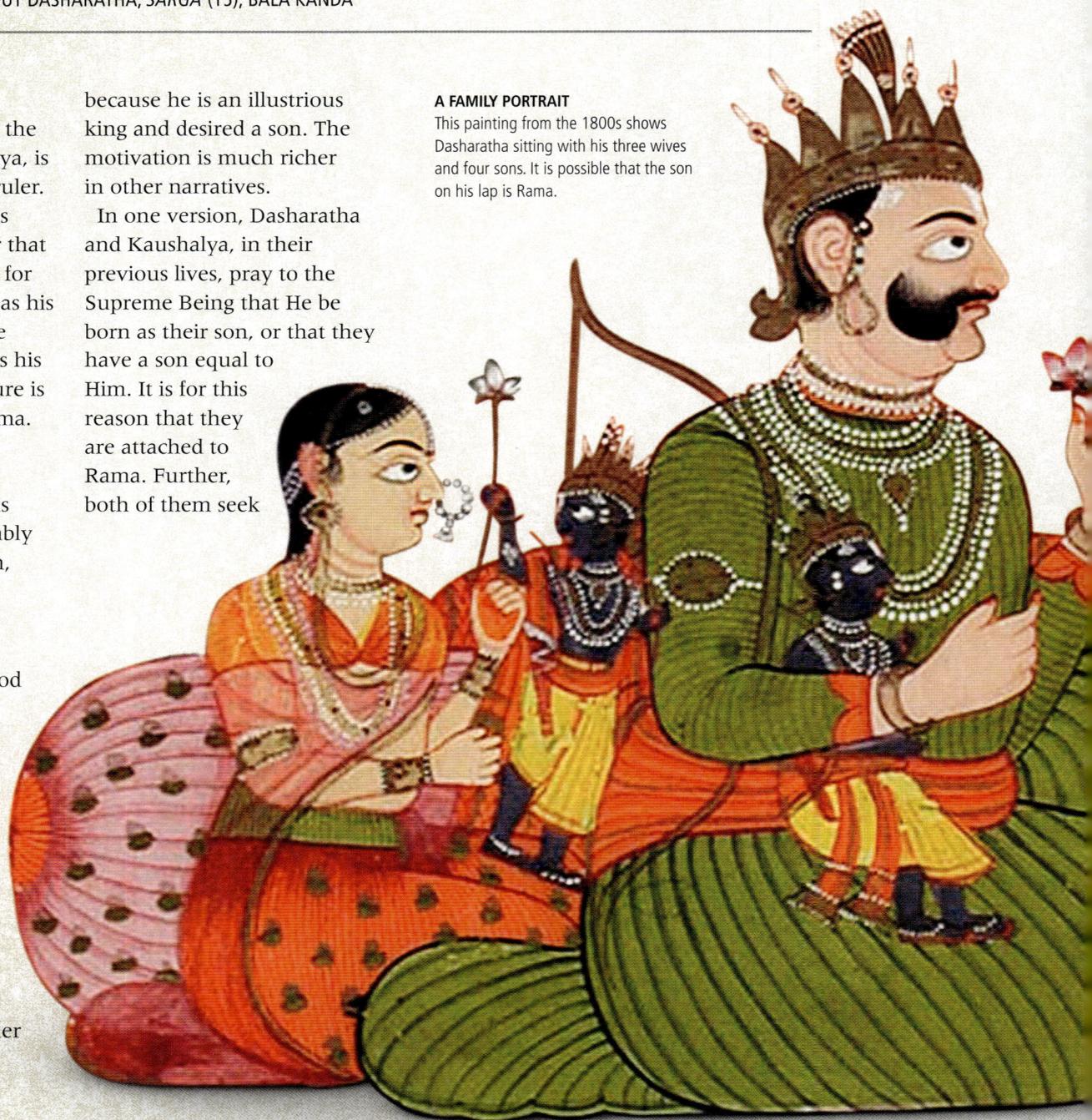

82

to love him as their son, rather than the divine being. Kaushalya, in many versions, is drawn to both aspects of Rama – the transcendental divine as well as the little child that she carried and played with. Rama rids her of her delusion in these versions.

Dasharatha's wives

The king is known to have several wives. The number in Valmiki's *Ramayana* is 350. Of these, Kaushalya, Sumitra, and Kaikeyi are mentioned. They are the ones who receive parts of the divine pudding so they can bear sons.

It seems that Kaushalya is the senior queen, both in her own right and by virtue of being the mother of the oldest son. Deeply pious, her chosen deity is Vishnu. Kaikeyi is the

youngest whom the king must have married when he was quite old himself. So, she is able to exert a certain amount of influence over him. Sumitra seems placed between the two.

The elder queen

Kaushalya, in Valmiki's *Ramayana*, seems to think of her son's consecration as the moment when her life's efforts shall bear fruit. At least, some part of her pain of separation from Rama comes from this. There are other renditions where the palace intrigue becomes only incidental, with Kaushalya never speaking a single harsh word against Bharata or the king. Whereas in Valmiki's *Ramayana*, when faced with Bharata, she calls him "desirous of the kingdom", in others, even if

AYODHYA

Ayodhya was the seat of power during Dasharatha's, and later Rama's, reign and was situated on the banks of the River Sarayu, in the Kosala region. Valmiki describes it as the perfect city, prosperous in agricultural produce and business activity, and inhabited by warriors and scholars.

Tamil poet Kamba, in his retelling, says that Sanskrit poets have described it so enticingly that even those who dwell in heaven feel the desire to abandon their home and live there. He says, "Indra's dwelling and Kubera's were but the handiwork of an amateur. On seeing this city with its tall towers, divine architects … gave up their craft." In the *Ramcharitmanas*, Rama praises it, saying that His divine abode, Vaikuntha, it is not as dear to him as Ayodhya.

THE ANCIENT CITY OF AYODHYA is located on the banks of the Sarayu river

there is an inkling of doubt she bears, it is removed by Bharata's visage and speech.

The young queen

While Kaikeyi seems fond of Rama and does not fear his reign, she is terrified of being subservient to a co-wife and of Bharata being harmed. The transformation in her character between first hearing of Rama's impending consecration and asking the king to banish Rama, is drastic. Her decision, once made, is unshakeable and she acts with immense cruelty until Rama leaves. Even after the king's death, she remains convinced that what she did was right. In a certain way, her actions needed to be precisely this cruel and dramatic in order

for Rama to leave and carry out the cosmic purpose of his birth. Indeed, such causality gets repeatedly attributed. It is clear that even Valmiki's Rama is somewhat puzzled by her actions, often attributing the events to destiny rather than human agents.

The balanced queen

Sumitra is perhaps the firmest of the three. She never demonstrates any desire for her sons to be consecrated, but in most versions, sends Lakshmana off without any regret. It doesn't even seem to occur to her that she could ask her son to stay, since he was not exiled. In her instruction to Lakshmana before he leaves, is the kernel of "Rama as refuge", which becomes much more systematically thematized in other versions of the *Ramayana*.

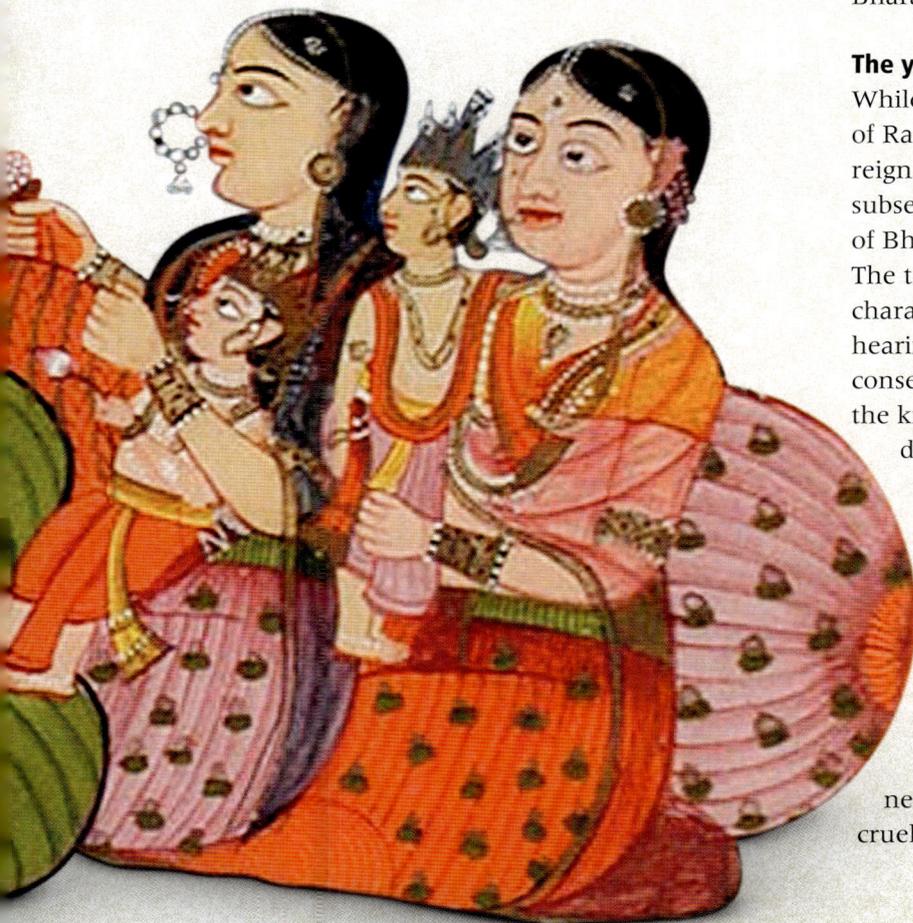

The King's **Plea**

Dasharatha heard Kaikeyi's words and found himself engulfed in grief. He writhed in misery and tried to convince the queen to give up her demands, but she remained unmoved. Instead, Kaikeyi reminded him of the dharma of keeping a promise.

A FATHER'S APPEAL
When King Dasharatha is forced to banish his son, Rama, he makes a final request, his hands joined, in an attempt to appeal to his youngest wife's better sense.

"I join my hands in salutation. **I do not wish for a morning.** Or pass swiftly. **I am shameless,** since I am beholding Kaikeyi, who has brought about this **great calamity.**"

DASHARATHA ADDRESSING THE NIGHT, *SARGA* (11), AYODHYA KANDA

The king, on hearing Kaikeyi's harsh words, fell to the ground, like a prey before a hunter. "Ah, pity!" he exclaimed and became unconscious.

When he regained consciousness he said. "Cruel one! You are intent upon destroying this lineage. What did Rama ever do to you? What did I ever do to you? He respects you as his own mother. I would give up Kaushalya, or Sumitra, or royal glory, or my own life, but I cannot give up Rama. The world may survive without the sun, or crops without water, but I will not live without Rama."

Dasharatha begs for mercy

The miserable king fell before Kaikeyi and asked her to change her mind. "I shall touch your feet with my head, show me favour," he begged.

Seeing a desolate Dasharatha weep, Kaikeyi said in harsh tones, "How shall you speak of your righteousness if you despair over promises you are sworn to grant? How shall you show your face before the great royal sages? Will you say that you violated your word to the one who once saved your life? Do you wish to abandon dharma, consecrate Rama, and live happily with Kaushalya? Let it be dharma or adharma. Let it be truth or falsehood. There can be no transgression of what you have promised me." She then gave him an ultimatum. "If you consecrate Rama, I shall consume poison and die as you watch. I would rather die than see Rama's mother accept the honour of being the queen mother. I swear upon Bharata's life and my own that I shall not be satisfied with anything other than Rama's exile."

Silence fell upon the room until Dasharatha said, "I have never seen you act this way. What shall I tell people? That I exiled my son because Kaikeyi tormented me? 'Rama has been exiled'– if this statement of mine is true, then the other statement I made, that he shall be king, becomes untrue. My ill fame and humiliation, in either case, is certain."

Day gave way to the darkness of the night as the king tried to placate Kaikeyi. "Have mercy on me. I am at the end of my life and desolate," he pleaded.

Kaikeyi remains firm

The queen remained unmoved. "Those who know dharma say that truth is the supreme dharma. King Shibi and King Alarka, too, followed dharma and obtained an extraordinary end (See box). Even the ocean, devoted to truth, does not stray from his pledge of staying within the shoreline. I have relied on truth to seek dharma. If you violate your word to me, I shall die," she said.

Bound by her words, the king tried to regain control of himself. Night passed as he said, "Your hand, which I took in mine with fire as my witness, I now renounce, along with your son."

Kaikeyi raged, "What is this blabbering? You should call Rama and exile him to the forest and consecrate my son. It is then that you will have done all that you should do."

"Go, bring Rama"

Dasharatha recoiled, as if struck with a whip. "I am bound by you in a bond of dharma," he said. "My senses are failing me. I want to see my eldest son, Rama."

Hearing this, Kaikeyi called Sumantra, the charioteer, and asked him to bring Rama. The king tried to speak, but could not. Sensing his distress, Kaikeyi repeated the instruction. "Bring the beautiful Rama here. I wish to see him."

On his way out, Sumantra saw the assembly of kings, citizens, royal priests, and Brahmanas at the gate, awaiting Dasharatha and Rama's consecration.

They requested Sumantra to inform the king of their arrival, so he returned to Dasharatha's inner quarters. As he woke him with words of praise, Dasharatha said, "I am not asleep. Bring Rama."

In Rama's residence

Rama, ignorant of what had transpired between Kaikeyi and Dasharatha the night before, was in his chambers with Sita. Sumantra entered and told him that his father and Queen Kaikeyi wanted to see him. Turning to Sita, Rama said, "Perhaps, the queen wants to do something for me and has convinced the king to summon me. He will certainly consecrate me today. Stay here with everyone. I shall go see him quickly."

Rama and Lakshmana left to see Dasharatha. As the chariot made its way through the city, people emerged to see their Rama, and bless him. They eagerly awaited for the moment he would become their king.

> "O king! **Why are you uttering** words that are like destructive **poison**? Without any hesitation, you should **summon** your son, Rama, here. Instate my son in the **kingdom** and make Rama a **resident of the forest**."
>
> KAIKEYI TO DASHARATHA, *SARGA* (12), AYODHYA KANDA

SHIBI AND ALARKA

This story of generosity appears in varying forms at many places, including the Book of the Forest of the *Mahabharata* and the *Jataka* tales. Once, the gods Indra and Agni took the form of a hawk and a dove, respectively, in order to test King Shibi's generosity. The dove sought refuge with the king, who gave him his word. The hawk, however, insisted that the dove was its prey and it wasn't right that he be deprived of it. The king gave the hawk his own flesh instead. In another version of this story, Indra approached King Alarka as a blind man and asked him to restore his vision partially. Alarka, instead, gave both his eyes to the blind Brahmana.

Rama **Exiled**

Rama entered the royal chamber and saw a despondent Dasharatha. When Kaikeyi told him of her wish, he remained unperturbed and agreed to fulfil his father's pledge.

Rama entered the inner quarters and saw his father looking desolate, and Kaikeyi nearby. The king could not bear to look at him or speak, and simply said, "Rama." Agitated to see his father in such a state, the prince wondered if he was angry with him.

He asked Kaikeyi, "Why doesn't he say anything? Are my brothers well? Are my mothers all right? What has angered him? Tell me what the king wants and I swear to bring it about."

The queen told Rama of the king's promise and her demand. "If you wish to protect the king's truth, then you should do what he promised me and go to the forest for 14 years," she said.

Rama did not hesitate. "So be it," he said. "I shall leave for the forest, bearing matted hair and rags. It only pains me that the king did not tell me himself. I would have happily given everything up for Bharata."

Delighted, Kaikeyi hurried him on, "I don't believe you would want to delay. Don't be pained at the king's embarrassment. Your father shall neither bathe nor eat until you leave."

Hearing this, Dasharatha cried out, "Shame!" He fell on the couch and Rama rushed to help him.

The prince told the queen, "I am intent upon dharma alone. You must not credit me with any virtue, for you spoke with the king when you could have commanded me yourself.

"I shall leave as soon as I have spoken to my mother and Sita." So saying, Rama walked out.

" Having **cast aside the earth**, he wished to **leave** for the forest. He was beyond **worldly pursuits** and **no mental disturbance** could be discerned. **"**

RAMA'S STATE OF MIND, *SARGA* (16), AYODHYA KANDA

KAIKEYI'S TERRIBLE DEMAND
Kathak dancer Uma Dogra dons the role of Kaikeyi
for a dance performance. Her postures suggest
that she has informed Rama of Dasharatha's boons
and her wish that Rama live in exile for 14 years.

DHARMA OF ACQUISITION AND RENUNCIATION

For the Sake of Truth

"I forsake the **dharma of Kshatriyas**. It is **adharma** in the name of **dharma**."

RAMA TO JABALI, *SARGA* (101), AYODHYA KANDA

Throughout the Ayodhya Kanda, there are conflicting ideals of dharma that play out in curious ways. There is, for instance, the dharma of the Kshatriya (warrior), which lies in acts of valour, and one view of this interpretation is that no Kshatriya could be faulted for wishing to establish control over a kingdom – let alone a kingdom that is, by rights, his own. Rama embodies a unique ideal, though, as he claims that a Kshatriya only bears arms so that those in need may be protected (See pp 130–31), and refuses to fight for his kingdom.

However, perhaps the more central idea affirmed in Ayodhya Kanda is that of the adherence to truth, which manifests as dharma in action.

The plot in Ayodhya can be explored at mainly two levels. One is the larger narrative, where Rama, by means of divine interplay, will certainly go to the forest since he has to kill Ravana. This perspective is simple, as it does not give any agency to any character and rests completely on what is destined by the Supreme Being.

The other, more complex way, is how specific decisions made by particular individuals shape the narrative. In this case, the choice is rarely between simply dharma and adharma. Various dharmas and their motivations complicate this central theme.

SONS AND FATHER
This illustration is an artist's representation of Dasharatha with his sons. At the time, dutiful sons followed their father's command and abided by dharma.

FOLLOWING RAMA'S FOOTSTEPS

Rama's brothers seem to adhere to a similar set of ideals. Lakshmana's dharma lies in following Rama into the forest, even though he may have preferred a different course of action. Bharata's dharma consists of not looking for loopholes, but the adherence to Dasharatha's word. He could have ascended the throne and nobody could have objected. Indeed, he is asked to do so. However, in his case, too, the highest ideal was for himself, and so he only holds the kingdom in trust until Rama returns.

When Rama is aware of his divinity, things are much more straightforward, for there aren't any decisions to be made. Then, Lakshmana's and Bharata's actions aren't interpreted in terms of dharma either, but rather in terms of surrender.

WHAT IS AT STAKE?

There are two things that Rama is particular about until he has left Ayodhya. One is that Kaikeyi is not agitated by his continued presence, and the other is that the king's word is not falsified. The second of these can sometimes seem to be a rather rigid adherence to something his father did not want in the first place. However, since in his granting of promises to Kaikeyi, Dasharatha had essentially enjoined what she had asked for, it would be something of

THE YOUNG QUEEN
This early 19th-century painting of Kaikeyi is part of a series of 61 artworks illustrating the *Adhyatma Ramayana*.

a loophole to think of it solely in terms of what the king wanted.

It is this loophole that reveals something essential about Rama's decisions. It is clear that they were driven by considerations of honour and truth. However, Dasharatha never asked him, so Rama's truth was never at stake. Even so, Rama did not look for a way out. It wasn't blind adherence to the letter of the promise, but a scheme where the closer one is to oneself, the higher the ideal to which one is held, the highest reserved for oneself. So, Rama is not willing to give his own mother any leeway in her service of her husband. This is why he compels her to

KAUSHALYA'S DHARMA

In Valmiki's *Ramayana*, Kaushalya urges Rama to listen to her rather than his father, or allow her to go with him, for she would not be able to live without him. In the 16th-century Awadhi text *Ramcharitmanas* by Tulsidas, however, Kaushalya responds to this by saying that if Dasharatha alone had commanded Rama to go, she would have asked him to stay, saying he should listen to his mother instead. However, as his father as well as Kaikeyi had commanded him, it is best that he leaves for the forest.

stay. Of course, this causes Rama to sound harsh in his interactions with those closest to him. His concern for his mother and frustration in not being able to make her happy is evident as he speaks with Lakshmana on one of the first nights after they leave Ayodhya.

THE KING'S DESIRE?

This complex theme of dharma can be understood in how Rama may have arrived at the decision to go to the forest. When Kaikeyi tells him what transpired between herself and Dasharatha, Rama's decision is almost instant. He discusses it in terms of Kaikeyi's wishes and Dasharatha's word.

When he later goes to meet his own mother, Kaushalya, she tries to stop him. At this juncture, he emphasizes two things – the fact that it is his father's command, and that

he is incapable of setting aside honour merely for the sake of the kingdom. The second thought bears importance here, for it does not seem unreasonable for a prince to desire the kingdom, particularly when promised the same just a short while ago. Indeed, Lakshmana embodies this position when he is willing to take harsh measures to ensure Rama's hold over the kingdom. Overall, Rama's decision to go is often portrayed as an example of obedience, but that is inadequate.

When Kaushalya urges Rama to listen to her rather than Dasharatha, for she, too, is an object of reverence for him as his mother, Rama lists examples of great persons who followed their fathers' orders even when they seemed dubious. The interesting point is that the spirit of the command did not come from his father. Indeed, his father actively discouraged him from going. It is Kaikeyi's will that he is acting in accordance with, and his father's word that he is trying to uphold.

ON HIS FATHER'S COMMAND
Rama (in blue) honours Dasharatha's promise and takes his leave in this 17th-century watercolour painting.

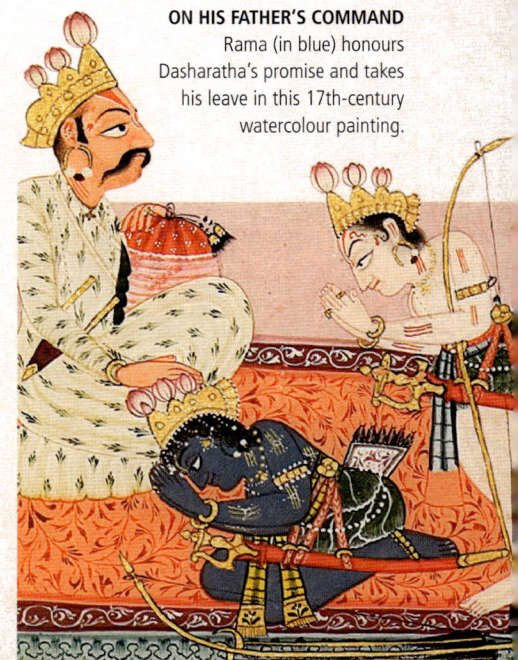

A Mother's Despair

Rama left Dasharatha's chamber and saw Lakshmana, his eyes ablaze with anger. With a sigh, Rama left for his palace to speak to Kaushalya who was busy preparing for the consecration. Lakshmana followed close behind, not leaving his brother's side.

Rama was deeply hurt, but kept a calm front as he entered Kaushalya's palace. He walked past old Brahmanas, as well as elderly women and young girls, and entered his mother's chambers. She was praying to Vishnu, the Preserver of the universe, and making offerings into the fire. Seeing him, she smiled and said, "Child, you must go to your father. Today is an important day and there are a thousand things to do."

Rama bowed and said softly, "You are then unaware of what has happened. This will be painful for you, and for Sita and Lakshmana. I have been exiled to the forest for 14 years. The king will consecrate Bharata as the crown prince."

A mother's grief

Hearing this, Kaushalya fainted. Rama picked her up gently. When she regained consciousness, she said, "It would have been better if I did not have a son, as I would only be afflicted with that pain. In the 17 years since you were born, I have lived in the hope that the honour I did not receive from my husband, I would receive through you. Can you imagine what I will have to listen to from my co-wives? Once you have departed, my death is certain. But no, my heart must be very stable, for it hasn't split."

A brother's anger

Seeing her distraught and crying, Lakshmana spoke up in great anger. "I, too, do not like this. Rama is going to the forest, abandoning his

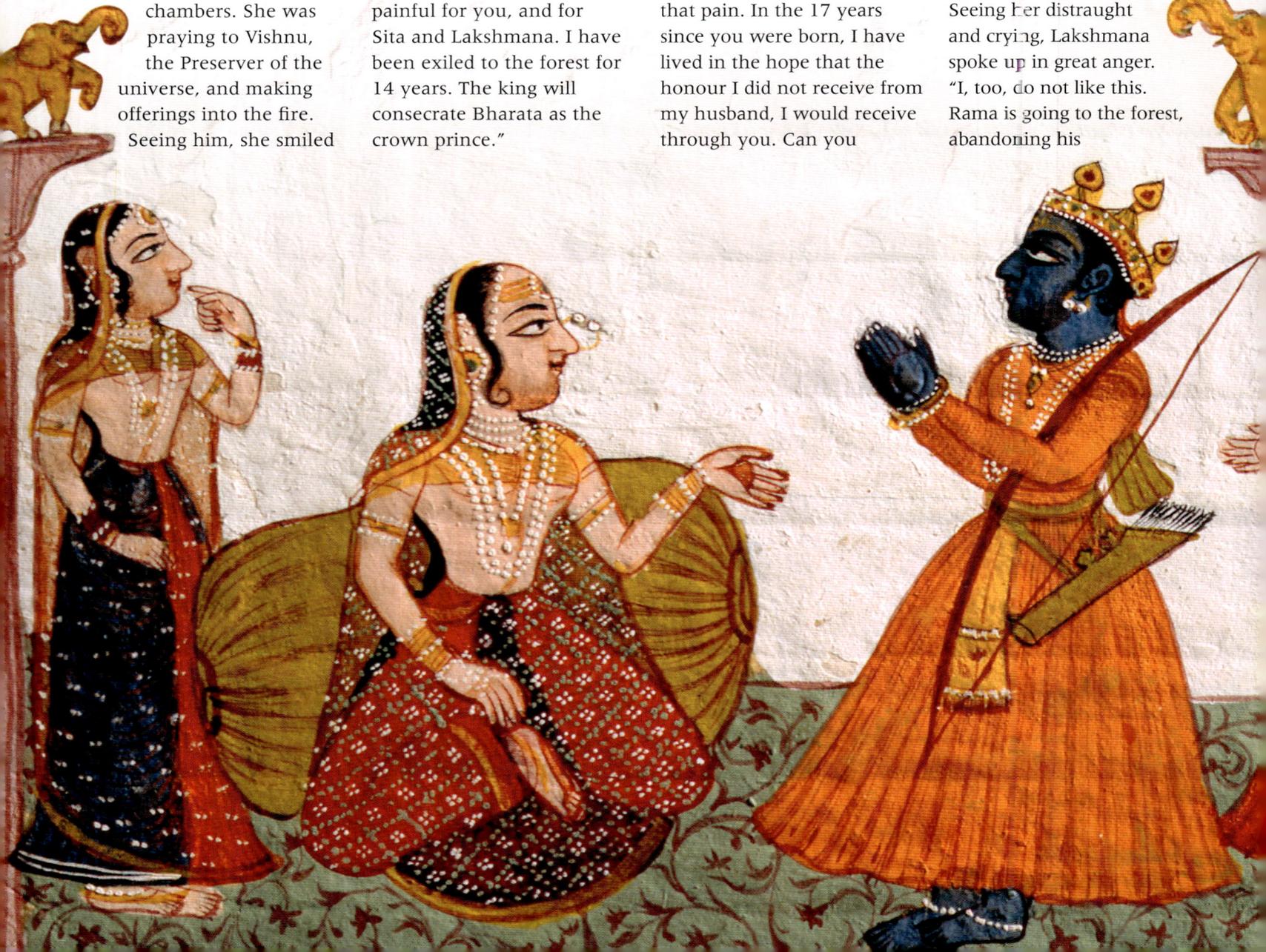

royal life. He hasn't done anything wrong. Even his enemies praise him. Who would abandon a blameless son, such as Rama, with no regard for dharma? What son would honour such an exile?

"Who can even think of harming Rama when I am beside him? I will destroy anyone who sides with Bharata. I am devoted to Rama. If he entered a forest or a raging fire, know that I will have entered before him. I will put an end to your pain. You will see my valour, and let Rama see it too."

RAMA AND HIS MOTHER
This 18th-century miniature painting depicts the scene where Rama informs Kaushalya of his exile. Lakshmana, who elects to go with his brother, is also present.

Kaushalya agreed with Lakshmana and said, "Rama, listen to your brother. If the king is to be obeyed because he is your father, I, too, am worthy of your obedience. I command you to stay."

Determined Rama
Calm and steady, Rama addressed Kaushalya first. "I cannot go against my father's wishes. Please allow me to leave for the forest." He reminded her of the sage who killed a cow at his father's word and of the sons of Sagara (See pp 50–51) who dug up the earth at their father's command and met their death. Rama then reminded her of Parashurama (See box) who killed his own mother with an axe at his father's command.

Turning to Lakshmana, he said, "I know you love me very much, but dharma is the ultimate good. Truth is established in dharma. I am incapable of transgressing from our father's words. The same energy that was directed towards my

STORY FROM THE *RAMAYANA*
THE OBEDIENT SON
Renuka, the mother of Parashurama, an incarnation of Vishnu, was once attracted to a semi-divine being called Chitraratha, whom she saw on her way to a river. Distracted, she forgot the time of the sacrificial offering she was to make. Her husband, the sage Jamadagni, was furious and asked his sons to kill her. They all refused, except for Parashurama who fulfilled his father's wishes, and killed his mother and brothers. Pleased, Jamadagni asked him what he would like as a blessing. Parashurama, whose name means "Rama with an axe", requested that his mother and brothers be brought back to life.

consecration must now be directed to stop it. Abandon this warrior-like way of thinking, rely on dharma and do as I do.

"I do not wish to cause our distraught mother even a moment of pain. That which makes no sense in the life of beings is fate, Lakshmana. Why else would Kaikeyi seek to injure me?"

He folded his hands and bowed before Kaushalya, "Permit me to go to the forest, mother. You are sworn by my very life to let me go to

the forest. I shall return to you in 14 years." With tears in his eyes, Lakshmana insisted on going to war, but Rama wiped away the tears and calmed him down.

Realizing that her son had made up his mind, Kaushalya asked if she could accompany him, but he refused. He told her that Dasharatha would need her support. Kaushalya had no choice but to bless him and let him go.

Rama bowed and left, for now, he had to tell Sita the dreadful news.

"Since **my heart** has not been shattered, like the banks of a **new river** overflowing... during the monsoon, I think that... it is certain that **I will not die** before my time. Because of this sorrow, my vows, donations, and control have **clearly been futile**."

KAUSHALYA TO RAMA, *SARGA* (17), AYODHYA KANDA

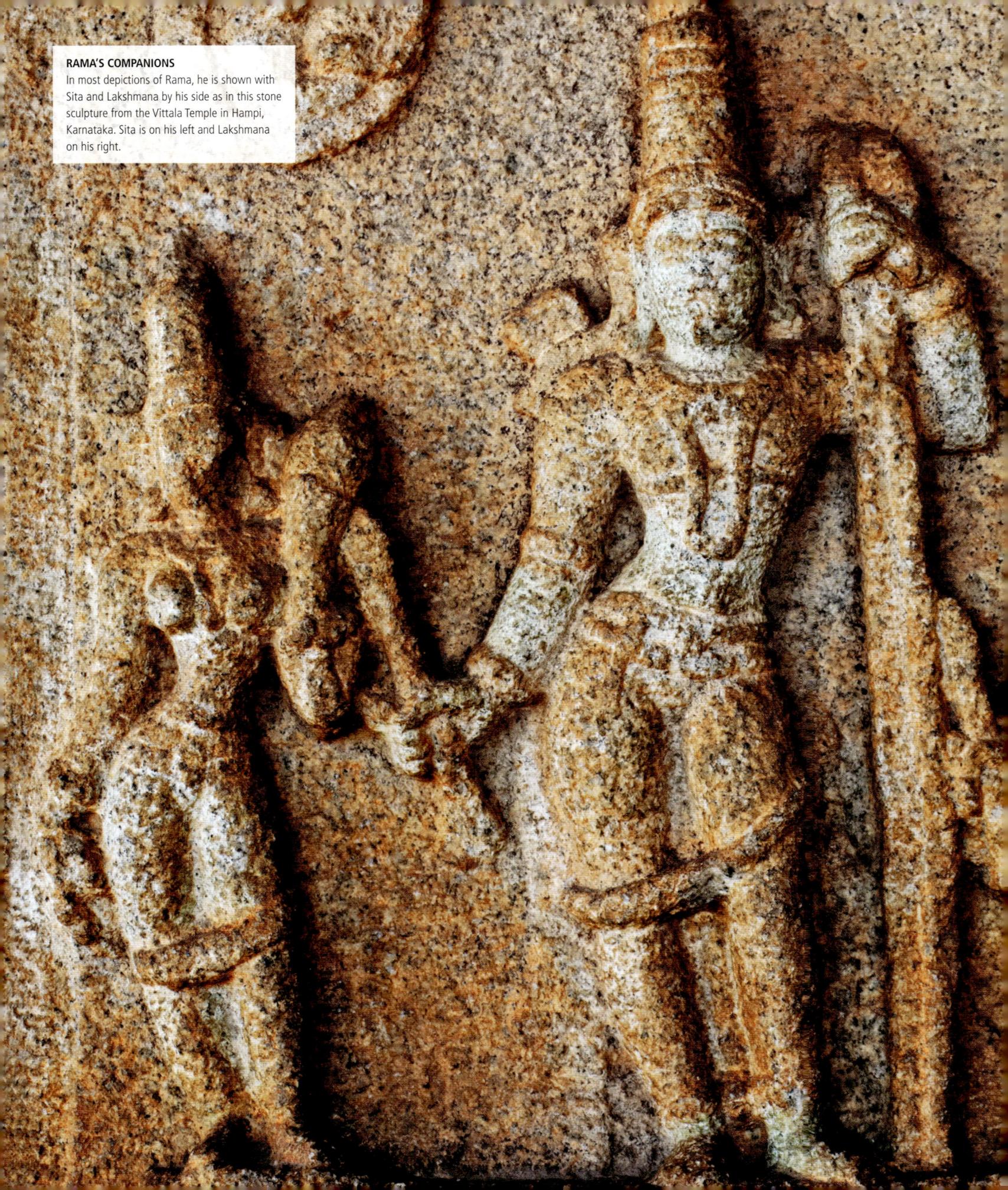

Wherever **Rama** Goes

Sita and Lakshmana refused to listen to Rama. They insisted on accompanying him, like his shadow. This was their dharma, they said, and nothing could shake their resolve.

Rama entered his chambers and Sita knew something was wrong. He was grief-stricken and trembling, without the royal paraphernalia. "Why can't I see joy on your face?" she asked.

Rama told her what had transpired and that he had come to see her before leaving. "Do not do anything that would seem contrary to Bharata," he said. "Revere my father and all my mothers. Treat Lakshmana and Shatrughna, who are dearer to me than life itself, as your own brothers and sons."

As she listened, the love she felt for her husband made her angry. She said, "If you leave for the forest today, then I will go before you, crushing the thorns in your path." Besides, Sita told him, as a child, some Brahmanas had prophesied a life in a forest for her. Rama tried to reason with her, but she insisted on accompanying him. "If you abandon me, I shall certainly die," she said. "I cannot bear the pain of separation from you for even a moment, what of 14 years."

Finally, Rama relented, "Sita! I do not desire even heaven if it causes you pain. There is nothing in the forest that I am afraid of. You may come with me." Delighted, Sita began preparing for their exile.

Rama turned to Lakshmana, who was waiting to leave with him, and requested him to stay back. "If you were to come to the forest with me, think of what would become of our mothers." But his brother refused to listen. He said, "Bharata shall honour the mothers by the force of your valour. I will come with you and serve you in the forest."

> **"I heard from Brahmanas that I was indeed going to live in the forest… That destiny… must indeed be fulfilled by me."**
> SITA TO RAMA, *SARGA* (26), AYODHYA KANDA

THE FOUR PHASES OF TRANSITION

Stages of Life

> "They wore **garments** made of **bark** and their hair was matted. Those two brothers... were... resplendent as rishis."

RAMA AND LAKSHMANA AS ASCETICS, *SARGA* (46), AYODHYA KANDA

ANALYSIS

RAMA'S VOW

Eighth-century Sanskrit playwright Bhavabhuti writes on Rama's deviation from student to ascetic. In his *Mahaviracharita*, on Rama's early life, Dasharatha says, "The vow of the forest-dweller, which is borne by the elder Ikshvakus whose royal glory has passed on to their sons, has been attained by you, who still has milk in your throat." In his *Uttararamacharita*, on Rama's life on his return to Ayodhya, Lakshmana says, "The sacred vow of the forest-dweller, which is borne by the elder Ikshvakus whose royal glory has passed on to their sons, was borne in childhood by the revered brother." The first line of both verses remain the same, most likely on purpose.

After Rama fails to convince either Lakshmana or Sita to stay back in Ayodhya, he prepares to leave in earnest. This involves inviting Brahmanas, ascetics, and the citizens of Ayodhya, and giving away his wealth and possessions to them. Rama requests Vasishtha's son, Sujanya's presence and gifts him an elephant and precious jewellery, while Sita sends ornaments for his wife. They also present the noble charioteer, Chitraratha, with jewels and clothes. In this way, they honour many men and women who are dependent on them for survival.

PREPARING TO LEAVE
This 17th-century painting portrays Sita in her royal garb giving away her jewellery to the people of Ayodhya. On the right, Rama and Lakshmana give away horses and elephants.

FOUR STAGES OF LIFE

Rama's departure to the forest, after abandoning most of his possessions, can be usefully put into conversation with the idea of the stages of life, or ashramas, that emerged in India. These stages are – *brahmacharya* (studenthood), *garhasthya* (householdership), *vanaprastha* (in the forest), and *sannyasa* (renunciation). These stages have come to classify a progression, where one is expected to marry and set up ritual fires after finishing time as a student.

After a certain amount of time, one is encouraged to turn one's mind towards concerns other than the worldly ones and finally, one orients oneself towards the ultimate good, liberation through renunciation. While this is the most familiar version of this system, there has always been scope for those who might wish to do things another way.

Sri Lankan Indologist Patrick Olivelle has demonstrated that the early version of this system was formulated not in terms of stages, but in terms of modes of life. So, after the successful completion of Vedic study, one could pick any one of these four stages. These, further, were grouped into two – those who stayed and those who left. In this schema, one could stay within a community either as a householder with one's own family or as an unmarried person continuing to live at the teacher's house. Similarly, those who would leave could either stay in one place as forest ascetics or move about as mendicants.

RAMA'S RENUNCIATION

In the *Ramayana*, we see many references to various kinds of ascetics and mendicants. However, Rama's own departure to the forest is of a particular kind. While the *Ramayana* itself does not say much about it, there are some telling statements. There is a reference to Rama being firm in the vow of *vaikhanasa*, often used as a synonym for *vanaprastha*, when he meets his friend Guha (See pp 98–99). In his 16th-century commentary on Valmiki's *Ramayana*, Govindaraja raises a problem with this term. If Rama had taken up the *vanaprastha* vows in their entirety, then his eventual return to the state of a householder would have to be censured. On the other hand, it is improper to adopt features that are exclusive to certain stages if one does not belong to them, such as matted locks. Govindaraja, however, suggests that this is acceptable because it is a particular kind of restriction born of a resolve produced by his father's command.

While it is not clear as to what point in its development was the idea of "stages" when the *Ramayana* was composed, it is something that becomes significant in the way the text came to be received. That said, it seems clear that the text regards Rama and Lakshmana carrying weapons to be a significant deviation from the usual ascetic ways, and chooses to comment on it repeatedly in the middle section of the story.

THE TRIO
This lithograph print from 1910 by artist Raja Ravi Varma depicts Rama, Sita, and Lakshmana in exile and the golden deer that lured the brothers away.

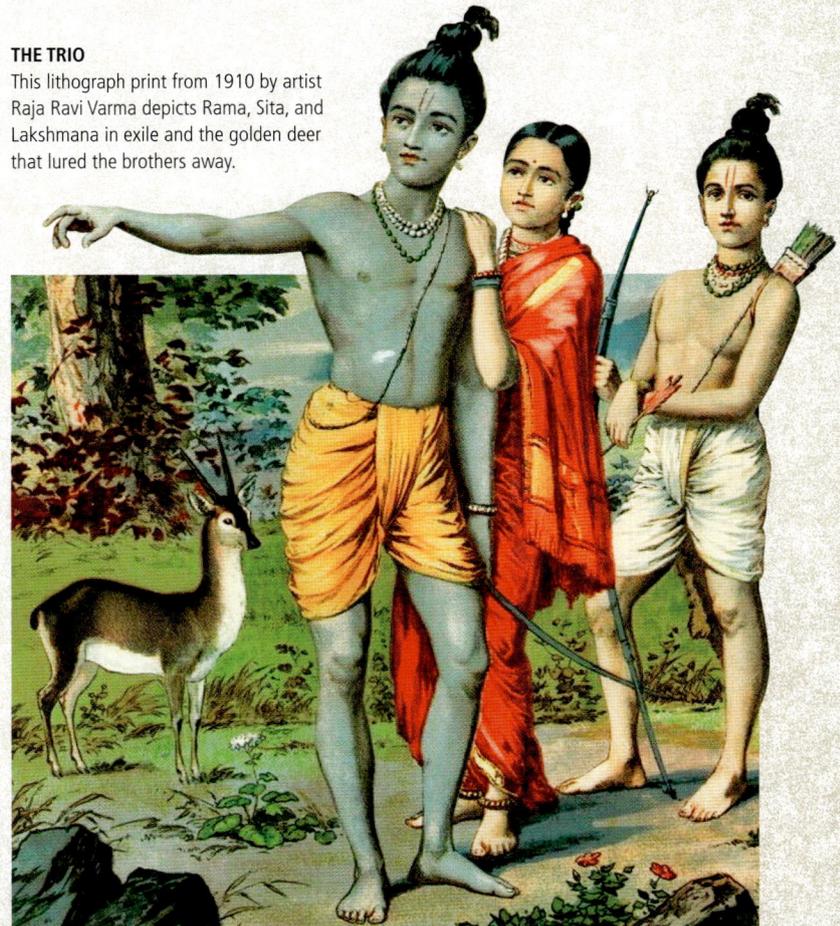

The Adamant Kaikeyi

Rama, with Lakshmana and Sita by his side, gave away his riches to Brahmanas, as he prepared to leave for the forest. The three then made their way to the king's palace. The people saw Rama on foot and were distressed. Engulfed in sorrow, they rued the misery that had befallen them. Rama, however, walked on, calm and undisturbed, with almost a smile playing on his lips.

"O king! I have **cast aside objects of pleasure**, to **dwell in the forest** on **forest fare**. When I have cast everything aside, **why should anyone follow me?**"

RAMA TO DASHARATHA, *SARGA* (33), AYODHYA KANDA

Rama made his way to his father's palace, and upon reaching, asked Sumantra to announce him. Dasharatha, hearing that his son had arrived, said, "Bring my wives here. I wish to see Rama surrounded by them all."

The king's 350 wives arrived in the chamber, and then Rama walked in. Dasharatha rushed towards his son and fell. Rama and Lakshmana lifted him up and placed him on the bed. When the king regained consciousness, Rama asked for permission to leave for the forest that very day. "I tried to dissuade Sita and Lakshmana from coming, but they refused. Do not grieve over our departure," he said.

Dasharatha's attempt
Unwilling to let him go, Dasharatha said, "Rama, I was tricked, I was deluded. I had given Kaikeyi my word. You are powerful and valorous. Capture me and take charge of this kingdom as the king." Unmoved, Rama instead asked his father to bless him with a safe return.

But, Dasharatha tried to delay the inevitable. "It is late. Stay for the night, at least. You can leave in the morning," he said.

Rama was unrelenting, "Who shall grant me the virtue tomorrow that I shall attain by leaving now? Please grant all this to Bharata. I do not desire this kingdom, pleasure, or even Sita. I only desire that you be true and never false."

Devoid of hope, Dasharatha turned to Sumantra and asked him to arrange for gems, an army, traders, grain, and money. "He will enjoy his time in the forest, hunting, eating, and, drinking. Or else, he will pass his time pleasurably in the company of sages," the king said.

Kaikeyi's protest
Outraged at the proposition, Kaikeyi turned towards her husband and said, "My son Bharata shall never accept this impoverished kingdom, and indeed, why should he? Let Rama go in disgrace like your ancestor Asamanja (See p 30)."

Dasharatha was incensed at the comparison, when Siddhartha, one of his advisers intervened. "Asamanja was exiled in disgrace for drowning children," he said. "What is Rama's offence? What crime has he committed that he should be sent away in disgrace?"

The king heard these words and told Kaikeyi, "I will go with Rama and abandon all that you desire. You may then rule happily at your son's side."

Rama heard the exchange and spoke up. "Father, I am going to the forest. I have accepted this life for 14 years. I do not need an entourage. Having given away the

ANALYSIS
WHO EXILES RAMA?

Rama's exile is dealt with in different ways across Sanskrit literature. Distinct from the divine intervention alluded to in devotional *Ramayana*s, plays come up with innovative ways of having other characters intervene to fit their plot better. For example, in 10th-century Sanskrit poet Rajasekhara's *Balaramayana*, as scholar Lawrence McCrea observes in his article, "Poetics of Perspective in Rajasekhara's *Young Ramayana*", Shurpanakha and a character called Mayamaya impersonate Kaikeyi and Dasharatha to force Rama into exile.

elephant, what sense is there in bothering with the rope that tied it? Bring me a shovel and a basket, and ascetic attire."

Changing garb

Kaikeyi brought out the clothes and handed them to Rama and Lakshmana, who put them on. Sita, however, seemed distressed, as she did not know how to wear the tattered rags. Rama helped her and tied them for her over her silken garment. When everyone saw Sita, whose very birth was distinguished, dressed in such a way, they cried out to shame Dasharatha.

Rama, however, said, "Take care of my mother, great king, who is deeply grieved at my departure. Please do what it takes for her to live through these 14 years."

The tormented Dasharatha wept and said, "I must have committed some great transgressions that I do not die and have to see my son departing in ascetic garb before my very eyes." He ordered Sumantra to bring a chariot with the best horses yoked to it. He called for clothes and jewels for Sita so that she could change her clothes. When she was done, she looked resplendent. Kaushalya said, "Do not abandon my son even when he is afflicted by calamity." Sita replied, "Do not worry mother. I am incapable of deviating from dharma, just like moonlight cannot abandon the moon." At this, Kaushalya and the other women mourned and wept.

Sumitra's instructions

Now ready to leave, Rama, Lakshmana, and Sita circumambulated Dasharatha and touched Kaushalya's feet. Lakshmana fell at Sumitra's feet and she said, weeping, "Do not act carelessly with regard to Rama. Whether he is prosperous or in dire straits, he alone is your refuge. Regard Rama as your father and Sita as myself. Regard the forest as Ayodhya. Go forth happily!"

> " **Ornaments** and **clothes** like bars for a bird, the body radiating like **water without moss**... accompanied by his **beautiful wife** and **wonderful brother**, as though he'd been a **guest in Awadh** for two days, the **lotus-eyed Rama** set off like a **traveller**, **renouncing** his father's kingdom. "

RAMA LEAVES HIS HOME, *KAVITAVALI*, BY TULSIDAS

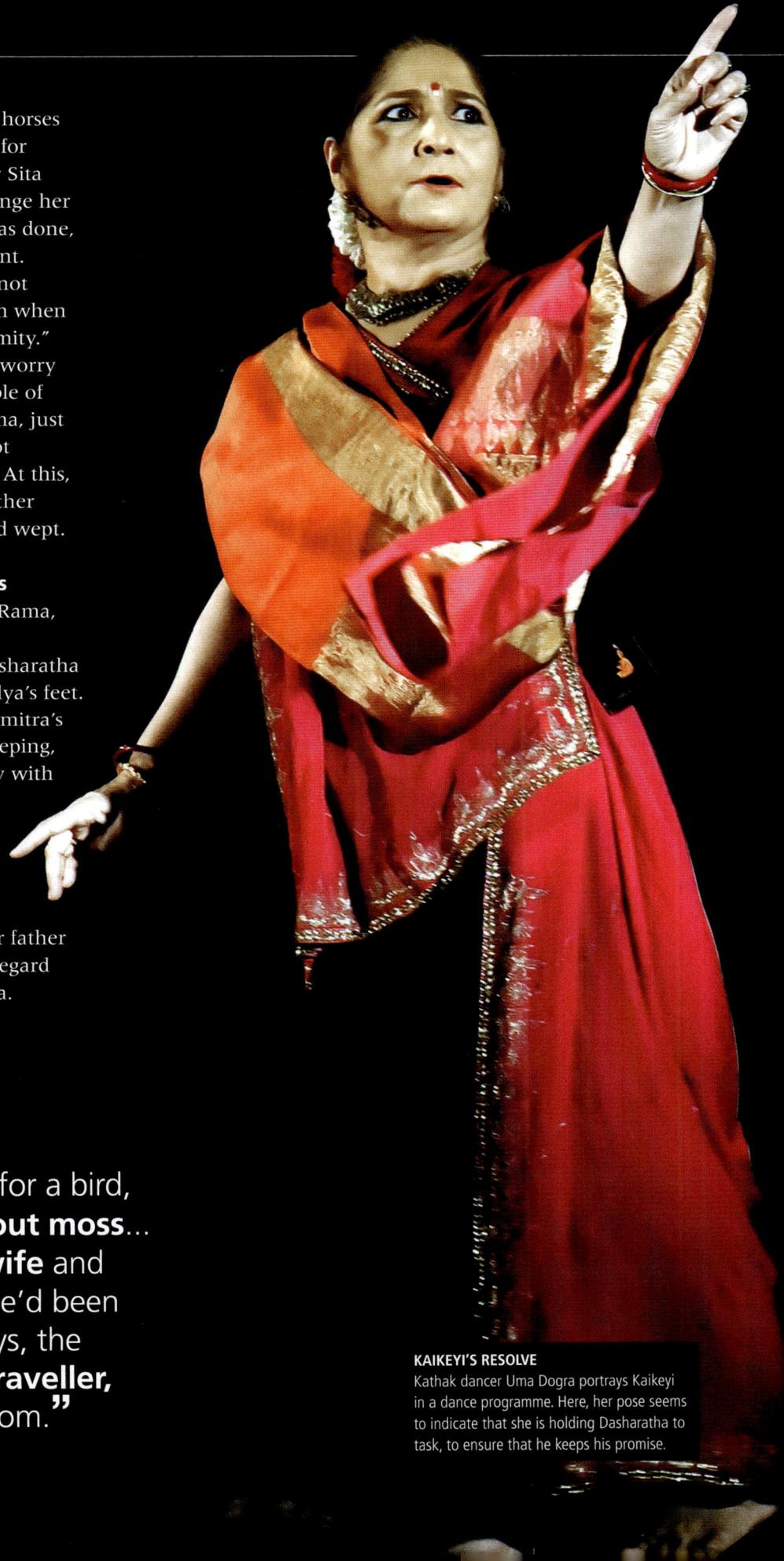

KAIKEYI'S RESOLVE
Kathak dancer Uma Dogra portrays Kaikeyi in a dance programme. Here, her pose seems to indicate that she is holding Dasharatha to task, to ensure that he keeps his promise.

Rama's Departure

Dasharatha's palace, which once resounded with the sound of the drums, now echoed with cries and wails, as everyone mourned the exile of Rama. The people of Ayodhya decided to follow him, steadfastly walking behind his chariot, determined to go into exile with him.

> "**What work** do they have **at home**? What will they do with **wives and riches**? If they cannot see **Raghava**, what **happiness** will they **obtain from sons**?"

THE WOMEN OF AYODHYA TO THEIR HUSBANDS, *SARGA* (42), AYODHYA KANDA

When Rama left Ayodhya, masses of city-dwellers followed him, unable to bear the thought of being away from him.

He addressed them with great affection, as if they were his own offspring. "I ask you to direct the love and regard you have for me towards Bharata, who is endowed with the virtues of softness and valour alike. He has the qualities of a king as well. I beseech you, ensure that the king does not suffer," he said. The more he tried to turn people away, the more they wanted him to be their king.

Aged Brahmanas followed, lamenting. When Rama saw them, he got down from his chariot and started walking instead.

The first night

Soon, they arrived at the River Tamasa, full of whirlpools, as if she, too, wanted to dissuade Rama from leaving.

Rama spent the night on the banks of the river, surrounded by the people of Ayodhya. As he and Sita slept on a bed made of leaves, Lakshmana and Sumantra spoke of Rama's virtues.

Early next morning, Rama saw the people of Ayodhya asleep under the trees. "Look," he told Lakshmana, "they sleep with no care for home, simply to accompany us. They will give up their lives, but not their intent to come with me. This misery is for us, and we should

not let the people suffer. We must leave while they sleep."

He asked Sumantra to take the chariot north and retrace its steps to confuse the people. They then boarded the chariot and left quickly, before the people awoke.

Meeting with Guha

Soon, the three crossed five rivers, leaving Ayodhya far behind. As their chariot passed through villages, its people cursed Dasharatha and Kaikeyi for exiling Rama.

Finally, they reached Shringaverapura. Here lived Guha, the king of the Nishadas (hunters) and a friend of Dasharatha, who came to see Rama. He honoured the prince and said,

"This land is as much yours as Ayodhya. What may I do for you?" Rama requested him to feed the horses that pulled his chariot as they were dear to his father. Then Rama drank the water Lakshmana brought for him and lay down.

Lakshmana leaned against a tree trunk after washing Rama's feet. Seeing him awake, Guha said, "You do not need to stay up. I will protect him. There is nothing dearer to me than Rama."

"Protected by you, we have no fear," he replied. "But how can I sleep when my brother, whom even the gods cannot defeat, sleeps on the earth?" Hearing this, Guha wept.

Into the forest

The next morning, Sumantra asked Rama, "What would you like me to do now?" The

prince replied, "Return. That is all I ask." The charioteer replied, "How will I return in a chariot devoid of you? I would sooner enter fire."

Rama replied, "When you return, my youngest mother, Kaikeyi, will be relieved to know that I have truly gone. Please tell the king not to worry for me." Sad and disheartened, Sumantra turned back.

Rama requested Guha bring him the milk of the nyagrodha (fig) tree. He used it to convert his and Lakshmana's hair into matted locks. They then donned garments made of bark, and soon the princes looked resplendent as sages.

They walked to the banks of the river, where they saw a boat (See box), and decided to cross the river and go into the forest.

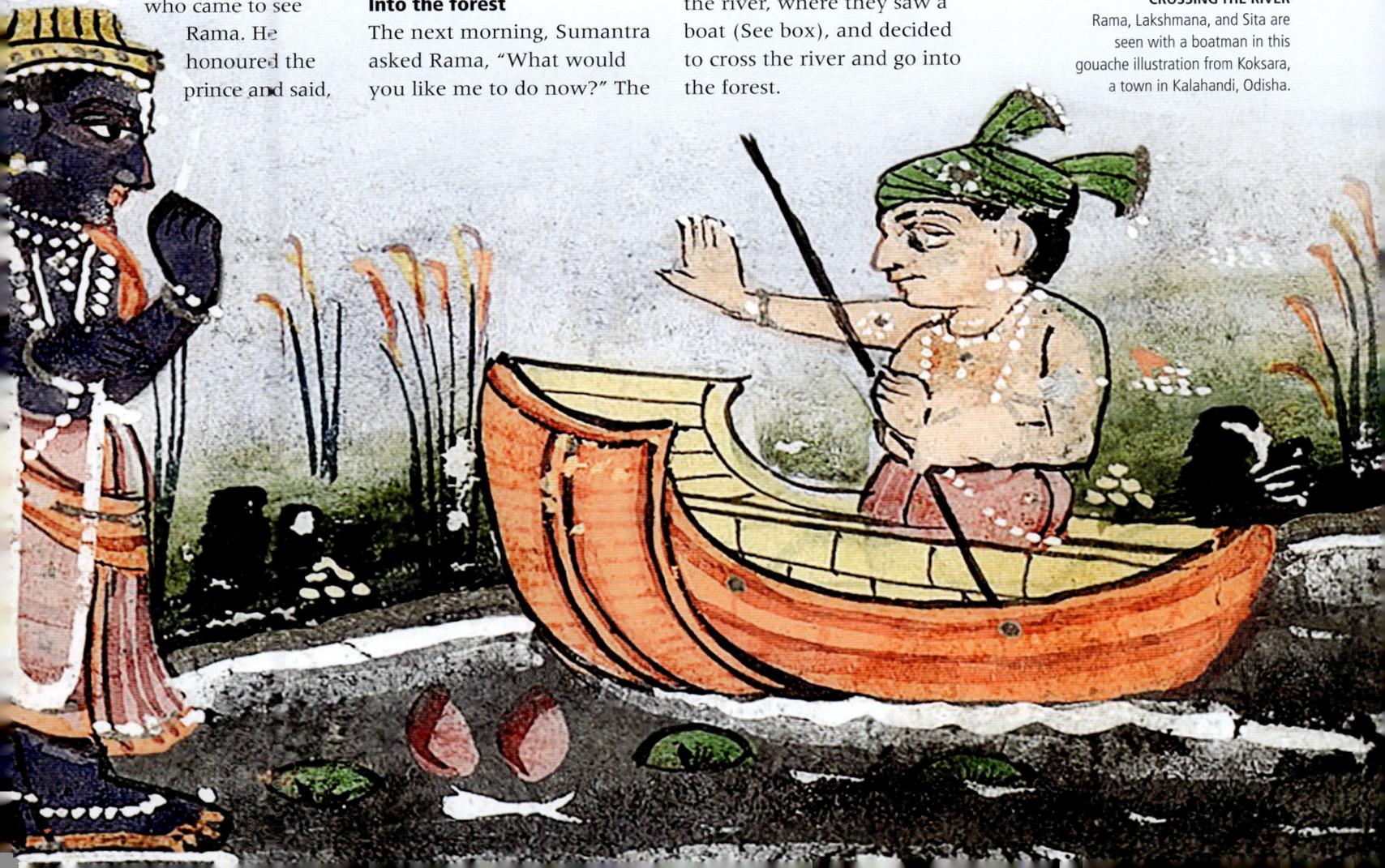

CROSSING THE RIVER
Rama, Lakshmana, and Sita are seen with a boatman in this gouache illustration from Koksara, a town in Kalahandi, Odisha.

ALTERNATIVE ACCOUNT

LAKSHMANA'S NIGHT

It is sometimes said that Sleep approached Lakshmana that night, but he asked her to return when he would be in Ayodhya.

In the *Adhyatma Ramayana*, Guha laments on seeing Rama sleeping on the ground. Lakshmana then instructs him about fate and detachment. He says, "Pain dwells in pleasure and pleasure in pain – the two are said to be inextricable like water and mud. Therefore, wise ones are neither pleased nor deluded upon the attainment of that which is desired or not desired."

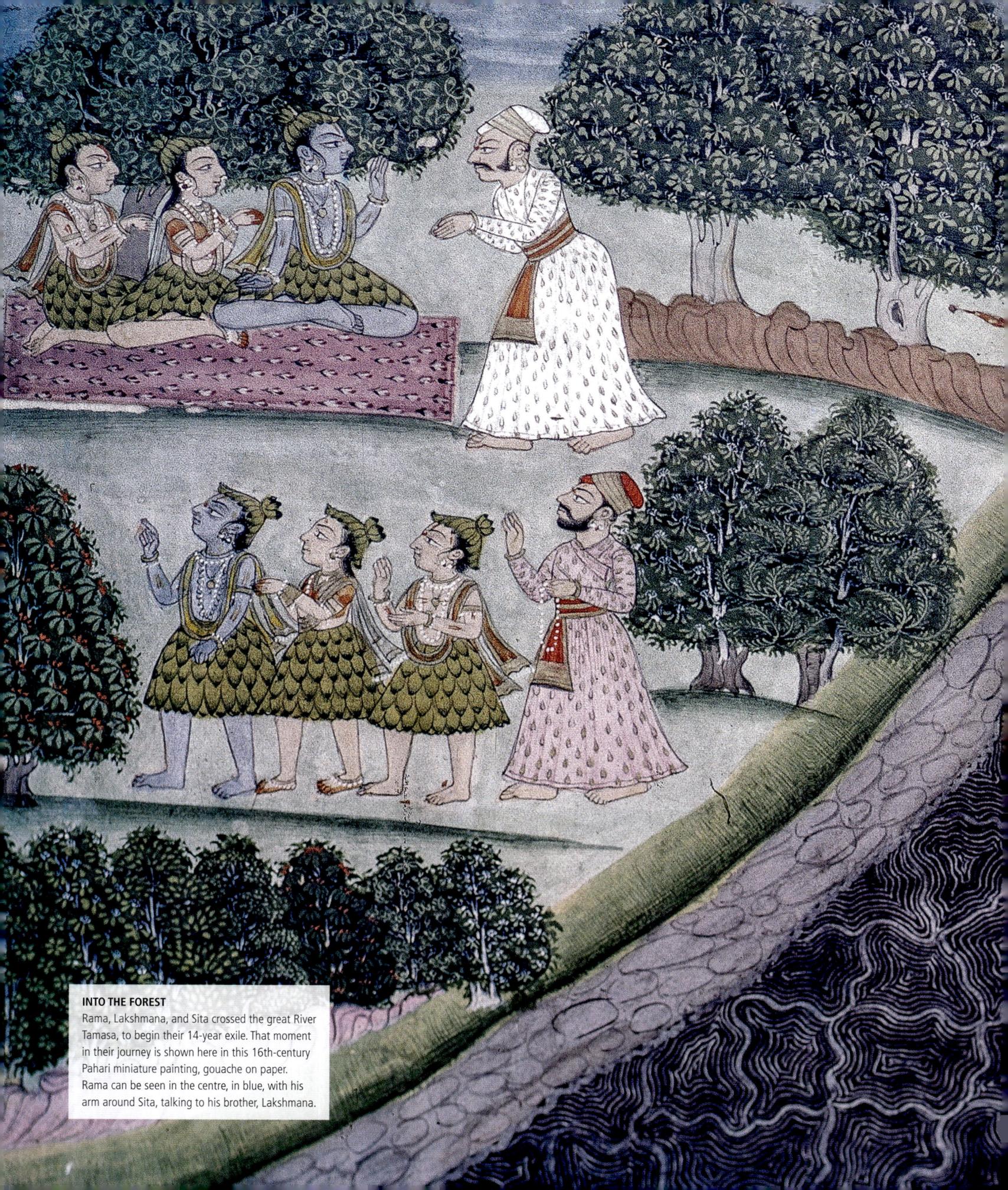

INTO THE FOREST
Rama, Lakshmana, and Sita crossed the great River
Tamasa, to begin their 14-year exile. That moment
in their journey is shown here in this 16th-century
Pahari miniature painting, gouache on paper.
Rama can be seen in the centre, in blue, with his
arm around Sita, talking to his brother, Lakshmana.

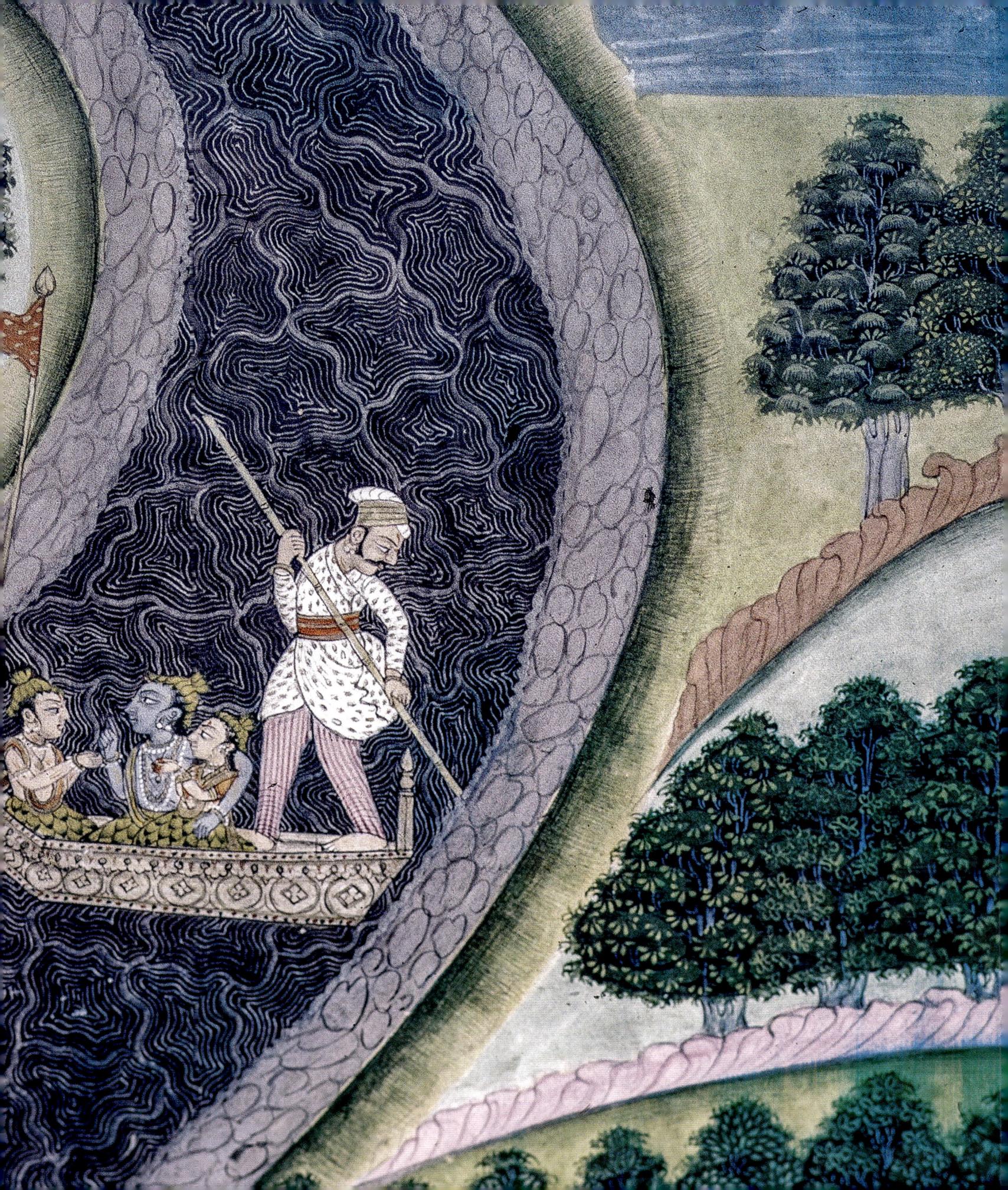

Rama Reaches Chitrakoot

Rama grew despondent after crossing the River Ganga. He mulled over the state of affairs in Ayodhya, but found comfort in Lakshmana. They reached Sage Bharadwaja's hermitage, before finally finding a place they could call their new home.

Rama, Lakshmana, and Sita boarded the boat and were ferried across the Ganga. When they reached the middle of the river, Sita prayed to Ganga for a safe journey and stay in the forest. She assured the river of appropriate worship on their return after 14 years. Soon, they reached the southern bank and took refuge under a tree.

Family matters

On the first night, Rama spoke to Lakshmana, first about ensuring Sita's safety during their exile, and then said, "The king must be sleeping uneasily tonight, but Kaikeyi would be satisfied. When Bharata comes, would she bring about the end of the king's life for the sake of the kingdom? What shall he do, when he is old and helpless, separated from me and at Kaikeyi's mercy? Seeing his actions and this current affliction, I am inclined to think that seeking desire alone must matter.

IN THE FOREST
This 19th-century Pahari painting from Kangra, Himachal Pradesh, in ink and colour on paper, shows Rama and Sita looking on, as Lakshmana prepares a meal over an open fire, during their 14-year exile in the forest.

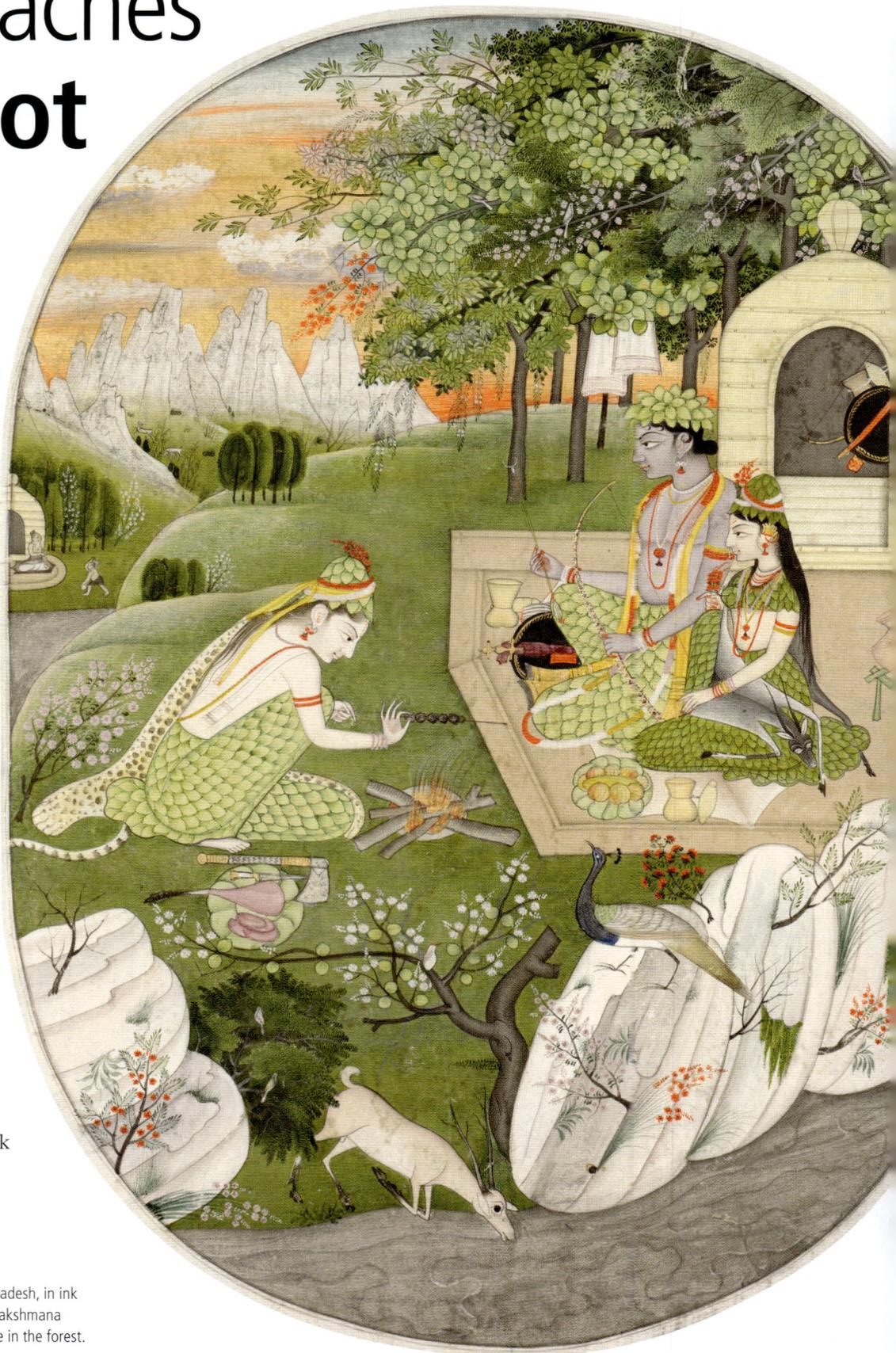

> "That **spot is sacred**, pleasant to see everywhere and frequented by *Maharshis*… As long as a man can see the **summit of Chitrakoot**, he performs auspicious deeds and the mind does not turn towards sin. Many **rishis have spent hundreds** of autumns there, performed austerities…"

BHARADWAJA TO RAMA ABOUT CHITRAKOOT, *SARGA* (48), AYODHYA KANDA

How else could a man abandon a son like me, who lives in accordance with his wishes? It is because of me that Kaushalya is deprived of all that she deserves, and at the very moment that should have been her triumph."

Worried that Kaikeyi, deluded by pride at her good fortune, would torment Kaushalya and Sumitra, he urged Lakshmana to go to them. "Leave for Ayodhya now," he said. "Sita and I shall go forth into the forest. Let no woman ever bear such a son as me, who only causes her pain. I could defeat Ayodhya, and indeed the world when angered, but this valour is pointless. It is only because of a desire to avoid adharma and of my concern for the afterlife that I do not consecrate myself." Rama fell silent, his eyes filled with tears. He was distraught, like an ocean but without force.

COIN WITH AN ENGRAVING OF RAMA AND LAKSHMANA

A brother's promise

Seeing him like the fire whose brilliance had dimmed, Lakshmana comforted him, "O best of warriors! Ayodhya is deprived of its glory tonight, for you have abandoned it. But what purpose is served by this lamentation, which only grieves Sita, and indeed, me? Neither Sita nor I shall survive without you even for a moment. I do not wish to see our father, Sumitra, Shatrughna, or even heaven, if it is without you."

Rama reconciled himself to his brother accompanying Sita and him into the forest.

At Bharadwaja's hermitage

The next morning, they started walking, and soon reached Prayaga, the confluence between the Ganga and Yamuna (See box, left). Rama saw smoke and recognized it as rising from Sage Bharadwaja's hermitage.

They entered his abode and introduced themselves. The sage said, "I have heard of your exile for no reason at all. This is a sacred and beautiful place, where you may spend your 14 years." Rama thanked him and said, "If I stay here, people will keep coming to see me. I am seeking a quiet place."

The sage saw the wisdom in Rama's words and said, "There is a place called Chitrakoot not too far from here. You will find ample food there and it is ideal for your time in solitude." So it was that the three settled in Chitrakoot.

ADORNED WITH MANY GHATS AND TEMPLES, Chitrakoot is an important pilgrimage centre even today

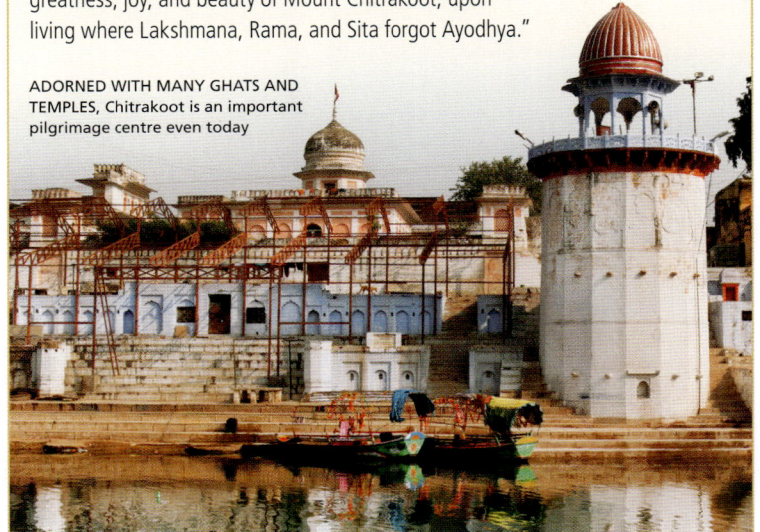

Ayodhya Mourns Rama

The citizens followed Rama, Sita, and Lakshmana, but turned back after they had been left sleeping on the banks of the river. They returned to Ayodhya and discovered that their beloved city had changed. It was immersed in grief, while the king and his queens lamented Rama's absence.

D istressed that Rama had left them sleeping on the bank of the River Tamasa, the people of Ayodhya returned to their homes, miserable and listless.

The city was grieving. Nobody opened their shops. Mothers did not rejoice when they saw their firstborn sons. Every house resounded with weeping. The people proclaimed Lakshmana as the one worthy man, who followed Rama and Sita into the forest and would serve them there. The women wept, saying they would serve Sita and the men would serve Rama.

A father's grief
In the royal palace, the king retreated to Kaushalya's chambers. Dasharatha had collapsed on the ground after Rama disappeared from view.

As Kaikeyi helped him, he looked at her and said, "Do not touch me. You are neither my wife nor kin. You care only for that which is material. I abandon you, who have abandoned dharma. I renounce the grasping of

your hand and the ritual circumambulation of the fire that we performed at the time of our marriage. If Bharata desires this kingdom, let the funerary offerings made by him not be received by me."

Now, resting in Kaushalya's chambers, Dasharatha mourned his son as he wept, "O Raghava! You have abandoned me. Fortunate are those who will witness your return." He reached for Kaushalya and said, "I cannot see you. My sight, after Rama's departure, has not returned."

Kaushalya's pain
Seeing the king in this state and afflicted by grief herself, Kaushalya said, "Bull among men! Rama could have lived in the city like a servant, feeding himself with alms, but he has been exiled to the forest. How will they live off fruit and roots, they whose time for royal pleasures had only just arrived? Kaikeyi shall now torment me, freed from all bonds. When will the moment of my release from grief come? When will

Ayodhya be pleased again, hearing of the arrival of the two heroes, accompanied by Janaka's daughter? When shall the city delight in seeing the two lions among men, like the sea is overjoyed on full moon nights? The grief of this separation from my son burns me. I cannot bear to live without him."

Wise words
Sumitra comforted Kaushalya and lent her words of strength as she said, "Do not grieve over Rama. Firmly established in dharma, he has ensured that his father remained true. Your son is the best of men. Why do you weep and lament? I am certain that Lakshmana will act in the best possible way towards Rama. Sita, too, follows him, despite knowing the hardship she will face in the forest. Your son will soon return to

KAUSHALYA'S STRENGTH
This intricately designed puppet of Kaushalya is from a traditional puppet theatre play called *Wayang* in Java, Indonesia, which enacts stories from the *Ramayana*. The once ignored Kaushalya, slowly finds strength in her son's decisions.

"The wind that blew was no longer cool. The moon was no longer pleasant to behold... Everything on earth was in disarray."

AYODHYA, AFTER RAMA LEFT FOR THE FOREST, *SARGA* (36), AYODHYA KANDA

Ayodhya and press your feet with his soft hands." Hearing these words, Kaushalya finally calmed down.

Sumantra returns

Time passed and soon Sumantra returned, after leaving Rama, Lakshmana, and Sita. Seeing him enter the city, people ran up to him and asked him where their beloved Rama was.

He went to the palace and entered the chamber, and told Dasharatha what Rama had told him.

"Where is he?" the king asked, "What will he eat? How will he sleep on the ground? How will he live in the deserted forest, he who was accompanied by horses and elephants? You are truly fortunate, charioteer, that you have seen Rama. Tell me how they lived. What did they say, Sumantra?"

The charioteer replied, "Rama, observing dharma, asked me to revere your feet with his words, and to convey his wishes for the welfare of everyone in the inner chambers. He asked me to say to his mother that she is to serve your feet like a deity. For Bharata, he has conveyed his best wishes and that he should act appropriately towards all the mothers and serve you when he is consecrated as the crown prince. The lotus-eyed Rama shed many tears as he spoke."

"Angered, Lakshmana said that he saw no reason in banishing Rama, and whatever motivated this, it was a terrible deed. He said, 'I, for my part, no longer regard Dasharatha as my father. Rama alone is my brother, master, kin, and father.' Janaka's daughter simply wept."

The king listened to Sumantra with tears in his eyes and said, "This calamity has struck me because of destiny." Grieving for his sons, Dasharatha fell unconscious.

ALTERNATIVE ACCOUNT

KAUSHALYA'S DEVOTION AND VISHNU

While the relationship between Rama and his parents seems to be quite similar across narratives, the early part of the text often differentiates the backdrop.

For instance, when Kaushalya saw Vishnu as her son, she did not know what to do. She brought her hands together in supplication and said, "What shall I make of this? Who shall believe that the One from whose hair arise innumerable universes lived in my womb?"

His response towards Kaushalya depends on the way the *Ramayana* in question regards His divine play, which always ends with Vishnu calling out to her and crying as a divine baby.

A 14TH-CENTURY NEPALESE STONE SCULPTURE of Vishnu, the Preserver of the universe, on his *vahana* (mount) Garuda

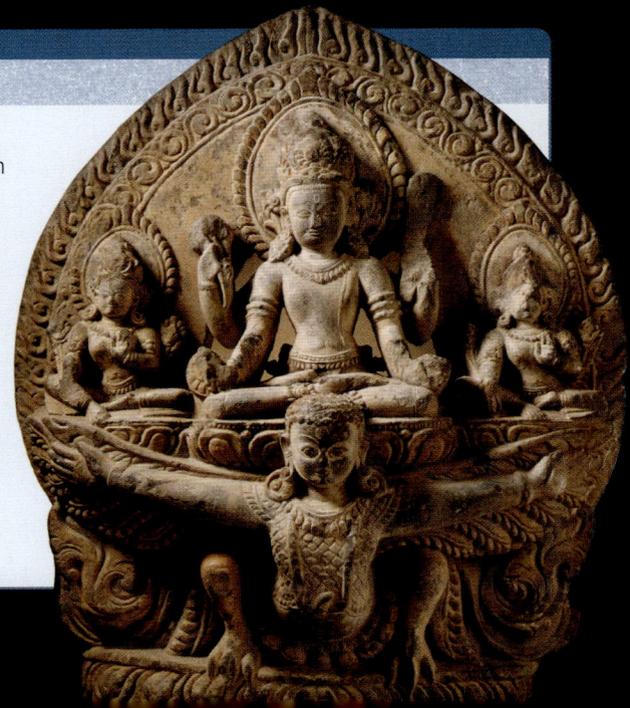

The **Killing** of an Ascetic

Dasharatha, deep in sorrow, spent the days reflecting on past mistakes. On the sixth day after Rama's departure, he narrated a story to Kaushalya – about an ascetic he had once killed. Dasharatha realized that this wicked deed could be the reason for his piteous state.

> "Some **look at flowers** and, desiring fruits, cut down **mango trees** and nurture palasha trees. They sorrow when the **fruits are obtained**. I have also cut down a grove of mango trees and **nurtured** palasha."
>
> DASHARATHA TO KAUSHALYA, *SARGA* (57), AYODHYA KANDA

Many years ago, as an unmarried prince, Dasharatha earned a reputation for being able to shoot a target without seeing it, but on hearing the sound it made. He was justly proud of his talent. One monsoon evening, he went on a hunt near the River Sarayu, for buffaloes and elephants would often come to the banks at night.

Striking in the dark

As he waited, he heard what sounded like an elephant, and shot at it. The sound that followed, however, was not an elephant roaring in pain, but a human voice, crying out, "Who would wish to kill me? What is the reason for this enmity? It is not my death that I grieve, but my parents, who have nobody but me, and are now all alone."

Shocked, Dasharatha's bow and arrow slipped from his hands as he ran to where a young ascetic lay dying. He spied an earthen pot, which when lowered into the water, had made a noise that caused him to shoot in the first place.

Seeing Dasharatha, the ascetic, agitated from the pain, blazed with radiance as he spoke, "What did I ever do to you, prince, that you have killed me? With this one arrow, you haven't just killed me, but my parents too. They await me and sit in thirst. My learning and self-discipline must not have borne fruit, for I lie here dying and my father doesn't know. What could he have done if he did know?"

A grave mistake

The ascetic asked Dasharatha to take the path to his hermitage where his parents were waiting. "Tell them what happened," he said. "Placate them and they won't curse you. And remove this arrow as it is tormenting me." So saying, he died.

Distraught, Dasharatha filled the pot with water and walked to the hermitage. Hearing his footsteps, the ascetic's father mistook him for his son and said, "What took you so long? Did you begin to sport in the river? Doesn't matter. Go quickly, your mother is thirsty. Don't worry about the time." Then, he added, "Son, you are like eyes for us who are blind. You are our very breath."

Facing the truth

Mustering courage, the prince said, "I am not your son. I am Prince Dasharatha." He told the old man what had happened and said, "I thought I had shot an animal, but the arrow found an ascetic.

He ascended to the heavens, thinking only of you. I have struck your son with a fatal arrow in my ignorance. I beg your forgiveness. I am yours to command."

The fiercely brilliant hermit replied, "If you hadn't told me yourself, your head would have fallen apart, for you have committed a terrible deed. If you had done it knowingly, the Raghu lineage would not survive. As things stand, you will live. Now, take me to my son." Dasharatha took the hermit and his wife to the banks of the Sarayu and their son's body.

The old man clutched his son's body to his chest, and grieved. "Now, who will recite from

CHARACTER PROFILE

SHRAVAN KUMAR

Valmiki never identified the ascetic Dasharatha killed, who gradually came to be referred to as Shravan Kumar. As a result of his close relationship with his parents, he has become the archetype for all devoted offspring.

the sacred texts for us? Or bring us roots and fruits? We are without a guide. We no longer have a protector," he said. They began the final rituals and as they offered water, their son

appeared in a celestial form, before ascending to the heavens. After completing the last rites, the old man turned to Dasharatha and said, "For this

sorrow you have caused us, I curse you. You will suffer as well. You will die grieving for your son." Filled with grief, the elderly couple died so after and joined their son in heaven.

A DEVOTED SON
Shravan Kumar is often portrayed as a young man who carries his beloved old parents in two baskets attached to a stick, as seen here in a wall painting from the Lakshmi Narayan Temple in Orchha, Madhya Pradesh.

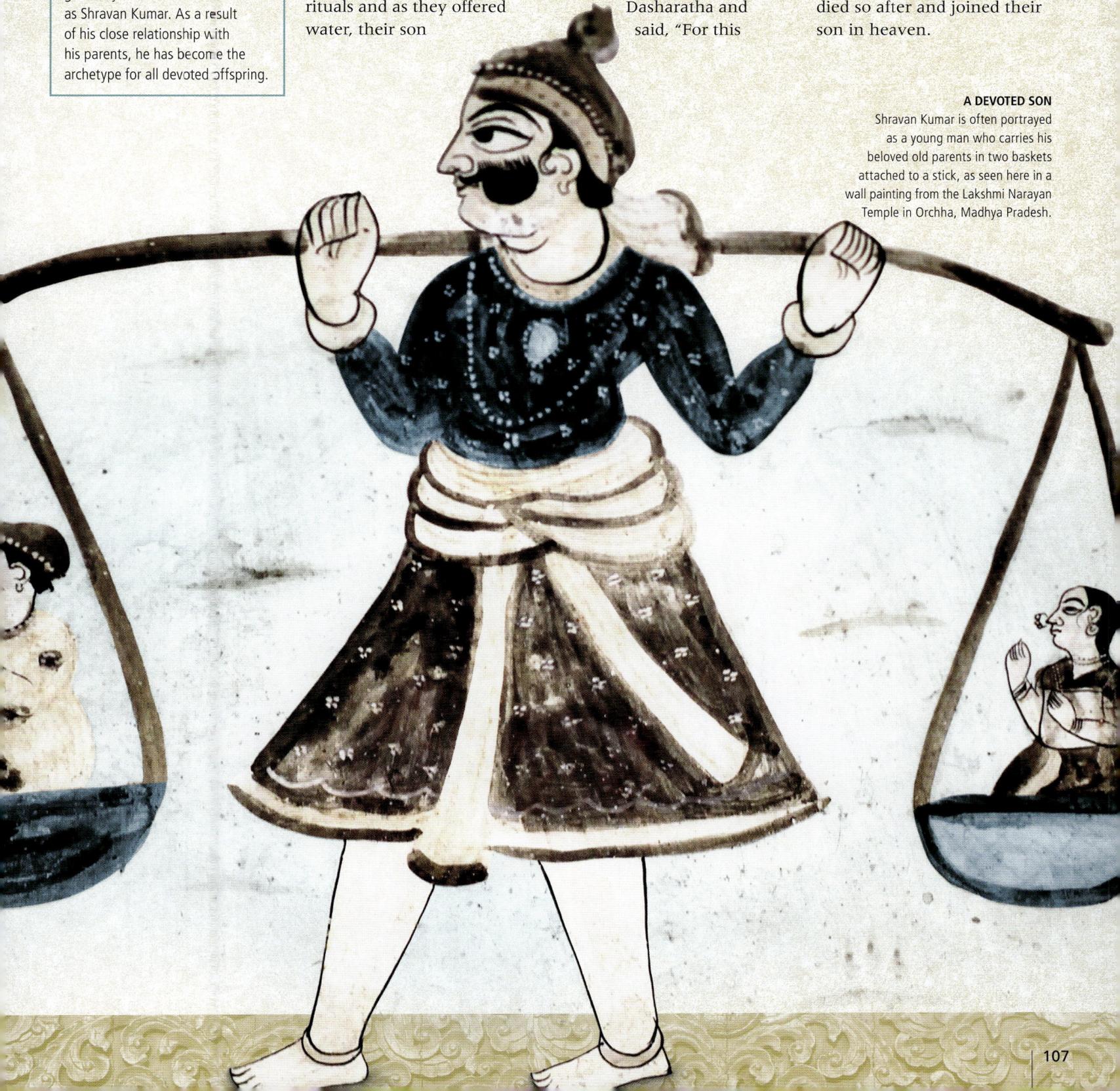

THE GRIEVING WOMEN
Titled "The Death of King Dasharatha, the Father of Rama", this painting from 1605 is in opaque watercolour and gold on paper. The idea of grief is portrayed through women with unkempt hair.

Dasharatha's Death

Rama's departure left everyone grief-stricken, but Dasharatha's misery was unparalleled. He could not bear to live in Rama's absence and soon gave up on life.

Kaushalya's grief intensified and she chastised her husband, as he sat ruminating, thinking back to the unknowing, cruel act he had committed towards a young ascetic in his youth (See pp 106–07). Moved by that grief and the pain of separation from Rama, Dasharatha joined his hands in supplication and said, "O Kaushalya! You are never cruel even to outsiders. I am your husband. Do not pain me. I am already deeply aggrieved by your harsh words."

Seeing her husband's terrible state, she folded her hands and placated him, "I know what constitutes virtue, and I know you are virtuous and honest. It is my sorrow that made me speak thus to you. It has been five nights since Rama left but it feels like five years."

Night fell, and the king, somewhat calmed by her, fell asleep. He woke up shortly after and told Kaushalya, "The agent only receives the result of what he does. A fool uproots a mango orchard and plants thorny plants in its stead, grieving at the time of fruition. Such am I, full of regret, having banished Rama."

He then told her of the young ascetic and said, "So it is that I will die suffering from this pain of separation from Rama. Those who would see him after the end of 14 years would be fortunate. Touch me, Kaushalya, for my sight is failing. The messengers of Yama, the god of death, are hurrying me on. Ah! What greater pain might there be than this, that in my hour of death, I cannot see Rama!" And so, longing for his son, Rama, the king left for his heavenly abode.

> **"Alas, Rama**! Alas, Rama's younger brother! Alas, the **ascetic Vaidehi**! You do not know that I am **without a protector** and am about to **die in misery**."
>
> DASHARATHA TO SUMANTRA, *SARGA* (52), AYODHYA KANDA

"I am **Not the King**"

Bharata heard the news of his father's death and was consumed with sorrow. A greater misery befell him when he learnt that Rama had been exiled because of his mother. Bharata, the follower of dharma refused consecration. For him, Rama was the true king.

> " My elder, **Rama**, whose deeds are unblemished, is **like a father** now... I will grasp his feet. He is my **refuge now**."
>
> BHARATA TO KAIKEYI, *SARGA (66)*, AYODHYA KANDA

The king's body was placed in a tub filled with oil, since none of his sons were present at the time. Eminent sages gathered with the ministers and counsellors and reiterated the dangers of a kingless land. They sought direction from Sage Vasishtha who suggested that they send messengers to bring back Bharata and Shatrughna who were still in Kekaya.

"Do not tell them what has transpired here. Instead, simply say, by my command that the ministers and priests wish them well and that they are to return posthaste," he said. The messengers left immediately, and reached Kekaya at night.

Bharata returns to Ayodhya

That same night, Bharata had an ominous nightmare that seemed to suggest his father's death. He was telling his friends about it, when the messengers from Ayodhya arrived at the royal palace.

Greeting them, Bharata inquired, "Is my father well? Does my brother Rama prosper, along with Lakshmana? Are the three mothers healthy?" The messengers, as instructed by Vasishtha, gave him a polite, but concise, response and urged him to return. The young prince quickly took leave of his uncle, Yudhajit, and left for Ayodhya, along with his brother Shatrughna. They travelled swiftly for seven days, crossing dense forests and beautiful villages, and entered the great city, with the rising of the sun.

Bharata found Ayodhya strangely desolate as the noises that usually resounded through the city were absent. Bharata told the charioteer,

THE PRINCE'S RETURN

The reactions to Bharata's return to Ayodhya are rather interesting. Citizens were often torn between blaming him for Rama's exile and respecting him as their king. Despite his unwavering devotion to Rama, he is seen often as an object of suspicion. This is clear even from Guha's and Lakshmana's reactions.

Awadhi poet Tulsidas too, in his version of the *Ramayana*, narrates a conversation between some townspeople, one of whom opines that everything was carried out with Bharata's approval.

A HOLY CITY
Ayodhya, a sacred city for Hindus, is located in the Oudh or Awadh region of Uttar Pradesh. It's known for its ghats and temples.

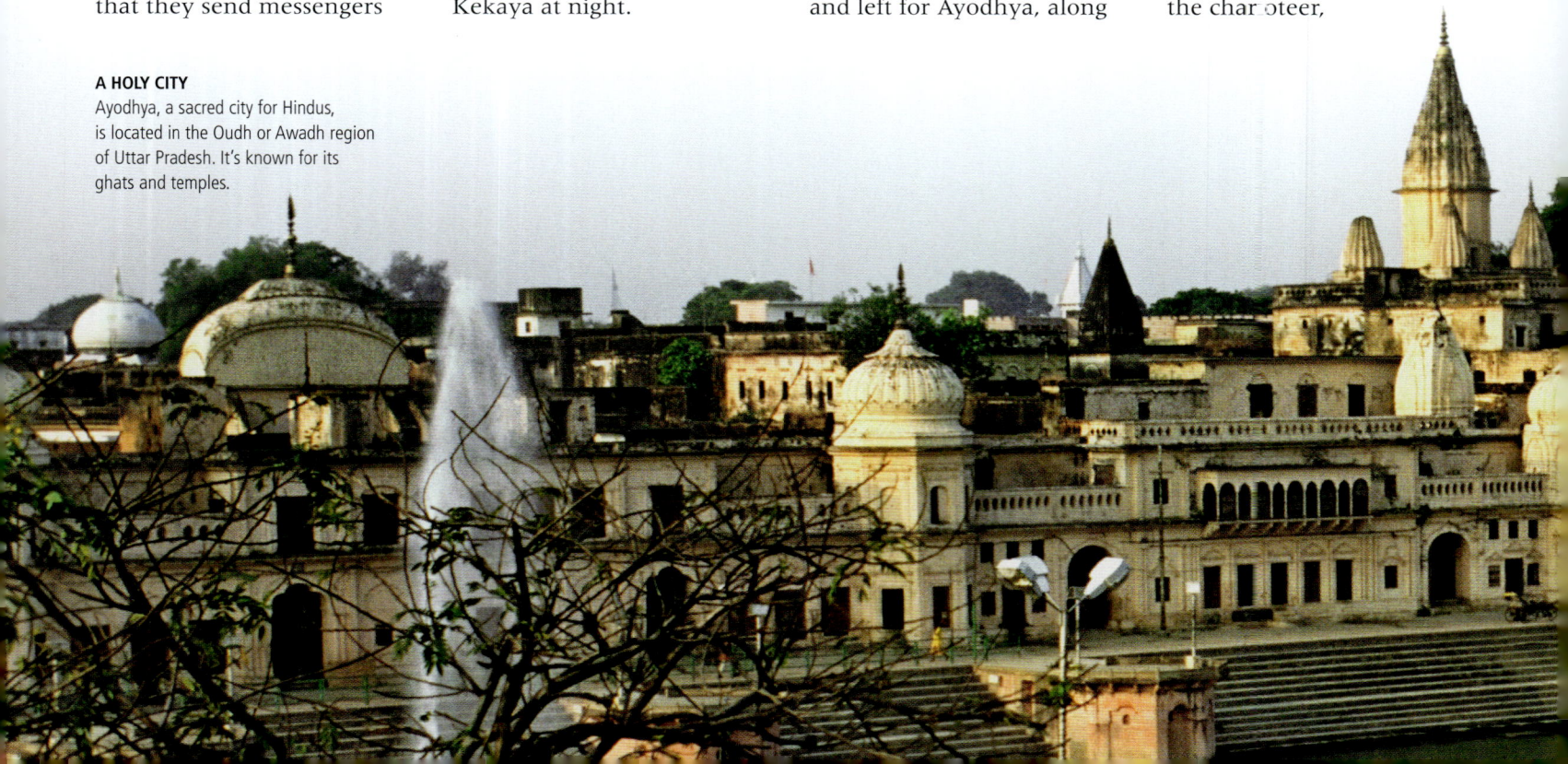

"The city looks to me as one hears cities do when kings are destroyed."

He entered his father's residence, but could not find him, and so went to see his mother, Kaikeyi. After exchanging greetings, he asked, "Why is your bed empty, mother? Where is my father? Is he with the eldest mother? Why does the city look so desolate?"

Bharata gets the news

"Your father," said Kaikeyi, "has gone to the state that must be attained by all those who live."

Hearing this, Bharata fell, senseless with grief. "I came in haste, thinking he was going to consecrate Rama, or that there would be a sacrifice," he said. "What were my father's last words, mother? Rama and the others are indeed fortunate, as they were able to perform our father's funeral with their

HEARING THE NEWS OF DEATH
This scene from a 17th-century painting from Udaipur, Rajasthan, shows Bharata fainting on hearing the news of his father's death.

own hands. Where is Rama? Let me grasp his feet. He is my refuge now."

Kaikeyi told him of the king's grief over the absence of Rama, Sita, and Lakshmana. "Where has Rama gone with Sita and Lakshmana?" he asked.

Kaikeyi replied, "Donning ascetic garb, he has gone to the forest, along with Sita and Lakshmana."

"Why was he sent to the forest, mother? He never tormented anyone, desired another man's wife, or killed anyone. Why was he sent to the forest like a murderer?"

Kaikeyi replied, "He did not commit any of these crimes." She told him of the promises she had asked of Dasharatha and what transpired after that.

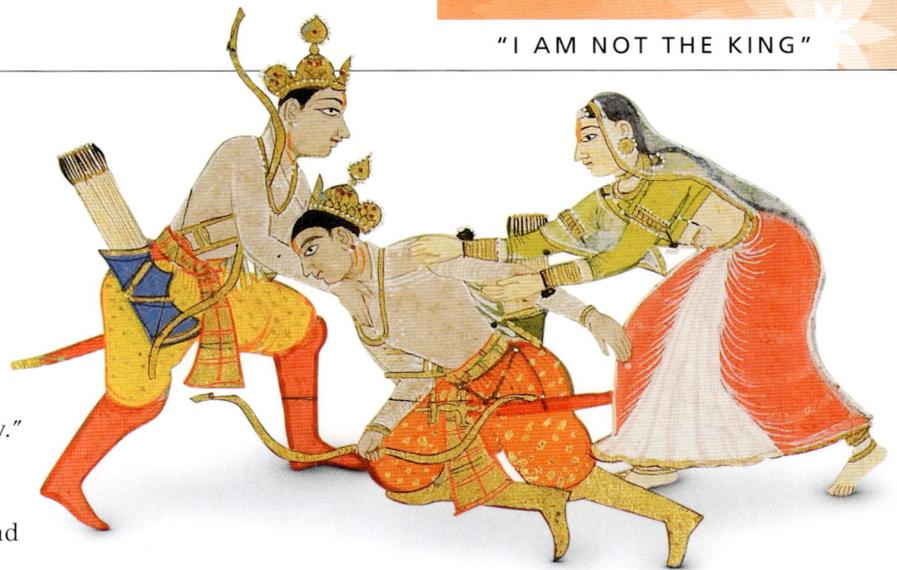

For the love of a brother

Bharata listened to his mother and found himself overcome with sorrow. He wept as he said, "What will I do with this kingdom when I am deprived of my father and my brothers? You have wounded me and then put salt in my wounds.

You caused my father's death and sent Rama to the forest. You have destroyed this lineage. Kaushalya treated you as a sister, and Rama considered you his mother."

Bharata roared, "How could you banish him to the forest. With what »

"**A king** is **to die** for a **thoughtless word**, a **hero** is to **give up this world** and **Bharata** is to **rule a world** thus got! Can there be a more **perverted dharma** than this?"

BHARATA TO KAIKEYI, *KAMBA RAMAYANA*, TRANSLATED BY PS SUNDARAM

≫ strength shall I protect this kingdom? I will not satisfy your desire by accepting this kingdom. I will bring my brother back."

A mother's sorrow

Kaushalya, hearing Bharata's voice as he railed against Kaikeyi, told Sumitra that she wanted to see him. Bharata and Shatrughna soon presented themselves before her. Too overwhelmed to remain standing, she stumbled and the two princes held her up. In anger, she told Bharata, "Here is the kingdom that Kaikeyi won for you. She should send me to my son, or perhaps you can take me there."

Bharata, pained by her words, spoke with great consternation, "Queen, why do you reproach me, when I was ignorant of what was happening here? You know of my love for Rama. If I had even an inkling of this nefarious plot, may I suffer just like those who commit the most heinous crimes, including betraying their king, arson, and having improper relations with one's teacher's wife."

Moved by Bharata's words, Kaushalya said, "Your oaths pain me. You constrict my breath by speaking in this way. It is fortuitous that you and Lakshmana have not deviated from the path of truth. You shall attain the superior realms." That night, the two princes and Kaushalya grieved for their losses.

Dasharatha's funeral

The next morning, Vasishtha told Bharata that it was time to perform the funeral rituals. "You have wept enough," the sage said.

Encouraged by Vasishtha, Bharata spent the stipulated 10-day period in a state of ritual impurity, making further offerings and performing charity on the 12th day. On the 13th day, he cried piteously, "I have been abandoned by the king and Rama has been exiled. Father, where did you go? With Rama in the forest and the king in the realm of the gods, I see no reason nor means to go on living. I shall enter fire. I shall enter the forest for asceticism instead."

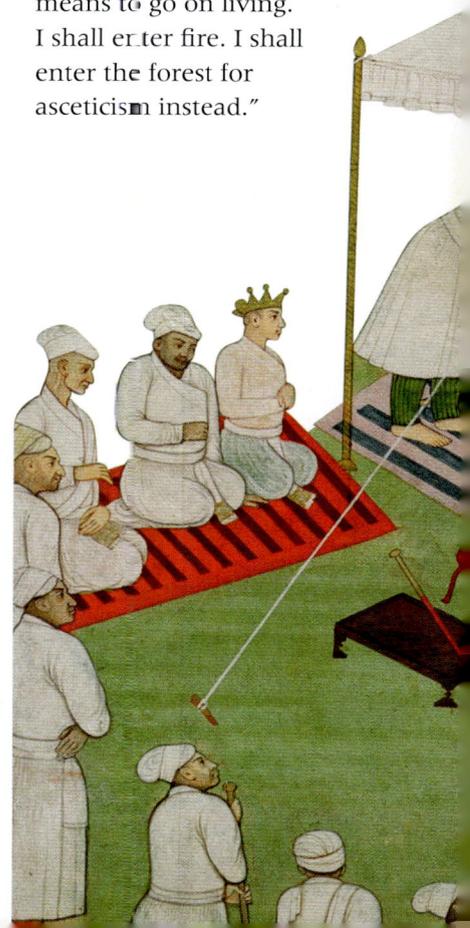

> "If **commit this crime**, I will act like an **ignoble person** and will not go to heaven. In this world, I will become the **defiler of the lineage of the Ikshvakus**. I do not take delight in the **wicked act perpetrated by my mother**."

BHARATA TO THE PRIEST, *SARGA* (76), AYODHYA KANDA

Sumantra and Vasishtha consoled Bharata and Shatrughna. Vasishtha said "Hunger and thirst, grief and delusion, old age and death – these three dyads afflict all beings. Death is inevitable."

Bharata's resolve

On the 14th day, the counsellors and ministers gathered and addressed Bharata, "Become our king now! A kingless land is under constant danger. Accept this kingdom of your forefathers and protect us."

Bharata listened and responded respectfully that only the eldest brother could become the king. "Therefore, Rama will become the king and I will live in the forest for 14 years," he said.

"Prepare the roads and ready the army. I will go to the forest, I will consecrate Rama there, and bring him back." The next morning, Bharata awoke to bards and musicians performing in the manner due to a king. "I am not the king," he proclaimed. Turning to Shatrughna, he said, "Look at what Kaikeyi has done. The glory that belonged to Dasharatha now wanders around like a boat with nobody to steer it." Listening to Bharata, the women wept. The priest tried to convince Bharata and said that since his father had died and Rama was in the forest, the throne was his.

"Enjoy this kingdom that has been granted to you by them," he said.

Bharata replied, "How can a son of Dasharatha rob somebody of their kingdom? My elder brother, superior to me in all ways, deserves it. I do not approve of what my mother has done and, standing here, I bow my head before him, who is in the forest. I shall either bring him back or live with him in the forest."

DHARMA AND LOVE

Shifts in the narrative of Bharata reflect the broader changes in emphases that mark retellings and novel engagements with Rama's story. In Valmiki's *Ramayana*, there is hardly any possibility at all that Rama would return in response to Bharata's entreaty. Later retellings or engagements with Valmiki, which focus more closely on the relationship between the submitting devotee and the Lord, tend to at least consider why Rama would not do it, since Rama's compassion and affection come to be emphasized.

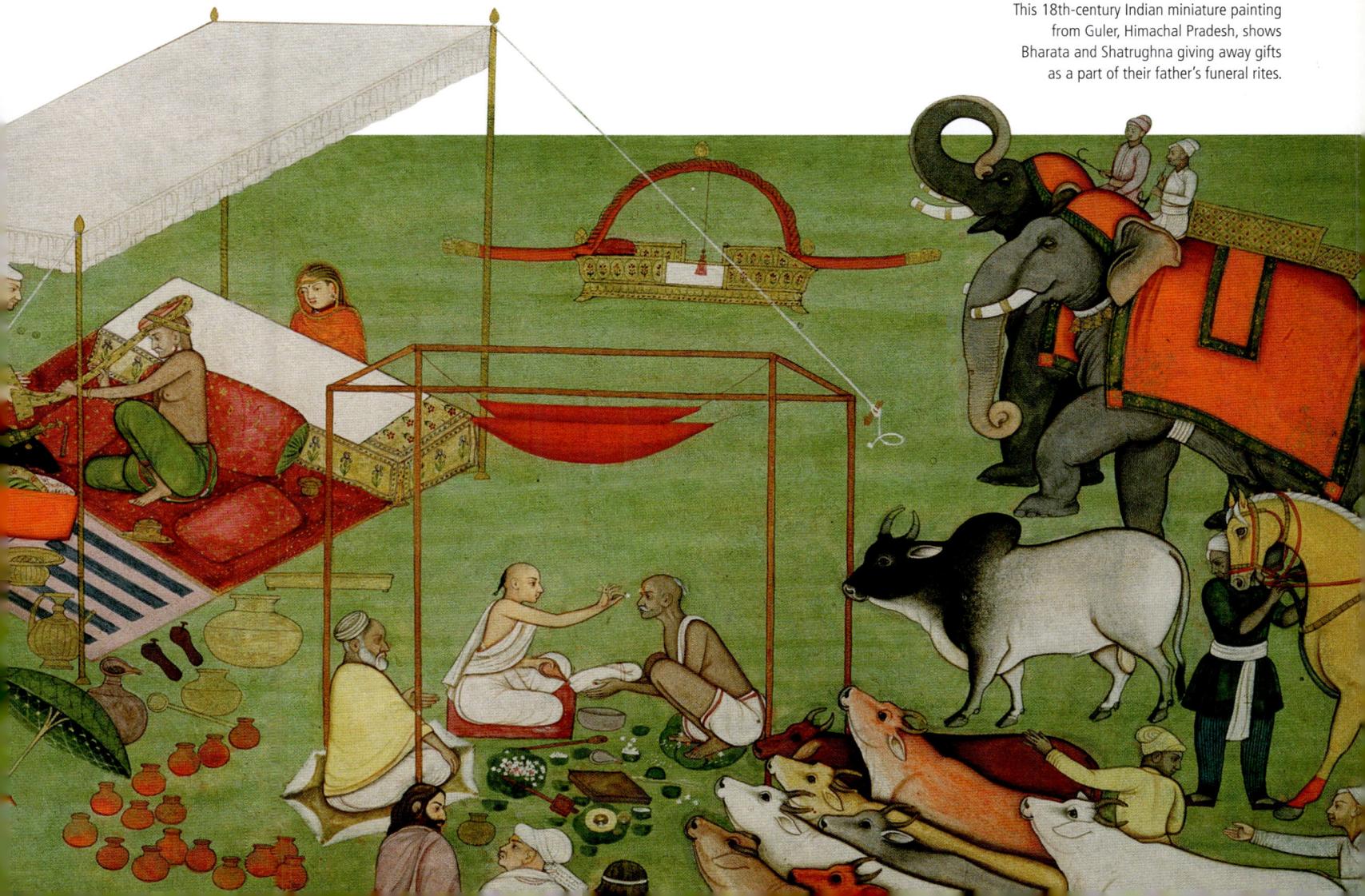

IN MEMORY OF THEIR FATHER
This 18th-century Indian miniature painting from Guler, Himachal Pradesh, shows Bharata and Shatrughna giving away gifts as a part of their father's funeral rites.

In Search of Rama

Bharata's determination to look for Rama delighted the ministers and arrangements began for his travel almost immediately. Workers built a grand road, camps for rest, bridges, and deep wells for thirsty travellers. Finally, Bharata set off, determined to bring Rama back so that he could take his rightful place on the throne.

Bharata left Ayodhya, along with people from all walks of life, the three queens, and priests. The army accompanied him as well. When they reached the River Ganga, he decided to stop for the night, so that the army could rest. "For now," he said, "I want to offer the sacred waters of this river to my father who has left for heaven."

Guha's doubt

The king of Nishadas, Guha, (See box) saw Bharata with his army and was deeply suspicious. "This immense army, which stretches as far as the eye, and even the mind, can see, will either

FINDING RAMA
This late 18th-century artwork in opaque watercolour and gold on paper depicts Bharata and Shatrughna and their entourage setting out to find Rama and Lakshmana.

capture or kill my fishermen. Bharata must be going to kill Rama. Rama is my master, friend, and kin. My men should stay here, prepared to defend his welfare," he told his kin.
"Be prepared for battle. If it turns out that Bharata is not going to cause Rama harm, the army will cross the river tomorrow."

Guha approached Bharata, carrying many gifts and was introduced as a friend of Rama. Bharata was eager to see him. Guha offered him the gifts and requested him to spend the night by the river. Bharata, grateful for his hospitality and generosity, asked him for help in reaching Sage Bharadwaja's hermitage.

"This region is very difficult to navigate," he said. Guha reassured him and told him that he and his men would go with him. "But," he said, "your

army arouses great suspicion. Are you going to Rama bearing ill will?"

"You need not suspect me," Bharata said. "That descendant of Raghu is my elder brother and I think of him as one would consider their father. I am going to bring him back. I have no other intention."

Pleased to hear this, Guha said, "You are truly blessed. I see no one equal to you on this earth today. Who else could renounce such a kingdom, attained with no effort? Your eternal glory shall certainly travel across the earth."

Bharata's agony

That evening, Bharata was occupied by thoughts of Rama, and became uneasy thinking of his brother's predicament. Guha described Lakshmana's devotion to

Rama, hoping that it would comfort him. Hearing of Rama's first night in Shringaverapura, however, made Bharata sad.

He thought of Rama and Sita sleeping on the ground, and Rama and Lakshmana going forth with their hair matted like ascetics. He held himself together for a moment, before falling like an elephant goaded. Shatrughna, standing nearby, held him up and wept.

The queens rushed over and Kaushalya embraced Bharata, asking him as she would have Rama, "My son, are you overwhelmed by some illness? The entire entourage is depending on

you. Child, Rama is in the forest and the king has departed for his heavenly abode. I live by your sight alone. Have you heard ill tidings?"

An ascetic like Rama
Bharata reassured her and asked Guha, "Where did my brother, Lakshmana, and Sita spend the night? What did they eat? Where did they sleep? Tell me everything."

Guha showed him the tree under which Rama had spent the night. Heartbroken to see that the son of Dasharatha, who once lived in luxury and honour, now slept on the bare earth, Bharata said, "From today, I, too, will sleep

"My brother made his bed on this **hard ground** and as he tossed around in his sleep, the grass bears the **marks of being crushed by his limbs**. Since, here and there, specks of gold can be seen, I think that **Sita** must have slept on this bed without **taking her ornaments off**."

BHARATA TO HIS MOTHERS, *SARGA* (82), AYODHYA KANDA

on the earth. I will consume fruits and roots, and bear matted hair and ascetic garb."

Meeting the sage
The next morning, they proceeded to Bharadwaja's hermitage. After Vasishtha and Bharadwaja exchanged pleasantries, the latter turned to Bharata and, out of love for Rama, asked, "Why have you come here when you are ruling the kingdom? I am unable to clear my mind of suspicion. Do you wish to cause Rama or his brother harm, so you may enjoy the kingdom without any fear?"

Hurt by the words, Bharata replied, "All is lost if your blessed self thinks this way of me. Do not fear any harm from me for Rama. I had no part in what my mother did. I am going to worship my brother's feet and will bring him back. Knowing this to be my intent, please grace me with your favour and tell me where Rama has gone."

Satisfied, Bharadwaja told him that Rama now lived in Chitrakoot. That night, Bharata and his army enjoyed Bharadwaja's hospitality. Before they set out for Chitrakoot, the sage asked

Bharata to introduce him to the queens. Bharata wept bitterly as he introduced his mother, Kaikeyi. The sage, though, asked him to give up his ill will towards her. Rama's exile would end in good, he said. The next morning, they left for Chitrakoot to continue their search.

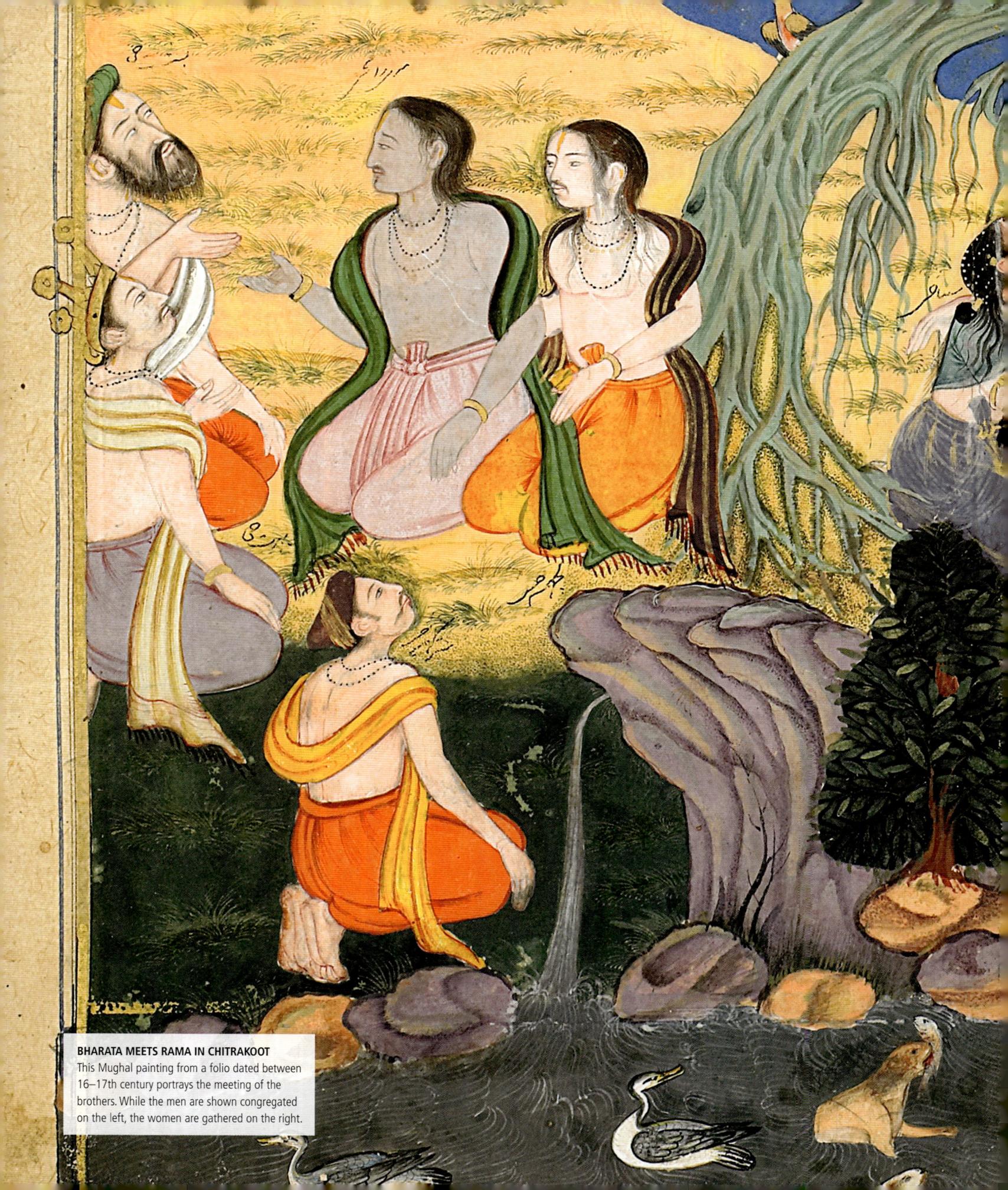

BHARATA MEETS RAMA IN CHITRAKOOT
This Mughal painting from a folio dated between 16–17th century portrays the meeting of the brothers. While the men are shown congregated on the left, the women are gathered on the right.

The **Brothers Unite**

A large dust cloud went up and animals scattered in fear as Bharata entered the forest of Chitrakoot with his army. Seeing them approach, Lakshmana grew alarmed, but Rama pacified him. Then, Bharata saw his brother.

Bharata saw Rama, the lord of the earth, seated in his hut in ascetic garb, radiant like fire, with broad shoulders, large arms, and lotus eyes, and Lakshmana and Sita accompanied him.

Overwhelmed with sorrow, he said, "He sits here with his body covered in dirt, a man whose body used to be covered in sandalwood paste. Rama, who deserves pleasure, has come to this state because of me. Cursed is my life!" He fell at Rama's feet and simply called out to him once, unable to speak further. Shatrughna, too, grasped Rama's feet.

Rama gathered them both in an embrace, then placing Bharata beside him with great affection, asked him why he had come. "You should not have left our father in Ayodhya," he said. Rama asked about his family and then reminded Bharata of the proper ways of kingship.

Bharata listened to Rama and replied, "What good is the dharma of kingship to me, who is devoid of dharma? The age-old dharma is that the younger son does not become king when the older one is present. Return to Ayodhya with me, bull among men.

"The king passed when I was in Kekaya and you were in the forest. Carry out the oblation with water for him. Shatrughna and I have done it already. In the realm of ancestors, it is believed that what is offered by one who is beloved is imperishable and you were undoubtedly the favourite of our father."

Struck by the thunderbolt of Bharata's words, Rama stretched out his arms in a vain attempt to contain the deluge before falling to the ground.

> **"Rama**… fell down in this way, like an **exhausted** elephant sleeping on a bank that has now been **washed away."**
>
> RAMA'S REACTION TO HIS FATHER'S DEATH, *SARGA* (95), AYODHYA KANDA

117

A Plea to **Return**

The next morning, Bharata tried to convince his brother to return, but failed. Rama was adamant, determined to follow his father's instructions. What followed is an episode that is considered the epitome of brotherly love.

After Rama and Lakshmana performed the last rites for Dasharatha and the rest of Bharata's attendants arrived, Rama asked Bharata again, "Why have you come here with matted hair and wearing bark and deerskin? Why aren't you performing the duties of a king?"

"When you are there, how can I **rule over the earth**? I am **inferior** to you in intelligence. I am like a child in qualities. I am **inferior in status**. Without you, I have no interest in remaining alive.**"**

BHARATA TO RAMA, *SARGA* (98), AYODHYA KANDA

The word of a parent

Bharata placed his head at Rama's feet and said, "Our father did the terrible deed of exiling you and then,

tormented by grief, departed for heaven. My mother, Kaikeyi, urged him to do this evil act, which deprived him of his due glory. She will go to hell, without acquiring the kingdom for which she did this. Destroyer of enemies, grant me your favour now. Accept this consecration, like Indra himself. Our widowed mothers and your subjects have all gathered here. You ought to grace them too.

"Accept this kingdom in accordance with dharma and please your well-wishers. Let the earth have a master so she is no longer like a widow," pleaded Bharata.

Rama embraced his brother and comforted him. "How can someone like you do anything evil for the sake of a kingdom? I do not fault you even in the slightest. You should not speak of your mother in this way. We should revere her the same way we revere our father.

"My mother and father told me to go to the forest, so how could I have acted otherwise?

The king made this decision that you should rule Ayodhya and that I reside in the forest for 14 years. We need to perform the roles assigned to us," Rama explained.

Inevitability of death

The next morning, while surrounded by family and friends, Bharata told Rama, "Lord of the earth! I give you this kingdom that was granted to me. Enjoy it without any obstacles. I seek you as my only recourse."

Rama, seeing Bharata in pain, consoled him, "A man cannot always act as he wishes, but follows the will of destiny. Just as anything stored is destroyed and meetings end in separation, so, too, does all life end in death. As two logs of wood come together in the ocean, only to part ways, so do husbands and wives, fathers, and sons. Our father has gone to heaven, his sins washed clean. Do not grieve for him, who had dharma in his soul. Control yourself and rule

from Ayodhya. We should not transgress from our father's wishes."

Bharata's request

"Who else could be like you, Rama, who is neither grieved by pain nor overjoyed at pleasure," Bharata replied. "My mother's evil deed while I was away is to my eventual detriment. Forgive me. You are worthy of the warrior's virtues and instead bear these matted locks. You ought to be ruling the kingdom and instead reside in the forest. How can you live in such a discrepant manner?

"The householder is the most important stage in a human life. How can you skip it? I am but a child. How can you expect me to rule over the kingdom? I do not wish to live without you. Let our well-wishers be delighted today at your consecration and our enemies flee in fear. Or else I will go with you wherever you go from here."

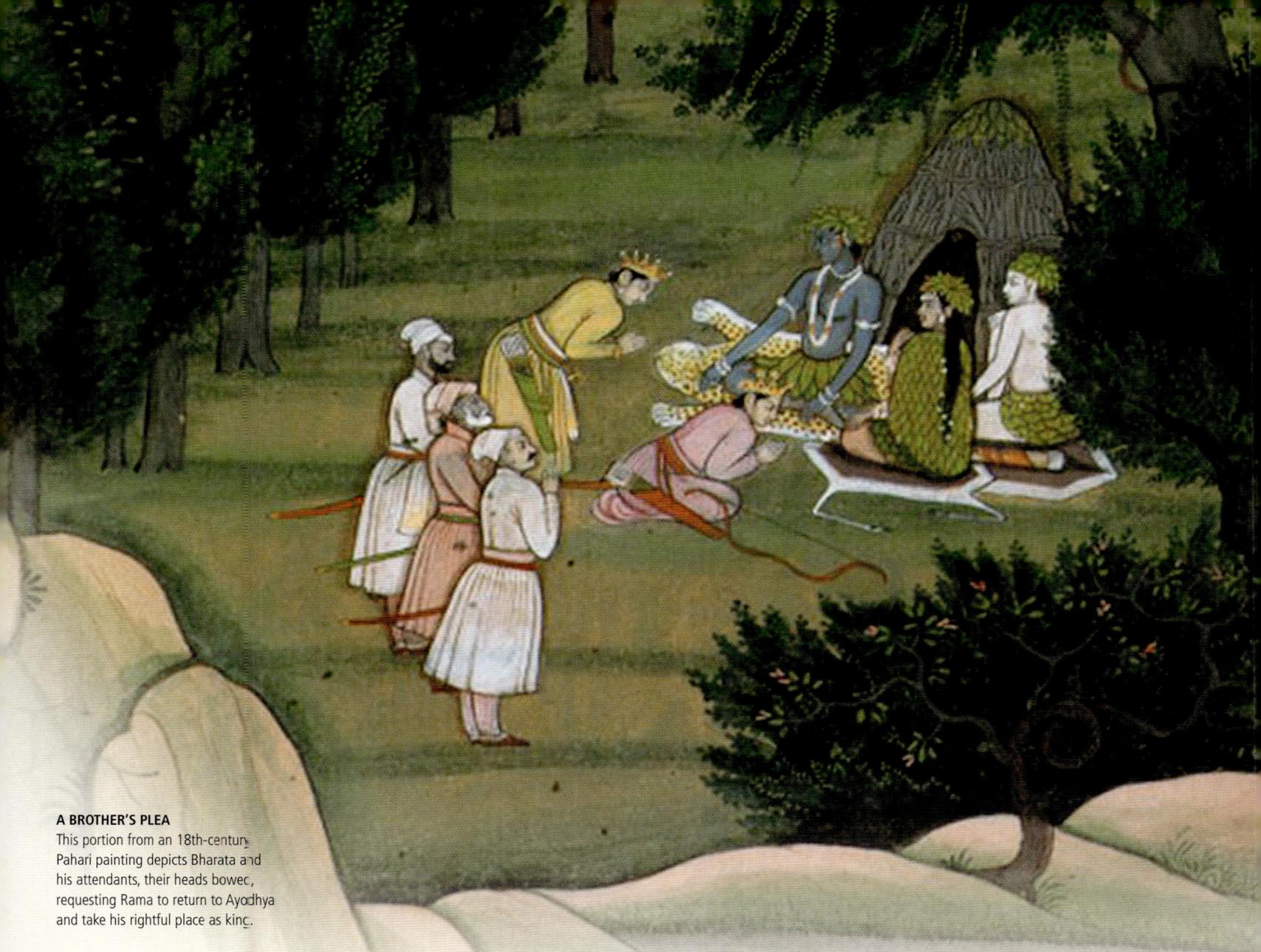

A BROTHER'S PLEA
This portion from an 18th-century Pahari painting depicts Bharata and his attendants, their heads bowed, requesting Rama to return to Ayodhya and take his rightful place as king.

Rama refuses to return

Jabali, a renowned sage (See box), tried to convince him as well, but, Rama replied, "What you said resembles that which is to be done, but isn't actually it. I reject that warrior's dharma, which is followed by the petty and cruel evil-minded ones. I hold the truth to be the ultimate good. How can I disregard my father's command and do as Bharata says?"

Vasishtha, seeing Rama angry, placated him, "Jabali knows the ways of the world and agrees with you. He says this only because he wants you to return."

Vasishtha tried to convince Rama as well, but met with no success. Hearing this Bharata, turned to the charioteer and said, "Spread some grass here. I will sit here before Rama's cottage without food until he agrees to return. Why do none of the citizens gathered here force Rama's hand?"

The gathered people longed to see Rama as their king, but hesitated, as they knew Rama would abide by dharma. They asked, "How can we ask him to turn away from following his father's command?"

> "When **he saw Rama**, Bharata's eyes brimming with tears, quite **forgot the reproachful words** he had rehearsed a hundred times... he could only **fall headlong**, as though he was **sighting his dead father**."
>
> BHARATA ON SEEING RAMA, *KAMBA RAMAYANA*, TRANSLATED BY PS SUNDARAM

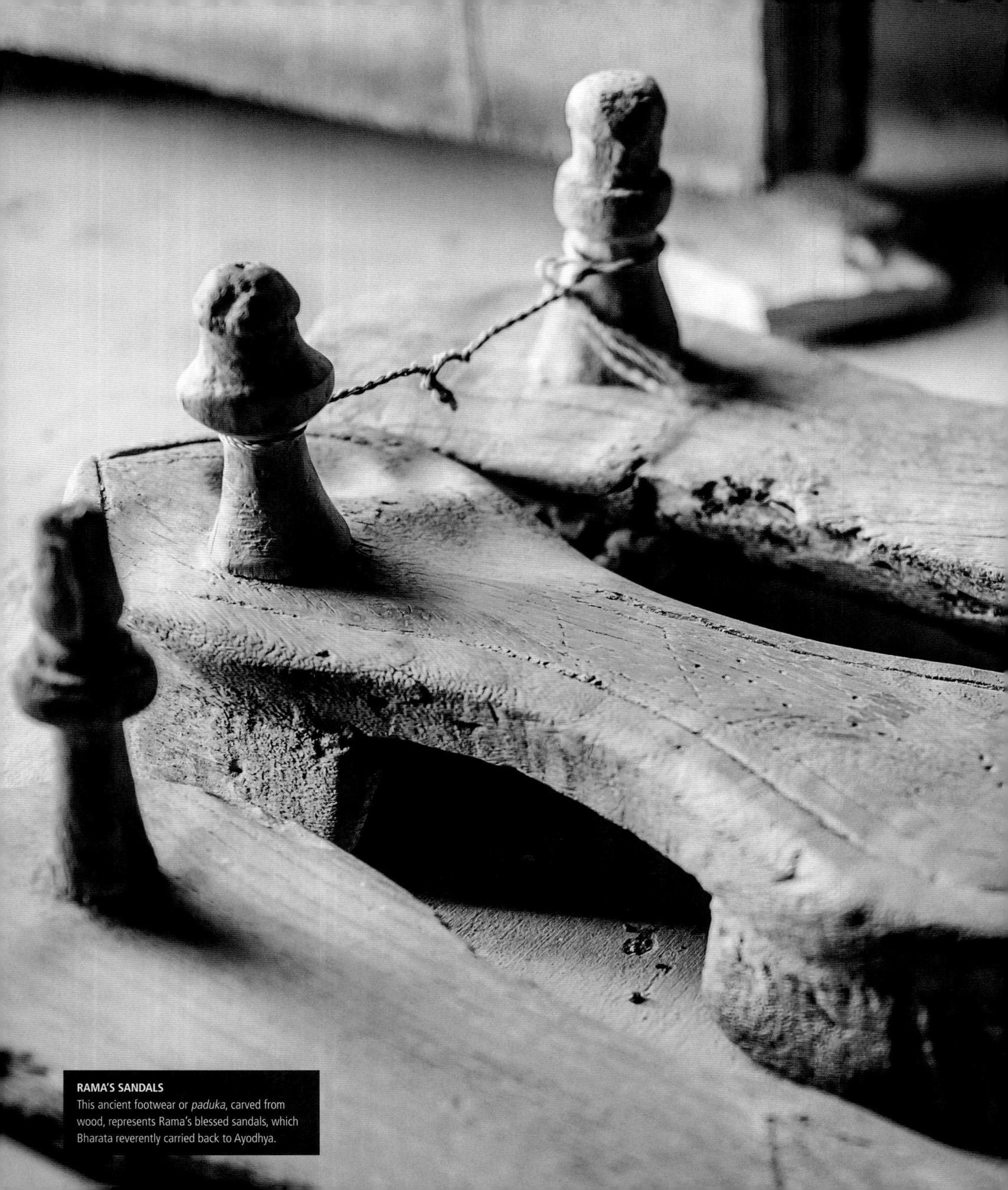

RAMA'S SANDALS
This ancient footwear or *paduka*, carved from wood, represents Rama's blessed sandals, which Bharata reverently carried back to Ayodhya.

Bharata **Returns**

Bharata sat outside Rama's hut ready to fast unto death, but Rama remained unmoved. He chastised him and instructed him to return. So, Bharata asked Rama for an extraordinary favour.

Rama looked at his brother and said, "Get up, Bharata! What have I done that you feel the need to sit here like this? Priests and the like can give up food in this way, but not those who have been ritually consecrated as yourself. Get up, tiger among men, and return to Ayodhya."

The citizens gathered around as the brothers concurred and so Bharata got up. "If Rama, following our father's command, must stay in the forest, then I, too, shall stay with him," he vowed.

Amazed at Bharata's words, Rama addressed everybody, "That which my father said while he lived, neither Bharata nor I may transgress."

When he heard this Bharata fell at Rama's feet, "I cannot rule this kingdom – I do not have it in me."

Rama seated him lovingly by his side and said, "You will be able to rule the entire earth. Act in accordance with counsel.

The ocean may overcome the earth, but I cannot transgress our father's words. For whatever reason our mother may have done this, you should not think of it anymore."

"Very well, then. Place your feet on these golden slippers. They shall ensure the well-being of the world." So saying, Bharata laid the slippers in front of Rama.

Rama placed his feet on them and then gave them to Bharata.

The young prince accepted them with due reverence and said, "I shall place the responsibility of the kingdom upon your slippers and live outside the city as an ascetic, living off fruit and roots. If I do not see you the day 14 years end, I shall enter fire."

Bharata then returned, spending the next 14 years in Nandigrama, on the outskirts of Ayodhya, refusing the heavenly pleasures of the capital in favour of the observance of dharma.

"The **powerful** Bharata... worshipped those **ornamented sandals**. He circumambulated Raghava and **placed them** on the head of an excellent **elephant**."

BHARATA'S REVERENCE FOR RAMA'S SANDALS, *SARGA* (104), AYODHYA KANDA

THE LOYAL BROTHER

Bharata

> "... he saw the **miserable Bharata**... was **grieving** because of the **hardship his brother had suffered**... With the sandals in front, he ruled over the earth."

HANUMAN'S SIGHTING OF BHARATA, *SARGA* (113), YUDDHA KANDA

In Valmiki's version of the *Ramayana*, the focus in the Ayodhya Kanda is the strange struggle over the kingdom, where the two brothers, Rama and Bharata, are adamant on refusing consecration. Indeed, by sheer force of repetition, the exceptional nature of this moment is often forgotten, despite there being precious few instances of any other conflicts involving a refusal, rather than tussle, over a kingdom.

Devotion to Rama

Bharata's love for Rama is evident, but is also imbued with a deep sense of righteousness and duty. Even before Bharata has learnt of Rama's exile, he seeks him out, asking Kaikeyi where his brother is, as he regards him almost as a father in the latter's absence. He is appalled when he discovers that it is his mother who has formulated the plan. He is disturbed, but his initial response has more to do with his incredulity at the possibility of Rama committing the kind of act that leads to such an exile.

There is no denying that his attitude is one of intense affection and subservience as a younger brother. On his way to Chitrakoot, he is repeatedly overcome with guilt and love. Once there, he insists that Rama return as an act of favour towards him and the people. He maintains his inability to rule, and Rama's right and competence.

Conflicting views

Scholars have observed that the earliest substantial treatment of the *Ramayana* as a narrative about surrender to Rama was done by the Shrivaishnavas, a community in southern India, which believes in Vishnu, the Preserver of universe. Within that tradition, some commentators see Bharata as being a shade too egotistical to be a perfect devotee of Rama. He approached his brother in the forest with regal paraphernalia. Rama, for that reason, chose not

A DUTIFUL BROTHER
This 14th-century bronze statue of Bharata, comes from the historic Vijayanagara dynasty of south India. Here Bharata can be seen carrying Rama's sandals over his head. The sandals were later placed on the throne in Ayodhya by him.

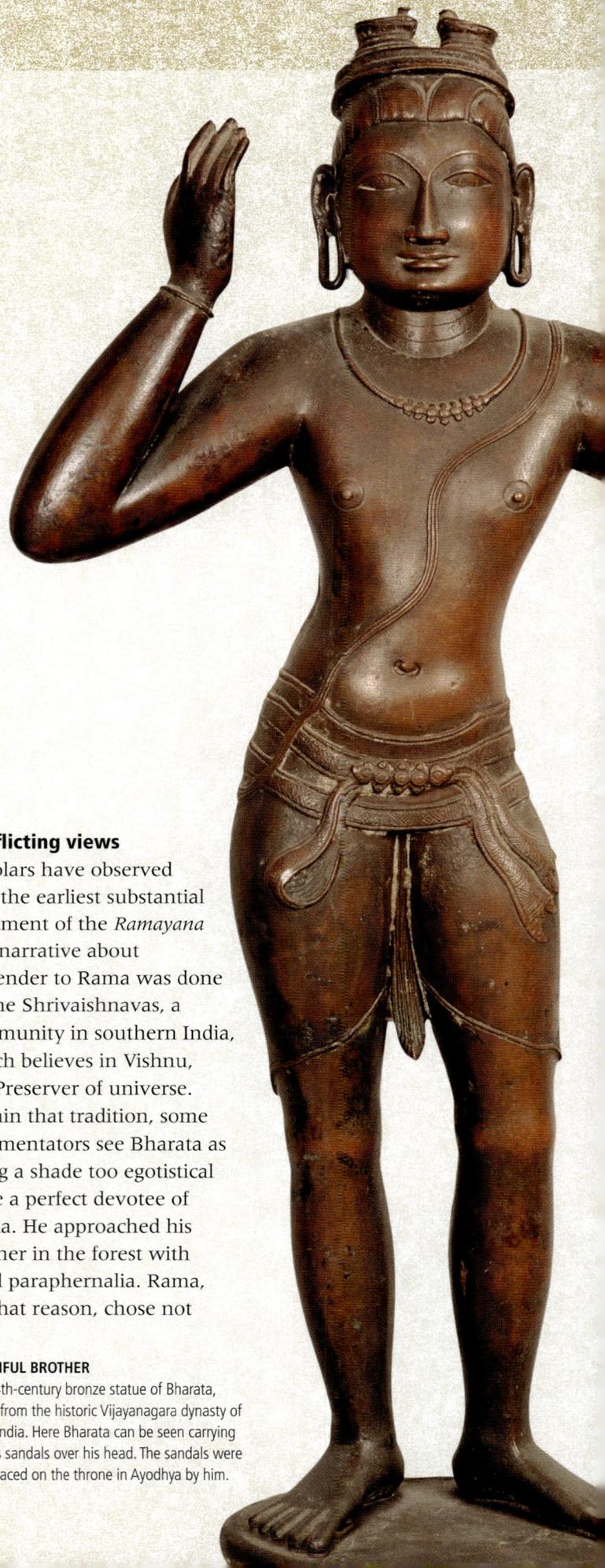

to honour his request. Instead, the honour of staying with him in the forest, went to Lakshmana. However, other authors within that tradition, regarded Bharata as an ideal bhakta or devotee. On this view, Bharata's non-insistence on his staying was part of the perfection of his servitude.

Question of surrender

The question that arises, though, is why did Rama not agree to Bharata's request? Sanskrit scholar Ajay K Rao, in *Re-figuring the Ramayana as Theology: A History of Reception in Premodern India,* writes that this has to do with the temporal priority of the surrender. The gods approached Rama first, seeking Ravana's destruction. Rama is obliged to fulfil their request first, even though he is moved by Bharata's plea.

This reasoning seems to play out in the *Adhyatma Ramayana,* a medieval Sanskrit text. There, Bharata, in an emotionally charged moment, gives up food and settles before Rama's cottage. Rama looks meaningfully at Sage Vasishtha who takes Bharata aside and tells him of Rama's incarnation and why he must stay in the forest. In both Kamba and Tulsidas's versions of the *Ramayana,* the gods are worried when they see Bharata and Rama's love for one another, afraid that Rama may be unable to refuse Bharata's petition. In the *Ramcharitmanas* of Tulsidas, however, although the gods are worried, they aren't really a factor in either Rama or Bharata's decisions.

The three movements

The Ayodhya Kanda of the *Ramcharitmanas* has at its centre Bharata's devotion. In it, Rama never refuses Bharata. Indeed, he goes so far as to say that he is willing to set aside his father's words. However, Bharata, recognizing the depth and dramatic quality of this statement from Rama – whose commitment to truth is unparalleled – puts himself and his fate in his brother's hands. For Tulsidas, Bharata is the ideal of devotion even in separation from God.

With respect to Bharata, there seem to be three movements, described in chronological progression.

The first is Bharata's intense pain at separation from Rama and his desperation to take his brother back, one way or another. The second is his surrender at Rama's feet, such that he doesn't even ask for his return. The third is his spiritual praxis in quiet acceptance of separation effected by Rama's will and his stay on the outskirts of Ayodhya in Nandigrama.

In *Ramcharitmanas,* Bharata's status is exalted above virtually anybody else's. Dharma is not his primary concern, although it does drive him in part. Ultimately, he is driven by his attitude of servitude towards the Supreme Being, manifest as Rama.

In each rendition of the *Ramayana,* Bharata comes to embody the supreme ideals of that particular text or tradition, whether it is the completion of his surrender or his insistence on dharma. To that extent, in each rendition, Bharata is second only to Rama. In Valmiki's version, he mirrors Rama in a way few other figures do, whereas in Tulsidas's *Ramayana,* as the model devotee, his significance is comparable to that of Rama.

ANALYSIS

THE ROLE OF SHATRUGHNA

In much of Valmiki's *Ramayana,* Shatrughna is hardly there at all, barring brief conversations in the Ayodhya Kanda. He begins to have much more of a role in the Uttara Kanda. Scholar Ajay K Rao draws attention to an interesting conundrum brought up by Shatrughna's status. In some of the commentarial material, Rama and his brothers are understood as the lords and embodiments of three kinds of relationships – servitude (Lakshmana), dependence (Bharata), and dependence on the Lord's devotees (Shatrughna, through his dependence on Bharata). Technically, since the subservience is more absolute in the last, Shatrughna should be the best of the three, which is contradicted by the text itself.

RAMA'S TRUSTED COMPANIONS
This illustration shows Rama seated on a throne with Sita on his lap. Bharata can be seen in the background along with Lakshmana and Hanuman, Rama's Vanara companion.

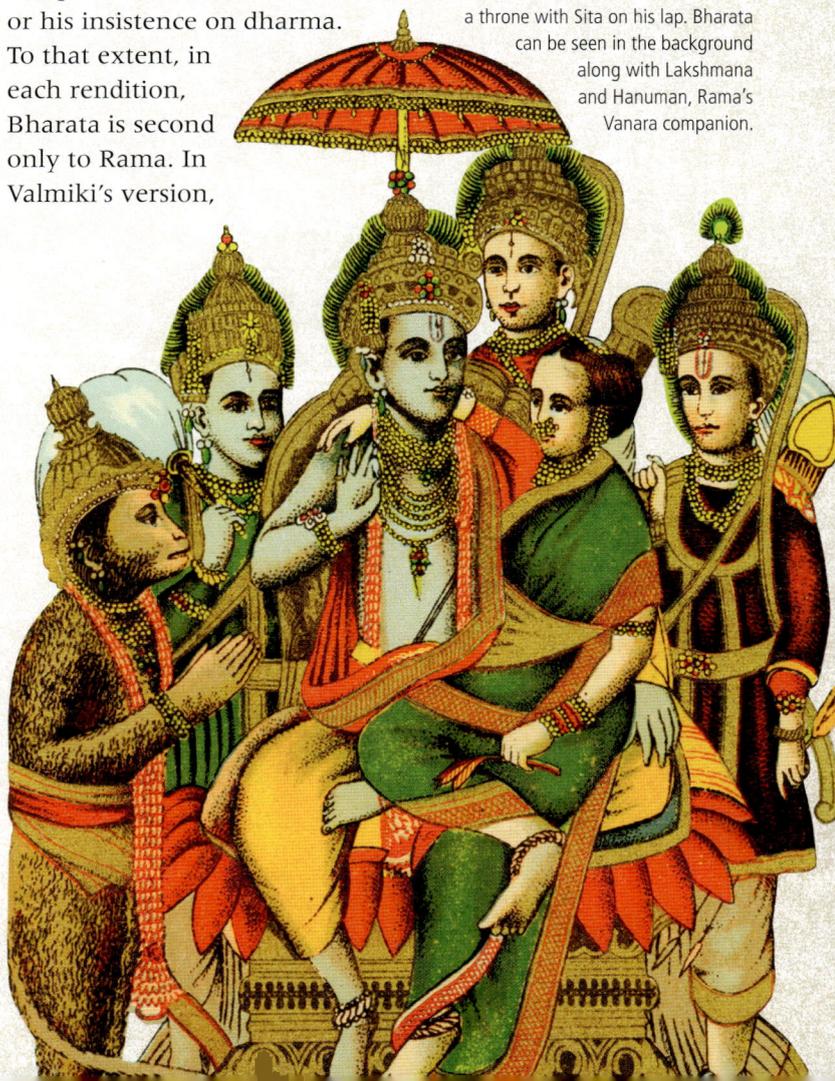

In Search of a Home

There was a great stir in the otherwise peaceful Chitrakoot, as Ravana's cousin Khara, unable to tolerate Rama's presence, tormented the ascetics and interrupted their sacrifices. The sages fled and found refuge elsewhere. Soon, Rama too decided to move, for now, there were too many sad memories in the forest.

After Bharata's departure, Rama realized that the ascetics who lived in Chitrakoot were somewhat agitated. The fear they felt was evident in their eyes and from their frowns. They seemed to point to Rama suspiciously, all the while talking among themselves. Rama worried that he or his companions may have done something to offend or trouble them.

He approached the head of their hermitage and asked, "Have I done something that has caused this shift in the sages' attitude, or did my younger brother, Lakshmana, act in an inappropriate manner? Or does Sita not act in the proper way?"

Khara, the tormentor

The sage assured Rama that the change in behaviour was not because of him, Sita, or Lakshmana. He told him of Ravana's cousin, the Rakshasha Khara, who had

> "The world **incessantly suffered** from ten years of drought and she is the one who **created roots and fruits** and made the **Jahnavee flow**."
>
> ATRI TO RAMA ABOUT ANASUYA, *SARGA* (109), AYODHYA KANDA

been tormenting the ascetics living in Janasthana (in the Dandakaranya region, capital of the Dandaka kingdom). "He cannot bear your presence here and has been unleashing his wicked acts on us ever since you arrived," the sage said.

"The Rakshasas are cruel and have terrible forms. They pour water on the sacred fire while we conduct the rituals, break sacrificial vessels, and fling filth at the ascetics. They have infiltrated this hermitage with their evil actions." He told Rama that the ascetics were leaving the region before the Rakshasas could inflict physical violence upon them. "Come with us – Rama, there is an old hermitage nearby where we shall live," he said. Rama

decided not to accompany them and instead wondered if it was time to leave Chitrakoot as well, as the forest was no longer the same.

Too many memories

Now, the memories of Bharata and his mothers haunted him and he could not stop thinking about them.

Bharata's army had also caused some damage, trampling on the grass while setting up camp. So, Rama, Lakshmana, and Sita set out in search of a new home.

He first visited the sage Atri, who received the three with great affection. The sage then asked Sita to meet his consort, the great ascetic, Anasuya.

"She has immense austerity to her credit and is also affectionate," he said.

Meeting Anasuya

Sita approached the ageing ascetic woman, who looked emaciated and had white hair. She was pleased to see Sita and said, "It is good, my child, that you followed Rama, abandoning material prosperity and your relatives for him." She instructed Sita on the duties of a wife, and Sita, in turn, reaffirmed her love for Rama.

Pleased with her, Anasuya said, "I have attained many powers through my austerities. Tell me, what might I do for you through them."

ANASUYA'S GIFT
Happy to meet Sita, Anasuya presented her with garlands, ornaments, clothes, and advice on being a dutiful wife.

MEETING ATRI

While the meeting between Rama and Atri in Valmiki's *Ramayana* is a standard meeting between a forest-dwelling sage and a deeply virtuous prince, the other texts bring out Rama's divinity more clearly. In one version, the sage praises Rama in beautiful verse and, when Rama seeks his permission to travel to a different part of the forest, says, "Rama, Brahma, Shiva, sages, and those who know the real truth of things, seek your grace; such are you, beloved of those who have no desire, and you have uttered such sweet words … Lord, how can I say, 'Now you may go?' Tell me, you are inside beings." Tears filled the sage's eyes as he said this.

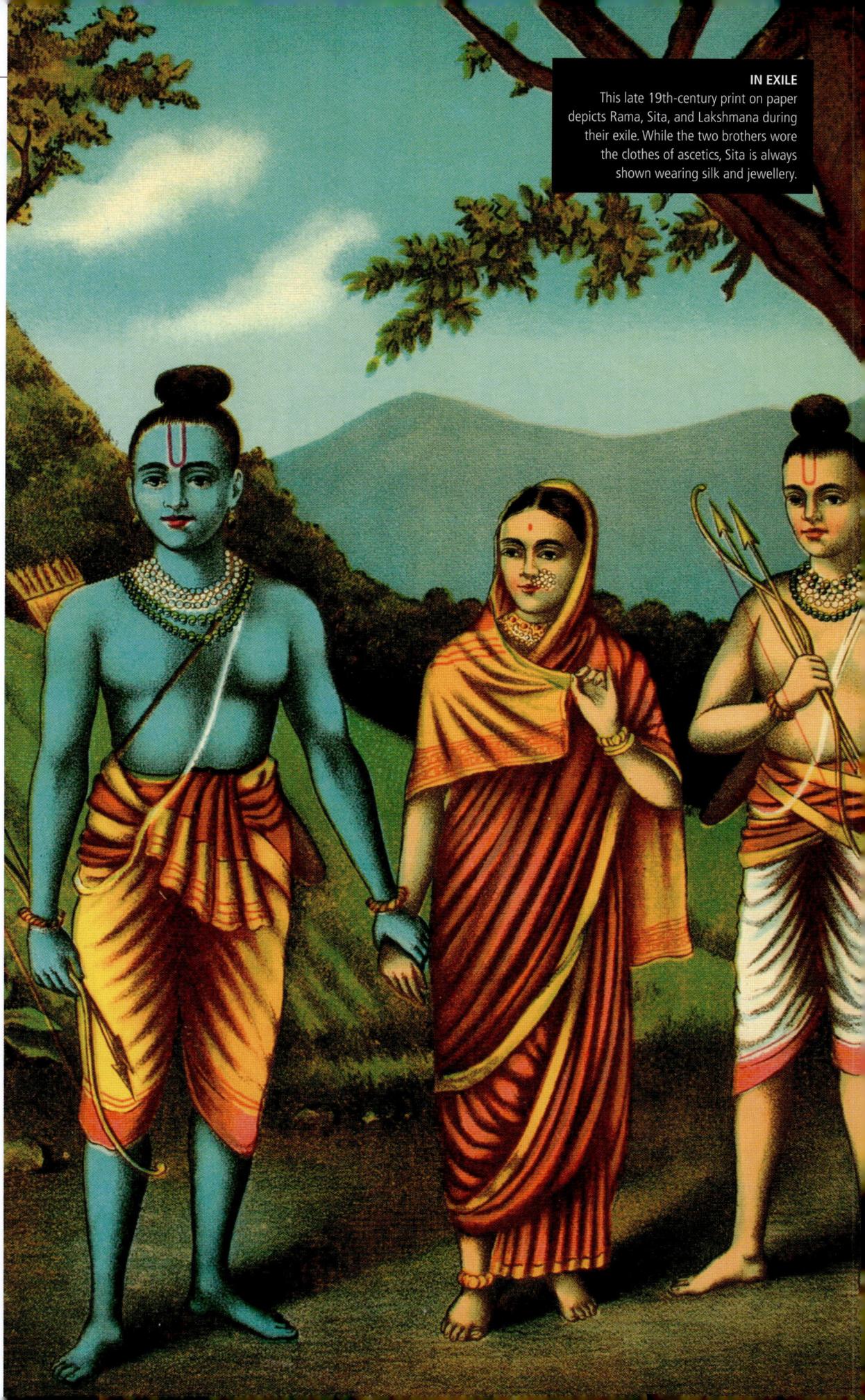
CHARACTER PROFILE
ANASUYA

In some narratives, Anasuya is the daughter of the sage Kardama and his consort, Devahuti. Stories around her often revolve around the power of her asceticism, by which she is said to have brought forth the Mandakini, a stream of the River Ganga. It is also said that once sage Mandavya cursed a woman named Shandeeli that she would be widowed in 10 nights. Anasuya responded with her own curse that there would be no dawn, but eventually, turned 10 nights into one. In this way, Shandeeli did not become a widow.

Sita politely replied, 'That you asked is enough!" Favouring her even more, Anasuya gifted her garlands, ornaments, and clothes. Sita accepted the incomparable gift of love and folded her palms in gratitude.

Anasuya then asked Sita to tell her the story of her *swayamvara* (See pp 60–61) and how Rama came to wed her. "I wish to hear that story in detail. Would you tell me how it all happened?" she asked.

Sita told her the story of how Janaka found her, and of Rama who broke Shiva's bow in two. Delighted, Anasuya embraced the princess and then, seeing that it was late, permitted her to return to Rama. The three spent the night at the hermitage.

The next morning, following the sage's directions, Rama, Lakshmana, and Sita walked into the deep forest.

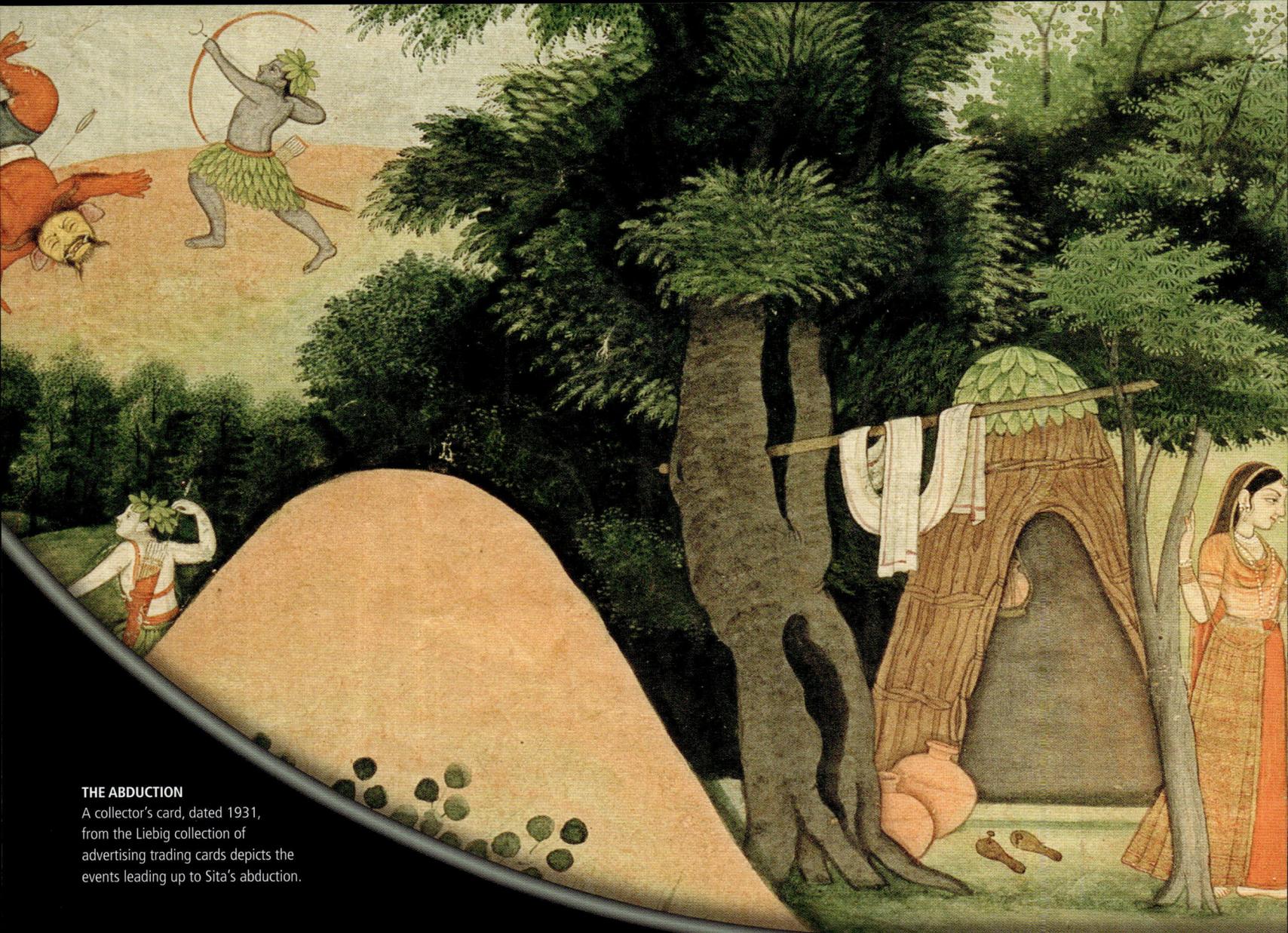

3 ARANYA KANDA:
LIFE IN EXILE

The third chapter of the *Ramayana* chronicles the banishment of Rama, Lakshmana, and Sita to the Dandakaranya forest. It covers their experiences during their 14-year exile, their meeting with the sage Agastya, their fateful encounter with Shurpanakha, and finally, the 10-headed Ravana's abduction of Sita. It also marks the beginning of the brothers' perilous journey to Lanka, the kingdom of the Rakshasas.

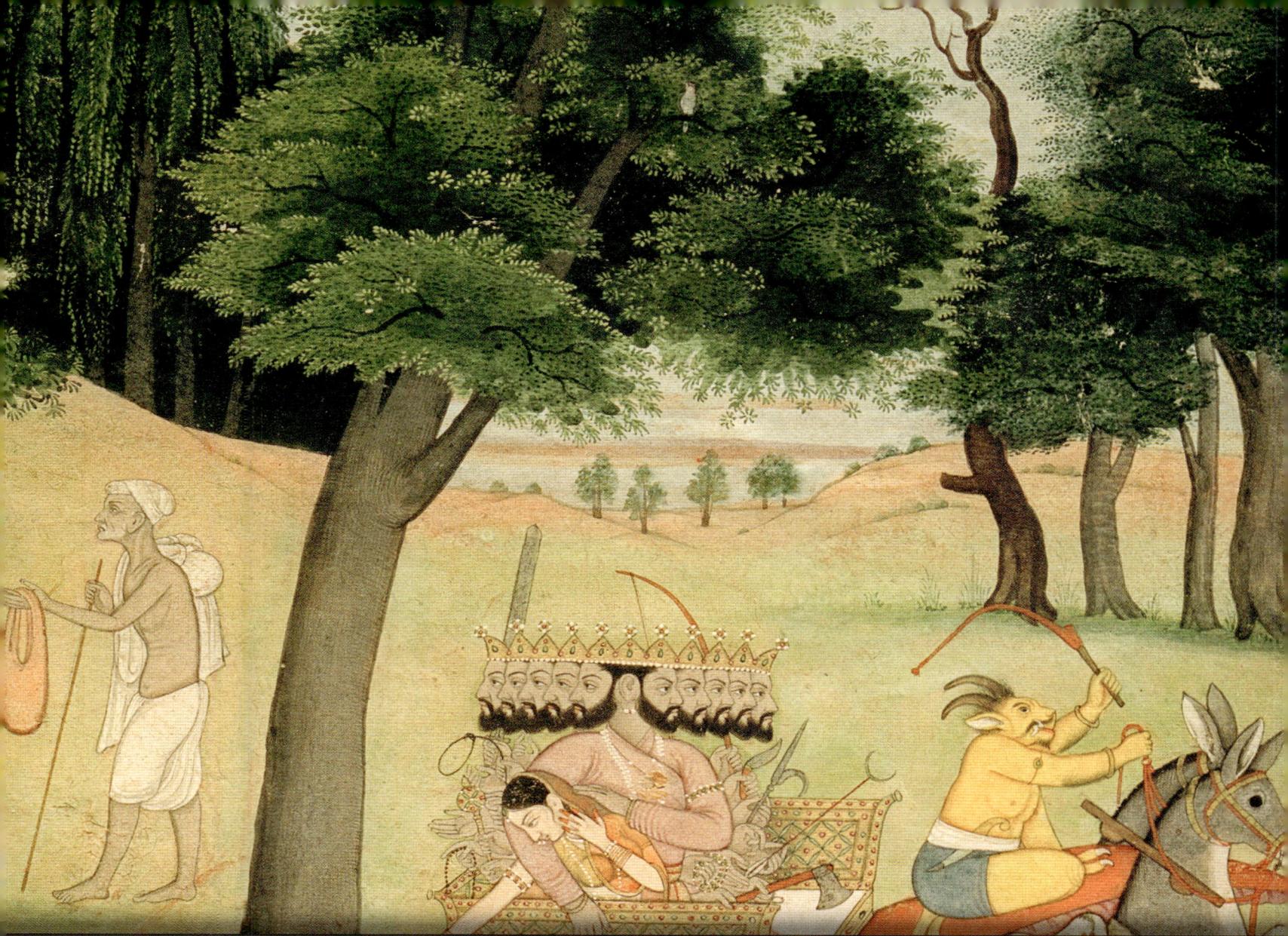

"She was **abducted by Ravana**, Indra among the Rakshasas... O son! I was **exhausted** and the roamer in the night severed my wings. Seizing Sita Vaidehi, he left in the **southern direction**."

JATAYU TO RAMA, *SARGA* (64), ARANYA KANDA

Seeking Refuge

Rama, Lakshmana, and Sita entered the impenetrable Dandakaranya forest, home to great sages who possessed divine sight. They sought Rama's protection from the Rakshasas that tormented them, and in turn helped the three in their search for a new home.

Rama entered the Dandakaranya forest and saw several sages who appeared radiant from their ascetic practice. He removed the string from his bow as a symbol of respect and walked towards them.

The sages were stunned at the beauty of Rama, Lakshmana, and Sita, for they reminded them of the rising moon. They welcomed Rama, offered him hospitality, and said, "The king is supposed to embody a part of Indra and is charged with the duty of protection. You are the king and you have to protect us as we are in a region under your influence. It does not matter whether you are in the city or the forest. We are deserving of your protection as we are ascetics who have renounced violence."

Viradha, the Rakshasa

The three walked deeper into Dandakaranya the next morning and came upon a strange patch of the forest. They saw a terrible figure standing in the middle. It was a man-eating Rakshasa, resembling a mountain in his immensity, wearing a tiger skin smeared with blood.

The Rakshasa ran towards them, picked up Sita, and asked, "Who are you? You bear matted locks, but carry a bow and arrow. If you are ascetics, why is a woman with you? Evil ones, following the path of adharma, I shall drink your blood, and this beautiful woman shall be my wife."

Sita trembled and, seeing her captured, Rama's mouth went dry. He told Lakshmana, "It seems that Kaikeyi's wishes will come true. Look, my beloved is in the arms of another. There is no greater pain than this."

Seeing Rama lose heart, his brother replied, "Why are you acting helpless when you are the lord of all beings? I shall direct the anger that had once arisen in my heart for Bharata towards this Rakshasa and the earth shall drink his blood."

Once again, the Rakshasa demanded to know who they were. When Rama told him their lineage, the Rakshasa introduced himself as Viradha and said, "Leave this woman here and go." Rama grew angry and replied, "It seems you seek certain death."

The end of a curse

Rama shot Viradha with seven swift arrows and then the brothers severed his arms. As he lay dying, he told them that he was once a Gandharva (magical being). "I recognize you, Rama. I know Sita and Lakshmana too. I was cursed and promised liberation if you killed me in battle. Cast me into a pit, so that I may return to the eternal realms. Then, seek out the sage Sharabhanga," he said.

Relieved, Rama embraced Sita and the three decided to meet the sage.

Sharabhanga's advice

As they neared Sharabhanga's hermitage, they saw the chariot of Indra, the king of gods leaving. When they asked the sage, he said, "Indra came here to take me to the realms of Brahma. I knew you were on your way and wished to see you." He told Rama, "I have attained many divine realms. If you wish you may have them."

Rama replied, "Revered sage, I shall accumulate realms for myself. For now, I seek direction from you. Where shall we go?"

Sharabhanga told Rama to meet the sage Suteekshna and then walked into the holy fire to give up his mortal form and ascend to heaven.

In the company of sages

Many sages met Rama while he was in the hermitage and reminded him of his duty as a protector, as the Rakshasas were hunting them.

CHARACTER PROFILE

AGASTYA

Of the stories associated with Agastya, perhaps the best known involves the Rakshasa brothers, Ilvala and Vatapi. Vatapi would turn into a ram and Ilvala would cook him, feeding him to Brahmanas. After the meal, Vatapi would emerge, killing the Brahmanas in the process. The gods asked Agastya for help and he consumed Vatapi completely, leaving no possibility for his exit.

Agastya is known to have caused the Vindhya mountains to stop growing. Along with his consort Lopamudra, he is also associated with a tradition of the worship of the supreme goddess known as Shrividya.

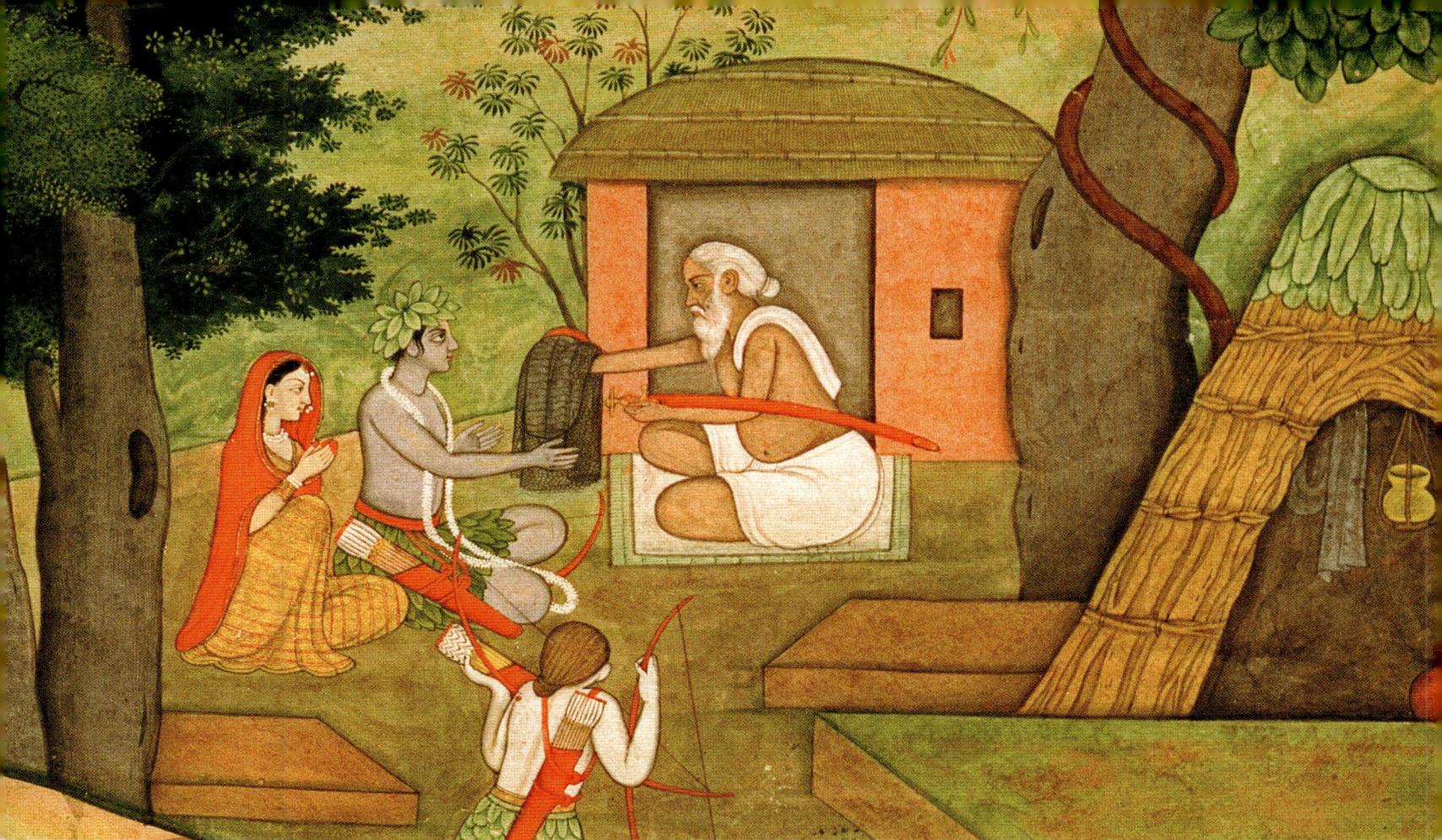

> "O Rama!... behold the bodies of the **sages with cleansed souls**... there are many of them, who have been **killed**... by **fierce Rakshasas**... **You** are the one who offers **refuge**."

SAGES LIVING IN THE DANDAKARANYA FOREST TO RAMA, *SARGA* (5), ARANYA KANDA

Rama said, "I am willing to be commanded by you. My service to you will make my time in the forest fruitful."

At Suteekshna's hermitage, the sage offered Rama hospitality and his home, but the prince hesitated. There were too many animals, he said. "I could get rid of them with my bow, but the violence may trouble your compassionate self."

The next morning, the three left and visited several hermitages, spending long periods of time at each of them. They eventually returned to Suteekshna and asked him about the sage Agastya. Pleased, Suteekshna gave them the directions to the great sage's hermitage.

Agastya's advice

Delighted to hear that Rama had arrived, Agastya invited the two princes and Sita to sit next to him. He completed the fire offering and offered them fruits, roots, and flowers.

He then brought out some weapons and said, "Rama, take these. This is Vishnu's divine bow, decorated in gold and diamonds. This is an arrow, which Brahma granted, and here are two quivers with an unending supply of arrows. And here is a gold-handled sword. Accept these as Indra, the bearer of the thunderbolt, accepted his weapon."

After Rama accepted the gifts, Agastya expressed his pleasure at seeing Lakshmana and Sita. He said, "Sita is worthy of all honour as she follows you in prosperity and in great calamity, wandering in the forest with you."

When the sage asked Rama to make his hermitage his home for the duration of his exile, the prince graciously refused. "I am truly blessed that you are satisfied with us. However, kindly direct us to a place where we may find water and fruits, so that we may build a hermitage."

The sage meditated on this request and then told them to go to Panchavati. This would be their new home for the remainder of the exile.

129

DHARMA IN RAISING ARMS

A Protector's Duty

"**O Sita**! I am capable of giving up my life, you, or Lakshmana, **but not abandoning a pledge** that I have given, especially one given to **Brahmanas**."

RAMA TO SITA, *SARGA* (9), ARANYA KANDA

Between the two main Sanskrit epics of ancient India, it is the *Mahabharata*, which, in popular imagination, is typically associated with the question of war and peace. However, the *Ramayana* has an interesting perspective on war as well. The question of violence and its motivations has an interesting context, since it focusses, not on rights for oneself, but the dharma of a warrior's duty of protection.

RAMA'S BATTLES

There are two parameters that encapsulate the idea of dharma vis-à-vis violence in the *Ramayana*. Firstly, there is almost no description of Rama ever fighting a war for political gain. For instance, in the two kingdoms, Kishkindha and Lanka, when engaged in battle, there is no sign that Rama coveted either of those for himself. Instead, he appointed his allies, Sugriva and Vibhishana, as rulers. Secondly, Rama doesn't seem to be fighting other warriors. His battles are mostly limited to Rakshasas, especially in response to aggression, towards him, his family, or forest-dwelling ascetics. The precedent for this is set when the sage Vishvamitra asks Dasharatha (See pp 42–43) to send Rama to battle Rakshasas, as they were disrupting his sacrifice.

Rama's perspective on political violence for limited gain is clarified in the Ayodhya Kanda. When Lakshmana is all set to take up arms against anyone who comes his way, Rama says, "Abandon this *kshatra* (warrior temperament." He later explains that temporal gain is inconsequential, and cares for dharma and honour over all things.

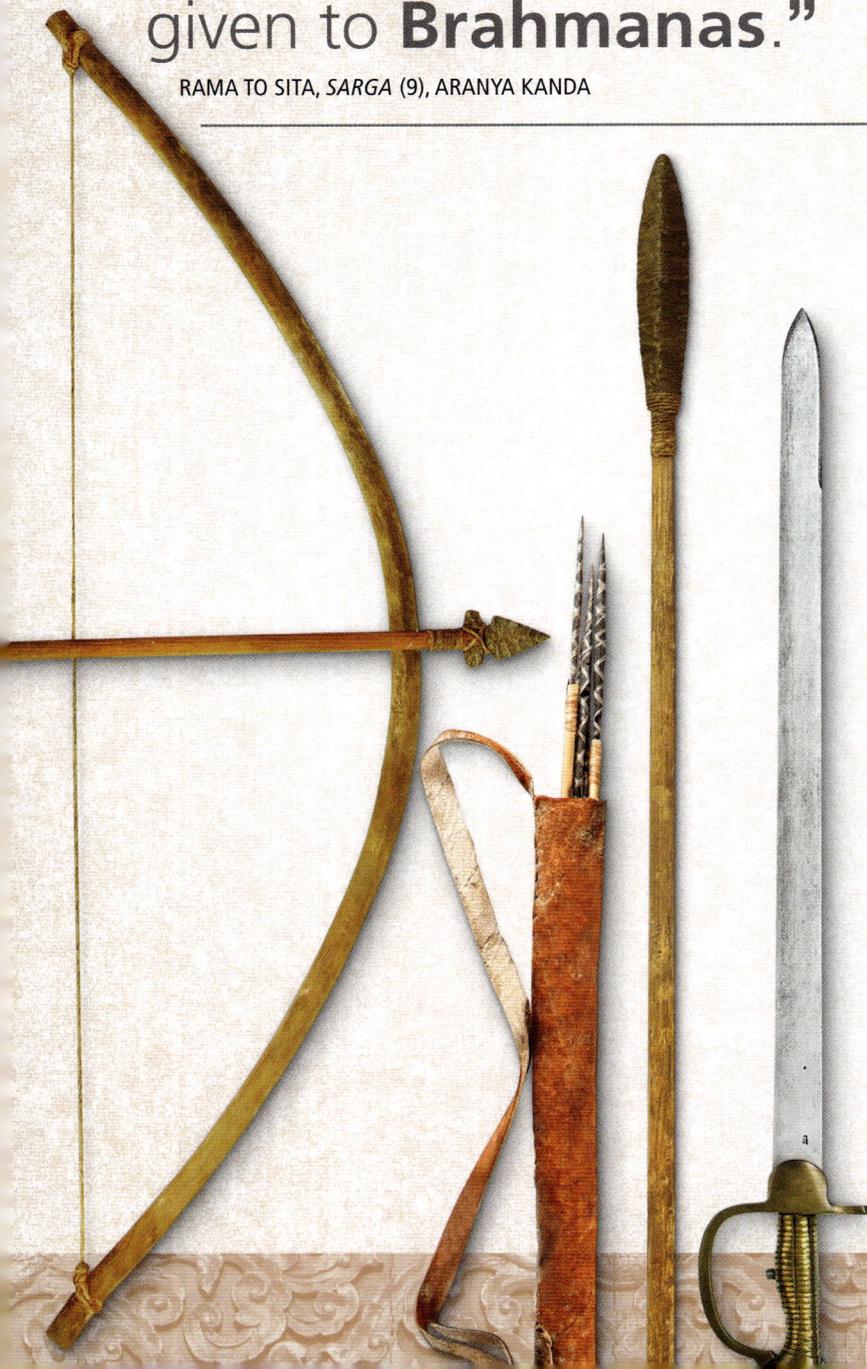

SITA'S DISCOURSE

This is the backdrop against which Sita addresses Rama after the sages ask for protection. She cautions him against the subtlest of faults, which may lead to sin. She outlines three faults – falsehood, attraction towards other women, and violence without enmity.

Convinced that he could never commit the first two, Sita warns him against the last, arguing that reliance on and addiction to weapons and violence will diminish ascetic merit. Seeing his resolve to protect the sages and destroy the Rakshasas, she grows distressed. She tells him the story of a sage whose ascetic practice Indra wished to disrupt. The god gave him a sword for safekeeping and he, intent on keeping his word, went everywhere with it. The sage began relishing brutality and fell into adharma.

Sita was averse to the idea of the death of those Rakshasas who have done him no harm. She remarks on the incongruence between Rama's life as an ascetic and his decision to bear arms. Rama may return to his life as a ruler on his return to Ayodhya, she says, and believes that the use of a bow for a heroic warrior living in the forest and whose self is restrained is for the protection of those in pain.

INDONESIAN DANCERS portray Rama (left) and Sita while performing the *Ramayana*

ANALYSIS

SURRENDER TO RAMA

The sages' requests to Rama may seem straightforward appeals for protection, but some have received more complex treatment. For 16th-century commentator Govindaraja, the protection the first set of sages seek refers to liberation (since protection is sought by the latter set at Sharabhanga's hermitage), and he reads the idea of surrender in their speech.

Similarly, Suteekshna's meeting with Rama is an emotionally charged one, between a lord and his devotee in the *Adhyatma Ramayana* and *Ramcharitmanas*. A verse from his prayer to Rama reads, "*People may know your form to be the illumination of densified consciousness, devoid of all qualifications of space and time; I desire nothing more than that the form that has come before me perceptibly today may appear in my heart.*"

RAMA'S DHARMA

To this Rama responded, "What shall I say, queen? It was said by yourself – the bow is borne by warriors so that there be no cry of pain." Rama's argument was that the sages in the forest came to him of their own accord and sought him as refuge. Living in the forest for ascetic practice, he said, they were killed and tormented by Rakshasas. Even though they had the power to curse the Rakshasas, they did not, as it would have been detrimental to their practice. Rama argued that they were left completely defenceless and since he had given them his word, it was impossible for him to go back on it.

His adherence to this line of reasoning is manifested in the events that take place in the *Ramayana*. For instance, despite the encounter with Ravana's sister, Shurpanakha, when he battles Khara and his army, he lays emphasis on their crimes against the sages. Most of his battles until Sita's abduction are focussed on the protection of the sages. Even if Sita had not been abducted, it isn't clear whether a direct confrontation between Rama and Ravana could have been avoided for very long. Vishvamitra had already indicated in the Bala Kanda (See pp 42–43) that Ravana had instigated the atrocities against the sages. Rama's incarnation was for that purpose. For those devotees who see his incarnation as an act of grace, the bearing of arms is closely associated with his love for them.

ALTERNATIVE ACCOUNT

PARALLEL IN *MAHABHARATA*

In the *Mahabharata*, Yudhishthira and Draupadi, the exiled king and queen of Indraprastha, have a parallel, but different, conversation. She remarks on the cruelty of Yudhishthira's cousins, the Kauravas, and emphasizes that there is a time for forgiveness and a time for revenge and exercise of authority. The two then enter into a complex debate about dharma.

A MURAL FROM AN ISKCON TEMPLE in Pune depicts the disrobing of Draupadi by the Kauravas

Home in Panchavati

Rama, Lakshmana, and Sita followed Agastya's advice and walked towards the forests of Panchavati. Along the way they met an old friend of Dasharatha, a large bird who promised to protect Sita.

THE DIVINE BIRD
Jatayu is depicted here as a puppet figure in Wayang kulit, a form of puppet-shadow play from Java, Indonesia.

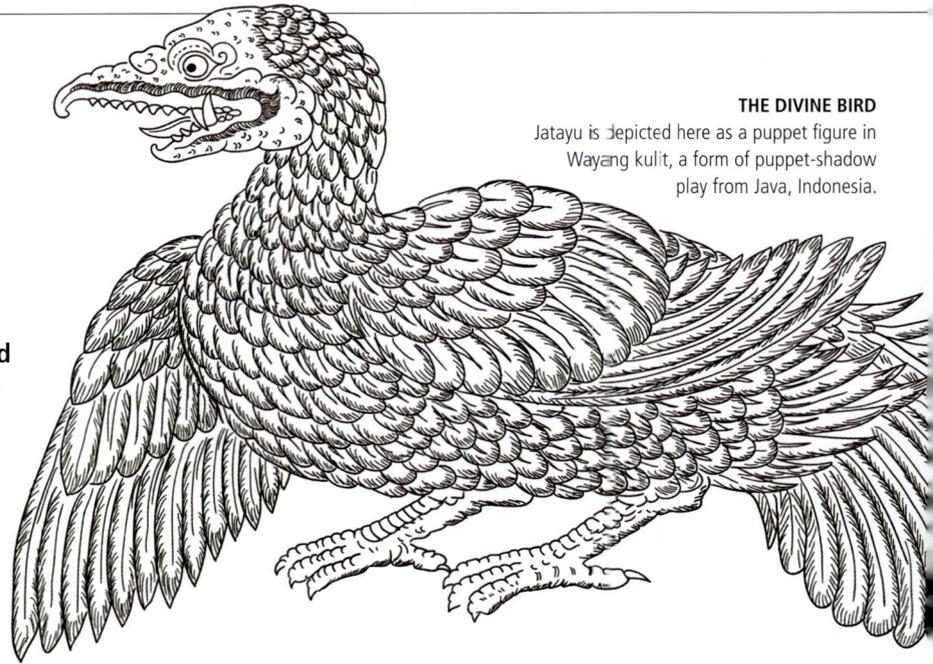

The massive vulture lay there, on their path to Panchavati. Rama, Lakshmana, and Sita wondered whether it was a Rakshasa in disguise. Rama walked up to him and asked him who he was.

The vulture spoke in a sweet voice, "Child, I am a friend of your father's." The three honoured him with great reverence and then asked him to introduce himself. Jatayu narrated his descent and said, "If you like, Rama, I shall assist you in your stay. When Lakshmana and you are away, I shall guard Sita myself." On hearing this, Rama embraced Jatayu and accepted his offer.

Building a home

When they arrived, Rama chose a spot surrounded by trees in bloom, near a lake full of lotuses, and close to the River Godavari. He requested Lakshmana to build a hermitage and he did so, quickly. The younger prince then bathed in the river, brought flowers, and made a ritual offering before showing Rama the cottage. Delighted, he embraced his younger brother and said with great affection, "What a wondrous place you have built, you who understands my very intent and not merely my words. It is in your affectionate care that I continue to feel the living presence of our father."

Remembering Bharata

The three spent their time peacefully in the hermitage and soon autumn turned to

"Having **performed** his ablutions, Rama was **radiant**. With Lakshmana, Sita... Having performed her **ablutions**, the princess was like the **daughter** of the mountain, with the illustrious Rudra Isha and Nandi."

RAMA, SITA, AND LAKSHMANA IN THE FOREST, *SARGA* (15), ARANYA KANDA

JATAYU'S FAMILY TREE

Jatayu traced his lineage to the sage Kashyapa who married eight daughters of Prajapati Daksha. One of them, Tamra did not agree to have sons and instead gave birth to five daughters, Kraunchi, Bhasi, Shyeni, Dhritarashtri and Shuki.

Kraunchi gave birth to owls, Bhasi to vultures, and Shyeni to eagles. Dhritarashtri gave birth to geese, aquatic birds, and the Chakravakas. Shuki gave birth to Nata and Nata's daughter was Vinata who was the mother of Garuda, the mount of Lord Vishnu, the Preserver of the universe, and Aruna, the sun god's charioteer. Jatayu and his brother Sampati descended from Aruna.

winter. One evening, Lakshmana told Rama, as they walked towards the river, "It is the time of the year that you are so fond of. The waters are freezing and fire becomes dear. The earth is rich with grain and cities are prosperous. Bharata lives the life of an ascetic for the sake of his devotion to you. He renounces all manner of honour and the kingdom, and sleeps on the cold ground like ascetics. Brought up in comfort, how does that tender prince, afflicted by this terrible cold, bathe in the River Sarayu before sunrise? Heaven has been won by Bharata, who follows you and lives as an ascetic in a palace in the city. They say people follow their mothers, but Bharata has reversed this."

"Sometimes, I wonder, how is it that a woman whose husband was a man like Dasharatha and whose son is as virtuous as Bharata, is as cruel as Kaikeyi?" Delighted to hear of Bharata, Rama cut Lakshmana off when he started speaking ill of Kaikeyi, "Go back to speaking of Bharata. Even my mind, fixed firmly in life in the forest, is shaken by my affection for Bharata. I remember his words, sweet like nectar, entering one's heart. When shall I be together with Bharata and Shatrughna?"

Thinking of his separation from Bharata, Rama bathed in the waters of the Godavari, even as Lakshmana and Sita worshipped the gods.

PRESENT-DAY PANCHAVATI
This photograph is of the Panchavati ghat at the Godavari river bank in Nashik, Maharashtra.

Shurpanakha Arrives

Rama, Lakshmana, and Sita were happy in Panchavati. Every morning, the three would go to the banks of the sacred Godavari and return in time for Rama to perform his morning ablutions. Until one day, a chance encounter with a Rakshasi changed the fate of the two princes and Sita.

Rama sat outside the hut, speaking to Sita and Lakshmana. At that moment, Shurpanakha, the sister of the Rakshasa king Ravana, wandered into the area. As she roamed about, her eyes fell on Rama, whose brilliance was equal to that of a god.

Shurpanakha falls in love

She saw a man whose chest resembled that of a mighty lion's. He had large arms, lotus eyes, and a certain gentleness about him. He bore all the marks of a king and Shurpanakha became captivated.

She walked up to him and said, "You bear matted locks and ascetic garb. Yet, your wife accompanies you, and you carry a bow and arrows. How is it that you are in this region frequented by Rakshasas? What do you seek in coming here?"

Rama replied, "I am Rama, the son of Dasharatha, the mighty ruler of Ayodhya. It is at his command, affected by my mother that I am currently living in the forest in pursuit of dharma. My brother, Lakshmana and my wife, Sita, accompany me. Now tell me, who are you?"

Shurpanakha's proposal

Overcome by desire, the Rakshasi replied, "I am Shurpanakha, the sister of the mighty Rakshasa king Ravana, whom you might have heard of. The extremely powerful Kumbhakarna, who sleeps all the time, is also my brother. So are Vibhishana, Khara, and Dushana. O Rama! When I first saw you, I was engulfed by desire, and decided that you will be my husband. What will you do with Sita? She is ugly and unfit to be your wife. I am suitable because of my beauty. I will kill this puny human woman and your brother. Then we shall sport on the summits of mountains and in wondrous forests."

Rama smiled and replied gently, "I am married, and I love my wife deeply. Women such as you cannot bear to be co-wives, surely." He pointed

> "As soon as I **first saw you** and **approached you**, I was **overcome by the thought** that you should be my **husband**."

SHURPANAKHA TO RAMA, *SARGA* (16), ARANYA KANDA

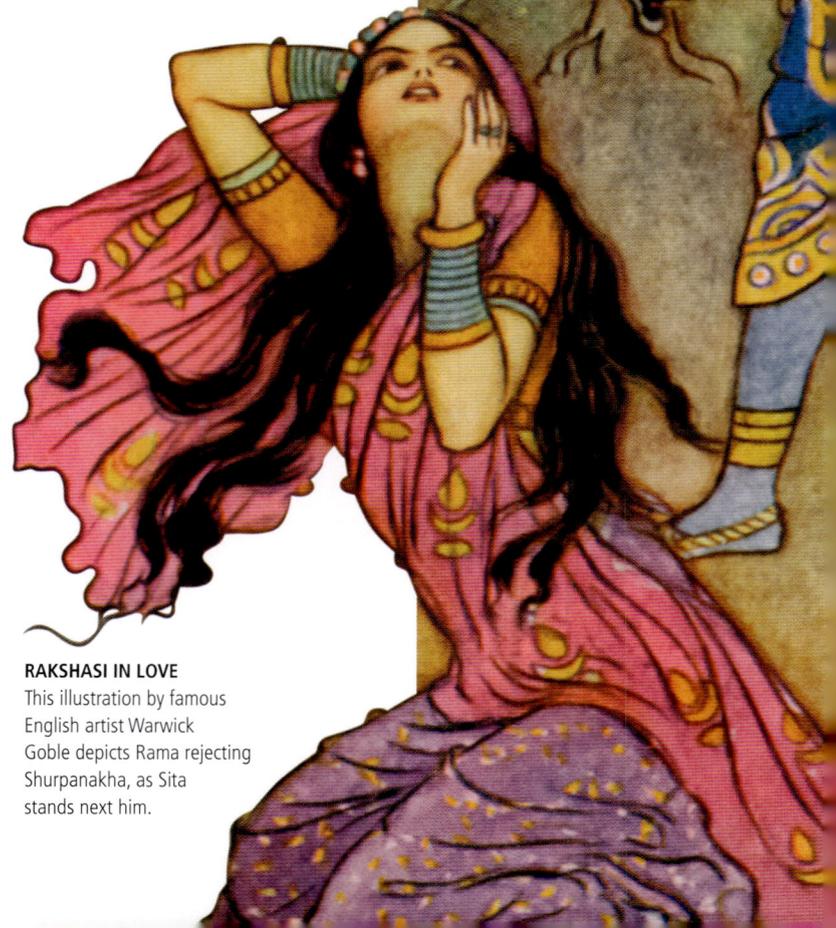

RAKSHASI IN LOVE
This illustration by famous English artist Warwick Goble depicts Rama rejecting Shurpanakha, as Sita stands next him.

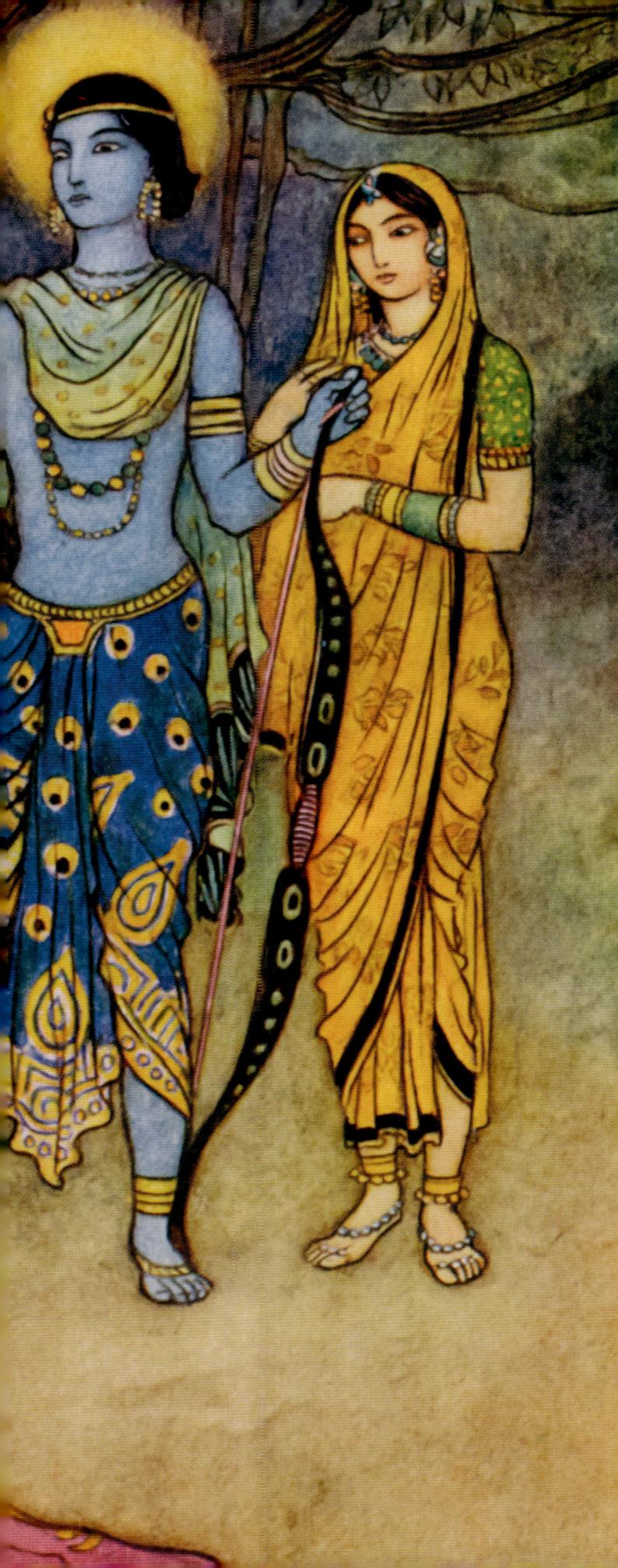

at his brother and said, "My brother is young and handsome, and without a wife. He would be a better husband for you."

Lakshmana's response
Abandoning Rama, Shurpanakha turned to Lakshmana, "You possess such beauty! I am certainly a suitable wife for you. Come, you shall wander about these forests delighting with me."

Lakshmana smiled as well. He said, "Why would you want to be the wife of a servant? I am dependent on my brother. You are fit to be his younger wife. Wouldn't he abandon his older wife when he sees you? Who would direct his affections towards a human woman and reject you?"

ANALYSIS

RAMA AND LAKSHMANA'S "FALSEHOOD"

This episode from the *Ramayana* has long troubled readers. Both Rama and Lakshmana appear to indulge in what appears to be falsehood. However, a defining characteristic of Rama is his utter honesty. Several strategies have been devised to overcome this problem. The most obvious, employed by some commentators, is that Rama speaks in jest and because statements in jest are not supposed to have truth-value, the question of falsehood does not arise. However, others raise the issue that Rama does not lie, even in jest.

Further, in some versions, there is a verse before Rama's first address to Shurpanakha which reads: "Falsehood is never agreeable to Rama, particularly in the hermitage and in the presence of a woman". Both Rama and Lakshmana's speeches are then reinterpreted. Rama's statement that Lakshmana is without a wife is understood to mean that he is unaccompanied by a wife. Lakshmana's statement where he seems to list Sita's supposed inferior qualities contain puns such that her "negative" attributes can be read as positive and vice versa for Shurpanakha.

IN MANY OF THE RE-ENACTMENTS OF RAMA'S STORY, Shurpanakha is often depicted as ugly and malformed, in stark contrast to Sita. In this scene from a performance in Amritsar, Punjab, the Rakshasi can be seen on the extreme left.

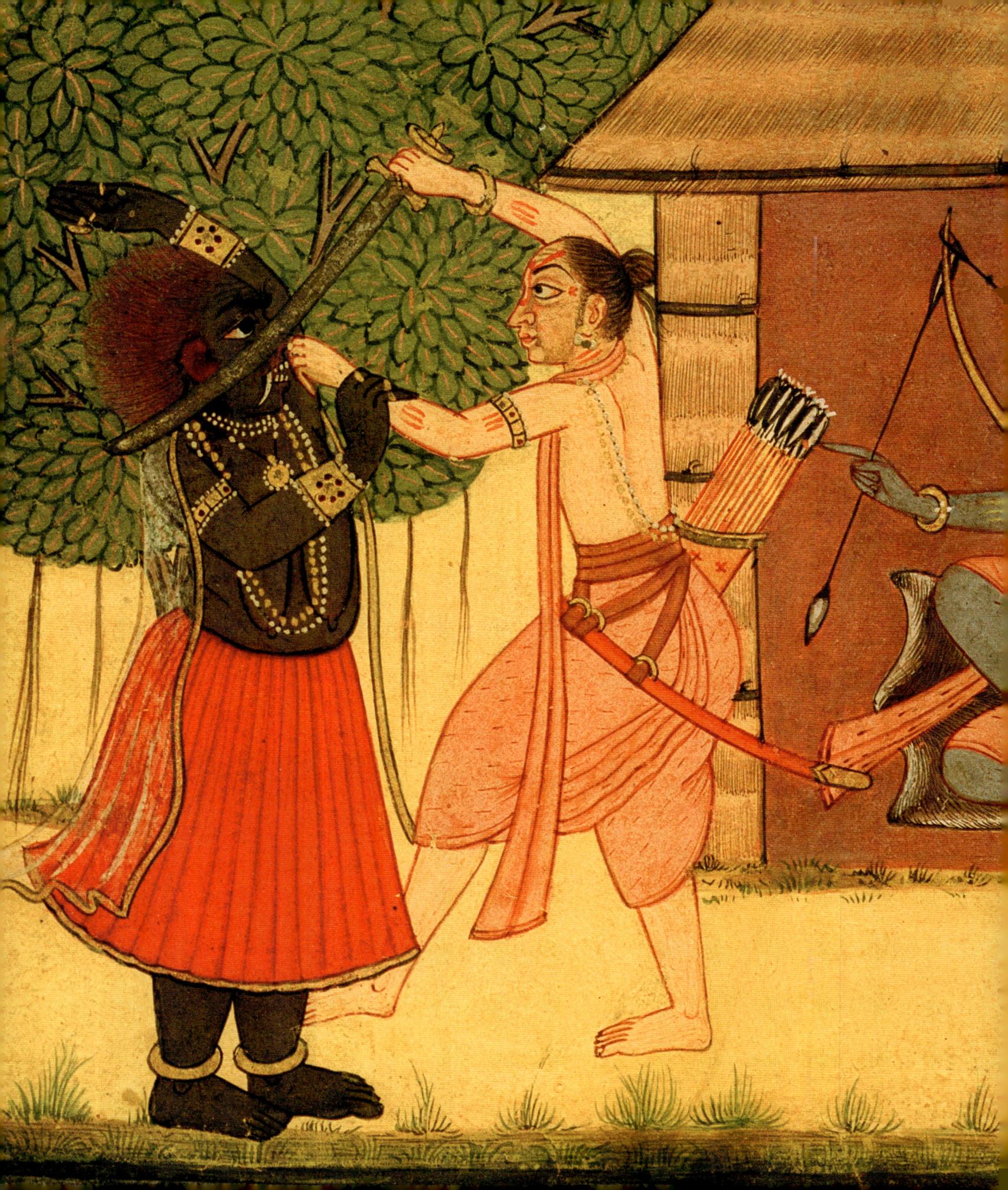

Shurpanakha **Disfigured**

Lakshmana's words to Shurpanakha were meant in jest, but the Rakshasi could not fathom the real sentiments. When she flew into a rage and attacked Sita, Lakshmana struck back.

Shurpanakha took Lakshmana's words seriously. She saw Rama with Sita and said, "You repose in seeming delight with your old and ugly wife, and pay no attention to me. I shall eat her as you watch."

So saying, she descended upon Sita like the very noose of death. Rama, finally angered, caught hold of her. He turned to Lakshmana and said, "One ought not to joke about with such evil, uncivilized ones as her. Look at poor Sita who is barely alive. You should deform this Rakshasi in some way."

Commanded by his elder brother, Lakshmana took out his sword and cut off Shurpanakha's ears and nose. Bleeding, she roared and screamed in pain and rushed away from the hermitage and into the forest.

She went to her mighty cousin Khara, who lived in Janasthana. Seeing her in such a state, Khara grew furious and asked, "Who did this to you? I can't think of any man powerful enough to challenge me. Whose blood does the earth seek to drink that they would hurt you so?"

Her eyes filled with tears as she said, "Two young sons of Dasharatha live in the forest, eating fruits and roots. They are handsome and powerful and accompanied by a beautiful woman. They have reduced me to such a state. I wish for them to die in battle and for me to drink their blood."

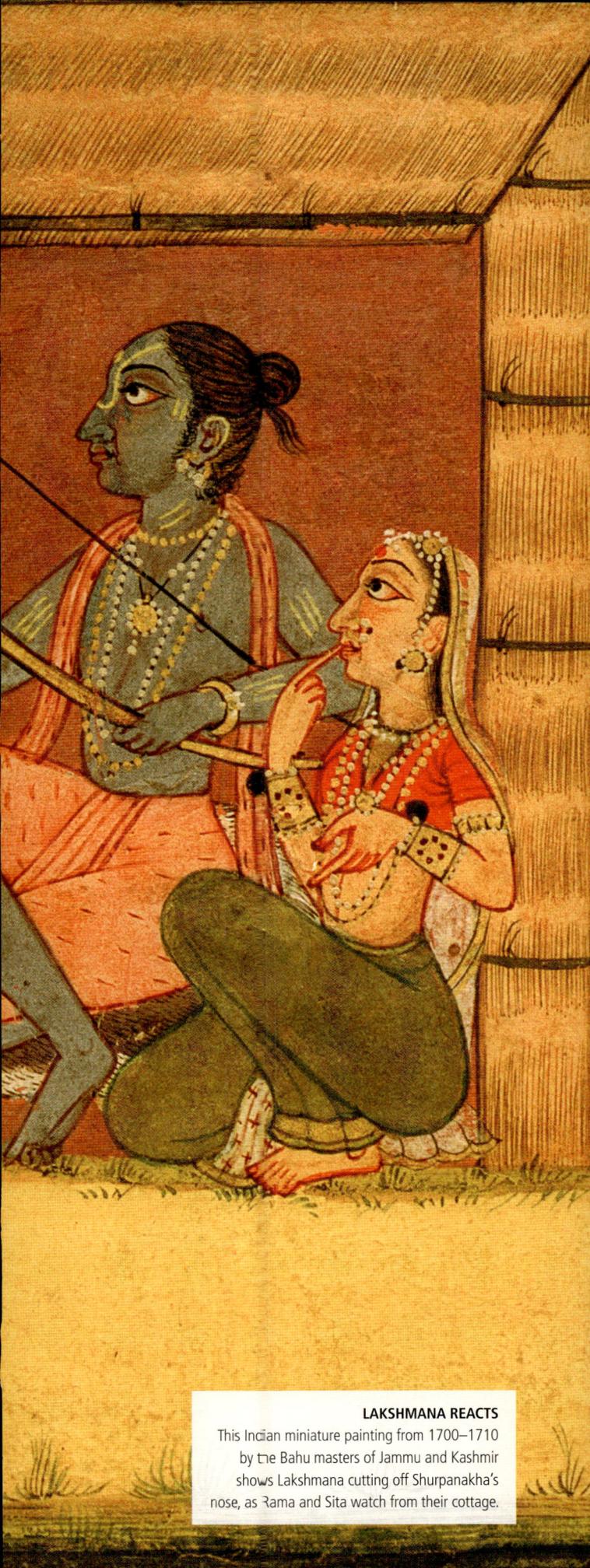

LAKSHMANA REACTS
This Indian miniature painting from 1700–1710 by the Bahu masters of Jammu and Kashmir shows Lakshmana cutting off Shurpanakha's nose, as Rama and Sita watch from their cottage.

> "**Extremely angry**, she then **dashed** towards the **deer-eyed one**, like a giant meteor towards **Rohini**."

SHURPANAKHA'S ATTACK ON SITA, *SARGA* (17), ARANYA KANDA

RAVANA'S SISTER

Shurpanakha

"My name is **Shurpanakha**...
I roam around alone in this forest
and **create fear** in all beings."

SHURPANAKHA TO RAMA, *SARGA* (16), ARANYA KANDA

Shurpanakha is a character that has always invited a fair amount of attention. Ravana's sister, she is the third of four children of Vishrava (the grandson of Brahma, the Creator of the universe) and Kaikasi (Rakshasa Sumali's daughter).

Ravana arranges her marriage to the Rakshasa Vidyujjihva, who is killed in the heat of battle by none other than Ravana himself. Ravana returns to Lanka and finds Shurpanakha grieving.

Realizing what has happened, he promises her all manner of riches and encourages her to go to the Dandakaranya forest where

their maternal cousin, Khara, lives with his 14,000-strong army of Rakshasas.

Encounter with Rama
In Valmiki's version of the *Ramayana*, the first time her path crosses Rama's is when he has settled in Panchavati. Herself single, she finds herself deeply attracted to Rama, who is quick to reject her advances, as he is happily married to Sita, whom he loves.

What follows (See pp 136–37) has been the subject of much controversy, but essentially, each brother, Rama and Lakshmana, turns her to the other, with no real intention of marrying her. Shurpanakha lunges

towards Sita, and Lakshmana disfigures her.

An exploration
Many scholars have explored this episode and its retellings to understand its significance for the plot and attitudes towards female sexuality. American scholar of South Asian religions Kathleen M Erndl in her essay "The Mutilation of Shurpanakha" offers an

ALTERNATIVE ACCOUNT

SHURPANAKHA AND SITA

Author and translator Velcheru Narayana Rao in his essay "A Ramayana of Their Own", records the engagement with Shurpanakha's story in Telugu songs. Here, Shurpanakha, to avenge her brother Ravana's death, is instrumental in Sita's second exile. Disguised as a female hermit, she requests Sita to paint a picture of Ravana. Sita reluctantly paints Ravana's big toe, as that's all she ever saw.

Shurpanakha completes the picture and asks Brahma, the Creator, to bring it to life. She then leaves it with Sita who, unable to destroy it, hides it under her mattress. Rama discovers it and believing that she is in love with another, banishes her.

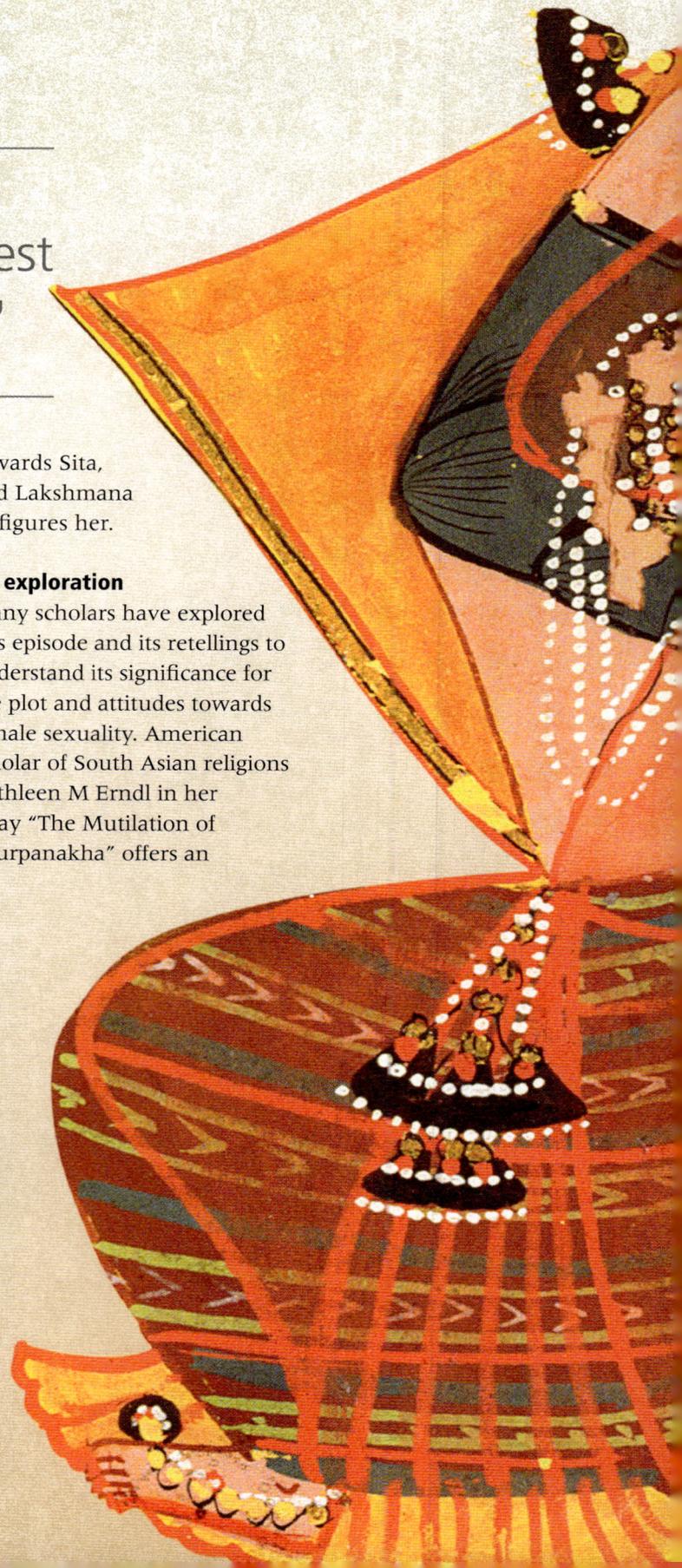

exploration of various readings of this episode in Sanskrit, Tamil, and Hindi.

She argues, for example, that Shurpanakha is treated more sympathetically in medieval Tamil poet Kamba's *Ramayana* where Rama's actions towards her are more tender. Here, though Shurpanakha employs subterfuge, for Rama, her desire is more appealing than her evil traits that are not described in detail. This is most evident when Shurpanakha tries to enter Sita's hut, not to kill her, but to "spirit her away".

While Shurpanakha's interaction with Rama often receives most attention, her conversations with Khara, and, more so, Ravana, are equally interesting. When she goes to Ravana, for instance, she delivers a discourse on kingly duty – quite similar to the ones he receives after his decision to abduct Sita.

In Sanskrit poetry

Although Shurpanakha features almost invariably in all retellings of Rama's story, unlike, say, Maricha, she does not necessarily receive a different treatment.

However, the Sanskrit poetic tradition is one place where such secondary characters get a rather curious treatment. Different genres within this tradition allow for different kinds of engagement.

Sanskrit drama, for instance, allows authors to give Shurpanakha a life outside of her moment of infatuation with Rama. She becomes important as an instigator, often along with Malyavanta, her great-uncle. It seems, at least partly, to invoke the interest in politics that may be extrapolated out of her discourse to Ravana in Valmiki's *Ramayana*.

One of the earliest such adaptations was by 8th-century Sanskrit playwright Bhavabhuti in his play *Mahaviracharita*.

Here, after Rama's marriage, Shurpanakha and Malyavanta appear repeatedly to discuss issues of policy and future plans, considering in detail how specific people are likely to react. She also takes on Manthara's form in order to set in motion the events that lead to Rama's exile. Interestingly, her actual intervention in Valmiki's *Ramayana* goes offstage. Instead, it is mentioned in a conversation between the divine birds, Jatayu and Sampati, which serves as a device to narrate the plot until Sita's abduction.

The *Balaramayana* builds on some of these themes, but here she also lies to Ravana about the reason for her disfiguration. Author and Sanskrit scholar Lawrence J McCrea, in his essay "The Poetics of Perspective in Rajasekhara's Young Ramayana", notes that she tells her brother it was inflicted when she was trying to acquire Sita for Ravana.

Another way that the poetic tradition interprets epic episodes has been demonstrated by Israeli scholar Yigal Bronner in "Extreme Poetry: The South Asian Movement of Simultaneous Narration". In discussing a genre where the stories of the *Mahabharata* and *Ramayana* are told in the same poem, he draws attention to how the particular episodes demonstrate the author's interpretation of them.

Bronner cites two different readings of the episode with Shurpanakha, drawn from the *Mahabharata*. One compares it with the king Kichaka, who is killed for harassing the Pandava queen Draupadi. The other compares it to the Pandava, Arjuna's, rejection of the celestial maiden, Urvashi, who in turn curses him.

SHURPANAKHA'S PAIN
This artwork from Malwa, Rajasthan, shows Shurpanakha with a bloodied nose, after Lakshmana cuts off her nose and ears.

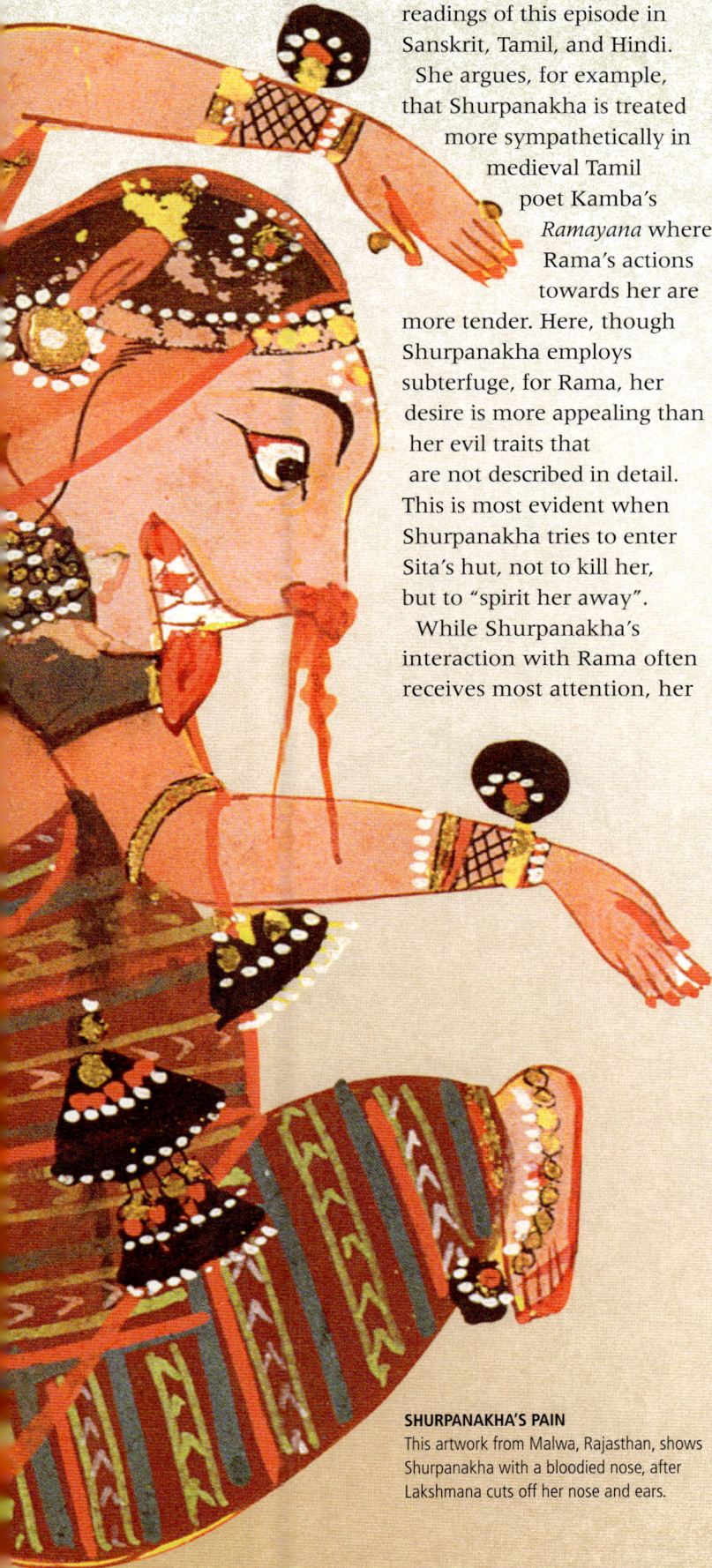

Battle with **Khara**

Furious, Khara raged against Rama and Lakshmana who had dared to disfigure his sister, Shurpanakha. He sent forth a fierce army of Rakshasas to kill the two exiled human princes. A great battle was on the horizon.

Khara sent 14 fierce Rakshasas to counter Rama and avenge his sister. Seeing them approach, Rama asked Lakshmana to stay with Sita, picked up his bow, and walked towards the Rakshasas.

"Why are you here?" he asked them. "Why do you trouble us? We are forest-dwellers, living off fruit and roots. If you care to live, go away, for I am here at the command of the sages to destroy evil ones like you."

The angry Rakshasas ignored Rama's warning and attacked with their spears. In turn, Rama killed each of them with 14 arrows that blazed like the sun.

A sister's plea

Shurpanakha, who had gone with them, saw the Rakshasas dead and ran to her brother, weeping. Nonplussed, Khara said, "Why are you shedding tears now, sister? I have sent 14 invincible warriors to fulfil your wishes. They are bound by my commands. Do not weep like one who is unprotected when I am here to protect you. Abandon this weakness."

Shurpanakha replied, "Rama took but a moment to kill your valiant warriors. I am terrified, Khara. Won't you protect me? If you do not kill Rama, I will die before your eyes. I do not think you can defeat him. There is no truth to your valour, it is mere superimposition. Flee Janasthana. Rama will destroy you – he is fierce and fiery, as is his brother, who disfigured me."

At these words, Khara boiled with anger. He promised to kill Rama and Lakshmana. "I don't count Rama among

> "There were **fourteen thousand Rakshasas** who were the performers of horrible deeds. **Rama,** a human who was on foot, **slew all of them** alone."

RAMA'S BATTLE WITH KHARA, *SARGA* (25), ARANYA KANDA

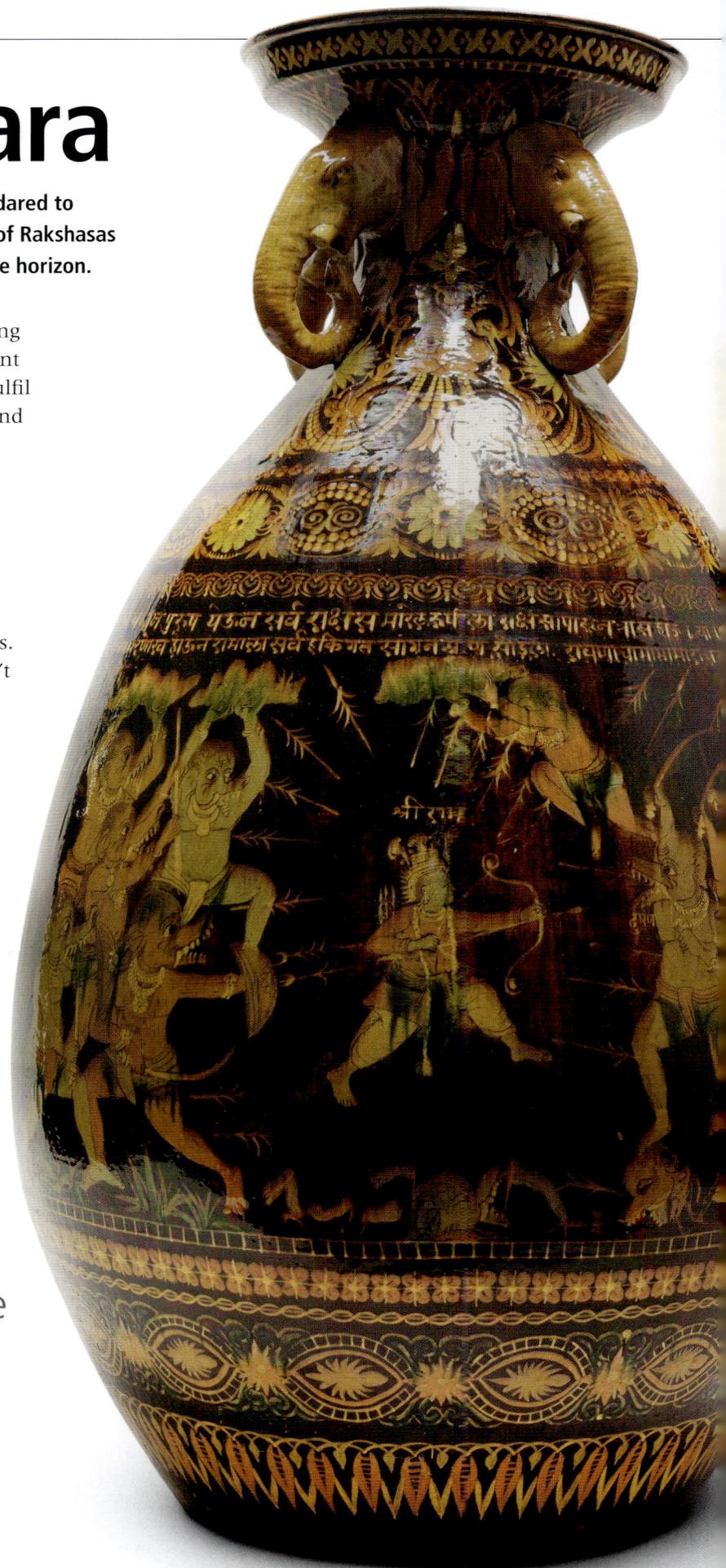

A DREADFUL BATTLE
Late 19th-century earthenware vases depict a series of events from the *Ramayana*, including Rama's battle with Khara, Dushana, and Trishira.

warriors," he told her. "Wipe your tears and abandon this despondent frame of mind." So saying, he set off with an army of 14,000 warriors and his trusted lieutenants Dushana and Trishira. Seeing him, many other powerful Rakshasas joined the army.

A fierce battle ensues

They marched towards the hermitage and terrifying omens appeared in the sky, as a black cloud rained blood, and flesh-eating creatures gathered around Janasthana.

Rama saw the army, turned to Lakshmana and asked him to take refuge in a mountain cave with Sita. Then, Rama donned armour that dazzled like a great fire in darkness. Sages and gods gathered to view the great battle. Rama felt rage build within him and, seeing his wrathful appearance, the celestial gods began to worry.

Rama drew his bow and released a 100,000 arrows and decimated the huge army. Alone and on foot, he made quick work of the powerful warriors, Dushana and Trishira, as well. Finally, Khara came face to face with Rama. He released several fierce arrows at Rama who responded with arrows of his own. Rama was not angered by Khara's attack, much like a lion who does not pay heed to a petty animal.

He destroyed Khara's chariot and left him standing with nothing, but his mace in his hand. He addressed the Rakshasa, first in gentle tones, but soon his words became as sharp as an axe. "A cruel person who torments other beings does not live long, even though he may be the lord of the three worlds. You have killed honourable ascetics who lived in the forest. The ones you have killed will witness your destruction."

Furious, Khara spoke, "I do not understand your pride at having killed petty Rakshasas. Now, I shall kill you." So saying, he flung his mace at Rama, who destroyed it swiftly. Khara grabbed a large tree and threw it at the prince, who countered it with ease.

Then, he shot an arrow that struck Khara in the chest and killed him. The gods rejoiced at Rama's victory and flowers rained from the sky.

ANALYSIS

ILLUSORY POWERS

In some narrations of Khara's defeat, it is said that the gods got worried when they saw Rama surrounded by such a large enemy army. However, Rama, the supreme lord who controlled all illusion and appearance, caused the entire army to see one another as Rama himself. Running towards each other, calling Rama's name in anger, they ended up killing each other. But, they attained liberation because they took Rama's name at the end of their lives.

The **Ruler** of **Lanka**

Shurpanakha saw the ease with which Rama defeated and killed Khara and felt fear settle in her bones. She realized that only Ravana, the 10-headed king of Lanka, could help her. So, she rushed to her elder brother to tell him what had transpired.

Ravana, the one who made the worlds wail, sat on his throne, surrounded by his ministers and counsellors. Shurpanakha walked up to her cruel brother and spoke, her words harsh, chastising him for being lax in his duty as the king.

"You are drowning in pleasure. You do as you like and are impetuous. A great fear descends upon you and your kingdom, but you sit there, unaware of what you should know. Kings who do not take care of their subjects and kingdom are quickly dislodged," she thundered.

A warning to Ravana

"Do you know that your kin in Janasthana have been vanquished?" she asked and then told Ravana about Rama and how he killed 14,000 Rakshasas, Khara, and Dushana, all by himself. She said, "You are deluded, Ravana, that you do not see what is happening. The sages and seers who live there are now fearless and perform their observances with no obstructions.

"Ravana, beware, for people do not seek a harsh and miserly king who is deluded, arrogant, and deceitful. If one does not fear what ought to be feared, one will not remain in control of the kingdom for too long," she said. She told him that a stable king is one who is all-seeing and has restrained his senses. "You lack these qualities, for you are not even aware of the massacre of your own Rakshasas," she raged.

Who is Rama?

Hearing his faults listed in this way, Ravana grew angry. He roared, "Who is this Rama that you speak of? What valour and strength does he possess? Why has he entered this terrible forest? What weapons did he use to kill Khara, Dushana, and Trishira?"

Shurpanakha told him of Rama, son of Dasharatha, who had large arms and wore an ascetic's garb. "He is as

> "He was **seated on** a supreme and **golden throne** that was **like the sun**… like **Death with a gaping mouth**… his **limbs** had been **struck** by the **weapons of the gods.** "
>
> A DESCRIPTION OF RAVANA, *SARGA* (30), ARANYA KANDA

ALTERNATIVE ACCOUNT

RAVANA LEARNS OF RAMA

In some recensions of Valmiki's *Ramayana*, a Rakshasa named Akampana informs Ravana about the destruction of the army in Janasthana. Ravana asks him who brought about such destruction and is told that it was Dasharatha's son, Rama. He asks, "Has he been accompanied by any army of gods?" Akampana then informs him that Rama stood alone in battle.

While Ravana is often portrayed as responding either in anger or out of desire for Sita, in other versions he decides to pursue a conflict with Rama because of his desire to die at his hands. He reasons that a warrior as mighty as Rama could hardly be a regular human, and death at the hands of such a god would certainly give him liberation.

A SISTER'S COMPLAINT
This painting from 17–18th century, in opaque watercolour and gold on paper, shows Shurpanakha in Ravana's court, complaining about Rama and asking her brother to avenge her dishonour.

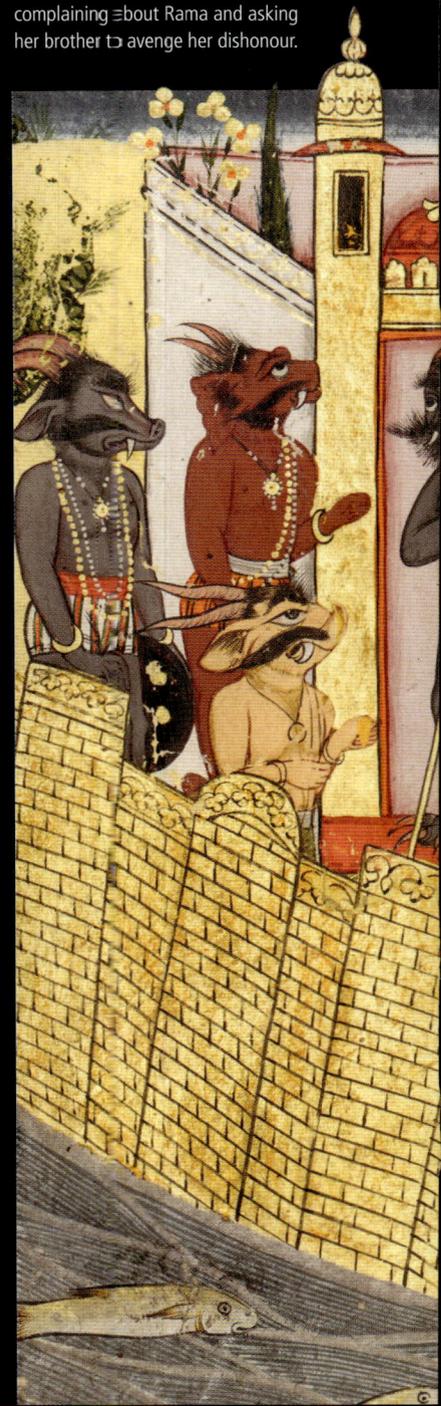

beautiful as Kama, the love god, and carries a bow that is equal to Indra's, the king of gods. I do not remember seeing him draw his bow or release an arrow, but I saw the dead Rakshasas before my eyes," she said.

She told him that Khara and Dushana were killed in less than an hour and that she managed to escape. She told him of his equally valorous brother, Lakshmana, "He is completely devoted to Rama, and is almost like his external breath."

The glorious Sita

Shurpanakha then spoke of Rama's beautiful wife, Sita. "I haven't seen a goddess or semi-divine woman of any kind whom I may compare her to. Ravana, he who has Sita as his wife, whom she embraces in joy – that person's fortune surpasses that of Indra," she said, looked at her brother, and added, "She is an appropriate wife for you, as you are a suitable husband for her. When you see her, I have no doubt you will be pierced by love's arrow. Kill Rama and Lakshmana with your fierce arrows and you will be able to enjoy Sita, when her husband is dead."

With this advice, Shurpanakha spoke the words that set Ravana thinking. "You know how Rama killed the Rakshasas. You know how he slayed Khara and Dushana. Arise now, and do what must be done," she said.

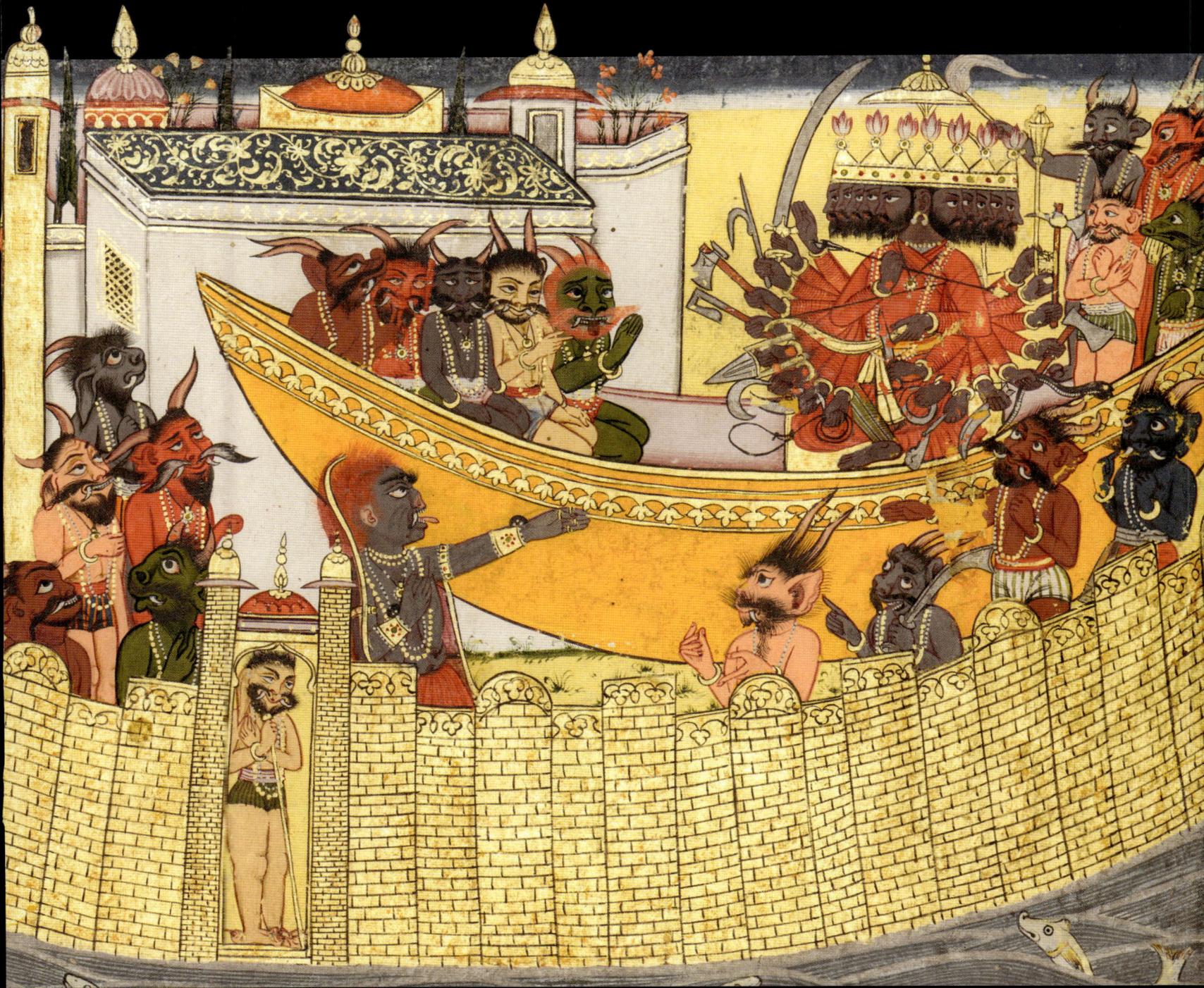

THE KING OF RAKSHASAS
A differently abled actor portrays the formidable Ravana in a modern-day interpretation of the *Ramayana,* in Bengaluru, Karnataka. The Rakshasa king is considered a symbol of evil and greed even today.

Maricha's **Advice**

Fuelled by Shurpanakha's words, Ravana thought long and hard, weighing the pros and cons, and soon a plan formed in his mind. He instructed the charioteer to prepare his chariot and left Lanka.

Ravana sat on his chariot that blazed like a cloud, surrounded by lightning, shining against the darkness. Crossing the ocean, he arrived at a hermitage ensconced in solitude in the forest.

This is where Maricha, the son of Tataka (See pp 46–47) lived, with all the restraint expected of an ascetic.

After Ravana and Maricha exchanged appropriate greetings, the king of Lanka said, "I am despondent and you are my refuge." He spoke of Khara's death and Shurpanakha. "There were 14,000 Rakshasas that wandered there, obstructing the activities of sages. Rama killed them all. Rejected and exiled by his father, this wicked human has abandoned dharma, harmed creatures, and disfigured my sister," he said.

Ravana's devious plan

"Rama's glorious wife, Sita, is in Janasthana too. With you by my side, I will bring her away," the king told Maricha. "Stand by my side. I do not fear the gods, and you are unparalleled in your valour." Ravana asked Maricha to take on the form of a golden deer, speckled with silver, and appear before Rama's hermitage. "I am certain that Sita will be attracted to your skin and ask Rama and Lakshmana to capture you. When they leave to fulfil her demand, I shall spirit her away," he said.

A warning

Maricha's mouth dried in fear when he heard Rama's name. Terrified, he warned Ravana not to anger Rama. He said, "It is easy to find people who will tell you what you want to hear. Far rarer is the counsellor who will tell you of harsh realities for your ultimate good. Rama is valorous and unsurpassed in virtues, and an equal to Indra, the king of all gods. The only path to the prosperity of the Rakshasas is one that does not cross an angered Rama.

RAVANA'S ROYAL CARRIAGE
This 19th-century gouache painting shows Ravana on his flying chariot as he prepares to meet Maricha.

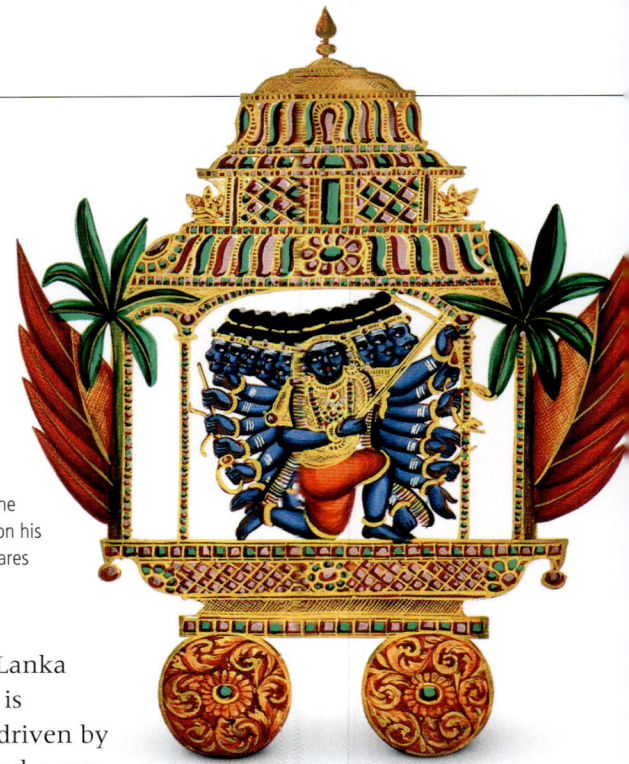

Do not destroy Lanka because its king is impetuous and driven by desire." Rama had never been rejected by his father, Maricha told Ravana.

"His conduct is incorruptible. He is engaged in the welfare of all beings. Do not even think of coming close to the fire that is Rama. Sita, who is dearer to him than life itself, is like a fierce flame," he said.

Encounters with Rama

Maricha recounted a time when he wandered the earth, drunk with power and tormented sages, until he met Rama in battle.

At that time, Rama was still a young prince and met him in battle, on the instructions of sage Vishvamitra (See pp 46–47). The prince shot him with an arrow that flung him deep into the ocean.

Maricha saw Rama again, years later, while wandering in the forest as a deer, with two companions. Fooled by Rama's calm demeanour, he charged towards him with his sharp horns. Rama killed Maricha's companions and the Rakshasha barely managed to escape. He said, "Since then, I see Rama wherever I look. Ravana, do not speak to me of him. Every tree looks like Rama,

> "**I am scared and can see thousands of Ramas**... I do not see anything that is without Rama. **Rama appears in my dreams** and my senses are whirled around."

MARICHA TO RAVANA, *SARGA* (37), ARANYA KANDA

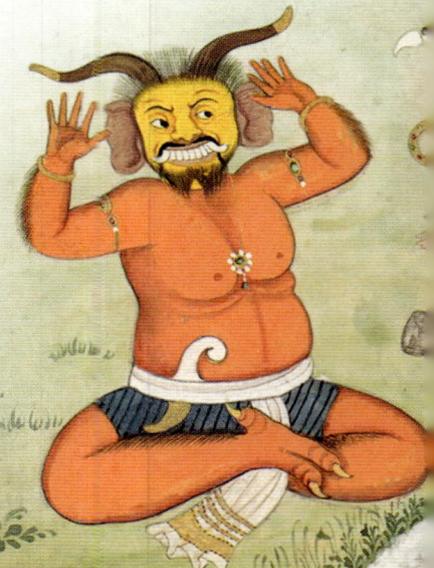

I cannot even hear the sound 'R' without shuddering. He is why I practise asceticism."

Ravana's stubbornness

Ravana rejected Maricha's advice, almost like a dying person rejects medicine.

Impelled seemingly by Death itself, he spoke sharply, "I am your king, Maricha, and do not care for your homilies. I do not remember asking you to evaluate the merits of my plan. Do this willingly and I shall reward you. If you accompany me, there is only a possibility of death, but if you do not, you will face certain death at my hands."

Seeing no way out, Maricha acquiesced, "I don't know what ill-wishers are advising you, but my death seems certain. Rather than be killed in disgrace by a king, let me die honourably at the hands of an enemy, for nobody returns alive after attacking Rama."

He looked at Ravana and said, "The body that I see walking and talking is a mere shadow of you. You have already been struck by Death's staff."

These words did not faze the king of Lanka. He embraced Maricha instead and said, with a smile, "Ah! In agreeing, you sound like the Maricha I knew. You sounded like a common Rakshasa earlier. Come aboard my flying chariot, and we shall go."

CULTURE

FROM FEAR TO DEVOTION

Maricha's fear of Rama sees a wonderful transformation in some renditions of the story, including 16th-century Awadhi poet Tulsidas's *Ramcharitmanas*. It is said that he identified Rama as the Supreme Being when he saw him earlier, and loves Rama as such. When Ravana insists on the plan, Maricha's eventual assent is explained as his desire to be killed at Rama's hands because he wants liberation. Commentaries on Valmiki's *Ramayana* also sometimes bring this up.

In Tulsidas's writing, however, Maricha is so filled with love for Rama that he is grateful even for an opportunity to see him. Tulsidas writes, "There was great joy in his (Maricha's) mind, [but] he did not express it to Ravana – today I shall see the dearly beloved … the one whose anger grants liberation, and devotion for whom brings under one's power the utterly independent one (Rama) – that Hari, who is an ocean of bliss, shall place an arrow with his own hands and kill me."

FAIR WARNING
Ravana reveals his plan to abduct Sita even as Maricha tries to dissuade him, in this 1780 painting from Himachal Pradesh.

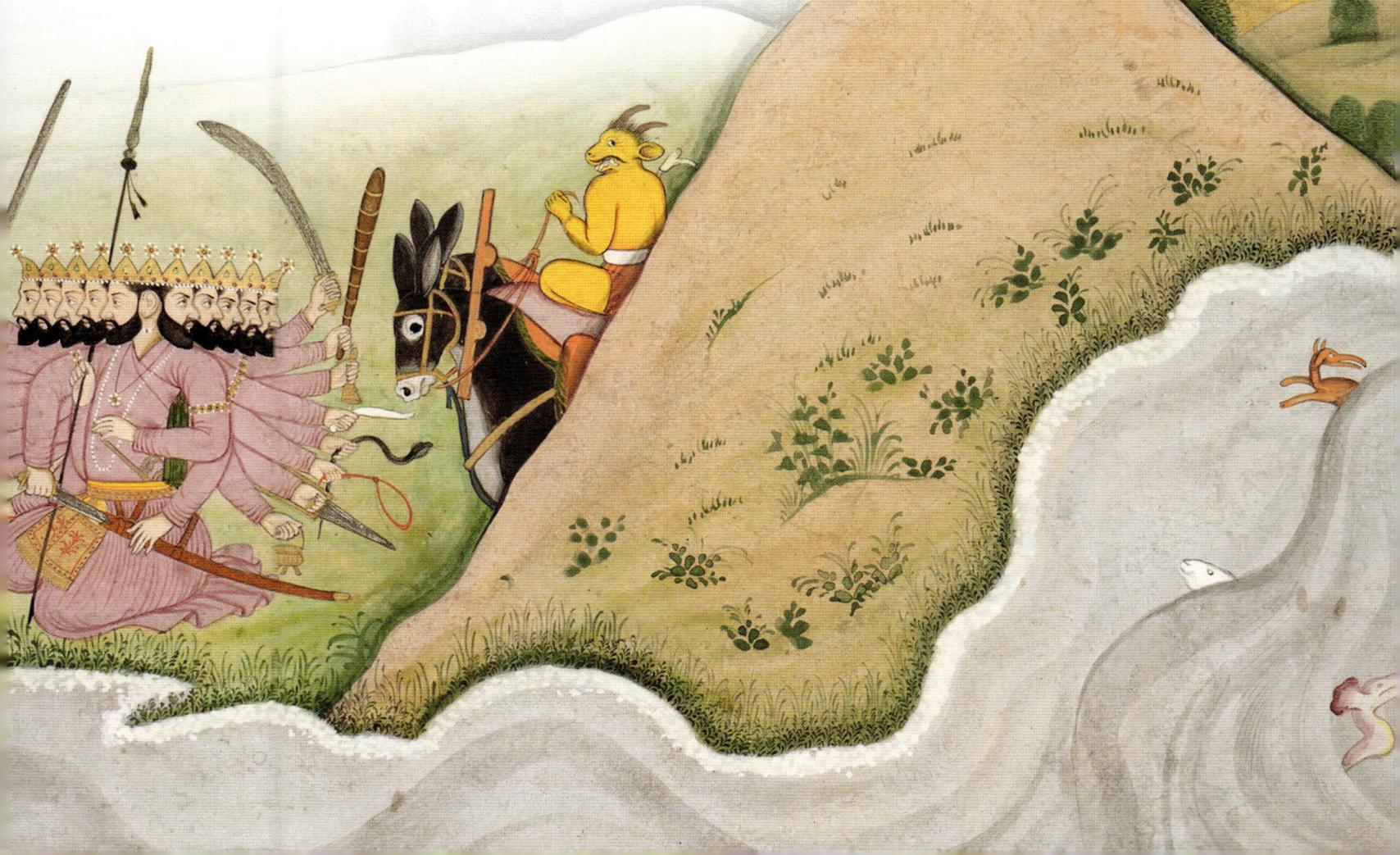

The Golden Deer

With Maricha by his side, Ravana left for Rama's hermitage in his flying chariot. As his plan played out Rama and Sita seemed to fall for the ploy almost instantly, but Lakshmana remained wary.

The golden chariot flew over mountains and rivers until it reached Rama's hut in the forest of Dandakaranya. It descended and the king of Lanka instructed Maricha to turn himself into a deer

The Rakshasa did as instructed and took the form of a deer. It was a wondrous beast.

The tips of its antlers bore gems and its mouth resembled a red lotus. The ears looked like sapphire coloured flowers, and its hooves resembled a cat's eye gem. The radiant tail had all the colours of a rainbow. As it walked, the forest and Rama's hermitage seemed to glow. It was a sight to behold. The deer wandered near the doorway of the hut, nibbling on leaves, in an attempt to catch Sita's eye. The other animals in the forest were wary of the creature for when they wandered near this strange deer, they sensed that something did not smell right. It seemed to be a predator and they retreated in fear. Maricha, too, refrained from killing them to remain in disguise.

THE ILLUSORY SITA

Rama, in some tellings of his story, knowing what was to come, arranges for Sita to be away at this dangerous time. He entrusts the real Sita to the deity of fire, Agni, so she that she remains safe. Sita is replaced by an image that is identical to her in all respects. It is this image that Ravana abducts. A commentator on Valmiki raises the question: how could Hanuman have burned Lanka with mere fire (See p 237), had Sita not been residing in it, since the deities were all subservient to Ravana at that point?

A CARVING OF LORD AGNI in Nanjagud, Karnataka

Sita sees the deer

Sita spotted the deer as she wandered near the trees, collecting flowers. Her eyes widened and, mesmerized, she called out to Rama, "Come quickly, and bring Lakshmana too. Look at this wonder."

The two brothers, lions among men, came rushing at the sound of her voice and saw the deer. Lakshmana, characteristically suspicious, sensed something was amiss.

"I think this is the same Rakshasa Maricha, revered brother, who has taken the

> "His limbs have… **wonderful hues** and he is **dotted with gems**… he beautifies and **radiates the forest**, like the moon. Look at his form… This **extraordinary**… deer is **stealing my heart**."

SITA TO RAMA, DESCRIBING THE DEER, *SARGA* (25), ARANYA KANDA

form of a deer. This Rakshasa, capable of taking on any form, has killed many kings in the forest while they were on hunts. He is well versed in the arts of illusory appearance. Such deer do not occur in nature, as you know, lord of the earth," warned Lakshmana.

Sita, however, taken in by the beauty of the deer, quietened him and turned to Rama. "Dear husband," she said, "This deer has stolen my heart. Would you not bring him here? We have seen innumerable creatures in the last many years, but none quite like this. Ah! Look at its beauty. If you can catch it alive, we can take it back with us to Ayodhya. It will delight Bharata and all my mothers-in-law. And if that is impossible, then look at its skin. It is exquisite. I have never seen anything like this creature. We can use it."

AN EXQUISITE DEER
This sculpture is from a museum in Xi'an, China. In many cultures around the world, the deer is a sacred animal associated with spiritual superiority.

"Look after Sita"

Rama looked at the deer with some wonder, and Sita's words further persuaded him. However, Lakshmana's objections were not to be easily dismissed.

Rama turned to his younger brother and said, "Sita desires this deer, and indeed, where else would we ever find such a marvellous animal on this earth? If you are right, and this is an illusion of some sort, and if it is Maricha in the form of a deer, then it is my duty to kill it. We know of Maricha's many crimes, particularly against the sages."

Rama then asked Lakshmana to be careful in his absence. "Arm yourself and stay alert. Take care of Sita and protect her. I will kill this deer and return with its hide. Jatayu, the strong bird, is also circling this forest. Stay in the hermitage and, in every instance, be suspicious."

So saying, Rama fastened his sword, picked up his bow, and went after the deer.

Maricha's **Final Gambit**

How could Rama refuse Sita's request? So, despite Lakshmana's warning, the prince of Ayodhya chased after the magical deer, as it leapt through the forest and hid behind the trees. Ravana's shrewd plan had come into play.

Rama chased after the radiant deer, but it appeared in and out of sight, frustrating his efforts. It would sometimes leap high into the sky, or disappear in an instant.

Angered, Rama decided to kill it and lifted his bow to release a divine weapon. The arrow dazzled like a serpent and pierced Maricha's heart. The Rakshasa fell to the earth with a terrible roar and abandoned the form of a deer. As he lay dying, Maricha used his last moments to imitate Rama's voice and exclaimed loudly, "Ah! Sita! Ah! Lakshmana!"

When Rama saw Maricha in his true form, fear settled in his heart as he remembered Lakshmana's warning. "How will Sita react to this pitiful appeal?" he wondered. "She will think it is mine. And what will my brother do upon hearing this?"

Sita's appeal

At the hermitage, Sita heard the cry for help and turned to Lakshmana, "What is this I hear? That … that sounds like Raghava. He seems to be in immense pain. Please, go and rescue your brother. He is alone in the forest, and crying for help." Lakshmana, following his brother's orders, refused to leave.

Tormented and angry, Sita spoke to him in harsh tones, "You are an enemy pretending to be a friend.

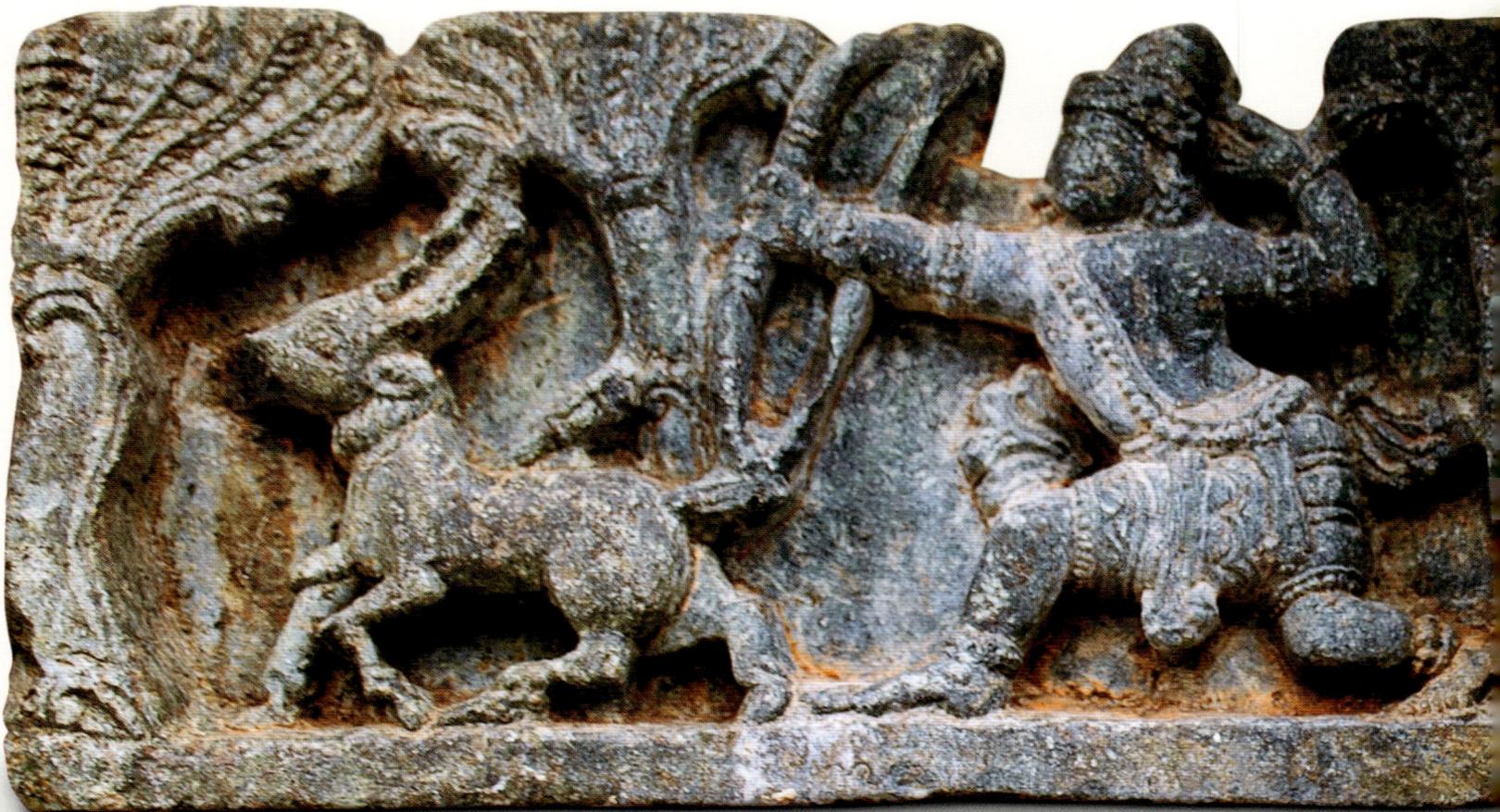

"O Lakshmana! Without Rama, I will bind myself and enter the **waters of the Godavari**. Or I will fling my body down from a high place... Other than **Raghava**, I will never touch another man with my foot."

SITA TO LAKSHMANA, *SARGA* (43), ARANYA KANDA

Won't you rescue your brother, even when he seems to be on the verge of death and alone? It seems that you desire me, and have no love for your brother. You would prefer that he be afflicted by some great calamity."

Giving him some benefit of doubt, and suggesting he might be staying for her sake in accordance with Rama's command, she said, "If he is in danger, what use is my protection? For it is certain that I would die without him. What will you achieve, then,

even if you keep me safe?" Lakshmana, supremely confident in his brother's might said, "Your husband is invincible. No one – gods, humans, Rakshasas, or semi-divine beings, can defeat him. He cannot be killed in battle. Do not say such things. Raghava is capable of protecting the three worlds single-handedly. Where is the need to rescue him? He could never have cried out so piteously. Rama has trusted me with your safety and I do not want to leave

you alone. We are surrounded by those who regard us as enemies."

Sita angered
By this point, Sita was furious, "You cruel man, you are a disgrace to your family. You speak in this way when he is in trouble somewhere because you want him dead. Is it at Bharata's command that you followed Rama here, Lakshmana, to fulfil his evil design? In any case, you shall certainly never so much as

touch me, for I would not live a moment without Rama."

Lakshmana, who had long restrained his senses, addressed Sita with his palms together, "You are a deity to me and I do not wish to answer back. Your doubt is unfortunate. I am merely following my brother's orders. May the deities protect you. I shall see you when I return with Rama."

So saying, he set aside Rama's instructions and went in search of his brother.

LAKSHMANA LEAVES SITA
This frieze at Kedareshwara Temple in Halebidu, Karnataka, depicts the moment Rama killed the golden deer (left) as Lakshmana and Sita wait at the hut.

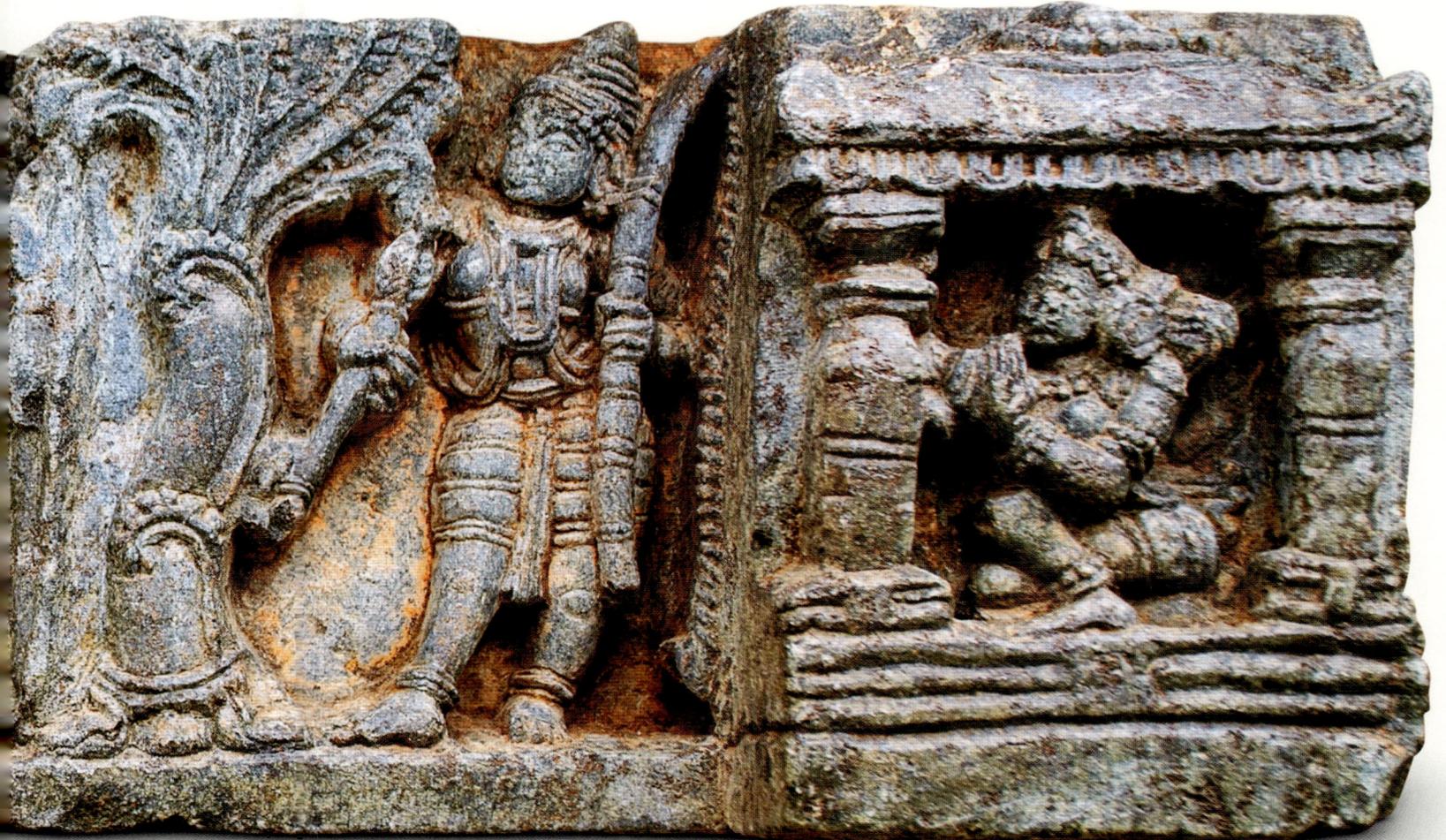

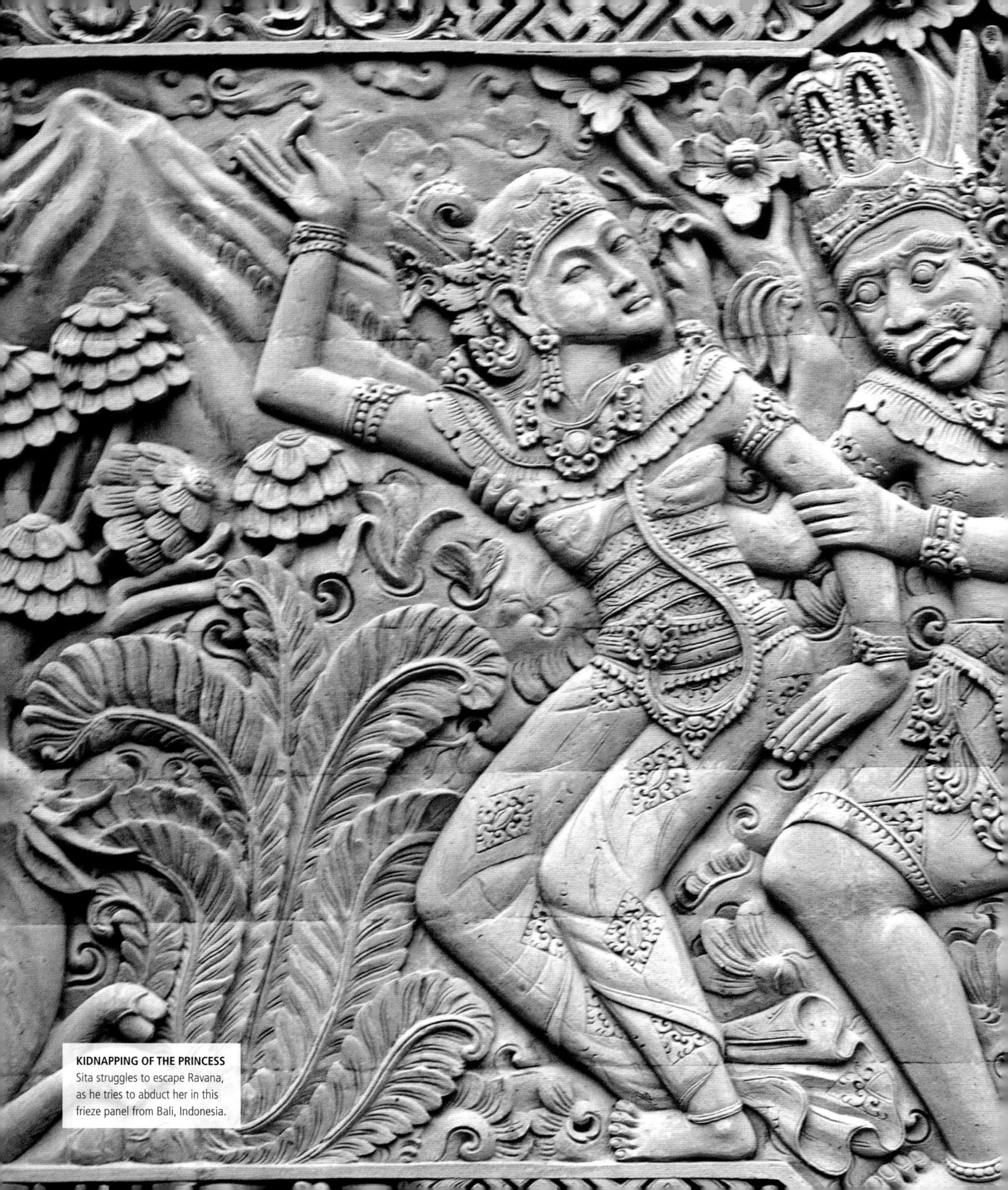

KIDNAPPING OF THE PRINCESS
Sita struggles to escape Ravana, as he tries to abduct her in this frieze panel from Bali, Indonesia.

Sita's Abduction

Ravana saw Sita and was besotted. Seeing her alone and unprotected, he seized the opportunity. He took on the guise of a mendicant and walked up to her.

Sita sat by herself, anxious and worried, with tears streaming down her face. She was like twilight, without either the sun or the moon.

As Ravana walked up to her, the trees saw him and stopped swaying. The wind paused, and the swift-flowing Godavari grew terrified and quiet.

"Who are you, golden-complexioned one, dressed in yellow silk? Are you the consort of one of the gods or a celestial maiden? What are you doing in this Rakshasa-infested forest?" he asked.

Sita looked up and, seeing a Brahmana mendicant, honoured him. She looked around, but saw only an unending forest, and no sign of Rama and Lakshmana. Thinking he may get offended and curse her, she introduced herself and answered his questions. She requested him to wait, as, she said, her husband was on his way back. "Who are you? Why do you wander alone?" she asked.

"I am that Ravana, golden-hued one, who terrifies the world and all divine beings. Seeing you, I do not care for my other wives. Be my chief wife. My city, Lanka, is filled with luxuries, all yours if you come with me"

Sita, trembling in fury, insulted Ravana, "You are a jackal, who desires a tigress. Desiring Rama's wife and expecting to live, is like anticipating welfare after consuming fire."

Ravana tried to scare her, "I am the brother of Kubera, the god of wealth, and Indra, the king of gods. Gods flee if they sense my anger. In Lanka, you will delight in human and divine pleasures, and forget wretched Rama."

Sita replied, "You act in this manner and then call Indra, the one all beings revere, your brother? Your days are numbered and there is no way to keep living after abducting me."

Unfazed, Ravana took on his fierce form, with red eyes and 10 heads. He lifted Sita, placed her on his chariot, and took flight.

> **"O beautiful** one! If you desire a husband who is **famous** in the three worlds, **seek refuge** with me."
>
> RAVANA TO SITA, *SARGA* (47), ARANYA KANDA

Sita's Lament

Semi-divine beings living in the forest and other creatures shrank away in fear as they saw Ravana drag Sita into his flying chariot. As he set off for Lanka, an old friend heard Sita's cries and appeared to help.

Sita's cries for help echoed across the sky as Ravana set off for Lanka in his flying chariot. "Mighty-armed Lakshmana! You always please your elder brother's heart, but are not even aware that a Rakshasa is abducting me. Rama! You stand for dharma, yet I am being taken away in an act of adharma. Why don't you punish Ravana for his action?"

She screamed, "Flora and fauna of Janasthana! Godavari! Mountain! Forest deities! Tell Rama that his consort, dearer to him than his very breath, has been abducted. Jatayu! Revered Jatayu! Tell Rama and Lakshmana that I have been taken away by force!"

The king of vultures

Jatayu heard Sita's cries of anguish and saw Ravana taking her away. He addressed the king of Rakshasas, "I am Jatayu, the king of vultures. Rama, the son of Dasharatha, is engaged in the welfare of all beings and this is his wife who is being abducted. How can a virtuous king even touch the wife of another man? Cease this wretched effort.

"Rama has not caused you any offence. If Khara came here on Shurpanakha's account and attacked, and Rama killed him in battle, how is he to blame? Why do you perform this act, which won't bring you glory or dharma, but will instead bring about your downfall? You are young and I am old, but I will not let you leave with Sita while I am still alive. If you were brave, you would wait for Rama and engage him in fair combat. But while he is away, I will be of service to Rama and Dasharatha, with my life."

Aerial battle

Ravana's 20 eyes lit up in anger. The two attacked each other and it was as if mighty mountains had collided. Ravana showered arrows on the king of vultures, and Jatayu ripped him with his sharp talons and beak. He shattered Ravana's armour and his bow and quiver, and killed the charioteer.

Ravana fell to the ground, with Sita still in his arms. Jatayu, praising Rama's valour, descended on his back and wounded him. Ravana, seeing Jatayu exhausted, swung his sword and cut off the bird's wings.

THE VULTURE'S DEATH
Jatayu's cold-blooded murder is depicted in this chromolithograph by Raja Ravi Varma. Here, Ravana cuts Jatayu's wings as he attacks him.

Sita rushed to the fallen bird and embraced him, mourning as she would a family member. "Rama! Look, the animals and birds flee at this calamity. Lakshmana! Where are you?" she exclaimed.

Ravana dragged her away, and Sita clung to tree trunks in an attempt to free herself, but he ignored her cries and grabbed her by her hair.

"It is done"

As Ravana took her away, Brahma sat in his realm, commenting on the turn of events. "Now, it is done," he said, for Ravana's destruction was as good as accomplished. The sages in the forest wept, and Ravana ascended the sky with Sita, who cried out to Rama and Lakshmana.

Sita turned to Ravana, "Are you not ashamed of running away like a thief? The deer, I now see, was there by your design, to draw away my valorous husband. Fie, Ravana, upon your valour. You wouldn't have lasted an instant before my husband and his brother.

"Your desire for me will remain unfulfilled, for I do not wish to live without Rama for even a moment. You are bound by the inescapable noose of death. How could there be any

welfare for you, Ravana, when my husband destroyed 14,000 Rakshasas." As she spoke, the flowers she wore fell to the ground below, as did her anklets and necklace. She looked down and when she saw some mighty Vanaras on a mountaintop, Sita quickly wrapped her ornaments in a silk cloth and threw it down to them, hoping they would tell Rama of her plight.

They reached the ocean and the fish and serpents became still when they saw Ravana with Sita. In heaven, the demigods exclaimed, "This is the end of Ravana."

In Lanka

Ravana dragged Sita into Lanka and instructed a Rakshasi, "Give her whatever she desires. If anybody speaks harshly to her, they should be prepared for death." He also ordered some Rakshasas to go to Janasthana and kill Rama. Ravana showed Sita the palace and enticed her with all manner of comforts.

Janaka's daughter, fearless, even though drowning in grief, placed a single blade of grass between them. "King Dasharatha ruled over Ayodhya and was so firm in

dharma that Indra respected him as an equal. His son is Rama, known in all three worlds, and he will kill you, by his sight." Seeing that she was adamant, Ravana took her to a grove of Ashoka trees and gave her an ultimatum.

"If you don't agree to live with me at the end of 12 months, the cooks will slice you into small pieces to make a meal of you," he said.

JATAYU

Jatayu, the king of vultures, descended from Kashyapa (See p 133), and was the nephew of Garuda, the lord of all birds. He introduces himself as Dasharatha's friend and accords immense assistance and affection to Dasharatha's sons and daughter-in-law. Rama performs Jatayu's last rites, which is an unparalleled honour. Further, since he is a scavenging bird and hence considered impure, he is sometimes held up as an example of the non-discriminatory nature of Rama's grace.

"Rama's wife, Vaidehi, is being abducted by Ravana, there is **no dharma. Where will truth come from?** There is no uprightness. **Where is non-violence?**"

LAMENT OF CREATURES AS SITA IS ABDUCTED, *SARGA* (50), ARANYA KANDA

THE 10-HEADED KING OF RAKSHASAS

Ravana

"There is a **Rakshasa named Ravana**... Thanks to **a boon** obtained from **Brahma,** he **oppresses**... the three worlds."

SHURPANAKHA TO RAMA, *SARGA* (16), ARANYA KANDA

SITA AS RAVANA'S PROGENY

There are many narratives in which Mandodari, Ravana's wife, is described as Sita's mother. In one of these stories, Ravana brings a pot with fluid to Mandodari and asks her to guard it. She consumes it instead and becomes pregnant. She gives birth to a child, which she eventually abandons and who is discovered by King Janaka as Sita.

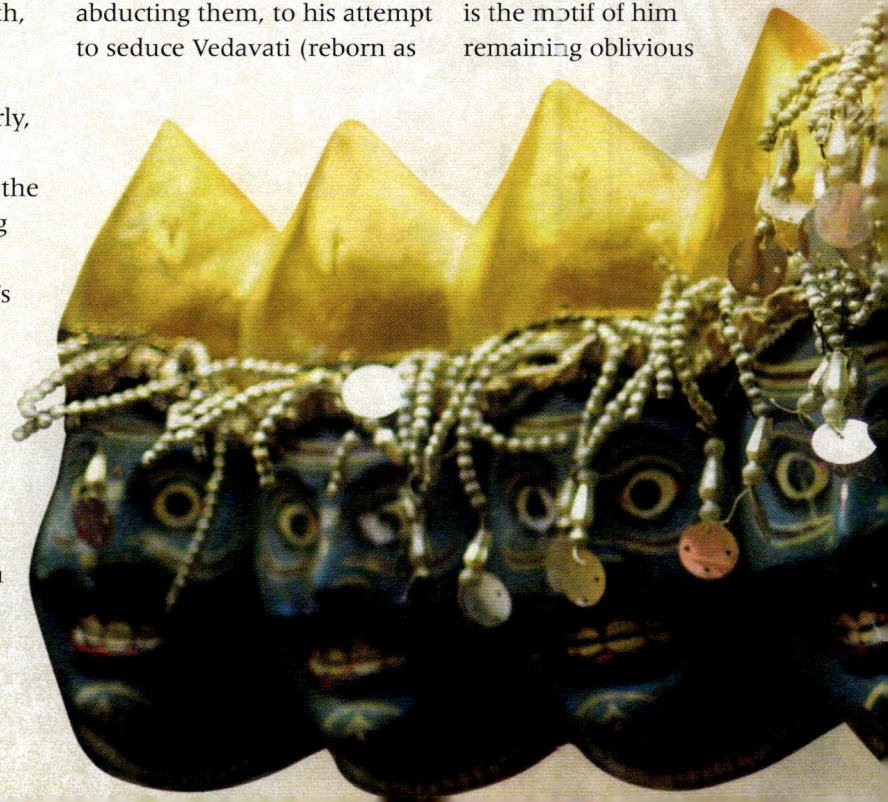

Ravana is as indispensable to the *Ramayana* as Rama himself. Indeed, it is a reflection of his strength that Vishnu, the Preserver of the universe, himself has to assume a human form to rid the universe of him. The extent of terror that Ravana inflicts on beings is established in Bala Kanda, as is the magnitude of distress that the Rakshasas cause the sages, during Vishvamitra's conversation with Dasharatha (See pp 42–43).

An envied tyrant

By all accounts, Ravana's strength and intellect are incomparable – it is only their employment that is a problem. Had he not decided to torment gods, kings, sages, and women, he would have been an admirable person. Rather than being a marginalized villain devoid of virtues, in true epic mode, Ravana's strength and cruelty are both exalted. He is the pinnacle of power and wealth, surrounded by warriors who are unassailable in their own

right, and who are his kin and advisers. The Uttara Kanda details his "making" (See pp 342–49) and describes his genealogy and rise to power.

Blessed by the gods

Brahma's blessing, acquired as a result of great austerity performed over thousands of years, augments Ravana's strength and success in battle. It ensures that no celestial or semi-celestial being can kill him. For instance, Brahma prevents Kala, time or death, from using his most lethal weapon during an intense battle with Ravana. Similarly, Kubera's father – also Ravana's father – prevents the god of wealth from fighting the 10-headed king.

The prosperity of Ravana's realm is also clear, as is evident from the descriptions of Lanka.

Ravana is often portrayed as a great devotee of Shiva, the Destroyer of the universe. This is touched upon when he lifts Mount Kailasa and is crushed beneath it after Shiva presses down with

his toe, and Ravana propitiates him. The offering of each head at the end of every 1,000 years of penance is sometimes seen as an offering to Shiva. Ravana is also believed to have played a lute made of his organs to please the god.

The villain's flaw

Ravana's actions as described in Uttara Kanda – from the torment to the sages, his treatment of women, whose families he kills before abducting them, to his attempt to seduce Vedavati (reborn as

Sita), and the rape of his nephew's wife Rambha – lead to his downfall.

To establish his dominion over the world, he is constantly engaged in battle. He is often portrayed as a classic cautionary tale, where even if one does everything right, it all comes to naught because of a fatal flaw. In Ravana's case, his flaw is his infatuation with Sita and his arrogant intransigence. Associated with this is the motif of him remaining oblivious

to matters of the state, raised first by Shurpanakha. However, when he decides to abduct Sita, there are references to specific criticisms of his policy and this is where Ravana's other defining flaw is highlighted. It especially becomes evident in his conversations with almost anyone who advises him not to abduct Sita or to return

her to Rama. Although this is sometimes attributed to his infatuation with Sita, it appears that his arrogance predates it. This is why he is also seen as a case of one whose intentions are not pure – therefore, the amount of time spent in ascetic practice matters little, for arrogance attached to austerity brings about one's downfall.

Representation in South Asia

There are several narratives where Ravana is actually a devotee of Rama. In such versions, it is not that he is rendered devoid of faults, but rather,

once he knows that Rama is a god, he realizes that he could only attain liberation if Rama were to kill him.

As a central figure in the Ramayana, Ravana is a part of what Indian poet AK Ramanujan describes as a "pool of signifiers", through which various positions are negotiated. For instance, as American scholar JW Henry points out, the Chola kings often cast defeated enemy kings into Ravana's role, which was made neater by the fact that sometimes their expeditions were to Sri Lanka.

In Sri Lanka, Ravana is perceived in several ways. He is often cast as the antagonist

in Rama's story, even though there is plenty of sympathy for him as a devotee of Shiva (often, in India too). Scholars Jonathan Young and Philip Friedrich speak of a mid-second millennium text, which demonizes Ravana for his failure to protect the Buddhist dispensation, honour gods, and not following his kingly dharma. Scholar Pathmanesan Sanmugeswaran observes, however that Ravana has also been held up as an emblem of resistance by both south Indian Dravidian movements as well as Sri Lankan Sinhala Buddhists.

THE ARROGANT KING
Also known as Dashagriva, or the one born with 10 heads, Ravana performed severe austerities to attain powerful boons from the gods. He abstained from food and water for 10,000 years and was offered a head at the end of every 1,000 years.

"Where Are You, Sita?"

After Rama killed Maricha, he hurried back, worried about his beloved and his brother's reaction to the dying Maricha's imitation of his voice. He would soon realize that the unthinkable had happened.

> " The **ascetic Sita** has been abducted, **killed**, or **devoured**. When **Sita was abducted** in the great forest, **dharma** could not **save her**."
>
> RAMA TO LAKSHMANA, *SARGA* (60), ARANYA KANDA

Rama hurried back, worried about Sita and Lakshmana and fearing the worst. "These Rakshasas must desire Sita dead, which is why they called out to Sita and Lakshmana in this way. Let them both be safe. They are protected by me in the forest," he thought.

Meeting Lakshmana
Suddenly, he saw Lakshmana, away from the hermitage, looking for him. "What have you done?" he asked his brother. "Why would you abandon Sita in this terrible forest? I am convinced she has been killed by the Rakshasas who dwell here. Where is Sita, my companion and refuge, even when I was exiled from the kingdom, desolate, and wandering about these forests? Where is she, Lakshmana, without whom I do not wish to live for even a moment? I will die if Sita does not address me with her usual smile in the hermitage."

Exhausted and anxious, he chastised Lakshmana for leaving Sita alone, despite his instructions. "My inauspicious left arm trembles and my heart is aflutter," he said.

"I did not transgress your command of my own accord," Lakshmana explained. "Sita forced me to come. You seemed to call out to us, and when she heard it, she told me to help you. I told her again and again that there is no Rakshasa who could possibly cause you fear. Out of loving concern for you, she addressed me harshly, accusing me of wishing you ill, either out of desire for her or at Bharata's incitement."

Rama replied, "It was wrong of you to come like this, simply because she said something to you in anger." "You knew I am capable of defending myself, and indeed, I killed the Rakshasa. In anger, Lakshmana, you transgressed my command."

SEARCH FOR SITA
This is a part of a late 17th-century painting in ink and opaque watercolour from Mewar, Rajasthan, which shows Rama and Lakshmana searching for Sita after her abduction.

An empty house waits
The brothers hurried back, but could not see Sita anywhere. "Is she abducted, or dead, or consumed? Is she hidden somewhere? Or has she gone to bring flowers?" Rama asked.

Not finding her, Rama spoke in utter desolation, "O Kadamba tree! Did you see my beautiful Sita? Deer! Did you see the doe-eyed one around? Ah, Sita, why do you not speak to me? Are you hiding away behind the trees? I am drowning in grief! When I die this way, my father shall see me in the afterlife and surely chastise me, saying, 'What right had you to see me when you haven't yet completed your vow?' Where have you gone, Sita, leaving me bereft?"

Lakshmana consoled his brother, "Do not let yourself go in this way, revered brother. Let us look for her. She might be at the river, or she might have gone out

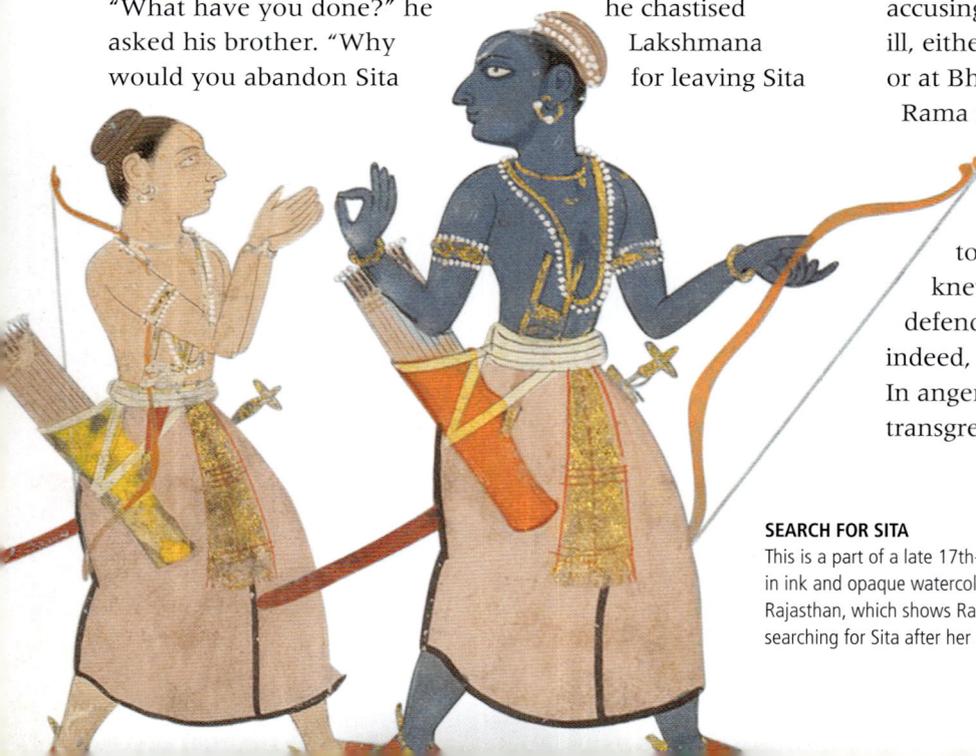

of the hut in search of us." Rama wept, his limbs unsteady, as Lakshmana tried to calm him. Rama then saw a garland on the ground and recognized the flowers as the ones he had gifted Sita.

Rama's fury

He suddenly became furious, "If Sita is dead or abducted, what can gods or virtue do for me? These gods think I am weak, because I am gentle and endeavour for the welfare of all beings. But watch me Lakshmana, as I fill the sky with arrows, depriving humans, Rakshasas, and gods alike of refuge. Nobody shall remain standing when I destroy the three worlds with my might. If I am not told of Sita's whereabouts, I shall destroy all creation."

With Rama intent upon the destruction of the world like the doomsday fires themselves, Lakshmana tried to calm him down. "You have always been gentle and intent upon the welfare of all beings. This intent to destroy the world does not befit you. I do not know who abducted Sita, but it is not right to destroy creation for that one man. Kings like you are gentle and accord appropriate punishment. You are the refuge of all beings, Rama! Who is capable of bearing such calamity if you cannot? Ones like you do not grow desolate. We shall find this man. I shall be by your side."

Rama, inherently wise, calmed down and restrained his fury. The two then walked into the forest.

IN THE FOREST
In Rama and Lakshmana's absence, the forest was a silent witness to the violence of Sita's abduction. Later, it seemed to manifest Rama's despair as he searched helplessly for Sita.

THE WOUNDED BIRD
Practised in Kerala, Kutiyattam, one of the oldest form of theatre traditions in India, is based on Sanskrit drama. This is a scene from a performance in 1998 where theatre personality K Rama Chakyar plays Jatayu.

Jatayu's
Death

Inconsolable, Rama, along with Lakshmana, searched for Sita, growing even more worried when they came upon the signs of a great battle. Then, they saw their father's friend, the great Jatayu, lying on the ground, dying.

Rama saw a great beast, resembling a mountain, lying on the ground, which was wet with blood. In his agitated state, Rama looked at the bird suspiciously. "I am certain that he killed Sita. It is clear that this Rakshasa wanders the forest in the form of a vulture. I shall kill him."

So saying, Rama fixed an arrow to his bow and approached the bird. At that moment, Jatayu vomited blood and spoke softly, "Ravana took Sita, whom you look for. Here is his armour, and here is shattered bow. I battled him and he cut my wings. Rama, do not kill a being that is already dead."

Rama, already lost to grief, was pained further. "Such is my misfortune, Lakshmana, that my kingdom is lost, Sita is gone, and my father's friend lies dying on my account. Fire itself would be burnt in my proximity. If I went to a roaring ocean, it would become dry," he said. He gently touched Jatayu's injured body, soaked with blood, embraced him, and wept.

"If you are able to, tell me of Sita's abduction and your death. What did my Sita say?" he asked.

In an exhausted voice, for every breath was difficult, Jatayu told Rama that Ravana had taken Sita southward through the sky. "O Rama ... I cannot breathe, nor see ... Do not grieve, for you shall soon find her. That son of Vishrava ..." So saying, Jatayu, the king of eagles, breathed his last.

Rama turned to Lakshmana, "Jatayu's death, as he acted on my account, pains me even more than losing Sita. Bring firewood, Lakshmana, and I shall offer the final rites to Jatayu, who died for me. If I perform his last rituals, he shall attain the state that is reached by all those who sacrifice."

> " My **grief at Sita's abduction** is not as much as that caused by the **eagle being destroyed** for my sake."
>
> RAMA TO LAKSHMANA, *SARGA* (64), ARANYA KANDA

Shabari's Wish

With a heavy heart, Rama performed Jatayu's last rites. The princes then took the southward route to find Sita. On the way they came across a Rakshasa and a mendicant, both equally enriching experiences.

Rama and Lakshmana walked southward in search of Sita when they encountered a peculiar Rakshasa.

It was Kabandha, a huge, broad-chested Rakshasa without a head or a neck. His mouth was on his stomach, and a single, dreadful eye was on his chest. His arms were the length of a yojana. He seemed as terrible as a dark cloud with a roar that sounded like thunder.

When Kabandha saw Rama and Lakshmana, he grabbed them in his hands, and tried to crush them. As he tried to eat them, the two princes swung their swords and severed his hands. Kabandha roared in pain and asked them who they were.

When the Rakshasa learnt of their identity, he revealed that he lived in a cursed form and had been promised deliverance at Rama's hands. He requested the brothers to cremate him.

Kabandha suggests a way

After the rites, the Rakshasa transformed into a semi-divine being and gained insight into Rama's search for Sita. He told them to meet the Vanara king Sugriva, who lived in Mount Rishyamuka. The best way to get there, he said, was to go to Lake Pampa, surrounded by beautiful flora. The hermitage of sage Matanga stood at the western bank of the lake, and was also the home of Shabari, a mendicant. Mount Rishyamuka was on the other bank of the lake.

Meeting Shabari

When Rama and Lakshmana reached the hermitage where Shabari resided, she grasped

> **"You have seen this entire forest.** You have **heard everything** that deserves to be heard. I wish to **obtain your permission** to **cast aside this body.** I desire to go near the ones with **cleansed souls**, the **sages whom I have served** in this hermitage."

SHABARI TO RAMA, *SARGA* (70), ARANYA KANDA

their feet. Rama asked her the appropriate questions one asks ascetics: "Do your practices proceed with no obstacle? Does your austerity grow? Is your mind pleasant? Have the restrictions been perfected? Is your service towards your guru successful?"

Overjoyed, Shabari replied, "When you arrived in Chitrakoot, sages that passed through here told me that you would come this way. They said that I should extend hospitality to you, for then I would attain a place in the supreme world."

She offered the brothers, fruits that she had gathered from the banks of the River Pampa. Rama accepted her hospitality and told her that they had heard about Matanga's spiritual powers and wanted to see their manifestation as well. So, Shabari showed them the altar and the forest that stayed fresh. Having fulfilled Rama's wish, she said, "I have seen you. My wish now is to see the sage whose hermitage I serve. I seek to abandon this body. Please give me your permission." So saying, she cast her body into the fire and attained the heavenly realm.

Rama and Lakshmana then continued their journey, for Rishyamuka was in sight.

ANALYSIS
DEATH IN RAMA'S PRESENCE

As a warrior-prince travelling in a forest full of hostile Rakshasas, it is unsurprising that Rama slays many enemies. However, several ascetics and sages seem to await his presence before their death, as in Shabari's case. Others, such as Jatayu, seem to await him before death, even if it is only to convey something to him. Seeing Rama appears to be an act of some merit. In devotional traditions, this is understood as Rama's efficacy as the deliverer from the cycle of rebirth.

ANALYSIS
SHABARI AND RAMA

Two aspects of the ascetic Shabari are emphasized in later *Ramayana*s to draw attention to the accessibility and universality of Rama's grace and the eligibility to worship her – for her origins are in a community considered low in the social order and she is a woman. Rama is also sometimes portrayed as instructing her in certain aspects of devotional practice towards himself. In *Ramcharitmanas*, after telling her about "ninefold devotion", he says, "Anyone who possesses even one of these, whether it is a man, woman, or any of the moving and unmoving beings, is excessively dear to me." But Shabari, he says, possesses them all, a state even yogis find difficult to attain.

WALL ART of Shabari (left) waiting for Rama at the Jagannath Temple in Telangana

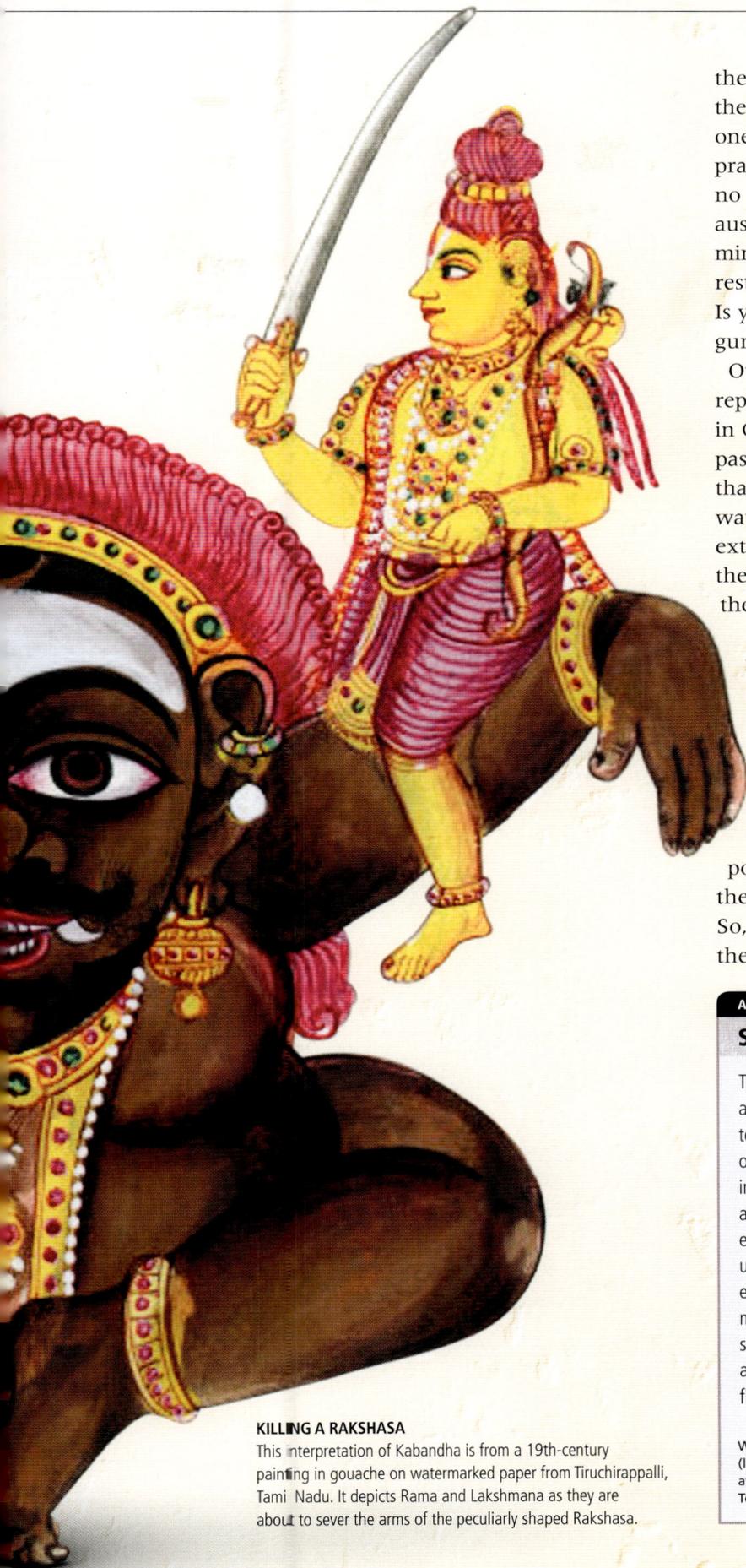

KILLING A RAKSHASA
This interpretation of Kabandha is from a 19th-century painting in gouache on watermarked paper from Tiruchirappalli, Tami Nadu. It depicts Rama and Lakshmana as they are about to sever the arms of the peculiarly shaped Rakshasa.

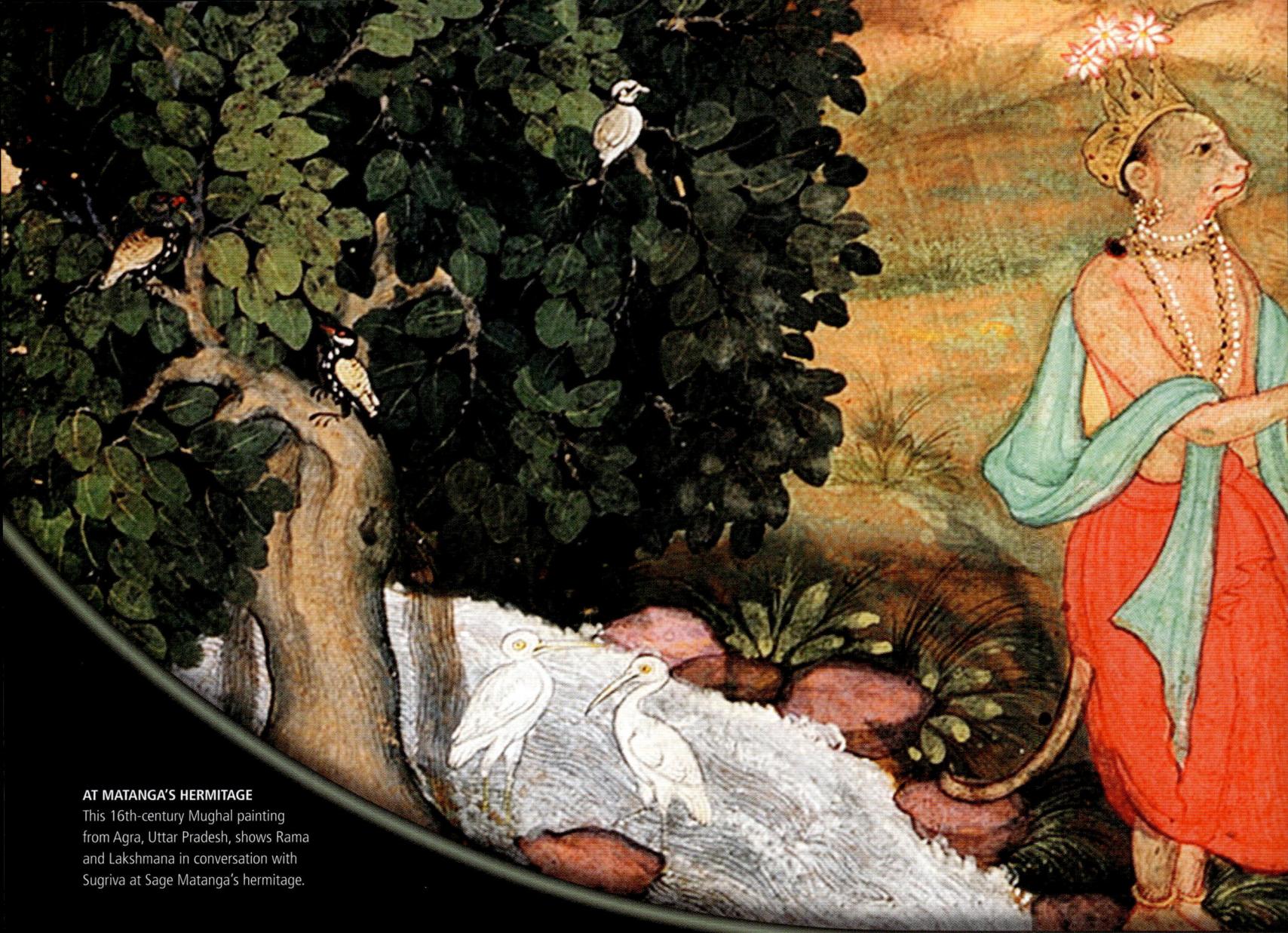

AT MATANGA'S HERMITAGE
This 16th-century Mughal painting from Agra, Uttar Pradesh, shows Rama and Lakshmana in conversation with Sugriva at Sage Matanga's hermitage.

4

KISHKINDHA KANDA:
REALM OF THE VANARAS

Kishkindha was the name of a great city, a shining beacon of prosperity in the kingdom of the Vanaras. This is the chapter where Rama and Lakshmana meet the Vanaras, Hanuman and Sugriva, thus paving the path to their ultimate confrontation with Ravana, the king of Lanka. When Sugriva humbly requests Rama's help in destroying his brother, Vali, for his misdeeds, the prince agrees. In doing so, he secures Sugriva's allegiance and the support of the vast army of Vanaras at his command.

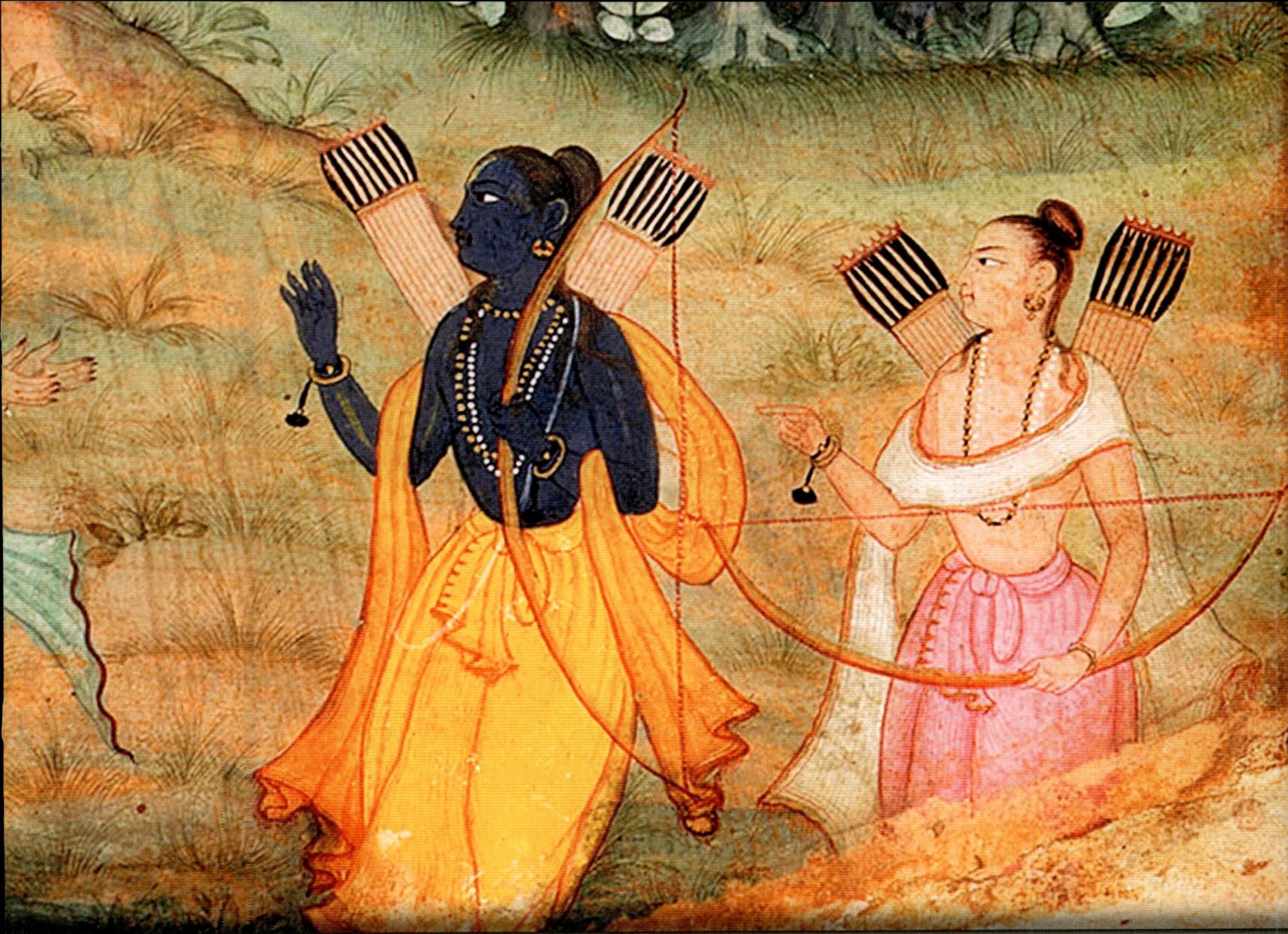

"We have reached **Kishkindha**, Vali's city. The gates are made out of molten **gold**... O brave one! **Fulfil the pledge** you made earlier about **killing Vali**."

SUGRIVA TO RAMA, *SARGA* (14), KISHKINDHA KANDA

The King of the **Vanaras**

Rama and Lakshmana made their way to Rishyamuka in search of Sugriva. The great Vanara, however, grew worried when he saw two men, armed with weapons, walking through the forest. He wondered who they were. Had his brother Vali sent them to kill him?

R ama could not take his eyes off the beauty that surrounded Lake Pampa. The mountain near it was covered in flowers and green grass formed a carpet around the lake. The pleasant breeze, the bees, and the karnikara trees with their golden flowers only intensified Rama's grief over Sita.

He said, "Look, Lakshmana, nature is so stunningly adorned. This beauty causes me immense grief because of Bharata's suffering and, now, Sita's abduction. I am certain it would only cause such pain to me, who is separated from my beloved. Or would it cause her pain too, who is bereft as well?"

Everything around Rama reminded him of Sita. "Spring only serves to evoke grief in those who are separated from their beloved. This peacock's beloved, surely, has not been abducted by a Rakshasa, for it frolics without care. Look at the female spotted deer with her mate on the mountain. Here, I have been separated from my Vaidehi, the dove-eyed one. This spring month is hard to get through, when I am separated from her," he said as he grieved.

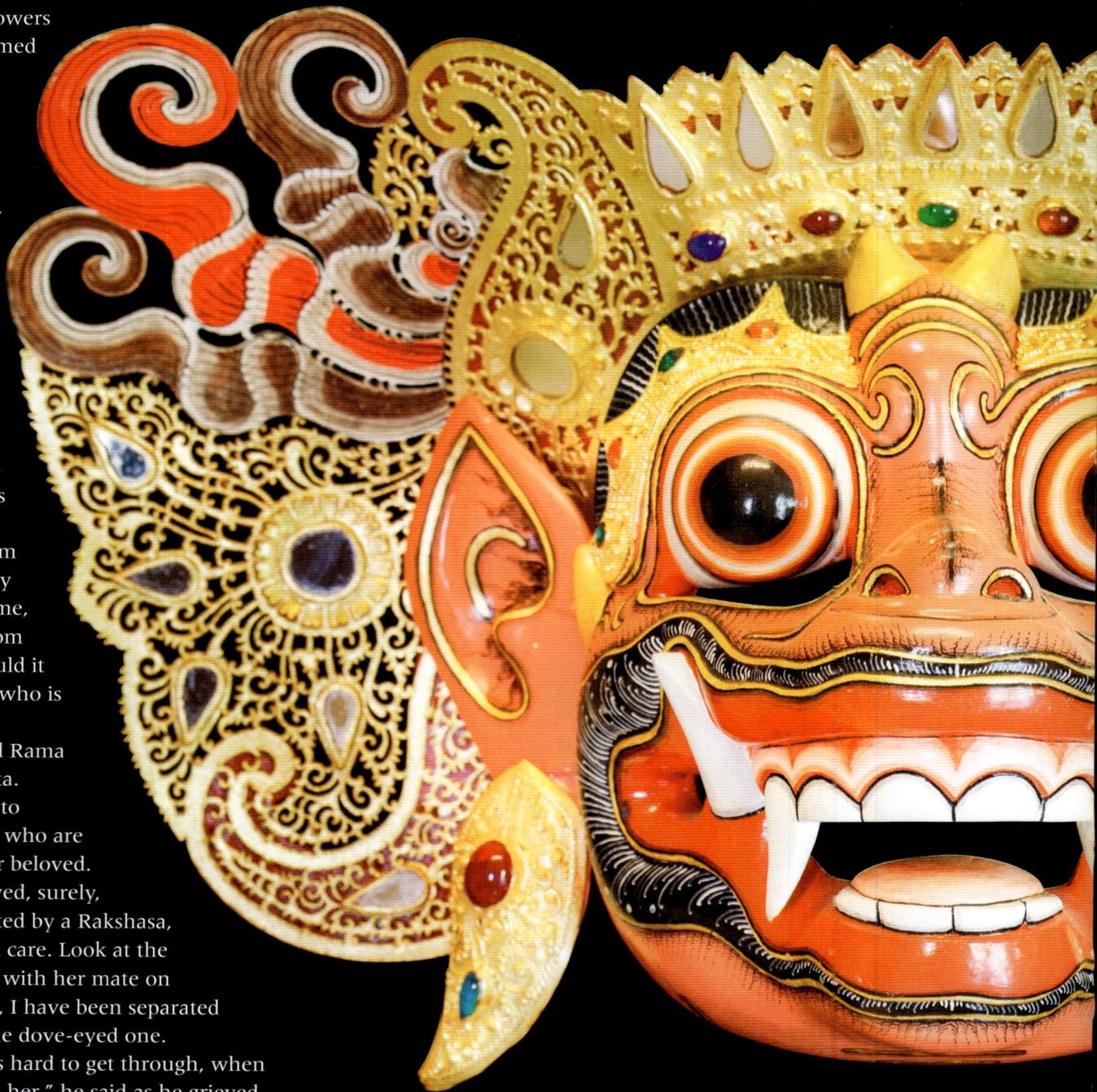

> "The **two brave** and **great-souled brothers**, Rama and Lakshmana, wielded the **best of weapons**. On seeing them, Sugriva was uncertain. **Anxious in his heart**, he looked at all the directions."
>
> SUGRIVA'S REACTION AT SEEING RAMA AND LAKSHMANA, *SARGA* (2), KISHKINDHA KANDA

Sugriva's suspicion

Rama and Lakshmana continued to walk towards Rishyamuka, not realizing that Sugriva, the Vanara king, had spotted them from his perch. The two warrior-like men, bearing mighty weapons, worried him. He became suspicious of them and looked about in all directions in fear. He grew convinced that his brother Vali had sent the two men to kill him. He thought they were disguised in ascetic garb to hide their identities.

Reacting in fear, he leapt from the mountain and moved to another summit. He called his advisers to discuss the matter. One of them,

Hanuman, told him, "I do not see Vali, who terrifies you so. You seem to be demonstrating the instability of an ape-like mind. Restrain yourself. Be firm in your intelligence. A king who descends to foolishness does not rule for long."

Unconvinced, Sugriva retorted, "Who would not be afraid of these men, with their powerful arms, bows, arrows, and glinting swords? It is certain that Vali has sent them." He added, "Go, Hanuman! Find out why they are here. Disguise yourself. Use your soft words to see if they are a danger to me. See if their intent is pure or malicious."

Hanuman, also known as Maruti, the son of the god of wind, leapt from the mountain and through the forest, towards the princes. He then took on the form of a mendicant and walked up to Rama and Lakshmana.

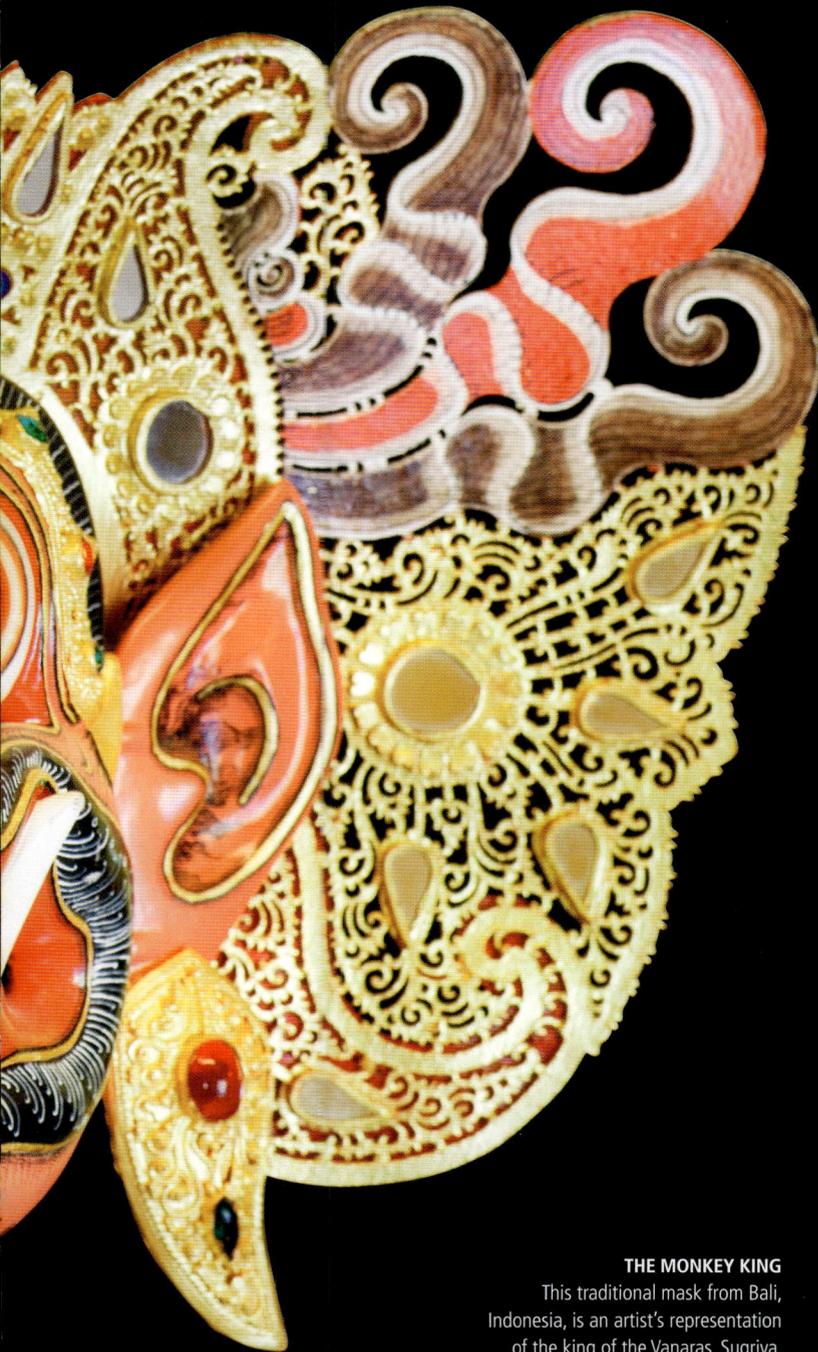

THE MONKEY KING
This traditional mask from Bali, Indonesia, is an artist's representation of the king of the Vanaras, Sugriva.

LOCATION

PAMPA

The Lake Pampa is often believed to be near Hampi in the present-day southern state of Karnataka. Considered a sacred spot, it was already significant because this was where Sage Matanga's hermitage was located, much before Rama went there as he searched for Sita.

The scenic beauty of the Pampa lake is also portrayed as causing Rama pain, for spring is often considered the time for people to meet their beloved. To be separated at that time is considered painful. However, those who believe Rama to be more conscious of his divine status sometimes describe his pain as a demonstration of the reaction of a regular person. Thus, when he sits on the bank of the Pampa, he reverts to his usual state.

THE LAKE PAMPA in Hampi, Karnataka

Hanuman Meets Rama

At first, the princes were surprised to see a mendicant approach them, but were soon delighted to discover who he was. They knew they were one step closer to finding Sita.

Hanuman spoke to the two princes in a gentle tone, "You seem to be ascetics, but your splendour brings to mind royal sages or gods. What brings you here, valorous ones? Where do you wander, terrifying beings with your strength? Are you the sun and moon, descended upon the earth? Why do you roam unadorned? You appear mighty enough to protect even the gods. Your weapons gleam, the bows like Indra's own missile, and the swords like serpents."

When they did not reply, he asked them who they were once again, and then, introduced himself. "Sugriva, the great Vanara, sent me and desires your friendship. I am Hanuman, the son of the wind, and I can take any form," he said and fell silent.

Pleased to hear such pleasant words, Rama turned to Lakshmana and praised Hanuman. He said, "Such expertly put sentences could not have been uttered by one who wasn't familiar with the Vedic corpus, for look, he hasn't uttered a single ungrammatical form. His speech is perfectly enunciated in every way, in addition to being delightful. A king with such a minister is bound to be successful in all his endeavours." Pleased, Hanuman realized that the two men did not have evil designs.

Lakshmana then told Hanuman who they were and of Sita's abduction by an unknown Rakshasa. "The son of Dasharatha who protected the worlds, Rama seeks refuge with Sugriva," he said. "Help us find Sita."

> **"** The **complexion** of his face is happy and it is evident that he is **speaking cheerfully**. The brave **Hanuman**, Marut's son, is **not uttering a falsehood."**
>
> RAMA TO LAKSHMANA, *SARGA* (4), KISHKINDHA KANDA

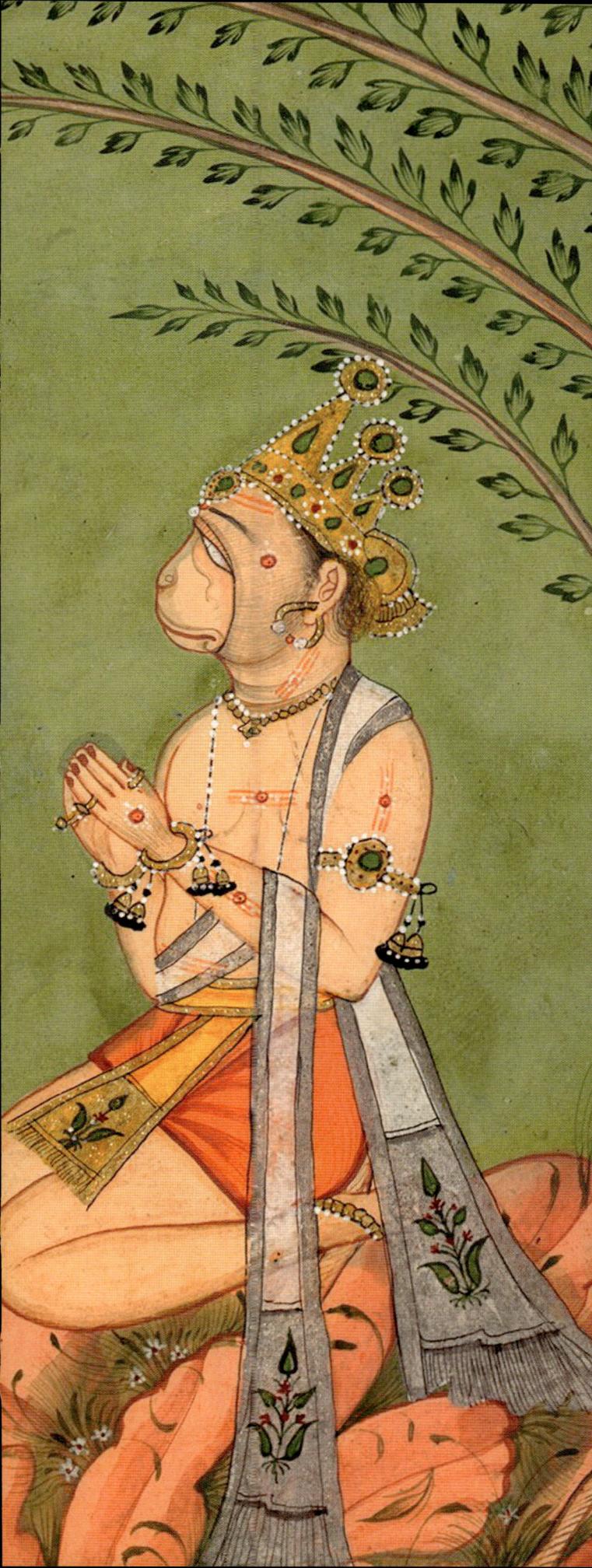

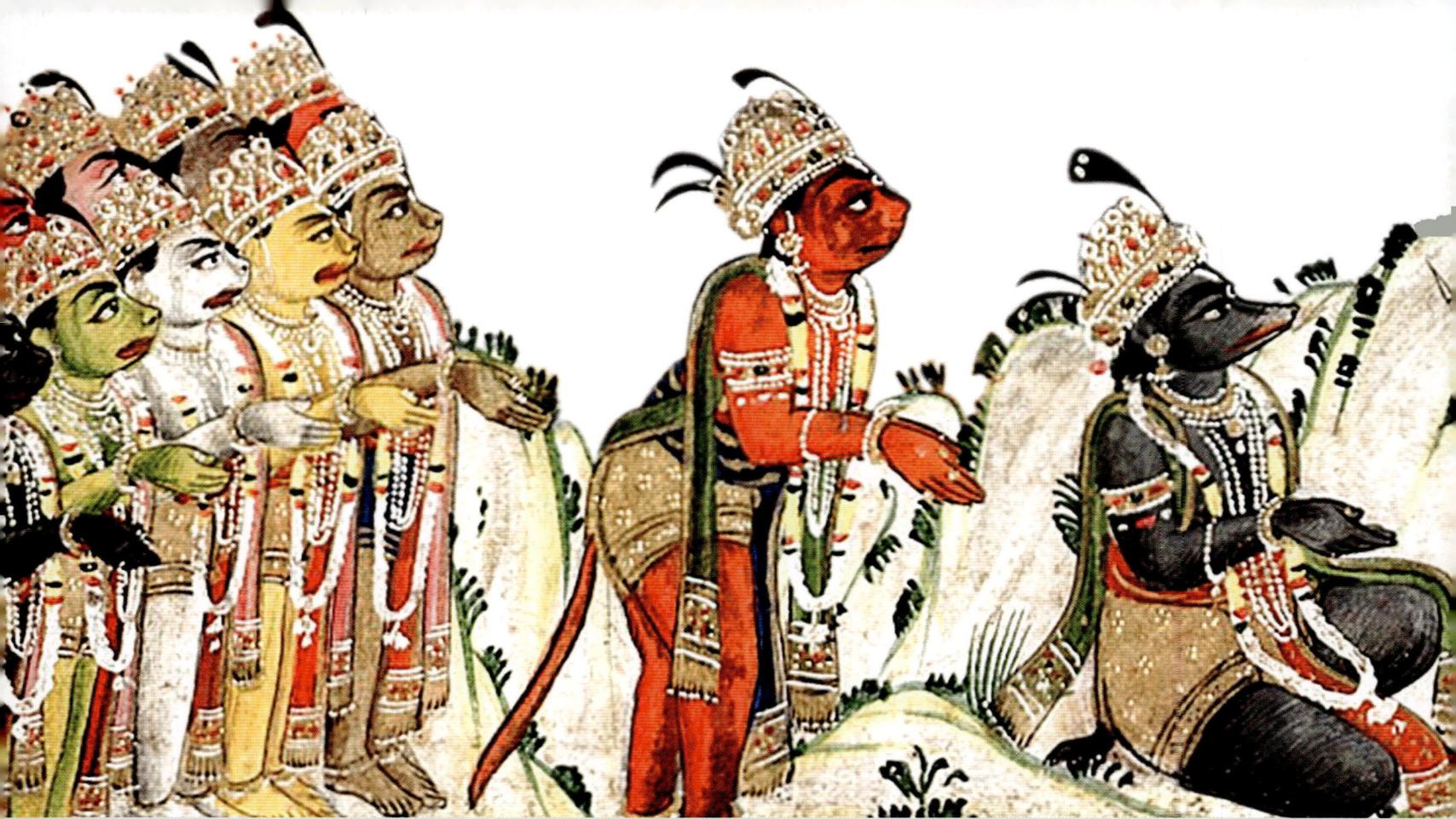

A Pledge of **Friendship**

When Sugriva realized that Rama and Lakshmana were not there to kill him, but wanted to form an alliance, he happily agreed to help them. He consoled the grieving Rama and promised to find Sita. Theirs would prove to be a powerful friendship.

Hanuman returned to his Vanara form and carried the princes to Rishyamuka. After reassuring Sugriva, who was hiding on Mount Malaya, Hanuman introduced Rama and Lakshmana to him as the sons of Dasharatha, from the lineage of Ikshvaku kings. He told Sugriva of Rama's exile and Sita's abduction and said, "Rama seeks your friendship. Accept the brothers, honour them, worship them."

No longer anxious, Sugriva assumed a human form and accepted the offer.

Forging an alliance

Sugriva said, "Hanuman has told me of your humility in righteousness, asceticism, and compassion. I am honoured by your desire to form an alliance of friendship with me. If it pleases you, here is my arm, extended towards you in friendship. Accept my hand with yours and let this bond be firm."

Rama held Sugriva's hand in a firm grasp as Hanuman lit a sacred fire, made the appropriate offerings, and placed it between them. Rama and Sugriva then circumambulated the fire. They looked at each another with immense affection, and Sugriva said, "Hanuman has explained why you are here. I will return your beloved Maithili to you no matter what the means and from whichever realm she has been hidden in." He told Rama that he may have seen Sita. "We were sitting on a

> "**Raghava** was **comforted** by Sugriva... Having **regained** his normal state, the **lord Kakutstha** addressed Sugriva... '**This is what a friend** should do, **gently** and with **one's welfare in mind**.'"
>
> RAMA TO SUGRIVA, *SARGA* (7), KISHKINDHA KANDA

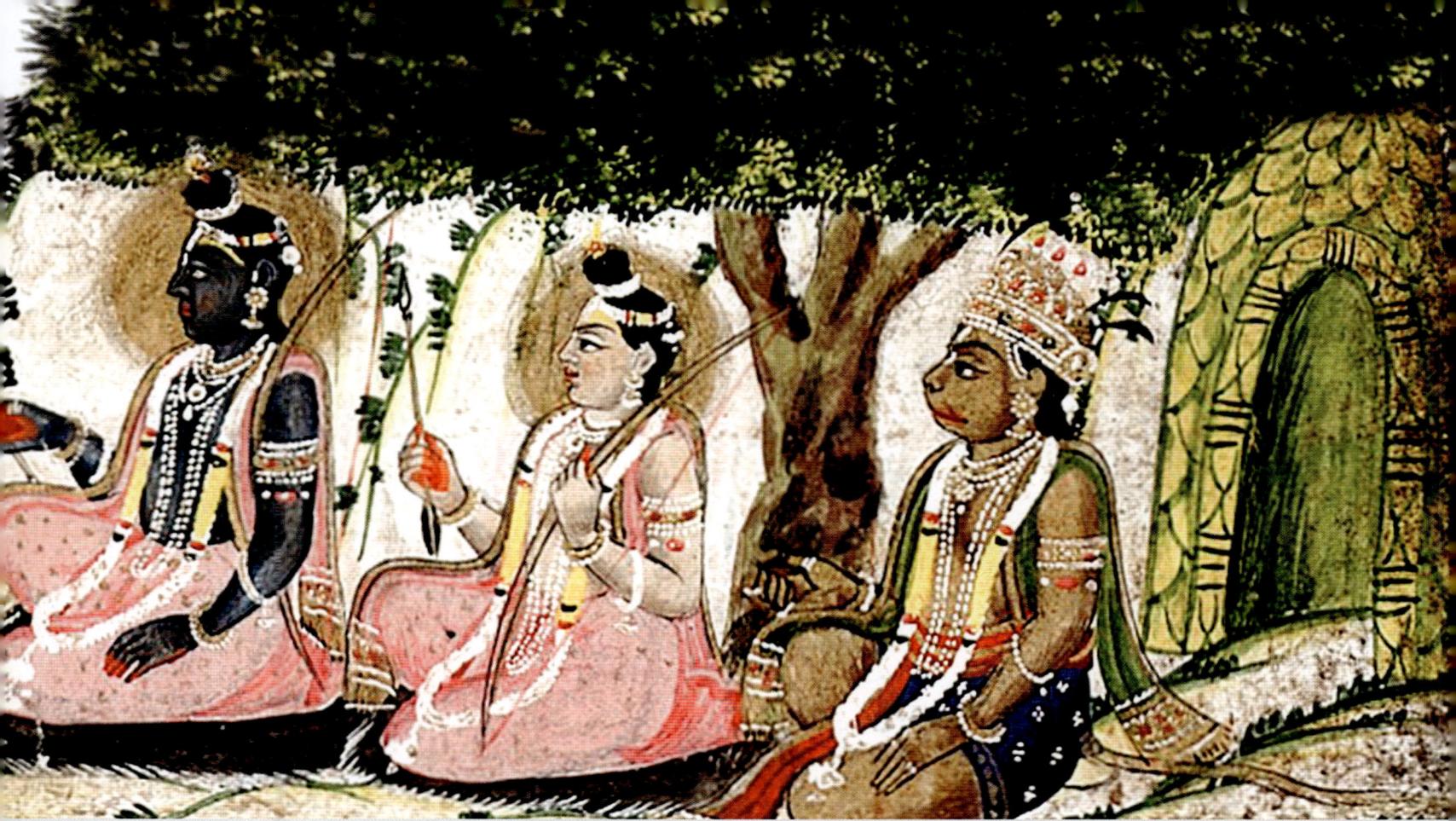

hilltop when a weeping woman threw down a cloth and ornaments. It could have been your wife being carried across the sky," he said.

A friend's consolation

Sugriva brought forth the ornaments and, seeing them, Rama's eyes filled with tears as he held them close. He showed them to Lakshmana, who looked at them with reverence and said, "I do not know her armlets or earrings, but I know her anklets, as I worshipped her feet every day."

Rama asked Sugriva with some desperation, "Where did you see her taken? Where does this Rakshasa live? What is the strength of his armies? Which family does he belong to?" Sugriva said he did not know the answers, but added,

"Do not lose hope, O scorcher of enemies. I am an ordinary Vanara and I have not grieved over my wife's abduction in such a way. You are an illustrious man, known for his forbearance and virtue across the land. Those who lose themselves to grief don't find joy, and their strength and valour diminish. Do not think I presume to preach to you. I merely speak as a friend."

Rama offers his help

Rama wiped his tears and embraced Sugriva, "You only speak as a friend would, Sugriva. Pacified by your affectionate address, I have returned to my natural state. You have promised to help me find Sita. Now, O tiger among Vanaras, tell me what I can do for you. Whatever you need will come to be, like the

seeds in a well-prepared field during the monsoon. What I have said in pride, take as bare fact, for I have neither uttered a lie in the past, nor shall I in the future. This, I swear upon truth itself."

Hearing the words of the mighty Rama, Sugriva knew his endeavour would be successful. "The gods must be smiling upon me today, for how else could a scion of the Raghus be my friend, witnessed by the sacred fire? One may win the kingdom of the gods with a friend such as you by one's side, what of my own kingdom. Friends, whatever state they may have fallen into, and whatever state one may fall into, remain the ultimate refuge," he said.
He then told Rama the story of his own misfortune.

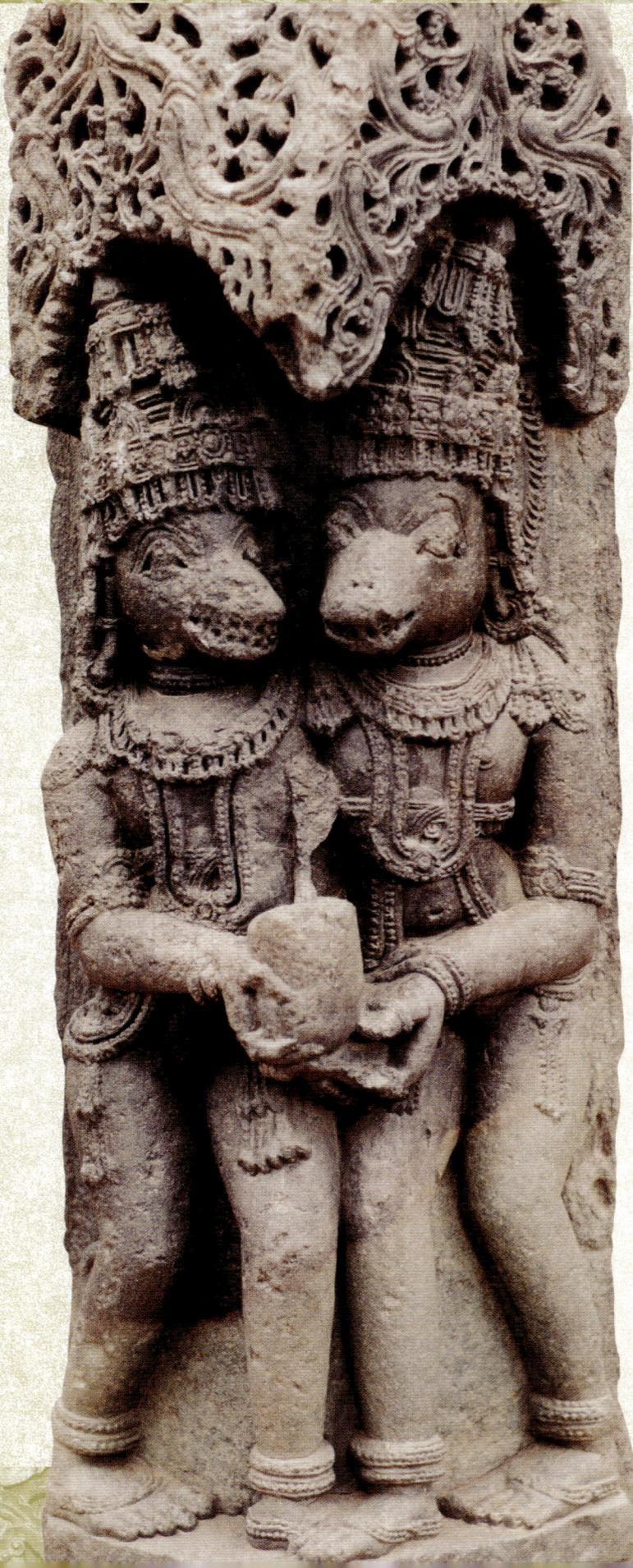

BROTHERS IN ARMS
A 12–13th-century sculpture from the Hoysala period in present-day Karnataka portraying Vali and Sugriva

STORY FROM THE *RAMAYANA*

A Tale of Two Brothers

Sugriva held back his tears as he told Rama that he feared his brother Vali would kill him. Then, tell me, said the prince of Ayodhya, the truth of your enmity with your brother.

Sugriva had always loved his elder brother Vali, as had their father, the king of the Vanaras. After their father's passing, the ministers agreed that Vali would be the new king, as he was the eldest. Sugriva, dutifully and willingly, served his brother, who ruled over the kingdom.

A midnight battle

One night, as everyone slept, the Asura Mayavi, Vali's great enemy, appeared at the gates of their kingdom, and challenged him to a duel. Vali, being valiant and proud, found it difficult to ignore the challenge. He disregarded Sugriva and his family's pleas and stepped out, intending to kill Mayavi.

Sugriva realized that Vali would not listen to reason and decided to go with him. As the two brothers approached the Asura, he turned and fled down the moonlit forest path. Vali and Sugriva followed until he entered an underground tunnel through an entrance, covered with twigs. Angry at the thought of his enemy escaping, Vali commanded Sugriva to stay by the tunnel opening, "Stay here while I go and kill this Asura." Ignoring Sugriva's protests, Vali forced his brother to take a pledge and went into the tunnel.

The missing king

An entire year passed as Sugriva sat by the entrance, waiting for his brother to return, and weakened by fraternal affection, wondered if Vali was dead.

One day, Sugriva saw a stream of blood, mixed with foam, flow out of the tunnel, followed by frightening and fierce roars of Asuras. Already worried about Vali's safety, Sugriva jumped to the conclusion that the blood was his brother's. He thought that the sounds were his brother's cries of pain, and a triumphant Asura's roars. He became convinced that Vali had lost the battle and

his life. Grieving and worried that Mayavi would return through the tunnel, Sugriva rolled a boulder the size of a mountain, across its opening.

He returned to Kishkindha and tried to hide what had happened. The ministers and advisers, worried about a kingless land, however, soon discovered the truth and consecrated Sugriva as king.

The brother returns

Sugriva as the ruler of Kishkindha, was righteous and just. However, one day, Vali returned, victorious from his battle with Mayavi.

He saw Sugriva on the throne and grew furious. Sugriva had the power and strength to defeat Vali in battle, but that did not even occur

SIBLING PRINCES
Vali and Sugriva were known for their uncanny resemblance. They are depicted in these statues in Neelkantheshwar Temple in Pune, Maharashtra.

to him, because of the love and respect he had for his brother. Instead, he greeted him with due reverence, knowing him to be a person of standing. Vali did not respond with the blessing that should follow such greetings.

Sugriva tried to placate him, saying, "We are fortunate that you have returned safely, after destroying your enemy. I was orphaned, but have regained my protector. Please accept this royal umbrella, which rightfully belongs to you. You are the king, and I return to you the kingdom, which I held in trust on your behalf, and remain your servant as before."

"Mighty destroyer of enemies," he continued, "You ought not to be

angry at me. I ask this of you with my palms brought together in supplication. The ministers forcibly thrust the task of being king on me."

Sugriva is exiled

Vali dismissed Sugriva's words with a derisive syllable and yelled, "Shame! Shame!" He summoned the ministers and the people of the city and said, "You know how the Asura Mayavi challenged me that night. This Vanara," he said, pointing to Sugriva, "came with me as I set off in search of the Asura. I told him I could not return to the city without defeating the enemy, and asked him to guard the tunnel. When I returned victorious, thinking my brother awaits me, I found the entrance blocked. I called to him, but there was no answer. I kicked the rock and got out.

He had as good as buried me alive because of his desire for the kingdom."

Vali narrated the events in this way and Sugriva found

LOCATION

KISHKINDHA

The region of Kishkindha is sometimes identified as being around the River Tungabhadra in the southern state of Karnataka. Apart from its treatment in the *Ramayana* as the abode of the Vanaras, Kishkindha is referred to, in some recensions of the Sanskrit *Mahabharata*, as being ruled by the Vanara brothers who battled and then allied with the youngest Pandava who was acting on behalf of his eldest brother. It is significant that since Rama had vowed to not enter cities or villages during the period of exile, he never actually entered Sugriva's realm, even after the latter had been installed as the ruler.

himself banished from the kingdom. Vali laid claim to his wife, Ruma, and the exiled Sugriva roamed the earth until he finally found refuge in Rishyamuka.

"**On seeing** that I had been consecrated, his **eyes turned red** with **rage**. He bound up all my ministers and spoke **harsh words**."

SUGRIVA, ON VALI'S REACTION TO HIS CONSECRATION,
SARGA (9), KISHKINDHA KANDA

A Show of **Strength**

Rama grew angry when he heard of Sugriva's unfortunate fate and promised to help him defeat Vali. How would Rama accomplish this, Sugriva asked the prince, as Vali was a great warrior, known for his courage and valour across all the lands?

Sugriva pleaded, "I am deeply pained because my brother cast me out and I now live here, in Rishyamuka, out of fear. Rama, please grant me your favour by defeating Vali."

With the hint of a smile, Rama said, "My arrows are unfailing and sun-like in their splendour. Angered, they shall strike the deviant Vali dead. The slanderer, who is a brother only in name and took your wife, only lives so long as he does not come into my line of sight. You will have what you desire."

Vali, the brave

Sugriva felt relieved, but could not rid himself of his doubt, so told Rama of Vali's valour. "Each morning, before the sun rises, Vali walks the earth from the western to the eastern and southern to northern oceans," he said. He told him of the fierce battle between Vali and the mighty bull-Asura, Dundubhi who once desired a partner to battle. He challenged the ocean who refused. He turned to Himavat, the father-in-law of Lord Shiva, the Destroyer, who thinking himself unequal to the task, suggested Vali.

The Asura went to Kishkindha and challenged Vali, who accepted and, after a fierce battle killed Dundubhi. He threw the Asura's heavy body across hundreds of yojanas.

"Look," said Sugriva, "this is Dundubhi's skeleton. And here, are the sala trees that Vali can single-handedly shake till they are leafless. How will you defeat such a mighty Vanara in battle?

I know you to be capable of doing so if you pierce these trees with a single arrow."

Rama lifted the skeleton with his toe and kicked it over 10 yojanas away (about 126 km or 90 miles). Sugriva remained unconvinced. "The body that Vali lifted and threw was heavy with flesh and blood, and you kicked a mere skeleton. This will not help me judge which of you is more powerful," he said.

Rama lifted his bow and, placing a single arrow, aimed at the trees. The arrow pierced through seven sala trees and the flat flank of the mountain, entered the seven layers of the earth, and then returned to Rama's quiver.

Sugriva placed his head on the ground, his palms respectfully together and said, "Who can stand in battle before the one who shattered seven sala trees, the mountain, and the earth with a single arrow! My grief has come to an end, surely, as I have gained a friend who is the equal even of Indra, the king of gods, himself."

Rama embraced Sugriva

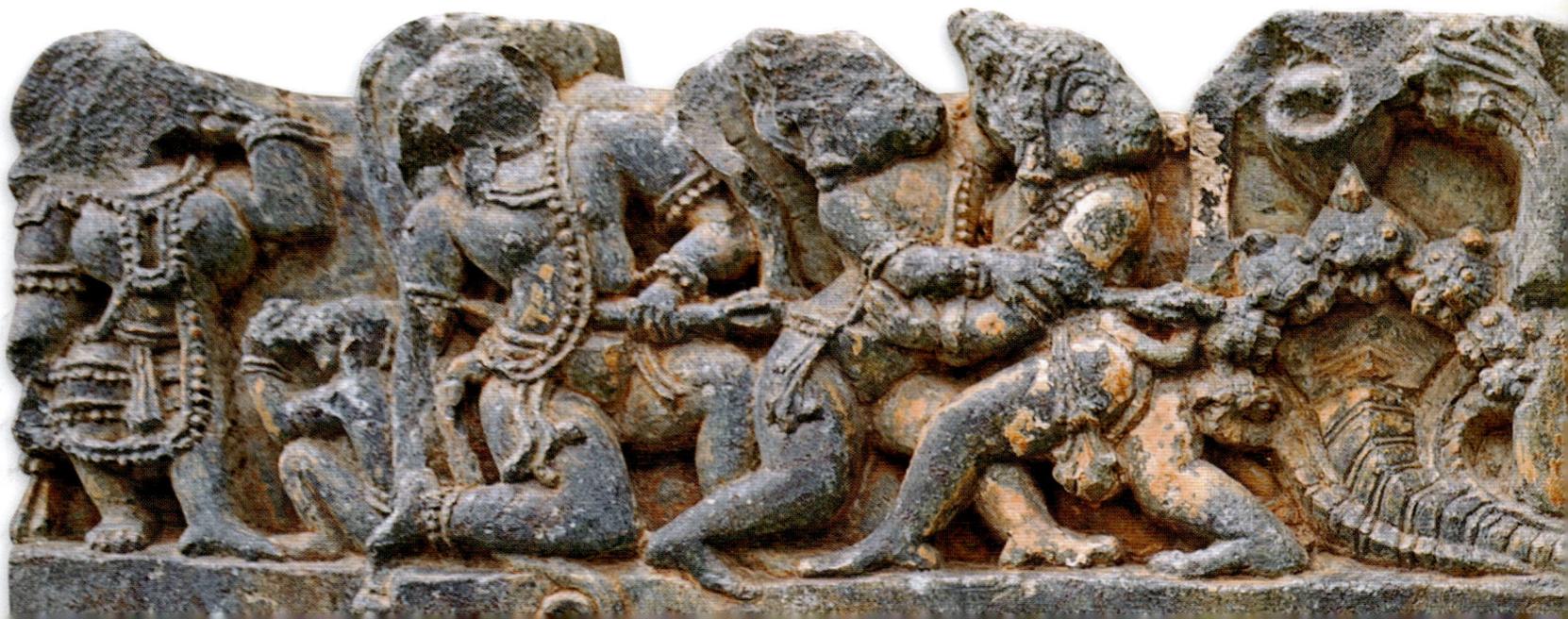

> "There is an **immensely wise**... Vali and he is like **Shakra in his valour**... He is immensely **wise and skilled** in fighting."

HIMAVAT, FATHER OF THE GODDESS PARVATI, PRAISING VALI TO DUNDUBHI, *SARGA* (11), KISHKINDHA KANDA

and, in agreement with Lakshmana, said, "If you are convinced of my strength, we shall go to Kishkindha. Led forth by you, we shall challenge Vali."

A battle between brothers

On reaching Kishkindha, Rama, Lakshmana, and the others hid behind trees as Sugriva called to his brother. Vali emerged and, when he heard his brother's challenge, grew furious.

The brothers fell upon each other, as if the planets Venus and Mars were attacking each other in the sky.

Rama stood behind the trees, bow in hand, and watched the brothers battle. Perplexed, because he found them identical and could not tell them apart, Rama decided not to release the fatal arrow.

Sugriva could not see Rama, his protector, anywhere. Beaten by Vali, he escaped to Rishyamuka, his limbs drenched in blood and body rendered frail by his brother's cruel strikes. Vali saw him enter Rishyamuka, a region he could not enter because of a curse (See box), and cried, "You have been saved!"

Mistaken identity

When Rama, Lakshmana, and Hanuman reached Rishyamuka, Sugriva saw them and looked at the ground, ashamed. He said to Rama, "You demonstrated your strength and asked me to challenge Vali. I did so,

presuming your strength to be on my side. What did you do, Rama? It was not for the lack of strength that you watched my enemy beat me."

Rama replied with pain and compassion, "My dear friend, let go of your anger and listen to why I did not release the arrow. Your ornaments, voice, and splendour were all so similar that I could not tell you apart. What if I had shot you? I have granted you my protection and had I killed you, it would have been a sin. Lakshmana, Sita, and I are dependent on you."

Rama then told Lakshmana to place a blooming *gajapushpi* (cardamom) vine around Sugriva's neck to make it easier for him to tell the brothers apart. "See, Sugriva, how I fell Vali with a single arrow now," Rama said. They left for Kishkindha once again, to challenge Vali.

Taaraa's request

Outside the city, Sugriva looked at Rama and said, "We are in Vali's city again.

Make good of the promise you made." The prince reassured him. Sugriva called out to Vali once again.

Vali heard him and got ready to step out when his wife Taaraa stopped him. "He is challenging you for the second time. There is something suspicious. Sugriva is not alone. Prince Angada told me that he is friends with the fierce Rama. Consecrate Sugriva as the crown prince and end this rivalry. Do as I say, please. He is your younger brother and deserves your affection," she said.

Vali retorted, "This angry brother of mine is also my enemy. I will not tolerate this. You should not worry about Rama's actions towards me, for he knows dharma. I won't kill Sugriva, I will only destroy his pride." He turned and walked out, prepared to battle his brother once again.

EYES ON THE TARGET
Rama shoots through trees at Vali in this 12th-century carving on the friezes of the base of the Kedareshwara Temple in Halebidu, Karnataka.

Vali's Death

Hidden amid the trees, Rama took aim and felled the fierce Vali. As the Vanara king lay dying, he accused the prince of not following the rules of dharma. He could not have been further from the truth.

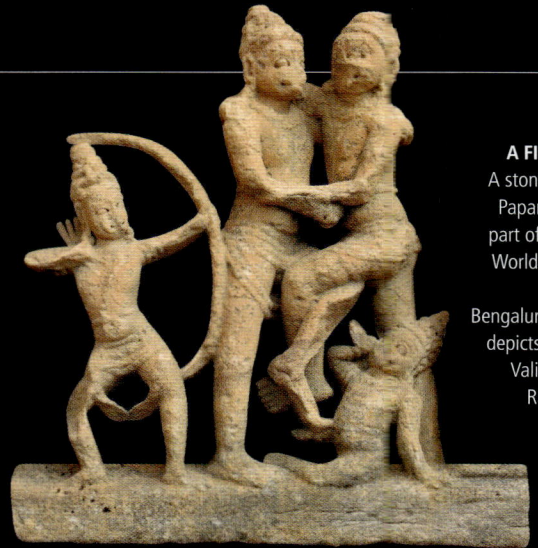

A FIERCE BATTLE
A stone sculpture at Papanatha Temple, part of the UNESCO World Heritage site, Pattadakal, in Bengaluru, Karnataka, depicts Surgriva and Vali in combat as Rama prepares to shoot Vali.

The two brothers, terrible and strong, advanced towards each other. Sugriva uprooted a sala tree and swung it at Vali, striking him like thunder upon a mountain. He retaliated and the fierceness of his attack broke Sugriva's pride. At that moment, Rama shot an arrow at Vali's chest and as it found its mark, he collapsed like a felled tree.

Vali was like the moon, dislodged from the sky and no longer illuminating the earth. Even fallen, Vali did not lose his splendour, as the necklace that Indra had bestowed upon him, held it in place.

"Why did you kill me?"

Rama and Lakshmana walked up to the fallen Vali. He saw them and said, "You are known as one who is engaged in the welfare of people, firm in your vows. Taaraa told me of your alliance with Sugriva, but I was convinced that you would not kill me when I had been challenged by another. Your adherence to dharma is well known. I now know that you are as vicious as a pit covered in twigs. I never harmed you or your realm. Why kill me when I am faultless?" So, accusing Rama of abandoning the path of dharma, Vali fell silent.

The dharma in the act

And so, on Vali's deathbed began a debate on dharma, and Rama pointed out Vali's chief crime, for which he had to be punished (See pp 178–79).

Rama said, "It is right to kill a man who acts with desire towards his daughter, sister, or younger brother's wife. You acted this way towards Sugriva's wife, Ruma. Also, my love for Sugriva is the same as that for Lakshmana.

I gave him my word, how could I ignore that?" Vali eventually accepted Rama's words and, joining his hands in salutation, said, "Act towards Sugriva and my son, Angada, as you would towards Lakshmana and Bharata. Protect them. Instruct Sugriva so that his behaviour with Taaraa is not harsh."

Rama consoled him as he said, "Having received your just punishment, you are devoid of blemishes and have

> "Though he had **fallen down** because his inner organs had been struck, **the garland, his body,** and the arrow dazzled."

ON VALI'S SLAIN FORM, *SARGA* (17), KISHKINDHA KANDA

DEATH OF A KING
This 1780 painting from Kangra, Himachal Pradesh illustrates Vali's funeral pyre and the Vanas grieving for their fallen leader.

CHARACTER PROFILE

TAARAA

Valmiki endows Taaraa with a rather distinct character. She is devoted to her partner Vali and Kishkindha, but is not afraid to speak her mind. She engages in matters of administrative and diplomatic importance. Angada seems to report certain goings-on of Sugriva's camp to her rather than Vali, which is why she is able to tell her partner about Rama's presence. Later, she is also the only one with the presence of mind to explain the situation to an angry Lakshmana (See pp 184–85). Though Sugriva earlier professes ignorance about Ravana, Taaraa gives Lakshmana details about the Rakshasa king's army. Later, the fact that members of Vali's retinue meet her as they return from the battleground and encourage her to take charge, as does Hanuman, emphasizes the power she wields.

established yourself in your natural state, which is in consonance with dharma."

Taaraa's grief

Taaraa heard that Rama had shot Vali, who lay dying, and rushed to be by his side. She chastised his retinue who had fled fearing Rama's anger. She ignored their advice to consecrate Angada and said, "What do I have to do with the kingdom or with life when Vali, the tiger among Vanaras, leaves us? I will follow him as well."

She sat beside her mighty husband and cradled his body. Sugriva, seeing Taaraa and Angada in such a state, mourned his dying brother as well. Taaraa lamented, "Your strength and valour remained undefeated in battle. Get up now, go to your well-appointed bed. Or is it that as a king you love the earth even more than myself that you do not abandon her even when I ask you to? How does my heart not split into a thousand pieces?

"Angada, look at your father with care, for to see him shall become impossible. Sugriva, enjoy your kingdom without any agitation, for your enemy, your brother, lies slain." Hanuman consoled her,

"The good or bad acts a being performs return to bear their fruit. And what is there to be grieved, and by whom, in this body that is as ephemeral as a bubble? The existence of all beings is impermanent. Do not grieve, for Vali has attained the realm of those who are triumphant in dharma." He told her to take solace in her son who would soon be consecrated and said, "The Vanaras and these realms look upon you as their overlord."

Vali, whose breath was slowing, asked Sugriva to rule well and take care of Angada. He said,

"You are Angada's protector. Follow Taaraa's advice, and make sure you fulfil your promise to Rama."

He breathed his last and Taaraa lamented, "Look, royal glory does not abandon you even when your breath has ceased, even as the sun's rays do not abandon the great mountain as it sets."

Rama said, gently, "The departed soul does not attain peace and happiness through the pain of grief that the family experiences."

> **"Listen, Rama,** my trickery will not work with the master. Lord, **am I still a sinner,** with you as **my refuge** in the final moment?"
>
> VALI TO RAMA, *RAMCHARITMANAS*, BY TULSIDAS

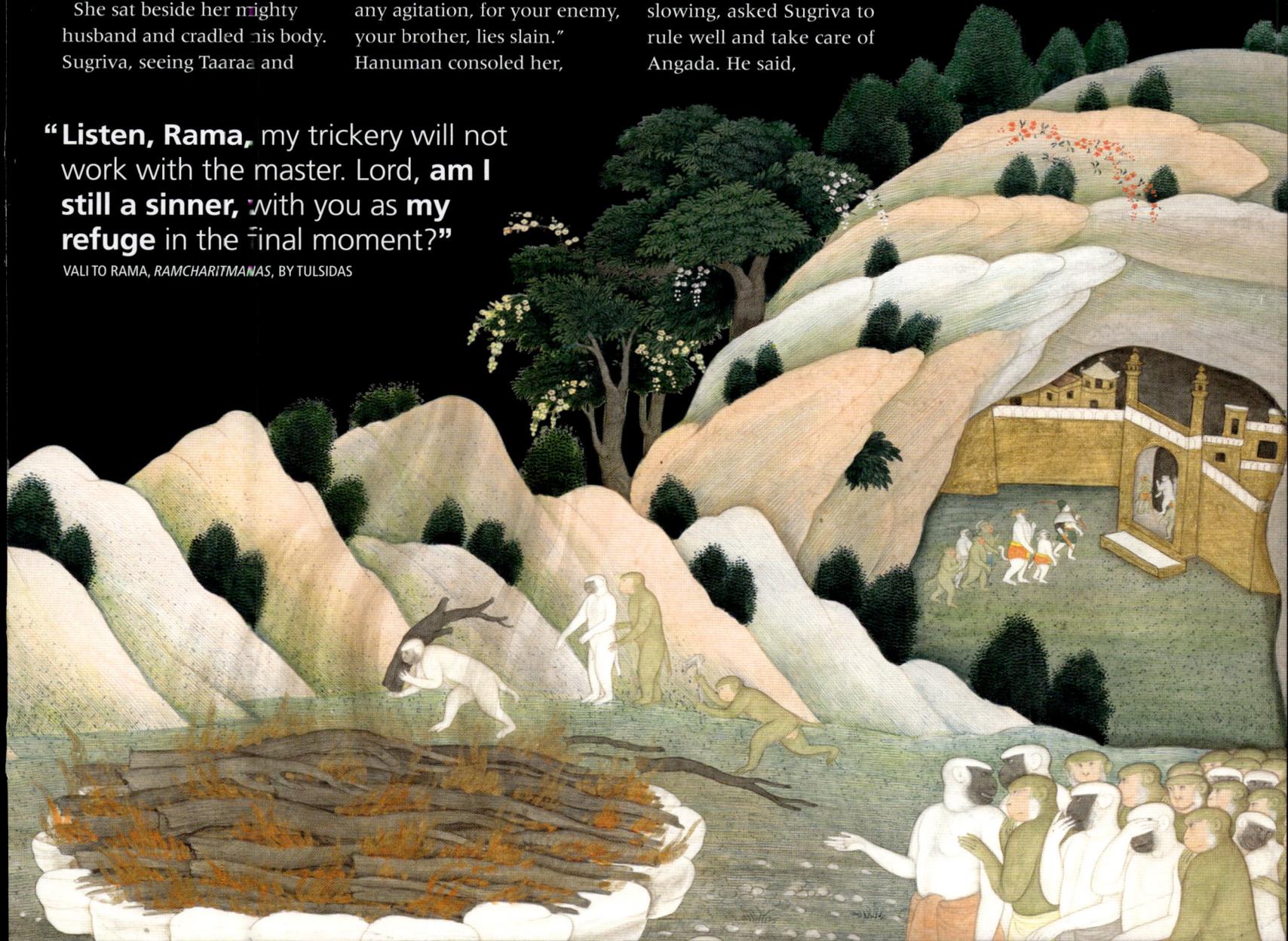

DHARMA OF PUNISHMENT

Vali's Offence

> "When I did **not see you**, I arrived at the **conclusion**, 'He should not **hurt me** when I am distracted and am **fighting against** someone else.'"

VALI'S FINAL WORDS TO RAMA, *SARGA* (17), KISHKINDHA KANDA

In the *Ramayana*, there is more than one occasion when Rama makes a choice that troubles both premodern and modern readers. There is rarely an instance, however, when Rama can be accused of taking an easier path. In what is one of the most controversial episodes, Rama exposes himself to this problem.

The treatment of Vali's death conveys the perspective taken by a retelling of the nature of Rama's person (human/divine), his mission, and the status of his acts, and whether they are to be examined by the same standard as regular human actions.

VALI'S CRITIQUE

In Valmiki's *Ramayana*, Rama stands unseen and shoots an arrow at Vali while he is battling Sugriva. In his version, Vali presents a scathing and powerful critique of Rama's actions. He suggests that Rama's reputation of adhering to dharma is undeserved and deceptive, as Vali's death is a result of not heeding Taaraa's advice and thinking of Rama as virtuous.

He goes through all the reasons Rama could have had to kill him and why they do not stand. In Vali's opinion, he never harmed Rama's realm or capital, and did not even know him well. To that extent, Vali is faultless. If he was shot as an animal, then it would still not make sense, for his skin and meat are prohibited for those following dharma. If Rama's act was to appease Sugriva, Vali would have dragged Ravana to Rama himself and helped in rescuing Sita.

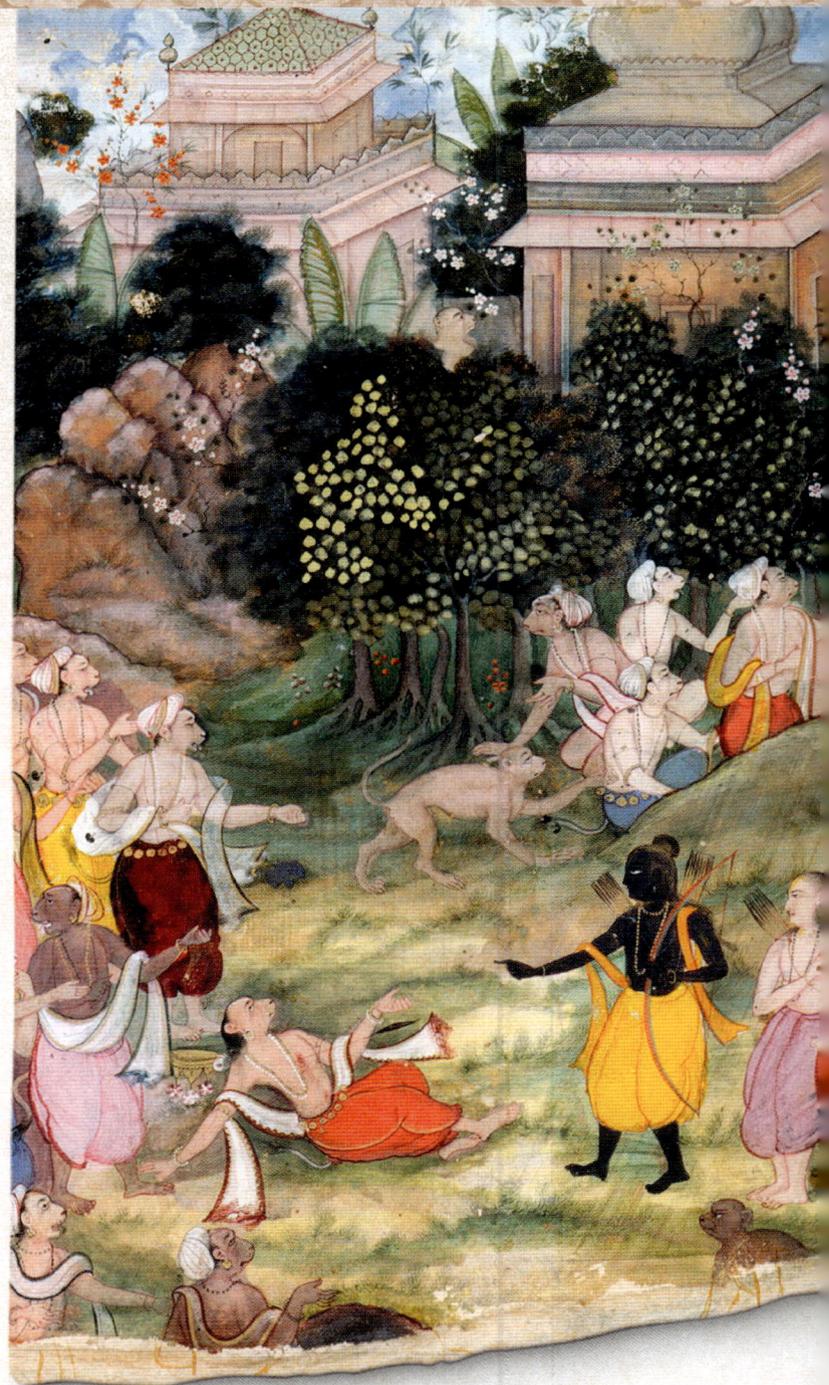

VALI'S ACCUSATION
A dying Vali questions Rama's dharma in killing him and the prince, attired in yellow, responds, in this painting from 1595 in opaque watercolour and ink on paper.

THE REBUTTAL

Rama's response to Vali focusses on his duty to punish. He says that the land upon which they stand belongs to the Ikshvakus, and is part of Bharata's realm. Being subjects of Bharata, the warrior class is obliged to uphold dharma whenever they come across its violation. Vali's chief lapse from dharma, as Rama puts it, is that he acted with desire towards his younger brother's wife, who should have been treated as a sister or daughter. Acting under Bharata's decree, Rama has no choice but to kill him. Besides, once Rama has given Sugriva his word, he cannot go back on a promise to a friend. Finally, according to Rama, it is fair to have hidden and killed him because Vali is, after all, an ape, and regular rules of engagement are, therefore, inapplicable. All attacks are permissible in a hunt.

Rama, while an incarnation of Vishnu, has to forget his divinity for the plan to kill Ravana to work. To that end, his actions are scrutinized as those of a person, and so he is questioned, to which he responds. One purpose of Valmiki's *Ramayana* is to articulate issues of dharma. In this case, it is certainly possible to argue on either side effectively on the basis of the text. There is, thus, within the *Ramayana*, the scope to argue on Vali's behalf, a position taken particularly by those seeking to highlight elements in Rama's story that are perceived as symptomatic of ills (or faults) in Indian society.

STANDING TALL
This depiction of Vali from Bali, Indonesia, has the Vanara king clenching his *gada* (mace).

RAMA'S INTENT

Not all of Rama's stories serve the same purpose. Readings of this encounter with Vali depend on changing the narrative or understanding Rama's subjectivity and motivations differently.

Eighth-century playwright and poet Bhavabhuti, for instance, portrays Rama more sympathetically than Valmiki. His strategy, more often than not, is to change the plot. In his play *Mahaviracharita*, academic Usha R Bhise points out that Rama's battle with Vali is not deceitful. Vali is asked to battle Rama because of his friendship with Ravana and he is not happy about it. What follows is a restructuring of Valmiki's narrative where Rama does not shoot Vali as he fights Sugriva.

If Rama is considered the compassionate Supreme Lord, there can be no doubt as to his intentions. His actions end up as beneficial for all beings. Dharma is longer the problem.

In his study, "Divine Order and Divine Evil in the Tamil Tale of Rama", Israeli indologist and historian David Shulman discusses Tamil poet Kamba's version, and writes, "This idealism persists strongly in Kampan's (Kamba) poem ... but here it seems at war with another current of feeling, one which regards divinity in a less monotonous light." Kamba's examination of the question, he points out, becomes an engagement with the relationship between God and dharma.

ANOTHER PERSPECTIVE

Tulsidas's *Ramcharitmanas*, which extols Rama as a compassionate being, narrates a dialogue between Vali and Rama. Vali's question at the end of it seems to make it entirely sound like a bit of *lila* (play), "Trickery won't work with the Lord," he says, and asks, "Am I still a sinner when killed by your hand?"

Rather than just comment on Rama's virtue as he rejects Taaraa's advice, he says, "... if he were to kill me – why, I would find refuge!" When Rama offers to let him keep his body he says, "You think of me as very arrogant, Lord, so you make this offer. Sages try for lifetimes, and can't even say "Rama" at their final moment. That Rama stands before me – how could this come about a second time?"

THE SINS OF THE TWO BROTHERS

In Valmiki's *Ramayana*, Angada brings up the fact that Sugriva accepted Taaraa as his wife, while she should have been like his mother. This, by the same logic is applied to Vali and Ruma, Sugriva's wife. Rather than seeing the fact that Rama overlooks this fault in Sugriva, Tulsidas quotes it outside its immediate context and praises Rama's affection for his servants, for the object of his worship is immensely loving.

A CARVING of the fight between Sugriva and Vali at a 15th-century temple in Hampi, Karnataka

THE KING OF THE VANARAS

Sugriva

"I will tell you about the Vanara named **Sugriva**… The valiant one can assume any form at will… With the **Vanaras**, he will search the rivers, the **large mountains** and **impenetrable summits** and **caverns** until your **wife is found**."

KABANDHA TO RAMA, *SARGA* (68), ARANYA KANDA

O ne would expect Sugriva, one of Rama's key allies, to be extolled uniformly as a straightforward and virtuous being. However, the picture that emerges of the Vanara king, first during his exile and then later, is much more real and flesh and blood, with plenty of virtue, but not a trace of naiveté.

Familial relationships

Sugriva has a complicated family situation much before his encounter with Rama. It seems that his relationship with Vali, before the battle with Mayavi (See pp 172–73), is amicable. His intentions in closing the tunnel, too, do not seem suspect. It makes sense that on receiving news of Vali's death, Kishkindha's ministers want to quickly install somebody as the king. After all, it is made clear in Ayodhya Kanda (See pp 70–71) that kingless kingdoms are magnets for danger. Sugriva is an obvious choice – it is not clear whether Angada, Vali's son, is born or old enough at the time.

Relationships become tense with Vali's return. After Sugriva's exile, Vali takes his brother's wife, Ruma, as his own.

Astute ruler

During his exile, Sugriva wanders across four quarters of the earth, enough to offer the armies a virtual map to follow, and chooses to settle close to Kishkindha in a region Vali cannot enter, due to a curse (See p 174). It is clear then that Sugriva has a real head for policy and has excellent advisers, including Hanuman. He is also careful, a trait possibly from his time on the run. This compels him to find out more about Rama and Lakshmana when he first sees them. In fact, his alliance with the princes is a good example of his astuteness, at least in Valmiki's *Ramayana*. It is clear that he is not willing to accept Rama's prowess on his words alone.

There is also the complication of how much he really knows of Ravana when Rama first asks him. Many commentators have tried to understand why Sugriva does not tell Rama what he knows, but it seems that it is too early in their friendship for him to give away all his cards. All this suggests that he has the qualities to run an effective kingdom.

It is also obvious from the way the Vanara armies rush to him that they respect and fear him as their ruler. It is

as apparent in his treatment of them, indicating that he is deserving of their respect as their commander.

A true friend

Sugriva puts everything he has at Rama's disposal until they find Sita and achieve victory, marking him as a true friend. He is also able to comfort Rama at a time when he needs it the most, reprimanding him ever so gently for his growing despondence, while filling him with self-confidence and trust in their victory. Being in a similar situation, allows him to address Rama in a way that Lakshmana finds it hard to.

He is willing to bring his astuteness to bear on Rama's decisions as well, as is clear in his suggestion when Vibhishana seeks refuge (See pp 250–51).

Sugriva's flaws

Sugriva is not without complexity, however, and his greatest flaw, which angers even Rama, is that he forgets his alliance as soon as he gets his kingdom. His relationship with Taaraa is also a cause for censure, for Rama killed Vali for a parallel crime.

It is natural, too, that he has a complex relationship with Vali's son, Angada. After all, Sugriva was instrumental in killing his father and marrying his mother. Indeed, it is Angada whom Valmiki utilizes to present an alternative

narrative of Sugriva's actions (See p 192), bringing under suspicion Angada's coronation as the crown prince.

Depending on how one understands Rama and his story, it is possible to view Sugriva's personality differently. In Valmiki's version, the actions of most figures are motivated by deducible ends, while in the Sanskrit text *Adhyatma Ramayana*, they are understood in terms of Rama's extension of his illusory capacity. In the *Adhyatma Ramayana*, when Sugriva sees Rama's prowess he knows Rama to be the

Supreme Lord and surrenders. For the purpose of his *lila* (divine play), however, Rama extends his illusory power so that Sugriva acts in a way that assists the plot.

In Tulsidas's *Ramcharitmanas*, after Vali's death, Sugriva asks Rama to grant that His grace be such that "abandoning everything, I [Sugriva] remember you [Rama] day and night." Rama accepts his surrender, but does not ask Sugriva to stay, and instead encourages him to rule his newly acquired kingdom.

PORTRAIT OF A KING
This 18th-century Tanjore painting in ink and colour on paper is of Sugriva, the exiled king of the Vanaras. He can be seen here covered in ornaments from head to toe.

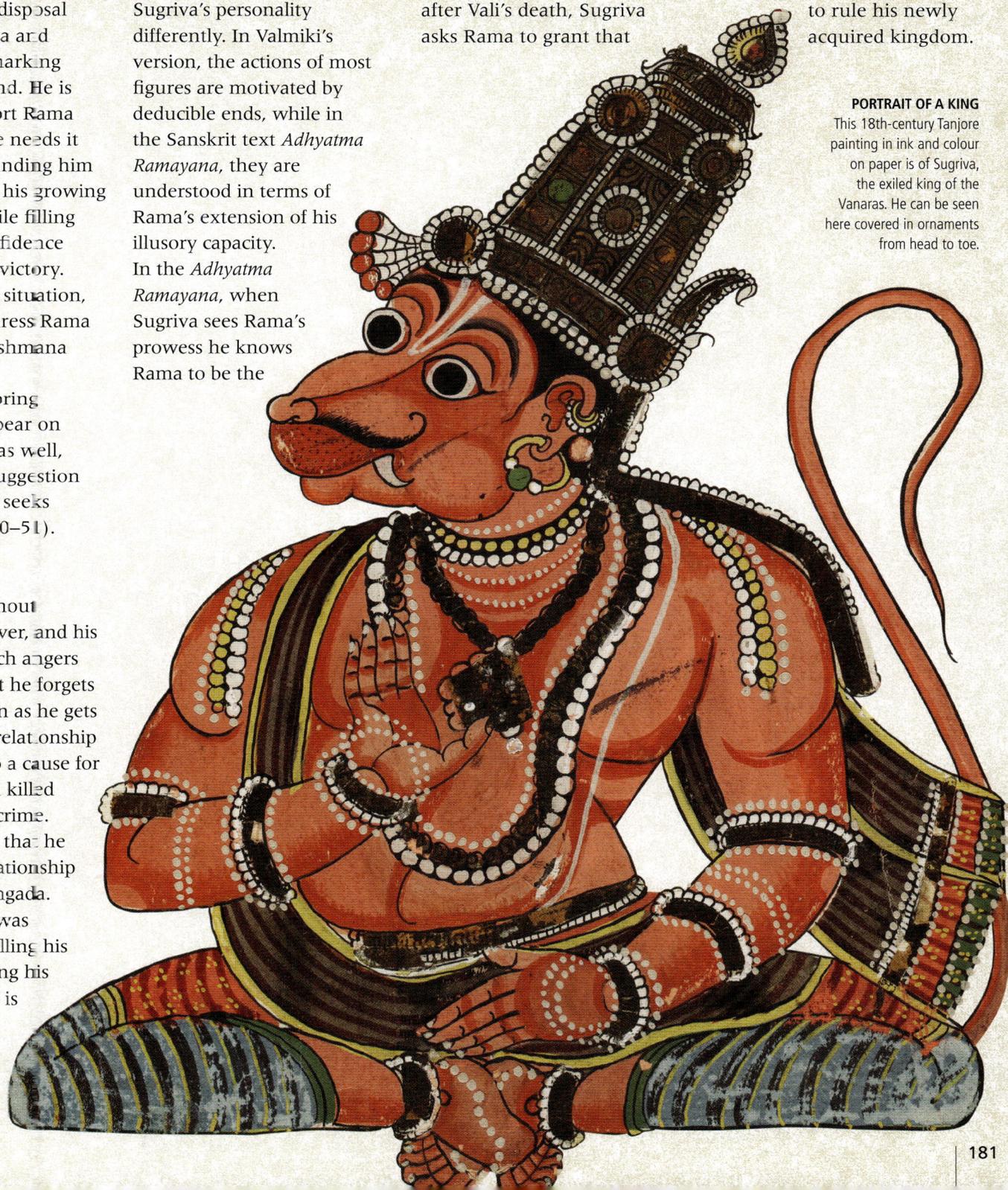

A Monsoon's Pause

After Vali's death and Sugriva's consecration, Rama and Lakshmana retreated to Mount Prasravana and waited for the monsoon to end. As months passed, Rama grew impatient for there was no sign of Sugriva. Had he forgotten his promise?

Lakshmana gently reminded Sugriva that it was time to conduct Vali's final rites. Weeping, their senses numb with sorrow, Sugriva and Angada carried out the rituals.

Once they were complete, Hanuman addressed Rama, "By your grace, Sugriva has obtained his ancestral kingdom. Lord, come to the beautiful Kishkindha where you will be an honoured guest."

Rama refused and explained that, following his father's command, he could not enter a city or village for 14 years. He instructed the Vanaras to consecrate Sugriva and make Angada the crown prince. He said, "The monsoon season has begun and the first of the monsoon months, *Shravana*, is here. We may consider Ravana's destruction in the month of *Kartika*, but this is not the right time for it."

Rama's agony

As Sugriva's grand consecration took place, Rama and Lakshmana found a large cave on the summit of Mount Prasravana, to live in. They were surrounded by the beauty of trees and animals, but Rama found no peace. He hardly slept, for he thought incessantly of Sita.

Lakshmana could not bear to see Rama's agony and begged him to abandon his despondence. "Enough, valorous one. Do not grieve this way, drowning yourself in your worry. All that is desirable diminishes for one who is consumed with worry. Uproot this despondence and become firm in your efforts to destroy the Rakshasa. You

> "The **path along** which the slain Vali advanced **has not withered** away... Adhere to your **pledge**. Do not follow **Vali's path**."
>
> RAMA'S MESSAGE TO SUGRIVA, *SARGA* (29), KISHKINDHA KANDA

are capable of destroying this earth, what of this mere Rakshasa?"

Rama responded with great affection, "You have spoken as a loving well-wisher would. Here, I abandon my grief. I await autumn when I will destroy the Rakshasa."

Pleased, Lakshmana said, "This is like you, destroyer of enemies. You have now returned to your natural state. We shall bear these months together."

The long wait

As the monsoon progressed, the brothers contemplated how expeditions of kings ceased, observed the change in nature, and thought of Ayodhya and Bharata. The memory of Sita, however, continued to torment Rama. He also thought of Sugriva and told his brother, "The Vanara king sleeps in peace, his enemies destroyed, his wife with him, and his kingdom won. I am exiled from mine and separated from my wife. I feel faint and unstable, like a drenched riverbank. My grief is immense, the rains seem endless and my enemy, invincible.

"I did not hasten Sugriva at the time because the monsoon months are inappropriate. He has just found happiness after so long. Further, what I am asking of him is difficult and time-consuming. I thought that when he was well rested and it was time, he will remember what I did and his promise. But I sit here, still waiting."

Losing hope

Soon, the skies cleared and autumn arrived, yet there was no word from Sugriva, and Rama grew faint in his great despair. Regaining some control, he sat contemplating as Lakshmana consoled him.

A forgotten promise

Rama said, "The four months of the monsoon, which were as hard as a 100 years, have passed, and I haven't seen Sita. Look, it is time for kings to resume their campaigns. But I do not see Sugriva make any effort. Has he no compassion for me?

"I have no kingdom and thoughts of Ravana trouble me. I am away from my home and Sugriva disregards me, for he thinks I have taken refuge with him. He does not remember his promise when it is time."

Rama then told his brother to go to Kishkindha. "Tell that foolish Sugriva that calamity afflicts those who do not fulfil their promises. Perhaps, he wishes to hear the terrible sound of my bowstring in battle once

THE MONSOON MONTHS

In many Indian calendars, the month names are variations of the following – *Chaitra, Vaishakha, Jyeshtha, Ashadha, Shravana, Bhadrapada, Ashvina, Kartika, Margashirsha, Pausha, Magha,* and *Phalguna.* The four months of monsoon, beginning in *Ashadha,* including *Shravana, Bhadrapada,* and *Ashvin,* and ending in *Kartika,* are called the *Chaturmasa* (the four months). This is considered a time when travel, military campaigns, and the movement of itinerant ascetics all ceases. This is a time for spiritual observances, particularly for ascetics or committed aspirants, but also has certain tropes associated with it. One aspect of the monsoon is that if one's beloved has not returned home at the beginning of this period, they will be away until autumn.

A BROTHER'S SUPPORT
This ivory relic shows Lakshmana consoling Rama. The relic can be traced to the rulers of the Madurai Nayak dynasty who ruled from the 16–18th century in the state of Tamil Nadu.

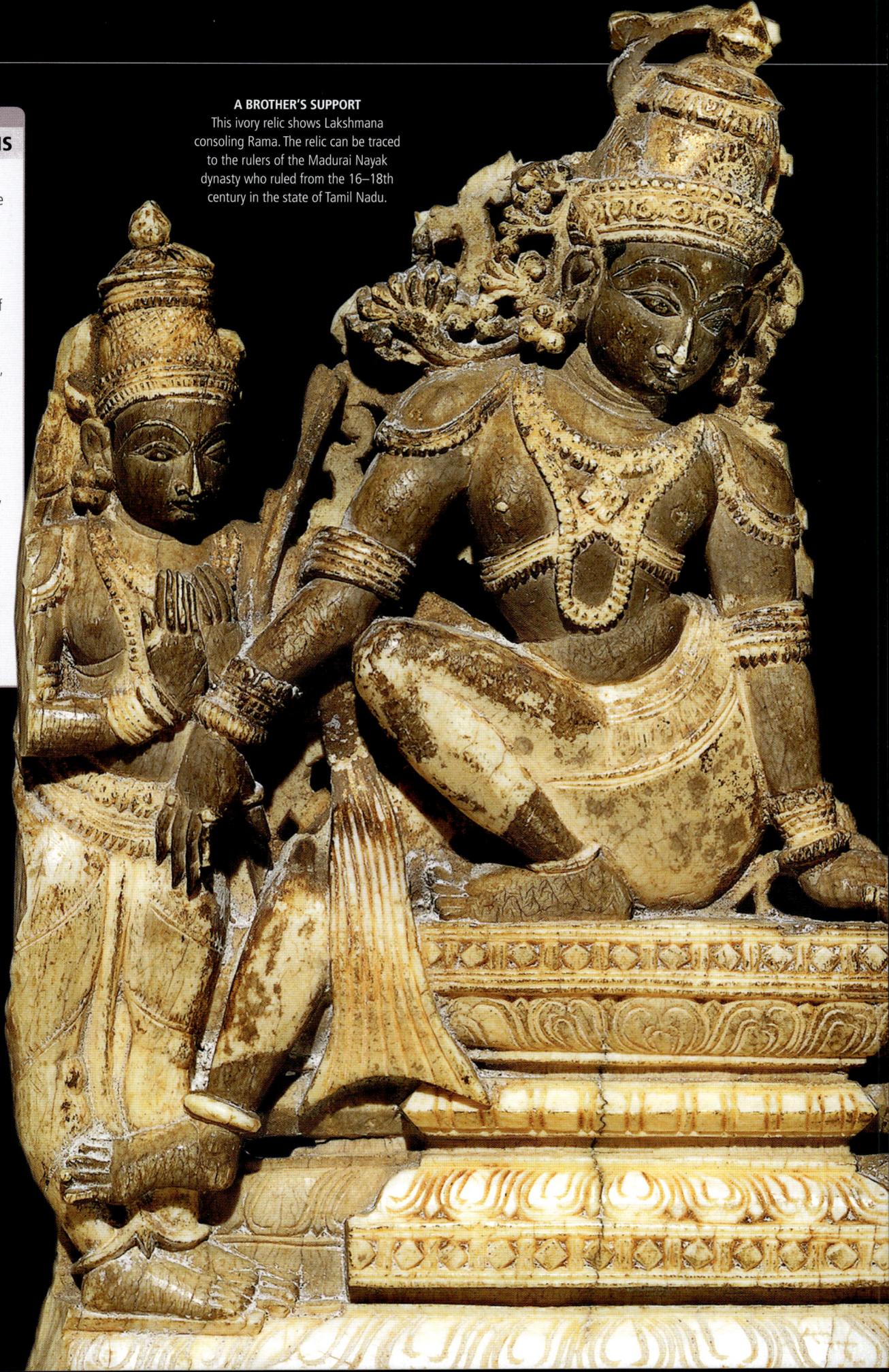

again. Tell him that I may well take the same route with him as I did with Vali."

Moved by his brother's grief, Lakshmana grew angry and said, "This ape shall not act the way virtuous ones do, and I cannot bear my anger, I shall kill this dishonest Sugriva today. Angada can help us instead."

"Do not speak thus, Lakshmana," Rama said, calming him down. "Simply remind him. A true warrior is able to defeat anger." So instructed, Lakshmana left for Kishkindha.

A Friend's **Promise**

Pleased with his victory, Sugriva celebrated like Indra would, surrounded by his celestial maidens. He seemed to have forgotten his promise to Rama. Hanuman reminded him of his duty, but soon, Lakshmana arrived in Kishkindha. Furious, he was ready to kill Sugriva, if needed, for not fulfilling his end of the bargain.

Hanuman observed the swift passage of time. In Kishkindha, he saw Sugriva, no longer beset with fear, luxuriating in his newly acquired prosperity. So, accomplished in the ways of the dharma, Hanuman spoke to him with great affection.

He said, "You have retrieved your kingdom and fame, and augmented your ancestral glory. Now, act in the interest of your friends. You may do something truly unprecedented for a friend after the appropriate time has passed, but that will be of no use. Do what you promised Rama, who possesses immeasurable strength and virtues himself and who helped you. Why don't you prepare to command the Vanaras?" Sugriva understood the import of Hanuman's words and quickly instructed the Vanara commander, Nila, to gather the armies.

REMINDED OF A PROMISE
This painting in two parts from Jammu and Kashmir, India, depicts Lakshmana's meeting with Sugriva and Hanuman in Kishkindha (left), as the other Vanaras (extreme right) look on.

Lakshmana arrives

Meanwhile, Lakshmana entered the great Vanara city, like a fierce storm. On seeing him, some Vanaras ran away, terrified, while others rushed to inform Sugriva. The king was with Taaraa and ignored them and Angada's urgent message. When two ministers finally managed to tell him of Lakshmana's arrival and fury, he wondered what had infuriated the prince.

Hanuman reminded him, "You obviously do not forget favours rendered unto yourself. Rama's anger, coming undoubtedly from a place of love, has compelled him to send Lakshmana. You have been lax in not noticing that time has passed and autumn has arrived. Since an offence has been committed, there is nothing to be done, but to placate him.

"In anger, Rama is capable of lifting his bow and bringing the cosmos with the gods and the Rakshasas under his control. He won't be angry if you go to him and please him, remembering what he did for you. Approach him with your head bowed."

Angry words

The furious Lakshmana entered Sugriva's inner quarters and heard the sweet

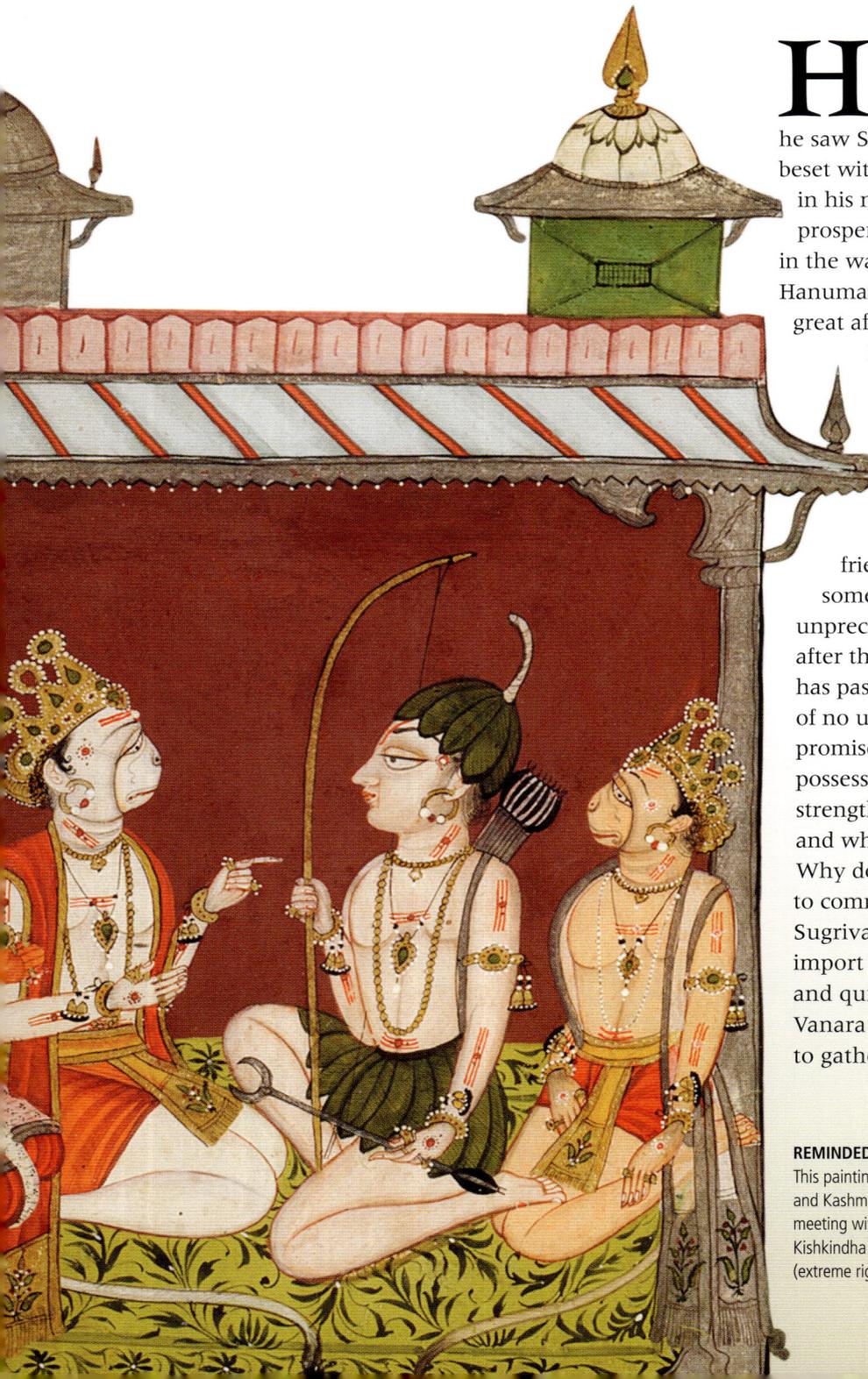

> "Let **Sugriva** be informed about my arrival. Tell him that **Rama's younger brother**, the **destroyer** of enemies, has come to see him. Tormented by his brother's hardship, **Lakshmana** is waiting at the gate."

LAKSHMANA TO ANGADA, *SARGA* (30), KISHKINDHA KANDA

ANALYSIS
SEASONS OF TIME

While there are many ways to understand temporality in relation to Rama's story, the commentarial tradition on Valmiki sometimes uses seasons or astronomical configurations mentioned to work out what happened when.

Commentator Govindaraja uses Rama's proclamation of the month of *Kartika* to clear up some of the dates. He holds that Rama left Ayodhya in *Chaitra* (first month of the year) and they arrived at Sage Agastya's hermitage 10 years later. The Shurpanakha episode and Sita's abduction took place in *Chaitra*, three years after their arrival in Panchavati. Sita is said to have lived in Lanka for a year, so it is likely that Ravana was killed in *Phalguna*. The armies were gathered in autumn and sent out in *Margashirsha*.

sounds of instruments. He saw Sugriva sitting on his golden throne, holding Ruma and looking scared, and said, "A king who restrains his senses remembers what was done unto him and is honest, is exalted in the world. And king of Vanaras, one who doesn't return friends' favours even when he has vowed to that effect, ought to be killed.

"Rama, moved by your pain, got you your kingdom. If you cannot remember the course of events, then you will have occasion for a reunion with your brother, for the path dead Vali took is not blocked. Remain in your vow and do not follow after Vali."

Lakshmana appeased

Taaraa spoke up, "These words do not become you. Sugriva is not an ingrate, nor is he crooked or cruel or deluded. He simply lost track of time when he acquired the kingdom and me and Ruma. If a great sage like Vishvamitra (See p 57) lost track of time when attracted to a celestial maiden, how can you blame a mere mortal? Bull among men, those such as you do not fall prey to anger. Sugriva would give up the kingdom, myself, Ruma, and all his wealth and prosperity for Rama's sake. He shall bring about Rama's reunion with Sita."

She told Lakshmana that Sugriva had sent for the Vanara armies to battle Ravana's army. "Abandon your anger, for millions of Vanaras come to your aid as we speak," she said.

A friend's anguish

Lakshmana accepted Taaraa's words and after he calmed down, Sugriva begged for forgiveness, saying, "I regained lost glory and this realm by Rama's grace. What need has he for help who pierced those trees and the very earth with a single arrow? I shall merely go with him. He will get Sita and slay Ravana in battle with his own strength."

Gentle Lakshmana, now placated, replied, "'My brother is not helpless when he is helped by you, mighty king. You are worthy of the glory of kingship. But come with me and console your friend who is in terrible pain. Forgive my earlier harsh speech, for I was tormented by my brother's anguished lament."

Sugriva quickly turned to Hanuman and instructed him to send messengers to the armies, asking them to hasten. "Those who take too long or are happy to continue indulging in sensory pleasures should be brought here by the force of my command. Whoever doesn't get here within 10 days shall be killed," he ordered.

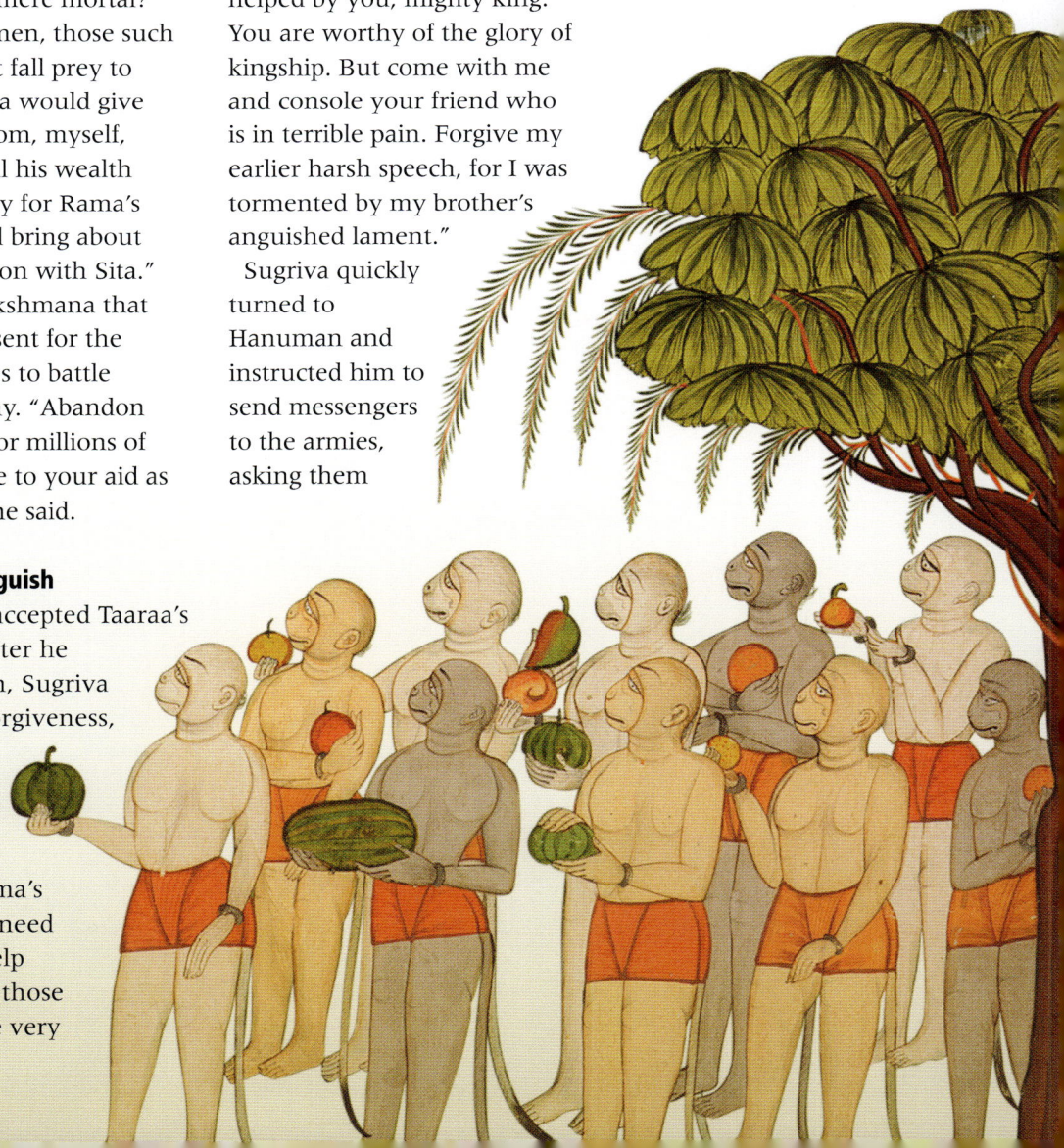

The **March** of the **Vanaras**

Sugriva's messengers went out in all the directions to gather the Vanaras that lived in the five great mountains, the lotus groves, forests, and hermitages. They arrived in millions, on their king's command, to be Rama's army, battle Ravana, and rescue Sita.

Countless Vanaras heard the command of their king Sugriva, who was like death itself in his ferocity. They came from all corners of the land and the great mountains of Mahendra, the Himalayas, the Vindhyas, Kailasa, and Mandara.

Pleased, Sugriva and Lakshmana left for Rama's abode on Mount Prasravana, on a golden palanquin, to the auspicious sounds of conch shells and drums. Surrounded by his fierce commanders and soldiers, he resembled the sun.

Friends reunited

Rama saw Sugriva and his army approach his cave, their hands joined in salutation, out of respect. Almost immediately, his dissatisfaction dissolved and he embraced Sugriva and asked him to be seated.

Rama spoke up, "The king who pursues dharma, economic and political prosperity, and desire at the appropriate times and in appropriate measure is a real king, best of the Vanaras. However, the one who pursues only desire, abandoning the other two, is like a person sleeping on the branch of a tree. Destroyer of enemies, the time for our endeavour has arrived. Contemplate the course of action with your advisers."

Sugriva replied, "I have regained lost fame and glory only because of you, Rama. Look, here are the chiefs of the

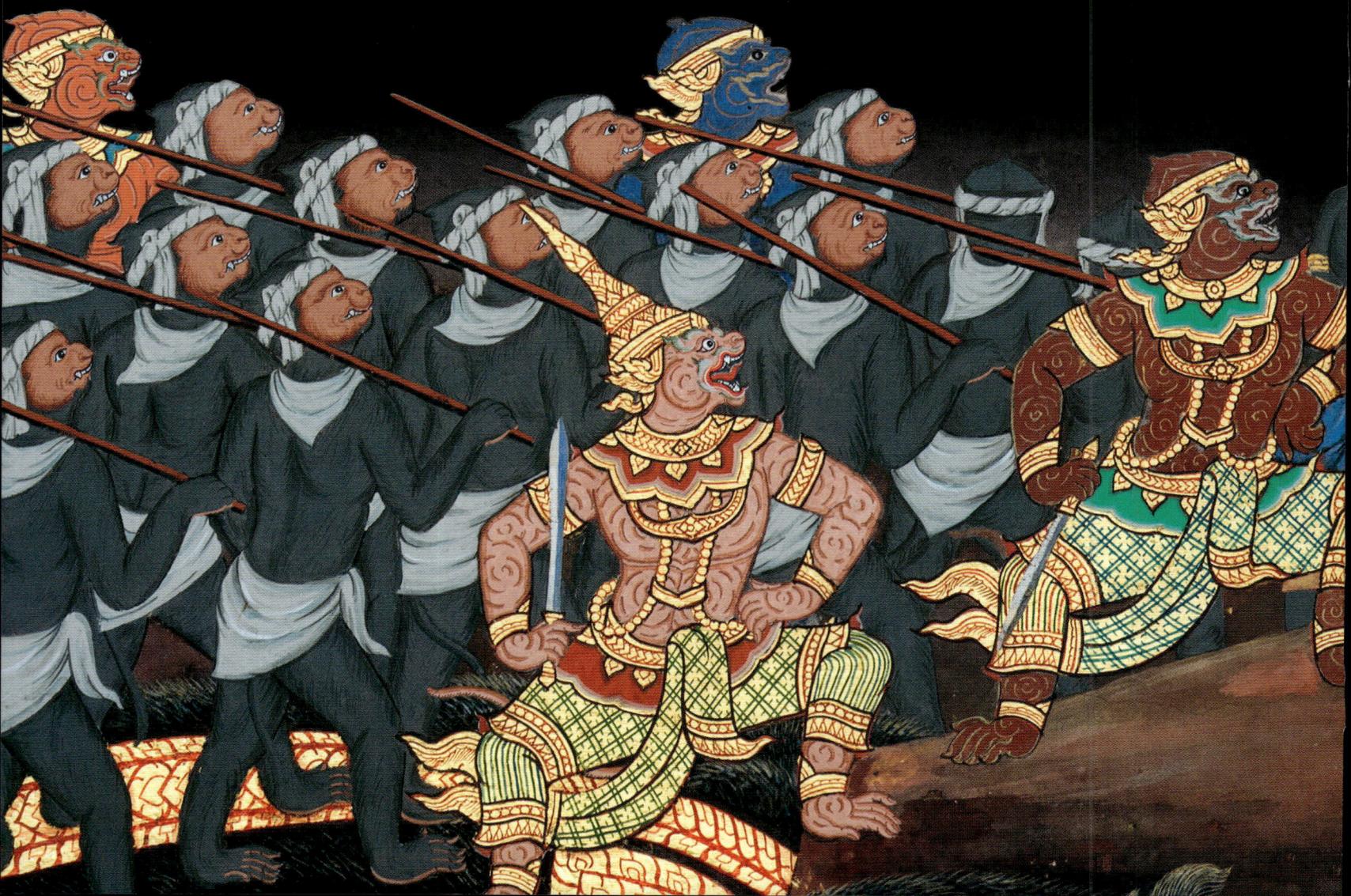

"Rama saw **Sugriva and that large army of Vanaras**, resembling **a lake filled with lotuses and lilies**. He was delighted."

SUGRIVA AND HIS ARMY GREETING RAMA, *SARGA* (37), KISHKINDHA KANDA

THE ARMY MARCHES ON
Hanuman leads the Vanara army in this mural depicting the *Ramakien* (Thai version of the *Ramayana*), inside the Temple of the Emerald Buddha in Bangkok, Thailand.

Vanaras, fierce to look at and familiar with various kinds of geography. They are the sons of gods and Gandharvas (magical beings) and can take on any form. They travel with immense battalions. There are brave Vanaras, Golangulas (apes with special powers), and bears, arriving like the great Indra, king of gods. They shall go to war on your behalf, kill Ravana, and reunite you with Sita."

Rama praised him, "Just as it is not surprising that Indra causes rain, and the sun removes darkness, so it is only natural that a friend like you should act in my interest. With you as my protector, I shall defeat all enemies. Ravana abducted Sita for his own destruction."

The glorious army

As he spoke, immense dust clouds rose, covering even the sun. The ground began to shake and the mountains, forests, and groves quaked. Soon, the entire earth seemed covered by the army of the Vanaras. They poured in from all directions, the strongest Vanaras from the forests, rivers, mountains, and seas, offspring of the gods with Vanara women (See pp 40–41). A large force accompanied each chieftain. The brave Shatabali arrived

with 100,000 million Vanaras, as did Sushena, Taaraa's father, whose face glowed like a golden mountain. Hanuman's father, wise Kesari, with a complexion that resembled lotus fibres, arrived, surrounded by a contingent of a million Vanaras. Gavaksha, the king of Golangulas, terrible in valour, was seen as well, surrounded by his army of 10,000 million Vanaras. The slayer of enemies and known for his speed, Dhumra, the lord of all the bears, came with his warriors, as did Panasa and Nila, with armies of Vanaras as far as the eye could see. Darimukha had 10,000 million Vanaras with him, Gandhamandana

brought thousands of millions of Vanaras, while Angada came with a billion, and Mainda and Dvivida brought 10,000 million each.

The great warrior Tara, who could be seen from a distance like a radiant star, brought 50 million Vanaras while Rambha, with a face like the rising sun, arrived with 11,100 Vanaras. Hanuman came as well, with 10,000 million mighty Vanaras, terrible in valour, like the great Mount Kailasa.

They roared and leapt high in the air. They approached Sugriva, like giant clouds that covered the sky, and honoured their king with folded hands.

LOCATION

MOUNTAINS IN THE *RAMAYANA*

Several mountains are listed when describing the places from where the Vanaras are to be brought forth. Five of them seem to form a set – Mahendra, the Himalayas, the Vindhyas, Kailasa, and Mandara. Valmiki also names the mountains where the sun rises and sets and the mighty Meru and Maharuna.

Of these, the Himalayas are personified most often. Mahendra is sometimes identified with the upper ranges of the Western Ghats in India, whereas the Vindhyas occupy central India. Mandara served as the base for the churning of the ocean (See p 52). Mount Meru has extensive mythological and Puranic apparatus, which often goes along with an understanding of its mystical significance.

Not much is known about the Maharuna, apart from this mention. Kailasa is most famous as the abode of Shiva, the Destroyer, as well as Kubera, the god of wealth, and continues to be of great significance. The locus of Kailasa has the great cross-sectarian and trans-Asian appeal due to the importance of that region not only for Hindus but also for certain Buddhist communities.

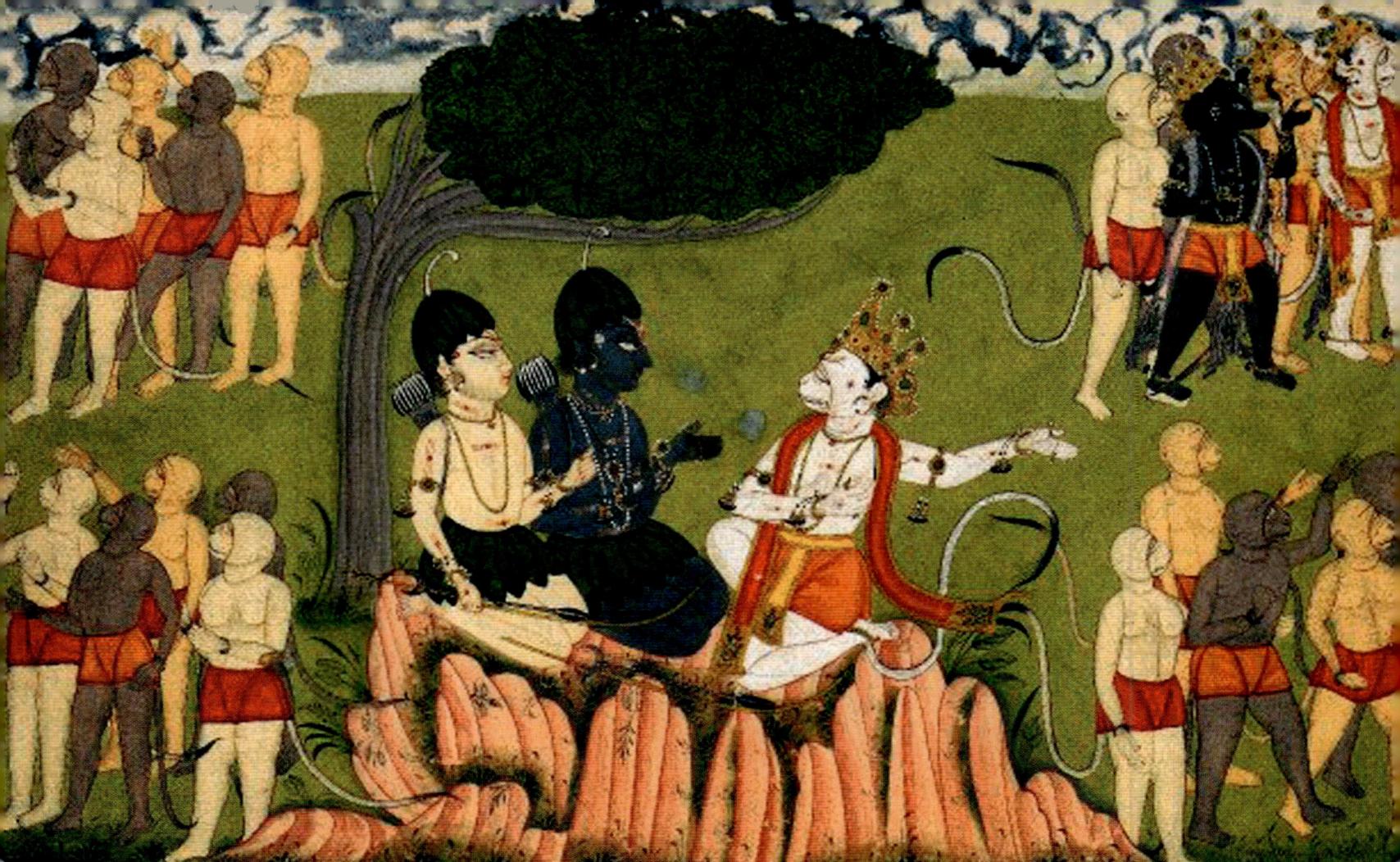

In Four **Directions**

The Vanara army was ready, awaiting Rama's commands, but the prince requested Sugriva to instruct them. So the Vanara king sent his trusted commanders to the four corners of all the realms. Search for Sita everywhere, he told them. Find her.

Sugriva turned to Rama and offered him his army of powerful Vanaras. "They are obedient and ever engaged in the welfare of their lord. Destroyer of enemies! They are capable of achieving your aim. Command them as they are at your disposal," he said.

Rama embraced Sugriva and asked him to find Ravana's realm and see whether Sita still lived. Sugriva, he said, was best suited to command the armies for this task. So, the Vanara king gathered his mighty commanders and gave them the instructions.

Orders for the east
Vinata, he sent towards the east. Sugriva told him to search the rivers, Ganga, Sarayu, Kaushiki, and Yamuna, and the mountain that is the source of the Yamuna. He told him to go to the lands where the Videhas, Malava, Kashi, Kosala, Magadha, Mahagrama, and Pundra lived. "Go to the Yava island, the massive Shishira mountain, and the other peaks," Sugriva said.

On crossing the seas, he said, the army would find Rakshasas and, beyond that, Udayaparvata with the Saumanasa peak, where one can see the sun as it rises. "Cross the Jambudvipa towards the north after sunset and look for Sita there. The eastern region is inaccessible beyond this," Sugriva said.

The southern contingent
He called upon the great warriors, Hanuman, Jambavan, Nala, and Tara next, and placed them under the command of Vali's son, Angada. He told them and their army to go to the south, towards the 1,000-headed Vindhyas, the rivers Narmada and Godavari, and the lands

> "If a **person returns** within a month and tells me that he **has seen Sita**, he will enjoy **affluence** and pleasures... like mine...There will be **no one** who will be more **loved by me**... Even if he has committed... crimes, he will be my **friend**."
>
> SUGRIVA'S ANNOUNCEMENT, *SARGA* (40), KISHKINDHA KANDA

of Avanti, Abhravati, and Vidarbha. "You will see the lands of the Andhras, Pundras, Cholas, and Pandyas. You will find the sacred River Kaveri, home of celestial beings, and Sage Agastya at the summit of the Malaya mountain. With his permission, cross the River Tamraparni, which rushes to the sea like a lover to her beloved," he said. Here, they would find Mahendra, the mountain that Sage Agastya placed in the sea, and, which celestial beings, sages, and even Indra visited.

The far end of that sea, he said, was difficult to access, as the evil Ravana lived there. "Look for Sita there with all your strength," he said, but warned them of the Rakshasi Angarak, who killed beings by capturing their shadows. "Across the sea lies the sacred Pushpitaka mountain, which the non-virtuous cannot see. Bow before it. Beyond it is the city of the serpents, so search there as well. You cannot go beyond this, for the realm of darkness begins at this point, as does the capital of Yama, the god of death," he said.

To the west

He turned to Sushena, Taaraa's father, and, with great respect, requested for his help in searching the west. He asked him to search the western ocean, the cities of the regions, and the forests. "See the 100-peaked mountain at the confluence of the Sindhu and the ocean. Search the peak in the ocean, protected by the Gandharvas (magical beings), but do not take any fruit, as the beings are terribly fierce," he said. Beyond this was Varaha, the mountain with golden peaks, the city of Pragjyotish, and the mountain Asta, where the sun sets. "The search ends here, for you cannot traverse the regions beyond the scope of the sun," he said.

Heading north

Finally, he asked Shatabali to go north, the direction adorned by the mighty Himalayas, where the Mlechchhas, Kurus, Kambojas, Yavanas, Bahlikas, Chinas, and Paramachinas lived. "Go to Somashrama and the mountain Sudarshana. You will find Kailasa, where Kubera, the lord of wealth, lives, and an immense lake adorned by lotuses. Search the Krauncha and Mainaka peaks and ask the ascetics there about Sita. Beyond is Somagiri, a region that does not get the sun's light, and yet is illuminated. The great Shambhu, Shiva with 11 forms, and Brahma live there," Sugriva said.

To each of them Sugriva said, "Go to all the places I may have neglected to mention. Return within a month. If you do not, the punishment shall be harsh."

ANALYSIS
SUGRIVA'S DIRECTIONS

American Sanskritist Rosalind Lefeber observes that this section of the Kishkindha Kanda has attracted the attention of premodern and modern scholars and raised many questions.

The extent of Sugriva's knowledge is unclear as he tells Rama in their first meeting that he has not heard of Ravana. Later, Taaraa shares details of Ravana's strength and Sugriva seems to know where to look for him. Another issue arises from Sugriva's description of directions to his army. According to a present-day map of India, many regions named in the "south" are actually north of Kishkindha. A commentator resolves this by saying that the directions should be understood by assuming that Aryavarta, the land between the Himalayas and the Vindhyas, as the centre.

LISTENING CLOSE
The Vanaras huddled close, as if planning their next move, are depicted in this mural from the Temple of Emerald Buddha in Bangkok, which narrates the *Ramakien*.

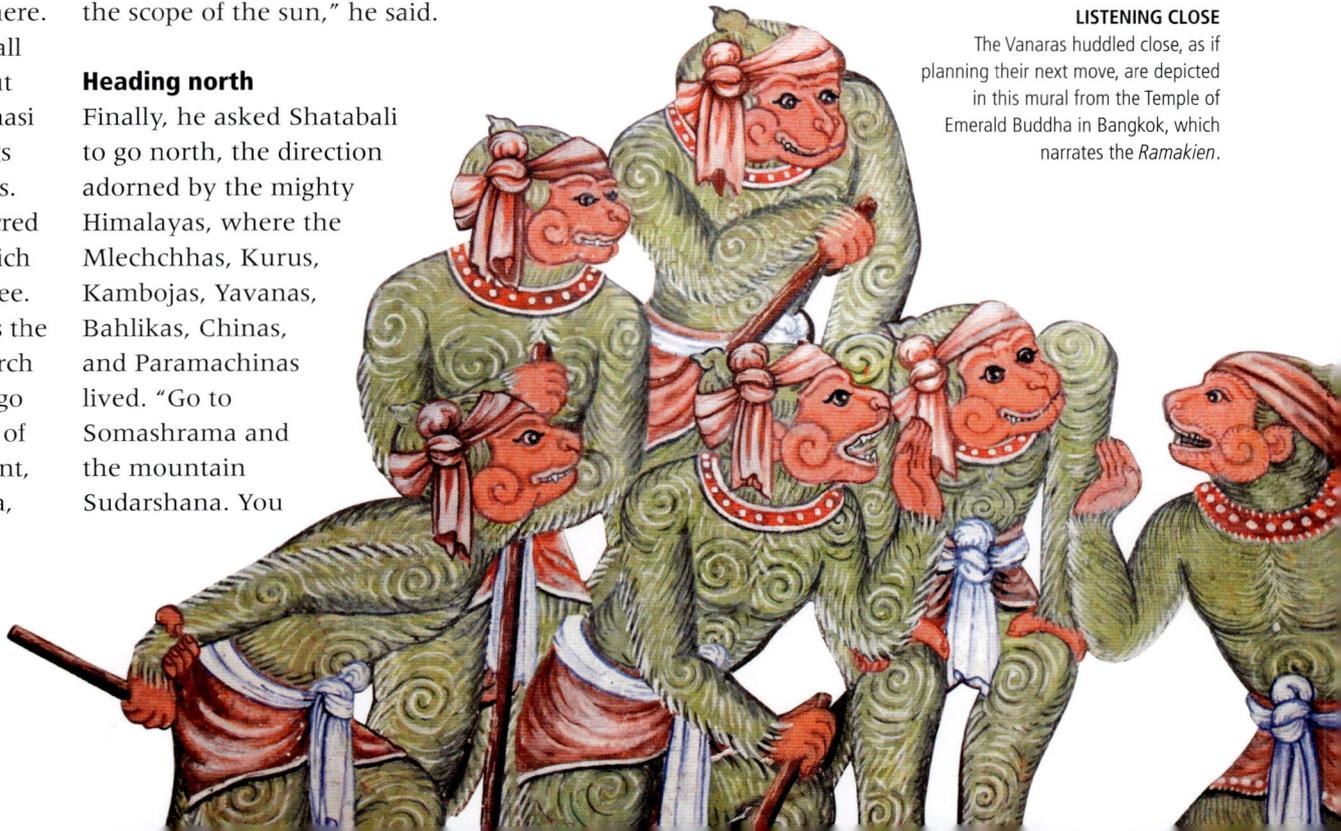

Futile Efforts

The Vanara armies left Kishkindha, but Hanuman carried a special message for Sita. Soon, the armies returned from the east, north, and west, and brought disheartening news. Sita was nowhere to be found. Would Hanuman succeed where everyone else failed?

Sugriva turned to Hanuman, in whom he possessed immense confidence. He knew that if there was anyone who would be successful in the search, it would be Hanuman. Sugriva told him, "I see nobody who is comparable to you in any of the realms, in the heavens or sky, let alone on the earth, in intellect or strength. You are like your father, the wind god himself."

Rama's messenger

Seeing the king's conviction in Hanuman's capability, Rama decided to trust him, believing that his success was certain. His heart grew light at the thought and he gave Hanuman a ring marked with his name. "By this, Sita will know that you are my messenger," he said. Hanuman took the ring, placed it upon his head with reverence, and worshipped Rama's feet before leaving.

When the armies had left, Rama asked Sugriva, with some curiosity, "How is it that you have such knowledge of all quarters of the land?"

Sugriva replied, "When my brother Vali chased me I traversed the limits of all the directions until Hanuman suggested that we live in the region that Vali could not enter because of the sage's curse." (See p 174)

The armies began returning on the 30th day from their departure. They told Sugriva that they had searched the cities, rivers, seas, and mountains, but failed to find Sita. The contingent from the south, however, had not returned.

The search continues

Tara, Hanuman, and Angada looked for Sita in the south, going from region to region, also passing through places where there were no edible fruits, roots, or animals. They even encountered a mighty Rakshasa whom they swiftly killed, but there was no sign of Sita.

Despondent, they sat under a tree and Angada said slowly, "We have looked everywhere – the forests, rivers, and mountains. But

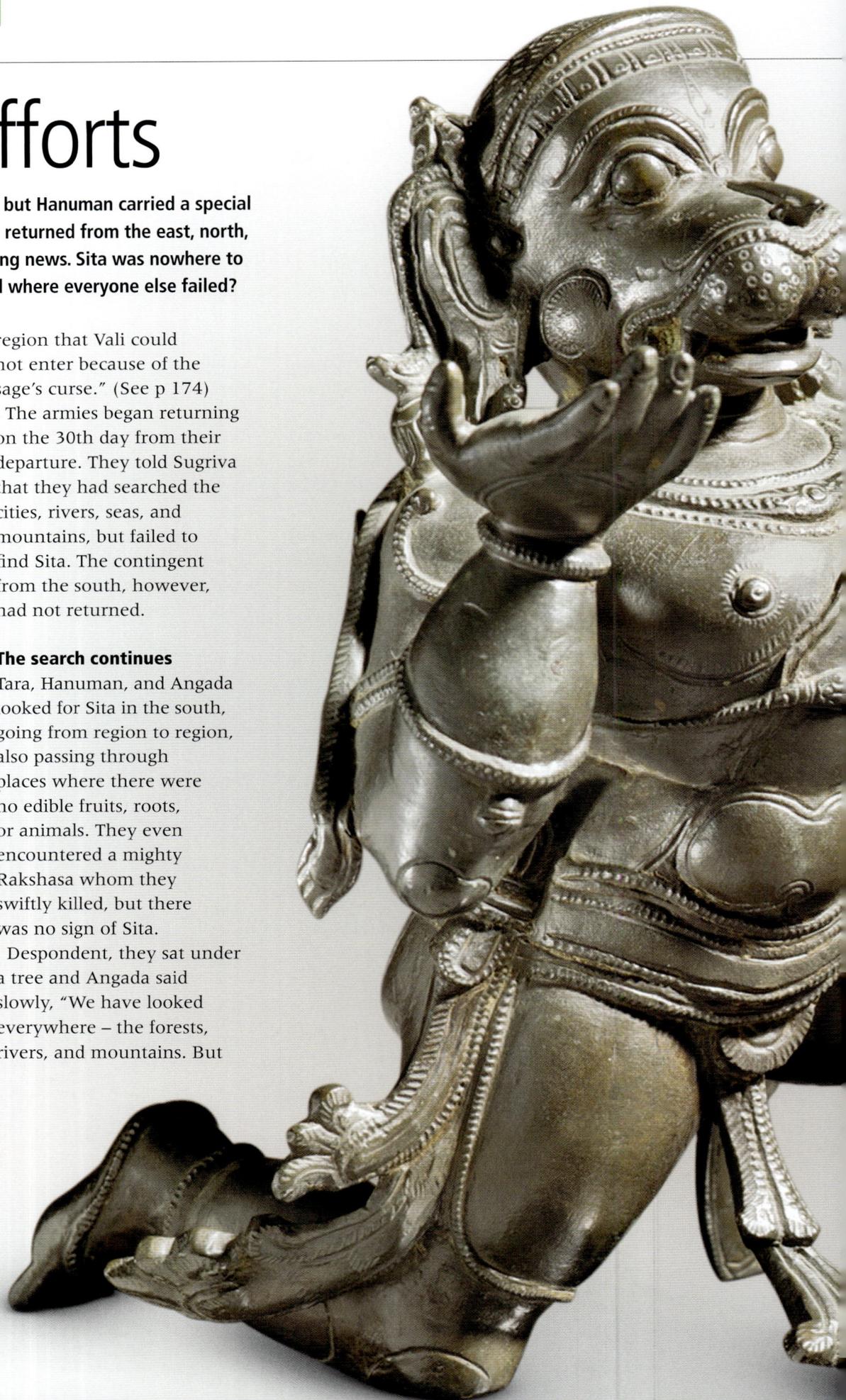

THE LOYAL HANUMAN
This copper sculpture of Hanuman from Tamil Nadu can be traced back to the early 17th century. The Vanara god is seen in a pose of supplication.

we haven't been able to see either Sita or the Rakshasa who abducted her. A great deal of time has passed, and Sugriva is a fierce ruler."

A strange place

The Vanaras rested and walked on, hungry and thirsty, until they saw a cave with many birds. Thinking that there could be a waterbody nearby, they entered the dark, tunnel-like cave. They walked for a while, holding one another, until they saw light. They realized it came from an illuminated forest within the cave, which had golden flora and fauna.

In the distance, they saw a woman in ascetic garb, who seemed to blaze with inner radiance. Hanuman folded his hands and asked her, "Who are you and to whom does this place belong? We were exhausted, hungry, and thirsty when we entered this cave. How are the trees and animals golden?"

The woman told them that she was Svayamprabha and that the place belonged to her friend Hema, a celestial maiden. Maya, a Danava (race descending from the goddess Danu), had built the place with his powers and lived here, until Indra, the king of gods, killed him for falling in love with Hema. "Why are you here? If your exhaustion and hunger has dissipated, tell me," she said.

Hanuman then told her about Rama and Sugriva, and of their search for Sita. Then he said, "Observer of dharma, we seek you as refuge. The time that our king had assigned for the task has lapsed. Please help us find a way out of here. We are terrified of Sugriva, for we have neither completed the task, nor returned in time."

THE SILENT FOREST

A sage named Kandu lived in the desert-like forest that Angada and his companions found as they searched for Sita. The region did not have any vegetation or animals. The sage, endowed with great asceticism and a bad temper, had cursed the region to be a desert devoid of any life after the death of his 10-year-old son in the forest.

Svayamprabha asked them to shut their eyes and transported them to a shore by an ocean. She then disappeared before they could even open their eyes.

"They saw the **terrible ocean**… Full of terrible and **turbulent waves**, it raged and the other shore could not be seen. The king had **set a time period** of one month. But in searching in the **mountainous caves**… this period had elapsed."

THE ARMY OF THE VANARAS IN THE SOUTH AS THE TIME FOR THEIR TASK LAPSED,
SARGA (52), KISHKINDHA KANDA

At the **Edge** of the **Land**

Hanuman, Angada, and the rest of the army reached the very tip of the south. Lush mountains rose up on one side and, in front of them, was the endless ocean. They looked around, but there was no sign of Sita and the army slowly sank into absolute despair.

The Vanaras looked around the ocean shore and realized that the season had changed while they were in the cave. They were well past the deadline set for the task.

Utterly defeated, Angada said, "We left in accordance with the command of the lord of the Vanaras. The limit he set for our return is gone. It is best that we give up food and await our death. Sugriva is harsh by nature and is our master. There is no way he will forgive us – our death is certain if we return late and unsuccessful."

A dilemma

"Death here is better than slaughter there. In any case, there is no love lost between Sugriva and I," Angada said. "It is not as though he crowned me his heir. It was Rama's decision. There is also long-standing enmity from earlier and he is not going to

let me live. I might as well sleep in peace in the sacred waters of the ocean."

Tara disagreed and said, "We can simply enter this cave and live in peace there. It is prosperous and we will be safe from Rama, Lakshmana, and Sugriva."

Hanuman objects

When Hanuman heard this conversation, he grew worried about Sugriva's position as the king of the Vanaras. He knew Angada had all the qualities of a king, and decided to employ one of the mainstays of policy, of causing dissention. He said to Angada, "You are both wise and valorous. But remember, Vanaras are unstable, and in any case, none of them are going to stay with you for long in this cave without their wives and children. It is folly to think that this cave

will protect you from Lakshmana's sharp and sure arrows.

"Your uncle Sugriva desires dharma and is firm in his vows. He is devoted to the truth. He is not going to kill you. He also loves Taaraa, your mother, and wants to please her. He will never kill you, who are her only offspring."

The Vanaras despair

Angada replied, "Stability, kindness, straightforwardness, and forbearance aren't qualities that one finds in Sugriva. He accepted his slain older brother's wife, by rights his mother, as his wife. He covered the mouth of a cave in which his brother battled. He even forgot Rama, to whom he owes everything. It was his fear of Lakshmana and not fear of dharma that compelled him to send out the search parties in the first place. I do not desire the kind of life I will have in Kishkindha with him as my enemy. The crooked and cruel Sugriva will have me captured. To that, I prefer death here."

He announced, "I am telling you, I will not return to Kishkindha. Greet the king Sugriva and mother

Ruma. Please try to hold onto my mother Taaraa, who naturally loves her son and is unlikely to live."

So saying, he sat down, weeping. The others praised Vali and censured Sugriva. Eventually, they decided to fast unto death as earlier agreed.

They were unaware that, all this while, a creature had watched them, and now approached them slowly.

THE SEARCH PARTY OF THE SOUTH
Hanuman, Angada, and Jambavan climb Mount Mahendra, one of the regions Sugriva told them to search, in this miniature painting from 1720, Himachal Pradesh.

CHARACTER PROFILE

ANGADA

The son of Vali and Taaraa, Angada was widely acknowledged as both intelligent and powerful. At this moment of utter despondence, his greatest insecurities and resentments rise. Rama killed his father and Sugriva began living with his mother. It was Rama who made the decision to consecrate him as the crown prince, and the idea was first brought up by Vali. In later tradition, Angada's loyalty to Rama is considered absolute, so much so that in the *Ramcharitmanas*, he tries to stay back in Ayodhya after Rama's consecration.

"**Those Vanaras**, who were like the **peaks** of mountains, lay down there, having traversed **many mountains** and stepped through many caverns inside them. The salty ocean roared, like **terrible thunder clouds**."

THE VANARA ARMY AT THE EDGE OF THE OCEAN, *SARGA* (54), KISHKINDHA KANDA

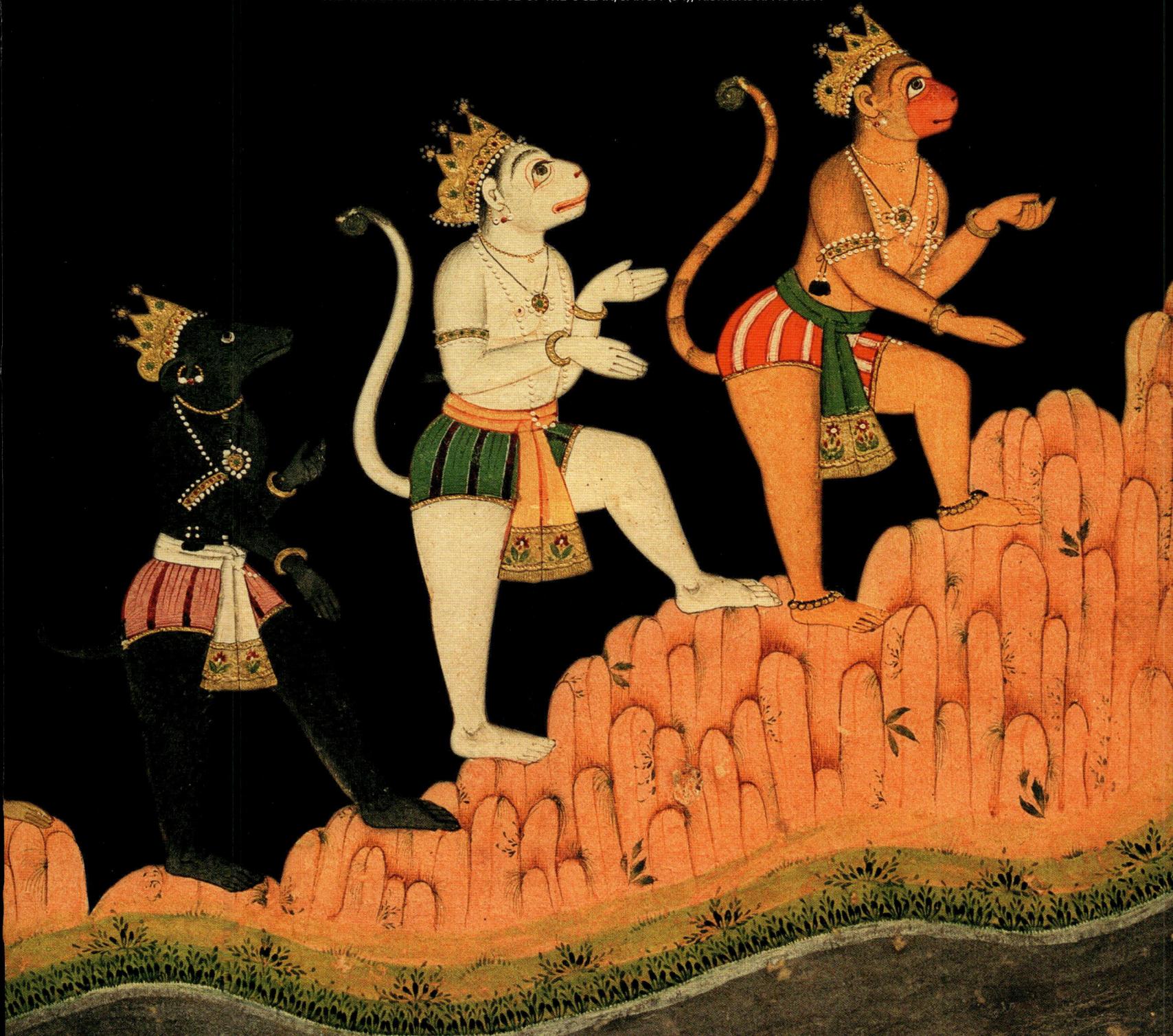

A Ray of **Hope**

As the exhausted Vanara army sat down, defeated and helpless, awaiting their death, help came from unexpected quarters. The wise, aged vulture Sampati had overheard them talking and then mention a name that brought back many memories, but distressed him greatly as well.

The lord of vultures, Jatayu's older brother, Sampati, heard the voices of the Vanaras and came out of his cave in the Vindhyas. He heard their conversation of fasting unto death and grew delighted at the thought of eating them one by one as they dropped dead.

Angada's voice interrupted Sampati's thoughts. "We did not accomplish Rama's task or fulfil our king's wishes," he said. "Look at how the promises Kaikeyi extracted, have effected everyone. Rama, Lakshmana, and

> "**I saw a young lady being abducted by the evil-souled** Ravana. She was beautiful and was **adorned in**… ornaments… Her… silken garment was like the **dazzle of the sun**."
>
> SAMPATI GIVES THE LONG-AWAITED INFORMATION TO THE VANARAS, *SARGA* (57), KISHKINDHA KANDA

Sita were exiled to the forest, Dasharatha died, Ravana abducted Sita, and Jatayu died as he tried to rescue her."

The grieving vulture

Shocked, Sampati spoke up, "Who speaks of Jatayu's death, causing my heart to tremble? It has been so long since I heard from him. My younger brother is virtuous and valorous. I wish to hear of his death, if that is what has happened."

At first, the Vanaras doubted Sampati's intentions, even though his voice trembled in grief. They realized that they had nothing to fear, as they were awaiting death by the ocean shore anyway, and so told him the entire story.

Sampati listened to them and then said, as he mourned his brother, "I cannot do anything even after hearing of my brother's slaughter in battle by that wretched Ravana, for I am old and without wings."

CHARACTER PROFILE
SAMPATI

Sampati and Jatayu are descended from Garuda's brother, Aruna. It seems that Sampati was a mighty vulture to begin with, but early on in their youth, he and Jatayu tried to fly to the sun. He got burnt as he tried to protect his brother and fell exactly where Sugriva's army would need to find him. While there is not much mention of a mate, he does have a son. Like many characters in the *Ramayana* who have been awaiting a particular point in Rama's story, often for several years, Sampati, too, was told that the return of his wings and strength was predestined for when he would come to the aid of the Vanaras looking for Sita.

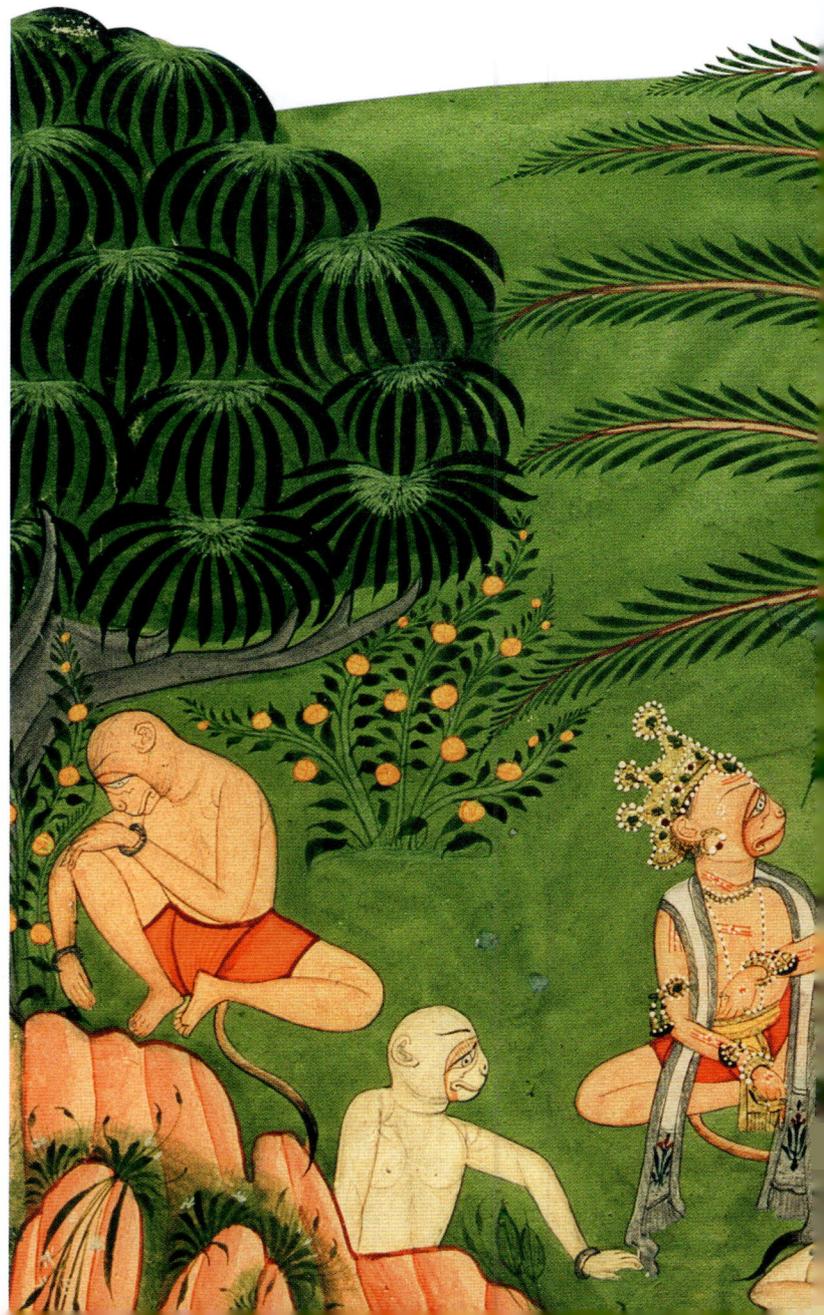

Angada replied, "If Jatayu is your brother, tell us where this Rakshasa lives, if you happen to know."

News, at last

Jatayu's elder brother said, "I am a bird without wings. My valour and might are gone. I will, however, help Rama through my speech. I saw Ravana take a beautiful young woman who called out to Rama and Lakshmana. From her cries, I surmise it must have been Sita.

"Listen as I tell you where Ravana lives. He is the brother of Kubera, the god of wealth, and lives in the city called Lanka, which is a 100 yojanas (about 1,260 km or 900 miles) into the ocean, surrounded by water on all sides. Vishvakarma, the divine architect of the universe, built this great city.

Sita lives there, held by the Rakshasas. You must find a way to get there.

"Now, take me to the ocean shore so I may offer the ritual water in the memory of my deceased brother, Jatayu." He looked at the Vanaras and realized that they were not fully convinced, so Sampati reassured them. He told them that he knew this information to be true,

for his son, Suparshva, had seen Ravana abduct Sita, as he foraged for food.

After performing the water rituals, Sampati told the Vanaras that he knew that they would succeed in their mission of finding Sita.

"Let me tell you how I know this," he said, and told them his story.

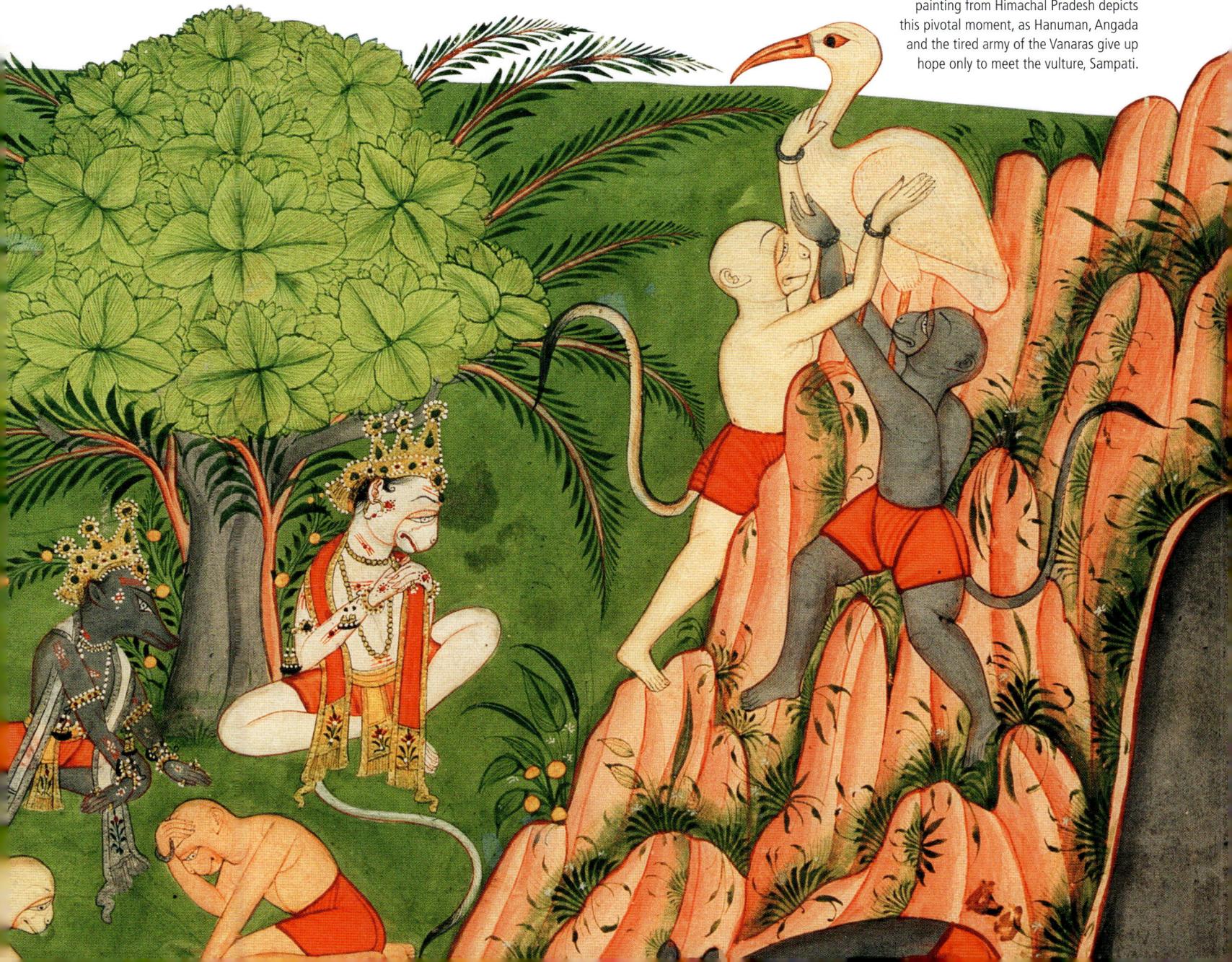

GUIDING THE WAY
This early 18th-century Pahari miniature painting from Himachal Pradesh depicts this pivotal moment, as Hanuman, Angada and the tired army of the Vanaras give up hope only to meet the vulture, Sampati.

Jatayu and Sampati

Hanuman, Angada, Jambavan, the king of bears, and the other Vanaras gathered around Sampati as he began telling them his story and how he came to be there.

Sampati told the Vanaras that because of his divine origins, he had divine sight, and could see that they would be successful in their endeavour. Then, he told them how he came to be there.

A race to the sun

In ancient times, when Indra, the king of gods, killed the Asura Vritra (See box), the brothers Jatayu and Sampati decided, in a moment of pride, to test their valour. They attempted to fly to the blazing sun, hotter than anything in existence. They ascended rapidly, but Jatayu got too close and was in great pain because of the rays of the sun. Out of love for his younger brother, Sampati flew ahead and shielded him from the fierce rays with his wings, which were burnt in the process. Both lost consciousness and fell to the earth.

The Vindhyas

Sampati fell from the sky and landed on top of a peak in the Vindhya mountains. He remained unconscious for six nights. When he finally came to, he could not understand where he was, as everything around him seemed unfamiliar. With great difficulty, looking at the mountains, rivers, and lakes, he realized that he was near the southern sea.

He remembered that Nishakara, a fierce ascetic, lived in that region, who knew him and his brother, Jatayu. The trees around his hermitage were never without fruits and the flowers remained fragrant.

THE VULTURE
This wooden artefact found in the state of West Bengal is of Sampati, the son of Aruna, the charioteer of Surya, the sun.

"The wings that were **burnt down**… have reappeared again… I can feel that **strength and virility** now. The **gain of my wings** convinces me that you will also be **successful** in your objective."

SAMPATI, AS HE REGAINS HIS LOST WINGS, *SARGA* (62), KISHKINDHA KANDA

SAMPATI'S HOME
In the modern-day context, the Vindhya range is located in the state of Madhya Pradesh. The Vindhyas of the *Ramayana* are said to be the southernmost point.

The truth in the prophecy

Sampati finished telling his story and then looked at the Vanaras. He said that he had waited for this moment for 100 years. He told them how, every time he slipped into deep depression, wondering about the purpose of his life, he remembered the wise sage's words.

As the Vanaras watched, Sampati's wings grew back and red feathers reappeared. Overjoyed, he said, "I can feel the strength of my youth. My wings have returned as well. This tells me that you will be successful in your objective," he said. "Now, go find Sita."

Searching for the sage

In deep pain because of his wings, Sampati decided to seek his help and went in search of him. Nishakara, upon seeing him, said "Who are you, bird? And how did you get here? I knew two mighty brothers, the kings of vultures, but you seem difficult to recognize. It appears that you are the older of those brothers, Sampati ... but your wings seem burnt and your breath seems unsteady. Is this an affliction of some kind? Or did somebody punish you? What happened?"

Sampati replied, "Blessed one, I am wounded and my senses are agitated in embarrassment. I am exhausted and cannot speak." He told the sage what had happened and concluded, "I think my beloved brother Jatayu fell in Janasthana and I fell here, in the Vindhyas. Bereft of my kingdom, my brother, and my wings, I do not have it in me to live anymore." So saying, Sampati wept before the sage.

Nishakara's prophecy

The sage fell into silent contemplation, and then said, "You shall have new wings, Sampati, and renewed strength and vigour. I have heard this, and seen through my ascetic powers that a king shall be born in the Ikshvaku lineage called Dasharatha. He shall have a brilliant son called Rama, who will come to the forest with his wife Sita and brother Lakshmana. Ravana, the invincible Rakshasa, will abduct his wife. The glorious Sita shall reject all luxuries offered to her. Even when Indra offers her food while in Ravana's realm, she will offer it to the ground, saying, 'This is for Rama.'"

He added, "Vanaras will come to this region as Rama's messengers and you will tell them about Sita. Don't go anywhere. But where can you go in this state anyway?

Await the right moment, and this great destiny shall be yours. You will be helping the princes, the gods and Indra himself. I would have liked to see Rama too, but I do not want to wait for that long and will cast off my body soon."

> "O heroes, **free of sin** and ever truthful, you have not plunged me in **grief** but given me life. You have removed the **darkness** that clouded my eyes."
>
> SAMPATI TO THE VANARAS, *KAMBA RAMAYANA*, TRANSLATED BY PS SUNDARAM

CULTURE

INDRA AND VRITRA

Although Indra's heroism in the epics is often limited, he is generally associated with the killing of evil beings. His battles are often considered prototypical in the epic, as seen in the example of his retrieval of Paulomi, his consort, or just references to his valour. As Indo-Europeanist Stephanie Jamison points out, the Indra-Vritra episode is perhaps the most important of the stories associated with Indra in the *Rigveda*. Vritra is described as a serpent or cobra-like creature who had to be defeated in order to release the waters from a mountain. Some of Indra's epithets simply mean "Vritra-killer".

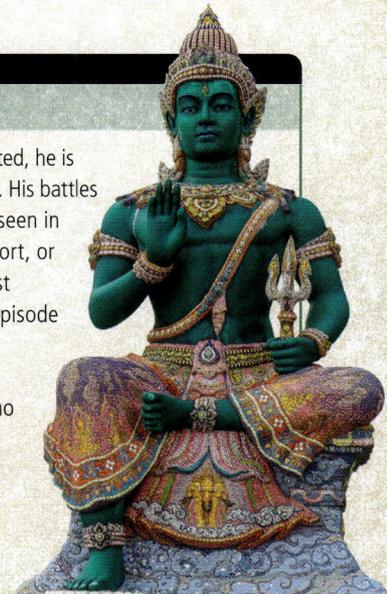

A STATUE OF INDRA at the Chiang Rai Blue Temple in Thailand

Vanaras **in Turmoil**

The Vanaras, their hope renewed, now faced a new dilemma. The vast, tumultuous ocean before them seemed an unsurmountable obstacle. They knew where Sita was, but how would they cross the ocean? Who could leap 100 yojanas?

Seeing the massive ocean rumble and roar around them in its many moods and hues, here calm, there fierce, the Vanaras began to despair once again.

They wondered how they would cross an ocean that seemed unfathomable and untraversable, like the limits of the sky. Angada discussed this with the elders and spoke to the Vanara army, "Which mighty hero will cross the ocean? Who will free us from this terrible fear of death at Sugriva's hand? By whose grace will we see our wives, sons, homes again? Who shall please Rama and Lakshmana? Speak up. If you can cross the 100 yojanas, grant us this blessing of fearlessness."

In a quandary

Slowly, the Vanaras spoke up. Gaja said that he could cross 10 yojanas, then Gavaksha claimed he could do 20. Gavaya said 30 and Sharabha said there was no doubt he could do 40. Gandhamadana, Mainda, Dvivida, and Sushena spoke up as well, but no one could traverse 100 yojanas.

Jambavan said, "Once I circumambulated Vishnu in his massive form. I was blessed with strength and immense speed. I am old and frail now, but this task is for Rama and the king of Vanaras, so I cannot look the other way. I can travel 90 yojanas now. That is not the limit of my strength, but this is as much as I can do at my age."

A ROARING OCEAN
A vast, turbulent ocean lay between the Vanaras and the kingdom of Lanka, which was nearly 100 yojanas away.

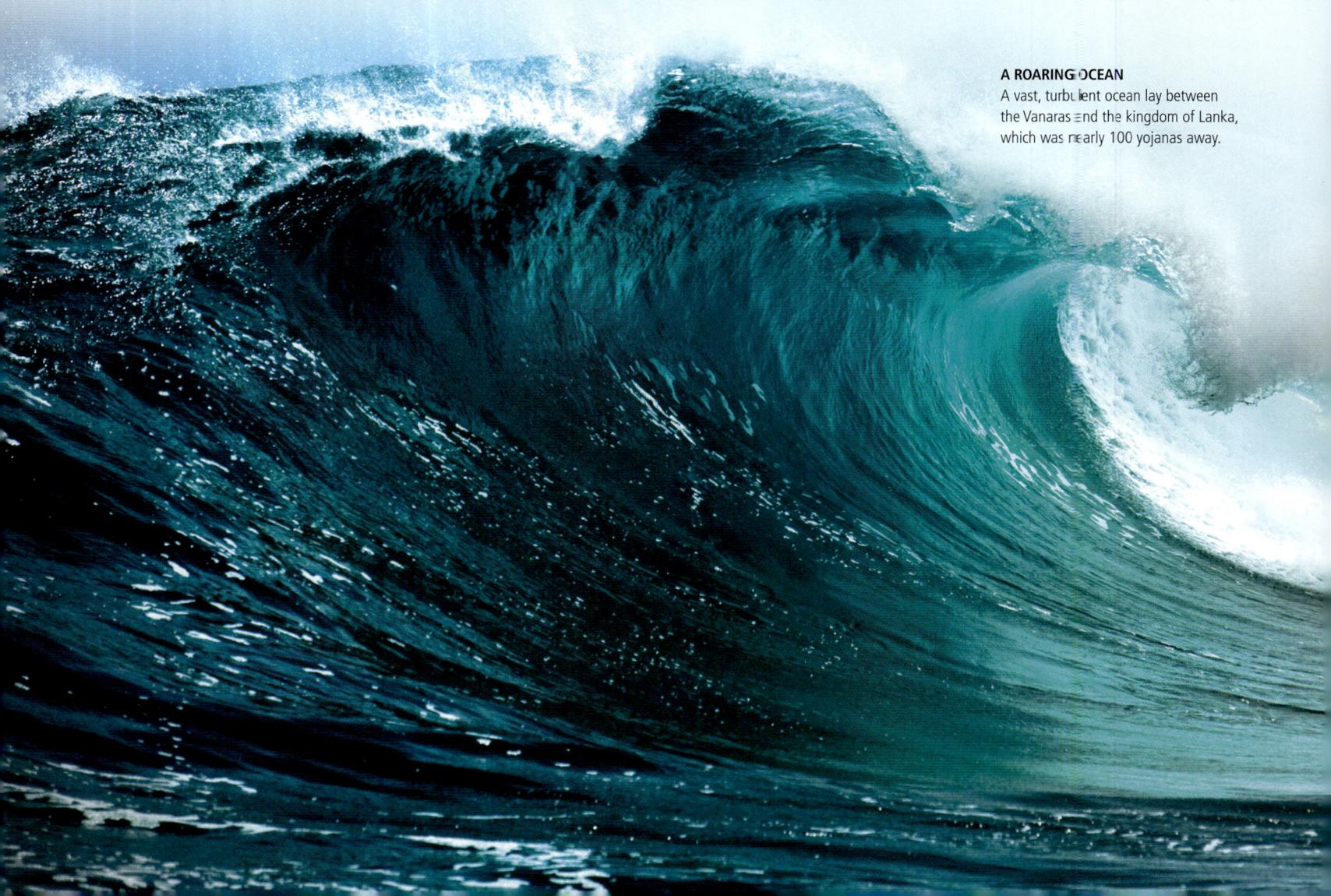

JAMBAVAN

The son of Brahma, Jambavan is often regarded as a bear, and at the time of the *Ramayana*, almost always considered an elder. When Ravana's spies describe Rama's army to him, they refer to Jambavan as the one who assisted the gods in their great battle with the Asuras. Jambavan himself says that he witnessed Vishnu ask Bali (See p 25) for the three paces of land, and also appears during Vishnu's incarnation as Krishna.

Jambavan's age often places him in the role of a wise adviser. Perhaps most significant is when he reminds Hanuman of his true strength as well as restrains him from overstepping his limits. In "Ram ki Shakti Puja", a 20th-century poem by Suryakant Tripathi "Nirala", Jambavan delivers the key advice to Rama: "Abandon the battle until you have attained success" [in the spiritual practice], and Rama honours him as an elder for his wisdom.

Angada said that he felt he could travel 100 yojanas without any trouble, but was not sure if he could return successfully.

Jambavan, however, told Angada that he could not go. "Best of Vanaras," he said, "You may be able to leap even 100,000 yojanas and return quickly, but you are acting as our master. We cannot send you on a perilous journey while we wait in safety. Young hero, it is important to protect the root at all costs, for one can rely on it for new leaves again." Angada was at his wit's end, and said, "If I cannot go, venerable Jambavan, and nobody else has the capacity, then perhaps we should return to our earlier resolve of fasting unto death."

Jambavan did not seem too concerned about Angada's pessimism. "I will speak to the one who will accomplish this task," he said.

Rise, Hanuman

He turned to Hanuman, took him aside, and said, "Why are you standing quietly, away from everybody? Why don't you speak? You are equal to Rama, Lakshmana, and Sugriva in strength. Your intellect and brilliance distinguish you from all beings. Do you not know yourself?

"You are the son of Anjana, Kesari's wife. The wind god was once attracted to her and embraced her. She called out, 'Who is this person, trying to violate my vow of monogamy?' The wind god replied, 'Do not worry. Since I have only embraced you with my mind, your vow shall remain intact.' He then blessed her with a heroic and brilliant son, who would be his equal in strength.

"As a young child, attracted to the red disc of the sun, you rose in the sky. Indra, the king of gods, grew worried, struck you with his weapon and injured your jaw as you fell. Angered, the wind god refused to move. Air fell still until Indra and Brahma, the Creator of the universe, blessed you. Your boons ensured that weapons would not kill you, and that only you could choose the moment of your death. As a child, you impressed the gods and as a dear son of the wind, you are his equal in brilliance.

"We have given up all hope of life and you are our only refuge now. Rise, tiger among Vanaras, and cross this immense ocean."

WISE JAMBAVAN
The king of bears, Jambavan was a venerable member of the Vanara army. Seeing Hanuman worried, he reminded him of his gifts.

> "It was **turbulent with waves**... In some places there were **masses of water** that were **as large as mountains**... The Vanaras saw that the **ocean was like the sky** and was **impossible to cross**."
>
> THE VANARAS, ON SEEING THE OCEAN, *SARGA* (63), KISHKINDHA KANDA

Hanuman's Resolve

Reminded of his power, Hanuman grew in size and prepared to leap across the ocean. Seeing him, the Vanara army cheered, for now, there was hope.

Overjoyed at Jambavan's words, Hanuman took on an immense form. His face grew radiant and his tail lashed about. He rose up from among the Vanaras and greeted the elders gathered there.

He proclaimed, "The wind, fire's companion, the mighty one, traverses the skies. I am his son, and have no equal. I can circumambulate Garuda, Vishnu's mount, as he flies. I can approach the blazing sun. I can agitate the sea and tear apart the earth. I can dispel clouds, and shake and pulverize mighty mountains. Except for Garuda himself, nobody can match me in flight. As I cross the sea, I shall look like Vishnu when he took his three great steps (See p 25). I can cross a sea 10,000 yojanas wide."

Delighted at Hanuman's words and form, Jambavan said, "Heroic son of Kesari and swift son of the wind you have destroyed our grief. Cross the sea with blessings from the sages and our consent. We await your return for, with you, we send forth our hope for life."

Hanuman climbed the mountain Mahendra, for only it could bear the force of his leap. As his feet crushed the mountain, it shrieked like an injured elephant.

At its summit, Hanuman invoked the force within him and got ready to leap to Lanka.

> "**My force** is like that of the **wind god**… My **speed** is like that of **Garuda**… It is my view that **I can go and bring back Lanka itself**."

HANUMAN TO THE VANARA ARMY, *SARGA* (66), KISHKINDHA KANDA

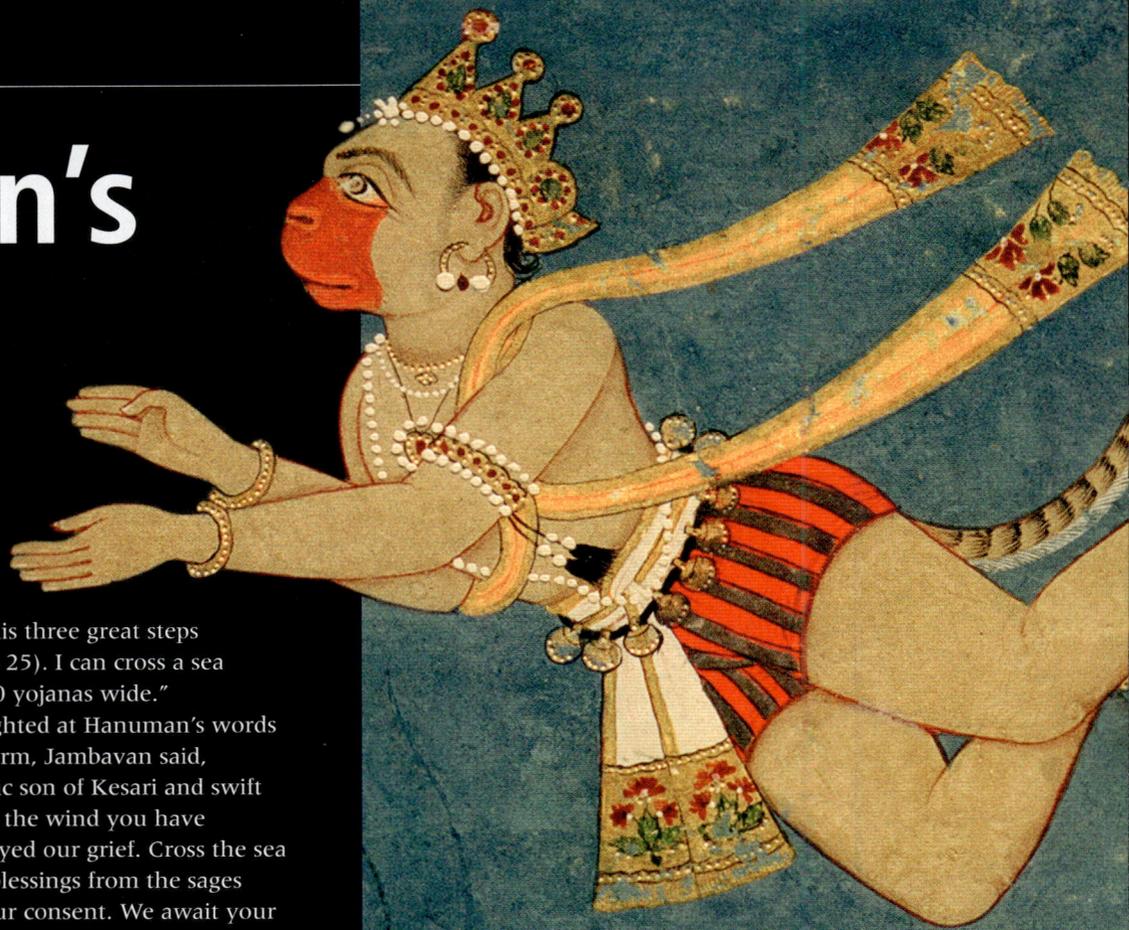

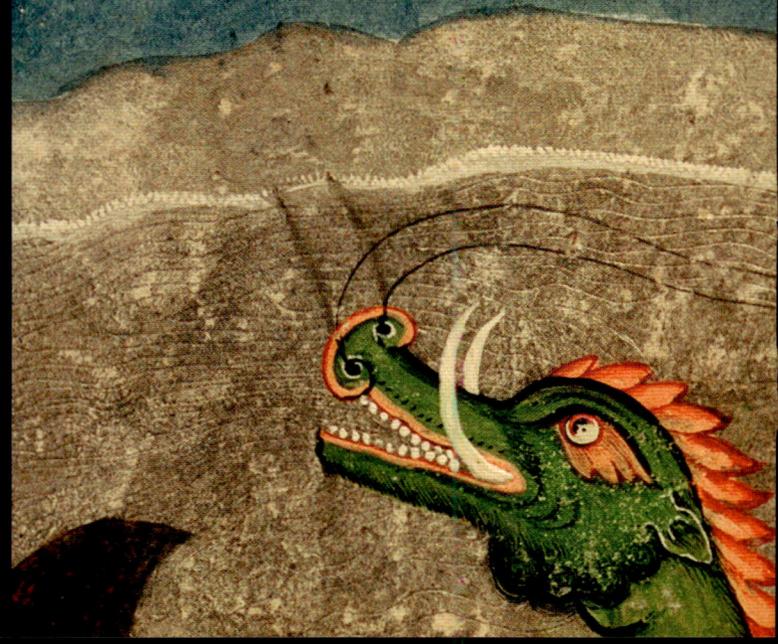

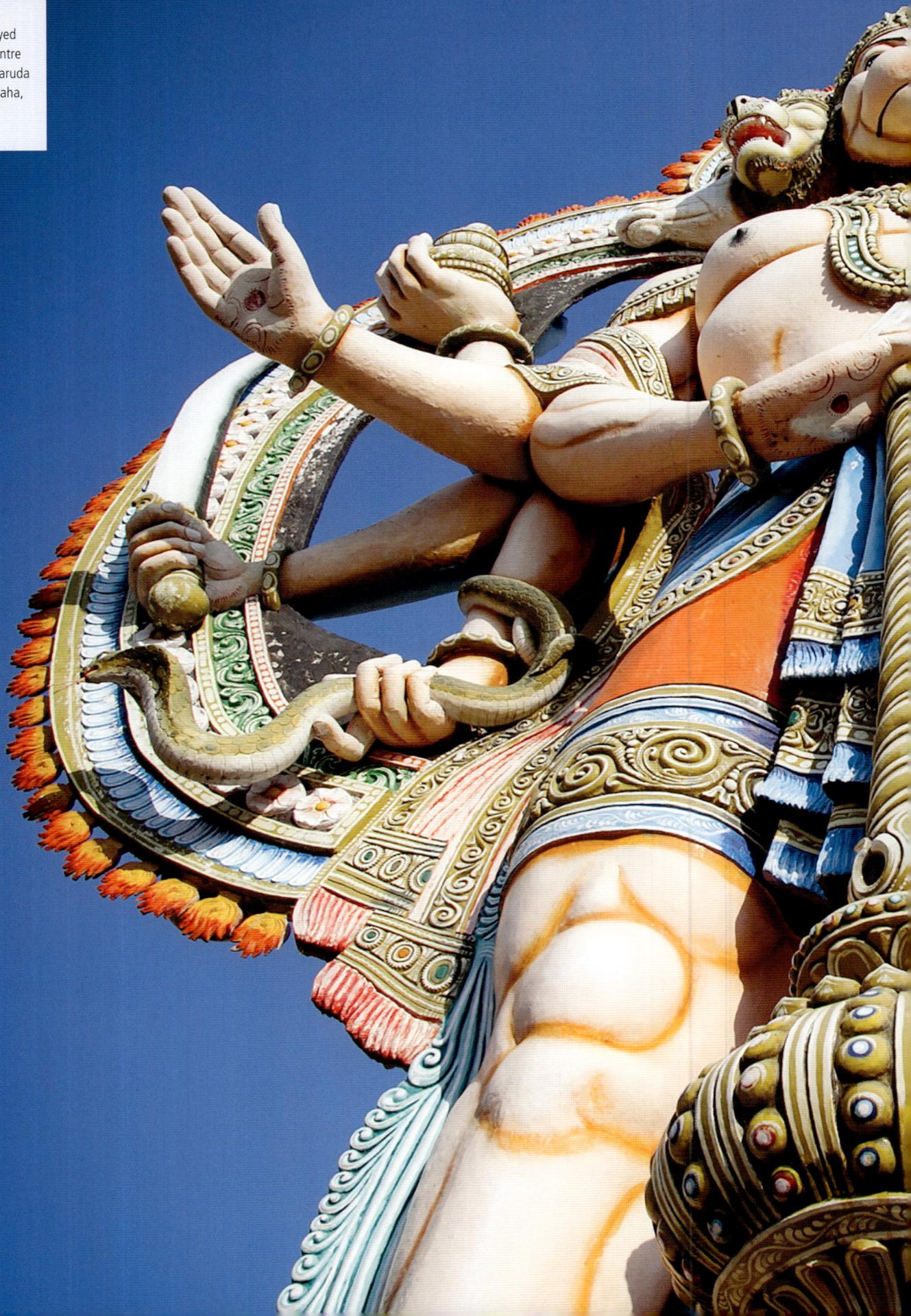

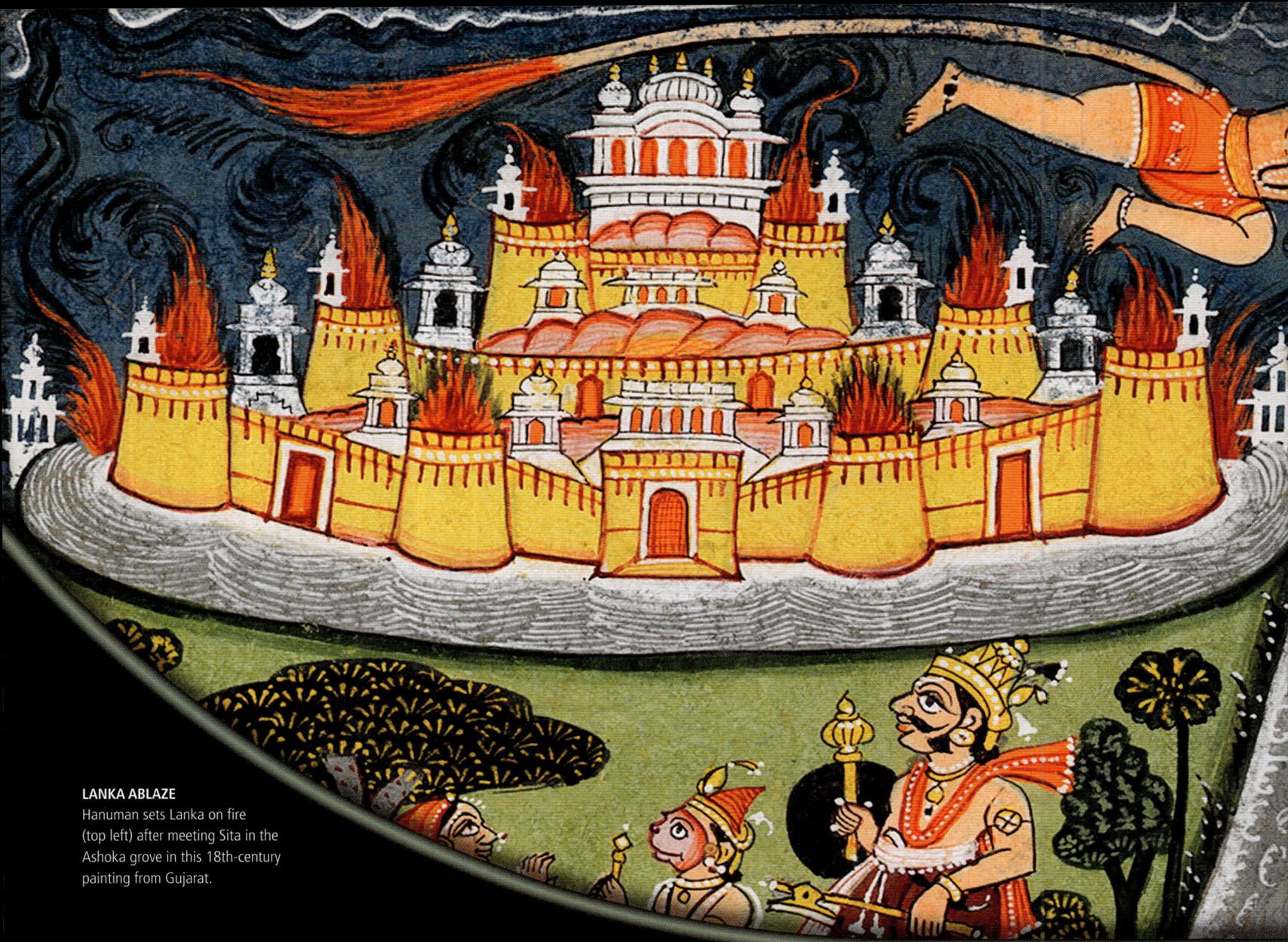

LANKA ABLAZE
Hanuman sets Lanka on fire (top left) after meeting Sita in the Ashoka grove in this 18th-century painting from Gujarat.

5

SUNDARA KANDA:
OF BEAUTY AND VALOUR

Sundara, the only Kanda that does not feature Rama centrally, is the fifth
chapter in Valmiki's *Ramayana*. It traces the journey of Hanuman, the valiant
son of Vayu, as he leaps across the ocean and makes his way to Lanka, the
kingdom of Rakshasas. The chapter, in the telling of Hanuman's escapades
there, lays emphasis on the Vanara's valour, strength, ingenuity, and his
unyielding devotion to Rama and the prince's search for his beloved Sita.

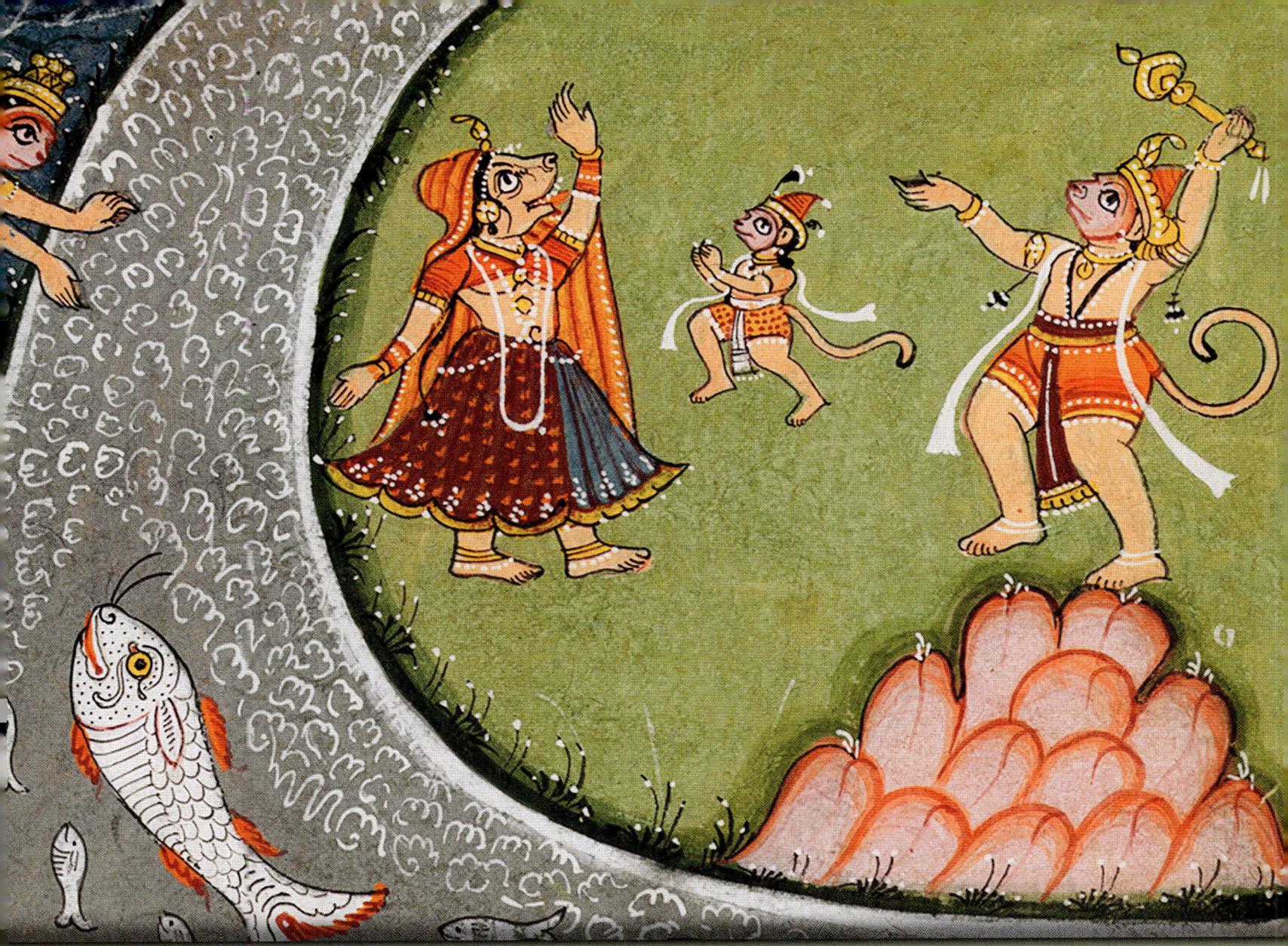

"Like an arrow released by **Raghava**, with the **valour of the wind**, I will go to Lanka… If I do not see Janaka's daughter… I will **uproot Lanka** and bring it here, **with Ravana**."

HANUMAN'S COURAGEOUS PROCLAMATION, *SARGA* (1), SUNDARA KANDA

Leap Across the Ocean

As Hanuman grew bigger and bigger, the mountain shrieked and the rocks split open. In the sky, the sages looked down and celebrated, but the Vanara was focussed on his destination. He took a deep breath, looked across the ocean, and prepared to leap.

Hanuman offered obeisance to the sun god, Indra, the king of all gods, and the elements as well. He faced east and folded his hands to honour his father, the god of the wind. He turned to the south and began growing in size.

Resembling an immense bull, he struck the mountain with his arms and feet. Water poured forth, the trees shook, and the flowers they shed made Mount Mahendra fragrant. The semi-divine Vidyadhara men and women, and the ascetics who lived there left their homes. They smiled and watched as he prepared to leave, for they knew that he was setting out on his mission.

CHARACTER PROFILE
MAINAKA

In the first of the great ages, mountains had wings and could fly like the wind or Vishnu's mount, Garuda. However, all beings were terrified at this idea, so Indra, the king of gods, cut off the wings of all mountains. He went to Mount Mainaka to do the same, but as he raised his weapon, the wind hurled Mainaka and he was thrown into the sea, so his wings remained intact. He continued to stay there. Later, Indra, pleased with Mainaka's attempt to help Hanuman, allowed him to stay as he was.

Hanuman takes flight

The son of the wind god roared, lifted his long tail, and brought his large hands that looked like giant clubs to his side. He placed his feet firmly on the ground and immersed himself in his energy and spirit. He called out to the Vanaras, "I now head towards Lanka as surely and swiftly as an arrow from Rama's bow. If I don't find Sita there, I will go to the abode of the gods with the same speed. And if she is not there either, I will bind Ravana and bring him. I shall either return with Sita or uproot Lanka itself and bring it here."

Hanuman leapt into the air and flew towards Lanka. His eyes blazed and the wind, in his wake, roared like a monsoon cloud. The serpents who saw him from beneath the ocean thought he was Garuda, the mount of Vishnu, the Preserver of the universe. His shadow extended over the ocean and it seemed like he was drinking up the sky.

The gods and Gandharvas (celestial beings) showered him with flowers. The sun did not burn him. Seeing him, the ocean thought, "This mighty Vanara is going across for Rama's sake, and Rama belongs to the Ikshvaku lineage, to whom

> "The **strong one** made **Mount Mahendra** suffer... **Boulders were dislodged**... Creatures hidden inside caves **howled in hideous voices.**"
>
> HANUMAN'S FLIGHT ACROSS THE OCEAN, *SARGA* (1), SUNDARA KANDA

I am indebted. I will be fit for censure if I do not help him." So he asked Mount Mainaka for help, "Rise out of the waters and offer Hanuman a resting spot. Rise, remembering Rama's compassion, Sita's anguish, and Hanuman's immense effort."

A resting spot

Mainaka rose and stood before Hanuman, who ran into him like wind rushes through the clouds. Delighted at his strength, the mountain took a human form and requested him to accept his hospitality on behalf of the ocean. "Moreover," he said, "you are the son of the wind god, to whom I am indebted. Sit here, eat some fruits and roots that I bear. Rest and rid yourself of exhaustion before you go ahead."

Hanuman respectfully touched the mountain and symbolically accepted the hospitality, and said, "I am

grateful, but there is a task at hand and time is short. I have given my word and cannot stay." So saying, he took flight again.

Indra's test

The gods and sages saw him fly through the sky without any support and praised him. Indra requested Surasa, a serpent deity, to test Hanuman. She took the form of a ferocious Rakshasi and claimed him as her meal. He folded his hands and said,

"Ravana has abducted Rama's wife. I am going to her as a messenger. You live in a realm that is subject to him, so you ought to help him. Otherwise, give me some time, let me see Sita and convey her message to Rama. You may then eat me."

But, Hanuman could not convince her, so he asked her to open her mouth. Surasa opened her mouth 10 yojanas wide (about 126 km or 90 miles). Hanuman grew in size and as he did, Surasa opened

her mouth wider. Suddenly, Hanuman shrank, took on a tiny form, and quickly entered and exited her mouth. Pleased, as he passed the test, she resumed her divine form and blessed him with success.

Hanuman set forth again and along the way encountered the Rakshasi Simhika who captured people by catching their shadows. She caught Hanuman's shadow too, but he killed her swiftly and continued to Lanka.

FACING THE RAKSHASI
As Hanuman flew across the ocean to go to Lanka, many obstructions came his way, including the Rakshasi Surasa. This 20th-century artwork depicts Hanuman's encounter with Surasa.

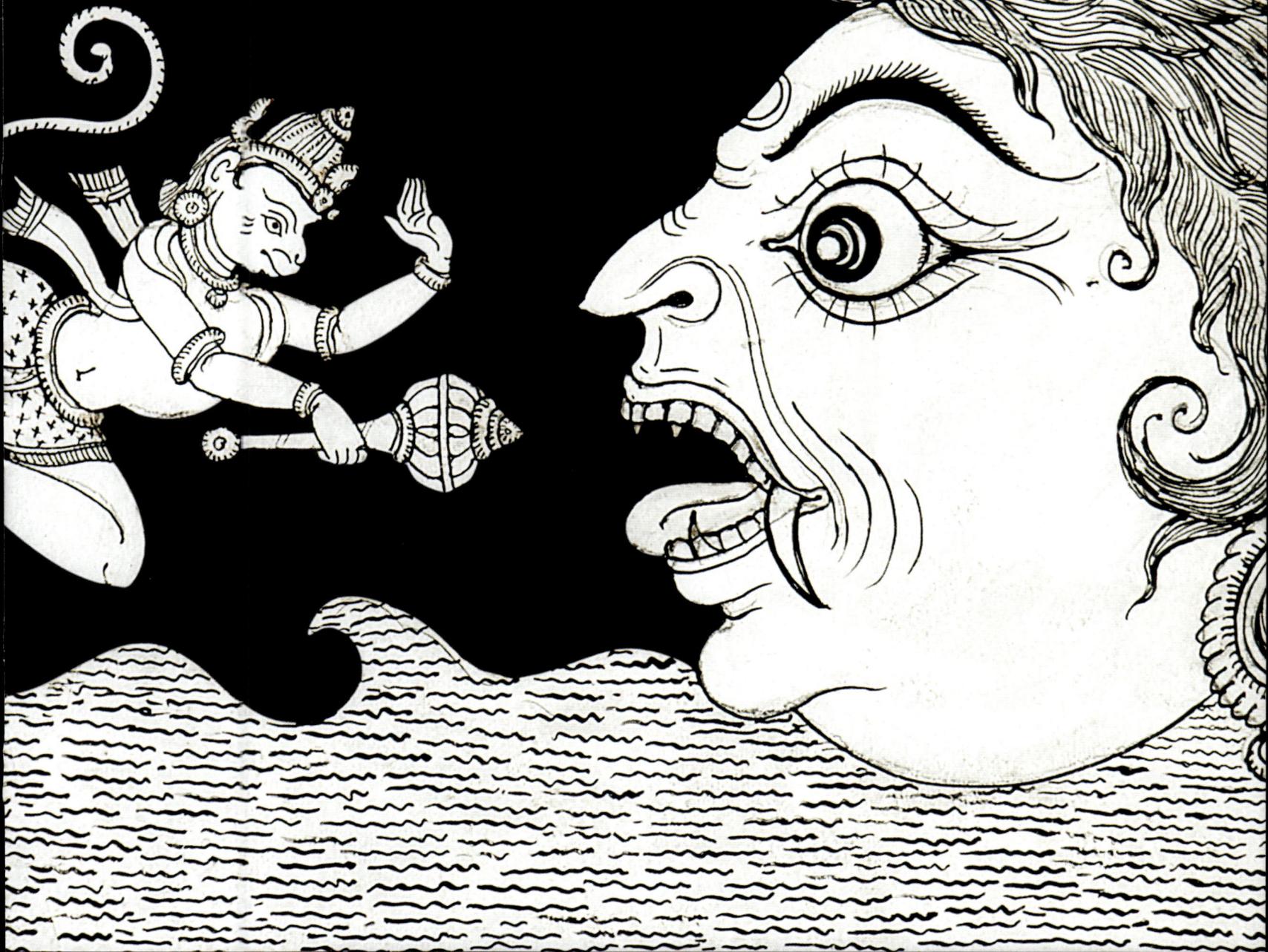

THE MIGHTY SAVIOUR

Hanuman

> "As long as **my account travels** around in the worlds... until that time, **life will reside** in your body."

RAMA TO HANUMAN, *SARGA* (39), UTTARA KANDA

Among all the figures in the *Ramayana*, Hanuman is perhaps the most present in people's lives in India, apart from Rama and Sita. Indeed, there are times when he can seem more ubiquitous than even those two. Whoever a person's chosen deity may be – Rama, Krishna, Shiva, or one of the many forms of the Divine Mother – Hanuman often remains a constant as an object of affection.

He is invoked in moments of triumph as well as calamity, and particularly at times when superhuman strength is required (or, if one simply needs to lift a heavy sofa!).

Devotees of Rama adore him as the one who guards his door, allowing entry into his realm, while devotees of Shiva revere him for being an aspect of Shiva himself. Valmiki seems to be one of his earliest recorded admirers, and Hanuman gets just as much, if not more, attention in the crucial Sundara Kanda and Yuddha Kanda. In Sundara Kanda, the reader learns of his journey to Lanka and back, sees how Hanuman understands his role, and experiences his anguish at his inability to find Sita and his complete reverence for her.

His formal respect for Sita as Rama's consort at the beginning of Sundara Kanda soon transforms into an incomparable affectionate reverence – his expression of obeisance to her before he recounts the story of his journey to Lanka to his comrades says it all.

Mighty lineage

The son of the wind god, Vayu, and Anjana, the apsara, wife of the Vanara chieftain Kesari, Hanuman, as a child, is immensely powerful. Perhaps one of the most well-known

incidents from his childhood involves him leaping towards the morning sun to eat it. The blessings he receives from the gods render him invincible (See pp 350–51). However, he does with them what any child would – create unbelievable amounts of trouble. So he is made to forget his powers until such a time that they are required.

That moment is recorded in Kishkindha Kanda, when Jambavan, the king of bears, reminds him of his powers (See p 199), so that he can leap across the ocean to find Sita.

Remover of all obstacles

He is the closest companion of Sugriva, the Vanara king, and is the first to take Rama to meet him. He is immensely powerful but also knows the Vedas and has a command over various branches of knowledge. During the war, as described by Valmiki, he is a key player, intervening where others fail.

Of significance are his two journeys, first to bring medicines for the entire army and then for Lakshmana. The second incident is important and

FAVOURITE DEITY
Statues of Hanuman marked with the auspicious vermilion and turmeric powder, similar to this painted stone carving from a shrine in Andhra Pradesh, can be found dotted across India.

imbued with great spiritual significance – for it is Hanuman who removes the final obstacle for the seeker – by providing the magical herb that awakens him. This association with his revival reflects Hanuman's role as the panacea for all physical, supernatural, and spiritual troubles.

In fact, the *Hanuman Chalisa*, a hymn by 16th-century Awadhi poet, Tulsidas, is dedicated to Hanuman. Its chanting is believed to invoke his divine powers in difficult times.

True devotee

Hanuman's relationships with Sugriva and Vibhishana, Ravana's younger brother, and their association with Rama are an important aspect of how devotees view him.

Not only does he take Rama to Sugriva, he is also the first to urge Rama to accept Vibhishana. In this way, Hanuman also acts as an intermediary for his devotees by taking them to Rama.

In the last chapter of the *Ramcharitmanas*, by Tulsidas, Bharata, Shatrughna, and Lakshmana urge Hanuman to ask Rama to speak. He is also the one who brings news of Rama in Valmiki's *Ramayana* as well as in other versions. His relationship with Sita, whom he regards as his "mother" in most understandings, is beautiful and helpful for the devotee as they view it as a narrative.

Hanuman is important in the transmission and reception of Rama's story,

SPIRITUAL PURSUIT

In two 20th-century vernacular poetic works, Hanuman participates in an unparalleled way in Rama's spiritual practice. In KV Puttappa's *Shri Ramayana Darshanam*, Hanuman is the only one who has the privilege of viewing Rama's meditation before the final battle. In 20th-century poet and novelist Suryakant "Nirala" Tripathi's "Ram ki Shakti Puja", Rama is despondent after a day's battle, as he sees the Divine Mother siding with Ravana. As Hanuman sits with his hands placed on Rama's feet, he sees Rama's tears fall, and is, for a moment, moved to destroy her realm, before he is deterred. Afterwards, he goes to fetch the blue lotuses for Rama's practice.

but also the ultimate secret of Rama. For instance, in the *Adhyatma Ramayana*, after Rama's coronation, Hanuman stands before Rama, after doing all that was to be done, without any desire, seeking knowledge alone (all the qualities that a seeker should possess), and Rama asks Sita to, "tell Hanuman the reality". After she explains her situation to him, Rama instructs him. The other aspect of Hanuman's presence in transmission and reception, of course, is his presence wherever the story is told.

For all of this, Hanuman is still the ubiquitous deity, so present that devotees do not even always realize they are invoking him – for who else could be invoked at all times!

Inside Lanka

The leap across the ocean did not exhaust Hanuman. Realizing that his immense form would attract too much attention, he returned to his original appearance and walked towards the great city of Lanka. Would he find Sita there?

Hanuman looked around the island, which was a sight to behold, with its forests and rivers. Ravana's Lanka was on the peak of the Trikuta mountain and equalled the city of the gods in its prosperity and splendour.

The impenetrable fort

He approached the city and took in the moat with its flowers, and the golden rampart. Mighty Rakshasas guarded Lanka, which Vishvakarma, the architect of the gods, had built. "What would have been the use if the Vanaras had managed to get here," Hanuman wondered. "What will even Rama do when he reaches this impenetrable fort? These Rakshasas do not look amenable to diplomacy, gifts, or schemes. In any case, only four of us – Angada, Nila, Sugriva, and I – can get here."

"For now," he told himself, "Find Sita and determine if she still lives." He stood outside the city for a moment, wondering how to achieve his goal and Rama's end. Even the wind seemed to move under careful scrutiny in Ravana's realm.

So, Hanuman abandoned his regular form and made himself smaller than a gnat and waited. As the moon rose and shrouded the city in a cascade of moonlight, he entered the gates.

Lanka was divided by pathways and rows of palaces that were seven or eight storeys high. The city's prosperity and invincibility worried Hanuman, but he continued his search for Sita. Finally, he saw Ravana's

LANKA PERSONIFIED

When Hanuman enters Lanka, in some recensions of Valmiki's *Ramayana*, he encounters the guardian deity of Lanka. When Hanuman defeats her, she tells him of Brahma, the Creator of the universe's prophecy that a Vanara would defeat her, and that it would mark terror for the Rakshasas. This story is retold in many versions, but in Bengali poet Krittibas Ojha's retelling, it is the goddess Chamunda whom Hanuman encounters. Her consort, Shiva, had told her that she could only return home when she had met Hanuman.

RAVANA'S ABODE
This 19th-century painting depicts the golden city of Lanka, guarded by the Rakshasas, with Ravana and Mandodari seated in the centre.

palace and sensed the beautiful fragrances that filled it. Inside, he saw a thousand of his queens lying entangled, exhausted after that night's sport. None of them seemed to have been brought there forcibly, and they all appeared to love Ravana.

For a moment, Hanuman wondered if any of them could be Sita, but dismissed that thought. He continued walking and saw Ravana, reclining on a bejewelled crystal bed, and retreated. Seeing Mandodari, the king's beautiful wife, Hanuman wondered if she could be Sita. "Sita would not sleep this peacefully when she is separated from Rama. She would not dress up or drink, or be so close to another man – and what man could equal Rama anyway?" he thought.

A moment of doubt

Soon, Hanuman, struck by anxiety about dharma, thought, "Looking at other women is censured, and I have been looking at so many sleeping women. This will certainly destroy my dharma."

He resolved this thought soon. "Yes, I looked but there was no disturbance in my mind, and the mind is the root of the activity of the senses," he told himself.

A more immediate, serious worry took its place. "I cannot see Sita anywhere, so she must be dead. This Rakshasa must have killed her as she tried to defend herself, or she slipped as he ascended the sky. Could it be that she saw the immense ocean and her heart simply stopped? Perhaps Ravana or the Rakshasis ate her." He renewed his efforts, but when he still could not find her, he began to panic.

"If I return without seeing her, what will Rama and Lakshmana say? What will I tell my comrades? If I tell Rama that I did not see her, he will certainly die. If he dies, Lakshmana cannot live and neither can Bharata or Shatrughna or their mothers.

"If Rama dies, Sugriva will not live, and Taaraa, Angada, and the rest of the Vanaras will also die. No, the end of the Ikshvakus and Vanaras will not be by my hand. I will not return. I will live here as a mendicant, or enter the sea."

He renewed his efforts and soon came upon the Ashoka grove. He invoked the deities, saying, "Obeisance to Rama and Lakshmana, to that daughter of Janaka. Obeisance to Rudra, Wind, Yama, Indra, Sun, Moon and the Maruts. Obeisance to Sugriva and all the deities. Grant me success." So saying, he entered the grove.

A MEETING WITH VIBHISHANA

In Valmiki's *Ramayana*, Hanuman merely sees Ravana's brother Vibhishana's palace as he passes by. In Awadhi poet Tulsidas's *Ramcharitmanas*, he stops at Vibhishana's house, noticing the signs of his devotion to Rama in the objects of worship outside. When Vibhishana wakes up and remembers Rama's sacred name, Hanuman is determined to go and speak to him. He comforts Vibhishana by reminding him of Rama's compassion, and Vibhishana tells him how to get into the Ashoka grove where Sita is confined.

A CARVING OF VIBHISHANA, at the Kelaniya Temple, Sri Lanka

> "This was the **residence of the Indra** among the Rakshasas... He was searching for the **whereabouts of the large-eyed Vaidehi...**"

HANUMAN ON SEEING RAVANA'S PALACE, *SARGA* (7), SUNDARA KANDA

211

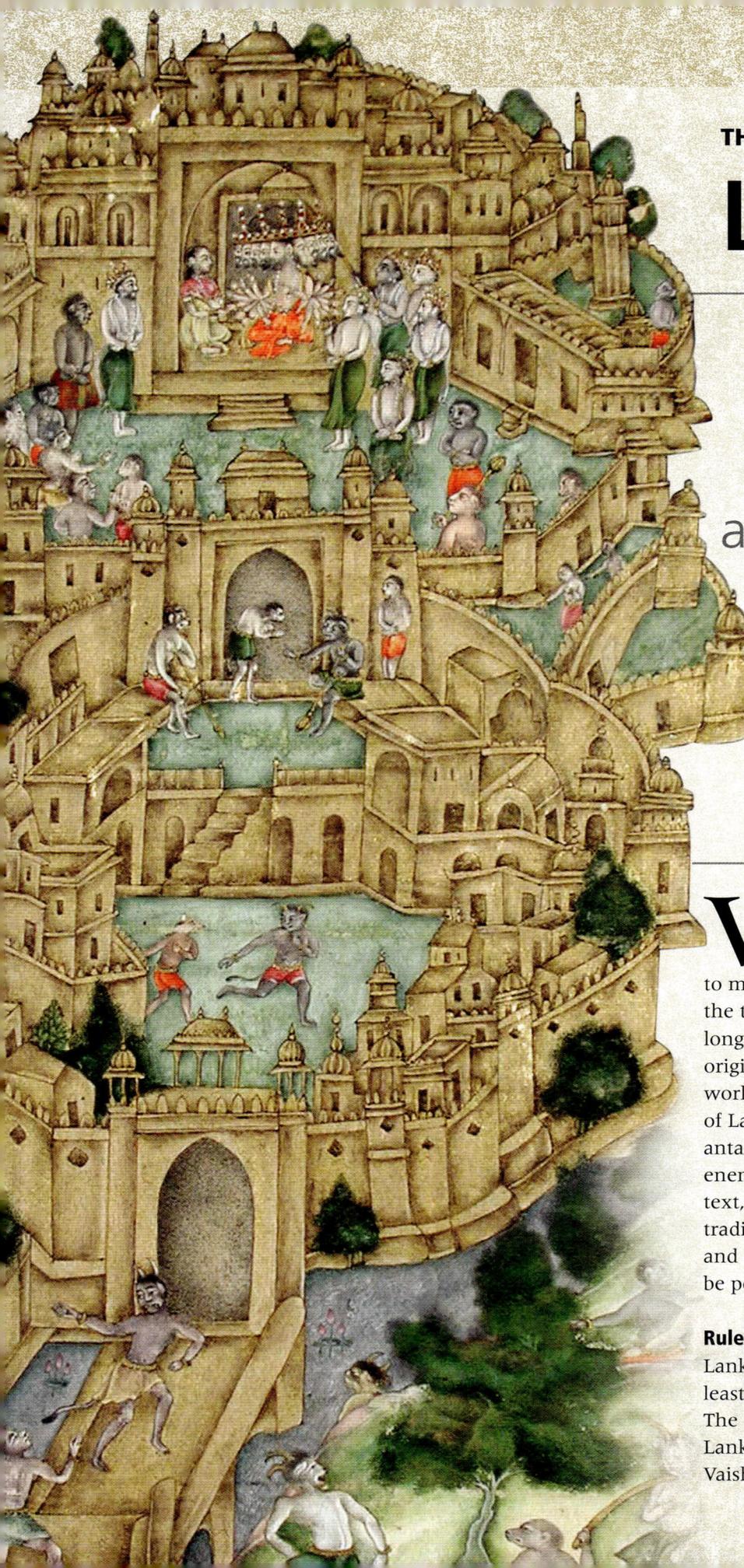

Lanka

> "The city was like a **beautiful** and **ornamented** woman attired in red garments... **illuminated** by **radiant** lamps that dispelled the **darkness**. "

HANUMAN'S VISIT TO LANKA, *SARGA* (3), SUNDARA KANDA

Valmiki and the *Ramayana* have meant many things to many people, but one of the things the *Ramayana* has long been regarded as is the original literary creation, a work of poetry. The portrayal of Lanka, the city of the antagonist Ravana, the enemy's realm, across the text, and in the broader tradition, is fascinating, and "Lanka" comes to be personified early on.

Rulers of the city

Lanka changes hands at least twice in the *Ramayana*. The first person to rule Lanka that we hear of is Vaishravana or Kubera, Ravana's half-brother, whom Brahma assigned the lordship of wealth. However, the construction of the city seems to have predated his appointment, because rather than building it from scratch for him, the architect of the gods, Vishvakarma only tells him that such a city had already been built at Indra's behest, and that he may settle there. Ravana takes it after their father advises Kubera to not fight him. Eventually, after Rama kills Ravana in battle, Vibhishana becomes the king.

The prosperous city

While we have the city portrayed from a few different perspectives –

perhaps the starkest are Hanuman's two visits The first description of any significance that we have of the interior of Lanka is in the Aranya Kanda, when Sita is first brought to Lanka. Ravana's residence, comparable to the residences of deities, is only really seen when the king of Lanka forcibly shows her the palace in an attempt to entice her.

A symbol of might

Ravana's Lanka is portrayed as a centre of might and prosperity, strength and aesthetics. One could argue that by the time he shows Sita the city's prosperity, she has already seen his, and by extension Lanka's, might in his act of abducting her. Hanuman's first sight of Lanka is described with greater patience. Unlike Sita, Hanuman has not merely the luxury but the necessity of circumspection. And so he takes in the first view of Lanka, the protections and fortifications alongside the fauna. He sees various kinds of flowers and trees, waterbodies and groves – and the moat with flowers, emblematic of the synthesis of the aesthetic and secure. Indeed, Lanka's very rampart is golden, a common trope – securing a realm that is unimaginably prosperous and virtually unassailable.

We see Hanuman go through a vibrant city, even at night. The verses, which describe the moon that night, are very different in tone from other parts of the text. Valmiki constantly brings images of decadence together with those of incomparable strength. There is also a detailed description of what Hanuman sees in the palace. It is the moment of the very apogee of Lanka – this is the last peaceful night the realm shall have before Hanuman sets it on fire. Between this first visit and the second at

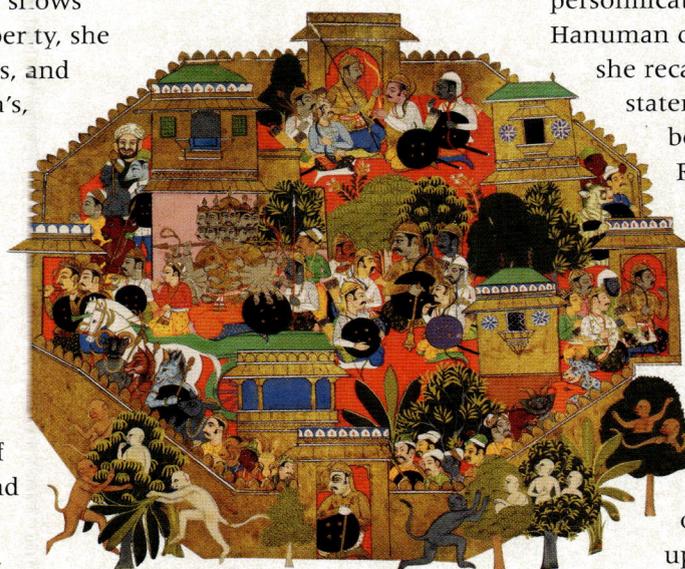

THE GILDED INTERIORS of Ravana's palace

the end of the war, the city has been laid siege to by the Vanaras, vanquished, and taken over by Vibhishana.

This time, it is described as desolate, a city defeated. Interestingly, both in Sita's words and the actions of the Rakshasas there is relatively little animosity towards and on part of the remaining denizens

of Lanka – although if Hanuman were to have his way he would extract revenge on them.

The city deity

The personification of Lanka as the guardian deity whom Hanuman meets upon entry is already available in some recensions of Valmiki and is picked up by various later authors. It is usually a variation on the following theme – when Hanuman enters Lanka, he is first encountered by a Rakshasi, understood to be the guardian deity or personification of the realm. Hanuman defeats her, and she recalls Brahma's statement that the beginning of Ravana's downfall would be her defeat by a Vanara. Hanuman's personal siege of Lanka is thus made clearly into a harbinger of Rama's upcoming victory.

Some authors within the literary tradition have also picked up on this notion, but somewhat differently. The 8th-century Sanskrit playwright Bhavabhuti in his *Mahaviracharita*, for example, has "Lanka" – Ravana's almost widowed city – converse with Amaravati – the capital of the king of the gods, Indra – the latter treating her as a younger sister.

LOCATION

LANKA AND SRI LANKA

While there is sometimes the notion that the island of Sri Lanka was where Ravana ruled, there was often a distinction drawn between Sri lanka and Ravana's realm. Later, the island of Sri Lanka came to be conflated with "Lanka" of the *Ramayana* and this identification has been used in various ways to articulate different historical and contemporary positions.

THE NATIONAL FLAG OF the Democratic Socialist Republic of Sri Lanka

It is significant, of course, that even before the war, it was clear that Rama did not intend to actually take control over Lanka. That remains within the family, from Kubera to Ravana, and Ravana to Vibhishana. The wealth of Lanka has often been contrasted with the asceticism of Rama. A popular notion is of barefoot Rama standing with his ragtag army of Vanaras against the imperial strength of Ravana, with the sheer force of moral strength on his side – until the gods themselves step up. Hindi author Narendra Kohli, in his multivolume novel published later under the title *Abhyudaya* ("The Auspicious Rise"), has described Lanka as the centre of despotic wealth and Rama as the leader who leads the charge for dharma.

Tormented Sita

Hanuman leapt over the wall and entered the Ashoka grove, full of blossoming trees that heralded the advent of spring, and ponds filled with cool water. Surely, he would find Sita here.

The grove was resplendent, flowers adorned the earth, and there were rivulets and artificial ponds. As Hanuman, the son of the wind, flew through the grove, the trees trembled, shedding flowers, and startling sleeping birds.

A single golden tree, the shimshapa or Ashoka tree stood in the grove. It blazed like fire, creepers wound their way around its trunk, and it was covered in a large number of leaves. Hanuman climbed up and settled on the top. "I will be able to see Vaidehi from here," he said and looked around.

Finally, he saw her. The woman resembled the moon on the first day of the bright fortnight, emaciated from fasting and her face tear-streaked. "This must be Sita," he thought. "She looks like the woman who was being abducted by Ravana."

He wondered if she was really Sita and looked at her again. It was through her grief that he finally determined that the unadorned one was Sita indeed. She was like faith that had been shattered. She glanced here and there, her eyes filled with tears. The clothes she wore were worn with constant use. She only wore ornaments that she had not dropped during her abduction, and the silk covering, which she had flung, was missing

"This," he decided, "is that golden one, for whose sake Rama is afflicted by tenderness, for she is away; compassion, for she is dependent on him; grief, for she seems lost; and desire and passion, for she is his beloved. Each of her limbs bears a comparable perfection to Rama's own. Her mind is established in him, and his in her – and that seems to be how they both still live."

> **"** He **lamented** and his **eyes filled with tears**. '**She is revered by Lakshmana**. She is **humble** towards her seniors... Raghava deserves the **dark-eyed Vaidehi** and she deserves him.'**"**
>
> HANUMAN ON SEEING SITA, *SARGA* (14), SUNDARA KANDA

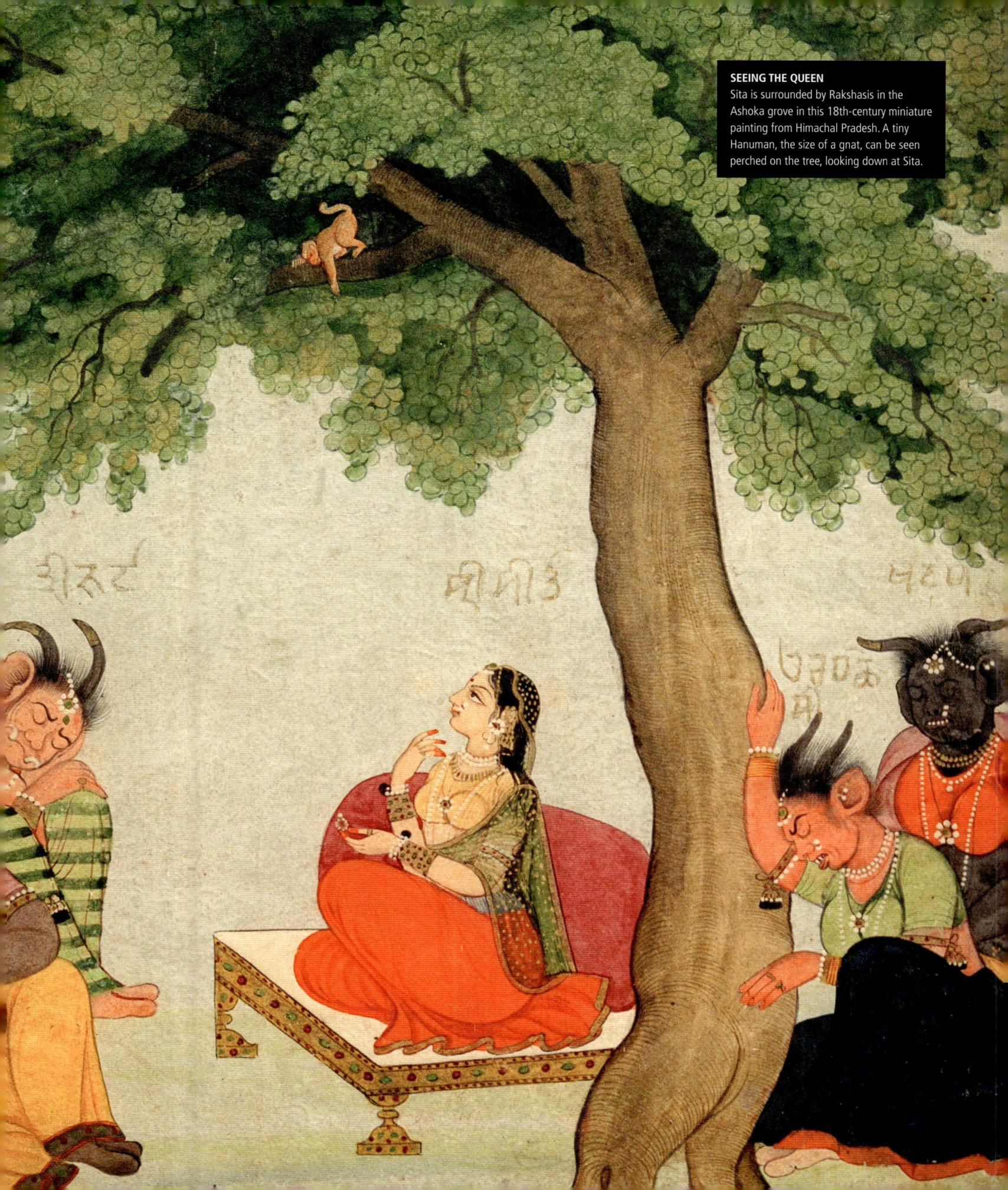

The Rejection

Obsessed with Sita, Ravana went to the Ashoka grove to convince the princess of Ayodhya to marry him. Sita instead assured the king of Lanka of destruction when Rama arrived. A furious Ravana refused to take no for an answer.

Night almost came to an end while Hanuman sat on the tree. Meanwhile, Ravana woke to the sound of auspicious instruments and his first thoughts were of Sita, sitting in the Ashoka grove. He set out with his retinue to see her.

Hanuman heard the sounds of the bells that adorned the women in Ravana's retinue, and saw the lord of the Rakshasas walk into the grove and towards Sita. He recognized him as the mighty-armed Ravana, and retreated into the tree, so that he remained hidden.

Ravana's desire

Sita saw Ravana walk up and pulled up her knees to hide her torso and covered her breasts with her arms. She retreated into herself, crying. Ravana saw her thus, drowning in an ocean of grief, trying to reach Rama, that lion amongst kings, through her resolve alone.

Seeing her, his desire aroused, Ravana spoke gently, "You seem to want to hide yourself in my presence, covering yourself like this. I desire you, large-eyed one, so view me with loving regard.

"It is true that it is the inherent nature of Rakshasas to act with desire towards other women, but do not worry. I will not touch you if you do not wish it. Trust me. You are a jewel among women, it does not befit you to sit thus, so adorn yourself."

The proposal

So saying, Ravana asked Sita to be his wife. "What more could you possibly want once you obtain me? Your beauty is unparalleled. You will be the chief amongst my wives," he said, promising her precious jewels and even his kingdom. "My might is exceptional – neither the gods nor Asuras have any influence while I reign," he said. "Of what use is that bark-clad, defeated Rama. I wonder whether he even lives or not. In any case, Rama cannot

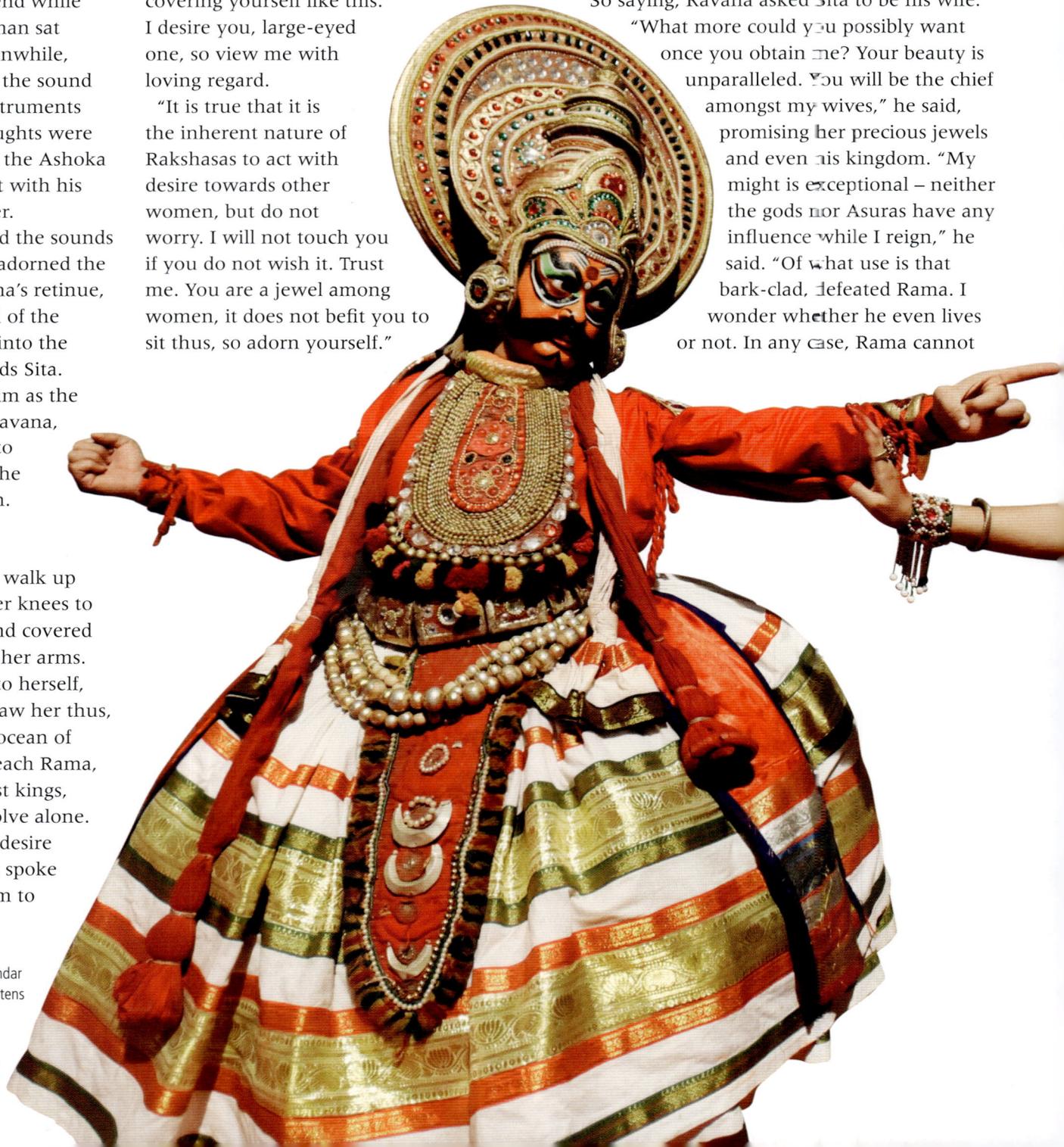

THE ANGRY KING
Performer Swapan Majumdar plays Ravana, as he threatens Sita in a menacing way. She in turn rejects him in this *Ramlila* performance.

defeat me. You have my heart, Sita. All these women will serve you when you are my chief wife."

A firm refusal

Sita trembled as she placed a single blade of grass between them. She said, "It is not right for you to seek or desire me, just as a sinner cannot seek accomplishment. I cannot commit the act you speak of. I am firm on my vow of only having a single husband.

"I am not a suitable wife for you, I am the wife of another. Look upon dharma. States and cities come to devastation when ruled by a king who indulges in ill conduct. So shall Lanka. You cannot entice me with riches or power for I am inseparable from the Raghu scion as radiance is inseparable from the sun. Having rested on the venerated arm of that lord of the worlds, how could I possibly rest on just anybody's arm?"

Sita reprimanded him further, "What you did in Janasthana was improper, for you came when Rama and Lakshmana were away, but you won't escape Rama."

Ravana's threats

Hearing her sharp rebuke, Ravana lost his temper, "Ah, contrary is the time when desire binds a person, for both anger and affection arise for the same person. It is for this reason alone that I do not kill you, who deserve to be killed for each of the sentences you spoke to me." He told her that of the one year deadline he had given her, two months remained. "If you do not come to bed with me then, I shall kill you," he threatened.

Sita remained unfazed and said, with pride, "There seems to be nobody who would ward you off this path. Why do your eyes not fall off when they look upon me? Why does your tongue not rot when it suggests such a thing to Rama's wife and Dasharatha's daughter-in-law?

"This must be fate's ploy to cause your destruction – for you could not have abducted me otherwise."

Breathing like a furious serpent, Ravana glared at her and stormed off.

> "It is appropriate that you should **wish to have Rama**,... as your friend. That is unless you desire a **terrible death** for yourself... when he is enraged, Raghava, the lord of the worlds, will not let **someone like you escape**."
>
> SITA AS SHE WARNS RAVANA OF RAMA'S MIGHT, *SARGA* (19), SUNDARA KANDA

ANALYSIS

FIERCE SITA

Sita's resistance after she was abducted by Ravana is quite iconic, in narrations of the full story of Rama and in the popular tradition. A Hindi song about her time there uses different metres and speeds to convey her fearlessness and the intensity of her suffering, emphasizing her fierceness when surrounded by the strongest army, in the vicinity of the man whom the three worlds feared. It opens, "When she went to Lanka, oh Sita suffered in the extreme!"

Mandodari, the queen consort, who is silver-complexioned, worries for her position on seeing the golden Sita. She goes to her, and asks, "Whose darling daughter are you, and whom are you married to? What is the name of your father-in-law, and why did you come here with my husband?" Sita replies, "I am the darling daughter of King Janaka, and married to Ramachandra. My father-in-law's name is Dasharatha, and I have come here to see your widowhood."

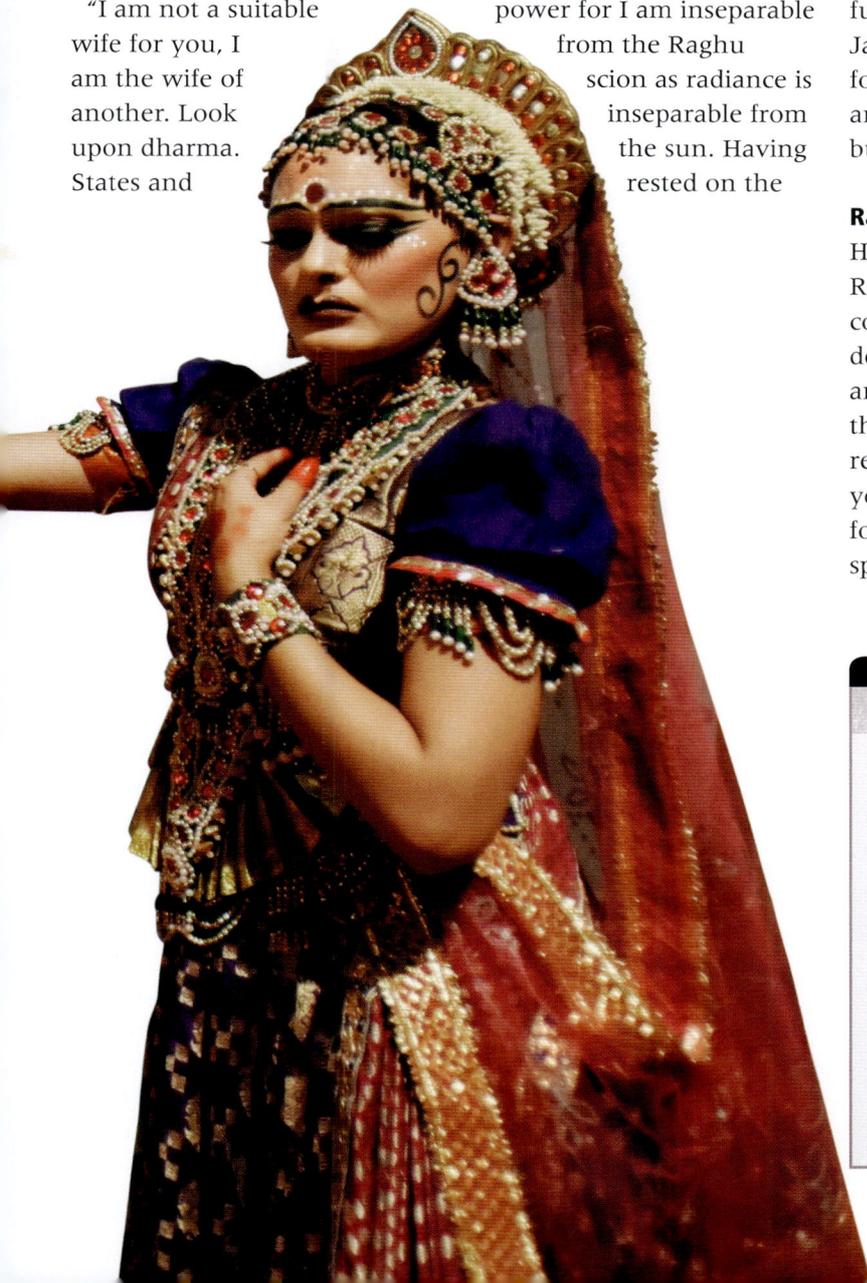

The Dream

Ravana stormed off, but before leaving, ordered the Rakshasis to torment Sita until she changed her mind. They surrounded her and heckled her, threatening her with horrifying words. As Sita began losing hope, she met an unlikely ally.

ALL ALONE
This portion of a 19th-century miniature painting from Himachal Pradesh depicts Sita in the Ashoka grove as Rakshasis watch over her every move. Hanuman can be seen spying from the walls of the garden.

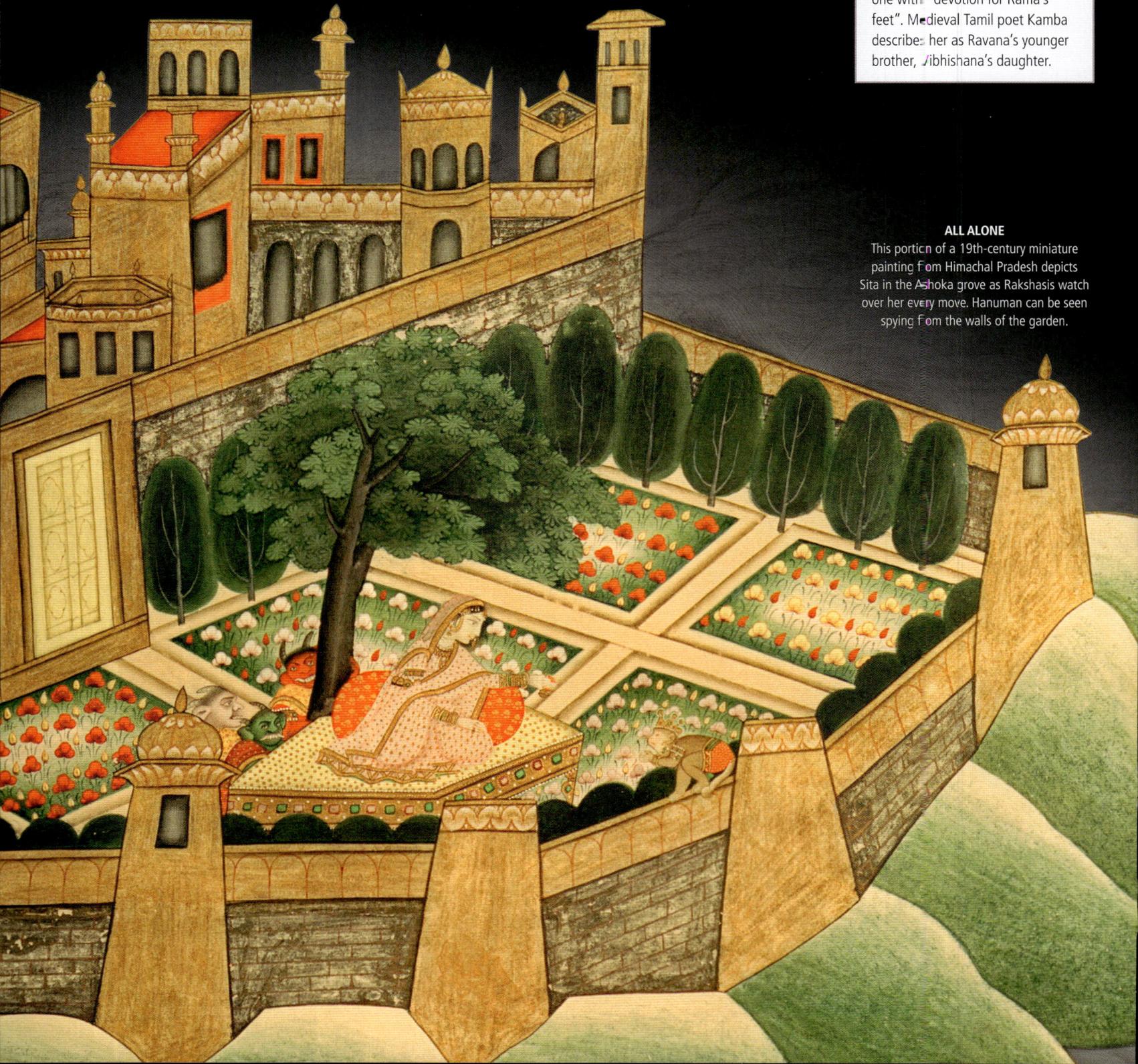

> "I can see that her eyes, which are as **large as lotus petals**, are **throbbing**. There is a reason for this and hear from me about this great joy… A **bird is entering** its nest on a branch and repeatedly uttering words of comfort, **that happiness will arrive**."
>
> TRIJATA, AN ELDERLY RAKSHASI DESCRIBING HER DREAM, *SARGA* (25), SUNDARA KANDA

Ravana left and the Rakshasis surrounded Sita. They were terrible to behold – some had no feet while others had long tongues, or none at all. Some had ears that covered their entire body while others had mouths or feet like lions, or cows or pigs.

They gathered around Sita, following their king's instructions, and extolled his qualities. One described his lineage, another recounted his victory over the gods, while another told her of the luxuries that awaited her if she accepted Ravana as her husband. They wondered why she desired an exiled man with no kingdom.

Sita replied, "These terrible words have no impact. You may eat me, but I will never do what you say. Whether my husband is piteous or without a kingdom, my place is with him."

Sita's torment

Her words and tenacity angered the Rakshasis who tried a different approach. They said she did not deserve the great Ravana as her husband. A Rakshasi named Vinata said, "You have demonstrated love and loyalty for your husband so far. Now, accept Ravana as your husband and abandon that miserable human. The lordship of all worlds awaits you if you agree, otherwise, we will kill you and eat you."

Vikata, another Rakshasi, raised her fist and said angrily, "An ocean separates you from anybody you may know. We guard you in Ravana's palace and Indra himself cannot rescue you. Do as I say. Abandon this grief. Youth is momentary. Enjoy it while it lasts. Otherwise, I will pluck your heart out and eat it."

The Rakshasis thought of ways to choke and kill her, so that they could tell Ravana that she was dead and he would grant them permission to eat her.

A lament

Sita repeated her resolve and cried out for Rama and Lakshmana as she lamented, wavering between hope and the desire for death. She said, "The saying must be true that death never graces a man or woman until it is time, for I continue to live without Rama, surrounded by these Rakshasas. I must be without merit for I will die without seeing my Rama. Without him, life is as unlikely as after tasting a deadly poison.

"What will I do in this state of subjection when I cannot even die at will? Won't he come to me, he who destroyed 14,000 Rakshasas single-handedly?"

Sita wondered if Rama knew that she was in Lanka and hoped that Jatayu had told him of her abduction. "Had he known I was here, he would have wiped the earth clean of Rakshasas," she said. She imagined the worst, "Perhaps Rama has departed to the heavens in his grief – how fortunate are those celestial beings who see him! Perhaps he does not need me any longer. Or … Ravana must have killed the brothers through stealth. Ah! I would rather die."

An unexpected saviour

Angered by her words, some Rakshasis went to report to Ravana while the others threatened to eat her. Trijata, an elderly Rakshasi, spoke up and told them that it was futile to speak of eating Sita. "I had a terrible, hair-raising dream – about the undoing of the Rakshasas and Sita's husband's victory." The Rakshasis gathered around and listened.

She said, "Rama was in an aerial palanquin, decorated with ivory and pulled by 1,000 horses. Sita was on a white mountain surrounded by the sea, clad in white.

"I saw Rama on a four-tusked elephant with Lakshmana, and Sita joined them. She stroked the sun and moon with her hands and the elephant was over Lanka. I saw Ravana, fallen from the Pushpaka Vimana, being dragged by a woman. I saw him dragged southward on a chariot pulled by donkeys. Ravana was on a boar, Indrajit on a porpoise, and Kumbhakarna on a camel. Lanka sank into the ocean, utterly destroyed, while the others were in a pool of cow-dung.

"Rama will find Sita and destroy this city and the Rakshasas. He will not be pleased to find his beloved wife terrified. So enough of your cruelty, we are better off placating her, for the one for whom such a dream has been seen, will soon be freed."

THE DIVINE FEMININE

Sita

> "**O Sita**! You have been **born in a great lineage**. You are always **devoted to dharma**."
>
> RAMA TO SITA, *SARGA* (25), AYODHYA KANDA

Even when invoked, Sita is rarely separate from Rama – as both she and Rama say on different occasions, she is non-different from him even as the light from the sun. Awadhi poet Tulsidas says, "I pay obeisance to the feet of Sita–Rama, who are spoken of differently, but are not different, like word and meaning, water and wave." This sentiment does seem strange as Sita is, in fact, separated from Rama for the entire Kishkindha, Sundara, and Yuddha Kandas, and a large part of the Uttara Kanda.

A mind of her own

Sita – Lakshmi incarnate, as Brahma tells us – has unfathomable love for Rama, but this does not mean that she is timid or quiet.

Although the *Mahabharata*'s Draupadi is usually credited with asking incisive questions even in moments of great adversity, one can hardly accuse Sita of remaining quiet when treated harshly. Her response is usually to try and enter the fire or earth. In the first occasion, she makes it clear that she is convinced of the flaw in Rama's reasoning, and walks in with her head held high (See pp 324–25). One could argue that the quiet departure in the second is even more powerful an act (See pp 368–69) – even though both instances may hold up problematic ideals of self-annihilation for women.

Nor does Sita's love for Rama in the poetic literature mean that she does not feel anger towards him. Rather, her love is able to overcome her anger towards his actions.

Of divinity

Sita also possesses an infinite capacity for compassion, which reveals immense inner strength. After all, to understand the perspective of and forgive one's oppressors is a superhuman feat.

She is also a manifestation of the divine feminine, and is regarded so in various readings, some of which exclude the reference to Sita's second exile. In the medieval Sanskrit text *Adhyatma Ramayana*, for instance, she says, "Know me to be the

SITA IN THE ASHOKA GROVE
An illustration of a scene from the Sundara Kanda when Hanuman presents Sita with Rama's signet ring as a proof of His identity.

primary cause, who effects the coming into being, staying, and end; through just his proximity, I create untiringly."

A different aspect

Literary texts often portray Sita sensitively; however, a fascinating version of Sita's story is explored in the *Adbhuta-Ramayana* (The Extraordinary Ramayana), featuring Valmiki as the narrator.

In one instance, as the sages praise Rama after his coronation, Sita smiles. When asked why, she says that praise at killing the 10-headed Ravana seems to be mockery, for the 1,000-headed Ravana still lives. Rama goes to vanquish him, with Sita and his brothers by his side. During the battle, he falls unconscious and Sita takes on the ferocious aspect of the divine feminine, who achieves victory and is eventually propitiated by Rama.

There are certain aspects in her revelation of her divinity to Rama that are reminiscent of the *Bhagavad Gita*. Devotees regard Sita in several, sometimes non-exclusive ways, including as the one who is closest to Rama and can act as an intermediary in his grace, and as non-different from the godhead. She is the one who creates, preserves, and annihilates the worlds.

Indian scholar Srilata Raman observes that some Shrivaishnavas (a Hindu community that worships Vishnu) see the goddess as characterized by her eternal union with and proximity to

the lord, her tenderness and compassion, her rulership through motherhood, and transcendence of transmigration. The Mithila region of eastern India regards her as their daughter, which does not interfere with her also being the mother of the universe.

Multidimensional characterizations

In the past couple of centuries, there have been a large numbers of interpretations and readings of Sita, including critical engagements with the Rama story and feminist critiques, readings of her as the real force.

Some authors have portrayed her as not only Rama's beloved but also his comrade-in-arms, who participated shoulder to shoulder in various conflicts. Others, such as Ayodhya Singh Upadhyay "Hariaudh", the composer of *Vaidehi-Vanvas* ("Sita's Exile"), have cast their text in Sanskrit playwright Bhavabhuti's mould, insofar as they reinterpret the events and motivations of the last chapter of the *Ramayana*.

Like much of the *Ramayana*, contestations over what Sita means or stands for are equally contestations over what divinity and womanhood mean more generally, and so is read, historically, in terms of the ideals of that moment.

At the same time, there is the transcendental aspect of the Divine, accessed through her various aspects, that need not be limited to the socio-historical.

> "The one from whose aspects emerge **countless** Lakshmis, Umas, and Brahmanis, and with the twitch of whose **eyebrow** the world comes into being – she is **Sita to Rama's left**."
>
> ABOUT SITA, *RAMCHARITMANAS* BY TULSIDAS

CULTURE

PANCHAKANYA

Five women from the *Ramayana* and *Mahabharata* are called *panchakanya*, or the five women. The term *kanya* is used for young, unmarried women, and this group is invoked together for auspiciousness and removal of sin.

Four of these women are from the *Ramayana* – Ahalya, Taaraa, Sita, and Mandodari – while Draupadi is from the *Mahabharata*. Each of these women either suffered because of accusations over their relations with men, or married after their husband's death. Ahalya was cursed because of Indra's actions, Taaraa and Mandodari lived with Sugriva and Vibhishana respectively, after their husbands' deaths, townspeople gossiped about Sita, while people called Draupadi names as she was married to five men at once.

The traditional invocation of these for the removal of sin is a powerful statement.

Rama's Messenger

Hanuman observed everything from his perch on the tree, hidden by the leaves. He wondered how to speak to her. What would he say? How would he give her Rama's ring?

Sita resembled a deity in the garden of the gods, and Hanuman wondered how he could comfort her. "If I return without talking to her, she will certainly give up on her life. Further, what will I say when Rama asks me for her message? I shall comfort her in human speech, for the divine language might remind her of Ravana," he thought. "But, if she sees me suddenly, she might be terrified and attract attention, which could lead to all kinds of complications."

Hanuman meets Sita

Slowly and in sweet words, Hanuman spoke up. He described that tiger among great kings, Dasharatha, and his devoted son Rama, endowed with all virtues and the best of bowmen. He described Rama's exile and all the events that took place up to his arrival in Lanka. "I have found Sita, who is just as Rama described," he ended and waited.

Sita looked around and spied Hanuman atop the tree. She became faint and wept in fear. Hanuman climbed down and stood next to her in perfect humility, and Sita wondered if it was all a dream. The son of the wind placed his hands on his head and asked, "Are you the consort of the moon fallen from his celestial abode? Or of the great sage Vasishtha? Who are you? Who is your father, husband, brother, or son, whom you lament in this way? I see the marks that identify you as the consort of a king and as a princess. If you are Sita, abducted by Ravana

222

from Janasthana, tell me. Your sorrow, beauty, and the self-discipline that surrounds you tells me that you are Rama's queen."

Pleased on hearing Rama's name, Sita told him who she was and spoke of Rama's consecration, his exile and her abduction. "Two months remain of the one year of grace Ravana granted me. I shall not continue to live at the end of that time," she said. Hanuman replied, "Rama, who knows the weapon of Brahma, greets you, as does his brother with his head bowed in reverence."

The ring as proof

As they talked, they delighted in seeing each other, but when Hanuman stepped closer, Sita, reminded of Ravana, grew terrified.

Hanuman placated her, but she did not look up. Instead, she said, "If you are Ravana and have come here in another form to torture me, who am already emaciated and terrified, it is not right. Or ... it could not be so, for how would I feel this joy then? If you are Rama's messenger, best of the Vanaras, tell me Rama's story. Tell me of his virtues ... is this a dream, or delusion? Is this madness? But no, it cannot be a delusion, and madness is also characterized by delusion, so it could not be that either."

This way, she concluded that he was Ravana and turned away. Hanuman replied,

> ## "I possess the strength to carry Lanka from here, with its mountains, forest regions, palaces, turrets, gates, and its lord... That being the case, remove all hesitation from your mind."
>
> HANUMAN TO SITA, *SARGA* (35), SUNDARA KANDA

"He who shall kill Ravana with his fiery arrows, released in anger, has sent me as his messenger. He is brilliant like the sun and delights the worlds like the moon, and is the lord of all beings. He and his brother have conveyed their greetings, as has Rama's friend Sugriva. They think of you constantly. You shall see them soon. I am Sugriva's adviser, and not he whom you mistake me for."

News of Rama

Sita asked him how he met Rama and knew Lakshmana. "How is it that the Vanaras and humans are allied?" she asked and told Hanuman to describe the two brothers. Hanuman described Rama's auspicious markings in great detail and added, "His half-brother, the son of Sumitra, is similar, except he is golden-complexioned while Rama is dark." Then, Hanuman gave her Rama's ring, and Sita grew delighted as if she had met Rama himself.

As she wondered, and worried, why Rama had not rescued her yet, Hanuman placed his cupped hands to his head and replied, "Rama does not know you are here, and has, therefore, not been able to come to you. He would battle

gods or Rakshasas or death itself, if they tried to stop him now. You will see him soon. Rama does not indulge in any comforts. He is so distracted by memories of you and his concern for you that he does not even make the effort to remove insects if they settle on him. He is sleepless, and if he does sleep, he wakes up calling out to you."

Sita's ardent devotion

"You have spoken words that are like nectar mixed in with poison," Sita replied, "for Rama still loves me, but is in such immense pain."

As she rued how little time remained of the year, Hanuman assured her tearfully that Rama would come soon. "Or," he said, "I can take you today. You can sit on my back and we shall cross the sea. You

will see Rama today itself. Nobody here can follow me. Come, climb onto my back."

Incredulous, Sita asked, "How? How will you carry me so far? You are so little." Hanuman realized she did not know of his prowess and showed her his massive form. She replied, "I know that you have strength and can carry me. However, what if I fall into the ocean? Or, if they attack you, how will you be able to defend me and fight at the same time? What if I am discovered and the demons hide me away where none of you can find me?

"I cannot touch a man other than Rama. When Ravana touched me, I had no choice as I was under his control. But I cannot do so voluntarily. It would be befitting if Rama rescues me."

SUNDARA KANDA – THE BEAUTIFUL CHAPTER

The Sundara Kanda, which translates to "the beautiful chapter" or "the chapter of the beautiful", has acquired a significance in Hindu religious practice that distinguishes it from other parts of the *Ramayana*. This is not only the case for Valmiki, but also for vernacular versions of the epic. In the introduction to their translation of the Sundara Kanda of Valmiki, scholars and translators Robert P Goldman and Sally J Sutherland Goldman, suggest that there is a reversal of fortunes in this chapter. Interestingly, Tulsidas's version includes Vibhishana's surrender here, rather than in the Lankakanda (his name for Yuddha Kanda). His Sundara Kanda, then, is a narrative of surrender, not only Vibhishana's, but also Hanuman's as the latter surrenders his ego regarding his strength and agency at Rama's feet, repeating that there is no great strength to be found among the Vanaras. It is all Rama's grace.

INDRA'S SON
The crow in the story is known as Jayanta and is the son of Indra. He resides in *svarga* (heaven) and disguises himself as a crow while on the earth.

STORY FROM THE *RAMAYANA*

The **One-Eyed Crow**

Hanuman requested Sita to give him a message for Rama, something only the exiled prince would know. So, Sita told him of an encounter on Mount Chitrakoot.

Once, while strolling through the lush groves by the River Mandakini, at the foot of Mount Chitrakoot, Rama and Sita decided to rest. As Rama lay on the grass with his head on Sita's lap, a crow swooped in and pecked at the princess's chest. She tried to ward him off with a lump of clay, but still attracted to her flesh, he kept pecking.

Rama saw her as she fixed her clothes, troubled and exhausted, and teased her, laughing. However, on seeing that she was angry and embarrassed, he wiped her tears and comforted her, before the two dozed off again.

Rama's anger

The crow returned and pecked Sita's chest repeatedly. She woke Rama who saw her hurt and breathed out in anger like a mighty serpent. "Who has hurt you in this way? Who is so foolish, or insolent, as to play around with a fearsome snake?" he thundered. Looking around, Rama saw the crow whose claws were dripping blood.

Enraged, his eyes fiery in anger, Rama, picked up a blade of grass and invoked the Brahmastra (the weapon of Brahma). Blazing like death's own fire, he hurled the blade towards the crow. The crow fled, but the Brahmastra, in the form of a blazing blade of grass followed him every where, even to the ends of the earth. In desperation, the crow went to his father, Indra, the king of gods, and pleaded for help. His father refused to give him shelter or help. The crow, then, begged the sages, but while some were helpless against Rama's own weapon, others were unwilling to protect him.

The crow searched the three worlds for a rescuer, but failed. Everyone had abandoned him and so, finally, he returned to Rama.

In his protection

Rama, who is to be sought as a refuge, saw the crow fallen to the ground, seeking

ANALYSIS

THE MANY TALES

Srilata Raman, scholar of South Asian religion and author of "Self-Surrender (Prapatti) to God in Shrivaishnavism"in her study of surrender in the Shrivaishnava (Hindu community that worships Vishnu) tradition, writes that this story of the crow has been used to articulate the importance of the presence of the Goddess when refuge is sought. In doing so, it demonstrates an instance where this case is contrasted with Ravana.

There are some versions where the crow returns to peck Sita again. The Critical Edition excludes the second episode of pecking. In some cases, including in the *Ramcharitmanas*, it is Sita's foot that is pecked by the crow.

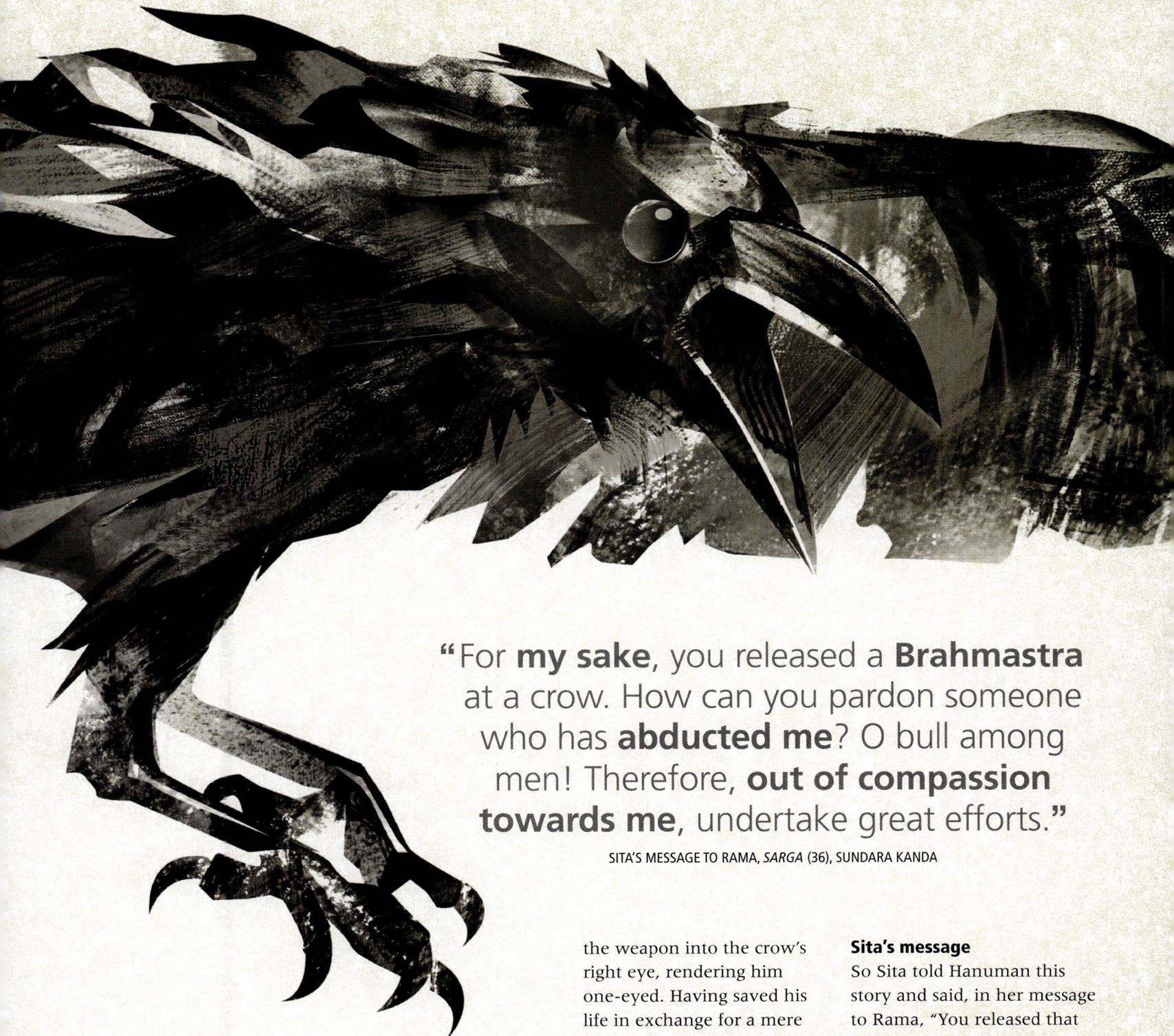

> "For **my sake**, you released a **Brahmastra** at a crow. How can you pardon someone who has **abducted me**? O bull among men! Therefore, **out of compassion towards me**, undertake great efforts."

SITA'S MESSAGE TO RAMA, *SARGA* (36), SUNDARA KANDA

help, miserable and pale. Out of compassion, the prince of Ayodhya granted him protection even though the crow was fit to be slain. Rama said, "I have released this mighty Brahma weapon. It is impossible for this to not find a target. Tell me, crow, what shall I do with it?" The crow replied, "Let it destroy my right eye." So, Rama released the weapon into the crow's right eye, rendering him one-eyed. Having saved his life in exchange for a mere eye, the crow was grateful and relieved. He went on to offer obeisance to Rama, the prince of Ayodhya, his protector in this instance from his own fury, and the great king Dasharatha.

Sita's message

So Sita told Hanuman this story and said, in her message to Rama, "You released that mighty weapon at a mere crow for my sake, so how is it that you are able to tolerate the one who abducted me from our hermitage? Lord of the earth, why are you ignoring me?"

A Promise to **Return**

Hanuman prepared to leave Lanka bearing Sita's messages to Rama and Lakshmana and a plea from her to return as soon as possible. Ravana's one-year deadline had nearly come to an end and Sita knew that time was running out.

Sita told Hanuman to ask Rama why he had not come to Lanka to rescue her. She said, "Tell him that I said, 'O bull among men, you directed that fatal arrow towards the crow (See pp 224–25) for pecking at me. Would you not render unto me that compassion, intermingled with immense strength? I heard that compassion is great dharma. I know that the gods cannot withstand your strength in battle. Why would you not release your weapons at this Rakshasa? Why does Lakshmana not rescue me at Rama's command?'"

Rama will come

Hanuman comforted her and said, "I swear to you, Rama has turned away from all pleasures out of his love for you. Lakshmana is tormented by Rama's sorrow. The time for grief is over. Those two lions among men will soon arrive. Rama will kill Ravana in battle and take you with him to Ayodhya." He asked Sita if there was anything else she wanted to tell Rama, Lakshmana, or Sugriva, the Vanara king.

Sita replied, "Offer to the son of the great Kaushalya my obeisance and ask after his well-being on my behalf.

"Ask after the well-being of Sumitra's son, Lakshmana, who followed Rama into the forest, abandoning all luxuries, and even his parents. He even protected Rama in the forest. He considers me as his mother and Rama as his father, and is dearer to Rama than even I am. He could not have known I was being abducted. He carries whatever burden is on him.

"You do not need much instruction, great Vanara. Act in such a way that Rama comes quickly. Tell him I will bear my life somehow for a month, but no longer."

A token for Rama

Sita removed her crown jewel, the *choodamani*, which she wore on top of her head, tied it in a garment, and handed it to Hanuman.

"This will remind him of three persons; myself, his mother, and the great king Dasharatha," she said. Hanuman accepted the powerful jewel with due respect, circumambulated her, and slipped it onto his finger.

Hanuman suddenly felt lighter, as if a huge burden had been lifted. He felt a deep sense of delight for he had finally seen Sita.

Sita asked him if he wanted to stay and rest. "Your company is a temporary reprieve from this otherwise torturous existence. The ocean is immense – how will the Vanara army cross over the ocean?" she asked. "How will the princes come? There are, perhaps, only three who can cross this distance – yourself, Vishnu's mount, Garuda, or the wind. It is true that you are yourself up to the task of my rescue, but it shall befit Rama to come himself. Act so that it comes about that way."

Hanuman reassured her. "Sugriva is honest and determined, and the Vanaras are under his orders. Do not worry about their strength. They are all as powerful as me or stronger. If I could come here, there is no doubt they will too. Enough grief now, wipe away your sorrow. The brothers will come soon, defeat Ravana, and take you safely to Ayodhya."

Sita replied, "Your words comfort me, like rain on parched earth. For a month I shall live, but no more."

A test of Ravana's strength

Hanuman left the grove, but felt that he had only accomplished a part of the task. He could not go back across the ocean, just yet, he thought. It was important to assess the

> "**Raghava**… **will kill Ravana** and his companions. O beautiful one! Having obtained you, **he will return to his own city.** O fortunate one! Therefore, **comfort yourself. Wait for the time and you will see Rama,** blazing like the fire."
>
> HANUMAN TO SITA, *SARGA* (37), SUNDARA KANDA

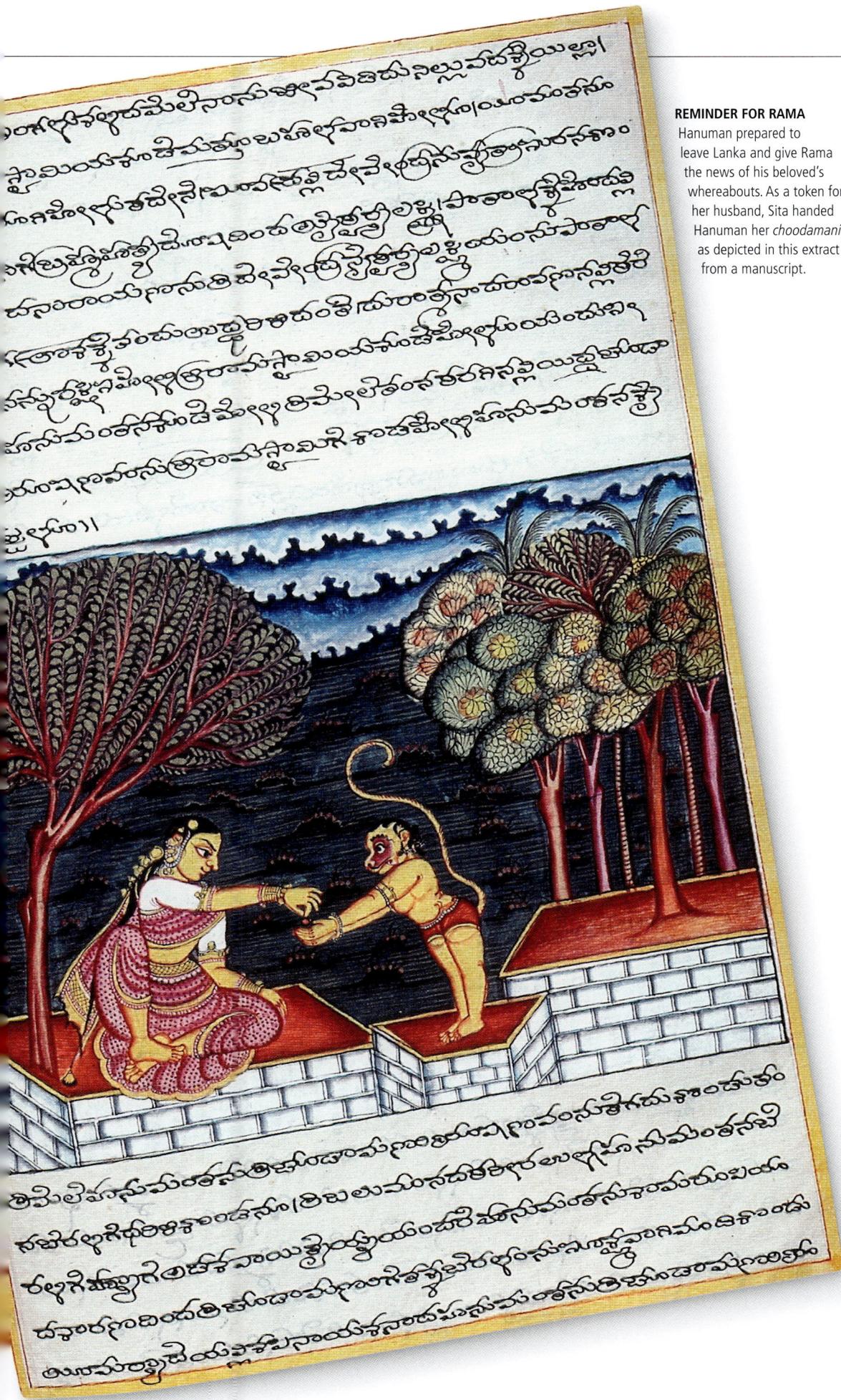

REMINDER FOR RAMA
Hanuman prepared to leave Lanka and give Rama the news of his beloved's whereabouts. As a token for her husband, Sita handed Hanuman her *choodamani*, as depicted in this extract from a manuscript.

strengths and weaknesses of the enemy. "Of the four means for engaging others, conciliation will not work with Rakshasas. Nor will the employment of wealth because they are themselves prosperous. Bringing about divisions will be ineffective too because they are proud and mighty people. This only leaves the exercise of force. I must figure out a way to compel Ravana to send his army to fight me, so that I get a sense of his strength."

Hanuman decided that there was only one way to do that. "First, I will destroy this grove, like fire that runs through a dry forest," he thought. "Then, I will slay the Rakshasas that Ravana sends to attack me. Only then will I return to the king of the Vanaras."

ALTERNATIVE ACCOUNT
RAVANA'S IMPATIENCE

In the medieval Sanskrit text *Adhyatma Ramayana*, it is made clear that Ravana actually seeks death at the hands of the Supreme Lord manifested as Rama, and is left wondering why Rama had not yet arrived. The night Hanuman enters Lanka, Ravana dreams of a Vanara who can change his shape at will in the Ashoka grove. On waking, Ravana decides to go and torment Sita while the Vanara watches so that he is forced to go and tell Rama, compelling him to come quickly. Ravana then insults Rama in Sita's presence through statements that can be read as praise and insults.

The Destruction of Lanka

The mighty Hanuman of terrifying heroism destroyed the Ashoka grove and then made for the city and its buildings and palaces. Ravana sent forth his armies, and then some of his bravest warriors, but the Vanara was impossible to kill or capture. Meanwhile, the golden city of Lanka lay in ruins.

Determined to assess Ravana's strength, Hanuman tore up the trees with his thighs and destroyed the Ashoka grove. He damaged the pools, pulverized the hilltops, and soon the grove looked like a forest fire had rushed through it. Only the place where Sita sat remained untouched.

Lanka's residents were bewildered at the sounds of shrieking birds and falling trees. The Rakshasis, now awake, were shocked to see the devastated grove and saw a Vanara presiding over its destruction. Hanuman saw them and took on a fearsome form.

A terrifying sight

The Rakshasis asked Sita where he had come from and what he had told her, but she feigned ignorance. "How should I know the illusory powers of Rakshasas? You must know who he is and what he is doing," she said.

Some of them rushed to Ravana and told him what they had seen. "Great king, he could be a messenger of Indra, or of Kubera, the god of

> **"I do not think** that he is a **Vanara.** He **possesses great strength**… I have seen Vanaras earlier, who were **quick and extensive** in their **valour**… "
>
> RAVANA TO HIS COMMANDERS, *SARGA* (44), SUNDARA KANDA

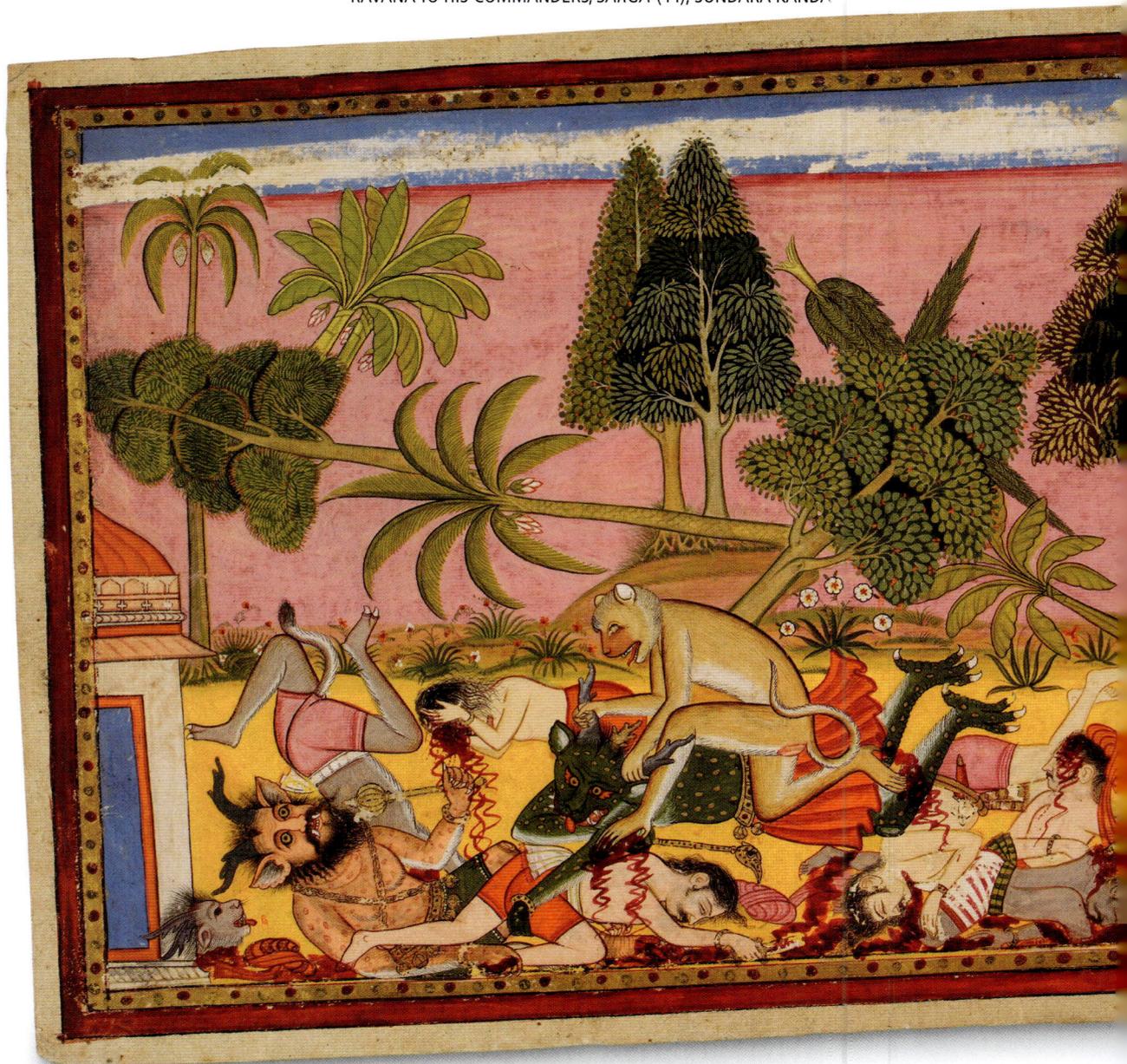

wealth, or of Rama. He has destroyed the grove, but he has not touched the place where Sita sits. Punish him."

Ravana burnt with anger and sent 80,000 mighty Rakshasas who rivalled his own strength. They approached the mighty Vanara, like moths that rush towards fire, and tried to restrain him.

Hanuman struck the earth with his tail and roared before taking on an immense form. He pulled a beam off the gate and destroyed the advancing Rakshasas. Then, Hanuman turned his attention to the buildings in the city.

A declaration of war

He climbed atop a structure, became immense in size, and attacked it. His thunderous roar resounded in Lanka as he cried, "Victory to the mighty Rama! Victory to Sugriva, protected by the Raghu scion! I am a servant of Rama, the king of Ayodhya, Hanuman by name. I am a destroyer of enemy armies. A thousand Ravanas are not my match. I have shaken this city and offered respects to Sita, and now return."

A hundred guards attacked him, but Hanuman uprooted a pillar and struck them, saying, "Sugriva has thousands of Vanaras like me. He will come here with them, and no one, not even Ravana, will survive."

The king of Lanka then sent forth Jambumali, a fearsome warrior

A SAVAGE ATTACK
This 17th-century painting from Rajasthan shows Hanuman attacking the Rakshasas in Lanka as Sita looks on.

who rode a chariot pulled by donkeys. Jambumali shot at Hanuman with a mighty bow, and the angry Vanara hurled a large rock at him. The Rakshasa shot arrows into the Vanara's arms and chest, but he ignored the arrows that pierced his body and picked up a beam. He swung it over his head and hurled it at Jambumali, who fell dead.

The king then sent his advisers' sons, but Hanuman made quick work of them, as he punched, tore, and slapped some, while others simply fell dead when they heard his mighty roar.

Ravana finally took the threat seriously and called his five commanders, Virupaksha, Yupaksha, Durdhara, Praghasa, and Bhasakarna. He warned them of Hanuman and his suspicion that he was not a mere ape.

HANUMAN, UNBOUND

Valmiki's understanding of the difficulty of capturing Hanuman has to do with the latter's might and the boons granted by the Creator, Brahma. Other texts, however, understand it differently. The medieval Sanskrit text *Adhyatma Ramayana* holds that when the fetters of ignorance can be broken by repetition of Rama's name, there is no question of Hanuman being bound, for he bears Rama's lotus feet in his heart and is thus ever free from all bonds.

A TRADITIONAL Nepalese wooden mask of Hanuman

They set out and saw Hanuman, blazing in brilliance like the rising sun garlanded by its own rays. They struck him with their arrows, but he leapt into the air and filled the 10 directions with his roar. He then killed each of them and their armies.

When Ravana discovered the fate of his commanders, he sent his son Aksha to face Hanuman. Aksha shot three arrows at the Vanara. The winds and the sun stopped to watch as the mountains shook and the ocean was agitated and a great battle began. Eventually, however, Aksha fell.

Hanuman's Capture

After his warriors were defeated, Ravana summoned his son, the mighty warrior Indrajit, who had knowledge of many magical weapons. Only he could stop Hanuman now.

Ravana summoned his son Indrajit, and instructed him to capture or kill Hanuman. The prince of Lanka, as powerful as the son of a god, with eyes like lotus petals, circumambulated his father and prepared for battle.

Indrajit, who surpassed all wielders of weapons in their skill, emerged like the ocean on the night of a full moon night, and boarded his chariot. Hanuman was thrilled to hear the sound of his chariot and the twang of his bowstring, even as semi-divine beings and sages gathered to watch the two warriors battle.

Hanuman saw Indrajit arrive and let out a fierce roar. Indrajit pulled at his bowstring, and the twang resounded like thunder. He released a torrent of arrows and Hanuman rose to the sky, to avoid them. He deftly moved between and around them and avoided them, even though Indrajit aimed them well and

they possessed the force of lightning. Both the warriors were fast and accomplished in the art of battle.

Indrajit soon realized that Hanuman could not be killed and decided to capture him instead. He released the Brahmastra, the weapon of Brahma, the Creator of the universe. It rushed towards Hanuman and bound him. When he fell to the ground, the great Vanara recalled the blessings of Brahma, Indra, and his father, the god of wind (See pp 350–51), and remained fearless even though he remained bound. He realized that it was beneficial for him as well, for now he could see Ravana in person.

The other Rakshasas ran up and bound Hanuman in physical restraints, which released Brahma's weapon, as that bond could not coexist with another. Indrajit fretted for the Rakshasas caused great harm in their ignorance, but Hanuman never realized that he was free.

> "Though I have been **bound** by the weapon, there is **no fear in me**. I am protected by the Grandfather, Indra, and the wind god."
>
> HANUMAN ON HIS CAPTURE, *SARGA* (46), SUNDARA KANDA

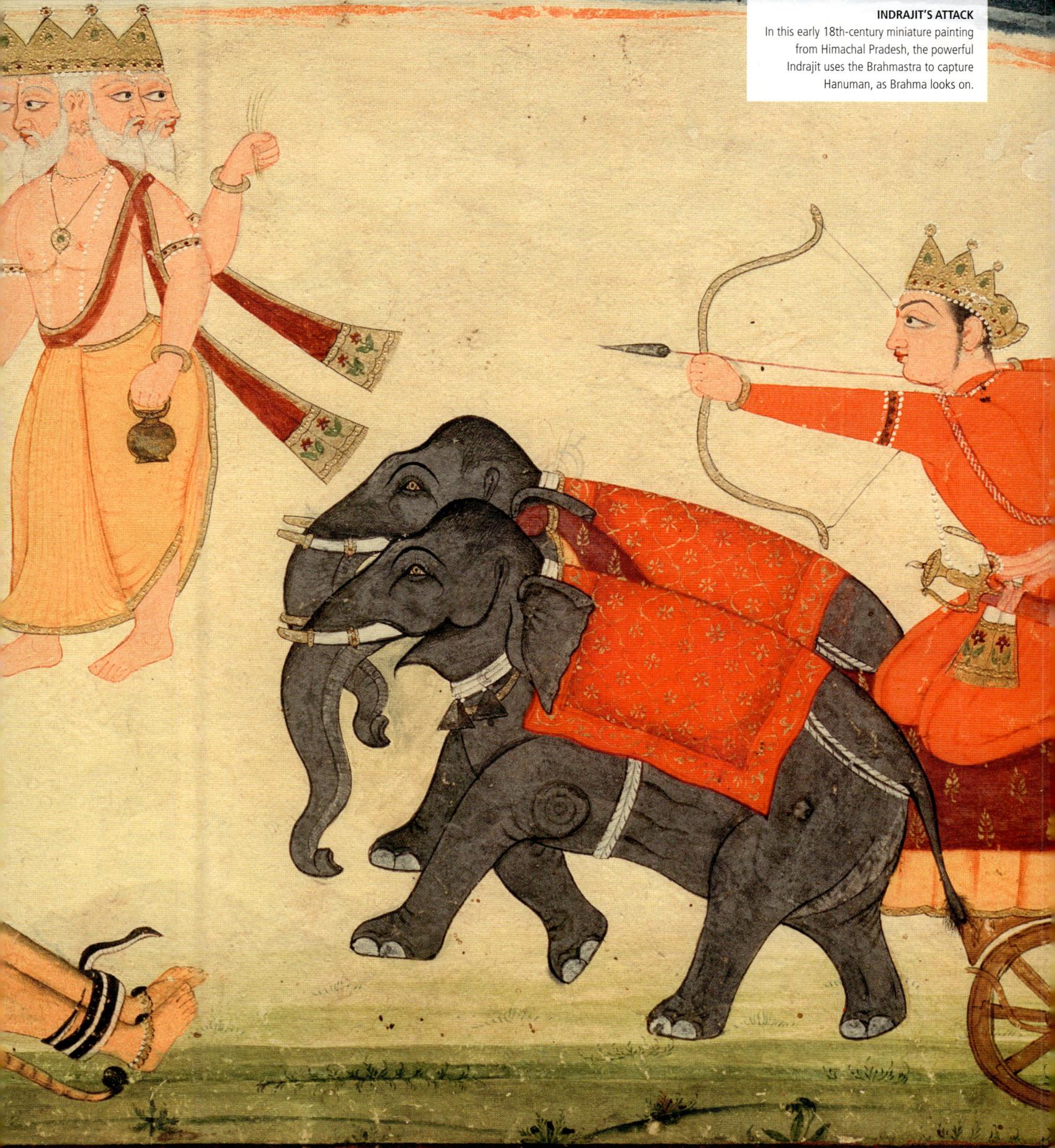

Meeting the
Ten-Headed King

Captured and bound, Hanuman was taken to see the mighty ruler of Lanka. There, surrounded by powerful warriors, the Vanara urged the mighty ruler of Lanka to walk the path of dharma or face the consequences.

"Had **adharma** not become stronger, this **lord of the Rakshasas** might have become the **protector** of the world of the **gods**..."

HANUMAN ON SEEING RAVANA,
SARGA (47), SUNDARA KANDA

THE GLORIOUS KING
When Hanuman first met Ravana, he was in awe of the king's strength and power. This bas-relief sculpture from a temple in Angkor Wat, Cambodia, depicts the king with his many heads and arms, a sign of great intelligence and strength.

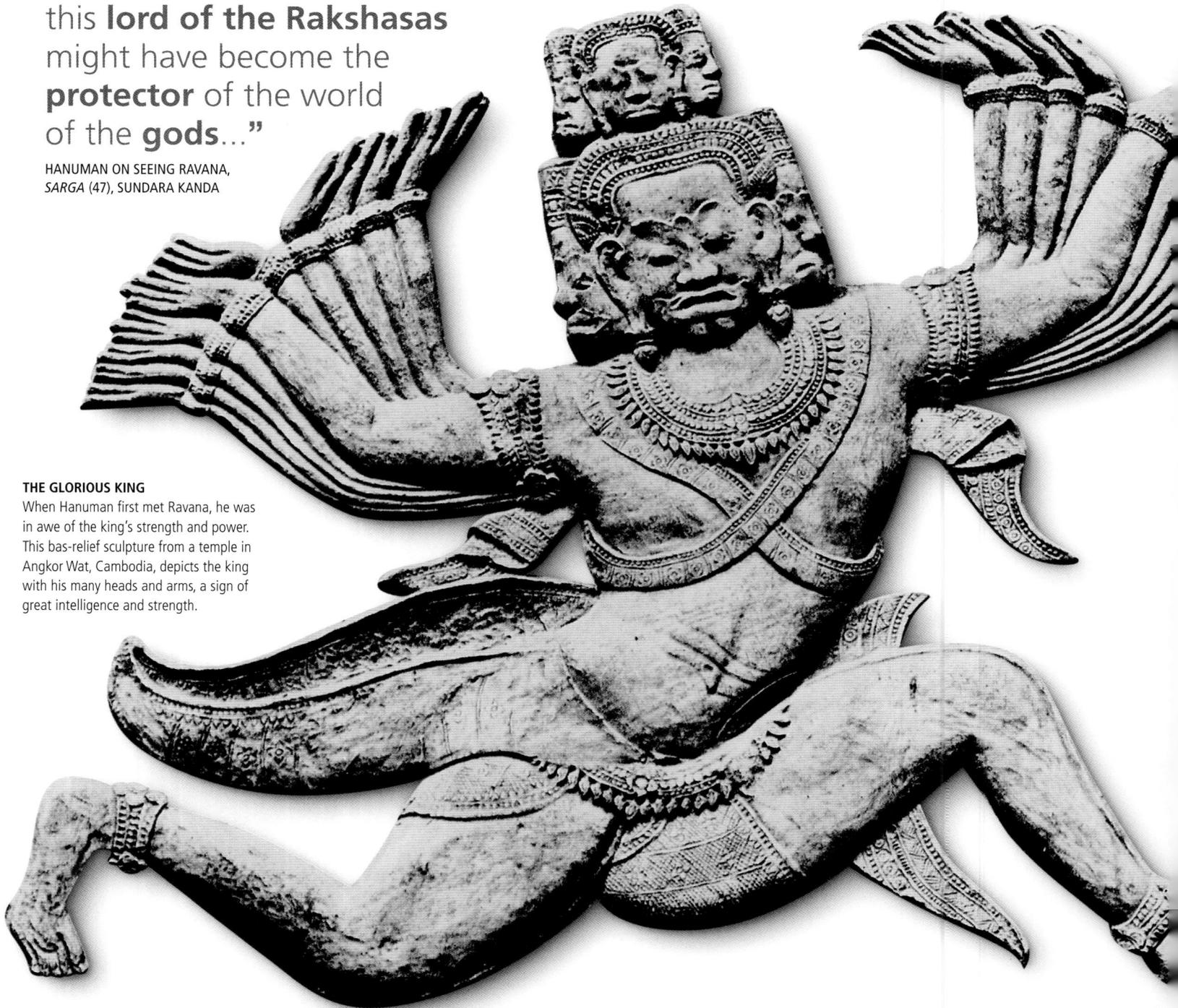

The Rakshasas dragged Hanuman, bound with ropes, and presented him before the king of Lanka. When they saw him, some Rakshasas asked each other, "Who is this?", "Where did he come from?", while others shouted, "Kill it!", "Burn it!", "Eat it!"

Hanuman found himself at Ravana's feet and saw the king resplendent in all his glory, surrounded by women and powerful Rakshasa warriors. He saw the king's strength, beauty, and all-round perfection, and contemplated on how Ravana's non-adherence to dharma had led to his downfall.

HANUMAN CAUGHT
This Kalighat painting from West Bengal depicts two Rakshasas taking the captured Hanuman to Ravana.

The interrogation

Ravana, his eyes burning with anger, faced the Vanara who had killed his son and caused such destruction. He turned to his adviser Prahasta and said, "Ask him where he came from, who sent him, and his purpose. Why did he destroy the grove and scare the Rakshasis?"

Prahasta asked Hanuman, "Tell us who sent you. Was it Indra or Kubera? Perhaps it was the lord of death, Yama? Was it Vishnu? Your form resembles an ape, but your strength distinguishes you. We will free you if you tell us the truth, but your life will be in peril if you lie."

Hanuman replied, "None of them have sent me. I am a Vanara and I destroyed the grove as I desired an audience with the king. I have Brahma's blessings and cannot be bound by any weapon. I went along just so I could see him."

A messenger's plea

Hanuman further said, "I am the messenger of the almighty Rama. Listen to my words for they are beneficial. I have come at the behest of Sugriva, the king of Kishkindha. He, as a brother, asks after your well-being. Listen to his advice, imbued with dharma and *artha* (meaning or purpose), and it will serve you well in this world and the next."

He then told Ravana of Dasharatha and his virtuous son Rama's exile, of Sita's disappearance, and Rama and Lakshmana's meeting with Sugriva. He spoke of the Vanaras who searched for Sita in all directions and then said, "I am Hanuman, the son of the wind, who has travelled across the ocean to see Sita."

A warning

"You know dharma," Hanuman continued. "You ought not act this way towards another's wife. Even the gods cannot stand before Rama and Lakshmana's fiery arrows. There is nobody in the three worlds who can cross the Raghu scion and sleep in peace. Accept what I say, for it is for your own good and in accordance with dharma and *artha*. Return Sita. I have performed the difficult task of finding Sita and the rest is up to Rama.

"You have lost your senses since you brought Sita to Lanka. Your attachment to dharma should not be destroyed in this way. Remember, the invincibility that you have received as a result of your self-discipline is only with respect to the gods and Asuras. Sugriva, being a Vanara, is neither, and Rama, too, is human. Do what you can to protect yourself.

"Good and bad deeds both produce results. You have been enjoying the results of the former. If you do not act, you shall soon reap the fruit of the latter. Even Indra cannot survive crossing Rama, what of one like you? Burnt by Sita's radiance and Rama's fury, you shall soon see this city in flames," Hanuman said and fell silent.

Hanuman's harsh and unpleasant words made Ravana angrier. Incensed, he cried, "Kill the ape!"

ALTERNATIVE ACCOUNT

IN RAVANA'S COURT

Hanuman in Valmiki's *Ramayana* is impressed with Ravana's brilliance and strength – however, his reaction in other versions is markedly different. In Tamil poet Kamba's rendition, Hanuman recalls how he left Ravana alive when he spied him sleeping. He wonders whether he should knock his crowns off, before determining that they were well matched and it would be a deadlock, and that Ravana would soon yield to Rama. In Bengali poet Krittibas Ojha's narrative, he remembers Rama's name. In *Ramcharitmanas*, when he sees the unspeakable lordship of Ravana's court, he is as fearless as Garuda among snakes.

Vibhishana's Interjection

Furious at Hanuman's words, Ravana ordered the Vanara's death. Help, however, came from unexpected quarters, as Vibhishana, the king's young Rakshasa brother, spoke up.

Vibhishana quickly realized that he could not agree with his elder brother Ravana's decision to kill Hanuman. He observed the king's behaviour and soon realized that Ravana was overcome with rage.

He chose his words with immense care and determined the course of action. He offered his brother due reverence and then he spoke. "King," he said, "the killing of this Vanara would be contradictory to dharma, censured in the world, and unbecoming of a person such as you. It is true that he has acted as an enemy and caused great damage and trouble. Yet, the killing of a messenger is not permissible – many other punishments have been enjoined instead. For instance, there is the disfiguring of his limbs,

whipping, or branding. Those like you, whose intellect is endowed with the examination of both dharma and *artha* should not act in this way. Whatever this Vanara did, good or bad, was not of his own accord. A messenger is sent by another, and is subject to another, and cannot be killed.

"Lord of Rakshasas, I cannot think of anybody else who could come here again and convey the situation to the two brothers. Who else would incite the princes into war? Would you deprive your Rakshasa warriors of the opportunity to battle?"

Ravana accepted the advice and said, "The killing of a messenger is universally censured. The tail, I hear, is an ornament for these Vanaras. Light it up. He shall go with a burnt tail and his loved ones shall see him in that way."

> "I do not see **any qualities** associated with **the killing of this Vanara**. That kind of **punishment** should be inflicted on **those who have sent this Vanara**."

VIBHISHANA TO RAVANA, *SARGA* (50), SUNDARA KANDA

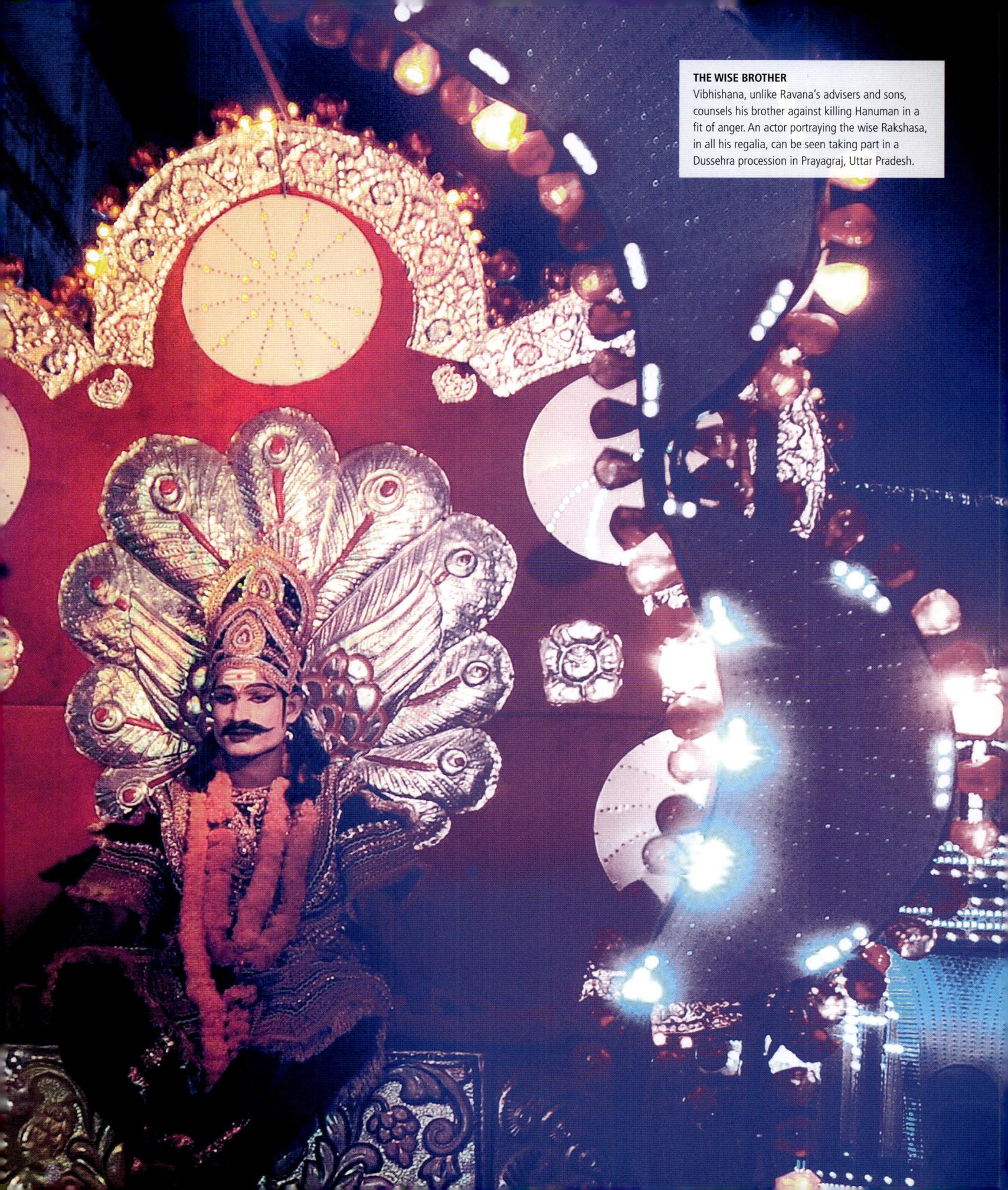

THE WISE BROTHER

Vibhishana, unlike Ravana's advisers and sons, counsels his brother against killing Hanuman in a fit of anger. An actor portraying the wise Rakshasa, in all his regalia, can be seen taking part in a Dussehra procession in Prayagraj, Uttar Pradesh.

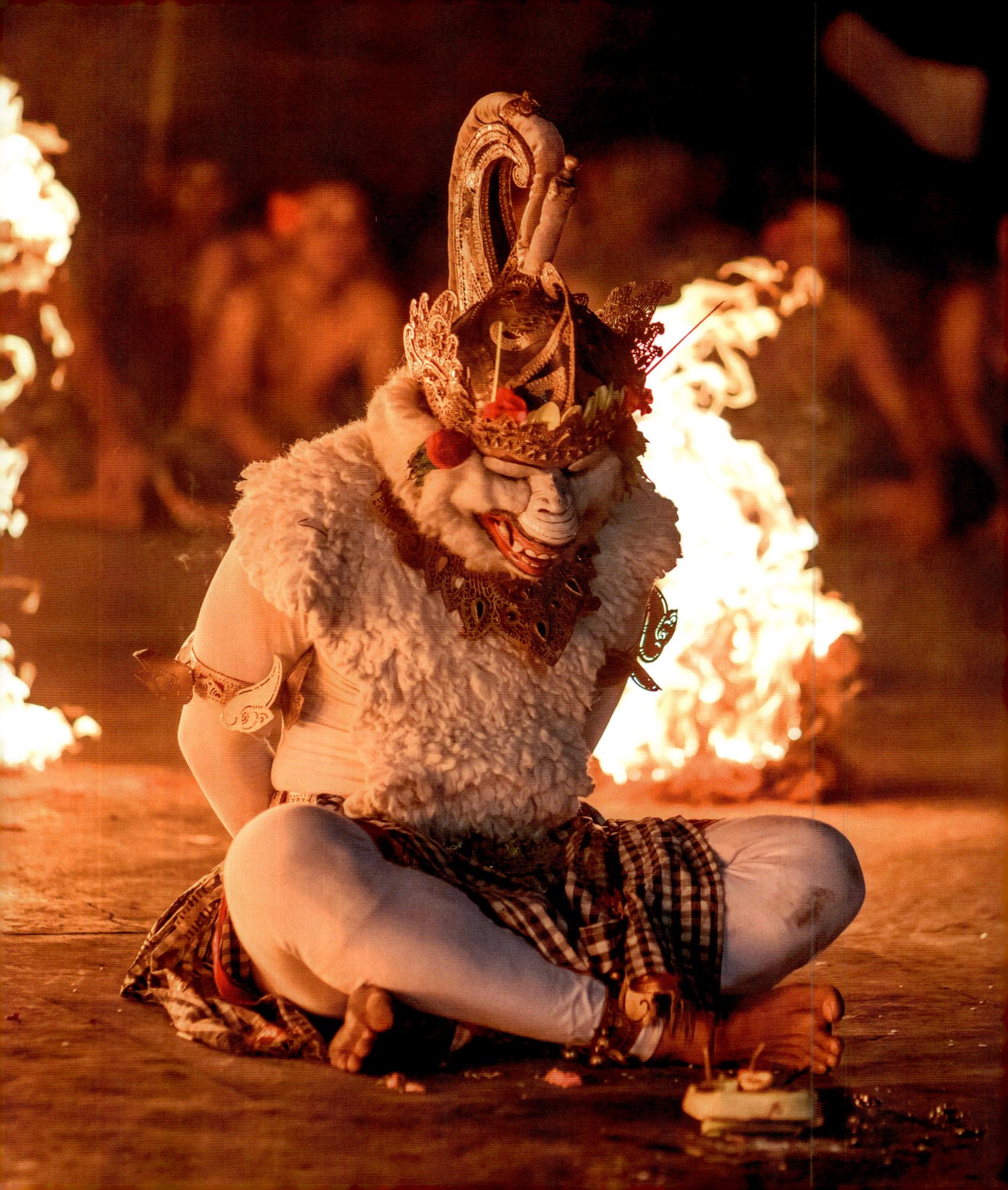

A **City** in **Flames**

The Rakshasas quickly followed their king's furious order and got ready to set Hanuman's tail on fire. They would then parade him across the city and its crossroads, and announce him as a spy. Hanuman, however, had something else planned.

The Rakshasas covered Hanuman's tail in rags, soaked it in oil, and set it on fire. Hanuman's face reddened in righteous anger and he swung his tail near the Rakshasas.

As they bound him in restraints once again, he realized that he had not observed the city during the day. "I have only seen it at night and so the plans for protection aren't completely clear," he thought. He masked his emotions and allowed the Rakshasas to lead him through the city, so that he could observe everything.

A plea to the fire god

In the Ashoka grove, the Rakshasis told Sita what had happened. Anguished, she invoked the deity of fire. "If I have performed austerities, if my loyalty to my husband is complete, if Rama has any compassion for me, if I have any good fortune left at all, and if Sugriva is to take me across this ocean of sorrow, then Agni, may you be cool for Hanuman," she prayed.

HANUMAN BURNS LANKA
Flames surround a captured Hanuman in a dramatic performance of the Balinese Kecak dance at Uluwatu Temple, Bali, Indonesia.

> "He has **unleashed a fire** in the residence of the terrible Rakshasa. He has **burnt this city of Lanka** with its mansions, ramparts and gates... **Janakee was not burnt** and we are astounded at this **extraordinary event**."
>
> CELESTIAL BARDS ON HANUMAN BURNING LANKA, *SARGA* (53), SUNDARA KANDA

Hanuman suddenly found that his burning tail no longer hurt him with its heat. He could see the flames rise, but there was no pain. He wondered, "Is this similar to the ocean and Mainaka seeking to help me? Or is this because of Sita?"

As he contemplated this, Hanuman roared, leapt into the air and went to the majestic city gates. He changed his form and became so small that his restraints fell to the ground. Hanuman then took on an immense form that resembled a mountain, and turned to face the Rakshasas. He picked up a beam and slew the Rakshasa soldiers. Then he wondered how he could torment the Rakshasas further.

Lanka, on fire

Hanuman looked at the city before him, with a garland of flames around his tail. "The sacred fire burns on my tail," he thought. "It is appropriate that I offer these excellent houses to it as kindling and satisfy it."

The great Vanara rose into the air to destroy the fortress, his tail resembling a cloud laced with lightning. He roamed through the city, lighting the tops of buildings. The fire spread gleefully from one house to another, and the buildings collapsed rapidly. The strength of Hanuman's rage overpowered the city, which was now enveloped in flames, as if it had been cursed.

The return

Hanuman went to the ocean shore and extinguished the fire on his tail. As he looked at the burning city, he had a worrying thought. The fires may have consumed Sita as well, he thought. But soon another thought replaced this one. "No, she couldn't have died," he thought. Her radiant brilliance protects her. Fire cannot burn fire. It did not burn me and would not burn her either. No, with her truth, she would sooner burn fire." He returned to the grove and was relieved to see Sita untouched and unhurt. "Through great fortune do I see you again, unscathed," he said. He assured her he would return soon, with Rama, and began his journey back across the ocean.

ANALYSIS
FIRE AND HANUMAN

Tamil poet Kamba says not only did the fire on Hanuman's tail cool down as a result of Sita's prayer, but so did all manner of celestial fires. Further, fire, which had been deprived of its offerings, set about consuming Lanka with much gusto. The dormant sacrificial fires in Rakshasa homes came alive too.

An *Adhyatma Ramayana* verse asks how mere fire could burn Hanuman as simply remembering him allows one to cross over the threefold torment of fire (physical, supernatural, spiritual), while Tulsidas's *Ramcharitmanas* holds that Hanuman did not burn, as he was the messenger of the one who created fire.

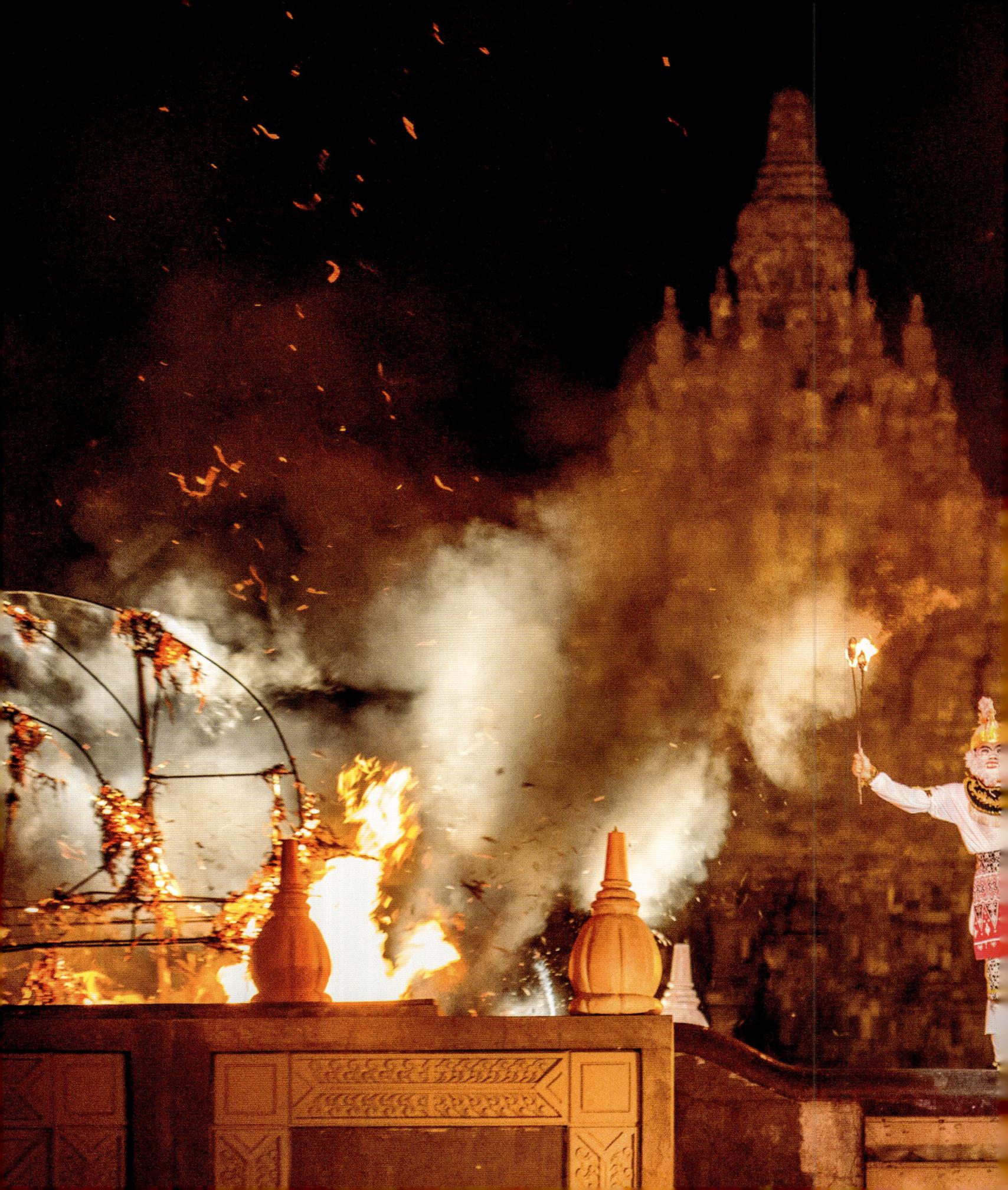

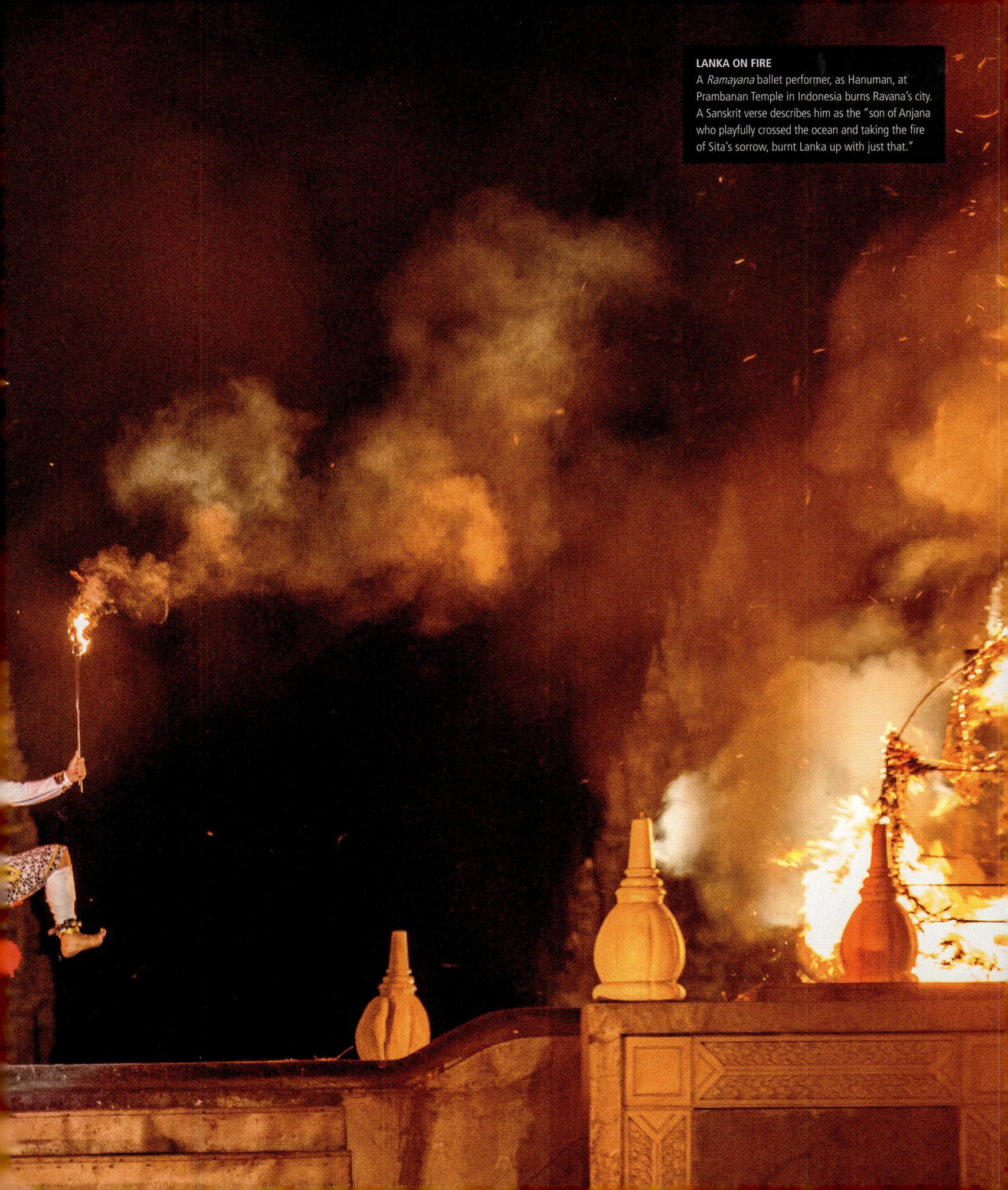

"I Have **Seen** Sita"

After Hanuman comforted and reassured Sita, he left the city of Lanka and climbed the highest mountain. From here, he would take the leap back across the ocean, bearing with him the good news. He would return soon, he knew, this time with Rama, to battle the Rakshasas and rescue Sita.

Hanuman, that tiger among Vanaras, climbed atop a mountain, eager to see Rama. He contemplated the northern shore of the sea and became immense in size. He pressed down on the mountain, flattening it in the process, and shot through the clouds, resembling an arrow released from a mighty bow.

As he approached the shore, he roared, and the Vanaras waiting by the shore heard him. Jambavan concluded that Hanuman had returned successful, for otherwise, he would not have roared with such joy.

When the Vanaras saw him, they stood with their palms together and then honoured him with roots and fruit. Their triumphant roars echoed across the shore.

The news

Hanuman said, "I have seen the daughter of Janaka in the Ashoka grove, guarded by Rakshasis, desirous of seeing Rama, downcast and emaciated." Hearing his nectar-like words, the Vanaras roared, and thundered, and cried with joy. Angada praised Hanuman, who had done the impossible and Jambavan asked him for a complete account to determine the future course of action.

Hanuman recounted his adventures ending with his encounter with Ravana, the burning of Lanka, and his second meeting with Sita. He said, "Rama's endeavour, Sugriva's effort, Sita's conduct, and my great leap have all borne fruit. The purity of that revered lady's conduct could bear the world, or burn it up if she is angered. Intent on Rama alone, she was prepared for death, but I have somehow managed to comfort her."

Angada replied with great enthusiasm, "Now that we have come this far, we should endeavour to see that Sita is reunited with the brothers. I could go to Lanka and kill Ravana. Nala and Nila are up to the task just by themselves. The mighty mountains might shake, but nobody can move

Jambavan in battle. It makes no sense for us to return without her."

Jambavan calmed him down and said, "It is not that we lack the strength, Angada, but we should meet the Raghu scion and proceed as he would determine."

In celebration

The Vanaras made their way back to Rama, Lakshmana, and Sugriva. On their way, they came upon a grove that belonged to Sugriva, which his maternal uncle, Dadhimukha, guarded.

They entered the grove to enjoy the fruits, roots, and intoxicating honey. As they got drunk on the honey, they began to create a ruckus. The grove's guards rushed to complain to Dadhimukha, who confronted them, but the drunken Vanaras overpowered and beat him as well. Angry, Dadhimukha went to complain to Sugriva so that they could be punished.

Sugriva, however, was pleased to hear this. He knew that had the Vanaras been unsuccessful, they would have neither returned after the time limit, nor dared to create such chaos. Filled with hope, Rama, Lakshmana, and he asked that they be brought immediately.

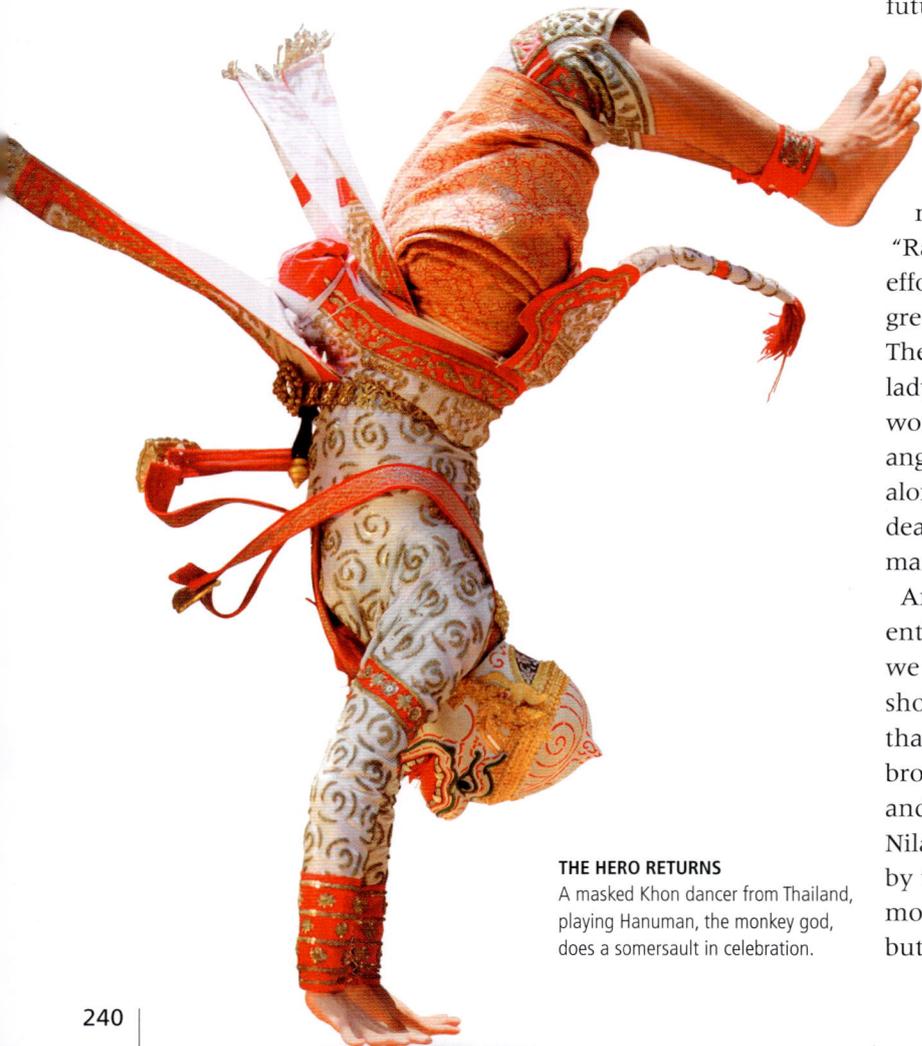

THE HERO RETURNS
A masked Khon dancer from Thailand, playing Hanuman, the monkey god, does a somersault in celebration.

THE VANARAS REJOICE
Intoxicated Vanaras celebrate Hanuman's success by imbibing honey from Dadhimukha's grove in this 165☐ painting from Rajasthan, India.

> **"O Rama**… I saw her in the midst of the Rakshasis, being **censured repeatedly**… She is **distressed** and is **thinking about you**."

HANUMAN TO RAMA, *SARGA* (63), SUNDARA KANDA

"Sita is safe"

Dadhimukha sent Hanuman, Angada, and the other Vanaras to Sugriva. Upon his arrival, Hanuman bowed his head and conveyed news of Sita's safety. Rama regarded him with unfathomable affection and asked, "Where is she, that revered lady, my beloved Sita? How does she act towards me? Tell me everything!"

Hanuman recounted his entire journey and handed him the crown jewel. He then conveyed Sita's message,

"Dasharatha's son! I will live for another month, and no more, in this Rakshasa's dominion."

Rama held the jewel to his heart and wept. "Lakshmana, I shall not live a moment without her. What greater agony could there be than seeing this jewel, but not seeing her?"

"Hanuman, tell me what she said again, and again, for her words are like water that revives a dying man." And so Hanuman told him everything once again.

ALTERNATIVE ACCOUNT

RAMA'S AFFECTION

That Rama regards Hanuman with great affection is far more intense in other narrations of the story. In the *Adhyatma Ramayana*, Rama tells Hanuman that he finds himself unable to repay the debt and embraces him. In Tulsidas's *Ramcharitmanas*, when Rama speaks of his gratitude, Hanuman looks upon his visage, and falls at his feet. Rama seeks to lift him up, but he is too lost in his loving devotion. After Rama embraces him, he asks Hanuman how he managed to perform such wonders, and Hanuman says that it is by Rama's grace, seeking devotion as a blessing.

241

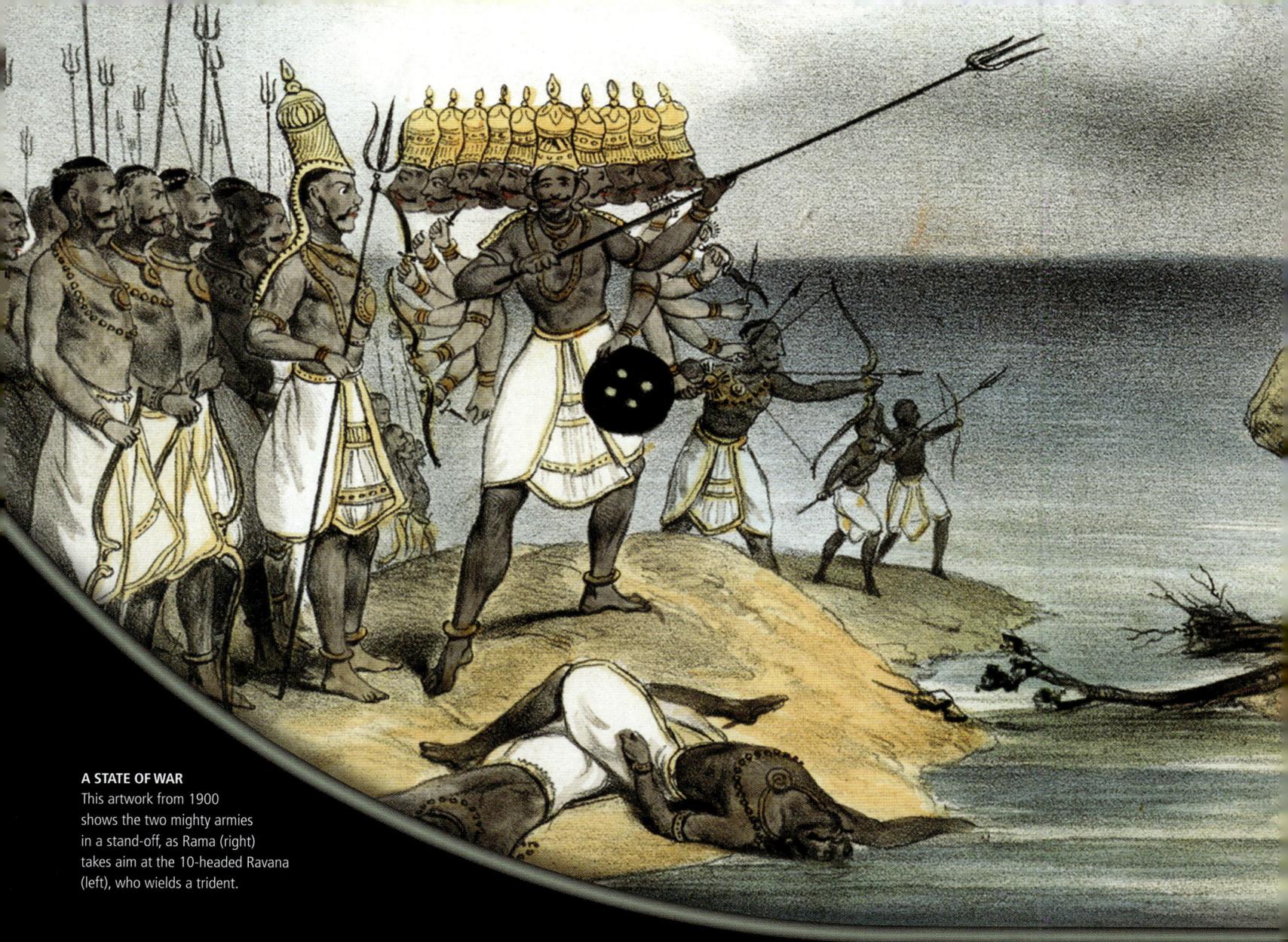

A STATE OF WAR
This artwork from 1900 shows the two mighty armies in a stand-off, as Rama (right) takes aim at the 10-headed Ravana (left), who wields a trident.

6 YUDDHA KANDA: THE GREAT WAR

Yuddha Kanda is the sixth chapter in Valmiki's *Ramayana*, and it narrates the crossing of the ocean by the vast army of the Vanaras to Lanka. It recounts the great war between the opposing forces of the exiled prince, Rama, and the king of the Rakshasas, the 10-headed Ravana. An iconic account of the eternal battle between the forces of good and evil, Yuddha Kanda ends with the inevitable triumph of dharma over adharma, of light over darkness.

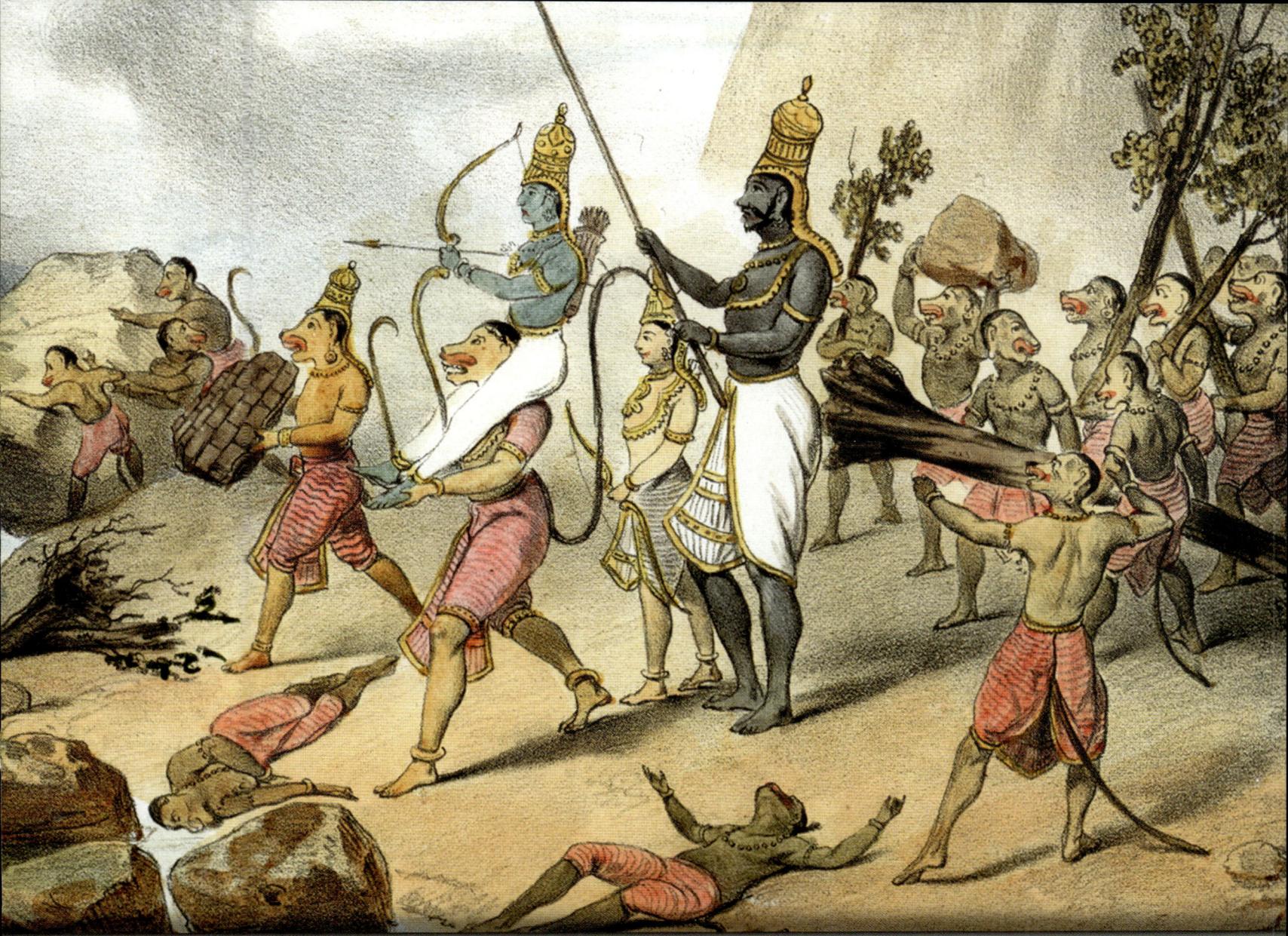

"When you **abducted Sita**, you resorted to your strength... **O Ravana!** Use all your strength to free yourself from my rage. When it is **tomorrow**, I will be like Vasava with his Vajra, unleashing his **Vajra** on the Danavas."

RAMA'S MESSAGE FOR RAVANA, *SARGA* (16), YUDDHA KANDA

By the **Shore**

Pleased with the news Hanuman brought him, Rama embraced the Vanara, and the vast and powerful Vanara army marched to the ocean shore. Yet, the young exiled prince of Ayodhya could not help, but grieve for his beloved.

Rama spoke to Hanuman with great affection, "I cannot imagine anyone doing what you have done, except perhaps for Garuda, the king of birds. Who else could have entered that invincible city and returned alive and successful? Yet, I worry. How could we possibly go to where Sita is. How will this army cross the immense ocean?"

Keeping hope

Sugriva replied, "Mighty Rama, abandon this sorrow, for which I see no cause. You have strength, perseverance,

UNCHARTED WATERS
The painstaking search for Sita led the Vanaras to the southern ocean. Now, all that stood between Rama's army and Lanka was the vast and turbulent ocean.

a firm knowledge of the scriptures, and are endowed with intellect. I am certain that we shall cross the ocean. These warriors are full of enthusiasm to do your bidding and act for your sake. Your might will bring down the enemy and you will return to Ayodhya with Sita.

"With allies like me, you will be victorious. Who among the beings in the three worlds could possibly stand before you when your bow is raised in battle? You will soon see Sita. Abandon sorrow and arouse your righteous anger. Your victory is certain!"

A decisive plan

Sugriva's words comforted Rama and he turned to Hanuman, and said, "We are capable of crossing this vast

ocean either by drying its waters or building a bridge. Tell me, how is Ravana's fortress protected?"

The Vanara described Lanka's prosperity and fortifications, and said, "It is a fearsome fortress, difficult to vanquish, even for the gods. It is on the far end of the ocean, but you cannot navigate the waters near Lanka. It's on top of a mighty mountain. Large battalions guard the four gates, and there are millions of them in the centre. However, I broke the bridges, filled the moat, burnt the city, and destroyed the gates."

They did not need the entire army, Hanuman told Rama, as Angada, the crown prince, the Vanaras Dvivida, Mainda, and Nila,

TIME TO MARCH

There is a reference to the astral configurations twice in these passages. Once when Rama orders the march and then again when Lakshmana lists favourable omens. The 16th-century commentator Govindaraja clarifies that on the first instance, although the specific time is inauspicious for initiating southward journeys, it is not a problem here as Lanka is to the southwest of Kishkindha.

In the second case, he brings in what we know or can infer about Rama's own horoscope and details how all the specifics Lakshmana states, fit in with the placement of planets there.

and Jambavan, the king of bears, were more than enough.

The instructions

Rama replied, "Lanka will be destroyed, Hanuman." He turned to Sugriva and said, "This is the right time to march to Lanka. The astronomical configurations are favourable for victory, and the sun is in the right place.

Tomorrow, it will shift. Auspicious omens are appearing and I know that I shall kill Ravana and be reunited with Sita."

Rama then turned to the army and gave instructions. He said, "Nila, go to the head of the army and lead it through a route that has plenty to eat. Gaja, Gavaya, and Gavaksha, go to the front and I will be in the middle, riding on Hanuman, with Lakshmana on Angada."

The march to Lanka

The immense army marched forward. Lakshmana looked at his brother and said, "I see good omens favourable for success. Look at how favourably the wind blows and how pleasant the birds and animals sound. Look at the clear sky and the stars shining auspiciously upon us."

They marched night and day until they crossed the mountain Mahendra and the ocean stretched out before them. This is where the army would spend the night, Rama told Sugriva. As they settled in, the army, crowded near the shore, resembled a second ocean.

Rama stood next to Lakshmana, looked at the ocean, and said, "I do not grieve that my beloved is away or because she has been abducted. I grieve because her life is passing by. Oh wind! Go to where she is and blow thence, touching me with her touch. Sita's cry for help when she called out for me as she was taken burns me like a poison.

"Lakshmana, had it not been for you, I would sleep in the ocean. Perhaps in its depths I would find some solace. I only remain standing because she, too, walks this earth. Ah! When shall Sita, comparable only to a goddess, eagerly come into my arms and shed tears of joy!" Rama wept, and as Lakshmana comforted him, the sun set.

"The **giant army proceeded**, covering the entire earth. It was full of **tigers**… **bears and Vanaras**… the Vanaras raised a **terrible dust** that entered inside the world and **took away the sun's radiance**. Through night and day, the great army… marched."

THE ARMY MARCHING TOWARDS THE OCEAN, *SARGA* (4), YUDDHA KANDA

THE KING OF BEARS
This painted wooden mask from Odisha, India, portrays Jambavan. Commonly depicted in blue or black, here he is seen as a brown bear with a long snout and a golden crown.

Vibhishana Chooses a Side

Back in Lanka, Ravana received news of Rama, Lakshmana, and the large army of Vanaras that were preparing to cross the ocean. The city had not recovered from Hanuman's assault on the city, so the king of the Rakshasas turned to his advisers. They recommended that he go to war, but his brother Vibhishana had a different suggestion.

For all his strength and might, Ravana was not entirely foolhardy. Hanuman's single-handed destruction of his forces was a cause of great concern.

Ravana called his council together and addressed them, his face a study in worry and embarrassment, "What do we do next? Victory is dependent on counsel, so tell me, wise ones, how should I proceed?

"The best people act after receiving counsel from their advisers, the middling contemplate matters alone, and the worst, act without thinking. Similarly, the best advisers speak in a single voice, the middling start out divergently but come to a consensus, and the worst remain divided. Rama is now headed for Lanka with a huge army and he will soon cross the ocean. Advise me."

The king's counsel

The Rakshasas folded their hands and said, "Our army is well appointed and large. You have not left anyone in the three worlds unvanquished, mighty lord of Rakshasas! Rama is certainly not nearly as powerful, skilled, or valorous as your previous enemies. Do not even worry about this. You will certainly slay Rama."

One of them, Prahasta, said, "The gods, Asuras, and Nagas have been unable to kill you in battle, what of these puny apes and humans? Hanuman tricked us but he shall not return alive again. Command me, and I shall render the earth devoid of Vanaras!"

Another, Durmukha, offered to kill all the Vanaras, while Vajradanshtra grasped his weapon and bellowed, "What have we to do with that Hanuman when Rama, Lakshmana, and Sugriva live? I will go and kill them, and be back soon." Nikumbha volunteered to kill the princes of Ayodhya as well. Slowly, all the Rakshasas expressed their intent to win the war on Ravana's behalf, as they waved their weapons and cried out in great enthusiasm.

A voice of reason

Vibhishana, who had been listening quietly all this while, stepped forward, his hands folded. He requested the Rakshasas to take a seat and said, in a calm voice, "Attacks succeed when undertaken against enemies who are deluded, in some great trouble, or struck by misfortune, and when the attack itself is properly pursued after taking account of the situation. How, exactly, do all of you propose to defeat somebody who is undefeated, desirous of victory, has complete control over his anger, and is invincible? Could any of us have even imagined what Hanuman did in Lanka?"

He asked them, "Why are we pursuing this enmity against Rama in the first place? What has Rama done to the great lord of Rakshasas? If you say that Khara was killed ... well, Rama was acting in self-defence."

Vibhishana's suggestion

He turned to Ravana, "Sita's presence here is not good for us and we should return her before this immense army of Vanaras attacks Lanka. The city and its inhabitants will be

> **"May you be fortunate. I am leaving. Without me, be happy**. Desiring **your welfare**, I tried to **restrain you**..."
>
> VIBHISHANA TO RAVANA, *SARGA* (10), YUDDHA KANDA

destroyed, lord of the Rakshasas, if you do not return Rama's beloved wife yourself. I stand before you in supplication out of fraternal affection. Do as I ask, for it is what shall bear the best results for you. Return Sita to Rama."

Furious, Ravana said harshly, "It is better to live with an enemy or an angered poisonous snake, than an enemy masquerading as a friend."

He berated his younger brother, "Nobody likes to see the progress of one's kin, and they are always jealous. If any other Rakshasa had spoken thus, they would have been promptly killed."

A brother's resolve

Vibhishana heard Ravana speak in such a manner, and grew angry. "You are my brother, king. I am completely willing to follow your commands, but I shall not suffer your harsh words," he said. "Those who have the noose of death around their neck naturally refuse to listen to words spoken out of a desire to ensure their welfare. It is easy to find men who will speak sweetly to you, but both givers and recipients of harsh, but, ultimately, good counsel are rare.

"I do not want to see you pierced cruelly by Rama's arrows. May you prosper, Ravana. I shall go now." So saying, Vibhishana left Lanka.

RAVANA'S BROTHER
This blue pigmented wooden mask from Odisha, depicts Vibhishana with his sharp, protruding teeth on display, a typical portrayal of a Rakshasa.

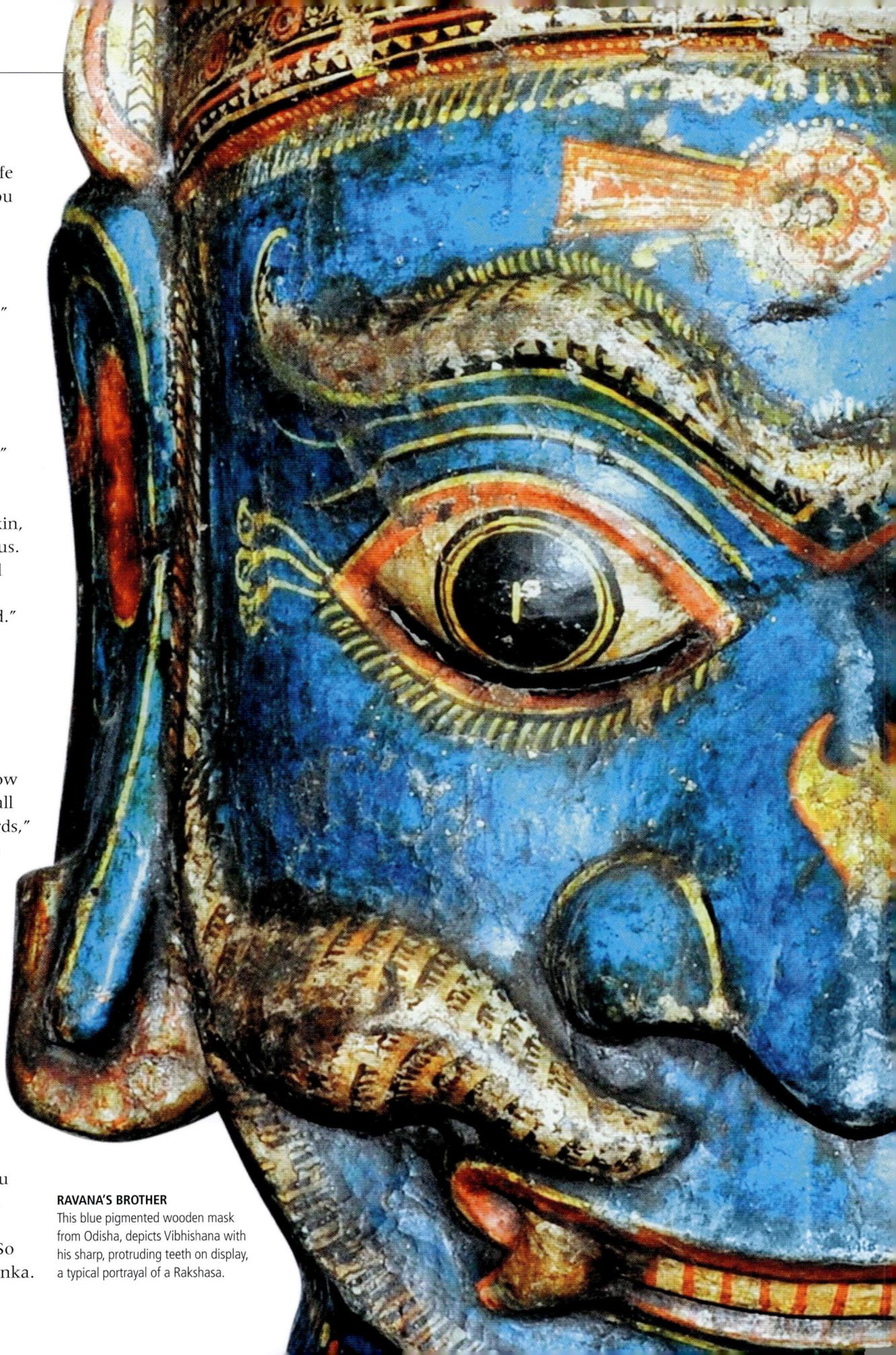

FOLLOWER OF DHARMA

Vibhishana

"I am Ravana's younger brother and I have been **humiliated by him**. You are the refuge of all creatures and I am seeking **refuge with you**."

VIBHISHANA TO RAMA, *SARGA* (13), YUDDHA KANDA

Vibhishana is often held as an example for two tendencies – the negative and the positive. Unlike Ravana's other brother, Kumbhakarna, Vibhishana's actions, as Valmiki portrayed them, are quite unambiguous.

Even when the three brothers were young, Vibhishana was rather unlike Ravana and Kumbhakarna in his steadfast pursuit of dharma. It is also apparent in the boon he asked Brahma, the Creator of the universe (See p 342), of always being at the feet of his Lord Vishnu, the Preserver of the universe. However, Vibhishana has always been received with some degree of ambiguity.

In one kind of reading, he is remembered mostly in a negative light for being the traitor, the insider who brings Lanka down. In another, he is admired as somebody who lives in accordance with dharma despite being in the company of, and under the rule of, a Rakshasa as ferocious as Ravana.

Both these views are understood as rooted in the narrative of the *Ramayana*, and the ambivalence of Vibhishana's actions cuts across perspectives on Rama's divinity.

A question of motive

In Valmiki's *Ramayana*, we find a rather pragmatic attitude towards Vibhishana's arrival at Rama's side. While Rama's advisers consider in detail what Vibhishana's intentions might be, Rama himself refuses to even consider them,

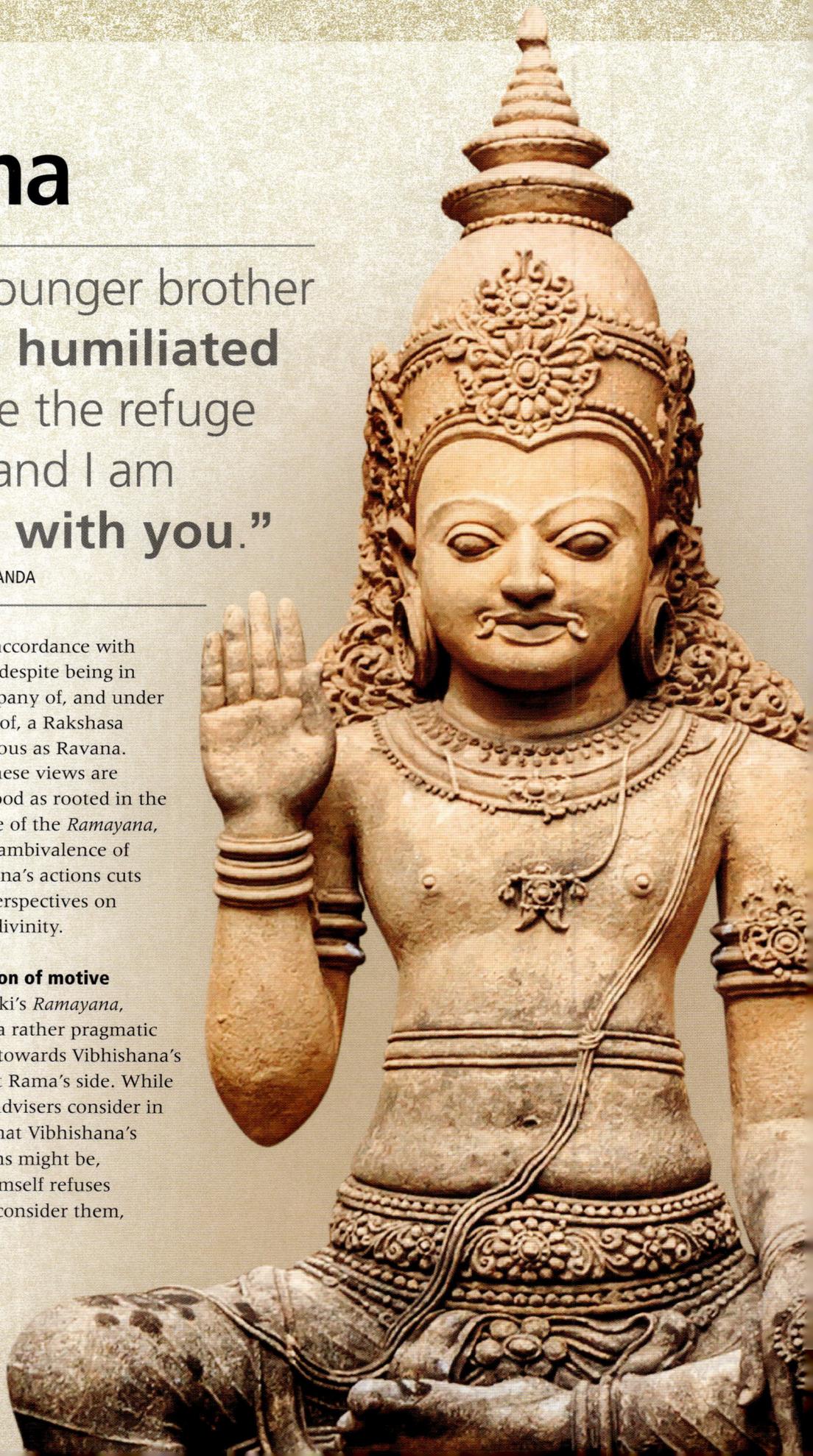

his position hinging upon *his* responsibility towards somebody seeking refuge with him.

A serious problem with Vibhishana's intent is whether he has abandoned Ravana to seek refuge with Rama because of his adherence to dharma (or devotion) or to find, in the latter, an ally for his claim to the overlordship of Lanka.

Indeed, even Hanuman – who was initially the only one of the advisers to suggest Rama accept Vibhishana – points out that the reason Vibhishana must have come to Rama for refuge is that he saw Rama's valour, Ravana's actions, the killing of Vali, and the consecration of Sugriva. Therefore, he has come seeking the Rakshasa kingdom for himself, implying a resemblance between Vali and Sugriva on the one hand and Ravana and Vibhishana on the other.

In "A Text with a Thesis: The Ramayana from Appayya Diksita's Receptive End", Yigal Bronner, a scholar of South Asian intellectual history, explains the 16th-century polymath

THE RAKSHASA KING
This sculpture from Kelaniya Temple found in Sri Lanka is of Vibhishana. He is said to be worshipped by the Sinhalese and in the past he was considered to be one of the four guardian deities. Though he is still invoked by them.

Appayya Diksita's argument that the purpose of the *Ramayana*, is the "suggested" praise of Shiva. The philosopher also critiques the privileging of this episode in Shrivaishnava (a Hindu community that worships Vishnu) theology (See pp 122–23).

An important aspect of his argument is that for the plot of the *Ramayana* to work, Rama had to be ignorant of his identity as Vishnu. Whereas, if Vibhishana is seeking refuge and Rama is granting it, then both of them must be aware of this fact.

Vibhishana, the devotee
The argument about refuge on the view of its proponents is precisely that since Rama is the Supreme Being, to abandon general rules of conduct to seek him is not improper at all.

In 16th-century Awadhi poet Tulsidas's *Ramcharitmanas*, for instance, Rama's divinity is not secret. Here, Vibhishana is a devotee of Rama and his house in Lanka is adorned with all the elements that a devotee of Rama or Vishnu would keep.

When Hanuman arrives in Lanka, Vibhishana calls out "Rama! Rama!" upon waking up – as a devotee is expected to. His conversation with Hanuman focusses on his longing for Rama. He also doubts whether Rama would grace a person such as him, and so Hanuman acts as Rama's messenger, not only for Sita, but also for Vibhishana. The Vanara

LOCATION

SRIRANGAM

Tiruchirapalli in the south Indian state of Tamil Nadu is home to one of the most sacred manifestations of Vishnu housed within the famous Sri Ranganathaswamy Temple.

Legend suggests that Rama had bestowed upon Vibhishana an idol of Vishnu, which he was carrying back to Lanka. However, when he stopped on the way and set the idol down, it refused to move again.

THE SRI RANGANATHASWAMY TEMPLE in Tiruchirapalli, Tamil Nadu

reassures him that Rama's grace does not consider the faults of the devotee. Vibhishana describes his existence in Lanka as resembling "the poor tongue amongst teeth", suggesting constant vulnerability.

The true king?
Significantly, on the question of desiring the kingdom, 16th-century commentator, Govindaraja argues that Vibhishana's non-response to Rama's statement that he shall make him the king, suggests that Vibhishana had not come to Rama out of a desire for the kingdom.

The medieval Bengali poet Krittibas Ojha has Vibhishana himself raise this possibility and resolves it through the intervention of Shiva.

On the other hand, Tulsidas is perhaps most explicit on the question, with Vibhishana actually saying to Rama, "There was some

desire in the heart before; it has flown away in the river of love for the lord's feet. Now, compassionate one, grant me the sacred devotion to you, which is ever dear to Shiva's heart." Rama says categorically that the only motivation behind Vibhishana's consecration is that seeing Rama must bear fruit, though Vibhishana does not himself desire it.

Vibhishana as deity
While views on Vibhishana in India have mostly focussed on his relationship with Rama, we find him significant in his own right in Sri Lanka. There, he has sometimes been regarded as a guardian deity. The portrayal of his relationship with Rama, as historian and archaeologist Sree Padma Holt details, has also been shaped by Buddhism on the island.

Vibhishana
Seeks Refuge

Enraged at being addressed so disrespectfully, Vibhishana along with four other Rakshasas left Lanka and crossed the ocean to see Rama and seek his refuge. At the shore, however, Vibhishana was met with great suspicion, for wasn't he Ravana's brother and the enemy?

A MATTER OF OPINION
Rama often turned to the Vanara advisers for their counsel on matters, such as Vibhishana's decision to seek refuge. This 19th-century painting from Maharashtra shows one such conversation between Rama and Lakshmana (left) and Sugriva.

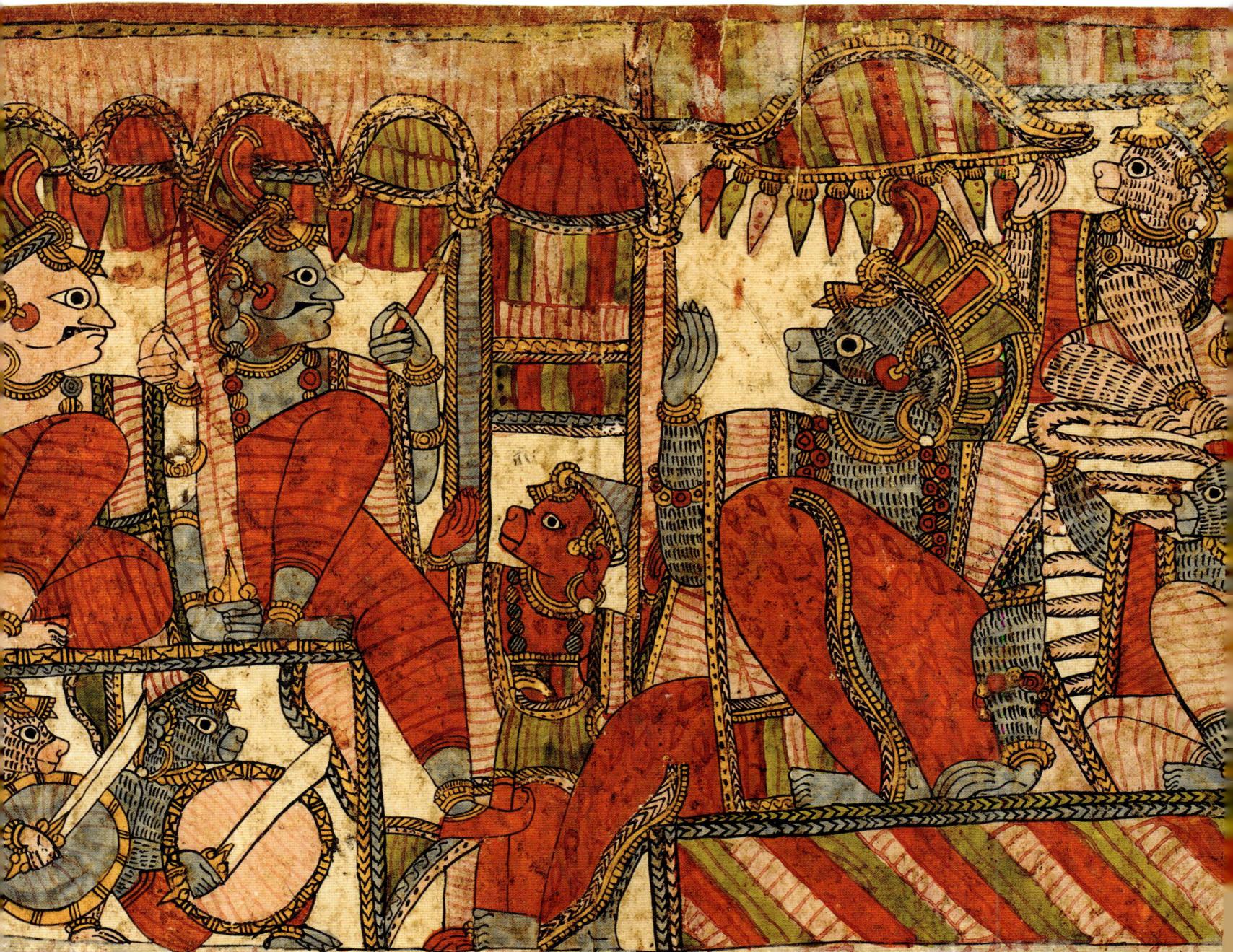

Vibhishana reached the northern shore in an instant and stood in the sky, blazing like a flash of lightning and immense like the great mountain Meru itself. Sugriva, who was near the shore, saw him with four other Rakshasas and told his commanders and Hanuman, "This Rakshasa, with all his weapons, is certainly here to kill us."

The Vanaras picked up trees and boulders and got ready to fight, when Vibhishana addressed Sugriva from the sky. "There is a Rakshasa called Ravana, who has abducted Rama's consort, the glorious Sita, and killed Jatayu," he said. "I am his younger brother and my name is Vibhishana. I tried to dissuade him, but it has proven impossible to convince him to return Sita to Rama without war. Instead, he spoke in harsh tones and disrespected and insulted me. I come here seeking Rama's refuge."

Question of intent
Sugriva promptly went to Rama and addressed him as Lakshmana listened. He said, "Ravana's younger brother, Vibhishana, seeks refuge with you. I believe Ravana has sent him here and I think he

should be captured. He has come here with malicious intent and it seems that his mission is to win your trust and cause you fatal harm. He and those who accompany him should be subjected to the harshest possible punishment. We ought to bear in mind that he is the brother of that evil Ravana, and that Rakshasas are capable of all kinds of deceit."

Rama heard Sugriva's words and asked the other Vanara advisers to share their opinions. Expressing due honour to Rama, they exclaimed, "Raghu scion! There is nothing that remains unknown to you. You are only asking for our opinion out of regard for our friendship. You are firm on truth, brave, intent upon dharma, and your valour is unmatched. You act after due contemplation, and so we shall express our opinions one by one."

Treading with caution
The intelligent Angada spoke first, "Ravana's brother has come from the enemy camp, and to that extent, can in no way be above suspicion. The wicked function through subterfuge, masking their

true intent, and they strike where it hurts the most. We should examine his virtues and faults, and determine whether to accept him in that way."

Sharabha, the brave, and some others emphasized the need to know Vibhishana's true intent either by sending a spy, or talking to him and trying to determine Ravana's intent. Jambavan, who was well versed in the scriptures, said, "He has come to us from Ravana, whose enmity towards us is certainly not in any doubt. Further, the time and place of his arrival are inappropriate and suspect. There is no reason to trust him and he should be treated with suspicion." It seemed that all the Vanara advisers wanted to err on the side of caution.

A different point of view
Hanuman spoke last, "Rama, even Brihaspati, the preceptor of the gods, could not presume to advise you, for you are the wisest of men. Even so, in my opinion, there are some problems with what has been stated so far. It is difficult, if not impossible, to employ subterfuge to find out what

Vibhishana's true intentions are. If we were to begin interrogating him, he would immediately figure out what we were up to, and could destroy a new friendship. The objections as to time and place are irrelevant, for he has come away from Ravana's misdeeds and unto you. In my opinion, he should be added to our side."

"Abandoning my sons and wife, I am **seeking refuge** with Raghava. Quickly **inform the great-souled Raghava,** the refuge of all the worlds, about **Vibhishana** presenting himself."

VIBHISHANA TO SUGRIVA, *SARGA* (11), YUDDHA KANDA

KEY CONCEPT
THE FOUR MODES OF POLICY
There is repeated mention of four ways of dealing with external parties, and they find recurrent emphasis throughout the *Ramayana*. The first is *sama*, which is understood as appeasement or conciliation. The second is *dana* or the giving of gifts. The third, *bheda*, implies causing dissension within enemy ranks, while the last, *danda*, is the actual deployment of force. Political actors are expected to make any situation favourable for themselves through the employment of one or the other of these four means.

SAMA IS STILL APPLIED in modern times during diplomacy

A **Friendship** Forged

Rama listened to his friends and allies counsel him against Vibhishana, but how could the great Raghava ignore a plea for refuge and a request for friendship?

Rama, pleased to hear Hanuman's words, said, "Once Vibhishana has sought refuge with me, I would not abandon him in any case, even if he may have malice."

Sugriva spoke in a spirit of affectionate friendship, "You have spoken as you should. My own mind finds purity in Vibhishana's intentions. Bring him quickly so that we, too, can extend our hands in friendship."

Rama, although in agreement with the general spirit of Sugriva's statement, said, "Whether there is malice, or there isn't, the Rakshasa is incapable of causing me any harm. And in any case, there is the story of the pigeon who gave up its life for the sake of the hunter who captured its mate (See p 254). I can destroy all Danavas, Pishachas, Rakshasas,

and Yakshas on this earth with a single arrow. I shall grant fearlessness to any being who supplicates, even once saying 'I am yours,' even if he is an enemy ... this is my resolve. So bring him here, whether he is Vibhishana or Ravana himself."

After Rama granted him refuge in this way, Vibhishana descended to the ground with the four other Rakshasas, walked up to the prince of Ayodhya, and fell at his feet.

He said, "I am the younger brother of Ravana and have sought you out. I shall assist in any way possible in your mission against Lanka and the Rakshasas. As long as I am alive, I will attack and infiltrate the army."

Rama lifted him up gently and embraced him.

"You are the refuge of all creatures and I am seeking refuge with you. I have abandoned Lanka, my friends and my riches."

VIBHISHANA TO RAMA, *SARGA* (13), YUDDHA KANDA

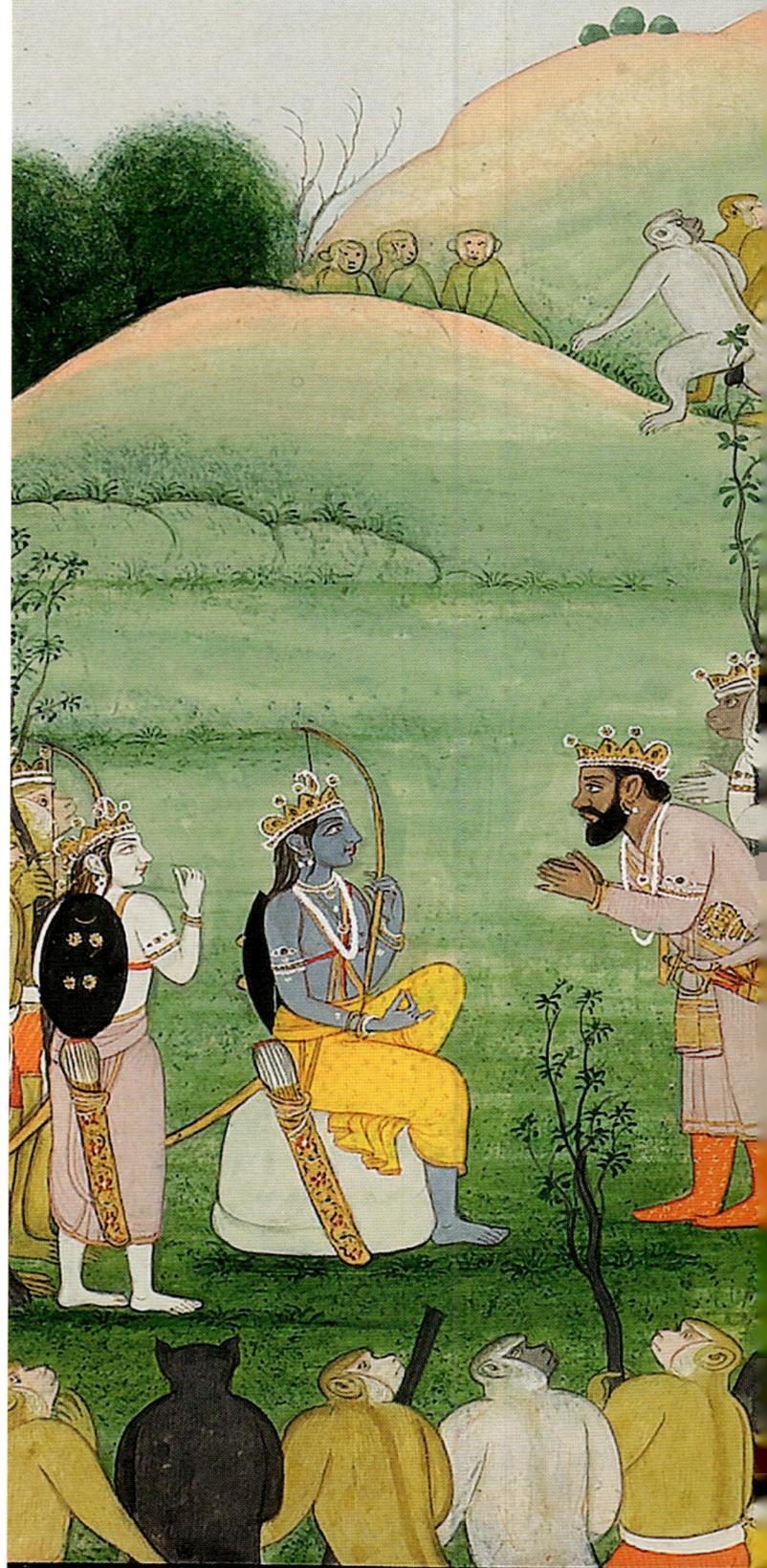

A NEW ALLIANCE
This late 18th-century miniature painting from Kangra, Himachal Pradesh, in opaque watercolour and gold on paper, portrays Vibhishana bowing before Rama, as the Vanara army looks on. Lanka can be seen in the distance.

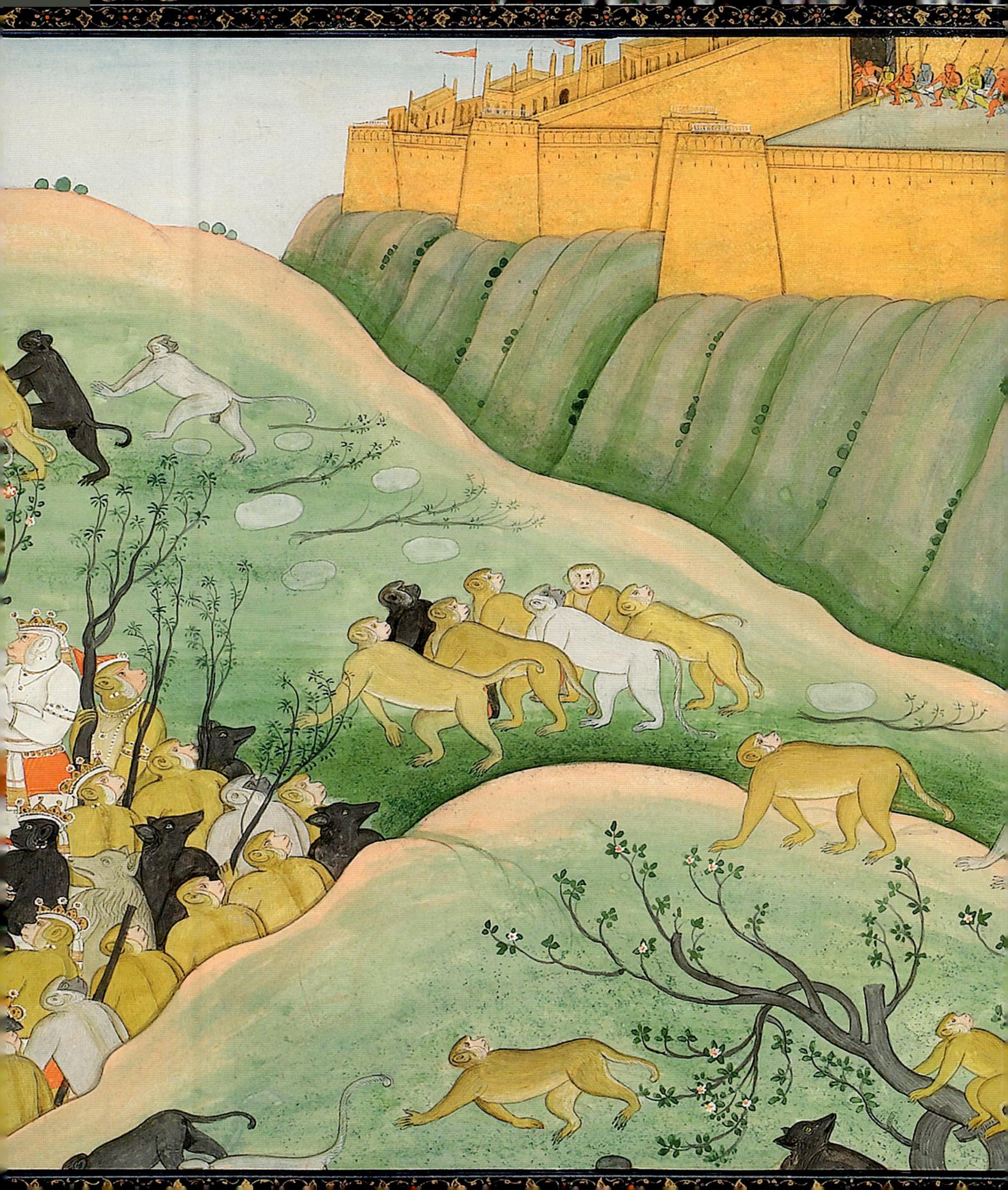

DHARMA TOWARDS ONE WHO SEEKS REFUGE

Seeking Sanctuary

"Bring him **here**. Whether it is **Vibhishana** or whether it is Ravana himself, **I will grant him** freedom from **fear**."

RAMA TO SUGRIVA, *SARGA* (12), YUDDHA KANDA

In the final set of opinions before Rama grants refuge, indeed the promise of fearlessness to Vibhishana, three kinds of positions are observed.

The first is Sugriva's initial position, which argues for prudential reasons that Vibhishana should be treated with suspicion. Then there is the position that Hanuman takes, which is also Sugriva's final position, where it is argued that it would be imprudent to employ subterfuge to understand Vibhishana's intent, and he seems trustworthy.

Finally, Rama's position takes matters outside the calculation of pros and cons, and places this decision in almost the same space as the moment he follows Kaikeyi's wishes. Dharma has little to do with protecting one's own interests, but more to do with taking the path that serves other people best, even if it brings one in harm's way.

PROTECTING THE SEEKER

Hanuman counters all the positions proposed by the preceding speakers on the grounds of sound and practical policy – it is not possible to question Vibhishana because he would obviously figure out that he was being questioned. His arrival is not inappropriate either, for the evil in Ravana has driven Vibhishana away from his brother, and propelled him towards Rama.

Rama agrees with Hanuman and adds that it would be inappropriate to reject Vibhishana now that he has already arrived. Sugriva agrees that he is able to discern purity in Vibhishana's intentions and he should, therefore, be made their equal in friendship.

As the 17th-century commentator Govindaraja points out, although Rama and Hanuman agree, it is not the same thing, for when Rama says he would not reject somebody who has approached him as a friend, it includes even those who are feigning friendship.

Thus, Rama's position is not based on Vibhishana's intentions at all. He begins by pointing out that whether or not Vibhishana is virtuous, he does not have the strength to cause Rama even the slightest harm. However, more importantly, a miserable person seeking refuge with his hands together in supplication, even if he is the enemy, should not be killed. To withhold protection on the grounds of either fear or greed is a terrible sin. Rama assures all beings of freedom from fear should they only seek him.

The censure of withholding protection on grounds of fear is what makes this episode remarkable. It would have

STORY FROM THE *RAMAYANA*

THE PIGEON WHO HELPED THE HUNTER

As he speaks of the necessity of granting refuge, Rama narrates the story of a female pigeon who is captured by a hunter (thus making him a parallel to Ravana). The male pigeon overhears the hunter seek refuge and protection with the forest deities, and assumes his protection upon himself as his duty, since he was the one who heard the statement of refuge. To make good on this, the male pigeon offers his life to satiate the hunter's hunger. Rama explains that if an untrained bird acts like this, how much more important is it for humans, who are trained in various kinds of learning, to act so?

certainly been easy for Rama to reject Vibhishana, but it would have been just as easy to accept him because he seemed virtuous. Further, since Rama was perfectly capable of protecting himself, it would have still been safe to accept him. The point here, however, is that for one being sought as refuge, none of these should be factors. Simply the fact that one has been sought should be enough.

SEEKING ASYLUM WITH GOD

The episode of granting refuge becomes theologically central to the Shrivaishnava (Hindu community that worships Vishnu) tradition. The 13th-century philosopher Vedanta Desika's *Abhayapradanasara* (The Essence of Granting Refuge) presents this as the central theme. Various aspects of both Vibhishana's surrender as well as Rama's acceptance have been the subject of much exegesis and commentary in terms of the appropriate way of seeking refuge and the lord's granting it. Awadhi poet Tulsidas's *Ramcharitmanas* adds within its narrative that Rama says, "The moment a being comes before me, the sins of a million births are destroyed."

Rama also emphasizes that no being could ever face him with malicious intent, which seems to suggest that it is impossible to seek refuge with Rama as a devotee until one has duly purified one's intentions. In Valmiki's *Ramayana*, when addressing Rama, Vibhishana refers to the fact that his family, kingdom, and life itself are subject to Rama.

In the *Ramcharitmanas*, Rama tells Vibhishana that the strings of attachment that extend to one's parents, kin, progeny, partner, body, material wealth, home, friends, and family should be collected and used to tie up the mind and place it at Rama's feet.

He tells Vibhishana with great affection that he only takes on a body out of love for such devotees as him.

Thus, Rama's granting of refuge, an act designed to be incalculable in terms of profit and loss, is also in line with and a development of the theme of grace unto all beings as articulated by Valmiki.

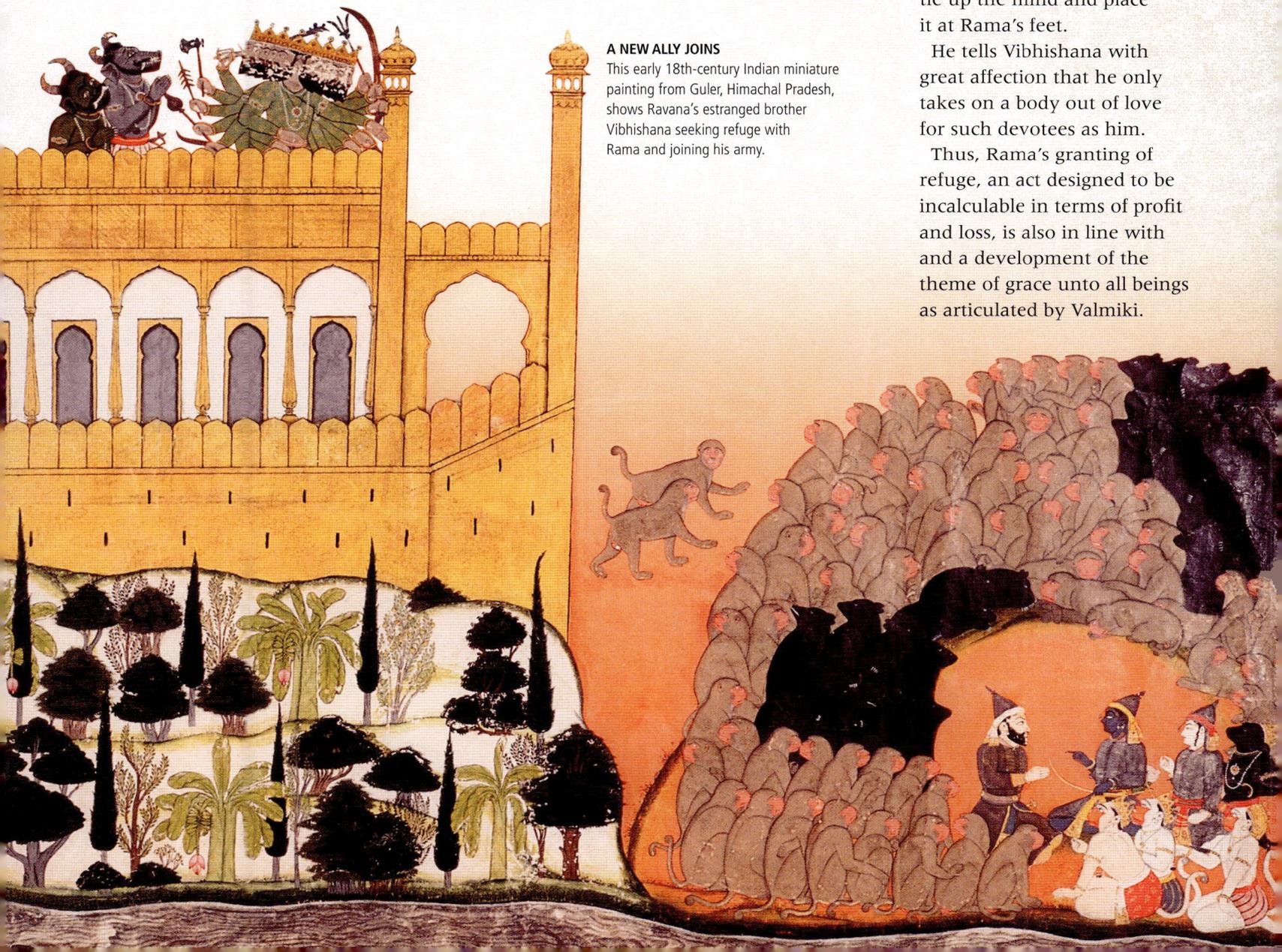

A NEW ALLY JOINS
This early 18th-century Indian miniature painting from Guler, Himachal Pradesh, shows Ravana's estranged brother Vibhishana seeking refuge with Rama and joining his army.

A **Petition** to the **Ocean**

Humbled by Rama's immensely merciful nature, Vibhishana swore to assist him in rescuing his beloved Sita. Vibhishana's intelligence and quick wit would soon prove to be critical in Rama's mission against Lanka.

> "But the **careless ocean** did not show himself to Rama... At this, **Rama became angry** at the ocean and the corners of his **eyes turned red**."
>
> RAMA'S ANGER TOWARDS THE OCEAN, *SARGA* (14), YUDDHA KANDA

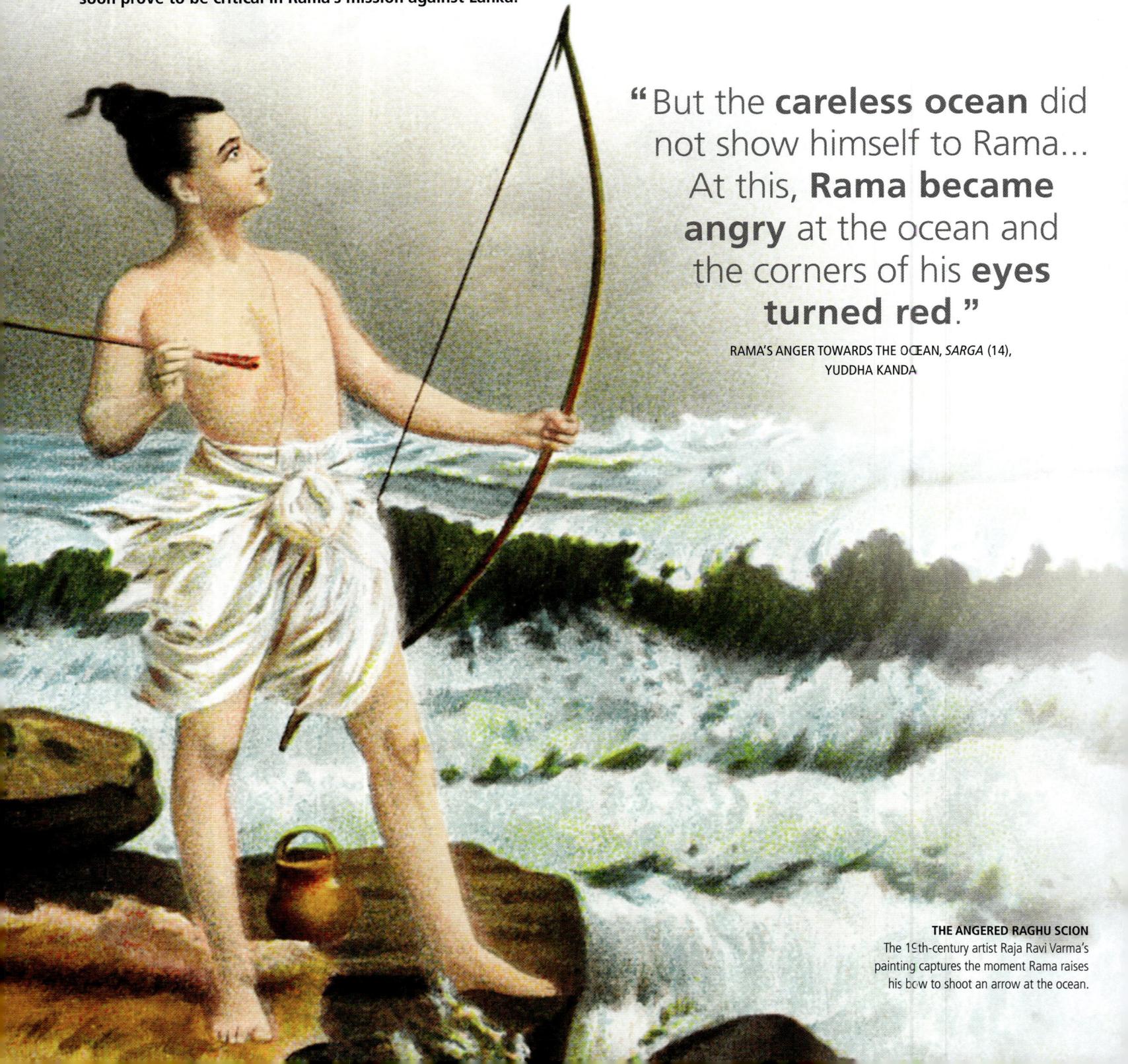

THE ANGERED RAGHU SCION
The 19th-century artist Raja Ravi Varma's painting captures the moment Rama raises his bow to shoot an arrow at the ocean.

R ama turned to Lakshmana and said, "Bring water from the ocean. I will consecrate Vibhishana as the king of Lanka." As Rama consecrated Vibhishana with the sacred water, the Vanaras cheered.

A new ally

Once the solemn ceremony was completed, Sugriva and Hanuman consulted Vibhishana on the best possible way to reach Lanka. "By what means might we cross this lord of all rivers with this army?" they asked.

Vibhishana replied, "The Raghu scion should approach the ocean for help. Rama's ancestor Sagara dug up the ocean (See pp 50–51), and to that extent it is part of his clan. He can be expected to extend assistance to his kin."

Rama, devoted to dharma, found this agreeable, but turned to Lakshmana, Hanuman, and Sugriva, and asked for their advice as well. He said, "Lakshmana, what Vibhishana says sounds appropriate to me. Sugriva and you are wise and I trust your opinion. What do you think of this plan?"

Lakshmana and Sugriva agreed with Vibhishana and concluded that there was no better way of reaching Lanka. This, they felt, was the surest and the speediest way to do it.

At the edge of the ocean

After they reached a consensus, Rama sat on the grass, similar to fire as it settles in the altar, and accorded the ocean the honour. Three

nights passed, but there was not even a whisper. Rama realized that the army would cross the ocean either as a result of the worship offered, or if he destroyed it altogether.

His eyes turned red in anger and he told Lakshmana, "Look at the arrogance of the ocean! I have offered him immense honour and he refuses to appear. Pacifism, forbearance, sincerity, and favourable speech are wasted upon wretches who mistake them for weakness. All people respect those undiscerning ones who go about full of themselves, acting with force towards one and all. One cannot get glory or fame in the world or victory in the battlefield through a conciliatory approach."

Rama's anger

Infuriated with the ocean's hubris, Rama said, "Today, the world will see how the water of the ocean is full of the limbs of creatures that my arrows will kill. Or I shall dry the ocean and we can simply walk

over to Lanka. The ocean believes that I am weak because I have acted with forbearance towards such a wretch. Bring my bow, Lakshmana, and my arrows, which are like poison itself.

"This day I shall perturb the ocean whose very name is unperturbable. It does not cross the shores, but today, it will be unable to remain within its bounds."

Rama picked up his mighty bow before which even the gods trembled and glared at the ocean. Resplendent like the fires at the end of an aeon, he stretched his terrible bow, shaking the worlds with the sound of its bowstring.

He released an arrow into the ocean and it cut through the sky and entered the water, terrifying and tormenting not just the creatures that lived there, but even the valiant Danavas who lived in Patala.

There was a great turbulence and thousands of waves leapt up like mountains, carrying with them creatures from the ocean's deep waters.

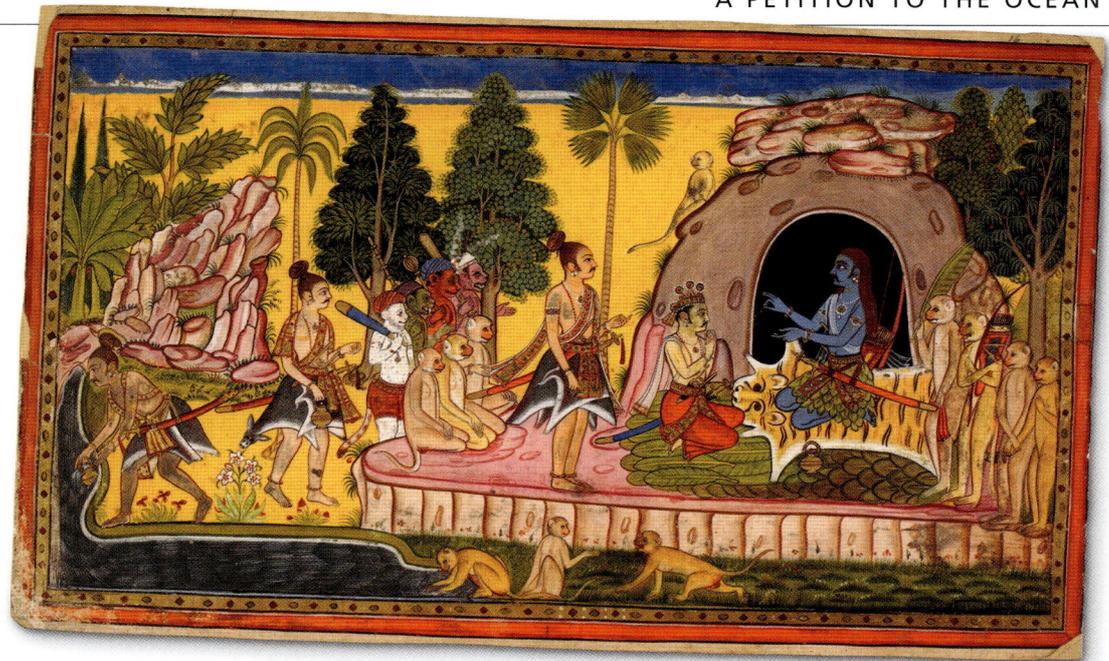
CROWNING A RULER
This 15th-century miniature painting from Udaipur, Rajasthan, depicts Lakshmana fetching water for Vibhishana's consecration, as the Vanaras look on.

ALTERNATIVE ACCOUNT
THE VIRTUES OF PATIENCE, OR NOT?
This incident is iconic as an instance of the impossibility of conciliatory strategies towards those who have no appreciation for them. The 20th-century Hindi poet Ramdhari Singh "Dinkar" writes, "For three days, seeking passage, the lord of Raghus sat by the sea, reciting verses in conciliation. When not a single sound rose in response from the sea, the fire of valour blazed forth from Rama's arrow." In some narrations of this part of the story, Lakshmana does not immediately agree to follow Vibhishana's strategy while in Tulsidas's *Ramcharitmanas*, he urges Rama to dry up the sea in the first place, and Rama smiles and says, "And so we shall," yet he waits the full three days.

THE UPHOLDER OF DHARMA

Rama

"Rama is **devoted to truth and dharma** and is a **virtuous man**… and **never wavers from the truth**."

INHABITANTS OF AYODHYA TO DASHARATHA, *SARGA* (2), AYODHYA KANDA

Rama, the protagonist of this immense composition and tradition, is different things to different people. He may be regarded as the lord of life and all beings, the ideal man striving for perfection, a flawed hero, or anything in between. Valmiki's Rama is Vishnu born to destroy Ravana because only a human could kill him. This seeming paradox, which lies at the centre of Rama's figure, informs and complicates most ways of viewing him.

Rama's feats, whether of a martial nature – protecting Sage Vishvamitra's sacrifice, breaking Shiva's bow, killing the Rakshasas – or of a more personal nature, such as giving up the throne of Ayodhya, have a sense, if not of the superhuman, then certainly of the spectacular.

God or human?

This paradox could be read into Valmiki himself – the human Rama wishes to avoid a bad name by keeping his beloved with him, and is filled with sorrow at both her departures, while the Supreme Lord knows her to be his eternal consort. His treatment of Sita is censured harshly within the *Ramayana*, repeatedly, and by various premodern figures who either rework that episode, or drop it, as it does not fit their divine ideal. His actions have come under scrutiny in the past several decades as well, and are often held as an example of the harshness that the ideal Rama represents.

The gentle hero

What distinguishes Rama in the broader *Ramayana* tradition and within the epic, is his gentleness, despite his strength. This is evident in his all-consuming sorrow at Sita's abduction, and whatever the purport of his statements on Sita at the end, his grief at the separation is true and his loss of hope is real.

His lament when he feels he has lost Lakshmana is equally moving, and his love for Bharata is reflected not only in the large gestures, but also in his words.

There is a deep pathos that marks him as well – Sumantra tells Lakshmana that it is predicted that Rama would have a life of great sorrow and little joy. For his devotees, this pathos is his compassion for his devotees, anguished in separation from him.

The Supreme Being

Viewing Rama with the premise that he acts in the interest of all beings, without any human frailties and motivations, also allows for his actions to be viewed differently. For instance, in killing Vali, both he and Vali can be understood as being "in" on the game, and Vali dies with Rama before his eyes, and in his heart.

In the medieval Sanskrit text *Adhyatma Ramayana*, Rama is the Supreme Being, truth-consciousness-bliss, free from all qualifications, pure, ineffable, pacific, unmodified, void of passion, all-pervasive, and self-illuminated(ing).

Awadhi poet Tulsidas's Rama is both at once – the Supreme Being and the compassionate lord who never abandons anyone seeking refuge, who embraces even those who are otherwise understood as outside the pale of society, and

ANALYSIS

RAMANAMA

A crucial aspect of Rama's divinity, is his compassionate grace in guiding beings across the ocean (See pp 262–63). Those who entered the River Sarayu after Rama were granted special realms (liberation from rebirth). Brahma granted the same privilege to those who would die thinking of Rama.

Rama's name has been called the *taraka* mantra, the mantra which takes one across. His name has also been invoked by various devotees who speak of a non-dual, formless divine. What the actual referent of "Rama" is remains a mystery – not the kind that needs to be solved, but needs to be realized and resolved. This is associated with the complex doctrines around the idea of the mantra and how the divine name brings one closer to the divine, as well as with the central secret of Rama, that he is both accessible and transcendental.

who assumes a human form out of love for his devotees. So loving is Rama that he is moved to transcend even the ideal of truth for Bharata's sake. He is so compassionate is he that even those who oppose him are granted the supreme station after dying by his hand.

Many poetic and devotional narratives exclude the events of the Uttara Kanda, suggesting that the divine being, who has become man, would not do such a thing.

Rama also has a complex relationship with spiritual knowledge. In Valmiki's *Yogavasishtha*, he receives knowledge of the nature of reality, whereas in many portrayals, he instructs his devotees, often Hanuman.

These narratives usually assume a particular position on Rama's self-awareness of his divine identity. Further, his human form, makes possible the cultivation of various attitudes towards him.

So, devotees may regard him the same way as Dasharatha or Kaushalya regarded their son, or Bharata or Shatrughna their brother, or as Hanuman, or Vibhishana did.

There have been many readings of Rama in the 20th century. Some seek to elevate other characters by suggesting that Rama's actions were suspect in comparison to theirs, while others portray Rama sympathetically, or devotionally. As a central figure in much Hindu thought, his more controversial actions have been used to draw attention to the darker recesses of Indian society. As much as Rama has sometimes been read in terms of a conservative ideal, he embodies a compassion that transcends that conservatism, as seen in his treatment of Guha, Shabari, and Ahalya, the Vanaras and Vibhishana, and the rejection or reinterpretation of the Shambuka and Sita episodes by many strands of devotees. The appeal of Rama, and his story, continue to endure.

"Rama, are you only human? **Are you not God?** Are you not **omnipresent**, pervading the world? **Then I am godless**, may God forgive me; if you do not pervade the world, let my mind be engrossed in you."

MAITHILI SHARAN GUPT, HINDI POET

THE DIVINE KING
This traditional portrayal of Rama, as a king, holding a bow in his hand, with an almost beatific smile, is often seen in Hindu homes across India.

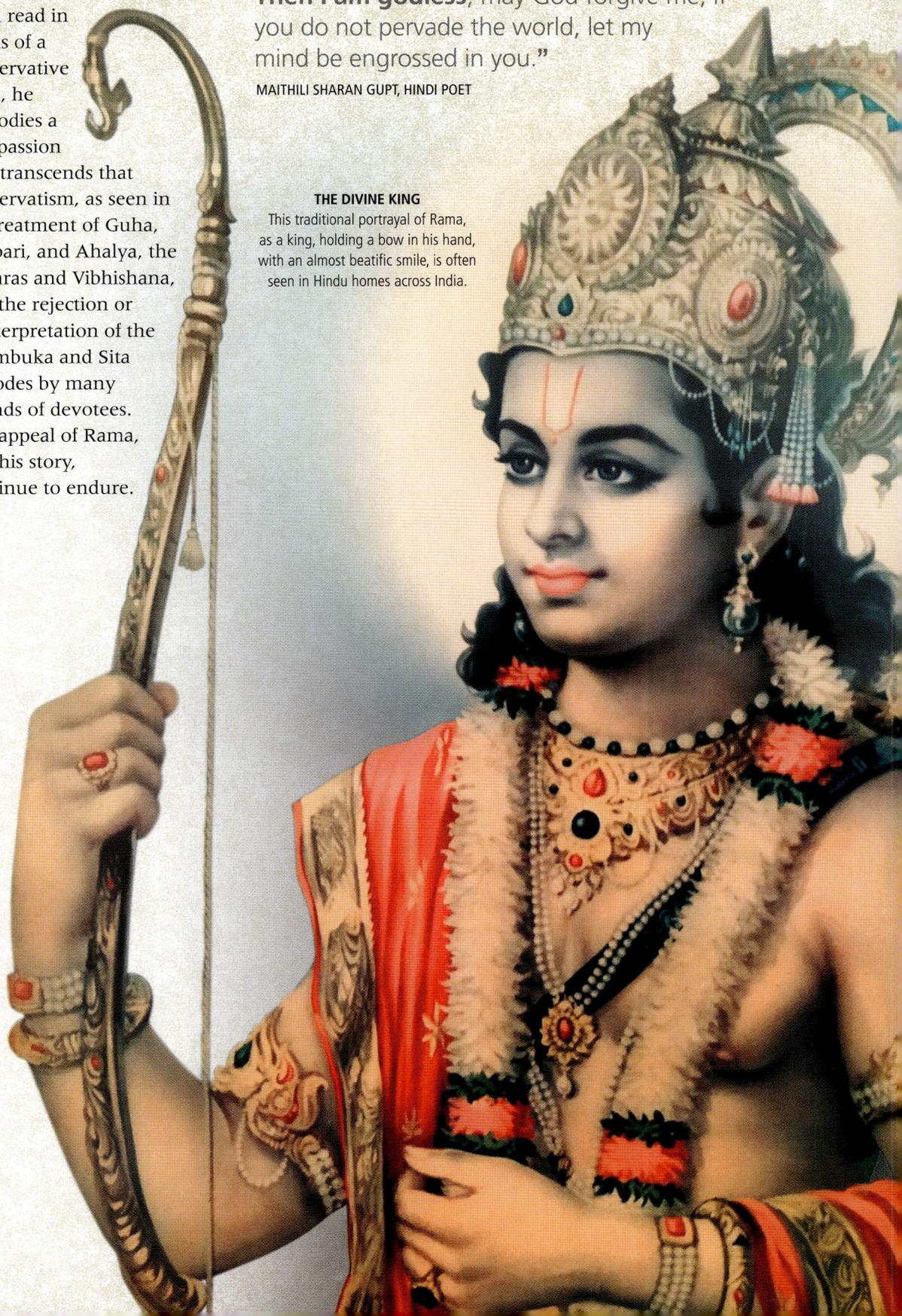

The **Bridge** Across the **Ocean**

The blazing arrow from Rama's celestial bow pierced the surface of the waters and the great Saagara rose, compelled to bow in front of the mighty prince. He offered him an extraordinary solution to the problem – to build a bridge that would rival any other.

Fearing absolute destruction, Saagara, the deity of the ocean personified, arose from the waters, radiant and lotus-eyed, dressed in red, and adorned with gold. He saw Rama, furious, with another arrow raised and went up to him, his palms together in supplication. He said, "Raghu scion! The earth, space, water, air, and, fire stay eternally firm in their own nature. My inherent nature is to be unfathomable and I cannot be traversed. It is impossible for me to be otherwise. I cannot act in desire or fear to stop the flow of my water. However, I can try to bear a bridge so that the sea creatures do not attack you as you cross."

Appeased, Rama asked Saagara to assign him a target as the arrow in his bow could not return unused.

BUILDING A BRIDGE
This 16th-century mural from a Ramaswamy temple in Kumbakonam, Tamil Nadu, shows the Vanaras as they build the bridge. Rama can be seen on Hanuman's shoulders, with Lakshmana on Angada.

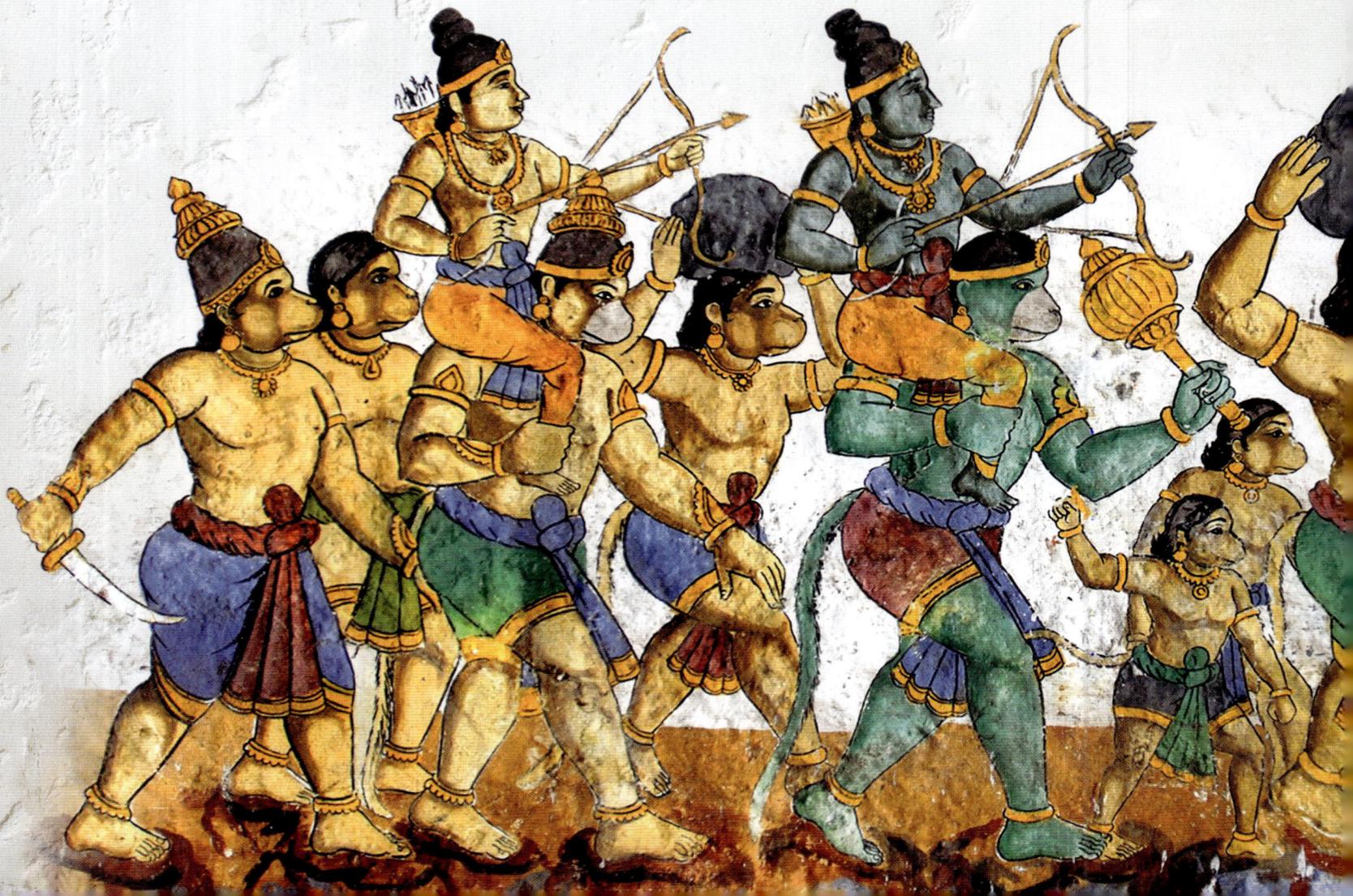

Nala, the architect

Once that was done, Saagara told Rama of Nala, the valiant Vanara and son of Vishvakarma, the divine architect and builder. "His father's boon was that he would be equal to him, and indeed he is," he said. If Nala built the bridge, the ocean would bear it and allow the army to cross safely. Saagara then disappeared, leaving a roaring mass of water behind.

Nala stood up and said, "Rama, I did not speak so far because it is improper to speak of one's qualities unless asked first. But I do possess the capacity to build such a bridge and it can be built immediately. My mother was granted this boon too."

A mammoth task

Following Rama's command and under Nala's guidance, hundreds of thousands of delighted Vanaras began to build the enormous bridge with great gusto.

They rushed into the great forest and pulled trees from their roots. They brought forth many varieties and threw them into the ocean. They dragged boulders to the shore, shattered them, and then hurled them into the waters. This impressive endeavour created a terrible din, which resounded in all directions and the ocean grew turbulent.

Finally, Nala's spectacular bridge stretched out before them. It was 10 yojanas wide (about 126 km or 90 miles) and connected the northern shore to Lanka, across 100 yojanas (about 1,260 km or 900 miles).

The beautiful bridge stood resplendent like a parting in the ocean, and as radiant as the Milky Way. The Vanaras leapt up and down, and roared and cheered at this extraordinary sight.

THE ARCHITECT
This wooden painted mask from Odisha, India, is of Nala who is in the Vanara army. He was the only one with the expertise to build the bridge, also called Nala's Bridge, across the ocean.

"The bull among Vanaras... **dragged boulders**... **shattered** these and started to drag them **towards the ocean**. The Vanaras filled the ocean with salas... blossoming karnikaras, mangos and Ashoka... some trees with roots and others without."

CONSTRUCTING THE BRIDGE, *SARGA* (15), YUDDHA KANDA

ALTERNATIVE ACCOUNT

THE SQUIRREL AND ITS STRIPES

A popular Tamil folk tale tells of a squirrel, also a Rama devotee, who scurried across the shore carrying pebbles and sand to the ocean, mimicking the Vanaras, who, of course, hauled huge boulders to build the bridge. The pebbles served to fill the gaps in the bridge and the sand acted as a binding agent. There are many variations to this story, including one, where a Vanara ridicules the squirrel's attempt at helping his Rama.

Rama overhears the conversation and chastises the Vanara, ultimately stroking the squirrel as a gesture of love, leaving behind three dark stripes on its back.

RAMA'S BRIDGE
This satellite image is of Adam's Bridge, which is located off the coast of Rameswaram Island in Tamil Nadu. It is made of limestone shoals and extends to Sri Lanka. Traditionally, it is believed that this is Rama's Bridge. This image was taken by Landsat 8 satellite in the year 2014.

The **Crossing**

Beings of all the worlds gathered across the sky to behold the wonder that was the bridge, stretched out before them, like a line drawn through the ocean. They watched as the army made its way across it and towards Lanka.

The mighty bowman, Rama, walked at the head of the army with Lakshmana by his side. Sugriva walked with him as well. Vibhishana stood at the shore, with a club in his hand, ready for battle. The rest of the army went as it willed – some walked along the sides of the bridge, some rushed down the centre, others leaped into the waters or up into the sky.

They crossed the ocean quickly and reached the far shore, which was abundant in fruits and water, and set up camp, following Sugriva's instructions. The gods, heavenly sages, and divine singers, marvelled at the immense and unprecedented task that Rama had accomplished.

They were delighted to see the lotus-eyed scion of the Raghus with large arms, seated and surrounded by the army of Vanaras, which was as vast as another ocean.

The celestial beings consecrated Rama with sacred waters and proclaimed his victory. "May you be victorious over your enemies and protect this earth for a long time," they said. They praised Rama with their auspicious words, and the gods and men honoured him in this way.

" Some... **passed** along the **middle**... Some resorted to the sky and leapt across... The giant roar of the ocean was surpassed by their loud roars. "

RAMA AND THE ARMY CROSSING THE OCEAN, *SARGA* (15), YUDDHA KANDA

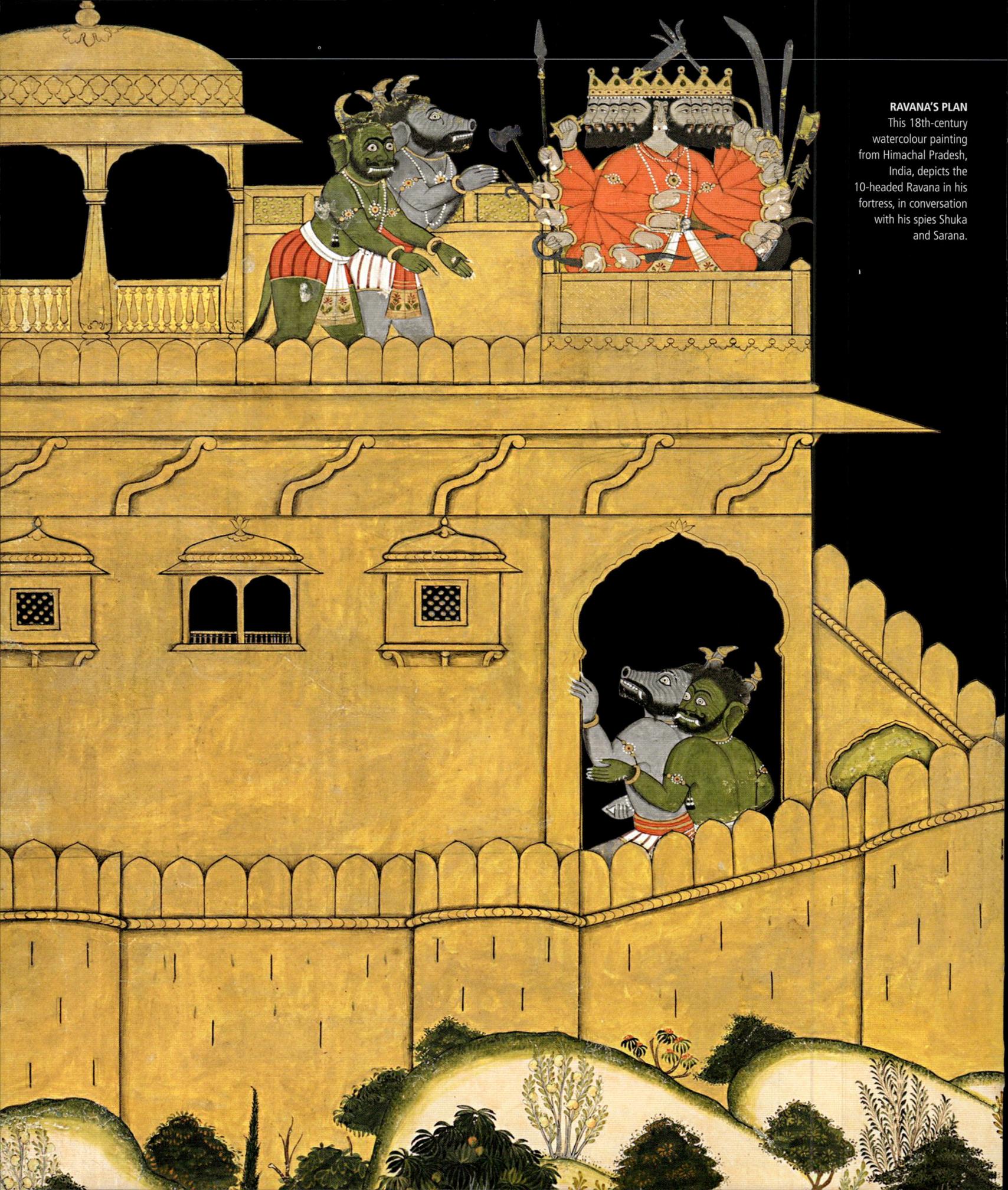

Ravana's Spies

Surprised that Rama and the Vanara army had crossed the vast ocean, Ravana decided to send his spies to their camp near Mount Suvela. Their mission was to ascertain the strength of the Vanara army and Rama's might. They returned with surprising news.

Ravana heard that Rama had crossed the ocean and called his spies, Shuka and Sarana. "This bridging of the ocean that Rama has achieved is unprecedented," he said. "We must get a sense of just how large this Vanara army is."

He ordered them to enter the enemy camp unseen to get a sense the army's strength. They were asked to find out who the chiefs and Rama's trusted advisers were, how Rama functioned, and the weapons he favoured.

Rakshasas in disguise

The Rakshasas took on the forms of Vanaras and entered the camp. They could not see how they could possibly get a sense of the roaring mass that surrounded them on all sides. As luck would have it, Vibhishana recognized them and took them to Rama, announcing that they were Ravana's spies. They looked upon Rama with no hope of continued existence and folded their hands in fear, saying, "Joy of Raghus, Ravana has sent us here to get a sense of your strength."

Rama smiled and replied, "If you have investigated the army and observed us enough, feel free to return to Lanka when you will."

Then, steel entered his voice and he said. "Tell the king of Rakshasas, 'You will soon get to demonstrate in battle the strength on which you relied when you abducted my Sita.'

"Tomorrow, my arrows, released in anger, will destroy this city and his army. Bring your forces together, Ravana!"

Revealing Rama's strength

Shuka and Sarana ran back to Ravana and the latter told the king how Vibhishana had captured them. "We deserved death, but Rama released us. The four mighty warriors – Rama, Lakshmana, Vibhishana, and Sugriva – are enough to bring the city down, and the rest of the army might as well rest. In fact, the other three might simply watch, for Rama alone could vanquish Lanka. The army together is invincible, even for the gods. Enough of your enmity with Rama, great king. Exercise restraint and return Sita."

Ravana replied that he would not return Sita even if the gods themselves commanded him and added, "You seem awestruck and afraid of the army. Name one being who has the strength to defeat me!"

Identifying the enemy

Ravana climbed to the top of his palace and looked upon the land overflowing with Vanaras. He told Sarana and Shuka to point out the commanders and the best warriors.

After Sarana was done, Shuka pointed at Hanuman and said, "The lotus-eyed hero standing next to Hanuman is the best of the Ikshvakus. Dharma is firm in him, and he is firm in dharma. He knows the mightiest weapons and knows the Vedas. His anger is like death and his valour, like Indra's. Lakshmana stands next to him, the one whose skin looks golden and whose hair is dark and curly. He is brilliant, triumphant in battle, and powerful. He is Rama's right arm and his external

breath. He would give up his life for Rama in a heartbeat." Then he described Sugriva in similar glowing terms.

Ravana, angered at the descriptions, and indeed, at the sight of the army and its leaders, censured them, "You are fools for praising your enemies and addressing harshly the one on whom you depend for a livelihood. Had your previous conduct not blunted my anger, I would have killed both of you."

Ravana soon sent another set of spies who were discovered as well, and sent back, after the Vanaras had beaten them thoroughly.

When Ravana asked them if all was well, one of them, named Shardula, said, "One simply cannot spy on this army. It was Rama who released us, or survival would have been difficult." He then described in detail the army and its battle formations.

> "**Dasharatha's young son** can withstand a lion… There is **no one on earth** who is **Rama's equal in valour.**"
> SHARDULA TO RAVANA, *SARGA* (21), YUDDHA KANDA

ALTERNATIVE ACCOUNT
RAVANA'S SPIES AND THEIR FATE

In some versions, one of Ravana's spies tries to create dissent among Rama's ranks by extending an arm of alliance to Sugriva, perhaps partly on account of Ravana's friendship with Vali.

In other versions, the spies are not discovered because of any special skill on the part of Rama's army, but rather because they speak of Rama with such love that they forget to conceal themselves.

After Ravana chastises them, Shuka, who, in some versions, is described as a great sage cursed into becoming a Rakshasa, is able to return to his earlier state after seeking refuge with Rama.

A Cruel Trick

Agitated by the news of Rama's arrival in Lanka, the king of the Rakshasas resorted to lies and deception in order to entice Sita to submit to his will. Though seemingly successful at first, Ravana's cruel schemes would eventually be rendered futile in the face of Sita's unyielding faith.

> " …the Rakshasa flung down **the beloved head** before Sita and quickly vanished. Ravana flung down the **large and radiant bow** and said, '**This is Rama's**, famous in the three worlds.' "
>
> RAVANA TO SITA, *SARGA* (22), YUDDHA KANDA

THE DEVIOUS PLAN
In a bid to trick Sita, Ravana presented her with a bow that was identical to the one Rama carried. This was a failed attempt to convince her that her husband had been defeated.

Troubled at the news that Rama and his army were camped at Mount Suvela, Ravana held a meeting with his advisers. After speaking with them in detail, he entered his residence, and called for the Rakshasa Vidyujjihva to present himself. He decided to delude Sita with his illusory powers and commanded Vidyujjihva to conjure up a likeness of Rama's head. Then, he left for the Ashoka grove.

Ravana's twisted game

There, he saw Sita with her head bowed, thinking of Rama alone. The cruel one addressed her, "The one whom you sit thinking of has been killed in battle. My men have killed your pride and the one upon whom you rely. Now, you shall be my wife. Sita listen to how your husband was slaughtered, you who think yourself to be so wise.

"Rama had indeed arrived at this side of the ocean to try and kill me. He arrived as the sun set and, along with his army, fell into a deep sleep because he was tired from the journey. My spies brought news of him and, at night, my army led by the commander Prahasta, attacked. Prahasta caught hold of Rama's head and cut it off. Vibhishana was captured and Lakshmana and many of the Vanaras fled. Sugriva lies there with his neck broken, as does Hanuman, with his jaw broken. My army has chased away the few that live."

Ravana then asked a Rakshasi to call Vidyujjihva and when he arrived, the king told him, "Let her see the state to which her husband has been reduced."

The Rakshasa placed a likeness of Rama's beautiful head before her and left. Ravana then presented Sita with a bow that seemed identical to Rama's, and said, "Here is your Rama's precious bow, which Prahasta brought with the head."

Echoes of sorrow

Seeing Rama's severed head and bow before her, Sita wept. She called out Kaikeyi's name and cried, "I hope you are pleased, Kaikeyi. The joy of the lineage is gone. You have yourself destroyed your family. What had Rama ever done to you that you exiled him to the forest?"

Shaking, Sita fell to the ground, held Rama's head close and sobbed, "Ah! Mighty-armed Rama! I am destroyed to see you in this state, and to know that I am widowed! My mother-in-law is bereft as a cow without its calf. You, who were the only one intent upon lifting me out of this ocean of sorrow, are yourself gone. Those who spoke of your long life have been proven liars, as your life was cut so painfully short.

"How could you have been assailed in this way, you who are so competent in warfare and can ward off such attacks? Why do you sleep on the earth as if she were your beloved and not me? Why do you not speak to me? Look at me, bull among men! I am your companion, the one who walks with you in dharma, whom you promised to not abandon. How is it that you, who performed all the sacred rites, shall not receive the ritual preparation by fire at death? Kill me now too, Ravana, so my head shall lie with his."

Meanwhile, a Rakshasa approached Ravana and whispered in his ear that Prahasta had arrived and needed to speak to him. The king left the grove and a short while later, the head and the bow disappeared.

A sigh of relief

The Rakshasi Sarama, who regarded Sita as a dear friend, saw her on the verge of losing consciousness and comforted her. She told her that she heard Ravana's words and had then gone to see what he was up to.

"Sita, it is impossible to have killed Rama in his sleep," she said. "That expert in illusion has presented you with something that is unreal. Listen to what has truly happened. The time for sorrows is past. Rama has crossed the ocean with his army. I have seen him myself with Lakshmana and his huge army. Rama and Lakshmana shall attack the Rakshasas like the mighty gods Indra and Vishnu. I shall soon see you in Rama's arms."

She told Sita that she could fly to the Vanara camp and tell Rama that she was well. "I can fly unseen and return," she said. "Life itself is not dearer to me than you."

Sita instead requested her to spy on Ravana to get more information on his cruel plans. "I am agitated and suspicious and my mind is not at rest," she said. Sarama agreed and spied on Ravana for Sita's sake. She returned and told her that the ministers reminded Ravana of Hanuman's valour and Rama's incredible actions in Janasthana and in bridging the ocean. "They urged him to return you to Rama, for these actions do not seem to be those of mere mortals. Yet, he does not seem willing to return you without facing defeat in battle."

CHARACTER PROFILE

SARAMA

Vibhishana's wife, the daughter of a Gandharva who was born by the Lake Manas, is also called Sarama. It is not specified here whether it is the same Sarama, but this Sarama, much like Vibhishana himself, is willing to risk her own life to assist Sita. Unlike in Sundara Kanda, where Trijata was willing to simply ward the other Rakshasis off, Sarama brings her considerable capacities to the table in order to help Sita.

SITA in conversation with Sarama

Preparing for War

War seemed inevitable. Despite requests to reconsider his decision, Ravana refused to listen to his counsellors. After all, he said, the 10-headed king bowed to no man.

> "Why should such a **Ravana** bear the **burden of fear** in an **encounter**? I will **never bend down**. I would rather be **sliced into two**. This is my innate nature. By nature, I am impossible to cross."
>
> RAVANA TO MALYAVAN, *SARGA* (27), YUDDHA KANDA

The lord of the Rakshasas heard the immense sound of the war drums that shook the fortress and sat contemplating for a while. He then told his counsellors, "I have heard everything you said about Rama's bridging of the ocean and the arrival of his huge army. I also know all of you to show firm valour in battle."

Malyavan's caution

Ravana's great-uncle on his mother's side, Malyavan, spoke up. "A king who is weaker should seek a truce and the more powerful should desire war. I feel conciliation is the way to go with Rama," he said "We have become enemies because of Sita's abduction and I suggest that you return her.

AN ANGERED KING
In this 2010 Kathakali performance from Bengaluru, Karnataka, a differently abled artist portrays the role of Ravana. The elaborate costume and strong movement is an attempt to encapsulate Ravana's anger.

"The grandfather Brahma, the Creator of the universe, created the gods and the Asuras who possess dharma and adharma respectively. In the first age, dharma swallows adharma, and in the last, it is the other way around. You have caused great harm to dharma, and the serpent of your adharma is getting ready to swallow us. You indulged in your senses and caused great pain to the sages. I see terrible omens, Ravana, and it feels as if the end of the Rakshasa race is near.

"I believe Rama is Vishnu himself in a human body. Such strength and valour as he has demonstrated could not possibly belong to a mere mortal man. Attempt a truce with the lord of men who has bound the ocean with a bridge."

Hubris at play

As if impelled by death, Ravana grew angry at Malyavan's words and replied in harsh tones, "Rama is a single, miserable man, relying on an army of Vanaras, and whose family exiled him to the forest. How can you regard him as more powerful? And on what grounds do you hold me, the lord of the Rakshasas, weaker? You speak out of malice, or because you side with the enemy, or because he has encouraged you. For who would speak this way to a king without direct encouragement from the enemy? Now watch as I kill Rama and Lakshmana. Why should I, before whom even gods do not stand steadily in battle, be afraid of a mere human?"

Malyavan heard these words and realized that the king had grown angry, and so he blessed him for the imminent battle and left.

Meanwhile, Ravana devised a powerful defence strategy. He deployed the Rakshasa Prahasta to the east, Mahaparshva and Mahodara at the south, and his son Indrajit to the west. He sent Shuka and Sarana to the north, where he would remain as well. Virupaksha was asked to guard the centre of the fortress.

CHARACTER PROFILE
MALYAVAN

Malyavan is Ravana's maternal grandfather's brother, and it is likely that is why he is able to speak as clearly to Ravana as he does. He is also a stock character in Sanskrit plays and is employed in different, innovative ways to serve crucial functions in the plot. Usually, he is portrayed as wise and possessing great foresight.

" Seeing the **fourteen systems** of knowledge in a **bad state** because of the congestion in his four faces, **Brahma** indeed created for them **another ten faces** – yours, his own great-grandson's; how are you **foolish**!"

MALYAVAN TO RAVANA, *ANARGHA-RAGHAVA*, BY MURARI MISRA

Rama Sees **Lanka**

Rama, Hanuman, Jambavan, Vibhishana, Angada, and the other Vanara commanders had arrived at the door of their enemy and now stood before the unconquerable fortress of Lanka. Rama formed a battle plan, and placed his valorous commanders at strategic positions. They were ready to go to war.

The king of men, Rama, and the king of apes, Sugriva, along with Hanuman, Jambavan, Vibhishana, Angada, and the other Vanara commanders stood together, looking at the fortress of Lanka, invincible for all beings. As they talked, Vibhishana told them that his four companions had entered the city in the guise of birds and examined the army and its strength, and, in doing so, discovered their plans. They told Vibhishana that Prahasta was at the eastern gate, Mahaparshva and Mahodara towards the south, Indrajit at the western gate, Ravana himself stood at the northern gate, while Virupaksha guarded the centre. "There are 1,000 elephants, 10,000 chariots, 20,000 horses, and over 10 million Rakshasas, all fierce in war." He turned to lotus-eyed Rama and said,

PREPARING TO FACE THE ENEMY
In this section of the famous *Ramakien* mural at the Grand Palace in Bangkok, Thailand, Rama and his army prepare to go into battle with Ravana's army.

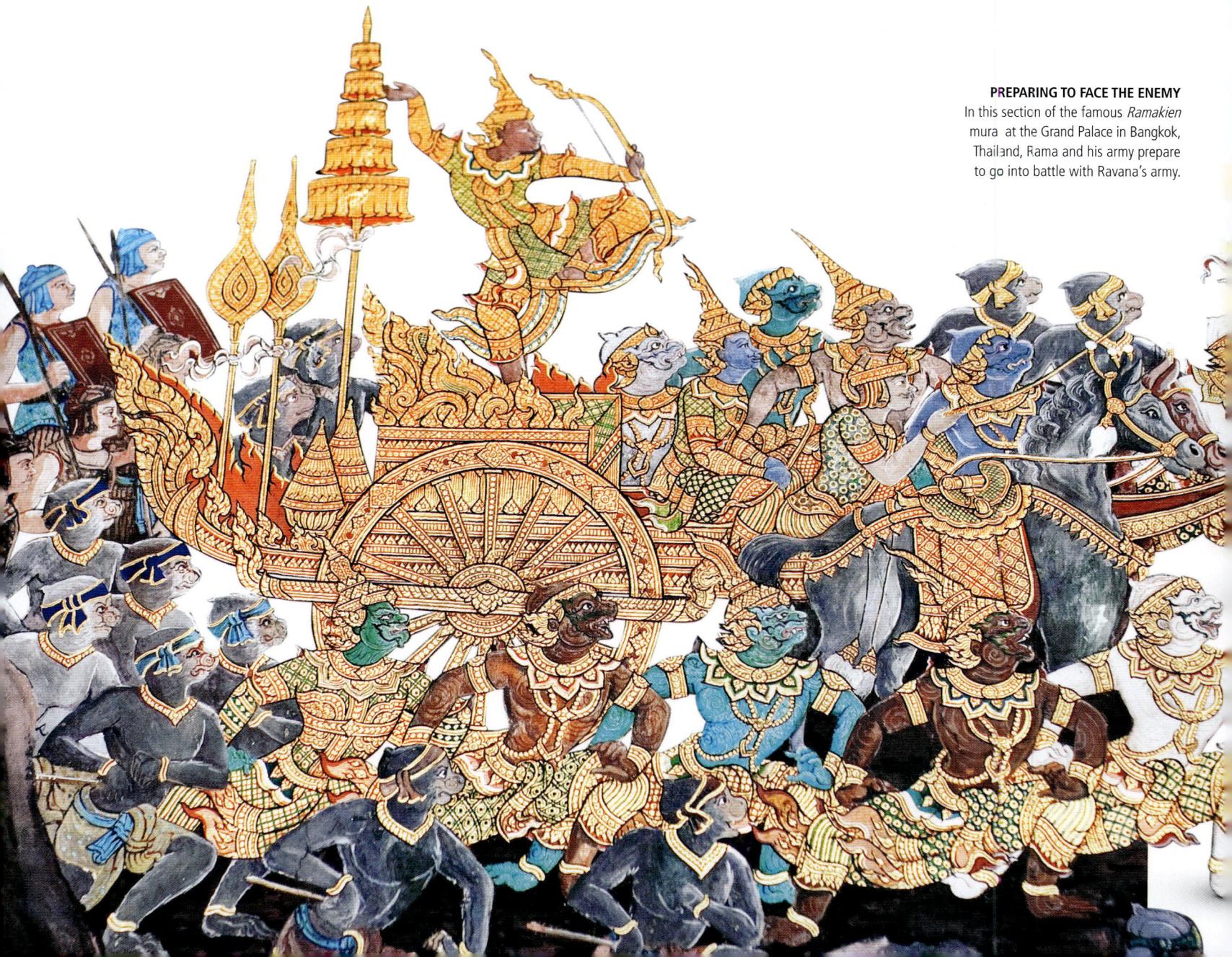

"This **sanctuary of the Indra** among the rakshasas was a **supreme ornament** for the city. **One hundred Rakshasas** always **protected** all of it. With the Vanaras, Rama… saw the **prosperous city**…"

LANKA AS SEEN BY RAMA FROM A DISTANCE, *SARGA* (30), YUDDHA KANDA

"Do not be angry. I do not tell you this to scare you. You can defeat even the gods. Once you have arranged this army of Vanaras in battle formation, you shall surely crush Ravana and his forces."

Battle plans

Rama gave the commanders instructions. "Nila, the bull among Vanaras, shall go to the eastern gate of Lanka to fight Prahasta. Angada will go to the southern gate and obstruct Mahaparshva and Mahodara's plans.

Hanuman, son of the wind, and his Vanara army will enter through the western gate, facing Indrajit. Lakshmana and I shall face Ravana be the northern gate and crush his forces.

Sugriva, Jambavan, and Vibhishana will be at the centre," he said.

"The Vanaras are not to take on human forms during the battle, so that we can recognize them," he said. "Only the seven of us – Vibhishana and his companions, Lakshmana, and I shall battle in human form."

Spying on the enemy

After finalizing the battle plans, Rama saw the beautiful slopes of Mount Suvela. He decided that it was important to scale the peak to understand his enemy's position better. He told Sugriva, Vibhishana, and Lakshmana, "We shall climb the mountain and look at Lanka from its peak. We will spend the night there and look upon the abode of that Rakshasa who has abducted my wife for his own destruction, who does not know dharma, in whom my anger grows, and because of whom we shall see the Rakshasas killed. A single man has done an evil deed, and the entire lineage shall have to pay."

Climbing Suvela

Rama climbed Suvela, the colourful mountain, with Lakshmana close behind, his bow raised and an arrow in position, ready to strike, if needed. The commanders and the rest of the army followed the two princes.

They reached the summit and saw Lanka, as if it were suspended in the air. They saw the city overflowing with Rakshasa armies, almost forming a second rampart.

The Vanaras saw their enemy and roared. The evening was red and the sun set. Night fell and the full moon rose as radiant as ever.

That night, the Vanaras roamed through the forests and groves, which were full of champaka, ashoka, and sala trees, with beautiful, blossoming creepers everywhere. Sugriva permitted some Vanaras to go into Lanka, the city that stood at the peak of the Trikuta, a mountain impossible to climb even in one's imagination.

Terrible omens

Rama looked at the night sky, turned to Lakshmana, and said, "We shall set up camp here, Lakshmana. Let us gather food and water from the groves. I see a horrible terror before us.

"See how the harsh winds blow and the earth shakes. The mountains tremble and the animals and birds make unpleasant, inauspicious sounds. Armies shall be slaughtered, Rakshasas and Vanaras alike. Look to the skies – they seem to be conveying that the end of the world is near. Let us prepare to attack."

Rama and the army descended from the mountain and looked at his army. He stood in front of them, bow in hand, and urged them to attack.

ALTERNATIVE ACCOUNT
THE NIGHT BEFORE THE BATTLE

Rama often sends warning shots into Lanka on the eve of the war. Sometimes they are targeted at Ravana, and sometimes his arrows skilfully displace Mandodari's earrings and Ravana's crown. In some versions, Sugriva and Ravana have a brief encounter on this night. Perhaps one of the sweetest conversations to take place involves Rama asking his friends what the mark on the moon could be. Hanuman is the one who speaks last, "The moon is your loving devotee, Rama, and so bears your dark form in his very heart."

The Siege of Lanka

Rama, Lakshmana, and the Vanaras were ready to attack Lanka and laid siege to the city the following morning. Ravana climbed up to the highest point in his palace to get a better view, and Rama sent Vali's son, Angada to the king of the Rakshasas bearing a message.

Rama and Lakshmana attacked the northern gate, for who other than the two brothers could have possibly faced Ravana, the 10-headed king, himself? Nila stood on the eastern gate, as commanded by Rama, with one part of the army, Angada led the charge to the south, while Hanuman stood firm to the west. At Rama's command, 10 million Vanaras laid siege to each gate. They seized trees and boulders, lashed their tails, bared their teeth, and possessed the strength of elephants. They seemed to cover the sky and envelop the earth.

Lanka, the city that even the wind found impossible to enter, was surrounded in all directions. The sudden attack stunned the Rakshasas and a great din rose. The city, its ramparts, forests, and groves began to tremble.

A message for Ravana

The battle was on the verge of breaking out when Rama called Angada, keeping the dharma of a ruler in mind.

"Son of Vali! I wish for you to see Ravana. Enter this terrible city and address him on my behalf. Tell him: 'Your glory is destroyed. You desire death and your intellect has abandoned you. I stand here because you abducted my wife. I bear the sceptre of punishment for all the crimes that you have committed against the gods, and celestial beings, such as the Gandharvas, Apsaras, Nagas, Yakshas, and Kinnaras (semi-divine species) in your deluded confidence because of the Creator, Brahma's boon to you.'"

Rama asked Angada to say, "It is time for you to show us a glimpse of the strength upon which you relied when you abducted Sita. I shall render this earth devoid of Rakshasas with my sharp arrows, unless you seek refuge with me and return Sita."

Rama reminded Ravana of Vibhishana, who lived by dharma and deserved the eternal splendour of Lanka. "You do not deserve the city because of your deeds. The other alternative before you is to battle me with all the resolve you possess, relying on your courage. Then, my arrows shall silence you and purify you in that way."

The fearless messenger

Fierce as fire itself, Angada took off into the sky to deliver Rama's message. He reached Lanka and saw Ravana with his council of advisers.

He introduced himself to Ravana and gave him Rama's message and said, "Rama has said, 'Come Ravana, and fight me. I shall slay you in

AT THE BRINK OF WAR
Titled "The Siege of Lanka", this folio from 1800 of the version of *Ramayana* from Himachal Pradesh, India, shows Rama's army entering Lanka as it prepares for battle.

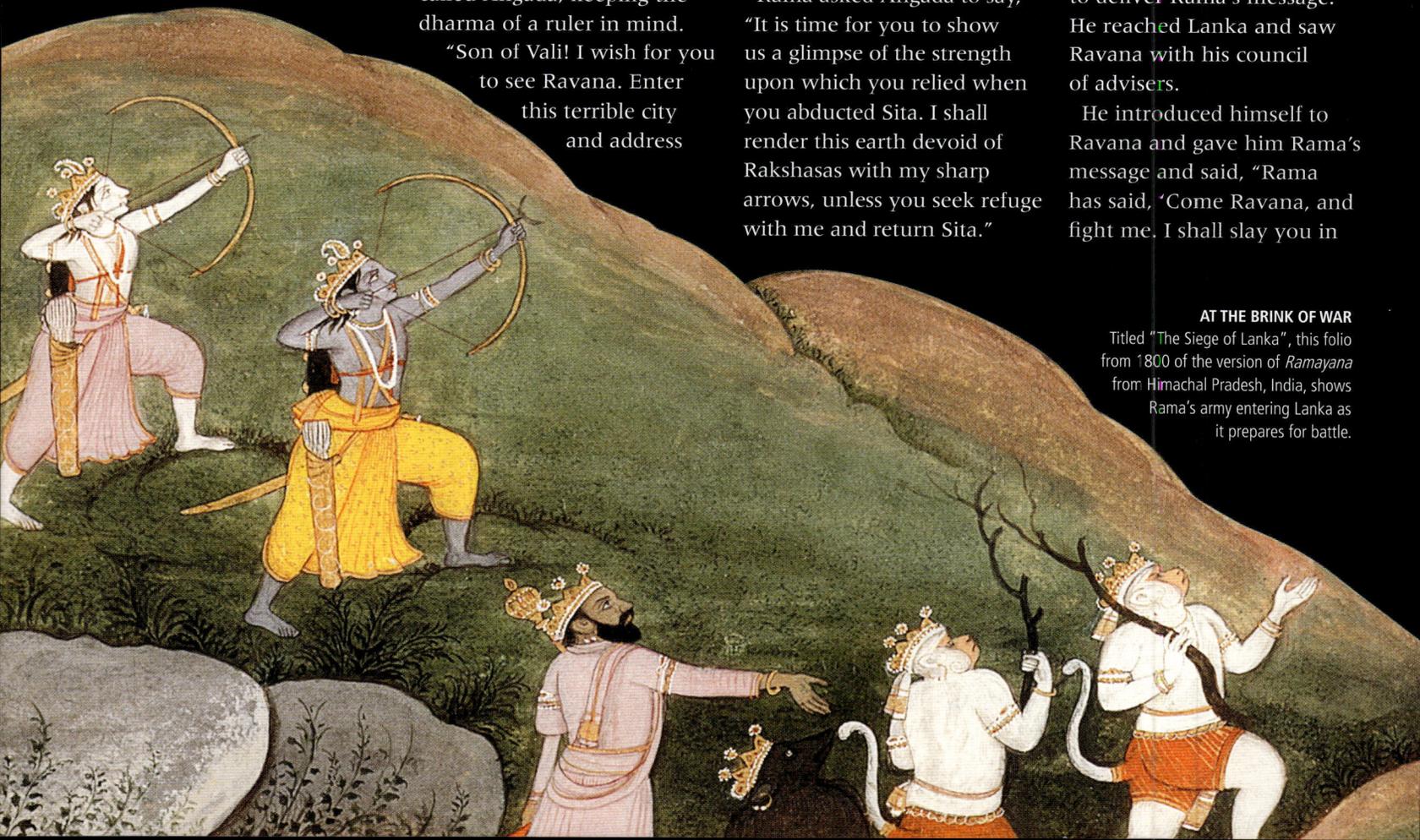

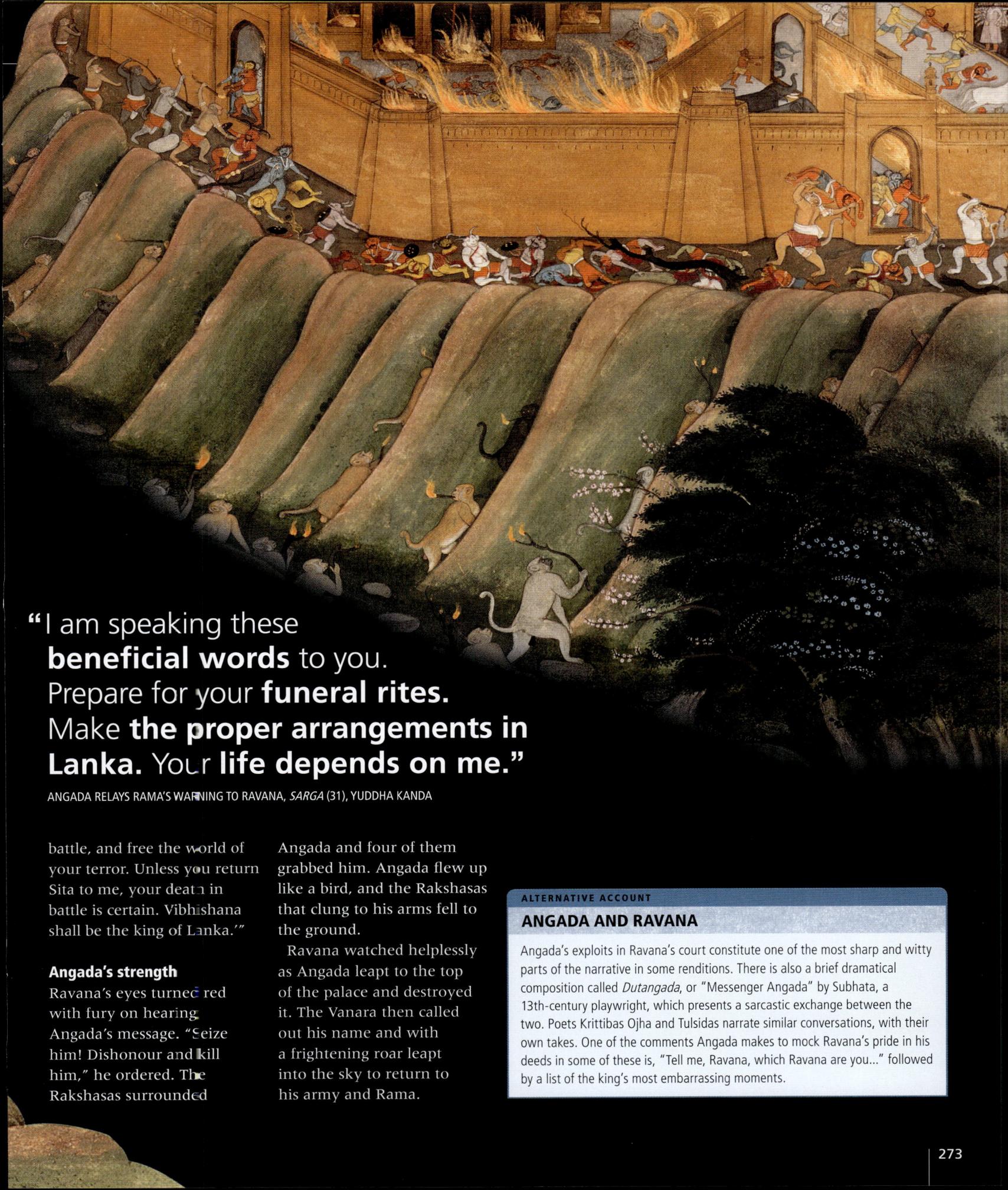

> # "I am speaking these **beneficial words** to you. Prepare for your **funeral rites.** Make **the proper arrangements in Lanka.** Your **life depends on me."**

ANGADA RELAYS RAMA'S WARNING TO RAVANA, *SARGA* (31), YUDDHA KANDA

battle, and free the world of your terror. Unless you return Sita to me, your death in battle is certain. Vibhishana shall be the king of Lanka.'"

Angada's strength

Ravana's eyes turned red with fury on hearing Angada's message. "Seize him! Dishonour and kill him," he ordered. The Rakshasas surrounded Angada and four of them grabbed him. Angada flew up like a bird, and the Rakshasas that clung to his arms fell to the ground.

Ravana watched helplessly as Angada leapt to the top of the palace and destroyed it. The Vanara then called out his name and with a frightening roar leapt into the sky to return to his army and Rama.

ALTERNATIVE ACCOUNT

ANGADA AND RAVANA

Angada's exploits in Ravana's court constitute one of the most sharp and witty parts of the narrative in some renditions. There is also a brief dramatical composition called *Dutangada*, or "Messenger Angada" by Subhata, a 13th-century playwright, which presents a sarcastic exchange between the two. Poets Krittibas Ojha and Tulsidas narrate similar conversations, with their own takes. One of the comments Angada makes to mock Ravana's pride in his deeds in some of these is, "Tell me, Ravana, which Ravana are you..." followed by a list of the king's most embarrassing moments.

The **Great War** Begins

Rama, Lakshmana, and the Vanara army laid siege to Lanka. Infuriated, Ravana sent his best warriors to fight and so began the mighty war – gruesome, bloody, and terrible. In the beginning, it seemed as if Rama's army was winning, until a mighty Rakshasa warrior emerged.

The Rakshasas informed Ravana that the Vanaras had besieged the city. An angry Ravana climbed up to the very top of his palace and looked around to see that Vanaras had surrounded Lanka on all sides. Indeed, it looked like they had swallowed the earth.

The first blow

As he thought of how best to respond to the siege, he noticed some Vanaras attempting to scale the fortress, ready to give up their life for the love of Rama.

They attacked the gates and buildings with rocks, trees, and their fists, filled the moat, and soon the commanders themselves climbed into the city with their large troops.

They flooded into Lanka as they cried out, "Victory to Rama, the mightiest! Victory to the powerful Lakshmana! The king Sugriva is victorious, protected by Rama!"

After they had scaled the ramparts, they tried to get into the city headquarters. Kumuda, with 100 million Vanaras stood at the eastern gate; Shatabali stood at the southern with 200 million;

Sushena was at the western gate with 600 million more. At the northern gate, the Vanara commanders and their armies surrounded Rama, Lakshmana, and Sugriva.

The war commences

Ravana was overcome with anger and commanded the march of his armies.

A fierce battle ensued, resembling the ancient battle between the gods and Asuras. The Rakshasas attacked with their maces, lances, spears, and axes, proclaiming their strength, and the Vanaras responded

with huge trees, rocks, their fists, and teeth. Soon, more Rakshasas emerged from the fortress on chariots that gleamed like the sun and went in 10 different directions. The Vanara army retaliated and attacked them. Ravana's son Indrajit battled Angada, as Jambumali fought Hanuman, and Sushena attacked Vidyunmali, and

IN THE BATTLEFIELD
Vanaras attack the Rakshasas with boulders as Rama, Lakshmana, and the other commanders battle Ravana's army, in this mid-17th century painting from Udaipur, Rajasthan.

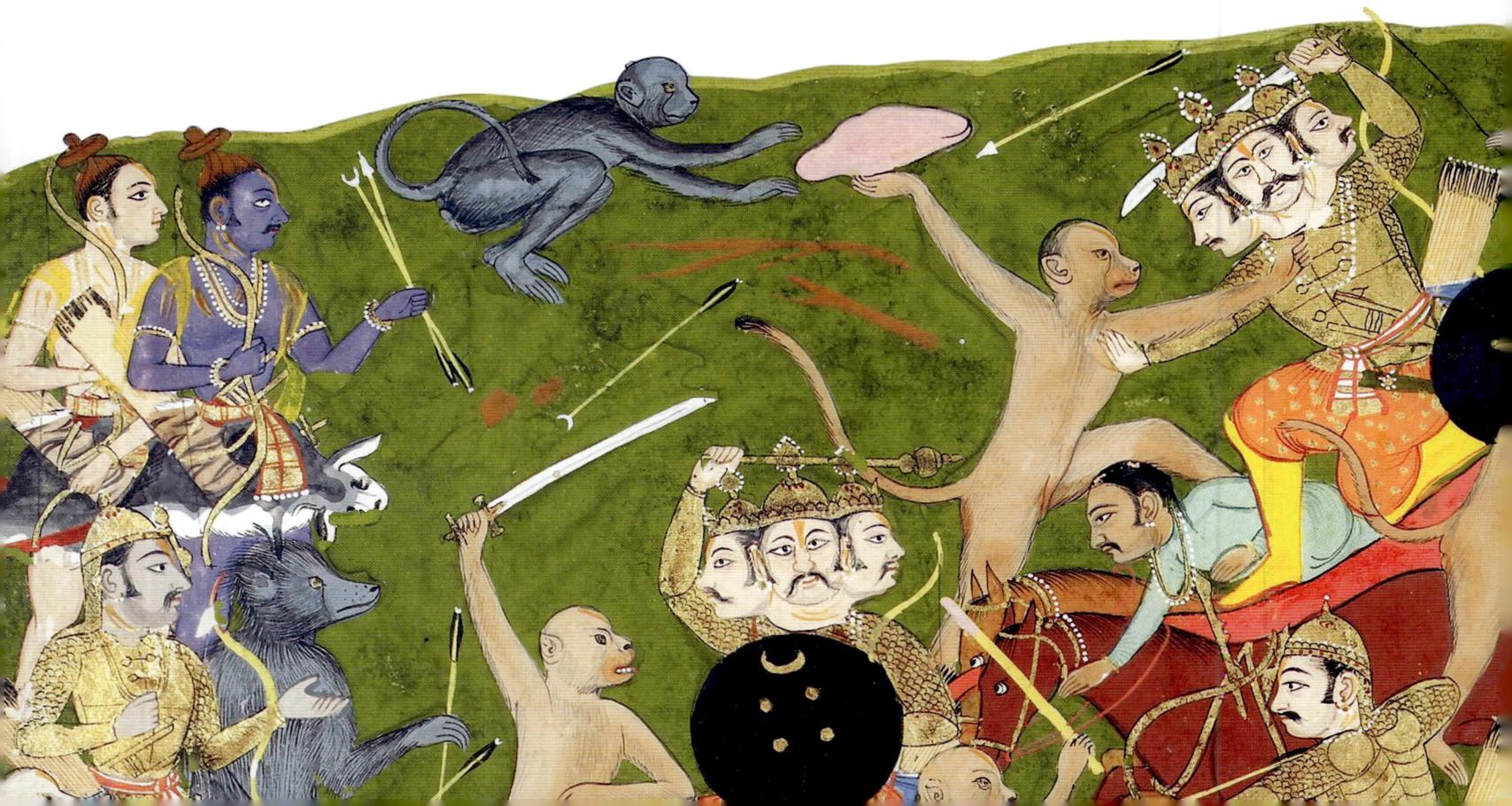

INDRAJIT'S ARROWS

Indrajit's serpentine arrows have been referred to in some texts and in popular usage as Nagapasha, or the serpentine noose. As Vishnu's mount Garuda clarifies later, these arrows are actually snakes that have been turned into arrows using illusory powers and are almost impossible to counter.

so each of them found equals to fight. Angada managed to destroy Indrajit's chariot and killed his charioteer and horses in a terrible encounter. Lakshmana killed Virupaksha with a single arrow.

The sun set, but the war did not pause, and continued long into the night. The skies were rent with the cries, "Kill!" and "Shatter!", while Rama and Lakshmana stood firm with their bows. Streams of blood drenched the ground and the fearsome sounds of battle resounded in all directions. Several Rakshasas rushed towards Rama at once, but he retaliated with a torrent of arrows, which forced them to withdraw.

An invisible adversary

Indrajit, who had been battling Angada, grew angry, turned invisible, and shot serpentine arrows at Rama and Lakshmana. Rama commanded the Vanaras to search for him, but they could not find him. The brothers stood next to each other as the invisible prince shot arrows that were in the form of serpents. The brothers' pierced bodies resembled flames of forests in bloom, as blood coursed down.

Still invisible, Indrajit declared, "Even Indra, the king of gods, cannot see me when I have disappeared in battle – what of the two of you? I shall now deliver you to death's door." He continued to shoot arrows into the two princes of Ayodhya. Rama fell first, bound by the arrows, his limbs pierced, broken, and riddled with arrowheads. Seeing him fall, Lakshmana lost the will to live and collapsed as well.

They lay there on the earth – the bed of valiant warriors – their bodies enveloped by arrows and they bled like two waterfalls with abundant water.

"Those two **brave** ones were **bound** and **lay down**, having fallen down. With Vayu's son at the **forefront**, the Vanaras... surrounded them. They were **afflicted and suffered** from great **misery**."

RAMA AND LAKSHMANA INJURED, *SARGA* (35), YUDDHA KANDA

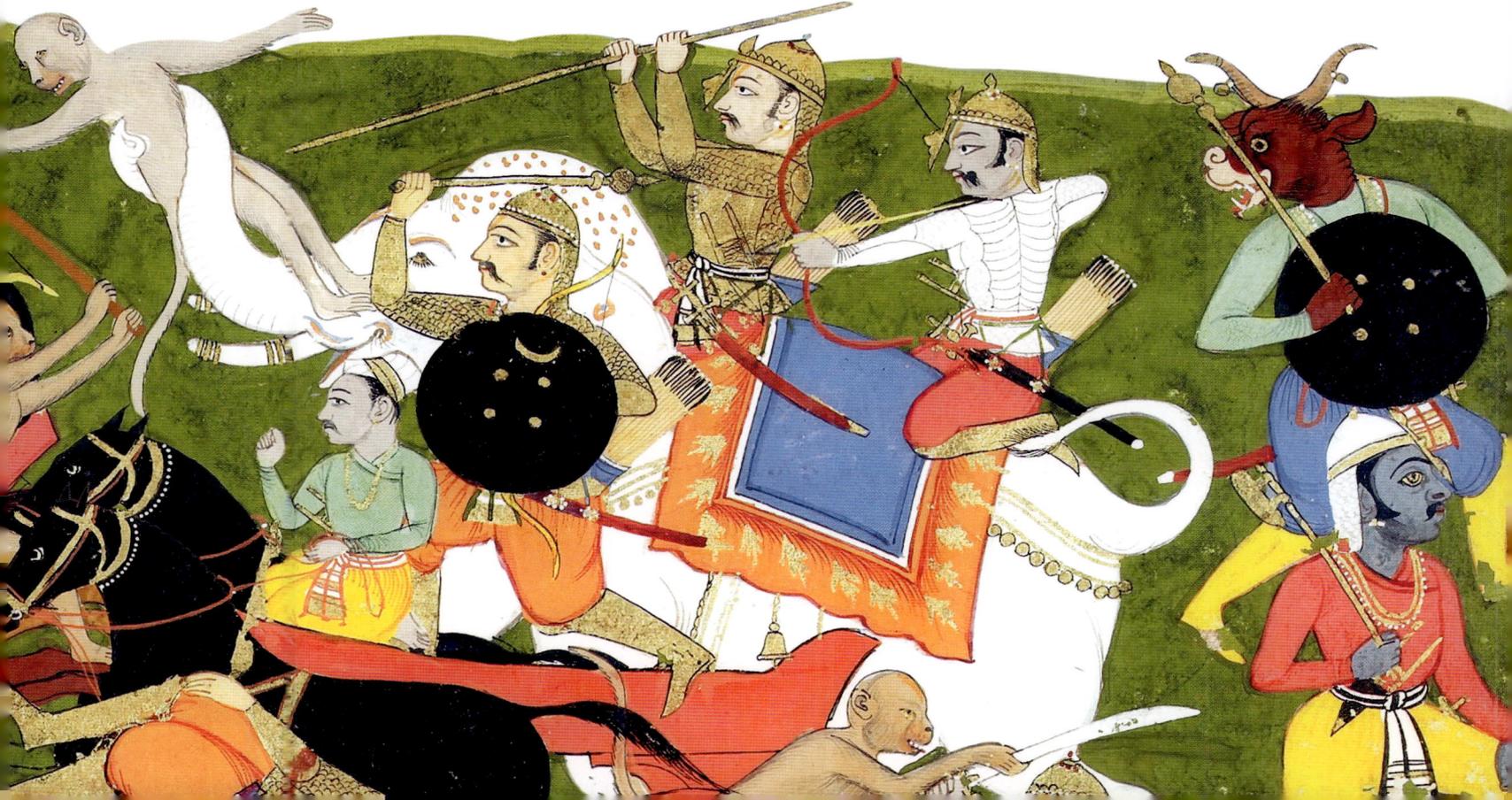

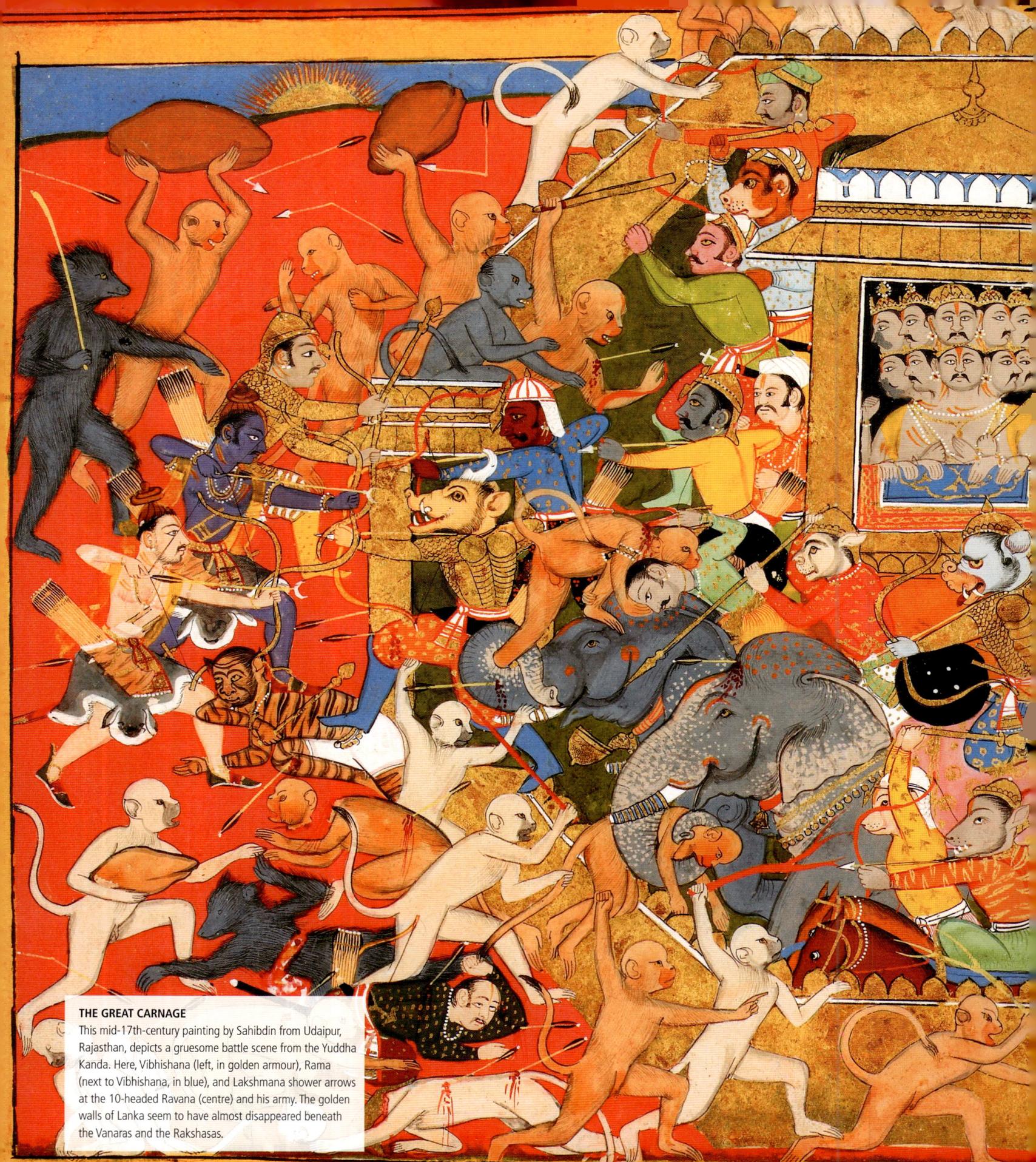

THE GREAT CARNAGE
This mid-17th-century painting by Sahibdin from Udaipur, Rajasthan, depicts a gruesome battle scene from the Yuddha Kanda. Here, Vibhishana (left, in golden armour), Rama (next to Vibhishana, in blue), and Lakshmana shower arrows at the 10-headed Ravana (centre) and his army. The golden walls of Lanka seem to have almost disappeared beneath the Vanaras and the Rakshasas.

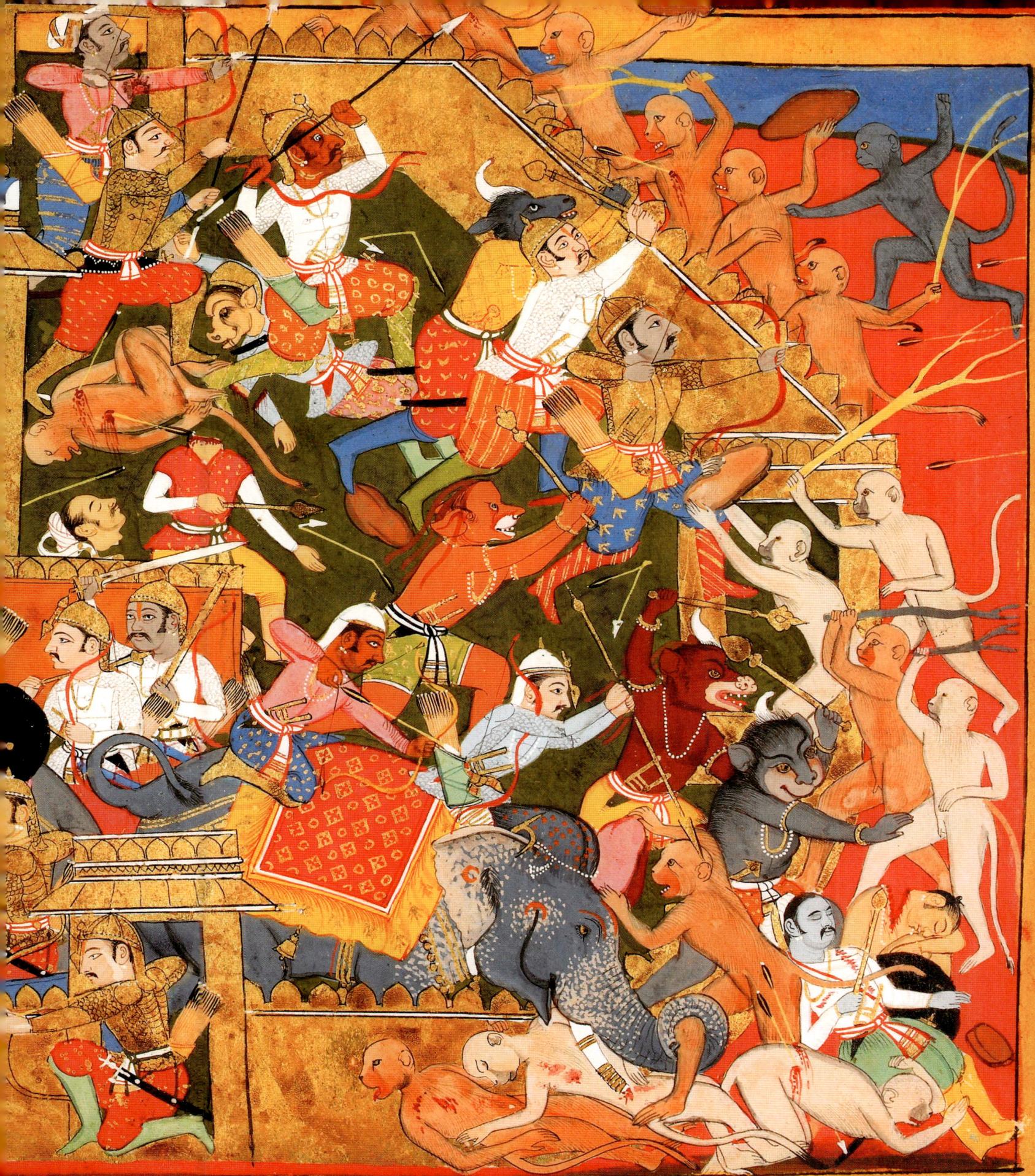

A **Short-Lived** Victory

Indrajit's infallible arrows injured Rama and Lakshmana who lay unconscious. Even as the Vanara army battled despair, Ravana celebrated his victory. He then gave a cruel order – that Sita be taken to the battlefield so that she may see the body of her dead husband.

Seeing Rama and Lakshmana grievously injured, Sugriva and Vibhishana swiftly regrouped to where they lay wounded as did Angada, Hanuman, and the rest of the army. They saw the brothers, unconscious, their breath laboured, and bodies covered in blood and grew perturbed. They searched the sky and yet, could not see Indrajit. At long last, Vibhishana used his abilities to counter Indrajit's illusory power and saw him.

Indrajit saw Rama and Lakshmana on the ground and proclaimed, to the delight of the Rakshasas, "The killers of Khara and Dushana lie dead. The gods, Asuras, and sages cannot free them of these bonds. The one who has caused my father sleepless nights, and who has agitated Lanka, has been killed. The endeavours of Rama, Lakshmana, and the Vanaras have been pointless." Indrajit left the battlefield and entered Lanka triumphant, even as the Rakshasas, who presumed that Rama was dead, honoured their prince.

No time for tears

Sugriva felt fear rise up as he saw Rama and Lakshmana lying lifeless. Vibhishana comforted him, "Do not grieve – such is war. Victory is never certain. If our fortune remains, the brothers will rise and fight again. Hold yourself, and also me, who has been orphaned."

He wet his hands with water and wiped Sugriva's eyes gently, and added, "This is not the time to lose control. Excess affection at the wrong time can prove fatal. Think of the welfare of the armies that Rama led – or guard him until his consciousness returns. When they wake, the brothers will ward off our fear." The commanders surrounded the brothers to guard them, as Vibhishana left to console the troops.

Victory in Lanka

In his palace, Ravana embraced his victorious son and asked him for the details of the battle. He then called for the Rakshasis who guarded Sita and ordered them to take her to where Rama and Lakshmana lay, on the Pushpaka Vimana.

"Tell her," said Ravana, "that the one for whose sake and on whose strength she had rejected me now lies dead. She is going to be my consort and sit by my side – for there is no other way out for her."

Ravana prepared for victory while Sita and Trijata (See box), flew over the battlefield and saw the defeated army. Sita wept piteously when she saw the brothers unconscious and wounded. She said, "The astrologers who said that I would not be widowed have been proven ignorant liars, now that Rama lies dead. Those who declared I shall be the wife of a king have been proven liars. Here are those marks on my body which suggest a woman will be consecrated with her husband, into sovereign kingship, and nowhere do I see the marks which presage widowhood – and yet, having searched for me in Janasthana and crossed over the immense ocean, the brothers have been defeated easily."

A friend in need

Trijata comforted Sita and said, "Do not grieve. Your husband lives. And I will tell you how I know that. Look carefully at the army. An army whose commander has died wanders rudderless on the battlefield. Here, they guard Rama and Lakshmana carefully, without fear and no sign of anxiety. Look upon the brothers' visages. They are unconscious, but their faces are not without radiance. I speak honestly, I have seen in their faces that they cannot be defeated, even by the gods and Asuras combined."

Sita folded her hands in prayer and said, "Let this be so." They then returned to the Ashoka grove.

CELEBRATIONS AT LANKA
When Ravana hears of the glorious victory of his son Indrajit over Rama and Lakshmana, he begins rejoicing over his triumph. Here, an artist portraying the role of Ravana, can be seen celebrating his victory.

> "Delighted, **the lord of the Rakshasas** arranged for it to be proclaimed in Lanka that **Raghava and Lakshmana had been killed** by Indrajit..."
>
> RAVANA CELEBRATES RAMA AND LAKSHMANA'S DEFEAT, *SARGA* (37), YUDDHA KANDA

The Injured Brothers

Rama regained his senses only to see his brother bleeding and unconscious, and was struck with overwhelming agony. Demoralized and exhausted, but ever so true to dharma, Rama mourned for Lakshmana, but also worried for the well-being of his devoted followers.

The sorrowful Vanaras surrounded the wounded brothers and waited. Rama regained consciousness after a while, even though he remained bound. Seeing Lakshmana, his brother, lying bloodied and unconscious, he was in even greater agony.

"What need have I for Sita or life itself, when my brother lies silent on the ground, defeated in battle? If Lakshmana has returned to the elements, I shall give up my life as well. How shall I tell Bharata and Shatrughna where I left the brother I came with? And … what shall I say to Sumitra, when she asks about her son? I would rather die than bear her reproach. Fie upon me, who have caused Lakshmana to lie dead on the ground."

A brother's grief

Rama wept, "It is you who comforts me in moments of anguish – even for comfort when bereft of you, I seek you. As you followed me into the forest, Saumitri, so shall I follow you to Death's abode. I can never remember Lakshmana addressing me unpleasantly, let alone harshly, even when filled with anger. He, who could counter Indra's own weapons, lies in this way on the ground."

Rama turned to Sugriva and told him to leave immediately as Ravana, thinking Rama was dead, would attack. "Place Angada at the head of the army, return to the other end of the ocean the same way as we came, by that very same bridge. Hanuman, Angada, you, and the other Vanaras performed such spectacular deeds in this battle for my sake. You have performed the duty of a friend, and they have acted as friends too. But there is no fighting fate. You should all go now."

Sugriva's iron will

The Vanaras wept when they heard Rama utter such bleak words. Vibhishana arrived, and wept when he saw the brothers' state. "They have been pierced with those terrible arrows and lie on the earth – the ones who are my refuge are lost," he said, "I have lost all hope of the kingdom and Ravana's wishes have been fulfilled."

Sugriva embraced Vibhishana and turned to Sushena, his father-in-law. He asked him to take Rama and Lakshmana, along with the army, back to Kishkindha and remain there till they regained their strength. "I will kill Ravana and his kin and return with Sita," he said.

A glimmer of hope

Sushena, who possessed great knowledge of mantras and herbs, however, spoke up. "There are two mountains called Chandra and Drona, where the Vanaras may find divine herbs – *vishalyakarani* and *sanjeevakarani*. Send the mighty Hanuman there, he will be able to find them."

Even as Sushena spoke, however, a mighty wind rose, agitating the waters of the ocean, shaking the mountains, uprooting trees and flinging them into the turbulent waters.

ANALYSIS

RAMA'S GRIEF FOR UNCONSCIOUS LAKSHMANA

While the exact details of the battle may vary across versions, there is usually at least one point in the battle when Rama looks upon an unconscious Lakshmana. This is one of the most poignant points in the narrative – Rama lost his kingdom, but had settled into a peaceful life with Lakshmana and Sita.

After Sita's abduction, with Lakshmana by his side, he is able to go as far as being on the same island as his beloved. However, Rama is left utterly bereft after thinking he has lost the only other companion who has been by his side for 14 years and who has often been described as his external breath. Yet, he instructs others to return to safety.

THE FALLEN BROTHER
This painting from 1775, Bilaspur, Himachal Pradesh, is of a folio from the *Ramayana*, which depicts an unconscious Lakshmana on Rama's lap.

THE MOUNTAIN HERBS

A long time ago, during a battle between the gods and Asuras, the preceptor of gods, Brihaspati, had cured the injured with certain medicines and mantras. Those divine medicines could be found in the Kshiroda sea. *Vishalyakarani* seems to refer to a herb, which helps heal arrow wounds, while the name *sanjeevakarani* suggests that the plant has reviving powers.

"I will **give up my body** here. I am not interested in remaining alive... **Lakshmana has fallen down** and is lying on a bed of arrows, **as if he has lost his life**."

RAMA GRIEVING FOR LAKSHMANA, *SARGA* (39), YUDDHA KANDA

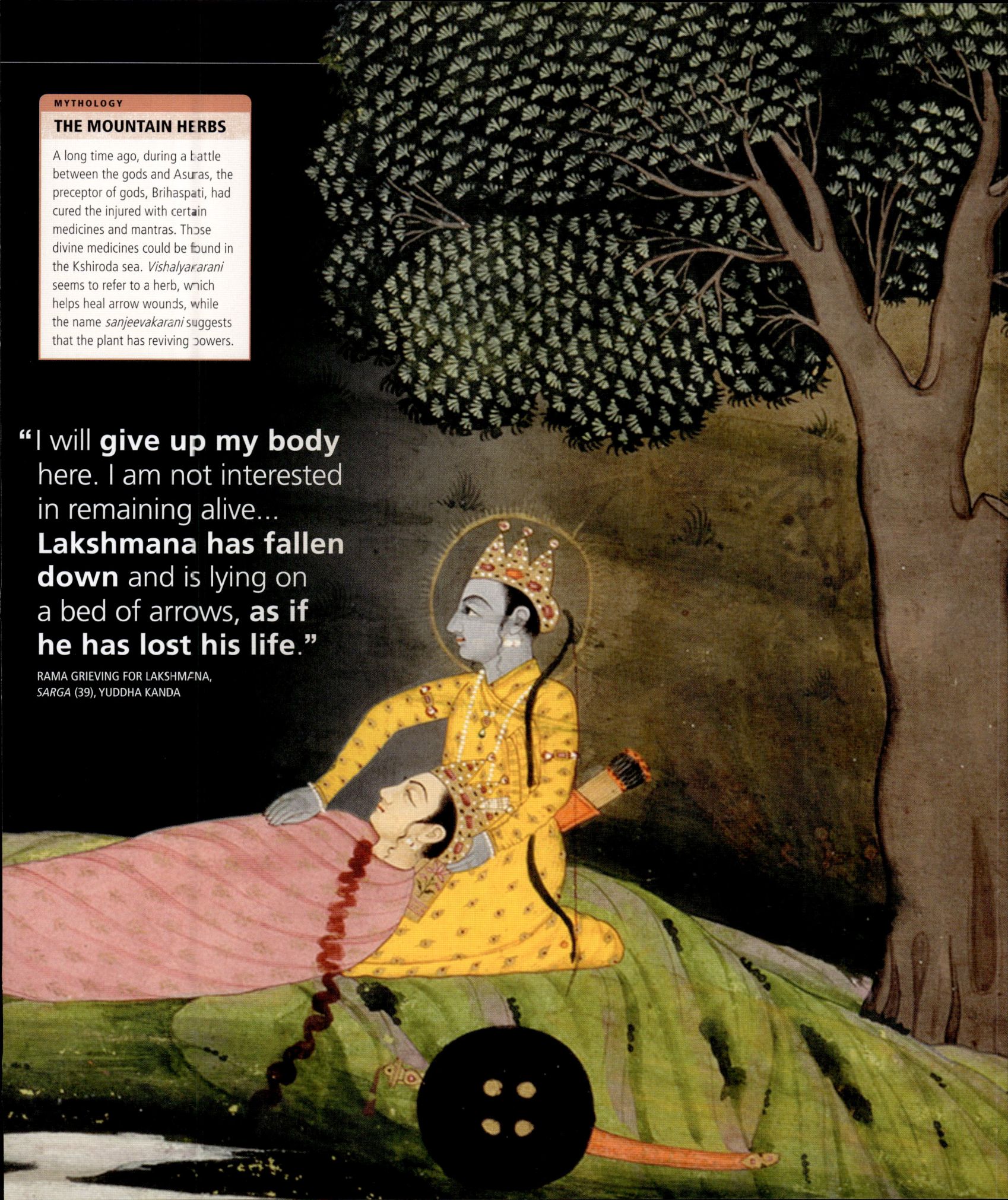

Garuda's Cure

With Lakshmana injured and unresponsive, Rama and the army were helpless and did not know what to do. Little did they know that help was on the way.

All the serpents that lived in the ocean ran for cover, terrified of the raging winds that disturbed the waves. The Vanaras looked up and saw the immensely powerful Garuda, the king of birds, arrive. Seeing the mighty eagle blazing like fire, the serpents that bound Rama and Lakshmana slithered away, freeing the brothers.

Garuda looked at the two with affection, greeted them, and touched their faces with his claws. The wounds closed and their bodies became resplendent again. Their strength returned, enhanced. Garuda helped them get up and pulled them into an embrace.

Rama said, "By your grace, the great affliction that Ravana's son caused is reversed and we have become powerful. Your presence pleases my heart as if you were my father, Dasharatha, or my grandfather, Aja. Who are you, beautiful one, clad in white and ornamented with divine jewels?"

Garuda introduced himself, his eyes unsteady in joy, "I am your beloved friend, Rama. I am Garuda, and have come here to help the two of you. No other being could have broken these terrible bonds." He warned them, "The Rakshasas' powers render serpents into arrows and their fangs are sharp and filled with poison. When I heard what had happened, I came quickly because of my affection for the two of you. Remember, the Rakshasas are inherently deceptive in battle and you ought not to trust them."

He said, "Rama, affectionate even towards enemies, you will vanquish Lanka, and return with Sita after defeating your enemy." He then flew away like the wind.

> **"Suparna,** swift in his valour, **removed the wounds** from Rama… The leaders of the Vanaras saw that the **wounds on the two Raghavas had healed."**

GARUDA (OR SUPARNA) AS HE SAVED RAMA AND LAKSHMANA, *SARGA* (40), YUDDHA KANDA

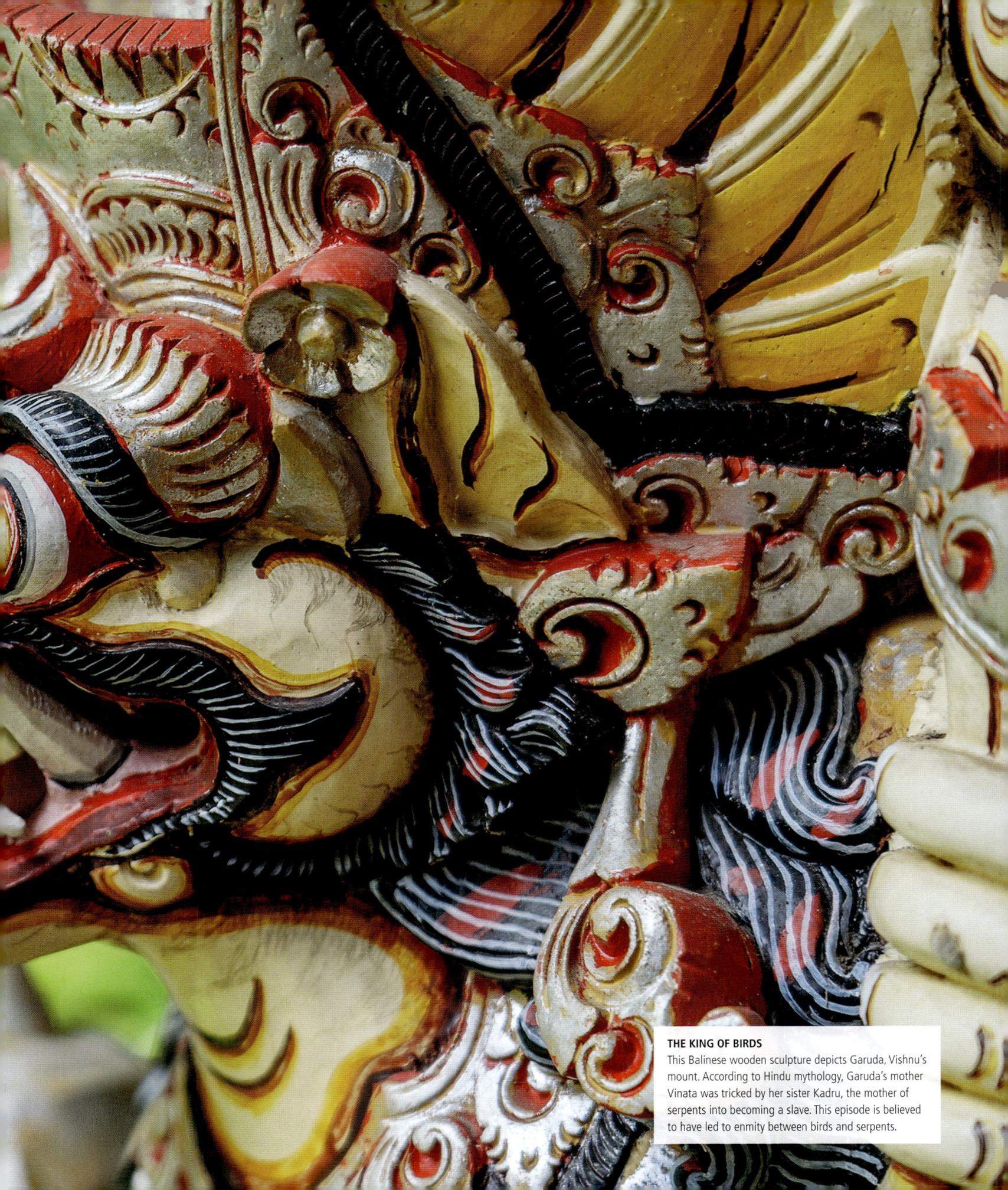

THE KING OF BIRDS
This Balinese wooden sculpture depicts Garuda, Vishnu's mount. According to Hindu mythology, Garuda's mother Vinata was tricked by her sister Kadru, the mother of serpents into becoming a slave. This episode is believed to have led to enmity between birds and serpents.

Ravana **Enters** the **Battlefield**

The Vanara army saw Rama and Lakshmana cured and cheered, their morale and faith restored. They entered the battle in earnest, ready to face the most dreaded Rakshasa commanders, and even Ravana himself.

The sounds of the Vanaras cheering reached Ravana and the king mused, "The roars of the Vanara army sound like thunder. It seems clear that they are celebrating some great joy. If the brothers are truly dead, then this does not seem apt." At his command, a Rakshasa climbed atop the rampart and saw the triumphant Vanaras alongside Sugriva, and Rama and Lakshmana freed from the effects of Indrajit's divine weapons. Ravana grew concerned when he heard the news. The effects of Indrajit's terrible arrows were unfailing,

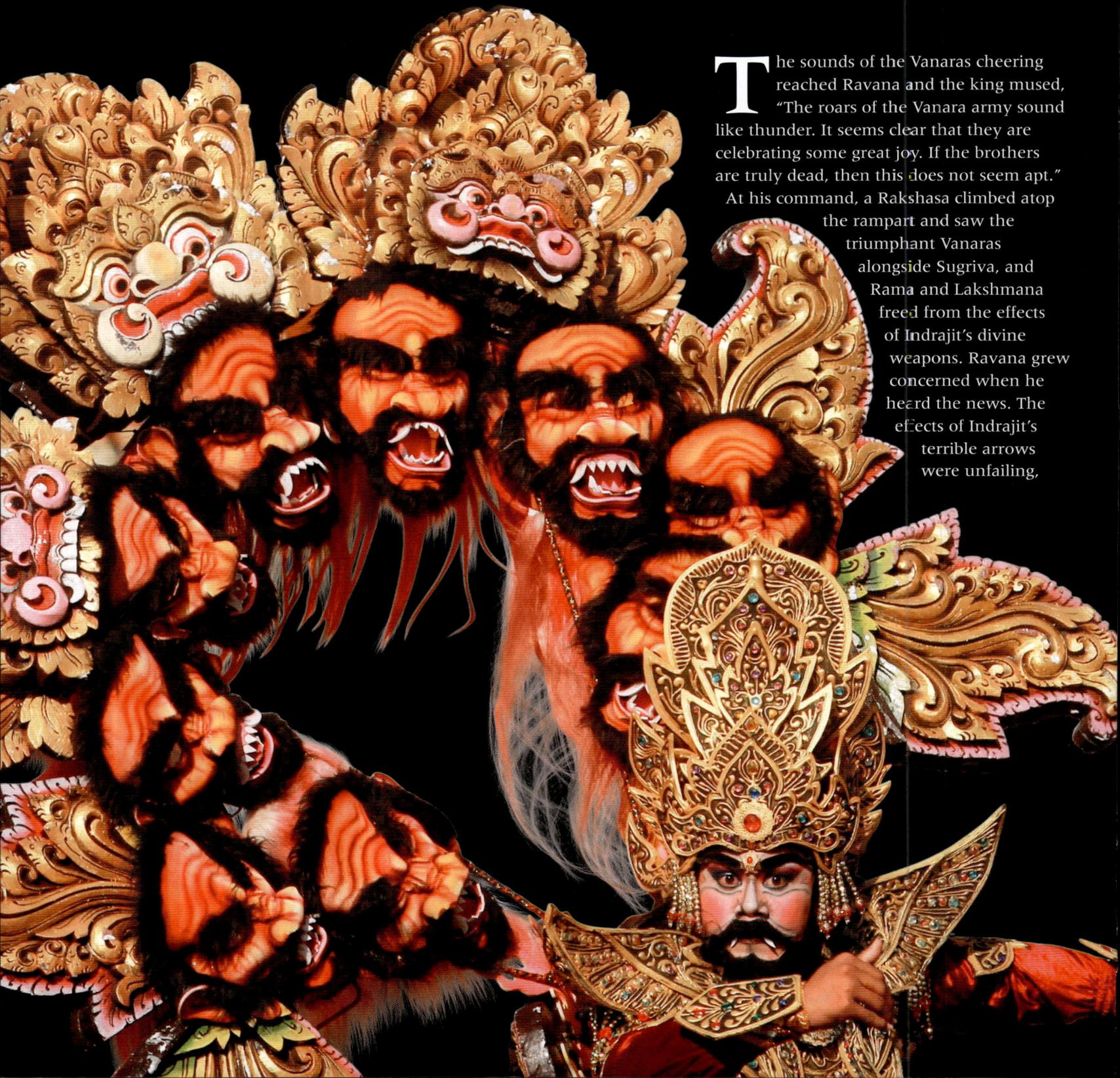

> "...It is evident that **you are exhausted**. In this state, I will not **use my arrows** to convey you to the **land of the dead**."

RAMA TO RAVANA, *SARGA* (47), YUDDHA KANDA

but his enemies were free and this would cast doubts over his entire army's competence.

Hanuman's triumph
Enraged, he commanded Dhumraksha to kill Rama. Terrible omens followed the Rakshasa warrior as he left for the western gate, where Hanuman stood. Blood showered from the sky, the ground shook, and the wind blew unfavourably. Yet, the Rakshasa army fought with renewed energy for Dhumraksha was with them. When a charge of Vanaras beat them back, Dhumraksha jumped into the fray, and chased them away with a shower of arrows. Dhumraksha met his match when he faced Hanuman who killed him in a duel.

The vicious Rakshasa general Akampana entered the battlefield and soon, bodies carpeted the earth, which was drenched in blood. The Vanara generals, Kumuda, Nala, and Mainda fought

Akampana, but he was stronger than all of them. Finally, Hanuman intervened and killed Akampana.

The king of the Rakshasas
After Hanuman made quick work of the Rakshasa general Prahasta, Ravana decided it was time to enter the battle. He set out on a chariot with mighty horses, to the sound of drums. Seeing him, Rama asked Vibhishana, "Whose army comes now, fearless and steady?" Vibhishana identified the commanders and said, "The crowned one, immense as the Vindhyas, is Ravana, blazing like the sun." Rama exclaimed in admiration, "Ah! The lord of Rakshasas is radiant! I know of no other being that possesses such brilliance."

A vicious onslaught
Sugriva faced the mighty king first, but soon fell to a powerful arrow. Lakshmana stopped Rama from entering the battle and stepped forward instead. Meanwhile, Hanuman approached Ravana's chariot and struck the king with an open palm. Ravana whirled like the earth during an earthquake, much to the delight of the sages and gods who watched the battle. The 10-headed king praised Hanuman's

RAVANA AT WAR
A participant in the Wonderful Archipelago Carnival Indonesia, is dressed as Ravana. He dons an elaborate headgear of 10 heads, in a fashion parade in Java, Indonesia.

ANALYSIS
LAKSHMANA'S REMEMBRANCE
This episode is one of the few in the *Ramayana* where the divinity of Rama and his brothers is explicated, particularly as something which Lakshmana himself remembers. The relationship between Lakshmana recalling his true nature and Ravana not being able to lift his body has been explained in different ways. Lakshmana is regarded as an incarnation of Shesha, the divine serpent on whom Vishnu, the Preserver of the universe, sleeps and who lifts the worlds on its heads, and it is said that Ravana is unable to lift him for that reason.

It is unclear whether the remembrance is meant to remind the reader that Lakshmana is Vishnu's aspect, thus making sense of Ravana's inability to lift him, or if the remembrance causes him to somehow become heavier than his human frame allows.

strength, but the Vanara replied with disdain, "Fie upon my strength, for you still live!" Ravana struck back with equal power and left Hanuman disoriented. Nila joined the fight too and took on a tiny form. He leapt onto Ravana's chariot, and attacked the king until he was shot as well.

Clash of the titans
Lakshmana approached Ravana and challenged him, and they exchanged arrows. Some found their mark and pierced Lakshmana. Once, he briefly lost grip of his bow, but swiftly regained his strength and broke Ravana's bow with an arrow.

The king then hurled a blazing javelin at him. The prince tried to deflect them with arrows, yet, it struck him in the chest, and he fell.

It was then that remembered that he was a quarter of Vishnu and could not be harmed. It was why Ravana, who could lift Mount Kailasa, could not pick up Lakshmana. Hanuman, however, saw Lakshmana injured, grew

angry and attacked Ravana. He struck him with his fist, like lightning and the king of Lanka trembled and fell to his knees. Hanuman then lifted Lakshmana in his arms – his affection and devotion helping him – and took him to Rama.

Rama's grace
Once Lakshmana recovered, Rama decided to enter the battle. Seeing this, Hanuman said, "Ride into battle on my back and fight Ravana." And so, Rama rode into battle on Hanuman's back. Seeing Ravana, he said, "There is nowhere you can go to save yourself." In retaliation, Ravana shot and injured Hanuman. Rama grew angry and destroyed Ravana's chariot and charioteer before turning his bow on Ravana. The mighty king of the Rakshasas, who did not so much as flinch at Indra's blows, trembled and dropped his bow. Rama shattered his crown and said, "You have fought bravely, but are exhausted. I shall not kill you at this moment." Left alive, the Rakshasa king retreated ignominiously into Lanka.

Arise, **Kumbhakarna!**

Ravana could not bear the ignominy of his defeat at the hands of Rama. He turned to the one person who, he thought, would be able to win him the battle. It was time to summon the mighty Kumbhakarna, but he lay fast asleep, and it seemed nothing could wake him up.

AN 18TH-CENTURY painting of Brahma, the Creator of the universe

Anger, shame, and concern assaulted Ravana as he entered Lanka, his pride shattered. The memory of Rama's arrows tormented him. He told the gathered Rakshasas, "The penance I performed has come to naught, for a mere man has defeated me. The words of the Creator, Brahma's ring in my ears that I face mortal danger from humans for I sought invincibility from the gods, Asuras, Gandharvas, but not humans."

It was time to awaken his younger brother, the dreaded Kumbhakarna. "He sleeps for months, but what use is that valorous warrior, if he cannot rise to this occasion?" Ravana said as he gave the order to wake him up.

The sleeping Rakshasa

The Rakshasas went to where Kumbhakarna slept, bearing items of luxury, food, and drink. They entered his cave, inlaid with gold, and beheld the lion among Rakshasas, asleep, terrible to look at, and as immense as a mountain. They arranged large amounts of food and pots overflowing with blood and other intoxicating drinks around him. They spread sandalwood and pleasant substances on his body, blew conch shells, and played the drums. The noise was enough to shake Lanka, and bring down the birds flying in the sky, but Kumbhakarna slept on.

They prodded him with maces and clubs, and punched him with their fists. They pulled his hair and bit his ears, and brought horses and asses to walk all over him, but Kumbhakarna continued to sleep, his breath like a gale. Finally, they brought 1,000 elephants that trampled all over him, and then, Kumbhakarna woke up. He yawned and realized that he was hungry and consumed the food and drink laid out for him.

AWAKING THE GIANT RAKSHASA
This giant statue of Kumbhakarna deep in slumber, even as the Rakshasas attempt to awake him, is located at the Kumbhakarna Gardens in the town of Penukonda in Andhra Pradesh.

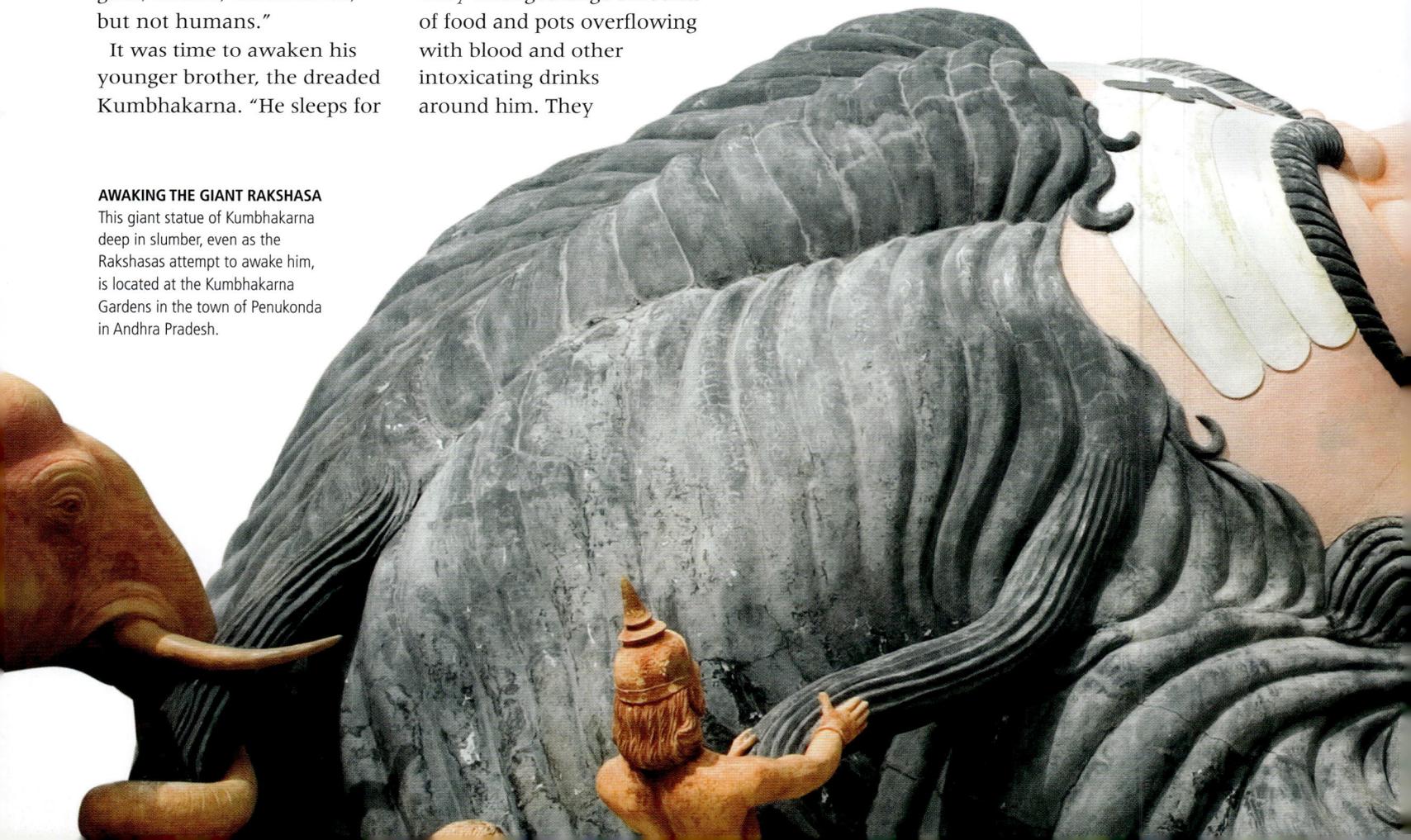

Request for help

"Why have you woken me?" Kumbhakarna asked the Rakshasas who stood with their heads lowered. "Is everything well with the king? He would not wake me up unless something calamitous had happened."

Yupaksha, a minister, folded his hands and said, "We do not fear the gods or Asuras the way we do this human called Rama. Vanaras have crossed the ocean and besieged Lanka, and we are in mortal fear of Rama, who is angered by his wife Sita's abduction. A single Vanara destroyed the city and killed the prince Aksha. Rama defeated Ravana in battle and then graciously allowed the king to leave."

Meeting the king

Hearing this, Kumbhakarna said, "I shall meet Ravana only after destroying the opponent army along with Rama." The commander Mahodara, however, insisted that he speak to Ravana first. So, Kumbhakarna made his way to meet his brother.

Rama, standing in the battlefield, saw Kumbhakarna walk towards Ravana's palace and asked Vibhishana, "Who is this immense being, who looks like a lightning-bearing cloud? Is he a Rakshasa or an Asura? I haven't seen anything like him before."

Vibhishana replied, "He is the one who has defeated the gods, Asuras, Nagas, Gandharvas, Vidyadharas, and humans alike. He is Kumbhakarna, the invincible. He is inherently brilliant, unlike other Rakshasas who

ANALYSIS

KUMBHAKARNA'S DESIRE

Kumbhakarna plans to win the war for Ravana, while disagreeing with his policy (See p 289). However, sometimes, instead of exclaiming that he would kill Rama, he says "I shall render my eyes worthy. I will see the one who removes physical, supernatural, and spiritual torments."

received their powers as boons." So Rama told the armies to prepare for Kumbhakarna's arrival.

When Kumbhakarna reached the palace, Ravana greeted him with great affection. A discussion on policy and righteousness, followed until, finally, Kumbhakarna agreed to go to war for Ravana, and defeat Rama.

> "**Thousands of elephants** were made to run around all over his body. At this touch, **Kumbhakarna awoke** from **his deep slumber**."
>
> THE RAKSHASAS' ATTEMPT TO AWAKEN KUMBHAKARNA, *SARGA* (48), YUDDHA KANDA

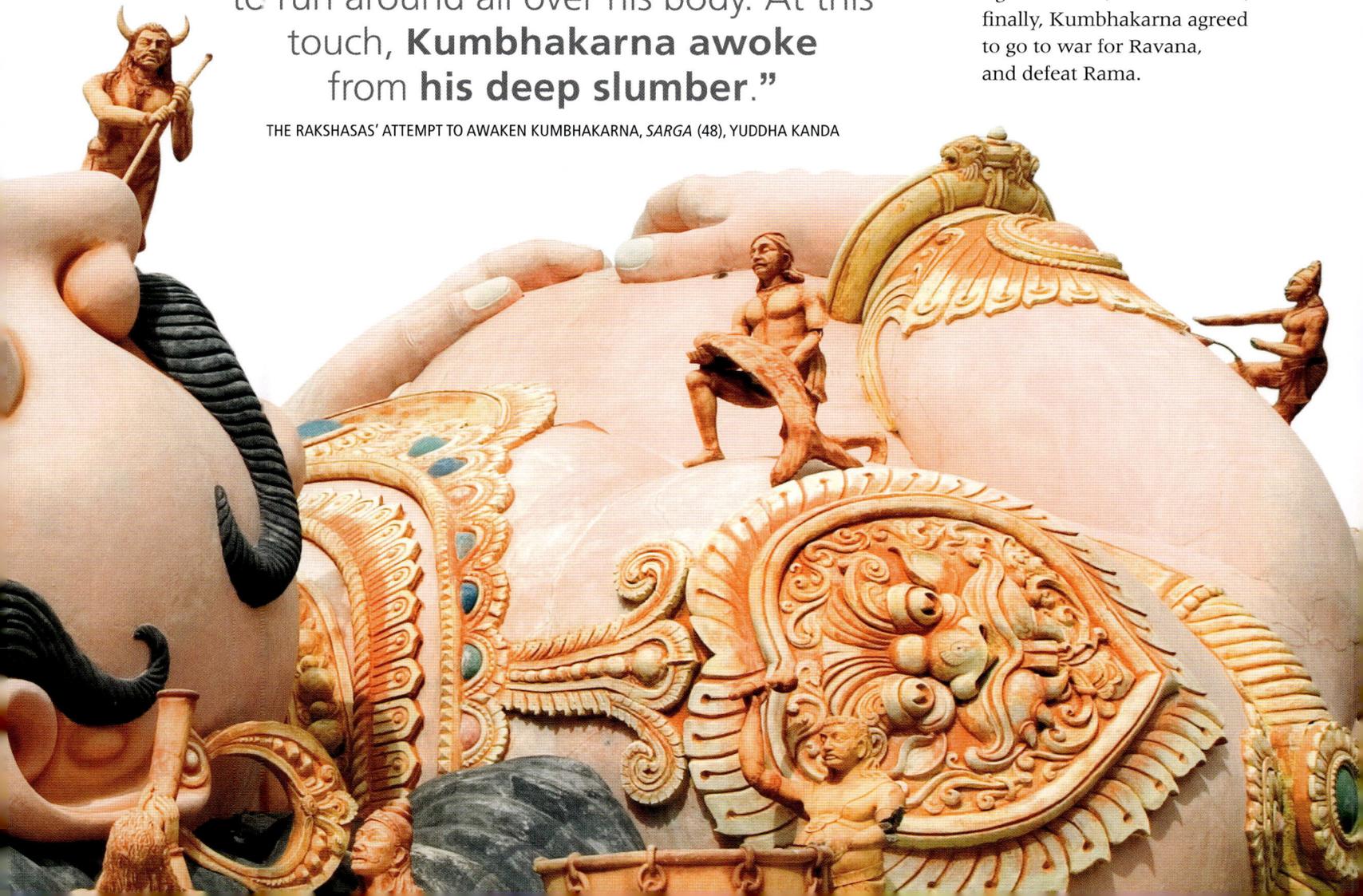

THE GIANT RAKSHASA

Kumbhakarna

> " ... Kumbhakarna is **naturally energetic**. The other Indras among rakshasas **obtain their strength because of boons**. "

VIBHISHANA TO RAMA, *SARGA* (49), YUDDHA KANDA

KUMBHAKARNA AND VIBHISHANA

In some narratives, including Kamba's and Tulsidas's renditions, Kumbhakarna and Vibhishana meet right before the former enters the battle. In Kamba's version, Vibhishana encourages him to join Rama, whereas in Tulsidas's version, Vibhishana simply presents his case for having defected to Rama's side. Kumbhakarna exalts him for his devotion to Rama, but elects to follow, instead, the dharma that tied him to his kin.

Kumbhakarna is something of a paradox even in Valmiki's *Ramayana*. As Ravana's brother who fights alongside him – unlike Vibhishana – it seems logical to paint him in a mostly negative light. Indeed, before the gods contrive to have him cursed, he comes across as Ravana's brother much more than Vibhishana's. That is precisely why Brahma "blesses" him so that he sleeps for extended periods.

This happens because he consumes beings at such a rate and gives the gods so much trouble that they intervene just as Brahma is about to grant him a boon. This ensures that rather than augmenting his power, the boon renders him out of commission.

When narratives relate stories of Ravana's previous births because of which he had to be reborn as a Rakshasa, Kumbhakarna is usually by his side. He is a mighty warrior, and Ravana feels his absence, because of his skill and strength, and also because he was beloved.

A matter of strength

It is also remarkable, as Vibhishana points out, that unlike the other Rakshasas, Kumbhakarna's strengths are inherent, and not gained as a result of divine blessings. His strength is such that while he wreaked havoc on all existence, all beings sought refuge with Indra, the king of gods. The god wielded his special weapon, the Vajra, and struck Kumbhakarna, who was shaken, certainly, but simply roared.

In the section of Kumbhakarna's "blessing" of sleep, Brahma summons him and declares that he will sleep as if dead. Ravana, invokes his relationship with Brahma and begs for clemency. So, Brahma allows Kumbhakarna to wake up once every six months.

Words of wisdom

When Kumbhakarna actually speaks, he sounds a lot more like Vibhishana than either Ravana or Indrajit. He is willing to at least try and advise Ravana in ways that might be disagreeable to him.

He points out the faults in Ravana's policy and clearly says that what has come about is the result of Ravana's own actions. He reminds his brother of the prerogatives of kingship, the kind of circumspection that is required in matters of policy, and the pursuit of dharma, *artha* (meaning or purpose), and *kama* (pursuit of pleasure or desire) at the appropriate times – with dharma trumping the others in cases of conflict.

More scrupulous than either Ravana or Indrajit, Kumbhakarna harshly rebukes the Rakshasa Mahodara, who proposes that they either defeat Rama or only pretend

APPEASING THE GIANT
In this painting from 1652, Rajasthan, India, by miniature painter Sahibdin, Kumbhakarna devours whole buffaloes as Ravana's attendants present him with plates and pots full of food and drink.

to, before telling Sita what has happened and compelling her to accept Ravana.

Internal conflict

We find Kumbhakarna faced with a dilemma typical of the *Ramayana*. Before him is the duty towards his brother and king, on the one hand, and a more abstract righteousness on the other. Kumbhakarna makes a choice very different from Vibhishana's. Vibhishana chooses to renounce Ravana, whereas Kumbhakarna, despite disagreeing with Ravana, keeps to his duty as his brother and lieutenant.

The *Ramayana* and the broader tradition have viewed both decisions with respect, although Kumbhakarna's earlier actions hardly allow him to be rendered a figure of admiration.

Different interpretations

Kumbhakarna's actions are naturally narrated with some variations. In the medieval Tamil poet, Kamba's version, Kumbhakarna has two conversations. One is before the battle has begun, where he raises the specific question of whether it was right to covet, abduct, and imprison Sita. However, he argues that it would be improper to return Sita at that juncture because it would smack of cowardice.

When he is woken up for the war and the war has turns truly fierce, he advises Ravana that Rama would forgive him if he were to return Sita and encourages him to mend his relationship with Vibhishana. He also refrains from proclaiming that he would return victorious, but rather that he would defeat all warriors, except Rama and Lakshmana.

In Bengali poet Krittibas Ojha's *Ramayana*, he expresses astonishment at the fact that, despite Rama's superhuman deeds, nobody has figured out that he isn't a mere man. In some versions, there is also a reference to a conversation with Narada, because of which he knows of Rama's divinity. In a certain sense, the nobility of Kumbhakarna's decision to fight despite not agreeing with Ravana is augmented in devotional perspectives, because he knows that he is going towards certain death.

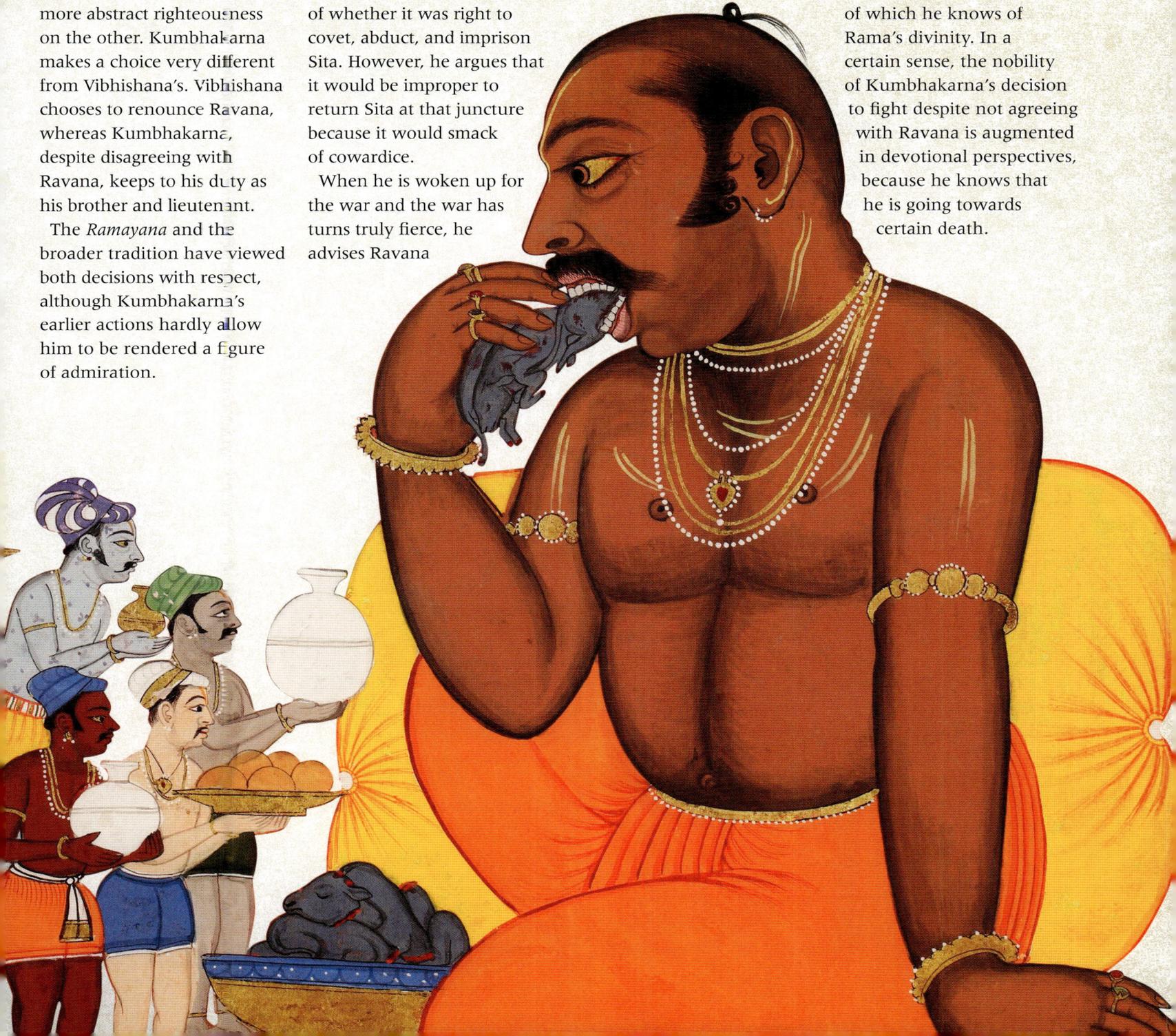

The Fall of the Giant

The fierce Kumbhakarna entered the battlefield and unleashed unthinkable carnage on the Vanara army. He fought off Nila and Sugriva, and brushed away trees, boulders, and even arrows that were flung at him. No one was a match for him, except Rama.

Kumbhakarna wanted to go alone, but Ravana insisted that he take an army with him into the battlefield, and then honoured him with ornaments. As he wore his armour, Kumbhakarna resembled a mountain covered with clouds reddened by the sunset. He embraced and circumambulated Ravana who blessed him.

Unleashing brute force

Loud and strong Rakshasas followed Kumbhakarna into the battlefield. He contemplated, as he walked, "Today, I shall destroy these Vanaras like a fire burns up moths – although, what is their offence? Rama and Lakshmana are at the root of this. If Rama is killed, the problem will be solved. He shall die today by my hands."

The Rakshasas roared in delight as he strode to the battlefield, but evil omens presented themselves. He disregarded them, as if impelled by death, and pressed on.

The Vanara armies fled when they saw him. Angada saw the army run, chastised them and turned them back to the battlefield with great effort. They eventually fought valiantly.

Kumbhakarna unleashed unimaginable destruction and while some warriors fell dead, others were simply eaten.

Fall of a leader

Hanuman showered rocks and trees on Kumbhakarna's head, but he broke them with his spear. Nila hurled the peak of a mountain at him, which he smashed with his fist. Five Vanaras attacked him together, but they were defeated. Others climbed on him, but he flicked them away angrily. He ravaged the armies, as if he were a fire in a dry forest.

Sugriva then challenged and goaded him into a duel. A clash of titans followed, but eventually, Kumbhakarna struck Sugriva with a powerful blow and rendered him unconscious. Kumbhakarna picked him up and thought,

> **"Surrounded by Rakshasas**, he was **angrily searching for Vanaras**… **Blood flowed** from his mouth and **he was like a cloud** that had arisen **during the monsoon."**
>
> KUMBHAKARNA IN THE BATTLEFIELD, *SARGA* (55), YUDDHA KANDA

"If I kill Sugriva, I can defeat the Vanaras and Rama easily."

Hanuman saw this and wanted to help Sugriva, but realized that the Vanara king would free himself as soon as he regained consciousness.

In that moment, Sugriva came to and attacked Kumbhakarna. He used his nails and teeth to rip out the Rakshasa's ears and nose. As blood coursed down his face, Kumbhakarna resembled a mountain with waterfalls. He flung Sugriva to the ground and tried to crush him, but the Vanara leapt into the sky and returned to Rama.

An enraged giant

Kumbhakarna returned to the battlefield and attacked with twice the fury, as he grabbed and swallowed several Vanaras at once. They rushed to Rama for protection, even as Lakshmana shot Kumbhakarna with several arrows.

KUMBHAKARNA SLAIN
Rama severs Kumbhakarna's head after cutting his arms and legs in this painting from 1850, Himachal Pradesh, titled "The demon Kumbhakarna killed".

BRAHMA'S CURSE

Several versions discuss Kumbhakarna's sleeping curse. One oral narrative tells of Indra, the king of gods, who requests Sarasvati, the goddess of knowledge, for her help. She confuses Kumbhakarna who ends up asking Brahma, the Creator, for *nindraasana* (a bed to sleep in) and not *Indraasana* (Indra's throne).

The giant ignored the arrows and Rama's divine weapons had no impact either. Instead, he ran about eating Vanaras and Rakshasas alike. Lakshmana told Rama, "He is destroying both armies. Let the Vanaras climb on him. He may fall then." The Vanaras tried to clamber onto him, but were thrown off. Rama then pulled at the string of his bow.

The confrontation

The twang enraged Kumbhakarna who said, "Do not think I am Viradha, Kabandha, Khara, Maricha, or Vali. I am Kumbhakarna. I defeated the gods and Asuras with this club. Do not think me weak because of my nose and ears, for that barely affected me. Come, show me your valour, but be quick about it so I may eat you afterwards."

Rama shot him with arrows, which did not affect him. Kumbhakarna, instead, raised his club, so Rama quickly cut off that arm, which fell and killed the warriors standing underneath. The giant uprooted a tree with his other arm and attacked Rama, who cut that arm off as well. When that did not stop him either, Rama, cut off his legs as well.

The final blow came with Rama's arrow, which was like the staff of Yama, the god of death, and severed the giant's head. Kumbhakarna toppled over and his body sank deep into the ocean.

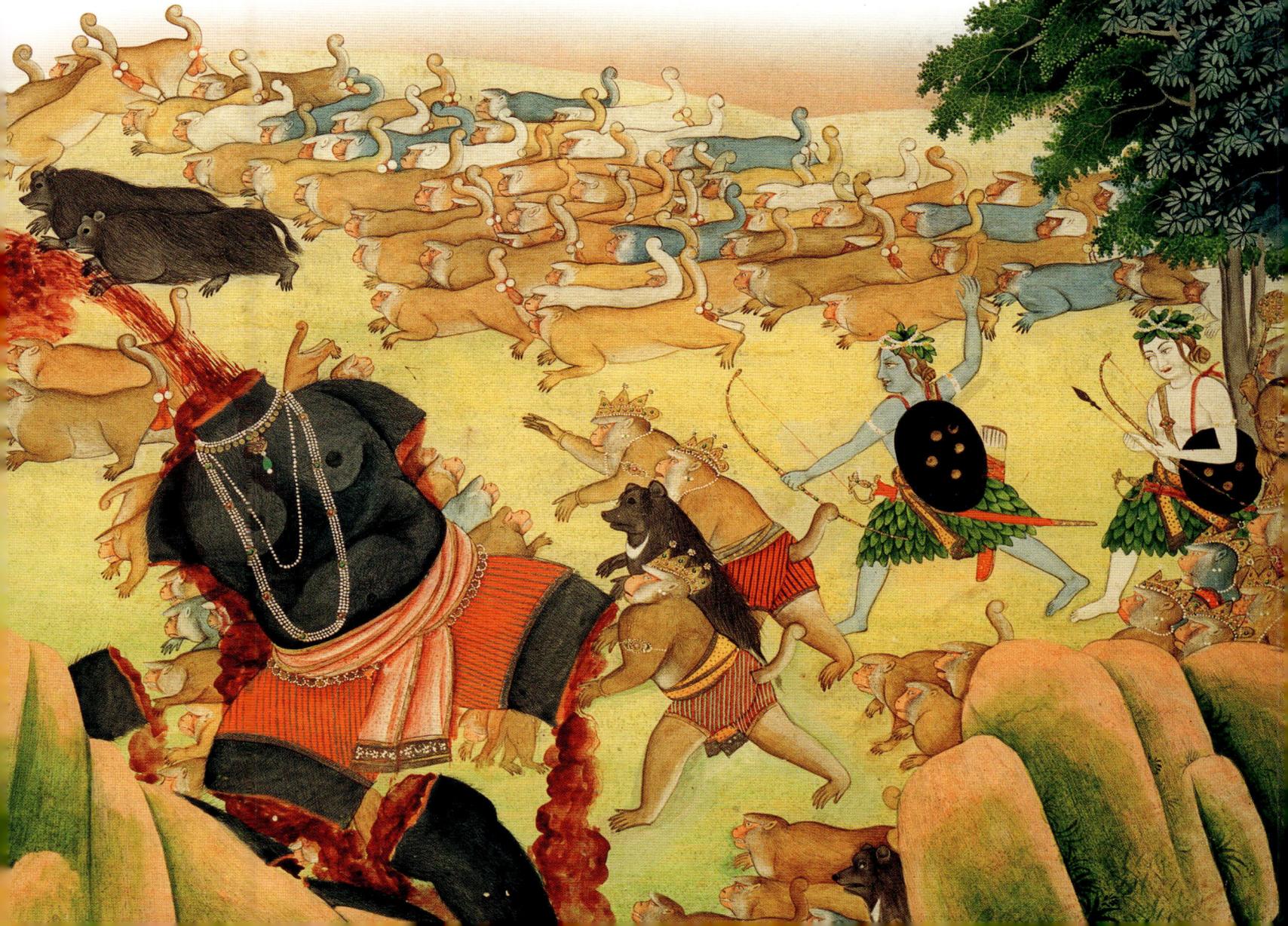

The **Rakshasas** Strike Back

Ravana distraught at the news of Kumbhakarna's death, sent his fiercest sons and warriors into battle, but they were all killed one by one. Infuriated, he sent Indrajit, who launched a vicious attack.

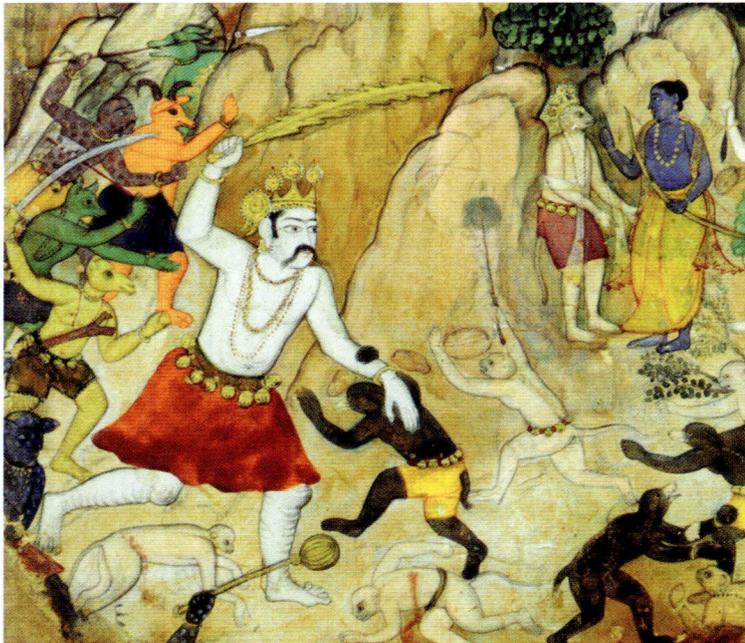

RAVANA'S SON AT WAR
Possibly commissioned by a patron of Akbar, this Mughal-style painting, 1595–1605, depicts Atikaya in the battlefield.

The mountains trembled, the gods cheered, and the Gandharvas rejoiced, as Kumbhakarna fell into the ocean, dead. The Rakshasas rushed to Ravana and gave him the news. Overwhelmed with grief, he fainted as his sons and brothers wept.

Regaining consciousness, Ravana lamented, "My valiant brother! Where have you gone, leaving me bereft? I have lost my right arm, on whose strength the gods and Asuras alike feared me. How could Rama's arrows have killed you when you were invincible even for the gods? The gods and sages rejoice at your death, and the Vanaras happily ascend the ramparts."

Seeking revenge

Ravana wept, "I do not need the kingdom or Sita. If I do not kill my brother's killer in battle, I would prefer death. I shall go today to join my brother – I do not wish to live without him. The gods will laugh at me – how shall I defeat them without you? This seems to be my punishment for rejecting Vibhishana and his advice."

His son Trishira, however, reassured him. "Those such as you do not grieve like this," he said. "I have mighty weapons and Brahma's blessings, and a thundering chariot pulled by 1,000 asses. Stay here, and I shall uproot the enemy." Buoyed by his son's promise and proclamations from his other sons and brothers, Ravana embraced them and showered them with his blessings.

The king's commanders

Six mighty Rakshasa commanders set out – Trishara, Devantaka, Narantaka, Mahaparshva, Mahodara, and Atikaya. Determined to return victorious or not at all, they marched on, and the earth shook in their wake. Narantaka led the assault and began to destroy the Vanara army, but Angada killed him. Infuriated, Devantaka, Mahodara, and Trishira attacked Angada, but Nila and Hanuman stepped in and killed them all. Mahaparshva lunged at the Vanaras, and he was killed as well.

Last man standing

Atikaya, Ravana's son, angered at the destruction of his kin, raised his large bow, and roared like a lion. He scared away the Vanaras as he entered the battlefield.

He challenged Rama, but Lakshmana pulled at his bowstring in response. The twang filled the three worlds. Surprised to see him, Atikaya said, "You are but a child. Why do you wish to fight me? Go away and do not awaken these sleeping fires of destruction."

Enraged, Lakshmana replied, "Words do not make one powerful. Self-praise does not make one virtuous. When I stand battle-ready, what is the point of speaking of your valour? Make it known through your actions. You will know me as death."

Atikaya grew furious and a fierce battle began between the two. No matter how much he tried, Lakshmana could not kill or injure Atikaya.

Finally, Vayu, the wind deity, arrived and told the prince that Atikaya was protected by Brahma's blessing, which could only be countered with the Brahmastra (Brahma's weapon). Lakshmana heeded the advice and shot Atikaya with the celestial weapon. All at once, the mighty Rakshasa fell dead like a giant mountain.

Indrajit's attack

Ravana was devasted at the death of his brothers and sons. Indrajit, however, consoled him. "Father, you need not be

> "All the **best among the valiant ones** have fallen down and **the army of the king of the Vanaras** is no longer resplendent. **Let us fall down**, unconscious. Let us **abandon all anger** and joy and withdraw from battle."

RAMA TO LAKSHMANA, *SARGA* (60), YUDDHA KANDA

A THAI KHON mask of Ravana's son, Indrajit

afraid so long as I still live," he said, and promised to kill Rama and Lakshmana. He mounted his chariot and entered the battlefield. There, he invoked Brahma's weapon, and assaulted the Vanaras.

Rama saw this and told Lakshmana, "Look at how the best of Rakshasas, blessed by Brahma, attacks invisibly from the sky. How can one kill somebody who cannot be seen? Knowing Brahma to be the blessed deity, whose weapon and power he is wielding, bear these arrows with me. Most of Sugriva's commanders have fallen. If Indrajit sees us fall, he will leave." So, Rama and Lakshmana fell to Indrajit's weapons, and the Rakshasa prince returned to Lanka.

Finding hope

The assault devastated the Vanara army, and they grew hopeless when they saw Rama and Lakshmana unconscious. Vibhishana consoled them, "Why do you grieve if Rama and Lakshmana fell out of respect for Brahma's powers?"

He walked through the battlefield with Hanuman, comforting the Vanaras, and found Jambavan lying wounded, and looked like a fire about to extinguish. "Where is Hanuman? Does he still live?" the bear asked.

Surprised, Vibhishana replied, "Why do you ask about Hanuman and not Rama or Lakshmana?"

Jambavan spoke through his pain, "If he lives, we will be revived. But if he is gone, then our death is certain even if we live."

Hanuman arrived and clasped Jambavan's feet. The king of the bears addressed him, "This is the time for your valour. Save the army and cure the wounds inflicted upon them. Save Rama and Lakshmana. You must go to the Himalayas."

He instructed Hanuman to fly to the mountain of herbs between the mighty Kailasa and Rishabha mountains. "Bring the *mritasanjeevani* (the reviver of the dead), the *vishalyakarani* (the remover of arrow wounds), the *sauvarnakarani* (which restores the golden complexion), and *sandhani* (the joiner). Return quickly," Jambavan said.

ALTERNATIVE ACCOUNT

HANUMAN'S JOURNEY TO THE MOUNTAINS

In Valmiki's *Ramayana*, Hanuman journeys twice to the Himalayas to fetch medicine. In other narratives, his journey to and from the Himalayas is fraught with obstacles. For instance, in one version, Ravana sends a Rakshasa called Kalanemi to prevent Hanuman from returning in time. Hanuman encounters a hermitage of Kalanemi's creation, where he dwells as a sage. When Hanuman gets there, Kalanemi pretends to be a great devotee of Rama. Hanuman decides to take a bath in a nearby lake, where a celestial maiden, lives as a water beast due to a curse. She tells him of Kalanemi's true intentions and Hanuman returns to kill him before proceeding to lift the mountain.

Hanuman to the Rescue

Hanuman flew through the skies towards the mountain that bore the medicines that would heal Rama, Lakshmana, and the Vanara army. He could not fail this mission.

Hanuman launched himself off a mountain, shaking the earth. As he roared, the Rakshasas of Lanka could not move in fear. He offered obeisance to Rama and set forth. As he flew, agitating the ocean, he saw the best of mountains, the Himalayas, with its waterfalls, springs, caves, and stunning peaks. He saw the sacred hermitages where the gods and sages lived and the residences of divine beings.

Soon, he came upon the lofty mountains Kailasa and Rishabha, and saw the mountain of medicinal herbs between them, radiant with fiery rays. Hanuman was amazed at the glorious sight. He tried to collect the herbs, but, realizing his presence and purpose, they concealed themselves and turned invisible. Furious, Hanuman roared and his eyes turned red. He said, "If you are determined not to favour Rama, then witness the strength of my arms. You will find yourself shattered."

Sure enough, he picked up the mountain, with its peak and herbs, and rose into the sky, terrifying the gods. He was like a mountain himself, bearing a second sun.

When the Vanaras saw him, they cheered. Hanuman placed the mountain in their midst, offered reverence to the elder Vanaras, and embraced Vibhishana. The fumes from the medicinal herbs soon revived Rama and Lakshmana, as well as the rest of the army. Hanuman then returned the mountain to its place in the Himalayas before returning to Rama.

"He **uprooted it** and **leapt up** into the sky scaring the worlds... He **seized** the summit, which was **as radiant as the sun** and resorted to the **path followed by the sun**."

HANUMAN CARRYING THE MOUNTAIN, *SARGA* (61), YUDDHA KANDA

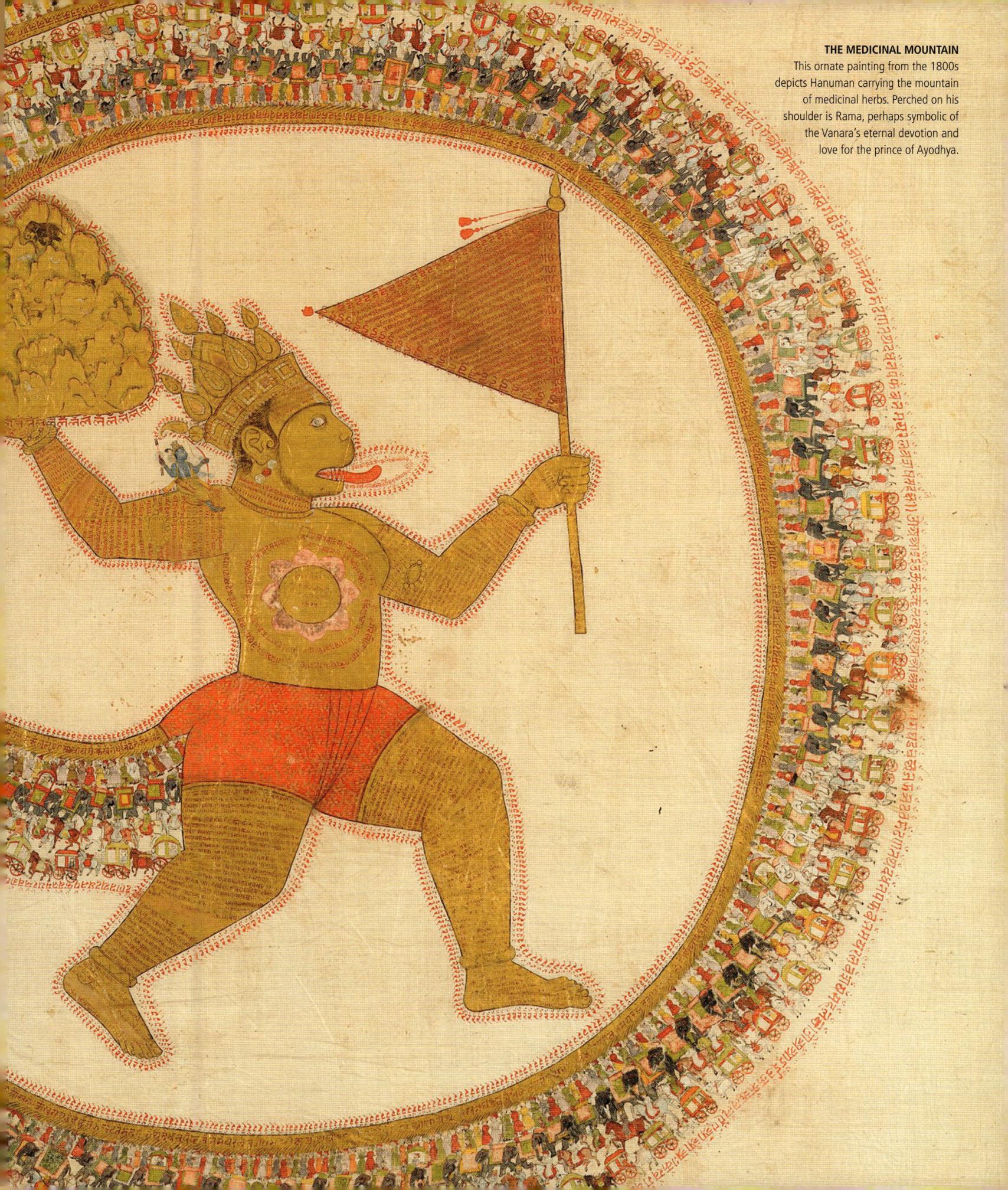

This ornate painting from the 1800s depicts Hanuman carrying the mountain of medicinal herbs. Perched on his shoulder is Rama, perhaps symbolic of the Vanara's eternal devotion and love for the prince of Ayodhya.

Kumbha, Nikumbha

Following the demise of Kumbhakarna at the hands of Rama, Ravana was paralyzed with grief. Fires of vengeance rekindled his diminishing will to live. He sent forth the mighty sons of Kumbhakarna, Kumbha and Nikumbha to kill the noble sons of Dasharatha.

Sugriva decided it was time to take advantage of Kumbhakarna's death, as well as those of Ravana's sons. What better time, he thought, as Rama and Lakshmana were now recovered. He told Hanuman to set Lanka on fire. "Let the mightiest of our warriors take torches and set fire to the fortress," he said.

As the fire spread throughout the city, there was only chaos and the air rent with the ferocious cries of attacking Vanaras and surprised Rakshasas.

Lanka resembled a summit shattered by lightning, and turned as red as the blooming kimshuka, or the flame of the forest.

Rama raised his bow and, when he tested the bowstring, the twang terrified the Rakshasas. With his bow raised, he resembled Shiva, the Destroyer, wielding the Vedas as his bow.

The despicable duo

Furious, Ravana sent Kumbhakarna's sons, Kumbha and Nikumbha, into the battle.

THE BROTHERS AND VANARAS BATTLE
Kumbhakarna's sons, Kumbha and Nikumbha, can be seen riding the chariot and showering arrows at the Vanaras in this painting from 1653, Udaipur, Rajasthan.

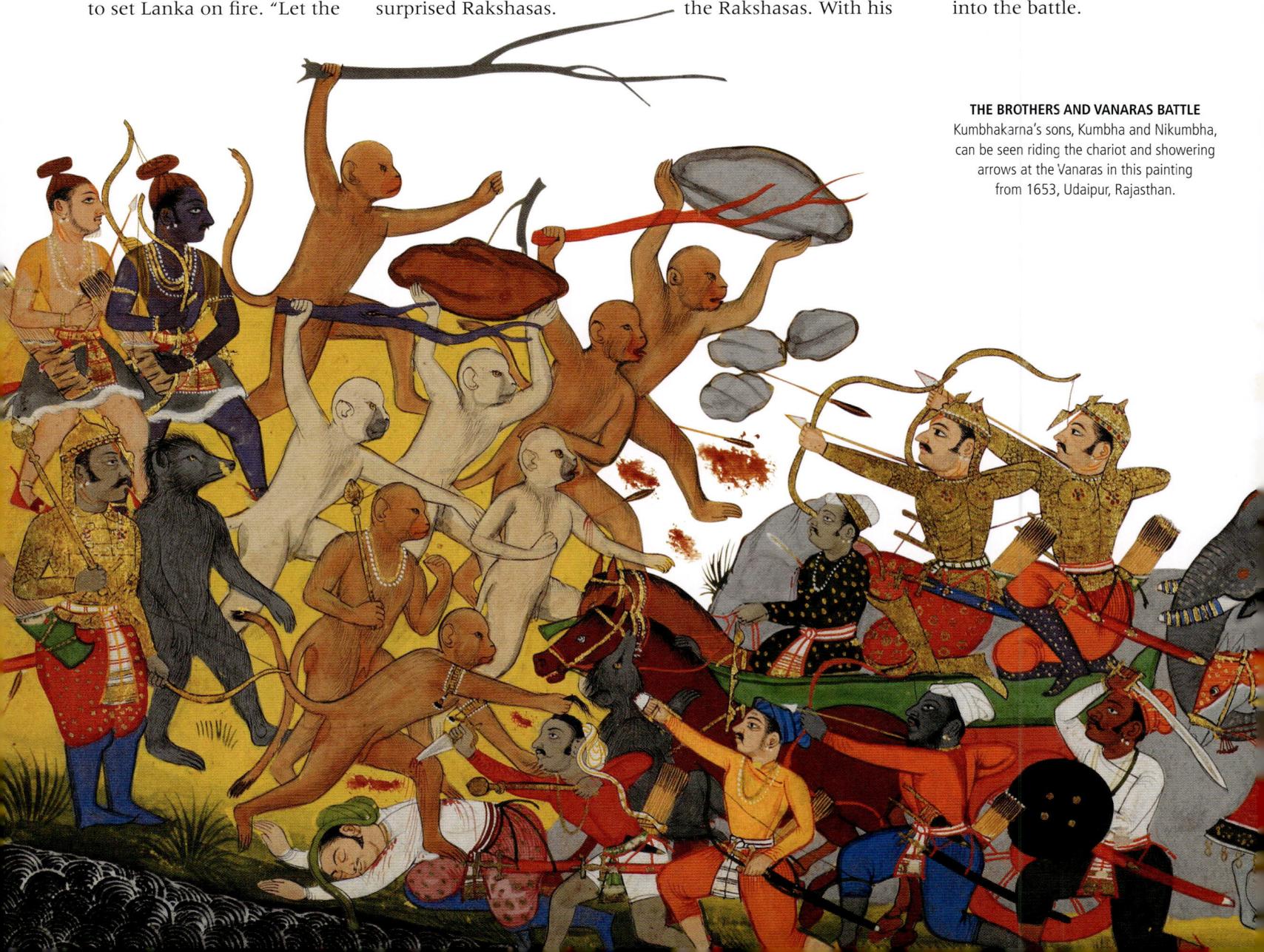

Angada's first battle was with the Rakshasa Kampana, whom he soon felled. Kumbha regrouped the forces and pulled the string of his bow all the way to his ear, and released an arrow at Dvivida, the Vanara. His brother Mainda saw this and hurled a huge rock in Kumbha's direction, but he smashed it with his arrows, and shot Mainda as well. Angada saw them fall and rushed at Kumbha, who shot eight arrows at him. The Vanara prince did not flinch and showered rocks and trees at Kumbha's head. Soon, Angada seemed like he would faint and the Vanaras rushed to his aid. Kumbha released a stream of arrows that pushed them back. Sugriva rushed to protect Angada, but Kumbha warded off his attacks until eventually, the Vanara king

managed to break his bow. Sugriva praised Kumbha's unparalleled prowess in battle, but then, added that he was sparing him because he seemed exhausted.

"Rest and then behold my strength," he said in a jeering tone. Kumbha could not bear the insult and attacked Sugriva. The bull among Vanaras punched back, his fist like thunder, and soon killed Kumbha with a crushing blow to the chest.

Victory for the Vanaras

Enraged, Nikumbha attacked Sugriva with a bludgeon and looked so fearsome that the Rakshasas and Vanaras alike seemed stunned. Hanuman, though, stood before him, unafraid, and his chest exposed. Nikumbha struck him in the chest, but the

bludgeon shattered. Although shaken, Hanuman struck back and soon, killed him. When Ravana heard of the death of Kumbha and Nikumbha, he sent Khara's son Makaraksha to fight, but Rama killed him as well, after a prolonged battle.

A cunning adversary

Ravana had no option but to send his son, the devious Indrajit, into battle.

First, Indrajit poured oblations into the sacred fire and offered an animal sacrifice. Then, he set forth, resplendent and unassailable, protected by Brahma.

When he saw Rama and Lakshmana in the battlefield, he prepared his bow, rose into the sky, became invisible, and fired sharp arrows at them.

The princes of Ayodhya released divine weapons into the sky, but, Indrajit was more than a match. He

created a shroud of dark mist and shot at Rama, injuring him everywhere.

The brothers retaliated, sending a storm of arrows in whichever direction they saw Indrajit's arrows, but failed to injure him. Soon, their bodies resembled kimshuka flowers as blood streamed from their wounds.

As the Vanara armies fell to Indrajit's arrows, Lakshmana lost his temper, "Enough! I am going to use the Brahmastra (Brahma's weapon)." Rama, however, stopped him and said, "It is not right to kill the entire race for one man. We will find a way to kill him."

"**Indrajit's blazing form** was like that of **the fire**... He was **protected by Brahma's weapon**, which was like the sun."

INDRAJIT'S GLORIOUS FORM, *SARGA* (67), YUDDHA KANDA

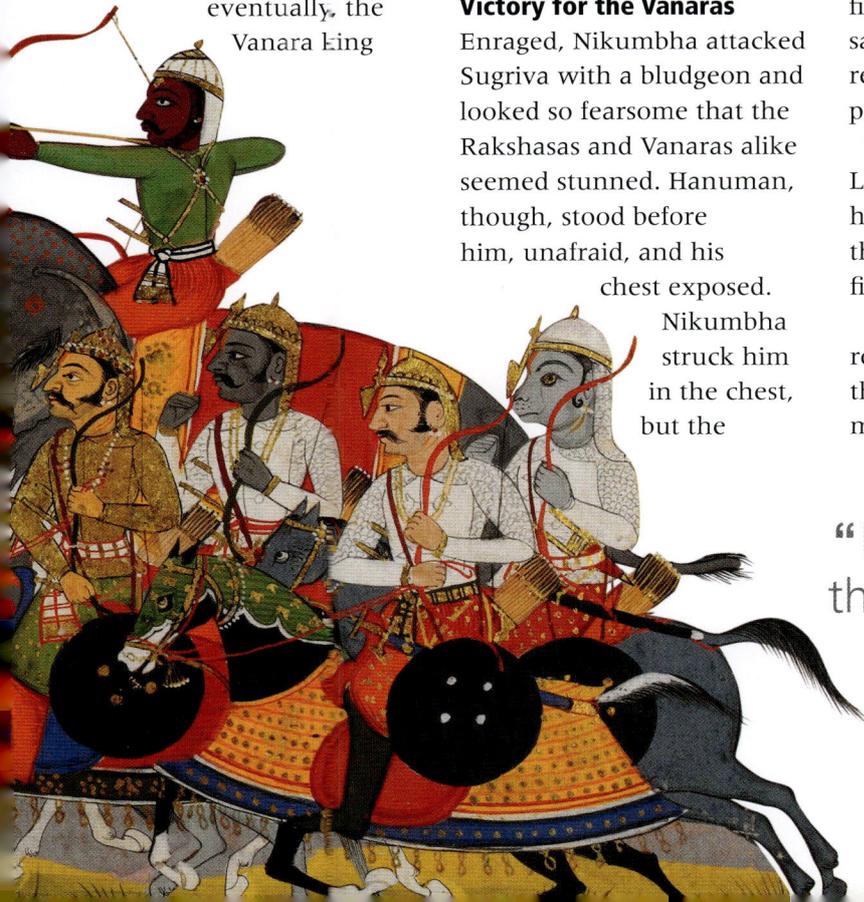

The **Great Deception**

Indrajit realized that Rama planned to kill him. So, he hatched a cruel plan meant to break the enemy's morale and make him even more powerful than ever before.

Indrajit became aware of Rama's resolve to kill him and withdrew from the battlefield. He returned to Lanka and ruminated over the deaths of his kin at the hands of Rama, Lakshmana, and the Vanara army. His eyes turned red with anger and he re-entered the battle through the western gate, determined to decimate the brothers.

Indrajit's trickery

He saw Rama and Lakshmana, bows in hand, ready for battle, and decided to use his maya, the powers of illusion, to confuse the enemy. He placed an illusory image of Sita on his chariot and rode out to meet the Vanaras.

Hanuman charged towards him with a large rock, when he saw the woman. He realized it was Sita in faded garments, her hair loosely braided, wearing no ornaments. His eyes filled with tears and he thought, "What has he decided?"

Indrajit saw Hanuman and grabbed the woman by her head and hit her. She cried out for Rama and Hanuman, distraught, yelled out, "You have touched her hair and ensured your death. Despite being born in a lineage of *Brahmarshi*s, you act like a Rakshasa. Have you no shame? What has she done to you that you wish to kill her? If you kill her, you will not live, and when you die, you will go to the realms of those wretches who kill a women."

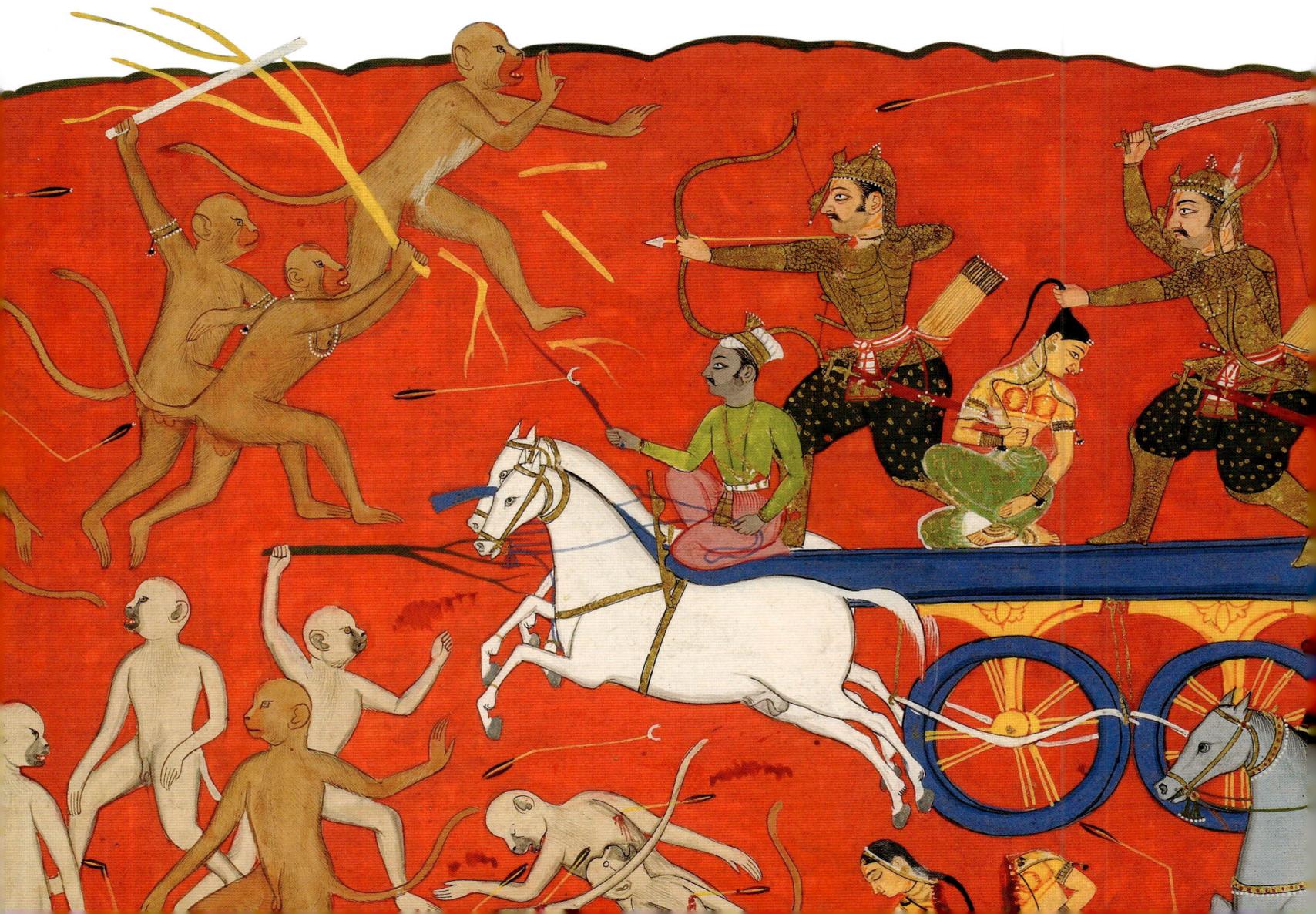

> "Sugriva, Rama and **you came here** for her. While you look on, I will **kill that Vaidehi today**. O Vanara! After killing her, I will take care of Rama, Lakshmana and you."

INDRAJIT TO HANUMAN, *SARGA* (68), YUDDHA KANDA

The illusion of Sita continued to weep and Indrajit said, "As you watch, I will kill the one for whom you, Sugriva, and Rama have come here. Then, I will kill you, Sugriva, Rama, Lakshmana, and that ignoble Vibhishana. As to whether women can be killed – one should do whatever it is that will hurt one's enemies."

So saying, he raised his sword and sliced the illusion's torso. She fell on the ground, dead, and Indrajit told Hanuman cheerfully, "Behold! She was Rama's and I have killed her."

The outraged Vanaras
He stood in his chariot and roared. The distraught Vanaras ran helter-skelter, until Hanuman called them back. They uprooted trees and mountains and attacked the Rakshasas who retaliated. After Hanuman warded them off, he told the Vanaras that it was time to turn back. "The one for whom we fight is gone. We should inform Rama and Sugriva, and ask them what to do next."

When Indrajit saw Hanuman and the Vanara army retreat, he left for Nikumbhila as well, to offer oblations.

Rama's despair
Meanwhile, Rama heard fierce cries from the western gate and realized that Hanuman was in the midst of

INDRAJIT'S IMPERTINENCE
This excerpt from a watercolour painting from 1653, Udaipur, Rajasthan, portrays Indrajit advancing in his chariot as he holds the tresses of an illusory image of Sita in the battlefield.

a great battle. He requested Jambavan to help Hanuman and the other Vanaras. The king of bears agreed and left with his terrible army, which resembled a dark cloud. They turned back when they saw Hanuman and the other Vanaras returning.

Hanuman went to Rama and gave him the news. "As we watched, Rama, Indrajit killed Sita in the battlefield. We stand before you utterly lost."

Rama, faint with grief, fell to the earth like a tree cut at the root. The Vanaras surrounded him and sprinkled fragrant water on him, as he burnt like a raging fire.

Lakshmana, drowning in sorrow, pulled an unsteady Rama into an embrace and said, "Dharma has to be meaningless, if it is unable to ward misfortunes off someone like you, who are firm on its path and have won over your senses, revered brother. If either dharma or adharma did exist, Ravana would have gone to hell and adversity would not have afflicted you again and again.

"Or, perhaps, dharma is weak and attaches to strength, in which case it is strength which should be sought. It seems that all

AN 18TH-CENTURY painting of Lakshmana

things proceed from *artha* (economic and political strength), and your troubles began when you abandoned the kingdom. A person deprived of *artha* is in his or her energy. Faults arise when somebody desirous of pleasure abandons *artha*.

"Arise, Rama, and watch me counter with my actions the grief that Indrajit's actions has brought."

As Lakshmana comforted Rama, Vibhishana arrived and was shocked to see Rama immersed in grief.

The truth revealed
Lakshmana told him what Hanuman witnessed, but Vibhishana stopped him almost mid-sentence. He said, "What Hanuman has seen is impossible. I know Ravana and he will not kill Sita. Everyone begged him to »

let her go so that we may avoid this calamitous war, but he refused. Rest assured, Sita is alive. Indrajit has deluded the Vanaras. He used this as a distraction so that he may complete his oblations that will render him invincible, if completed. Stand steady, Rama, and send Lakshmana to fight him. If Indrajit completes the sacrifice he will be invisible to the gods and Asuras. There will be great danger to even the gods."

Rama composed himself and asked Vibhishana to repeat his words. He considered what he knew of Indrajit and his battle strategy and realized that Vibhishana was right. He asked Lakshmana to take an army with him and fight Indrajit.

Lakshmana grabbed his bow, wore his armour, and clasped his sword cheerfully. He touched Rama's feet and said, "Today, the arrows from my bow will pierce Indrajit's body and destroy him."

Two mighty warriors

Lakshmana, surrounded by the army of Vanaras and bears, flanked by Hanuman and Vibhishana, reached Nikumbhila. He saw Indrajit's army before him, thick and dense, like darkness.

Vibhishana told Lakshmana that Indrajit would become visible if they shattered his army, so the Vanaras and bears fought valiantly, with trees and boulders. The Rakshasas fought back with swords, arrows, and spears, but the Vanara army was stronger and larger.

Indrajit heard the sounds of battle and of the destruction of his army. He left the rituals midway and climbed his chariot to join the battle. He saw Hanuman destroy the Rakshasa armies and showered him with battle-axes, swords, and javelins. As he raised his bow and arrow to slay Hanuman, Vibhishana alerted Lakshmana who challenged Indrajit.

Ravana's son noticed Vibhishana by Lakshmana's side and grew angry. "Have you no shame, uncle? How can you cause me harm? You do not understand dharma, and you have no love for your family. Kin, even if devoid of virtues, should be valued over virtuous outsiders."

Vibhishana retorted, "You are an ignorant child, and yet you presume to instruct me in dharma. I do not rejoice in adharma and abductions of other people's wives. Ravana has many vices, and soon, neither you, nor him, nor this city will survive. Come, fight Lakshmana – you will not live long after challenging him."

The battle of the champions

Indrajit grew senseless with rage and stood in his chariot, pulled by black horses, like Death himself. "Behold my valour. I will release showers of my invincible arrows from my bow," he said with pride.

The battle between Indrajit and Lakshmana began. They were well matched, both strong, valiant, were unassailable, and knew all there was to know about weaponry. They resembled planets striking one another.

Lakshmana sent a volley of sharp arrows towards Indrajit, which made him feel faint for a moment. He retaliated and shot 100 arrows at Vibhishana. Lakshmana smiled and said, "Heroes desirous of victory do not fight this way."

As the battle continued, Indrajit also fought Vibhishana before he turned back to attack Lakshmana again. However, neither grew tired as the two exchanged a flurry of arrows.

AN ILLUSTRATION of Nikumbhila, the goddess

"**Lakshmana** calmly went forward to meet it, recalling that he himself was **Vishnu**, the presiding deity of the astra... Instead of coming at his body, that **missile** went around him worshipfully... and shot up to the air, where it lost its **fire and smoke**."

LAKSHMANA FACES INDRAJIT'S MISSILE, *KAMBA RAMAYANA*, TRANSLATED BY PS SUNDARAM

THE WIELDER OF WEAPONS
A shadow puppet of Indrajit from the Pinguli village in Sawantwadi Maharashtra, depicts him fighting in the battlefield, weapons in hand.

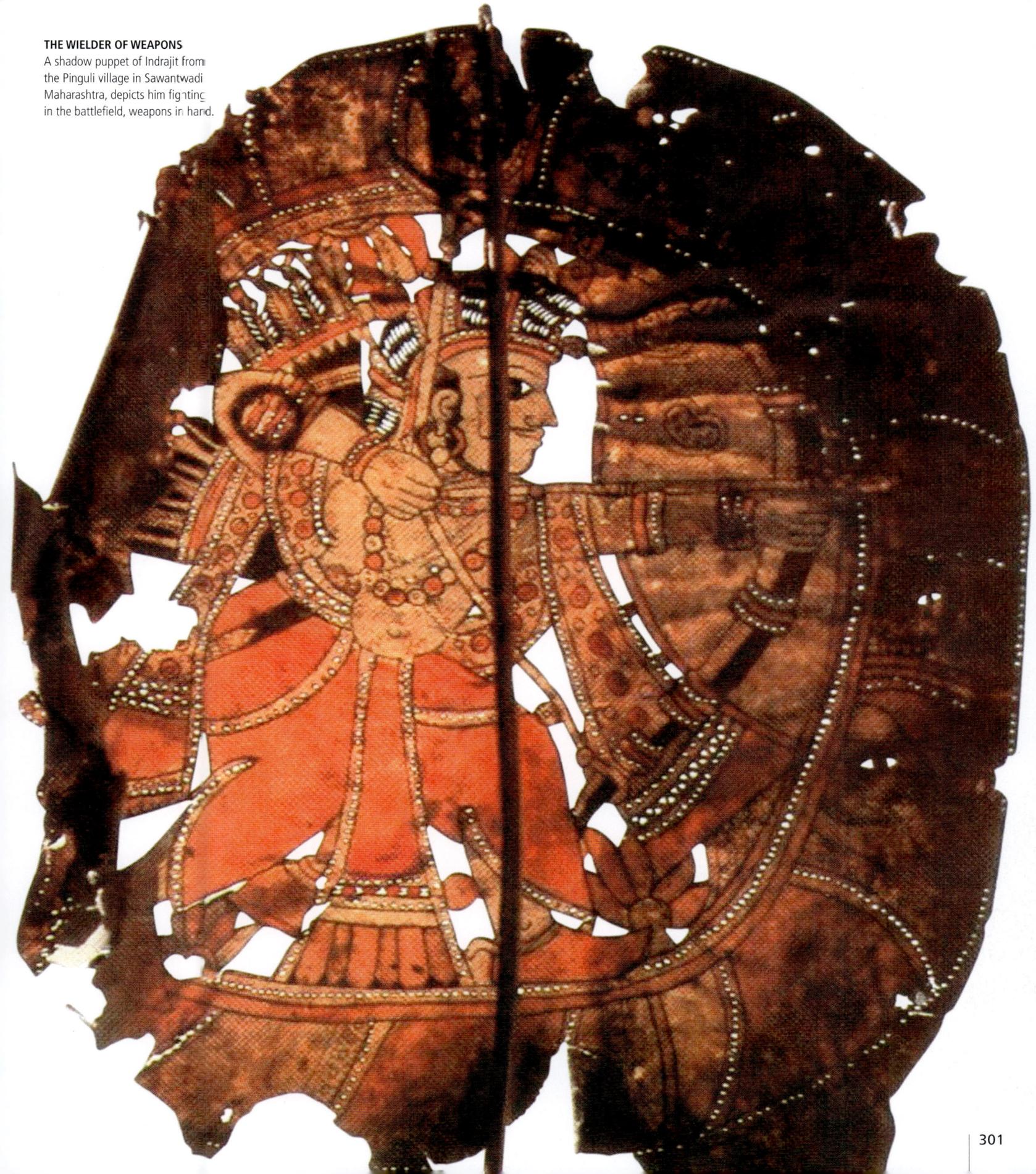

Indrajit Vanquished

The tense battle continued as the mighty warriors, Lakshmana and Indrajit, hurled their celestial weapons upon each other. Each was as valiant and agile as the other. But, who would win?

Lakshmana and Indrajit, both of whom wished the other dead, shot innumerable arrows at each other. They fought with such speed that it was impossible to actually see when either of them raised the bow, placed the arrow, or released it. The wind ceased to blow and fires ceased to burn, while sages prayed for the welfare of the world.

Indrajit raised an arrow that bore the strength of the god of death, Yama. In response, Lakshmana raised a weapon that Kubera had granted him in a dream. The arrows struck each other and shattered into pieces. Angered by this failure, they continued their relentless attack.

The deities in the sky – sages, gods, Gandharvas, and Nagas prayed to protect Lakshmana. He finally raised the perfect arrow, placed it on his bow, and said, "If Rama, Dasharatha's son, is perfectly truthful, and if his valour is unparalleled, then this arrow shall kill Indrajit." Pulling the bowstring all the way to his ear, Lakshmana invoked the Aindrastra (Indra's weapon) and shot the arrow at Indrajit.

Severed, Indrajit's head, studded with earrings and covered with a grand helmet, fell to the ground.

Indrajit was dead, his body bloodied, and armour shattered.

The celestial beings roared in delight, as the Vanaras and Vibhishana rejoiced on the earth.

The Vanara army descended on the Rakshasas with even more vigour and passion. They, in turn, grew frightened and retreated to Lanka, abandoning their weapons.

Seeing Lakshmana's great victory, the Vanaras leapt with joy and embraced one another.

"The rays of the sun had been pacified. The fire had been put out. The immensely energetic one had departed and his life had set."

THE DEATH OF INDRAJIT, *SARGA* (78), YUDDHA KANDA

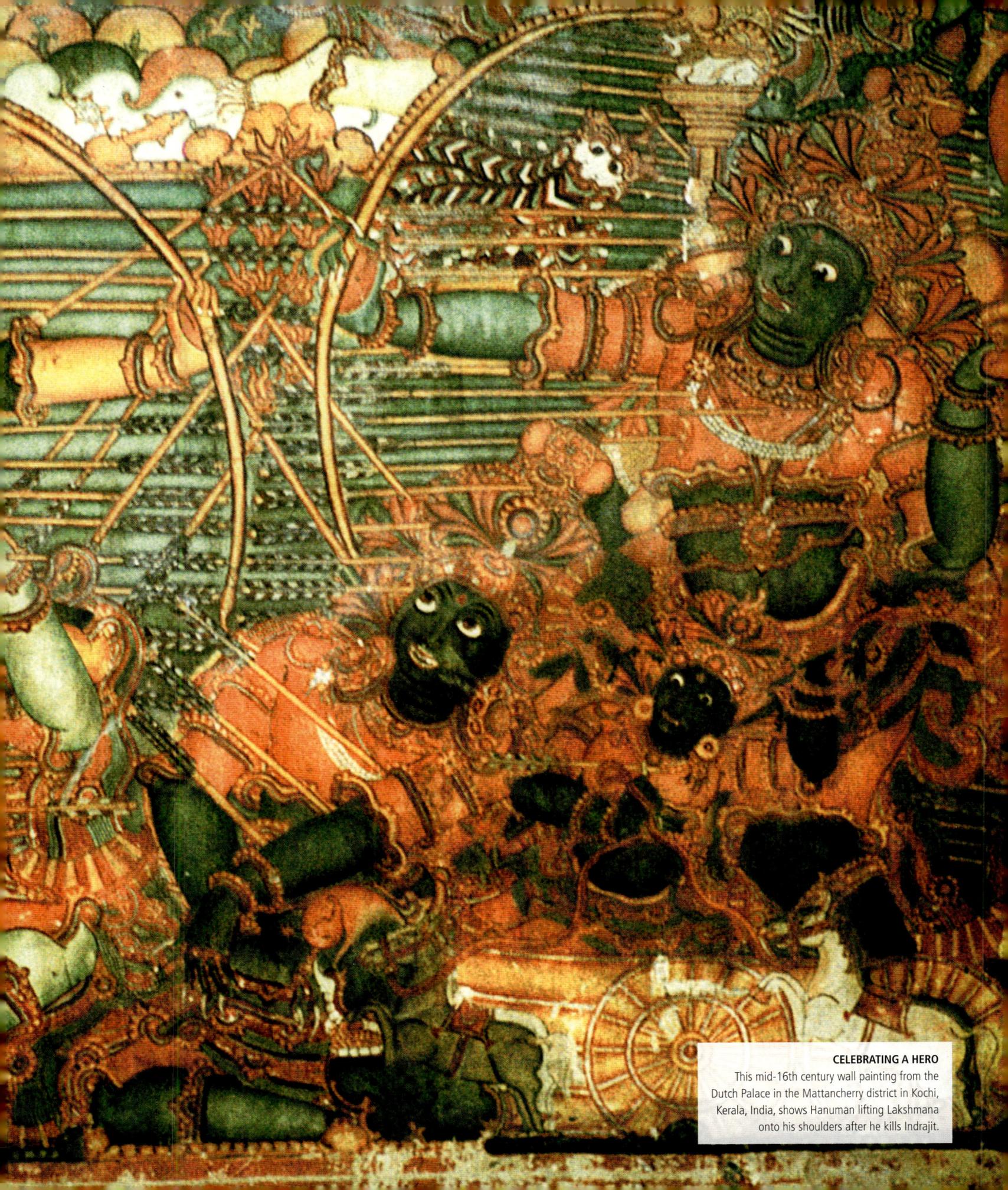

The Sorrow that Follows

Ravana was beside himself in grief and fury when he heard of Indrajit's death. He unleashed his army's might on the Vanara army, decimating them, until Rama stepped onto the battlefield.

Drenched in blood, yet pleased with his victory over Indrajit, and held up by Hanuman and Vibhishana, Lakshmana went to Rama and gave him the news. Rama embraced him, kissed his forehead, and said, "You have rendered me without enemies! When Ravana leaves the fortress now, I will kill him easily. With you protecting me, I have no doubt that I will obtain Sita, or even the entire earth, with ease." He then asked Sushena to treat Lakshmana and Sugriva's wounds, which healed rapidly and soon ceased to be painful.

Grief of a father

In Lanka, Ravana fell into great despair and fainted when he heard of Indrajit's death. When he came to his senses, he wept, "Oh best of warriors, my son, how could Lakshmana have bested you when you defeated Indra himself? All the realms seem deserted to me. Where have you gone, my heroic boy, leaving this kingdom, your mother, your wife, and me? You should have performed my funerary rites, how has it come to be the other way round?" As he wept, his grief transformed into rage and he resembled Rudra

THE RAKSHASA KING
After the death of Indrajit, Ravana was first full of grief, which then swiftly turned into rage for those who killed his son. Here, a dancer is seen portraying the role of Ravana, displaying his anger through his facial expressions and hand gestures while performing the Kutiyattam, an ancient form of theatre from Kerala.

himself. Tears dropped from his red eyes, like drops of oil from blazing lamps. He was like Death himself, seeking to devour everything and everyone.

No Rakshasa dared to move, as he spoke in a terrible voice, "I performed austerities for 1,000 years and pleased the Creator, Brahma. I have the armour he granted me, impenetrable even for Indra's own weapon. I will don it and carry into battle the divine weapons I have received to kill the two brothers."

"I will kill Sita"

Still tormented by his grief, Ravana decided to kill Sita, "My son pretended to kill Sita to delude the Vanaras. Let me make good on what he said." He unsheathed his sword and rushed to where Sita was.

Sita saw him come towards her in anger and wondered, "Has he finally lost patience? Why did I not listen to Hanuman and return with him? If the brothers are dead, what will Kaushalya do when she hears of her only son's death? She will die herself."

At that moment, Suparshva, one of Ravana's advisers, held him back and said, "Lord of the Rakshasas, you are Kubera's own brother. You are one who has duly completed your Vedic study and your conduct is pure. Why do you now do the adharma of killing a woman? Kill Rama in battle and Sita will be yours."

Rama's valour

Ravana returned to the court and sent some of his mightiest commanders into the battlefield. The battle that followed was as fierce as it was gruesome. As the Rakshasas slaughtered the Vanaras, they rushed to Rama to seek his protection.

Rama raised his bow, but so swift was its movement that nobody could see quite what he was doing. He used the great Gandharvastra, the divine weapon of the Gandharvas, to delude and destroy the Rakshasa army. They saw a 1,000 Ramas at once, and, at the next moment, there was just one. So great was the speed of his bow, as he turned in all directions to shoot arrows that its golden top gave the impression of being a ring, which resembled the wheel of death. He destroyed the entire Rakshasa army in the last watch of the day, standing alone on the battlefield. The celestial beings praised Rama, who turned to Sugriva, and said, "Only Shiva, the Destroyer, and I possess this weapon."

The Rakshasis whose husbands, sons, or brothers had died, wept. They lamented, "Why on earth would Shurpanakha, herself unpleasant, desire Rama, who is verily like the god of love? It is her misplaced desire that has brought this about. Ravana did all this for her sake, and Sita's abduction is going to be the cause of his death. If he had only listened to Vibhishana. We have no hope. Nobody can protect us from Rama. This human shall be Ravana's end."

ALTERNATIVE ACCOUNT

THE MYSTICAL STRUGGLE

It is said that Ravana worshipped the Divine Mother, and she granted him protection in battle. When Rama saw Ravana on her lap, he realized that the war was lost. However, that night, he was encouraged to invoke the Mother, and he began to worship her with 108 blue lotuses, which he had asked Hanuman to bring. Offering a single lotus at each completion, he went through all the lotuses but one. At that moment, the goddess made that last lotus disappear. Determined to complete the practice, Rama raised an arrow to pluck his eye to offer to her, but the goddess intervened, granting him her blessing. This is narrated by the medieval Bengali poet Krittibas Ojha, and a version of this story is rendered into modern Hindi in 20th-century poet and novelist Suryakant "Nirala" Tripathi's "Ram ki Shakti Puja" (Rama's Worship of the Divine Feminine).

THE LOTUS is an auspicious offering in Hindu mythology

> " He **brandished it like a circle of fire** and they **could not see Raghava**. The bow was like the **rim of a wheel**…"

RAMA'S FIERCE FORM IN BATTLE, *SARGA* (81), YUDDHA KANDA

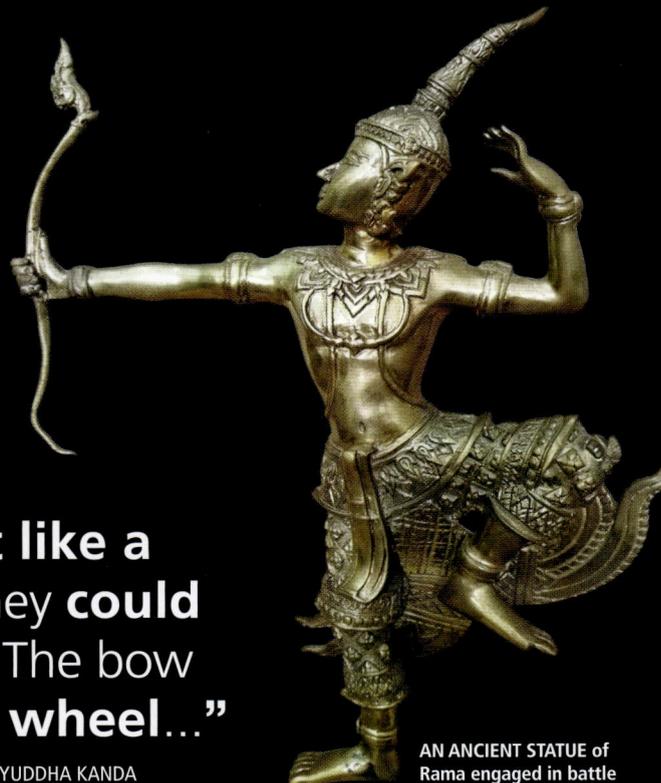

AN ANCIENT STATUE of Rama engaged in battle

MIGHTY SON OF RAVANA

Indrajit

"**All the creatures found it impossible to kill him**. He could invoke **great maya** in a battle."

THE SEVEN *MAHARSHI*S TO RAMA, *SARGA* (1), UTTARA KANDA

Indrajit, or Meghanada – the vanquisher of Indra or the one who thunders like a cloud – is unflinchingly by his father's side through all manner of conflict. So great is his valour that we only come to learn his given name in the last Kanda of the *Ramayana*, hearing of him as Indrajit alone for the rest of the text.

Like father, unlike son

It seems that for the early part of his life, Meghanada was left mostly to his own devices, his father busy vanquishing the worlds and abducting women. When Ravana finally returns, he finds Meghanada in a grove nearby, performing ritual offerings to acquire various kinds of powers. When Meghanada's priest informs his father of his achievements, Ravana is a little miffed that his son has been making material oblations to the gods who are his sworn enemies.

He is, however, a rather beloved son, seemingly above all others, for Ravana grieves his passing with great desperation. It is Indrajit who captures Indra, the king of gods, and brings him back to Lanka. When the Creator, Brahma, comes to negotiate Indra's release, Indrajit secures for himself the blessing that he would only be killed in battle if he went in without offering oblations to the fire.

Perhaps characteristically, Indrajit proclaims that unlike all other people, who get their powers and blessings through penance, he has managed to get them through the strength of his arms. Unlike his father's clashes with the gods, Indrajit fights his first battle with Indra without the protection of invincibility.

Supreme wielder of weapons

Indrajit is a formidable warrior and causes more trouble to Rama's side in general, and to Rama and Lakshmana in particular, than his uncle, Kumbhakarna, or even Ravana himself. Indeed,

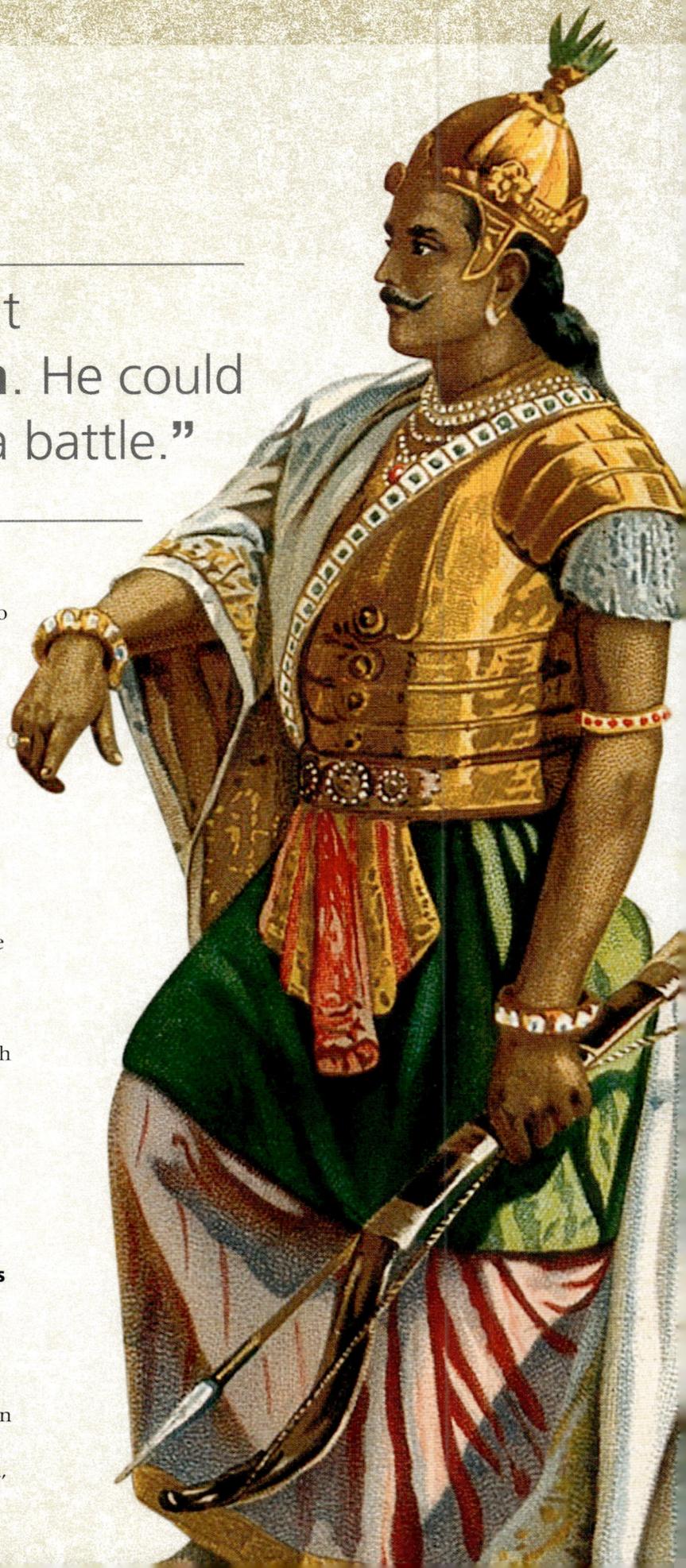

his strength is actually said to be greater than Ravana or Kumbhakarna. Further, rather like his father and unlike his uncle, he has no qualms about tricking his enemies into defeat, as evidenced in the episode of the illusory Sita whom he pretends to kill (See pp 298–99), causing Rama to fall to anguish until Vibhishana clarifies matters.

It is unclear if Indrajit means what he says to Hanuman when the latter raises the issue of whether it would be appropriate for Indrajit to kill a woman in this way, but it is not outside the realm of possibility that it might be so.

Even before the war begins, Indrajit, by virtue of the boons bestowed upon him by

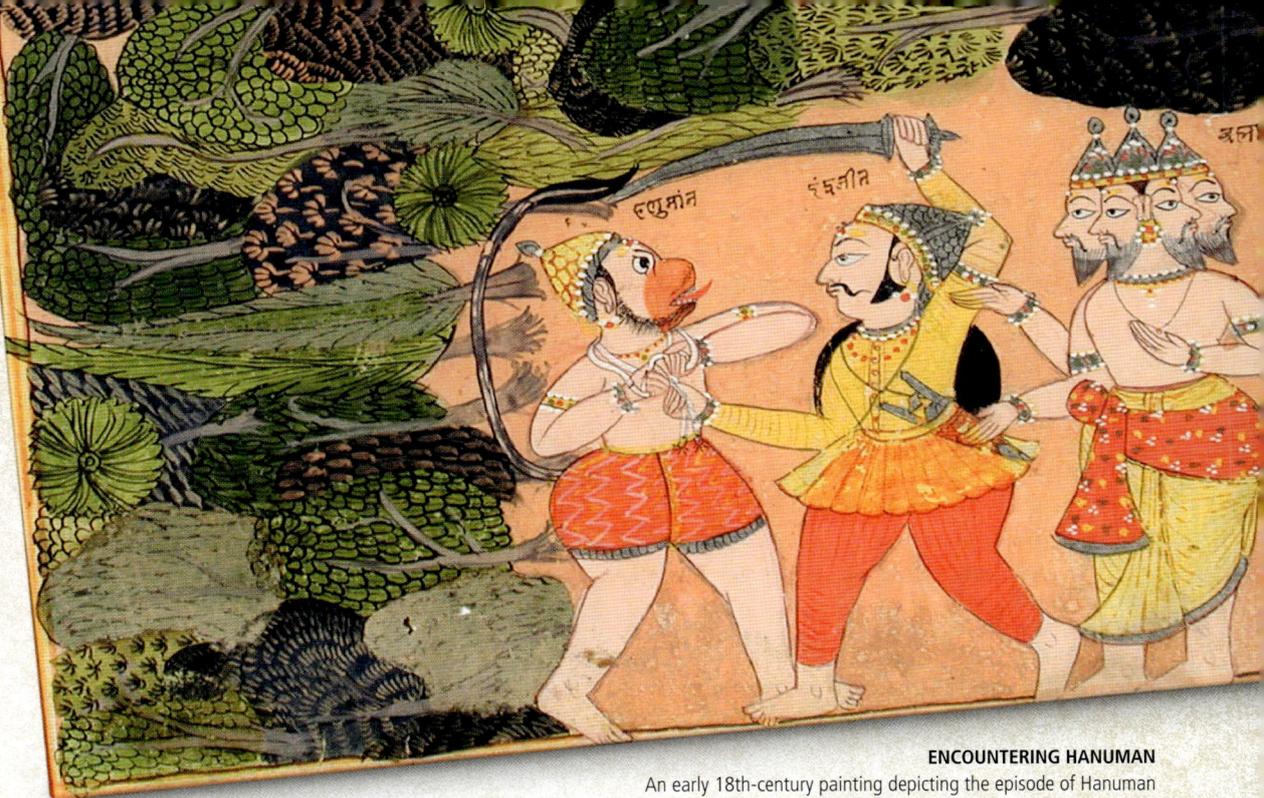

ENCOUNTERING HANUMAN
An early 18th-century painting depicting the episode of Hanuman being captured by Indrajit in Lanka as Brahma looks on.

THE PRINCE OF LANKA
An early 20th-century colour lithograph of Indrajit by renowned painter Raja Ravi Varma shows the prince dressed in fine clothes and wearing precious jewels.

Brahma, is the one who can even come close to actually vanquishing Hanuman, who is bound and presented before Ravana (See p 233).

In the war itself, each time Indrajit enters the battlefield, he unleashes a new terror upon the Vanara armies. In his very first visit, he renders himself invisible and shoots arrows in such a way that Rama and Lakshmana are unable to aim at him, making it impossible to actually fight him. Finally, he fells them with serpentine arrows, until Garuda releases them from it (See pp 282–83).

Death of a titan

Valmiki's narration of Indrajit's death seems to be that he was performing certain rituals while being concealed by the Rakshasa armies, and fights Lakshmana before he is killed. It is Vibhishana who reveals the trick to killing him. This is however, complicated. Some narrators have questioned the degree of battle-preparedness in which Indrajit sat when Lakshmana approached him. This became a particularly delicate issue from the 19th century onwards. Michael Madhusudan Dutt, a seminal figure in Bengali literary history and indeed, the story of Indian modernity, composed the "Meghanad Badh Kavya", or a

composition dealing with the slaying of Meghanada. His work is important in many regards, but as English poet and translator William Radice observes, he was perhaps early among the figures of colonial modernity to subvert the perspectives in the epic narrative, such that he cast Meghanada as a tragic hero.

Similiarities

In a sense, Indrajit's religiosity is rather like Ravana's own, in that he is willing to transact with the gods – whether using sacrificial offerings or Indra's freedom – but remains deeply egotistical. There are ways in which Ravana and Indrajit are the counterparts of Rama and Lakshmana, the latter components of both pairs utterly devoted to the other, and the final battle between Lakshmana and Indrajit is portrayed as one between equals.

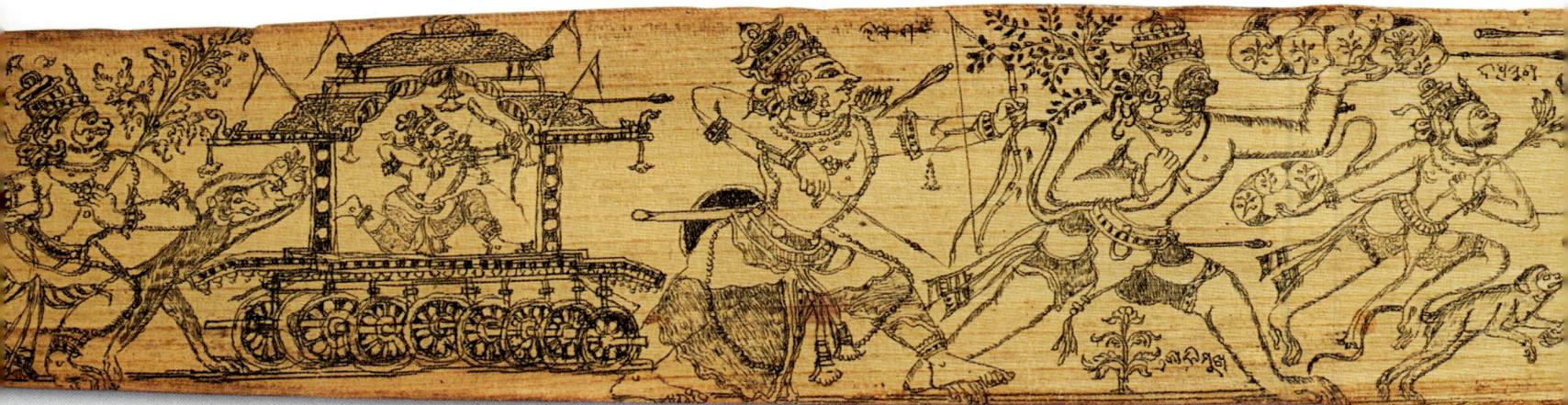

Death of the Advisers

The death of his son and the most powerful of his warriors left Ravana furious and even more determined to kill Rama and Lakshmana. He stepped onto the battlefield once more, this time with his advisers, to avenge the death of his sons and brothers.

Ravana heard the piteous sounds of the grieving Rakshasis and, after a moment's quiet, let out his fury and ordered his advisers, Mahodara, Mahaparshva, and Virupaksha to follow him into battle.

The king's command

Bow in hand, Ravana ascended his splendid chariot, as did the three advisers. With his permission, they descended to where Rama and Lakshmana stood. The sun stopped shining, the birds shrieked, the earth shook, and blood showered from the sky. Terrible omens presented themselves, but Ravana paid them no heed, as if pushed by Death himself. He attacked the Vanaras and soon covered the earth with their bodies.

King of the Vanaras

Sugriva faced the 10-headed king unflinchingly, roared, and hurled large rocks into his army. The Rakshasa

Virupaksha, a skilled archer, climbed onto an elephant and shot at Sugriva. Pierced by the arrow, the enraged king of the Vanaras uprooted a massive tree and flung it at the elephant. Virupaksha struck Sugriva with his sword and, in retaliation, the furious king threw a boulder at him. Virupaksha fell to his death, his eyes dilated and body bloodied.

Furious Angada

Ravana's anger doubled at Virupaksha's death and he sent the invincible Mahodara into the battlefield, but Sugriva killed him as well.

Mahaparshva, the third adviser, attacked Angada's battalion with his arrows. To protect his force, Angada lifted an iron beam and hurled it at Mahaparshva, causing him to fall off his chariot and onto the ground.

Regaining his strength, the Rakshasa fired arrows at Angada, Jambavan, and

Gavaksha. Furious, Angada whirled his club in the air and threw it at Mahaparshva, whose bow, arrow, and helmet fell to the ground. He grabbed his battle-axe and struck Angada, who freed himself, and struck a fatal blow to the Rakshasa's chest.

The king's resolve

The enraged Ravana ordered his charioteer to bring him face to face with Rama and Lakshmana. He took out his weapon, Tamasa (darkness), and attacked the Vanara armies with his arrows. Only Rama stood unvanquished, with Lakshmana by his side.

> "He saw that the **unvanquished Rama** was stationed there. He was **with his brother**, Lakshmana, **like Vasava with Vishnu**."
>
> RAVANA SEES RAMA AFTER THE DEATH OF HIS ADVISERS, *SARGA* (87), YUDDHA KANDA

Rama raised his bow, filling each direction with the terrible sound of his bowstring. Lakshmana, seeking to face him first, released fiery arrows at the king, which simply passed him by. The two then exchanged arrows of different shapes and sizes so quickly that the air turned thick with clouds and lightning.

Ravana shot a garland of iron arrows at Rama's forehead, but it did not affect him. Rama instead, spoke a mantra and invoked the Roudrastra (a divine weapon) that severed Ravana's arrows. The Rakshasa king released

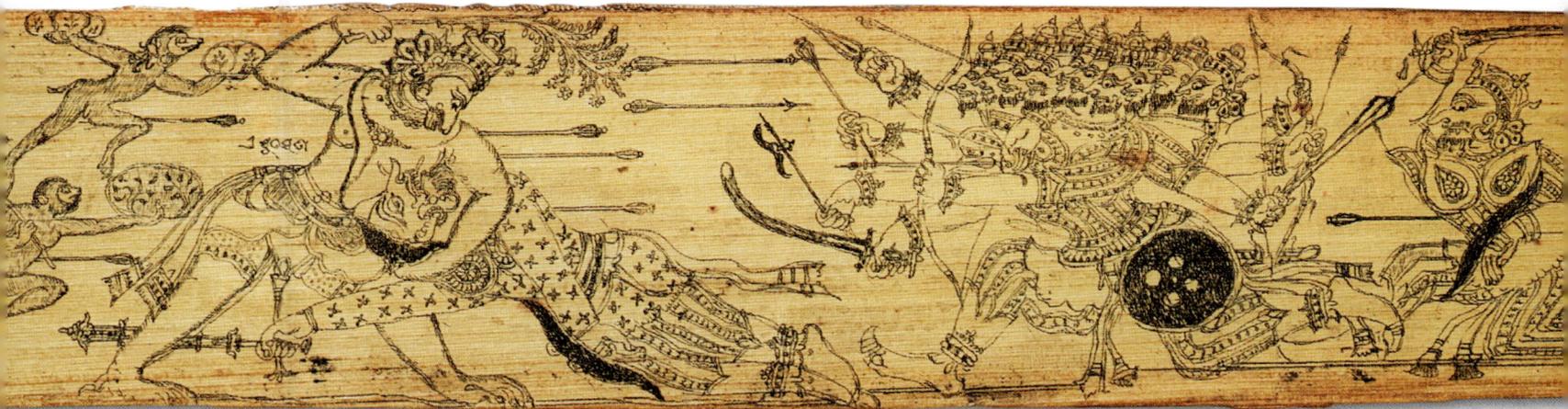

HANUMAN BRINGS BACK A MOUNTAIN
This late 18th-century palm leaf manuscript in charcoal and gum tempera from Odisha, India, shows the series of events – Hanuman brings the mountain to cure Lakshmana (left) and the Vanara army faces Ravana (right).

arrows that bore faces of fierce animals with gaping mouths or flickering tongues. Rama repulsed them with the Pavakastra, which was like fire, and had arrows that resembled blazing fires, giant meteors, or had tongues of lightning.

Ravana attacked Rama with weapons created by Maya, the architect of the Rakshasas, but he countered them all. The king then invoked the Sourashtra (the sun god's weapon), but Rama fought it off. When Ravana shot 10 arrows at Rama, which pierced his entire body, the prince of Ayodhya barely trembled.

Wrath of the brothers

Lakshmana grew angry at this assault on Rama and shot seven arrows at Ravana's chariot and charioteer, and Vibhishana attacked the horses. Ravana hurled a lance at Vibhishana but Lakshmana broke it midway with his arrows. When he raised

another towards Vibhishana, Lakshmana shot Ravana with his arrows.

Ravana exclaimed, "You have saved Vibhishana, now escape this javelin." He released the lance, a creation of Maya that bore eight bells. Rama saw it rush towards Lakshmana and prayed, "Let this lance fall midway, its strength spent."

But, the weapon found its target and struck him in his chest. Lakshmana fell to the ground and Rama nearly lost himself to grief, but steadied himself. This was not an opportune moment, he told himself and returned to battle Ravana.

Rama, however, saw Lakshmana on the ground. The lance had impaled him and lodged itself in the earth underneath his body. The desperate Vanaras tried to get to the fallen prince, but Ravana showered them with arrows every time they got too close.

Rama ignored Ravana's arrows, pulled out the lance, and instructed Hanuman and Sugriva to stand guard. "The moment has come for me to show my mettle and for Ravana to be dead. Only one of us will remain alive beyond

this point," he proclaimed. He pulled at his bowstring and aimed golden arrows at Ravana who hurled iron arrows and clubs in return. Soon, their shattered arrows lay all over the battlefield and Ravana fled.

A cure

Rama gave in to grief, turned to Sushena and said, "The hero, fallen to the ground, exacerbates my sorrow. How can I fight when my brother is drenched in blood?"

Rama wept, utterly desolate, "My valour is shamed, my bow slips and tears obstruct my sight. I care for neither the war, nor Sita, nor life, for my brother lies dead."

Sushena gave Rama hope, "Lakshmana is not dead – look, his face retains his radiance, and his chest still moves. His palms are still red. Do not give in to grief. This destroyer of enemies still lives."

Sushena instructed Hanuman to return to the medicinal mountain once more (See pp 294–95) and bring back herbs. He left at the speed of light, but on reaching the mountain, grew concerned, for he was unable to identify the herbs. Wasting no time, he picked up the entire peak and returned. Sushena administered the medicine and Lakshmana opened his eyes.

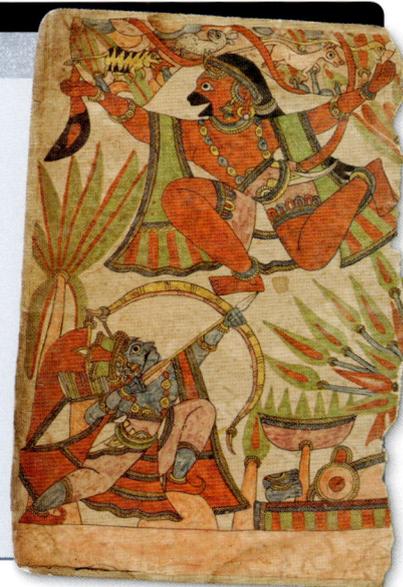

ALTERNATIVE ACCOUNT

HANUMAN'S RETURN

To reach Lanka from the mountains, Hanuman had to pass over Ayodhya. Bharata saw him and was suspicious of the fearsome creature that seemed to be flying over Rama's realm with a mountain.

He shot at Hanuman who fell with Rama's name on his lips. Hearing his brother's name, Bharata prayed that Hanuman be revived and then aided his journey by placing him on an arrow and then shooting it.

AN 1850 FOLIO FROM PAITHAN, MAHARASHTRA, depicting Bharata shooting down Hanuman

The Last Battle

As Lakshmana recovered, he told Rama that he wanted Ravana dead by sundown.
Rama, encouraged by his beloved brother's words, stepped into the battlefield
for what would be the war to end all wars.

Rama embraced a revived Lakshmana and said, "I am so fortunate to see you returned from the dead – for I would have had no reason to live had you departed."

Pained by these defeated words, Lakshmana replied in a weak voice, for he was still recovering, "Having vowed to kill Ravana and install Vibhishana as the king of the Rakshasas, you ought not to despair like this. Sinless one, those like you do not make false vows. Do not despair on my account. Fulfil your vow. Your enemy will not return alive from the path of your arrows. I desire to see Ravana dead before sundown today."

Indra's gift

Rama heard Lakshmana's words, rose, and released fierce arrows in Ravana's direction, but the Rakshasa struck them down easily. Rama stood on the ground, but Ravana was on his chariot. The Gandharvas who watched the battle from the heavens said that this was an unequal war. Soon, Indra, the king of gods, sent his own chariot, covered in bells and drawn by horses in golden harnesses, along with Matali, his charioteer, his bow, armour, and powerful weapons. Rama mounted the chariot and looked resplendent as he rode into battle.

The great war

Divine weapons clashed with each other on the battlefield, as Rama, who possessed the greatest knowledge of weapons, destroyed Ravana's Gandharvastra, the weapon of

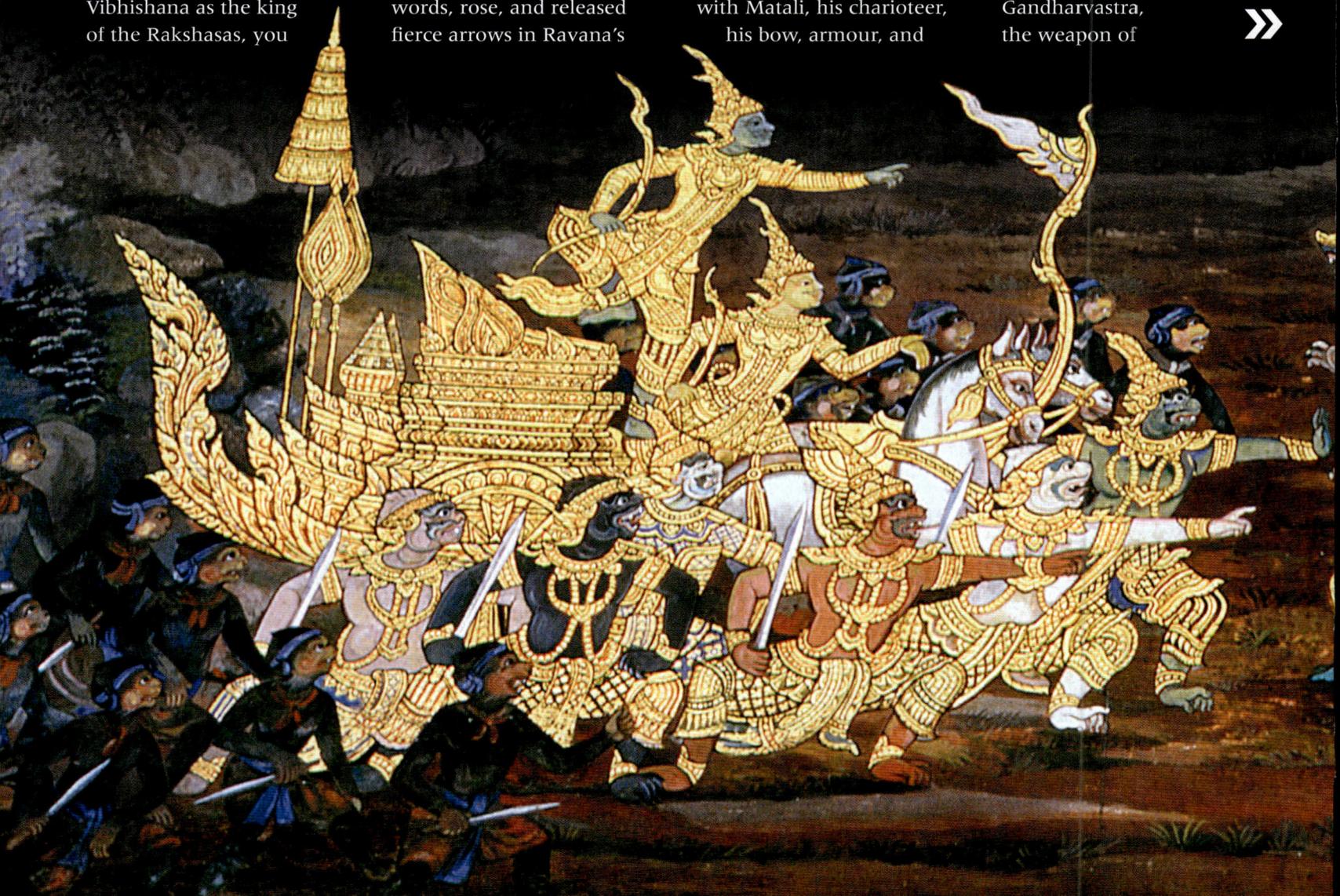

»

"O Kakutstha! **For your victory**, the one with the one thousand eyes has sent this chariot... This is Indra's great bow and this armour is like the fire. These arrows are like the sun and this **javelin is sparkling and sharp**. O brave one! **Mount this chariot** and **slay the Rakshasa Ravana**..."

MATALI TO RAMA, *SARGA* (90), YUDDHA KANDA

THE EPIC BATTLE
Rama and his army (left) stands against Ravana (right) in this battle scene as depicted in a wall mural at Wat Phra Kaew Temple in the Grand Palace in Bangkok, Thailand.

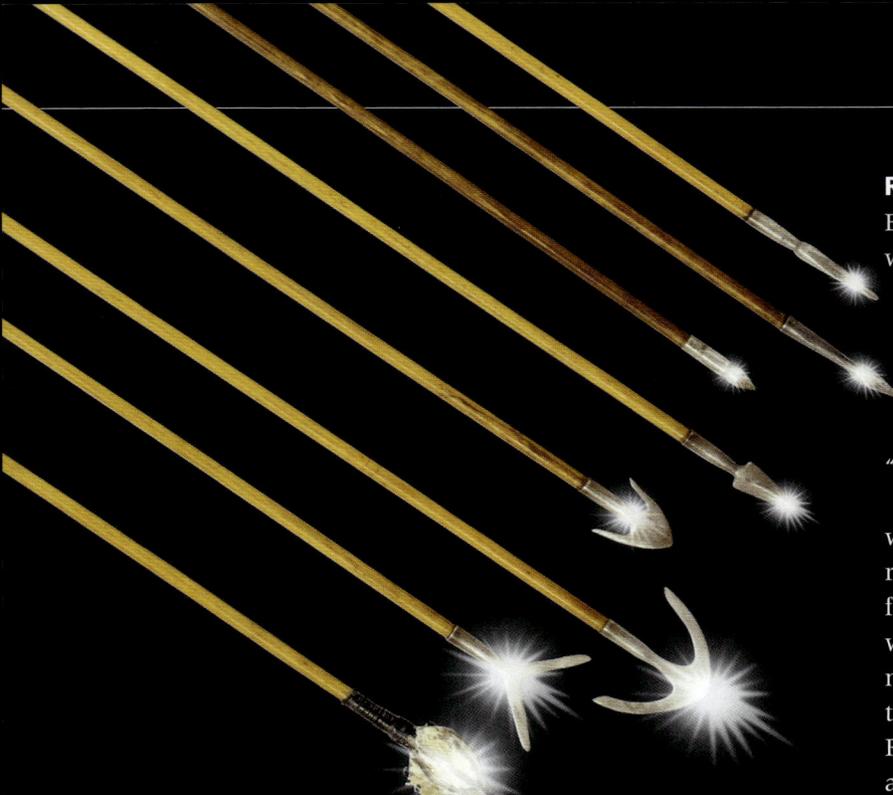

the Gandharvas. Furious, Ravana, the roamer in the night, released a weapon whose gold arrows turned into serpents in mid-air with fire that blazed from their mouths. Rama countered them with Garuda's weapon, which turned arrows into golden eagles, the enemies of snakes, who roamed the field and destroyed the snakes.

In retaliation, Ravana shot arrows at Matali and covered the chariot and horses with nets of arrows. So fierce was the attack that Rama was unable to place arrows onto the bow. The celestial beings were distressed, but Rama only became more furious, his brows furrowed, and his eyes seemed to exude fire.

ALTERNATIVE ACCOUNT

THE VICTOR'S CHARIOT

According to Awadhi poet Tulsidas, before Indra's chariot arrived, Vibhishana asked Rama how he would defeat Ravana standing barefoot.

Rama replied that the chariot that leads one to victory is quite different, its wheels are valour and steadiness, its flagpole and banner are truth and good conduct, its horses are strength, discriminatory knowledge, restraint, and acting in others' interests, its reins are forbearance, compassion, and equanimity, and its charioteer is remembrance of the lord. He added that dispassion is the armour and satisfaction, is the sword, the battle-axe is charity, and the intellect is the lance. Supreme knowledge is the firm bow and worship of the guru is the impenetrable armour. Anyone who possesses such a chariot can vanquish the enemy of rebirth.

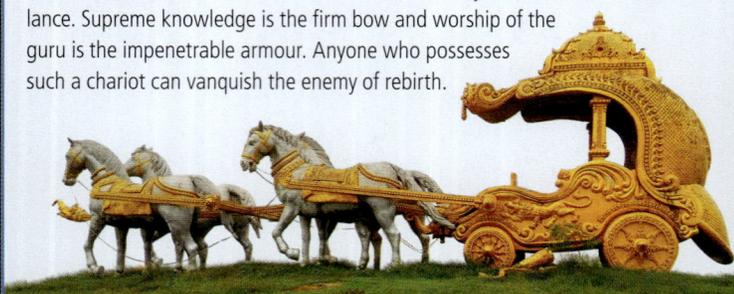

Rama's onslaught

Everyone ran to take shelter when they saw Rama's fury. The earth shook and the ocean rose in gigantic waves. The gods cried out for Rama's victory, while the Asuras shouted, "Victory to Dashagriva!" Ravana conjured another weapon that emitted a loud roar and smoke appeared from its pointed end, a weapon even Death could not ignore. The king released the dreaded weapon, but Rama countered it with his arrows and reduced it to dust. He then raised Indra's javelin, and as he got ready to throw it, bells rang. Rama flung the javelin at the lord of the Rakshasas, who fell to the ground. Soaked in blood, Ravana's eyes were now red with rage.

The battle continues

Arrows rained from the sky like rain and it grew so dark that Rama and Ravana were unable to see each other. Rama, the slayer of enemies, addressed Ravana in harsh words, "O worst of the Rakshasas, you think you have valour, yet you abducted my wife while I was away. You are not brave, but a shameless coward. My arrows will bring your death today."

He was determined to kill Ravana and his valour and strength of weapons doubled. The arrows rose swiftly to his hands, even as divine weapons manifested on their own accord.

MYTHOLOGY

AGASTYA'S INTERVENTION

When Rama is beginning to become weary, Sage Agastya comes to the battlefield in person and initiates Rama into the practice of the *Aditya-hridaya*, a potent hymn in praise of the sun, which is a complex mystical symbol. This hymn appears in some recensions of Valmiki's *Ramayana*.

Understanding the auspicious omens, Rama aimed volleys of arrows at Ravana.

A charioteer's decision

Ravana tried his best to counter the weapons, but they did not serve any purpose, for the time of his death had arrived. Ravana's charioteer realized that his king was about to collapse and gently withdrew from the battle.

When Ravana realized what he had done, he roared, confused and angry. "You are an enemy in a friend's guise," he raged. "Worthless coward, you have destroyed the glory, fame, and valour which took me years to build. How dare you remove the chariot from the enemy's presence, with little regard for my wishes? Now return, I wish to face the enemy before he leaves!"

The charioteer, who was a well-wisher, explained himself. "I am neither a coward nor a fool, nor do I lack affection for you. I have, rather, protected your fame and glory. I know that you and the horses are exhausted. A charioteer must always

"In his **heart lives Sita**, in Sita's heart is My [Rama's] abode. In My belly there are **many worlds**; if the **arrow strikes**, it means the **destruction of them all**."

TRIJATA TO A WORRIED SITA WHO WONDERS WHY RAMA IS UNABLE TO DEFEAT RAVANA, *RAMCHARITMANAS*, BY TULSIDAS

know about the time and the place; he should be able to read the signs and know the warrior's weakness. I have not acted out of my will, but was rather driven by my affection for you. I withdrew so that you could rest, as could your horses. Now command me, and I shall do as you say."

Calmed, Ravana praised his charioteer and asked him to return. "Ravana does not retreat without killing the enemy in battle," he said.

The omens

Soon, Rama saw Ravana's chariot return and stand before him. He requested Matali to control the reins and drive the chariot quickly. "Do not be distracted. Do not be frightened," he said. He explained that his intention was not to instruct Indra's charioteer, but to remind him, so that he could focus on killing Ravana.

The sages, gods, and Gandharvas gathered in the sky and prayed for the end of the lord of the Rakshasas.

Terrible omens appeared in the form of white rays that descended from the sun and on to Ravana. Storms appeared and giant meteors fell, even as large vultures roamed the sky. The Rakshasas grew scared

for they knew that misfortune was about to befall their leader.

The final move

As Rama and Ravana faced each other, the Rakshasa and Vanara armies ceased to fight. Ravana, as if ablaze, shot arrows at Rama's horses and at Matali. Rama grew angry and released a volley of weapons at the king. The earth and the oceans were agitated and the celestial beings prayed for the well-being of the worlds.

The charioteers expertly guided the two chariots as Rama and Ravana struck each other with arrows, countering each attack and each blow. The earth, mountains, and forests trembled, the winds stopped blowing, and the sun lost its radiance.

THE VALIANT WARRIORS
This statue of Rama engaged in combat with Ravana is made of recycled ship brass.

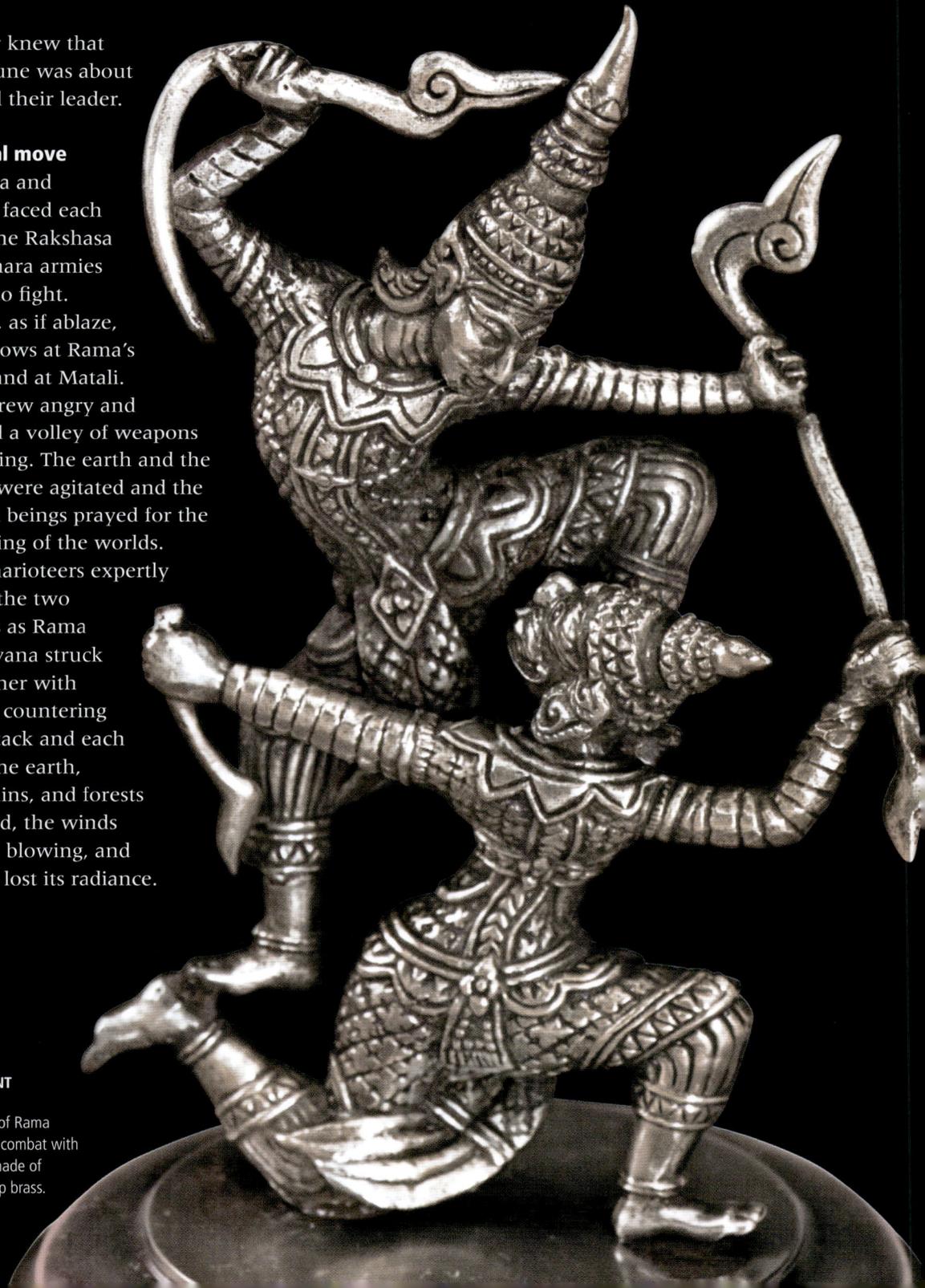

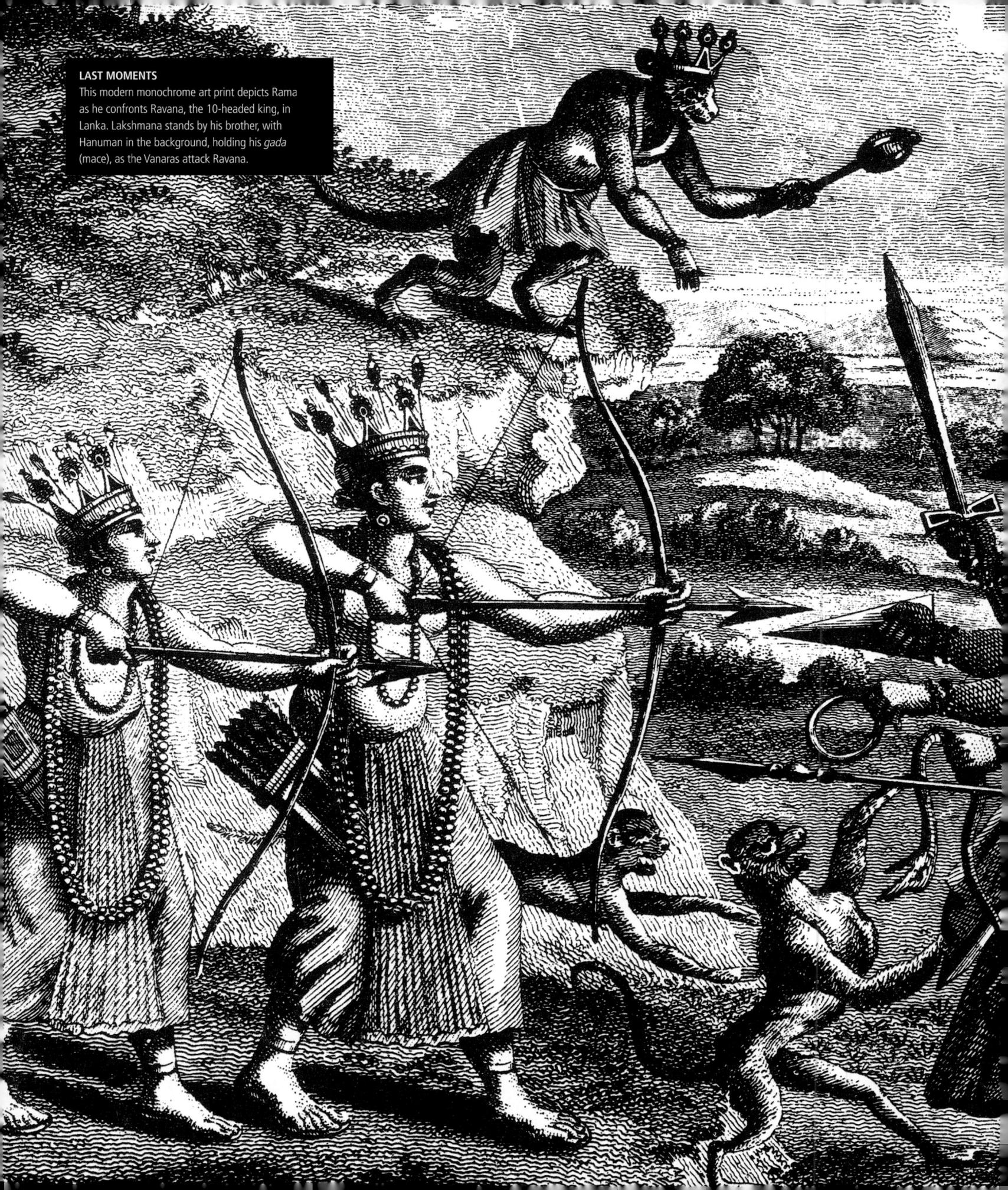

LAST MOMENTS
This modern monochrome art print depicts Rama as he confronts Ravana, the 10-headed king, in Lanka. Lakshmana stands by his brother, with Hanuman in the background, holding his *gada* (mace), as the Vanaras attack Ravana.

The Death of **Ravana**

The two great warriors, Rama and Ravana, faced each other. The omens were clear. Ravana's end was near, but he still had a few tricks up his sleeve.

The gods, Gandharvas, sages, and giant serpents prayed for the well-being of all creatures. "May the worlds remain till eternity. May Raghava be victorious over Ravana," they said.

Rama released an arrow that severed Ravana's head. But lo! Another head replaced it. He quickly shot another arrow, but another head replaced the severed one. He severed 100 heads this way and there was no sign of Ravana's end. Rama wondered why his arrows that had killed the fiercest of Rakshasas, now ceased to be efficacious.

Matali spoke up, "O brave Raghava, why do you act as if you do not know what must be done. The time for Ravana's destruction, which the gods spoke of, has come. Use the Creator, Brahma's weapon and kill him."

Rama raised the arrow that the sage Agastya had given him. It had the wind in its feathers and fire and sun in its points. The body was made from space and it was as heavy as the mountains Mandara and Meru. Its energy came from all the elements and it was as radiant as the sun. It sighed like a serpent and was as fearful as Yama, the god of death.

Rama invoked its powers through the prescribed mantras and released it. As irresistible as death, the weapon cut through the air like a thunderbolt and shattered the evil-souled Ravana's heart. The terrible Indra among Rakshasas fell down, dead.

> **"The arrow,** which could bring an end to the body, was released with great force. It **shattered the evil-souled Ravana's heart**... It took away Ravana's life..."

RAVANA'S DEATH, *SARGA* (97), YUDDHA KANDA

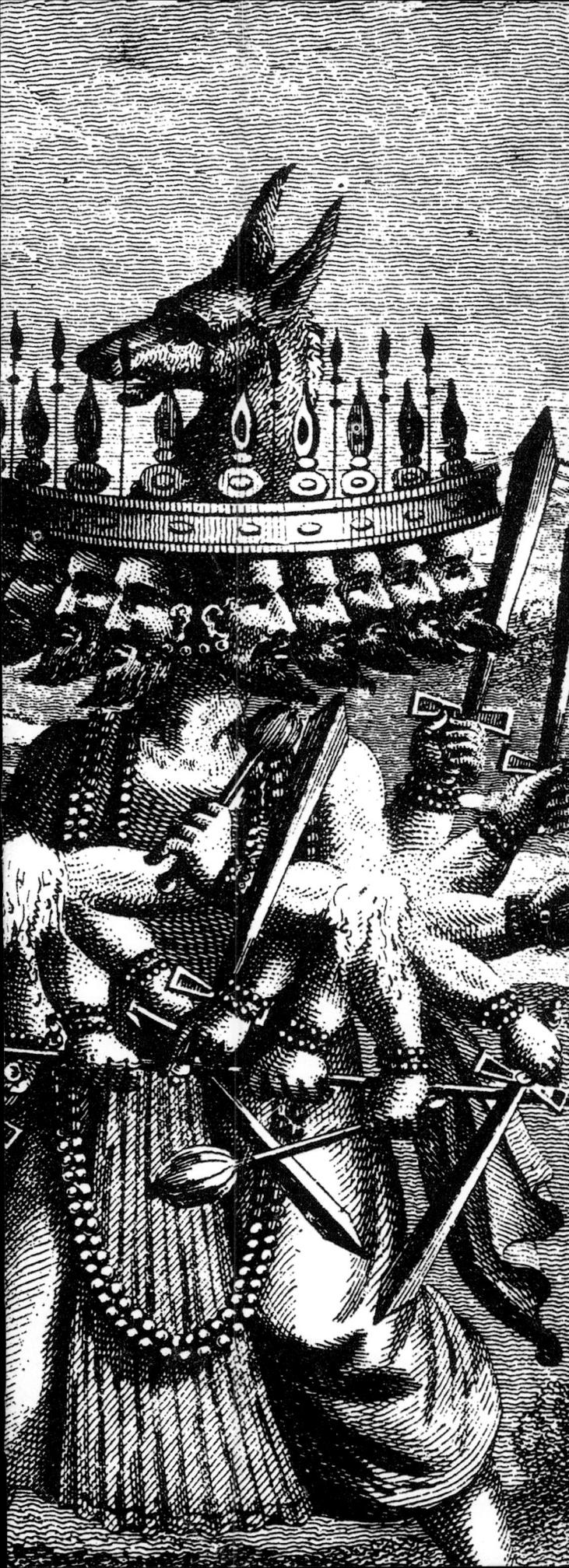

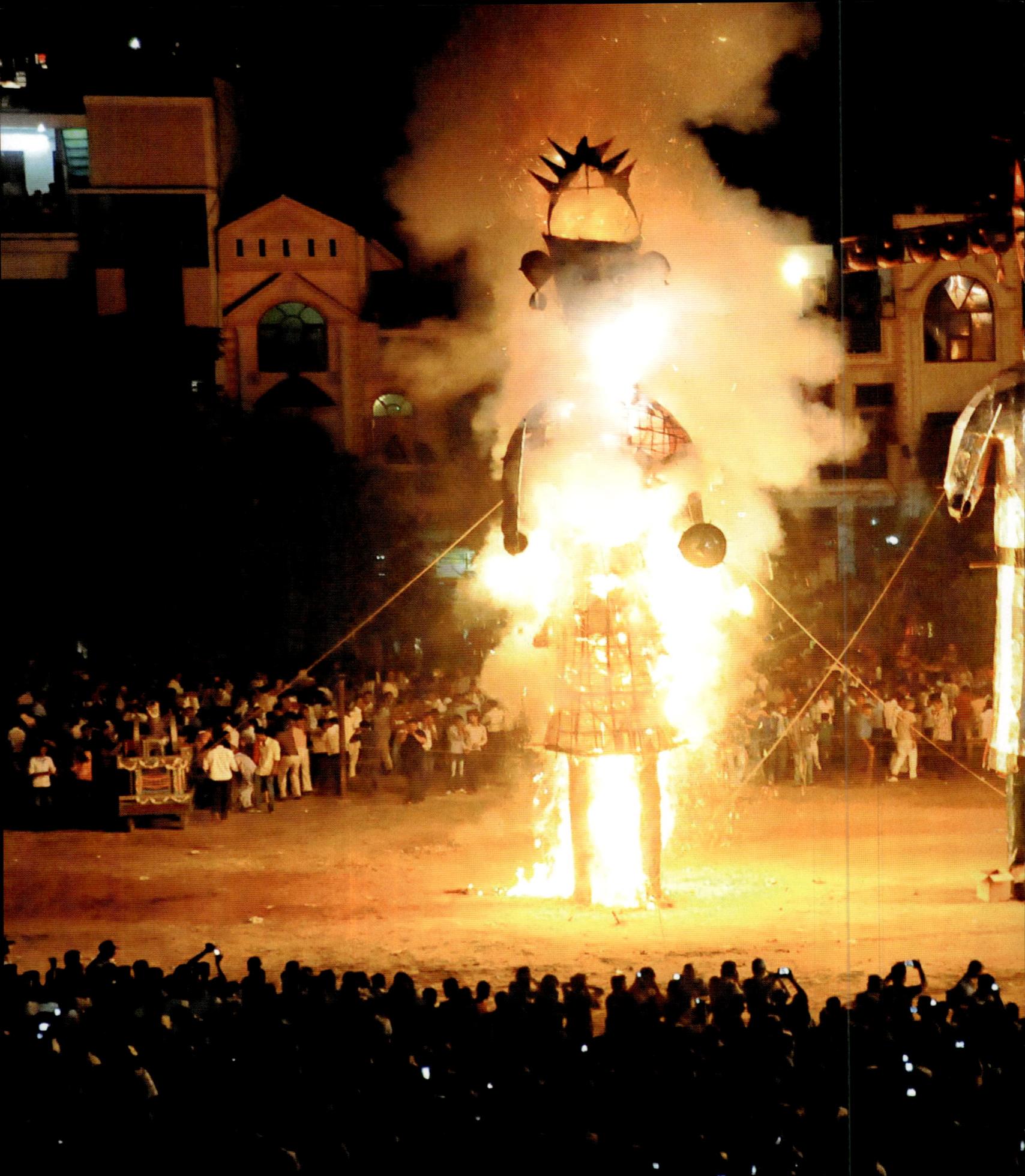

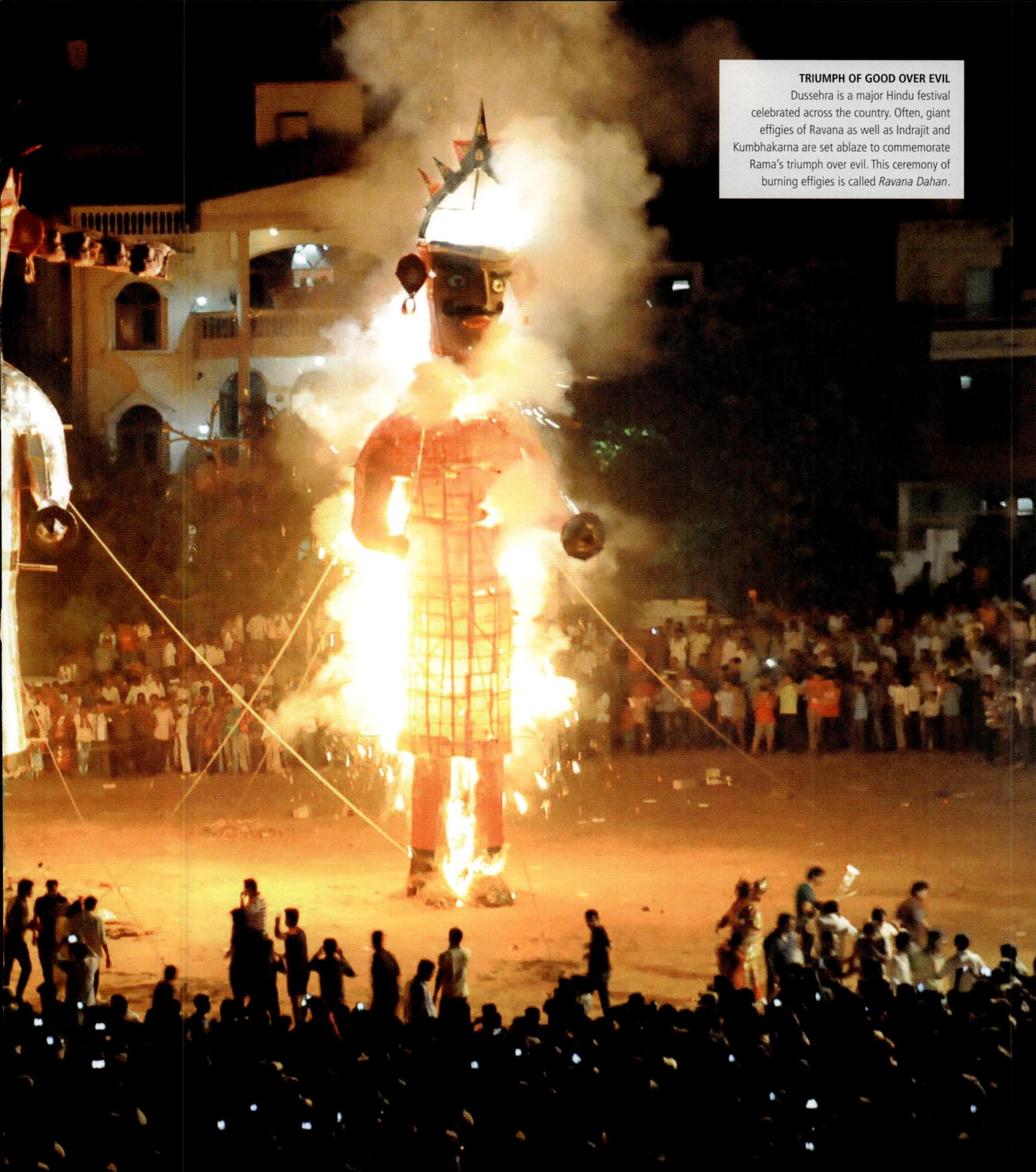

Ravana's Funeral

The reverberations of Ravana's death were felt across the kingdom, which soon succumbed to a wildfire of despair that ran amok amongst the Rakshasas and the king's many wives.

The Vanaras roared triumphantly at Rama's victory and at the death of the king of the Rakshasas. Fortunate omens appeared, as a fragrant breeze began to blow, flowers were showered upon Rama, and the gods played auspicious instruments. Vibhishana, Sugriva, Jambavan, Hanuman, and the chief commanders of the Vanara army went to Rama and accorded him all honour.

A husband's death

The Rakshasis heard of Ravana's demise and rushed out of the inner quarters, their hair loose. They exited from the northern gate, crying for their husband, and rushed through the ground, which was covered in blood. They saw the mighty Ravana, fallen to the ground, and wept. One of them grasped his feet, another held on to his neck, while one placed his head on her lap, regarding it with unspeakable affection.

They lamented, "You who terrified Indra and Yama sleep on the ground, killed in battle. You were fearless in the face of all beings, but now lie dead. You did not regard the advice of those who wished you well and told

> ## "With death, enmity ends and we **no longer** have any need for that. He **belongs to me**, just as he does to you."
>
> RAMA TO VIBHISHANA, *SARGA* (99), YUDDHA KANDA

you to stop. You rejected Vibhishana, and held Sita here against your will – thus killing yourself, the Rakshasas, and us, who are now bereft of you."

Moment of truth

His chief wife, Mandodari, cried, "Ah, large-armed hero! The king of gods, Indra himself was afraid to face you in battle. Gandharvas and celestial sages would flee at your sight. Yet, you were killed by a mere man in battle! I do not believe Rama could have defeated you.

"You first vanquished your senses, and then vanquished the world. It is your senses which finally emerged victorious. Or perhaps, Indra himself has appeared as Rama. He killed Khara and the 14,000 Rakshasas (See pp 140–41), and that was hardly a human deed. I advised you against fighting Rama, but you did not listen. Look at what has happened now. Your obsession for Sita

THE MOURNING WIVES
This 17th-century miniature painting by Sahibdin shows a portion of the artwork where Ravana's wives, including Mandodari, surround the king, mourning his death.

ANALYSIS

LAMENT OF THE WIVES

Descriptions of arch-enemies in Indian epics typically exalt their valour. One of the ways their humanity becomes evident is through the laments of their wives. There are three women who weep for their slain husbands in the *Ramayana* – Taaraa for Vali, Sita when Ravana shows her the illusory head of Rama, and Mandodari. There are some stock motifs, such as the idea of the earth as a jealous co-wife, which works in two ways – in life, a king who seeks to conquer other lands often has to stay away from his wife, and in death, he sleeps on the earth instead of his wife's arms.

In later literature, some of Sanskrit poet and dramatist Kalidasa's most powerful writing occurs in the lament of Rati, the consort of Kama, the god of love. It plays on some motifs seen in the *Ramayana*, when Kama is not killed in a battle, but burnt while trying to effect infatuation in Shiva's heart.

AN 8TH-CENTURY stone statue of Kama

was destined to end this way, and I am rendered to this state, bereft of you. My brother-in-law was right. There is no reason to grieve for you, for your prowess and valour are well-known. I grieve because of my own pain. I am anguished at my separation from you. You do not even look upon me. Shame on my heart, which does not shatter into a thousand pieces!"

For dharma's sake
Rama instructed Vibhishana to perform Ravana's funerary rites and return the Rakshasis to the fortress.

Vibhishana, however, hesitated, for, how could he perform the last rites for one such as Ravana, who had abandoned dharma so completely? "He was an enemy in a brother's guise and desired to harm all beings. Ravana does not

deserve honour even though he may be honourable as my older brother. People may think I am cruel at first glance, but I am sure they will understand," he said.

Rama, the very best of those who bear dharma, said, "I have won this battle because of you, and as such, ought to do as you will. However, listen to what I have to say. It is true that he was engaged in adharma and

falsehood. However, he was always invincible and valiant in battle. In any case, all enmity ends in death. What we sought has been achieved. Perform his last rites, Vibhishana, for he is to me what he is to you."

Vibhishana arranged for Ravana's final rites, offering him water, and sent Ravana's wives back to the fortress after comforting them.

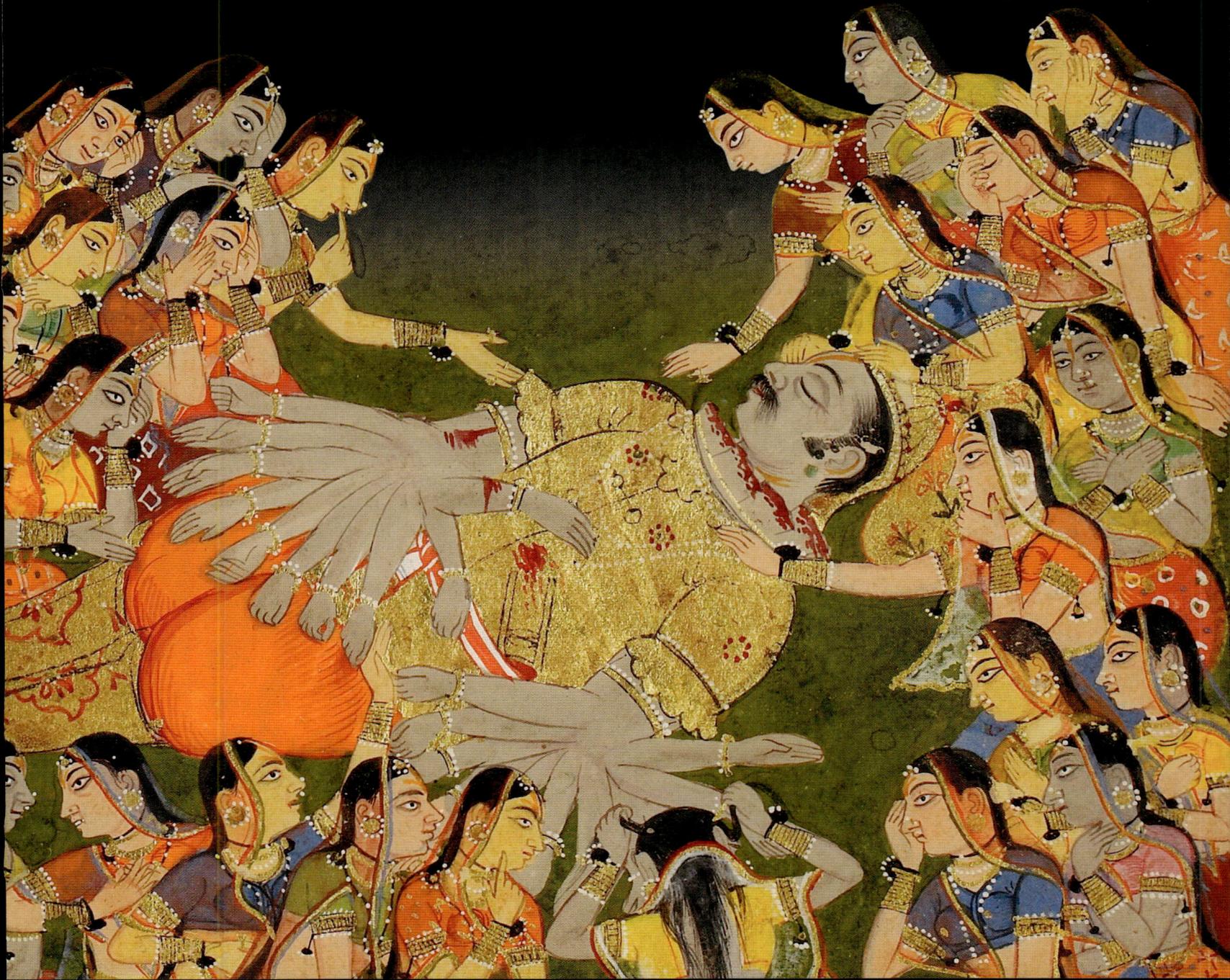

Long Live the King!

Once the funeral rites for Ravana had come to a close, Rama requested Lakshmana to crown the wise Vibhishana as the new king of Lanka. He, then, turned to Hanuman with a special request.

Rama, resolute in his vision to enthrone Vibhishana as the new lord of the Rakshasas, turned to Lakshmana, who was standing by his side, "Consecrate Vibhishana as king, he who is affectionate and devoted, and to whom we are indebted. It is my supreme desire to see him consecrated in Lanka."

Lakshmana did as Rama commanded and the two princes of Ayodhya delighted in his coronation. After he had comforted his subjects, who had just lost their king, Vibhishana went to meet Rama, and took with him auspicious offerings. Seeing Vibhishana attain what he sought, Rama accepted the gifts.

A vow fulfilled

Rama then turned to Hanuman, who stood nearby. He said, "Best of the victorious Vanaras, inform Sita that Lakshmana, Sugriva, and I have emerged unhurt from the battle and that Ravana has been slain. Since Vibhishana is now the king, take care to enter and exit the royal complex with great courtesy. Convey this to Sita and return with her message."

Hanuman entered Lanka and all the Rakshasas honoured him as he passed them. He entered Ravana's residence for the second time, but under completely different circumstances, for it now stood desolate.

VIBHISHANA'S CORONATION
This Mughal watercolour painting in ink and gold, from 1597–1605, shows Vibhishana being crowned the king of Lanka.

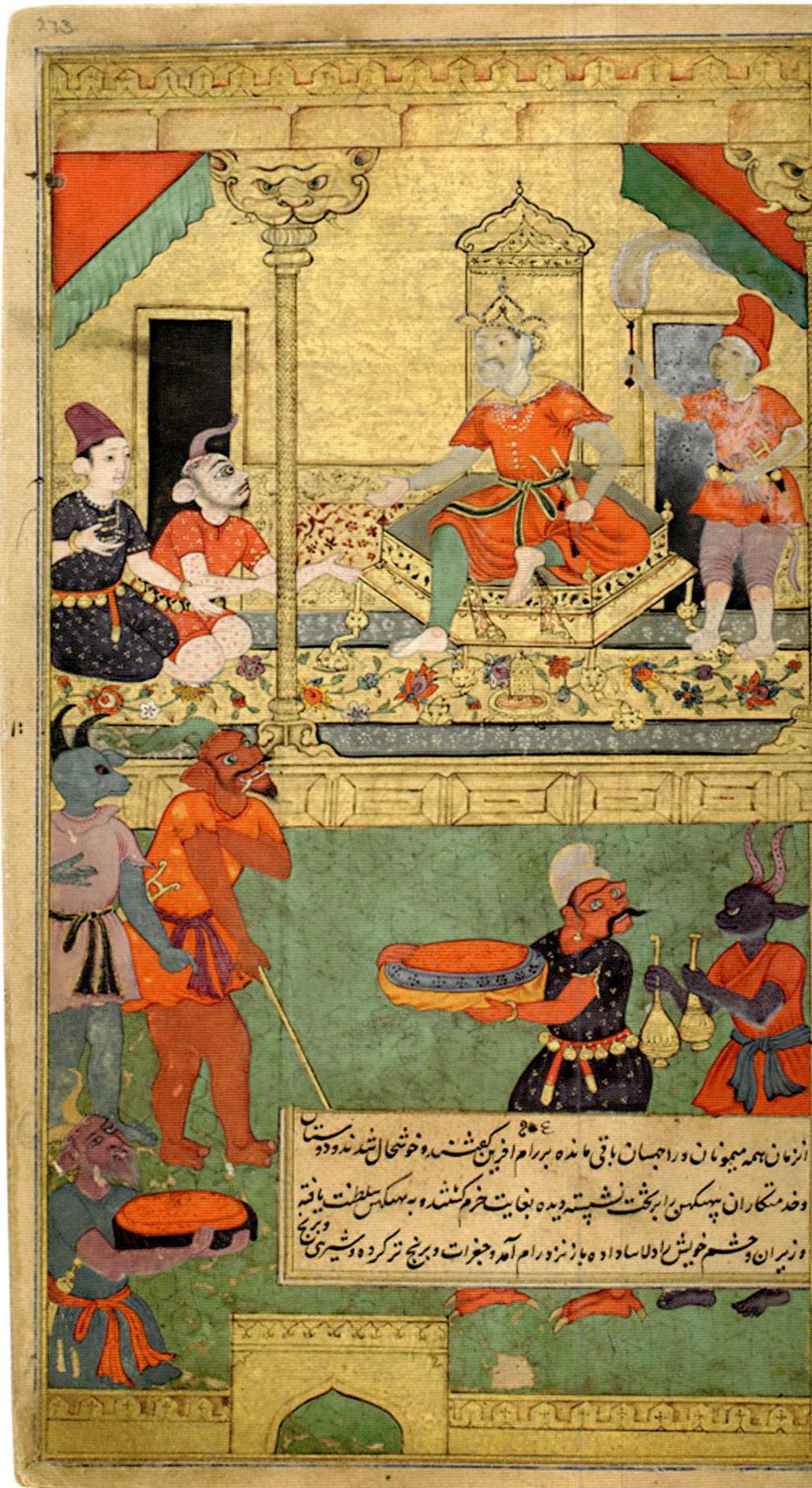

He found Sita and said, "Revered lady, Rama is well, along with Sugriva and Lakshmana, and asks after your well-being. Rama, assisted by Lakshmana and Sugriva, with the Vanaras by his side, has killed Ravana.

"Supremely delighted, Rama has sent you this message, 'I am sending you good news, beloved lady! Renounce your fear We have won, Sita, be happy, be steady! I have fulfilled my vow. Do not worry about being in Ravana's palace. Vibhishana is now the king, so you are as safe as in your own house.'"

At a loss for words

Sita rose, but overcome with emotion, could not speak. Hanuman grew concerned, "What are you thinking? Why do you not say anything to me?"

When Sita spoke, her speech was indistinct, so great was her joy, "Hanuman! You have brought me news of Rama's victory – I could not say anything for sheer joy. I cannot think of anything at all that could equal what you have given me – not gold, not gems, not even the lordship of the three worlds." Hanuman, his palms together in supplication, said, "You alone could have

AN 11TH-CENTURY Chola bronze sculpture of Hanuman from Tamil Nadu

spoken thus. Your words are more distinguished than the things you have listed. And I have attained all there is to attain in seeing Rama victorious.

"I seek your permission; these Rakshasis who tormented you while you were in captivity deserve to be killed. I wish to inflict cruel deaths upon them."

Compassionate Sita

Sita said in a gentle tone, "Best of Vanaras, why do you rage against those who were dependent on royal protection, and merely obeying commands? Whatever happened to me must have been a result of my own actions. Who are we to punish? Is there anybody who does not sin? We ought to regard all beings with compassion."

Hanuman replied, "You are indeed a fitting consort for Rama! Now tell me what I should take to him as

> "The **wicked do not deserve to be killed.** Since there is no one who does not commit a crime, it is better... to **show them compassion.**"
>
> SITA TO HANUMAN, *SARGA* (101), YUDDHA KANDA

your message?" Sita, however, had one simple wish. "I want to see him," she said.

Sita's wish

Hanuman reassured her, returned to Rama's side, and urged him, "Please, meet with the revered lady for whose sake you undertook this entire endeavour. Grief torments her and her eyes are brimming with tears. She is overjoyed at the news of your victory and wishes to see you soon."

Hearing this, Rama grew silent for a moment, his eyes filled with tears, and he sighed deeply. He stared at the ground, as he told Vibhishana standing nearby, "Bring Sita before me, cleansed, and adorned with divine ornaments."

ALTERNATIVE ACCOUNT

SITA DURING THE FINAL BATTLE

Sita does not always appear as waiting quietly in the Ashoka grove. In 20th-century Kannada poet KV Puttappa's rendition, translated by well-known writer Shankar Mokashi Punekar, Ravana proceeds to meet Sita once before departing for the final battle, but instead, is overwhelmed by a vision of her hut burning. Upon hearing that he tried to approach her but left, Sita says "his thread of Maya is broken. Mother Adishakti/ Flies kites of lives. Now on, the king's life-kite is racked/ And left to time's control."

Sita then speaks of the primacy of karma, and how all the spectacular events are affected by the entwined threads of the actors' karma. She remarks that her "preternatural powers" have been affected by constant repetition of Rama's name and immediately after, decides to engage in penance in order to assist Rama.

DANCER PADMAJA REDDY as Sita, performs in a *Ramayana* dance ballet

The Test of **Truth**

Sita prepared to meet Rama, ecstatic at the thought of finally reuniting with her beloved. Yet, this meeting would prove to be much more than a moment of loving union. It would leave Sita heartbroken and, at the same time, reveal to Rama, the ultimate truth.

Vibhishana hurried to Lanka and told Sita that Rama wished to see her. She wanted to leave immediately, but he said that Rama wanted her to be bathed, dressed, and ornamented. Devoted to Rama, she allowed the

OVERJOYED SITA
Elated at the thought of meeting Rama, Sita was ornamented in exquisite jewels and adorned in fine clothes. This Thai pantomime actor portrays Sita.

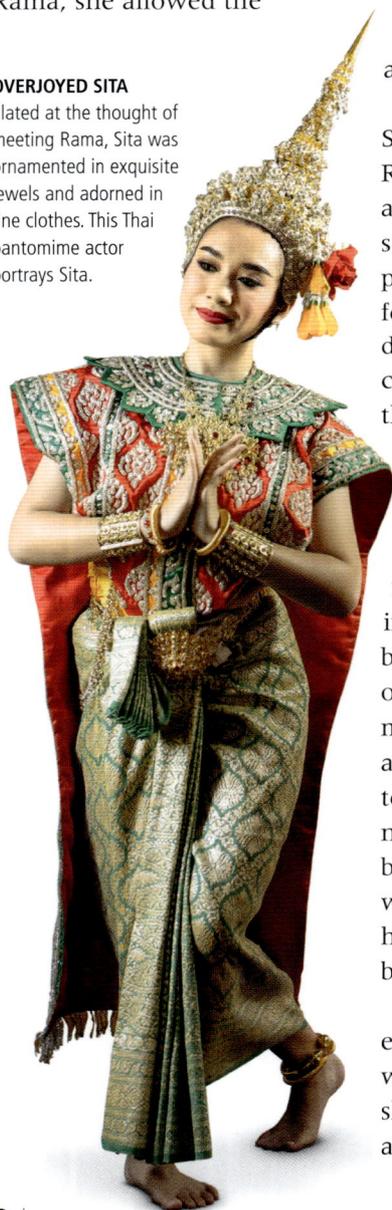

young maidens to bathe and ornament her, and then boarded a beautiful palanquin. When she had arrived, Vibhishana, supremely pleased, told Rama of Sita's arrival. The prince, who had been sitting in contemplation, was filled with joy, tenderness, and anger, all at once.

Many guards surrounded Sita as she walked towards Rama. As the Vanaras, bears, and Rakshasas clamoured to see her, men wielding canes pushed them away, and forced them to stand at a distance. "Stop it!" Rama commanded, angry to see them being treated like this. "Why are these people being warded off? They are like my kin. In any case, a woman may be seen in times of calamity, in war, in adversity, while choosing a bridegroom, during a ritual observance, or at the time of marriage. Sita was in a war and has been through a terrible calamity. There is nothing wrong with her being seen, particularly when I stand close by. Let her see me here, surrounded by my well-wishers."

Distressed, Vibhishana escorted Sita to Rama, who shrank into herself in shyness. Lakshmana, Sugriva, and Hanuman sensed that

something was not right, for Rama seemed uncharacteristically harsh. She reached Rama and wept, calling out to him affectionately. "O noble one," she exclaimed, filled with joy, disbelief, and love, and looked up at her beloved's face.

Cruel words
Anger raged in Rama's heart and he said, "Fortunate one, I have vanquished the one who abducted you and his army, and have freed you. I have done what honour demanded of me. My anger is at an end, for the insult and the enemy have both been wiped off. Today, my valour is proven, and the efforts of Hanuman, Sugriva, and Vibhishana have borne fruit."

Sita's eyes filled with tears at these cold words. Rama's brows furrowed as he continued, "Let it be known that this endeavour was not

> " Having **suffered** a false accusation, I am not interested in remaining alive... I should **enter a fire**, the **destination** for those who do not have a destination."
>
> SITA TO LAKSHMANA, *SARGA* (104), YUDDHA KANDA

for your sake but to wipe the blemish on me as your protector and on my lineage. I have no attachment to you. You may go where you will. It is impossible that Ravana saw you, with your divine form, and let you remain in his house, safe."

Defending her honour
Rama's cold and cruel words left Sita humiliated. She wiped the tears from her face and spoke slowly, "Mighty hero, why do you speak to me in the way that lesser men speak to women? Things are not as you think they are. I swear upon my conduct. Abandon your suspicion, Rama. »

SITA ENTERS THE FIRE
A Mughal painting from 1600 portrays the moment Sita enters the fire, as Hanuman, Sugriva, anc Jambavan (foreground) look on, horrified. Rama and Lakshmana (left) and the gods Brahma, Shiva and Indra (right) can be seen on either side of the fire.

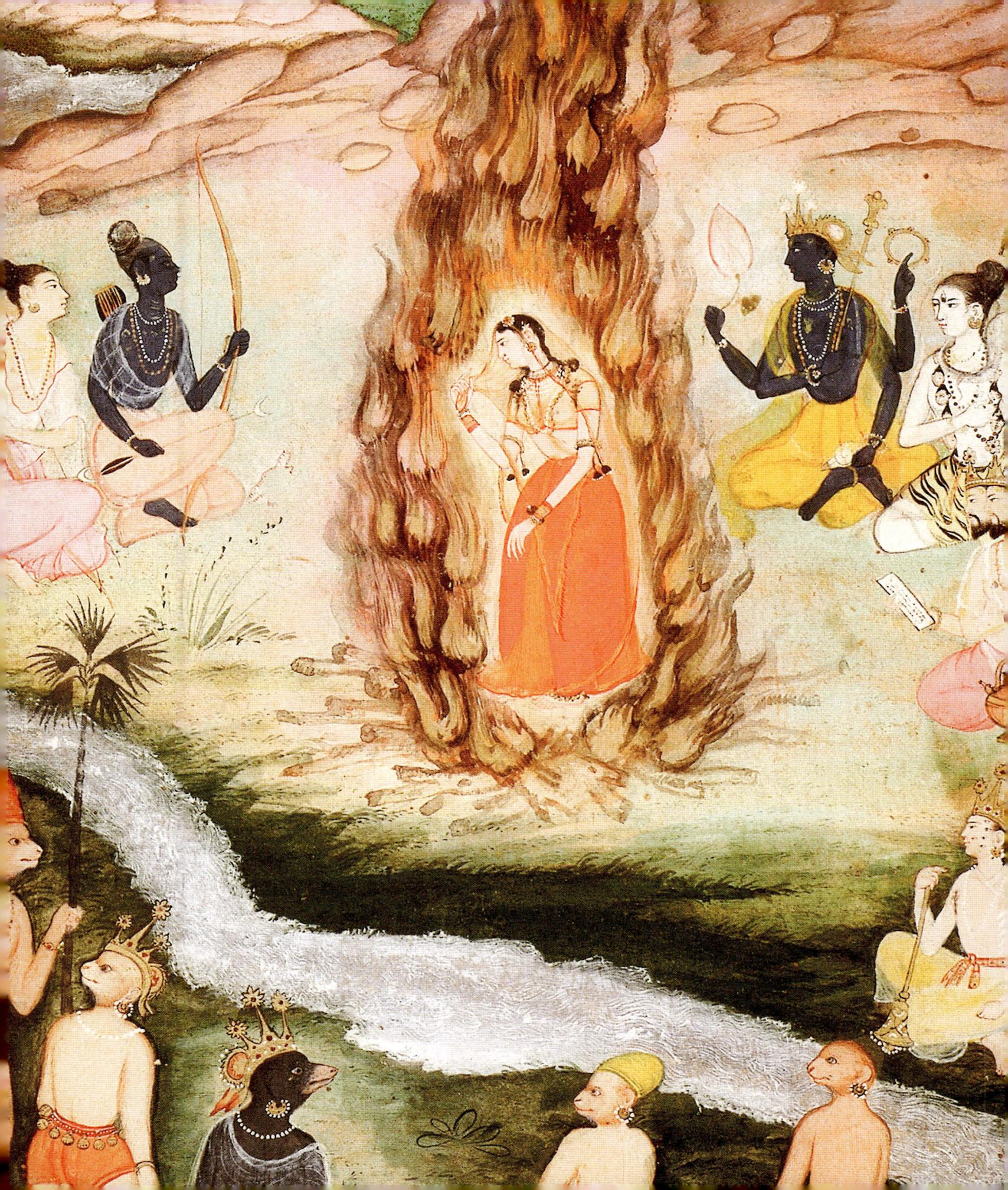

"**What need has she for another purifier**, who is **purified by her birth** – sacred waters and fire do not require purification from elsewhere."

RAMA, *UTTARARAMACHARITA*, BY BHAVABHUTI

Ravana only ever touched me without my consent. What could I have done when my body was under the control of another? As to my mind, however, and my heart, which I do control – they have ever been fixed upon you alone. I am doomed if after our years of shared love, you still do not know me. Why didn't you renounce me when you sent Hanuman? At least I could have ended my life at that moment.

"In your anger, Rama, you have neglected the fact that I was not really born of Janaka. I was born from the earth. You have neglected the hand that you held when we were children, and you have neglected my devotion and conduct."

Trial by fire

Sita turned to the distressed Lakshmana, who stood nearby, and said, her throat constricted by tears, "Make a pyre, dear Lakshmana, which will be the cure for this affliction. I do not wish to live with this false accusation, renounced publicly by my husband. I shall enter the carrier of oblations, the sacred fire, which is the only path left for me."

Indignant and resistant, Lakshmana looked at Rama, who did not soften at Sita's words, nor did he make a move to stop him. He realized his brother's intent through his expression and did as he was told.

Sita propitiated the gods and Brahmanas, her hands folded in supplication.

VISHNU'S AVATAR
This 18th-century illustration by French naturalist and explorer Pierre Sonnerat depicts Rama as the seventh incarnation of Vishnu with Hanuman by his side.

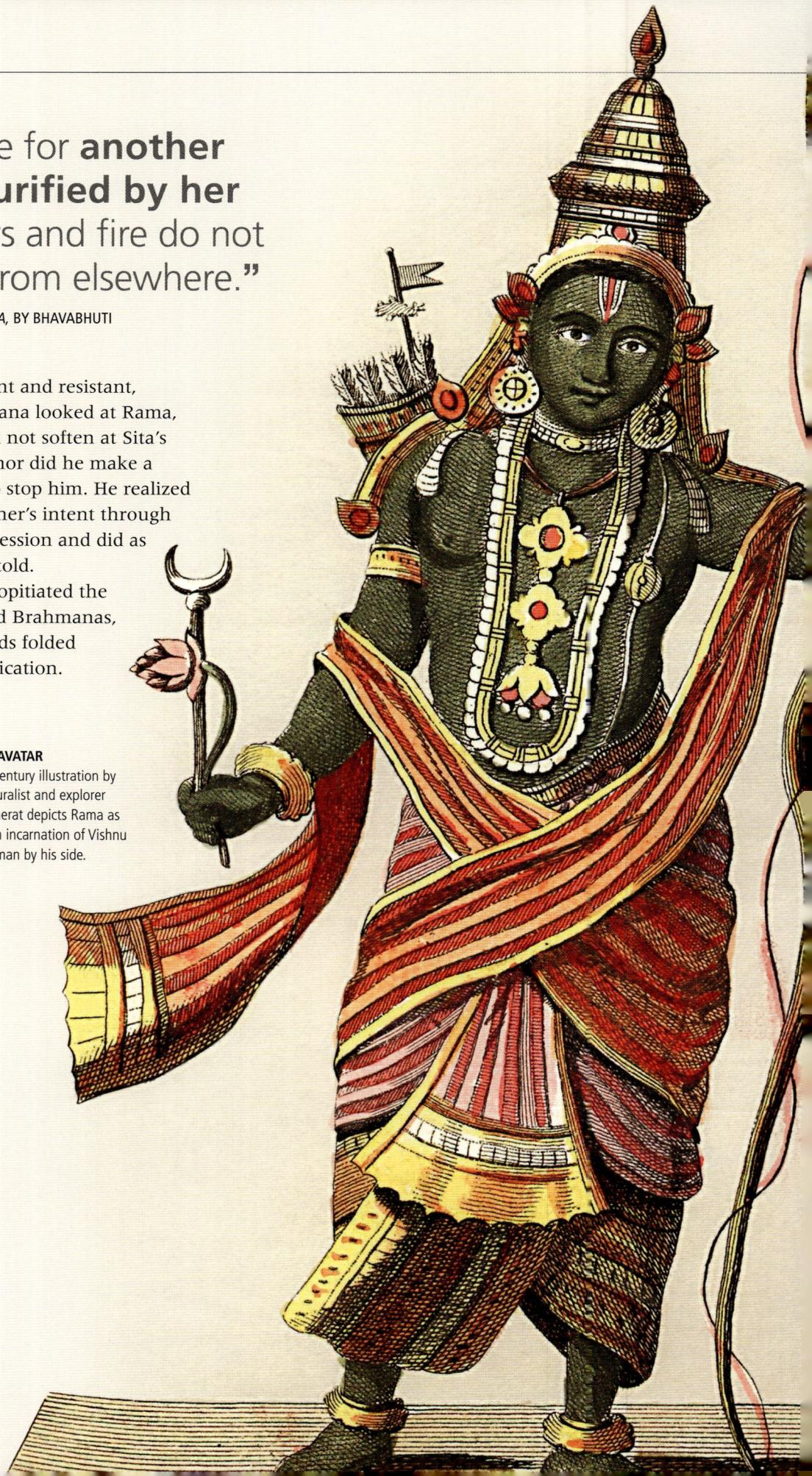

She stood by the fire and said, "My heart has not strayed from Rama for a moment – so protect me, O purifying fire." She circumambulated the fire and entered its flames without any hesitation. The entire gathering watched, horrified, as the Vanaras and Rakshasas lamented in dismay and shock.

Moment of truth

Kubera, the god of wealth, Yama, the god of death, Indra, the king of gods, Varuna, the god of water, and the Supreme Beings, Shiva, the Destroyer of the universe, and Brahma, the Creator, arrived at that very moment, in their vimanas (celestial chariot), as radiant as the sun.

They told Rama, "You make the world and are the best of the wise ones. Why do you disregard Sita as she enters the fire? You are the creator of all the worlds, the omnipotent lord. The Vedic twin gods, the Ashvins, are your ears and the sun and moon your eyes. Tormenter of enemies, you are present at the beginning and at the end of creation, so why do you ignore Sita the way a lesser mortal would?"

Rama folded his hands and replied, "I believe myself to be a mortal man, Rama, born to Dasharatha in the lineage of the Ikshvakus. Let the blessed one tell me who I am."

Brahma spoke up: "You are the blessed lord Narayana, the bearer of the discus. You are the constant Brahman (universe), who exists at the beginning, middle, and end of everything. You are the ultimate dharma of all the worlds, the bearer of the mighty bow, the lord of the senses. You are invincible, the Preserver of the universe, you are Vishnu.

"You are the sword-bearing, supremely powerful Krishna. You are the essence of the Vedas. You are the sacrifice. You are Om. You bear all beings and are seen as the immense serpent at the end of the world. No one knows your beginning or your end.

"I am your heart, and the goddess of learning and arts, Sarasvati, is your tongue. Your anger is the god of fire, Agni, and your grace is the moon. It is said that Night is when you close your eyes, and Day, when you open them. There is nothing without you.

"Sita is the goddess of wealth and good fortune, Lakshmi. You entered a human body to kill Ravana, and you have now done that for us. You are unfailing as is your valour – and they are unfailing who are devoted to you. There is no defeat for those who praise you."

"You are **intelligence**. You are the **spirit**. You are **forgiveness**. You are **self-control**. You are the **origin**. You are the **destruction**… **You are omkara**."

BRAHMA TO RAMA, *SARGA* (105), YUDDHA KANDA

"There is **No** Sin in Her"

When Sita, devastated at Rama's cruel words, stepped into the sacred fire, the gods gathered to address the exiled prince of Ayodhya. Agni, the fire god, emerged as well, holding Sita, a testament to her faith, purity, and loyalty.

Agni, the fire god, rose, and he held Sita on his lap. She was like the rising sun, dressed in red and adorned with gold ornaments and garlands that could never fade.

The witness of all beings and all worlds, the purifying Agni said, "This is your Sita, and there is no sin in her. Her speech, thought, and eyes have never strayed. Ravana abducted her and she remained in his inner quarters, guarded by Rakshasis. Her mind and vows were firmly placed in you, enticed and tortured in equal measure. Accept her, Rama, whose thoughts are pure and who is sinless, blameless. She should not suffer in any way. I am commanding you."

Rama said, "Sita needed to be purified before the three worlds, for if I had accepted her otherwise, people would have thought that I was driven by desire.

"I know that my beloved Sita is devoted to me alone. I remained silent for the three worlds to witness it. Indeed, her own brilliant radiance protected her.

"She is as impossible to grab as a fierce flame. Ravana could not even have mentally touched her. As for abandoning her, she is not different from me as light is not different from the sun." And so Rama was reunited with Sita.

> " She was like the **blazing flames of the fire** and there was **no question** of his **approaching** and **oppressing** her. "
>
> RAMA TO AGNI ABOUT RAVANA AND SITA, *SARGA* (106), YUDDHA KANDA

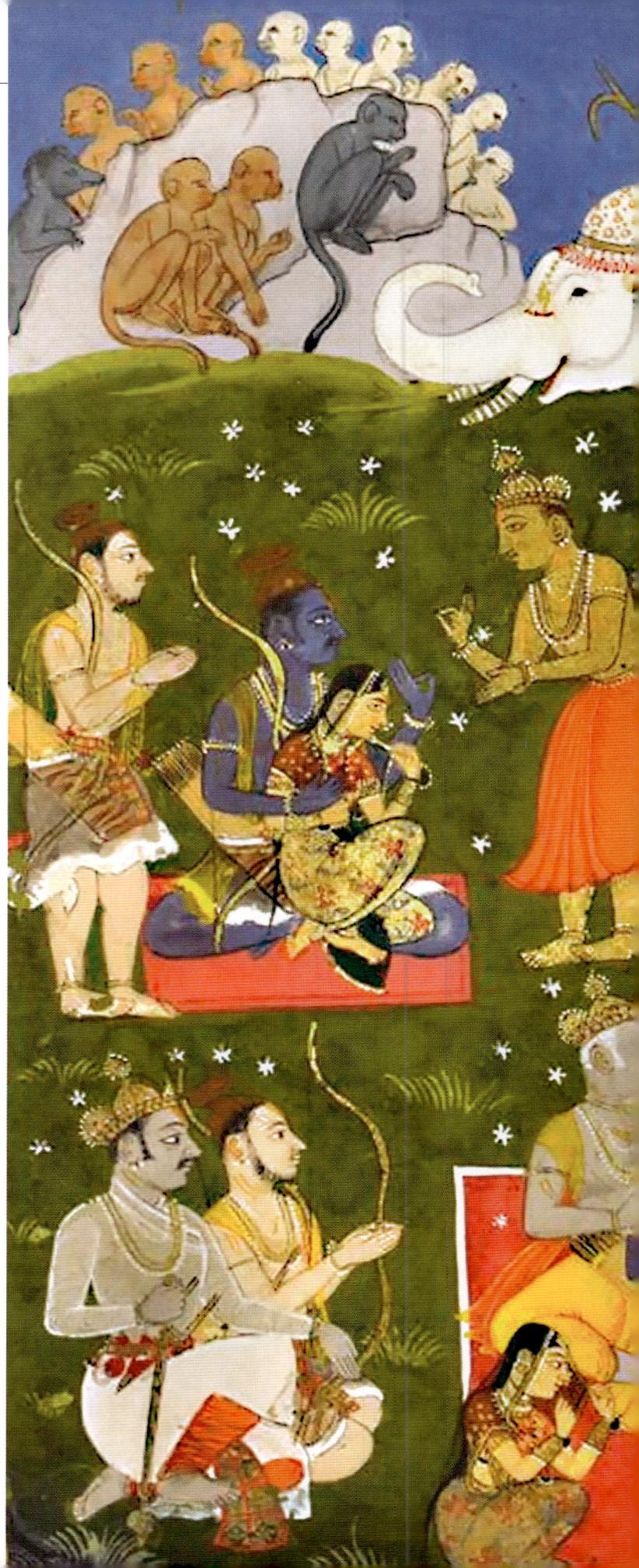

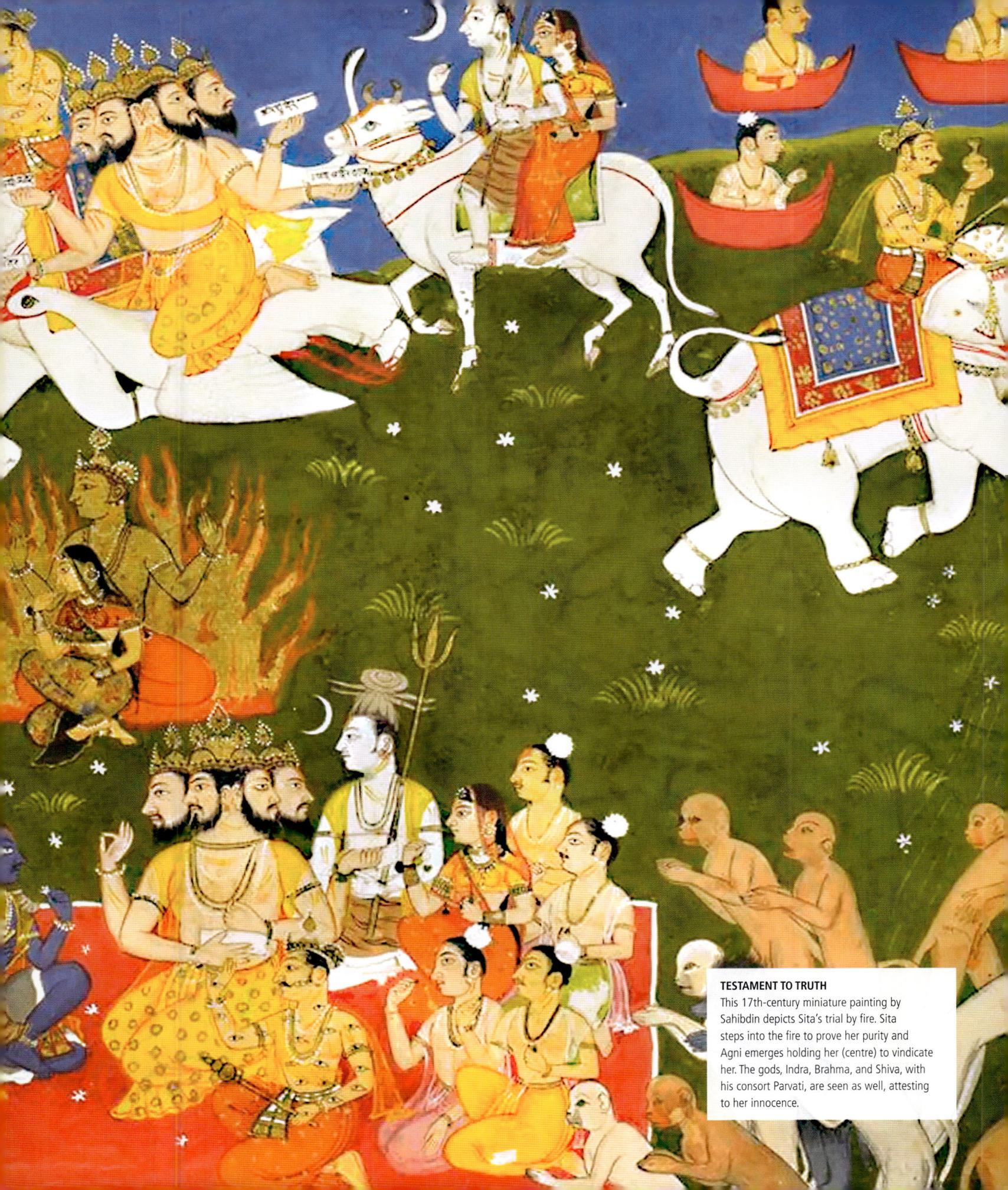

TESTAMENT TO TRUTH
This 17th-century miniature painting by Sahibdin depicts Sita's trial by fire. Sita steps into the fire to prove her purity and Agni emerges holding her (centre) to vindicate her. The gods, Indra, Brahma, and Shiva, with his consort Parvati, are seen as well, attesting to her innocence.

Aboard the Pushpaka Vimana

Rama was restless. He had won the war and was reunited with his beloved, Sita. Now, he wanted to return to Ayodhya, to see his dear brother Bharata, who had taken an oath to live an austere life until Rama's return.

> "I see that **you are well with Lakshmana** and I have embraced you. Today, I have been **freed from my misery**, like the sun from mist."
>
> DASHARATHA TO RAMA, *SARGA* (107), YUDDHA KANDA

Shiva, the Destroyer, praised Rama and expressed delight at his victory. He spoke of how Rama would return to Ayodhya and comfort Bharata and his mothers, perform the horse sacrifice, and establish his lineage before returning to the realm of the gods. He then presented Dasharatha, who had gone to the realm of Indra, the king of the gods, because of his son's offerings, and urged Rama to greet him.

A father meets his sons

Rama and Lakshmana greeted their father who was aboard a vimana (celestial chariot) and radiant. Dasharatha told Rama, "No joy equals the joy of seeing you. Having seen you well, and embraced you with Lakshmana, I am free from sorrows. Kaushalya is fortunate as she will see you return safely to Ayodhya, and the citizens are fortunate to see you dripping with the consecratory waters as their

king." He blessed his beloved son and said, "May you live long!" Rama requested for his father's compassion when it came to Kaikeyi and Bharata. "May the curse you uttered in abandoning her, not touch either of them," he pleaded.

Dasharatha granted him this wish and praised Lakshmana for his conduct. He asked Sita not to retain any anger for Rama's earlier words and momentary renunciation, and returned to Indra's realm.

Indra told Rama to ask him for anything he desired and the prince of Ayodhya asked that the Vanaras who had died for his sake in the war, be brought back to life. Indra granted this request and the gods returned to their abodes.

Homeward bound

The next morning, Vibhishana offered Rama a luxurious bath, clothes, and ornaments, but he affectionately declined and said instead, "Invite the Vanaras instead. I cannot

indulge in any of this, while my beloved brother, Bharata, who deserves all joys, he said, lives a life of restraint and firm vows for my sake." It was time to leave for Ayodhya.

Vibhishana offered him the Pushpaka, a chariot, which once belonged to Kubera and could take him to Ayodhya in a day. He said, "Please leave after I have honoured Sita, Lakshmana, and you. I can only request you, for I am, but a servant."

Rama replied with love and respect, "I have already been honoured by your advice and friendship. It is not that I do not wish to do as you say, it is just that I cannot wait to see Bharata."

Rama had last seen Bharata in Chitrakoot (See pp 116–17) when he refused to return to Ayodhya. He added, "Nor do I wish to remain away from my family any longer. Bring the Pushpaka, if you will, Vibhishana, for how is it right for me to stay here any longer now that my work is done? I do not wish to offend you in the least, but please, permit me to hasten."

Vibhishana brought forth the glorious gold chariot, studded with jewels. Its

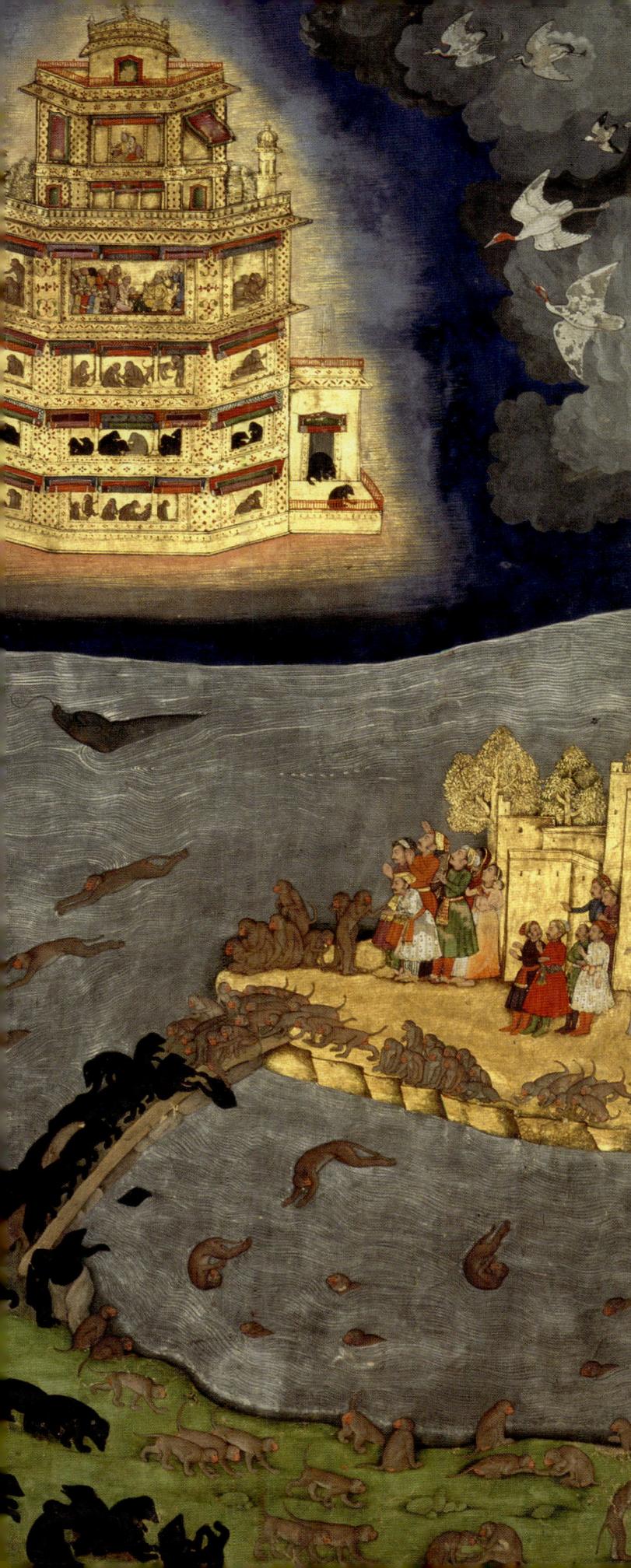

windows, embellished with pearls, its chambers with white flags, and golden lotuses adorned it.

Rama ascended it, a shy Sita on his lap and Lakshmana by his side. When he sought to leave, however, Sugriva, Vibhishana, the Vanaras, and the Rakshasas asked to accompany him to Ayodhya for his consecration.

Almost home

As they got closer to Ayodhya, Rama pointed towards his home and the Vanaras leapt to get a glimpse of the sacred city. On the fifth lunar day or *panchami*, Rama visited Sage Bharadwaja's hermitage and inquired about his family's welfare. Pleased with his victory, the sage offered him *arghya* (a gift). Rama accepted and asked for a boon: "May all the trees along the road overflow with honey." Soon even the trees without flowers and dried leaves began to bloom.

As they neared Ayodhya, Rama asked Hanuman to go ahead and let Bharata know of his arrival. "Should he wish to retain control of the kingdom, let him continue to rule," he said.

Bharata rejoices

Following Rama's orders, Hanuman approached Ayodhya in a human form and met Guha along the way. Close to the city, he saw the

THE CELESTIAL CHARIOT
The residents of Lanka look on as the Pushpaka Vimana leaves the island with Rama and Sita in this 17th-century painting from Himachal Pradesh.

ALTERNATIVE ACCOUNT
SITA AND FIRE

The returning of Sita by Agni has been read, both in a section of the commentarial literature on Valmiki's version as well as other full-length narrations of the *Ramayana* as the retrieval of Sita, who had been entrusted to Agni by Rama for her safety before the final stretch of exile began. It was a replica that had been abducted, and Rama had to say what he did so that Agni would appear and return his beloved to him.

emaciated Bharata living in a hermitage, hair matted, covered in dust, in ascetic garb, consuming only fruits and roots. He radiated brilliance that rivalled a *Brahmarshi*. He was surrounded by advisers, priests, and commanders who were dressed similarly.

Hanuman said, "The one whom you constantly contemplate living in the forest, clad in black antelope skin, has asked after your well-being. I bring good news. You shall soon abandon this sorrow and be reunited with your brother. Having killed Ravana and reunited with Sita, he returns with his friends and allies."

Bharata fainted in joy, and on regaining consciousness, embraced Hanuman. He said, "Whether you are human or divine, what can I give you? The tidings you bring cannot be weighed against anything I can think of." Promising him all manner of riches, Bharata said, "I have heard the mention of my lord after many years. Recount his auspicious story."

So, Hanuman recounted the story and promised him that he would see Rama the next day.

A Joyous Reunion

Bharata instructed Shatrughna to prepare the city and kingdom for Rama's arrival. His revered brother was returning and Bharata wanted to spare no effort to welcome him back.

Ayodhya was aglow with lamps, its buildings decorated to welcome their beloved prince. The deities had been worshipped and the welcoming parties waited for Rama to return from exile. Shatrughna arranged everything and the entire city seemed to rush to Nandigrama.

Bharata, emaciated from fasting, adorned with matted locks, stood with Rama's slippers on his head, and a white parasol. Filled with anticipation, he turned to Hanuman and said, "Are you certain you were not mistaken? I do not see my revered brother anywhere."

Hanuman directed Bharata's attention to the sky and pointed towards the flying chariot Pushpaka, bearing Rama, Lakshmana, Sita, Sugriva, and Vibhishana. The people gathered to welcome Rama shouted his name. Bharata stood facing in that direction, honoured his brother and welcomed him.

He went closer and Rama pulled him onto his lap. He embraced Bharata, overjoyed at seeing him after so many years. Bharata greeted Sita and Lakshmana, and their companions.

Rama grasped his mother Kaushalya's feet, and then went to Kaikeyi, Sumitra, and the other mothers. He turned to the priest, even as the gathered people extended their own welcome.

Bharata took Rama's slippers and placed his feet on them, his hands together in supplication, and said, "King, I return your kingdom to you."

> " A **great sound** of **rejoicing** arose and seemed to **touch the sky**. Women, children, the young and the aged **shouted, 'Rama is coming.'** "

RAMA ARRIVES IN THE PUSHPAKA, *SARGA* (115), YUDDHA KANDA

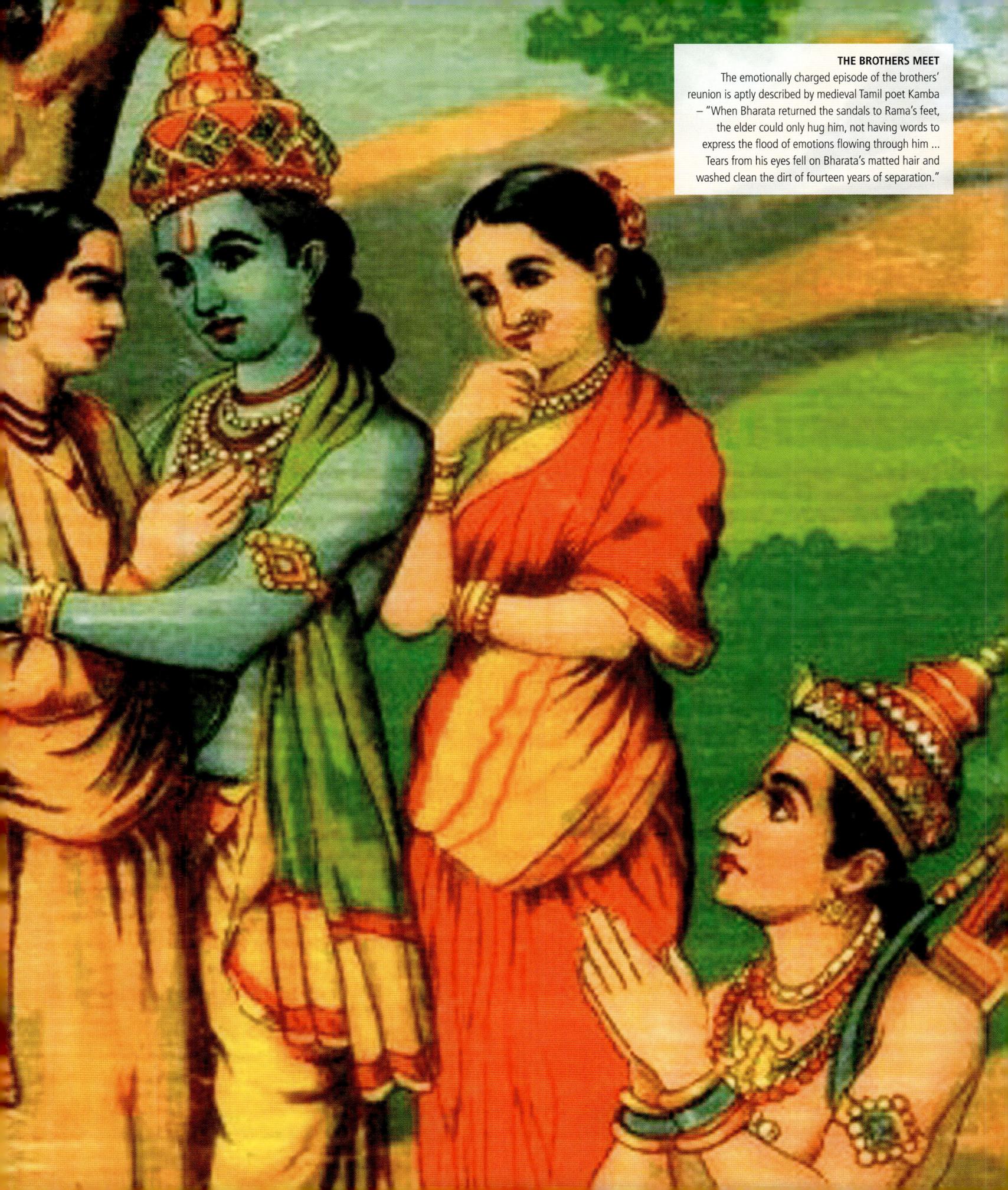

All Hail **King Rama**

The long wait was over. The people of Ayodhya watched, overjoyed, at the consecration of their beloved Rama, as did the gods in the sky. They knew that this was the beginning of a time of peace, prosperity, and dharma.

Rama accepted Bharata's offering, held him close and proceeded to his hermitage. There he dismissed the Pushpaka so it could return to its rightful master, Kubera, the god of wealth.

Placing his cupped hands on his head, Bharata said to his older brother, "Please, investigate the armies and the treasuries. I return them to you tenfold. You have honoured my mother, and now I return the kingdom to you as you gave it to me.

"I have no desire to bear this burden, or to try and walk the path that is yours. I would see you consecrated today – command your followers and subjects."

> **"As long as Rama ruled** the kingdom, **people were without disease** and **devoid of sorrow."**
>
> RAMA'S REIGN, *SARGA* (116), YUDDHA KANDA

Rama returns

Bharata, Lakshmana, Vibhishana, and Sugriva were bathed and their hair straightened, before Rama went to bathe and remove his matted locks. Shatrughna looked after the needs of Rama and Lakshmana, while Dasharatha's queens helped Sita. At Shatrughna's command, the charioteer Sumantra brought forth a resplendent chariot, which Rama ascended.

Bharata held the reins of the chariot, and Lakshmana fanned Rama while Shatrughna held the royal parasol. Sugriva and Vibhishana flanked him, holding fly whisks. The sweet voices of sages and gods praising the prince filled the air. Rama reached Ayodhya to the sound of auspicious instruments, where Dasharatha's advisers had prepared for his arrival. The people of Ayodhya were delighted and had decorated their homes as if it were a personal celebration.

Rama entered his father's palace and asked Bharata to arrange for Sugriva's stay, who led the king of the Vanaras away affectionately. At his request, Sugriva sent the Vanaras to bring the waters of the seas and rivers for Rama's consecration.

Crowning of a king

On the day of the consecration, at the instruction of sage Vasishtha and the priests, Rama sat on a gem-studded seat with Sita by his side. Great sages consecrated them with clear, fragrant waters. The men and women of Ayodhya gathered across the city, while the gods gathered in the sky. At Indra's

KEY CONCEPT

RAMA'S REIGN

Rama's reign, referred to as "Ramraj" or "Ramarajya", is an important concept, not only in terms of devotion to Rama, but also in the Indian political imagination. It is a term that is often used to describe a particularly just and well-run government. It is contested by those who argue that it is just as often a veneer for a conservative and inherently unequal system. However, the ultimate idea of "Ramarajya" can be best described as when the limits of the individual self are abandoned in the service of all existence, which leads to a better run polity, free from oppression, and unbridled consumption.

A 5TH-CENTURY terracotta sculpture of Rama from Haryana

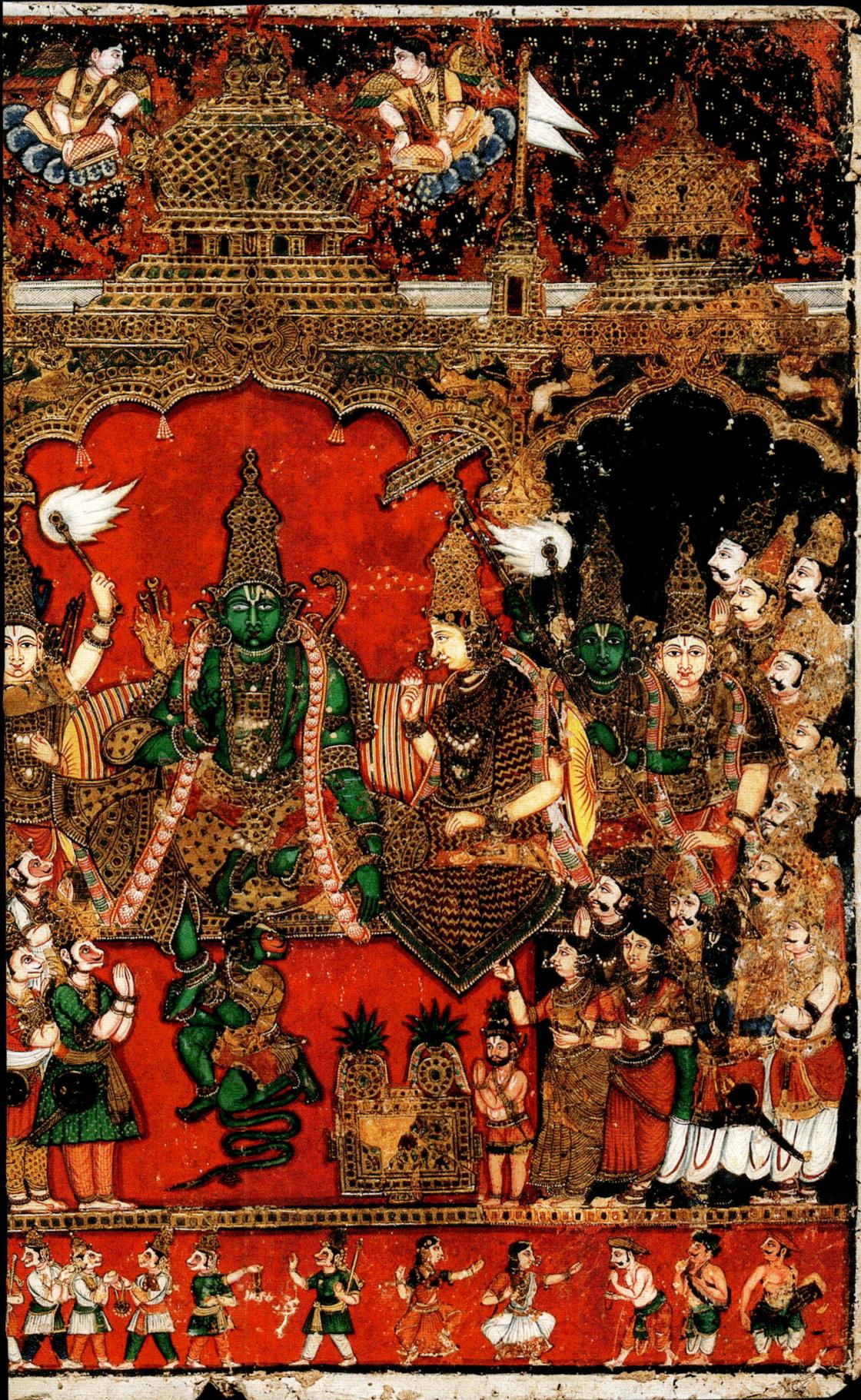

THE SUPREME BEING AS KING OF AYODHYA

Rama's splendour as the king of Ayodhya is unparalleled. However, a natural question arises, particularly in devotional traditions – what meaning would this kingship have for the Supreme Lord, in each of whose body hairs, it is said, countless universes are contained. Some devotees answer that this *lila* or divine play, is attained by a devotee as a result of knowing that supreme glory and give this *lila* greater importance than even the realization of the Supreme Being.

urging, Vayu gave Rama a golden garland with 100 blue lotuses and a gem-studded pearl necklace.

Rama gave away immense gifts to the priests and Brahmanas, and beautiful ornaments to Sugriva and Angada. Sita gifted clothes and ornaments to Hanuman. She removed her necklace and looked at Rama who said, "Beautiful one, give it to whoever you are pleased with." So, Sita gave it to Hanuman, who had found her when she had been all by herself, and who was as mighty as he was wise, as devoted as he was efficient.

Rama offered to consecrate Lakshmana as the crown prince, but he could not be convinced, so Bharata was consecrated in his stead.

During his reign, Rama performed various sacrifices. He protected the earth, his brothers by his side. There was, it is said, no grief in Rama's land and everybody followed their dharma. Rama's reign thus lasted 10,000 years.

THE GREAT KING
A 19th-century gouache painting with gold foil shows Rama sitting with Sita on the royal throne as sages, Vanaras, and citizens of Ayodhya stand in supplication. Hanuman can be seen holding Rama's foot in reverence.

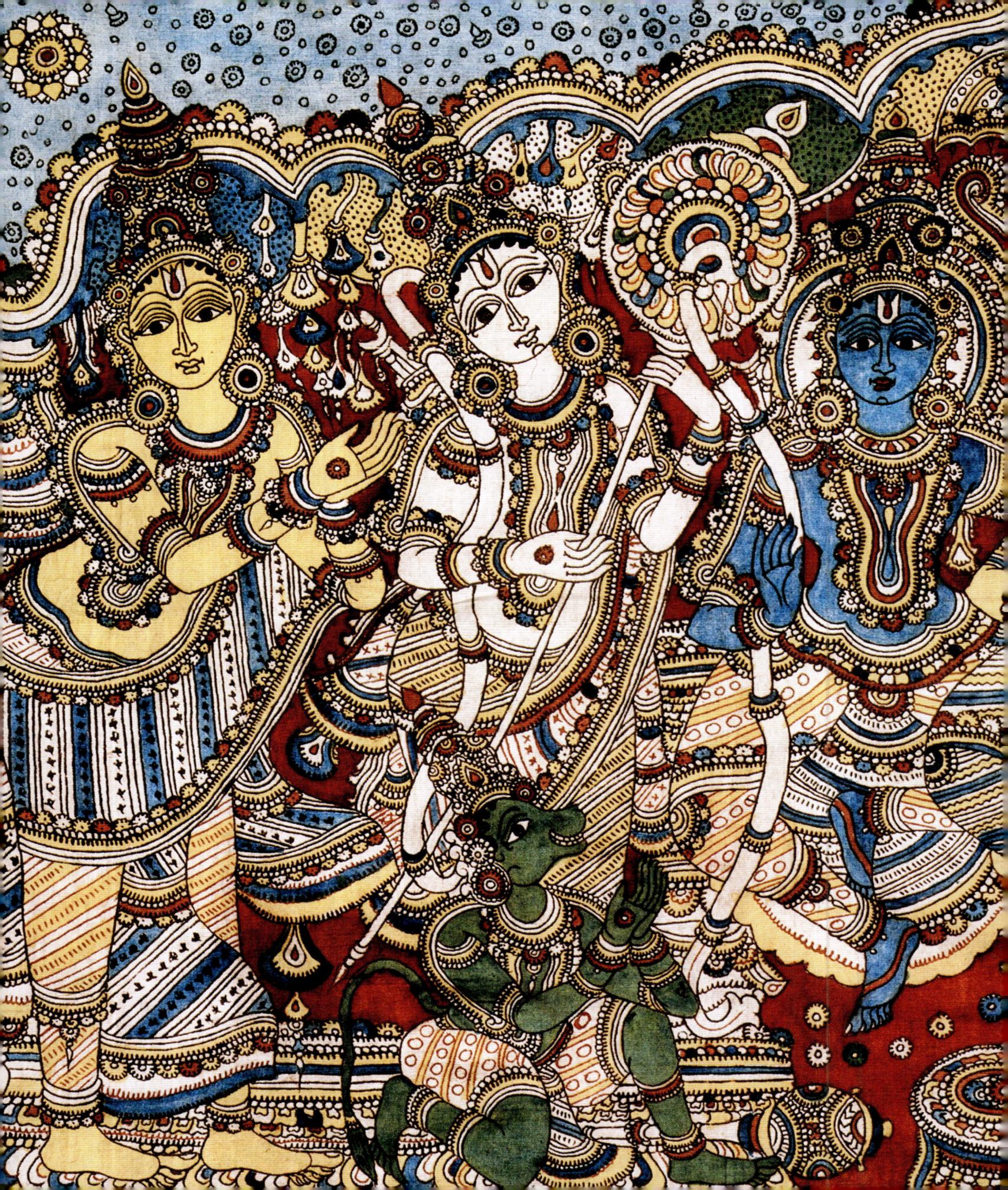

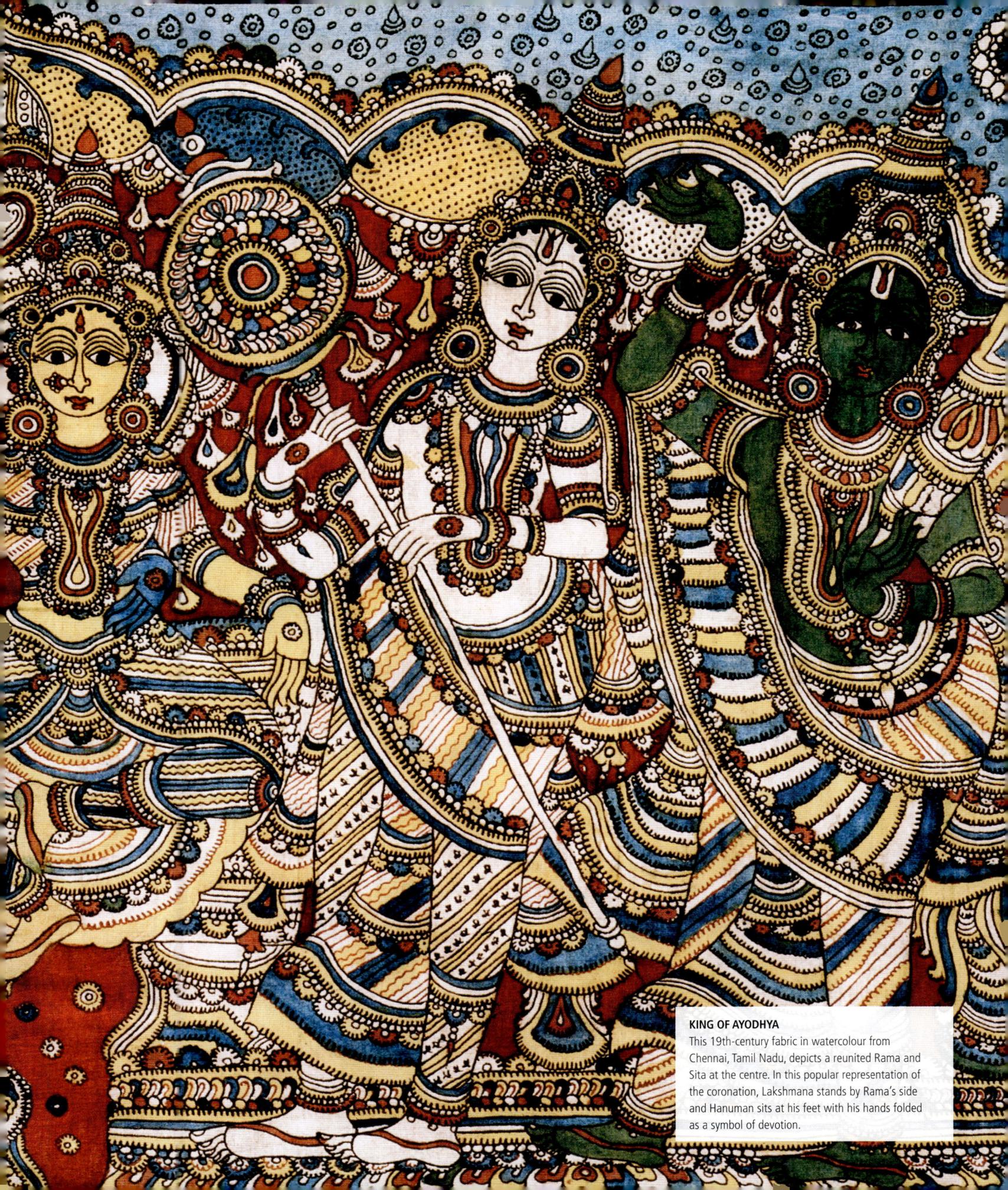

KING OF AYODHYA
This 19th-century fabric in watercolour from Chennai, Tamil Nadu, depicts a reunited Rama and Sita at the centre. In this popular representation of the coronation, Lakshmana stands by Rama's side and Hanuman sits at his feet with his hands folded as a symbol of devotion.

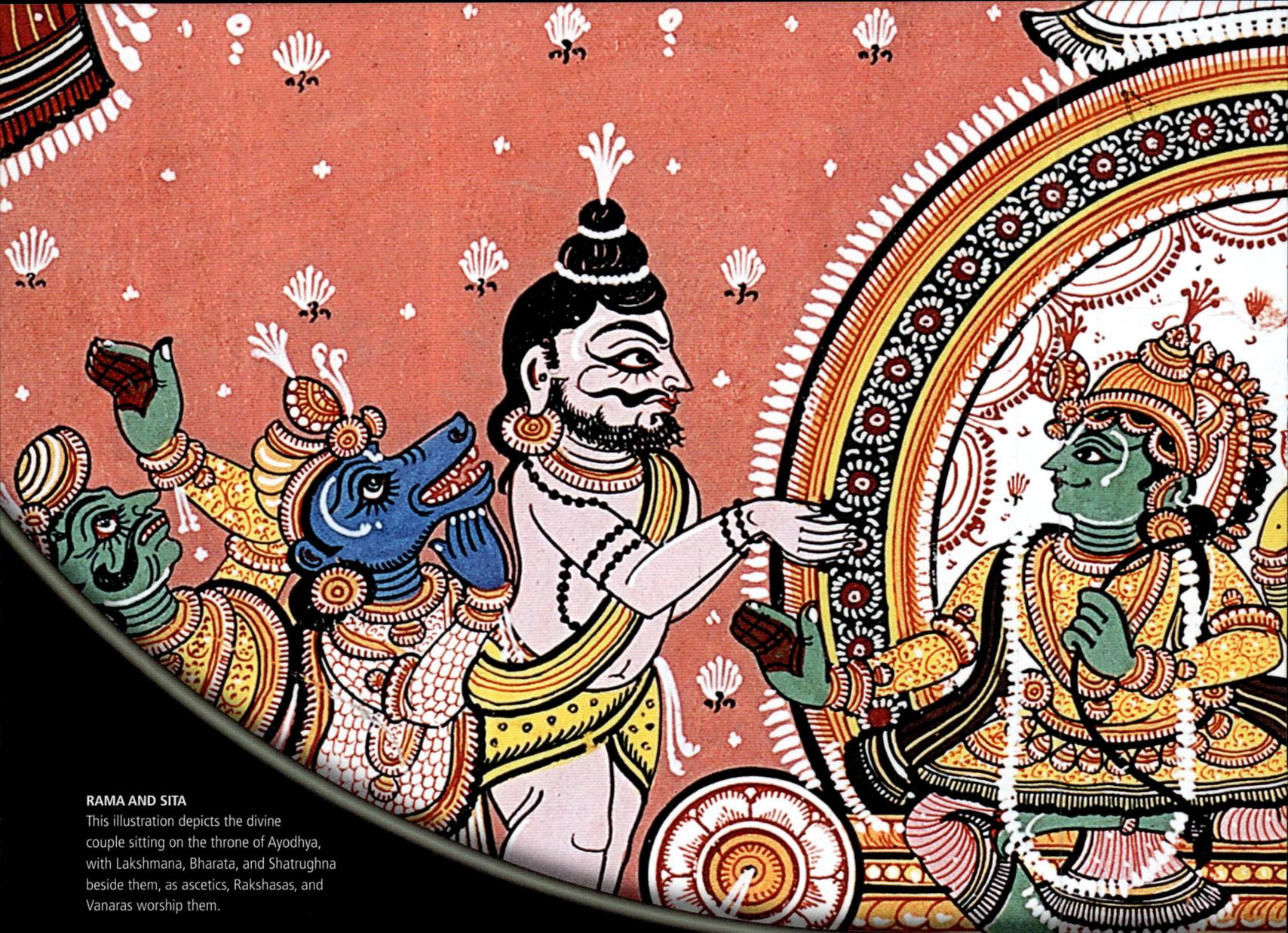

RAMA AND SITA
This illustration depicts the divine couple sitting on the throne of Ayodhya, with Lakshmana, Bharata, and Shatrughna beside them, as ascetics, Rakshasas, and Vanaras worship them.

7 UTTARA KANDA:
RAMA'S RETURN

The epic journey comes to a definitive conclusion in the last chapter of the *Ramayana*, the Uttara Kanda. As Rama rules over Ayodhya, Sita faces a final ordeal and her honour is put on trial for all to see, while Lakshmana makes the ultimate sacrifice for dharma. With balance restored and his purpose fulfilled, the lord of the earth and the protagonist of the epic that is the *Ramayana*, finally takes his rightful place among the gods, as Vishnu, the Preserver of the universe.

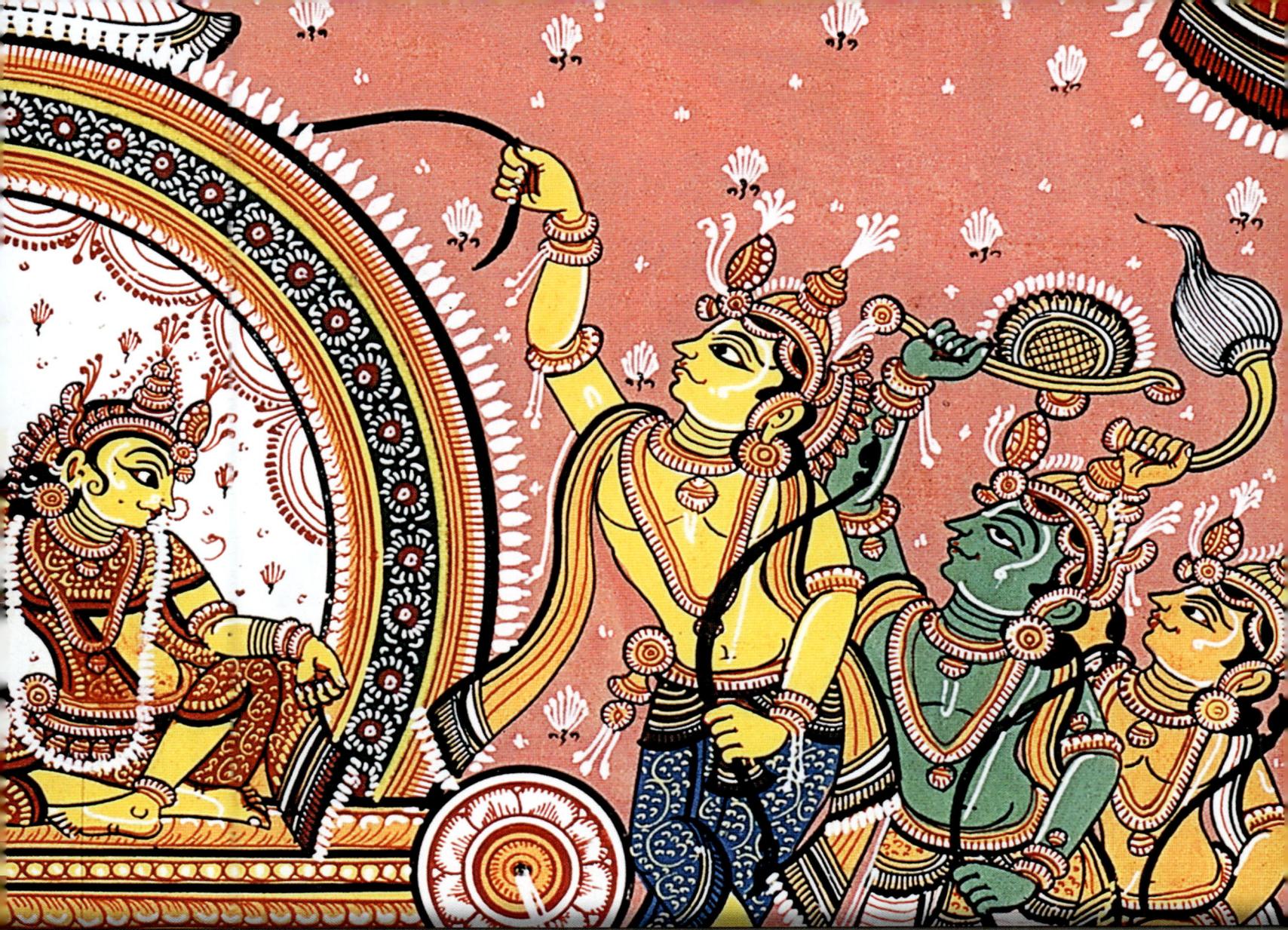

"O descendant of the Raghu lineage!... It is **good fortune** that we see you are well, having **slain your enemies**. O Rama! We **no longer suffer** from the burden of **Ravana**, lord of the Rakshasas."

THE SEVEN *MAHARSHIS* TO RAMA, *SARGA* (1), UTTARA KANDA

Quest for Answers

Astonished to learn that Indrajit, Ravana's son, whom Lakshmana had slain, was more powerful than any other Rakshasa, Rama requested Agastya to tell him his story. The great sage agreed, but first, he said, Rama needed to know the story of Ravana and his lineage.

The greatest of sages visited Rama after his coronation. From the east came Yaakrita, Raubhya, Chyavana, and Kanva. Svastyatreya, Namuchi, and Dreya came from the west. The seven sages, Vasishtha, Kashyapa, Atri, Visvamitra, Gautama, Jamadagni, and Bharadwaja arrived as well.

After receiving them with respect, Rama asked after their well-being. They replied, "We are delighted to see you victorious and enthroned. The worlds are gladdened by your victory over Ravana and his warriors, particularly over Ravana's son Indrajit, who was otherwise impossible to defeat for all beings."

Rama's curiosity

Surprised at this statement, Rama asked, "Why do you consider Indrajit more powerful than even Kumbhakarna and Ravana? In what way does his strength exceed Ravana's? I am curious. I would not dare to presume to request you to narrate the story. If it is not a secret, could you tell us how he became so powerful and defeated Indra." Agastya agreed to tell Rama Indrajit's story. But first, he said, he would have to listen to the story of Ravana, his lineage and birth.

Brahma's son

In the first age, Brahma, the Creator of the universe, had a son named Pulastya, who was as virtuous and brilliant as Brahma himself. He lived on the mountain Meru, in Sage Trinavindu's hermitage and he performed severe austerities and Vedic study.

However, divine, semi-divine, and human women often visited the hermitage and sported there. Pulastya grew frustrated because of the many disruptions. He placed a curse, so that any woman who came near him would instantly become pregnant.

Most women stopped going there. However, Trinavindu's daughter did not know about the curse and went to the hermitage. She heard the sound of Pulastya's Vedic recitation and instantly noticed her body's transformation. When she told her father about it, he realized what had happened and arranged for her to marry Pulastya. Their son was named Vishrava.

MYTHOLOGY

KILLING INDRAJIT

Medieval Bengali poet Krittibas Ojha inserts the secret of killing Indrajit at this point. The sages tell Rama that only one who had neither slept nor eaten in 14 years, or looked upon a woman's face could kill Indrajit. Rama was taken aback for, to the best of his knowledge, Lakshmana ate and slept. Since the three lived together, Rama wondered, how he could have never seen Sita's face?

To this, Lakshmana said that he stood guard outside while Rama and Sita were asleep, attacking Sleep with his arrow if it came too close, did not eat because although Rama told him to keep his share of fruits, he never really told him to eat it, and he had only ever looked upon Sita's feet. This may also be read as victory over sense organs in terms of victory over desire, which lends this story a spiritual undertone, for the penultimate moment before complete victory and the attainment of what lies at the end of spiritual pursuit is of vanquishing desire.

A WAYANG KULIT puppet of Indrajit from Indonesia

VAISHRAVANA'S STORY
This 1653 painting from Udaipur, Rajasthan, shows a series of events that led to the birth of Ravana. Brahma grants Vaishravana the title of the lord of wealth on the left, and he seeks his father's advice on where to live, on the right.

The god of wealth

Vishrava, himself an ascetic, married Sage Bharadwaja's daughter and their son was named Vaishravana. He performed severe austerities as well. Pleased, Brahma and the gods offered him a boon. He sought the status of a guardian deity, a status held by Indra, the king of gods, Varuna, the god of water, and Yama, the god of death. Brahma granted his desire and he became the lord of riches. The Creator also granted him the flying chariot Pushpaka, but not a place to live in.

So, Vaishravana asked his father, who told him to go to Lanka. This was where the Rakshasas once lived, before Vishnu, the Preserver, drove them away.

" ... why are you **praising Ravana's son**? What were his **powers**? What was his strength and his valour? What was the **reason** for his being **superior to Ravana**?... I wish to hear the story."

RAMA TO THE SAGES, *SARGA* (1), UTTARA KANDA

The Earlier **Rakshasas**

Surprised to learn that other Rakshasas were the first inhabitants of Lanka, the city on the summit of a mountain, Rama wanted to know more about them. Who were they? Were they stronger than Ravana? What were their crimes? Why did the Lord Vishnu drive them away?

Rama found his curiosity piqued. He had been under the impression that the Rakshasas emerged from the lineage of Pulastya, Brahma's son. The sage Agastya, however, explained how Brahma created the waters, and the beings to protect it. These creatures were scared because of hunger and thirst and asked Brahma what they should do. He told them to protect themselves and others. Some said they would protect and they came to be named Rakshasas. Others said that they desired to consume, so they were named Yakshas.

Among the Rakshasas lived the mighty Heti and Praheti. While the latter, intent upon dharma, did not seek to

VISHNU'S FEROCIOUS FORM
Vishnu prepared for a battle with the Asuras in this bas-relief from the Angkor Wat temple in Cambodia, which was built as a spiritual home for Vishnu.

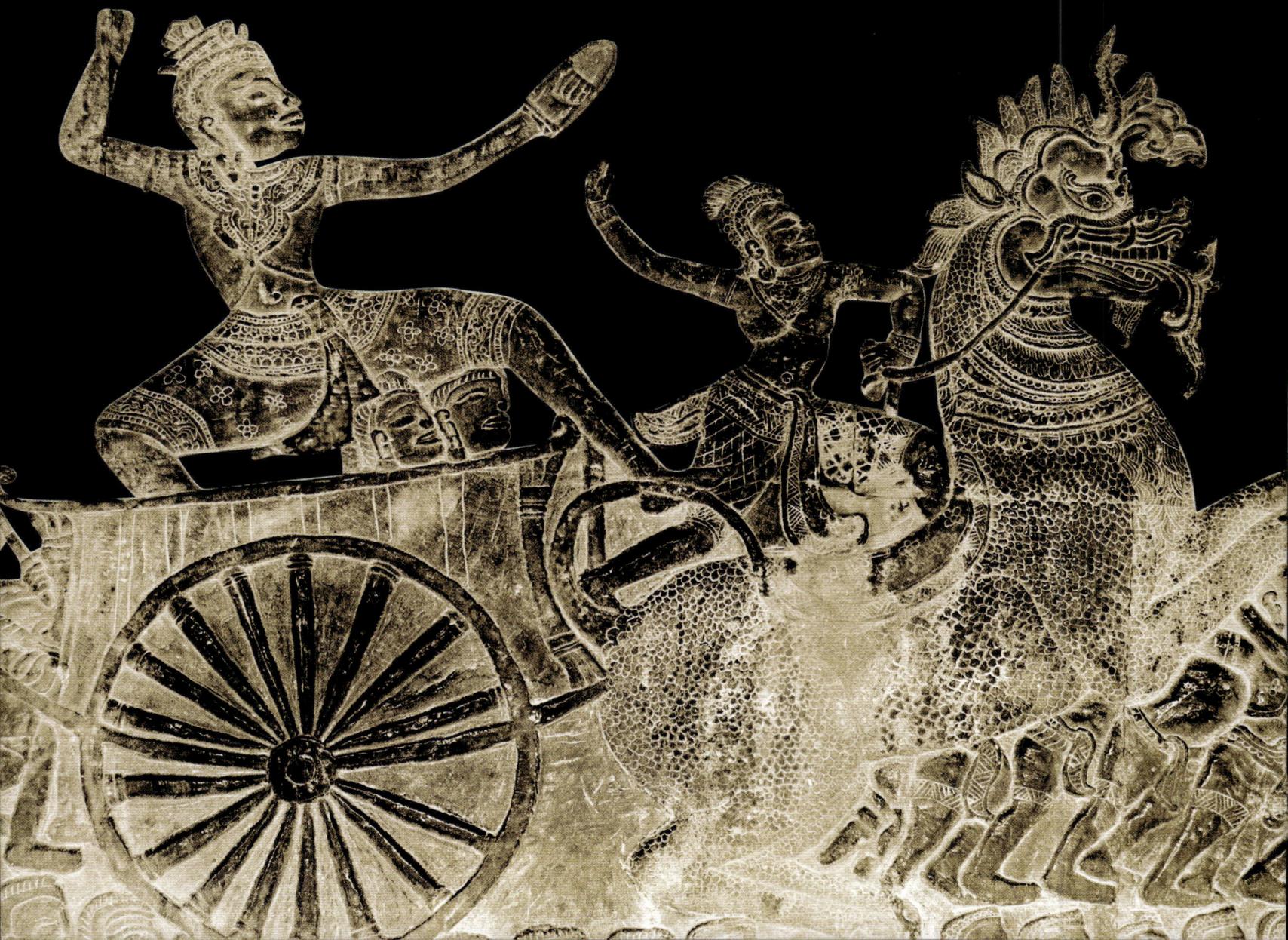

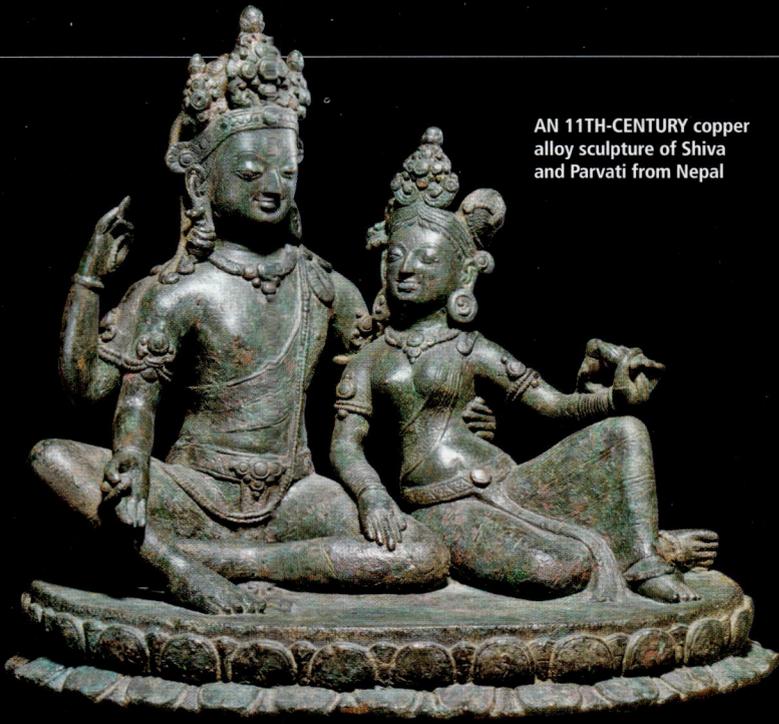

AN 11TH-CENTURY copper alloy sculpture of Shiva and Parvati from Nepal

" He used the **Sharnga bow** against the Rakshasas. He stretched the bow all the way back and **shot arrows** that were as swift as thought, with faces like the **Vajra**. Vishnu **shattered** hundreds and thousands into **fragments** as small as **sesamum seeds**."

AGASTYA TO RAMA, *SARGA* (7), UTTARA KANDA

marry, Heti married Bhaya (fear), the sister of Kala or time and destiny. Their son, the radiant Vidyutkesha, married Salakantakata, the daughter of Sandhya, the twilight deity.

She gave birth to Sukesha, but left the baby on Mount Mandara to return to her husband. As the child cried mightily, Shiva, the Destroyer of the universe, and his consort, Parvati noticed him.

Urged by Parvati's compassion, Shiva blessed the child so that he became as old as his mother, and granted him immortality as well as an aerial city. Parvati, for her part, blessed the Rakshasi women so that they would conceive and deliver instantly, and their children would immediately grow to be the mother's age.

The three brothers
Sukesha soon married Devavati, the daughter of a Gandharva (magical being).

Their sons, Malyavan, Mali, and Sumali, performed great austerities until Brahma gave them three boons.

He blessed them so that they were invincible in battle, had a long life, and were devoted towards one another. Soon, they became fearless, battled the gods, oppressed the Asuras, and slaughtered rishis. They soon sought the help of Vishvakarma (See box) to build them a city.

Vishvakarma urged the brothers to settle in Lanka, by the shores of the southern ocean, on a peak that even birds found difficult to approach. He had built it there at Indra's urging. The brothers did so, and married the daughters of a Gandharvi.

Malyavan and his wife, Sundari, had seven sons, Vajramushti, Virupaksha, Durmukha, Sutapaghna, Yajnakopa, Matta, and Unmatta, and a daughter named Anala.

Sumali and his wife Ketumati had 10 sons, Prahasta, Akampana, Vikata, Kalakaramukha, Dhumraksha, Danda, Suparshva, Samhradi, Praghas, and Bhasakarna, and four daughters named Raka, Pushpotkata, Kaikasi, and Kumbhinasi.

Mali and Vasuda had four sons, Anala, Anila, Hara, and Sampati, who later became Vibhishana's advisers.

Battle with Vishnu
The three brothers continued to torment the gods, who went to Shiva for help. Shiva advised them to ask Vishnu, the Preserver of the universe, for help instead.

Vishnu declared that he would kill the three brothers in battle. When Malyavan discovered this, the brothers made a plan to attack the gods. A long and protracted battle with Vishnu followed.

Vishnu killed Mali and chased Sumali and Malyavan away. They abandoned Lanka and settled in the netherworlds. These Rakshasas, Agastya told Rama, were far mightier than the descendants of Pulastya. No one, except Vishnu, could have killed them.

CHARACTER PROFILE

VISHVAKARMA

Vishvakarma is the divine architect, builder, and craftsman, who builds the homes, weapons, and cities of gods. He, sometimes, builds homes for human heroes, such as like the Pandavas, the protagonists of the *Mahabharata*. Vishvakarma is also the patron deity of craftsmen, and a day is set aside in his honour.

THE DIVINE ARCHITECT, Vishvakarma

STORY FROM THE *RAMAYANA*

The **King of Lanka**

The pieces of the puzzle that was Ravana fall into place as Sage Agastya told Rama the story of the 10-headed king, his penance, the boons he received, how he got his name, and the curses his arrogance and lust brought to him.

The great Rakshasa Sumali emerged from the nether regions after some time had passed, to look for a suitor for his daughter Kaikasi. He saw Sage Vishrava, aglow with austerities, performing the daily fire ritual and told her to approach him.

A dutiful daughter, she approached him immediately, even though it was an inopportune hour. The sage asked her, "Who are you? Who is your father? From where have you come? Why have you come to me? Tell me truthfully."

She folded her hands and said, "You can discover all this through your ascetic powers, but know me to be Kaikasi, who has come here at my father's command. You surely known the rest."

He contemplated for a moment and said, "You have come at an inauspicious time, so our children will be terrible and perform dreadful deeds."

She clasped his feet and said, "Blessed one, such children would not befit you, who are a descendant of Brahma himself." To this, Vishrava replied, "Of all of them, your youngest son will be as befits my lineage. He will have dharma in his soul."

The birth of Ravana

Kaikasi and Vishrava's first son – a fearsome 10-headed child – was born to terrible omens. Jackals spouted flames from their mouths, giant meteors fell to the ground, and the gods showered blood. Vishrava named him Dashagriva.

Kumbhakarna, the second son, was gigantic and the third, a girl, was named Shurpanakha. The last son, Vibhishana, born later, was devoted to dharma.

While Dashagriva and Kumbhakarna wandered the three worlds tormenting and devouring *Maharshi*s, Vibhishana lived in accordance with dharma, pursued Vedic study, and observed restrictions.

Quest for power

Once the powerful Kubera visited his father Vishrava and Kaikasi saw him blazing with his energies. She told Dashagriva, "Ensure that you become as powerful."

So, Dashagriva resolved to become more powerful than Kubera and the three brothers

IN SEARCH OF POWER
Dashagriva, who was later known as Ravana, performed severe austerities with his brothers. This statue of Ravana at the Murudeshwar Cave Museum, Karnataka, shows him engaged in meditation.

performed severe ascetic practices. Kumbhakarna surrounded himself in fire in summer, stood in the rain, and submerged himself in water during winter. Vibhishana stood on one leg first and then with his arms raised in the "hero" pose for several thousand years. Dashagriva gave up food, and at the end of every 1,000 years, offered one of his heads. In this way, 10,000 years passed, and as Dashagriva prepared to offer the last of his heads, Brahma, the Creator, appeared and offered them boons.

Brahma's boons

Dashagriva believed that death was the worst of torments so he asked that no celestial or semi-celestial would possess the ability to kill him. Brahma granted him the boon and restored the heads he had sacrificed.

Vibhishana requested, "Whatever intentions arise in me at various stages in life, let them be in line with dharma and may I follow them."

Brahma granted his desire and turned to Kumbhakarna. At this moment, the gods

turned to the goddess of learning, Sarasvati. Kumbhakarna had tormented and devoured many beings and they feared his request. The goddess made it so Kumbhakarna mistakenly asked for many years of sleep, and, for all his regret, he could not change it.

A plan

When Sumali realized his grandsons had obtained these blessings, he abandoned his fear and left the netherworlds along with Malyavan. He approached Dashagriva and said, "We are so fortunate that you have received these blessings and are now more powerful than all beings. We retreated to the netherworlds for fear of Vishnu. We left Lanka and our homes. Your brother Vaishravana (Kubera) lives there now, but it is the home of the Rakshasas. There is no doubt that you should be the lord of Lanka."

Dashagriva was unsure and said, "The lord of wealth is my older brother. You should not to speak of him this way."

The lord of Lanka

Prahasta replied, "Mighty Dashagriva, listen carefully. There are no 'good brothers' amongst heroic warriors. Kashyapa's wives Diti and Aditi gave birth to the Daityas and gods. Vishnu defeated the former and the gods took over. We are not asking you to commit an offence; you are only following in the gods' footsteps."

Dashagriva thought and then acquiesced. He sent Prahasta, as a messenger to his brother, and said that Lanka rightfully belonged to the Rakshasas. Vaishravana told him that he would leave Lanka for his brother to enjoy, but also consulted his father before taking any decision.

Vishrava told him, "Son, listen carefully. He once brought this up in my presence, and I chastised him. In anger, I inadvertently cursed him to 'destroy'. He is so intoxicated in the power the boons have given him

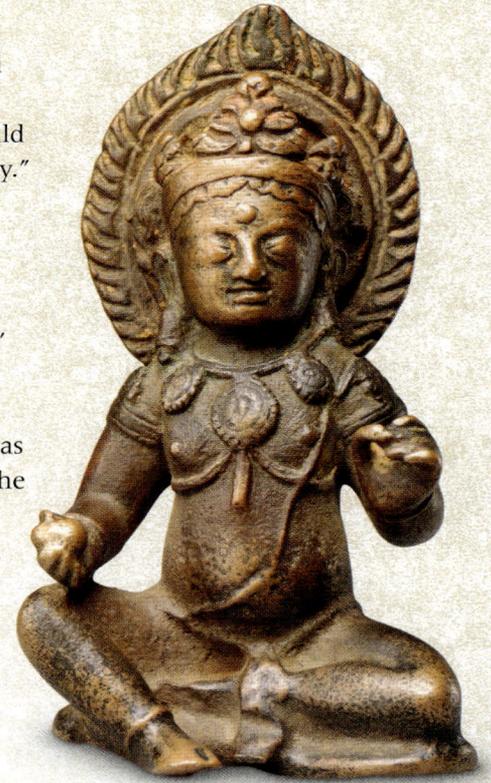
12TH-CENTURY BRONZE sculpture of Kubera from Nepal

that he does not realize the terrible fate that awaits him. Go and settle in Kailasa and live in peace by the banks of the Mandakini."

Kubera honoured his father and moved to Kailasa, and left Dashagriva to rule over Lanka.

Mandodari

Soon, as the king of Lanka, Dashagriva started thinking about a suitable spouse for his sister, Shurpanakha, and arranged for her to marry the mighty Danava, Vidyujjihva.

Shortly after, while on a hunt, he met a Daitya, Maya and his daughter. He told the king, "My wife, the celestial maiden Hema and I lived happily, until she left to perform a task for »

> "Look at your **brother, Vaishravana.** He is **enveloped in energy**. You are **brothers** and **should be similar**."
> KAIKASI TO DASHAGRIVA, *SARGA* (9), UTTARA KANDA

the gods. I left the city I built for us, for I could no longer bear to live there. I have two sons, Mayavi and Dundubhi, and this is my daughter, Mandodari. I seek a husband for her."

He asked Dashagriva who he was and grew delighted to hear that he was the son of a *Brahmarshi* and agreed to give the king of Lanka Mandodari's hand in marriage. Maya also gave him an invincible javelin, which he later used to injure Lakshmana. (See p 309)

Dashagriva also arranged for Kumbhakarna to marry Vajrajvala, the daughter of Vairochana, and Vibhishana to marry Sarama, the daughter of a Gandharva king.

It was around this time that Kumbhakarna began to feel the effects of Brahma's boon. As sleep descended on him, Dashagriva built him a palatial cave to sleep in.

Soon, Mandodari gave birth to a son, whose cry sounded like the thunder of a cloud. So, Ravana named him Meghanada, or one whose roar is like that of a cloud.

A brother's message

Dashagriva continued to wreak havoc on the worlds. Vaishravana (Kubera) heard of this and decided to intervene and remind his brother of the path of dharma. He sent a messenger to the king of Lanka – he presented himself and then repeated Kubera's words, "I heard of your destruction of the gods' grove and your atrocities upon the gods themselves.

"Once, I chanced upon an area where the lord Shiva was sporting with Parvati, and cast an eye in her direction, merely out of curiosity. She

DEVOTION TO SHIVA

Ravana's devotion to Shiva is a widespread idea. A popular hymn to Shiva, called the "Shiva-Tandava-Stotra", is attributed to Ravana. Much of the magic of the hymn is in its energetic metre, alliteration, and the kinds of sounds employed, which is lost in translation. One of the verses reads: *"My constant delight is in the one whose head is resplendent with the vines of the swinging waves of the divine river, whirling agitatedly in the cauldron of matted locks, the fire in the surface of whose forehead pulsates dhak-dhak-dhak, and the young moon is on whose crown."*

burnt my eye. I performed great penance and, pleased, he granted me his friendship and the name Ekapingaksha because of the tawny colour one of my eyes had taken on.

"I know what you have been up to. Stop tainting our lineage! The gods are looking for ways to destroy you."

A rampage

Dashagriva grew furious. "He has not sent this message out of concern for my welfare, but wants to tell me that Shiva is

his friend. I let him be because he is my elder brother, but now I will vanquish the three realms and kill the four guardians, including him."

Dashagriva slew the messenger and went to Vaishravana's abode on Mount Kailasa. He attacked his brother, defeated him, and took the Pushpaka Vimana, to mark his victory.

Encounter with Shiva

Dashagriva travelled to the mountain, Sharvana, the birthplace of Shiva's son and while there, realized that the Pushpaka could not move forward. Nandi, Shiva's follower, asked him to turn back, as Shiva was sporting on the mountain.

"Who is this Shiva?" Dashagriva proclaimed, in his arrogance and went to the base of the mountain, where he saw Nandi, who was like a

MAN AND WIFE
Artists portraying Ravana (left) and his first wife Mandodari can be seen in this classical Thai mask dance performance of the *Ramayana*.

> "... In the **lineage of the Vanaras**, there will be born **those who are like me in form**, so as to **ensure your destruction**."

NANDI TO DASHAGRIVA, *SARGA* (16), UTTARA KANDA

RAVANA'S ARROGANCE
To prove his strength, an arrogant Ravana lifted the mountain where Shiva and Parvati sported, despite Nandi's warning. This wall carving at the Hoysaleswara Temple in Halebidu, Karnataka, depicts the episode as Shiva in turn presses down the mountain.

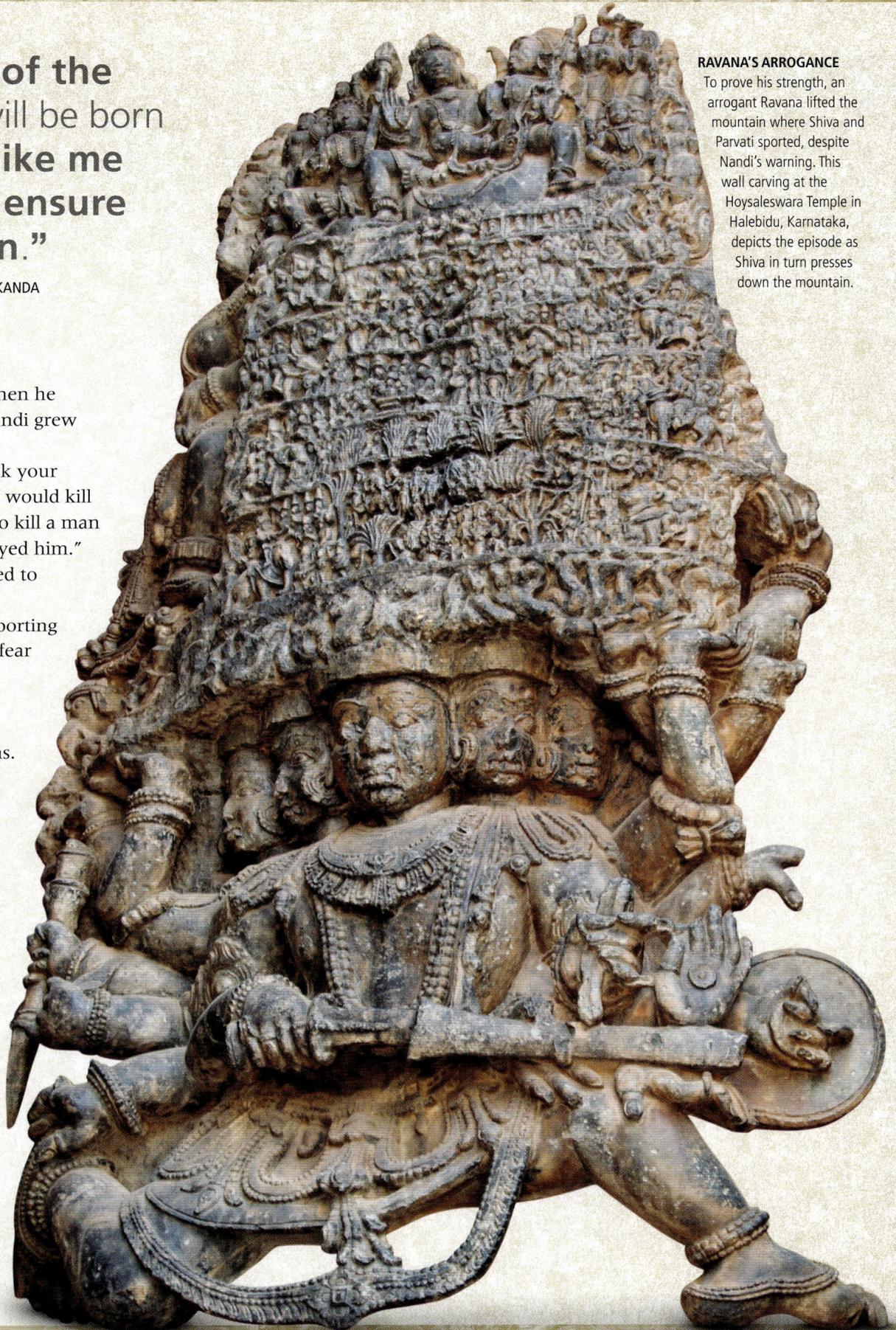

second body of Shiva himself. When he laughed at his ape-like visage, Nandi grew furious and cursed him.

"Apes will destroy you and break your pride, Dashagriva," Nandi said. "I would kill you now, but it makes no sense to kill a man whose deeds have already destroyed him."

Dashagriva ignored him and tried to uproot the mountain, as he said, "Whom does Shiva think he is, sporting here, not realizing that a terrible fear has arrived?"

As he lifted it, Shiva playfully pressed down on the mountain with his toe, and crushed his arms. Dashagriva let out a roar that shook the three worlds. Pleased, Shiva released him and said, "Roamer of the night, your roar of pain was terrible, so you shall be known as Ravana, or the one who makes the worlds shriek." Pleased, Ravana bowed before Shiva and left.

Curse of a woman
Ravana roamed the earth and entered the Himalayas where he happened upon a young woman performing difficult austerities and instantly desired her. He asked her, "Whose daughter or wife are you, blameless one, and why do you engage in these austerities in such a secluded place?"

345

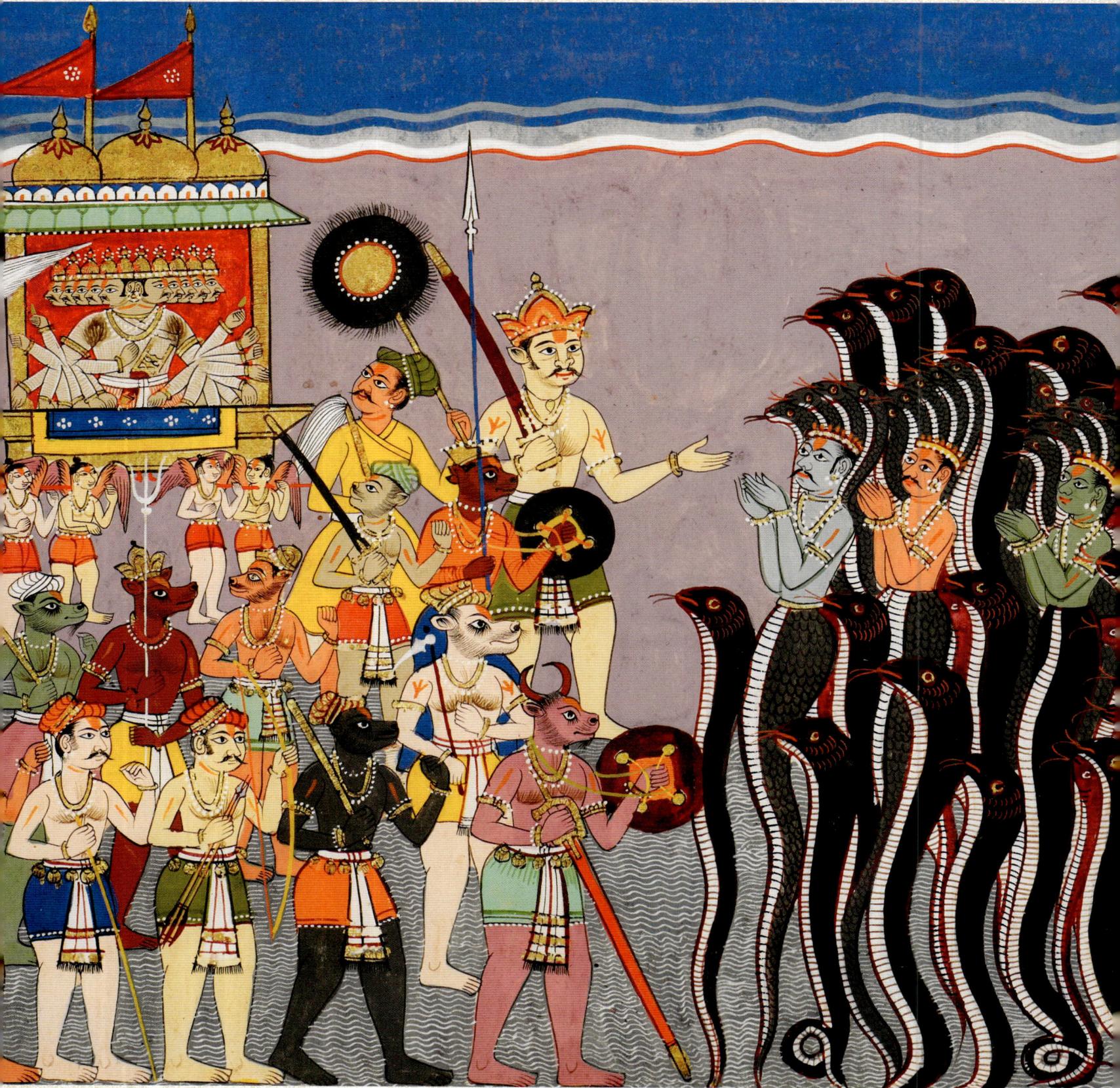

She replied, fearlessly, "I am Vedavati and I was born to Kushadhvaja, son of Brihaspati. All manner of beings approached my father for my hand, but he was determined that only Lord Vishnu would be his son-in-law. A Daitya killed him in his sleep for this, and my mother followed him in death. I am performing these austerities to obtain Narayana as my husband, and to fulfil my father's wishes."

Ravana chided her for her foolishness and told her that he would make a better husband. She refused, but he caught hold of her hair. Enraged, Vedavati built a fire and said, "You have touched me and so I shall cast off this body and return to kill you. It would diminish the strength of my ascesis if I killed you with a curse, but if I have ever done any charity or ever performed any worthy penance, may I be born without copulation to a person possessing dharma."

She then entered the fire to divine showers of flowers, and was later reborn as Sita.

Ravana's arrogance

Ravana boarded his Pushpaka and went to a sacrifice where Brihaspati's brother Samvarta was the priest. The sacrifice was being performed for the king Marutta, and Ravana challenged him to a fight or accept defeat. When Marutta asked him who he was, the arrogant Ravana told him of his victory over Kubera.

The king censured him and prepared to fight, but his priest stopped him, for leaving the sacrifice incomplete would destroy his family. Ravana promptly proclaimed himself victorious.

He went on to challenge and defeat many kings, including Anaranya, the then ruler of Ayodhya. In death, Anaranya cursed Ravana that the person to kill him would be of the Ikshvaku lineage.

Battle with Death

Ravana also decided to battle Kala. On his way, he met Narada, the celestial sage, who said, "Why do you, who are invincible even for the gods, torment these mortals, who are anyway as good as dead?"

Ravana then told him of his next destination and left. Narada reached before Ravana and told Kala of the Rakshasa king's intentions. A fierce battle followed, and when Kala realized he was as good as defeated, he raised his sceptre. Brahma intervened, dissuaded him, and told him of Ravana's boon.

Kala faced a dilemma. If he used the sceptre and Ravana lived, his powers would be rendered false, and if he died, Brahma's words would be false. So, Kala disappeared and Ravana declared victory.

The Rakshasa king went to the netherworlds where he defeated the Nagas, struck a friendship with the Daityas, and destroyed the Kalakeyas. He defeated the army of Varuna, the god of water, as well for the god was away at the time.

On the way back to Lanka, he abducted women from the families of sages, kings, gods, and Gandharvas, killing their families and pulling them onto the Pushpaka. They wept, grieved, and lamented, and in their agony, cursed Ravana that a woman would cause his death.

A 15–16TH CENTURY stone carving of Narada from Nepal

RAVANA IN RASATALA
This 17th-century artwork shows Ravana descending into Rasatala, as Vasuki, the god of water, and the Nagas greet him.

> "Since **you have oppressed me**, for the sake of **your destruction**, I will be **born again**."
> VEDAVATI TO RAVANA, *SARGA* (17), UTTARA KANDA

"Your son, **Ravana's son**, is extremely strong. He will be **famous in the world as Indrajit**. This **Rakshasa will vanquish strong enemies**."

BRAHMA TO RAVANA, *SARGA* (30), UTTARA KANDA

KARTAVIRYA ARJUNA

Arjuna is also very important in narratives about Parashurama. It is said that Parashurama's father, Sage Jamadagni, welcomed him and used a magical cow to produce a meal (much like the Vasishtha-Vishvamitra story). Jamadagni was killed because of Arjuna's desire for his cow, and Parashurama killed Arjuna to avenge his father.

A sister's lament

On his return to Lanka, he found Shurpanakha in tears as Ravana had killed her husband in the war with the Kalakeyas. "You should have protected him in the battle? Are you not ashamed of killing him?" she wept.

Ravana comforted her and told her that it had happened in the heat of the battle. He then sent her to their maternal aunt's son, Khara. "Go to Dandaka," he said, "where the Rakshasas dwell."

Shiva's blessings

Later, as Ravana walked through Nikumbhila's grove near Lanka, he saw his son Meghanada performing a sacrifice. The priest told him

RAVANA'S LOSSES

That Ravana was defeated at the hands of Vali and Kartavirya Arjuna becomes the basis for snarky comments made by Angada or Hanuman in some texts. Sometimes, after Ravana had proclaimed his strength with great arrogance, the mocking might begin with, "So there are many Ravanas, Ravana; one whom Vali carried under his arm, another that was captured by Arjuna… which of them are you again?"

of his son's achievements, Shiva's blessings, and the gift of a chariot that moved with the mind and illusory powers. Ravana chastised him for the oblations to his enemies and returned to the palace.

There, Vibhishana saw the women who accompanied Ravana and reprimanded him. When he told him of Rakshasa Madhu's abduction of their aunt, Kumbhinasi, Ravana rushed to the Rakshasa's kingdom. The two became allies, however, after Kumbhinasi stopped Ravana from killing Madhu.

Rambha's curse

Ravana then left for Kubera's abode on Kailasa. On the way, he saw the apsara Rambha and grabbed her. She pleaded with him and told him that she was his daughter-in-law through Kubera's son, and was under his protection. Ravana ignored her pleas and raped her.

Desolate, she went to her husband, Nalakubara, and told him what had happened. Enraged, he cursed Ravana that his head would slipt into seven fragments if he ever tried to assault a woman.

Meghanada's power

Ravana reached the realm of the gods, and Indra went to Vishnu, the Preserver, for help. The god refused to fight Ravana because of Brahma's boon. He did, however, promise to be the agent of his eventual destruction.

Meghanada managed to capture Indra and took him to Lanka. The gods, along with Brahma, went to Lanka to seek Indra's release. The Creator praised Meghanada's valour in battle and asked him what he wanted in exchange for Indra. The prince asked for immortality, which Brahma could not grant. Instead, Meghanada asked, "Men seek the boon of immortality through austerities. Let immortality be conferred upon me through my valour."

Brahma agreed, making it so Meghanada would not die as long as he offered oblations to the fire before entering a battle. This is how Meghanada came to be known as Indrajit, or the vanquisher of Indra.

As the gods returned to heaven, Brahma noticed that Indra looked despondent. The Creator reminded him that his defeat was because of Ahalya and Gautama's curse. (See pp 54–55)

Defeating Ravana

Of course, Ravana's tale was not without its embarrassments. Ravana once pursued the lord of Mahishmati, the Haihaya overlord Kartavirya Arjuna, as he worshipped Shiva on the banks of the Narmada. Arjuna captured him and the sage Pulastya had to come to his grandson's aid and secure his release.

Similarly, when he challenged the Vanara king Vali, the latter tucked him in his armpit and carried him around as he went about his day. Ravana was deeply impressed and they became great friends.

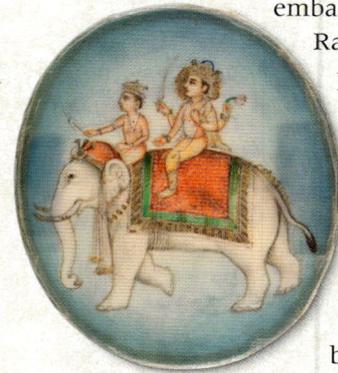

A 19TH-CENTURY gouache painting of Indra

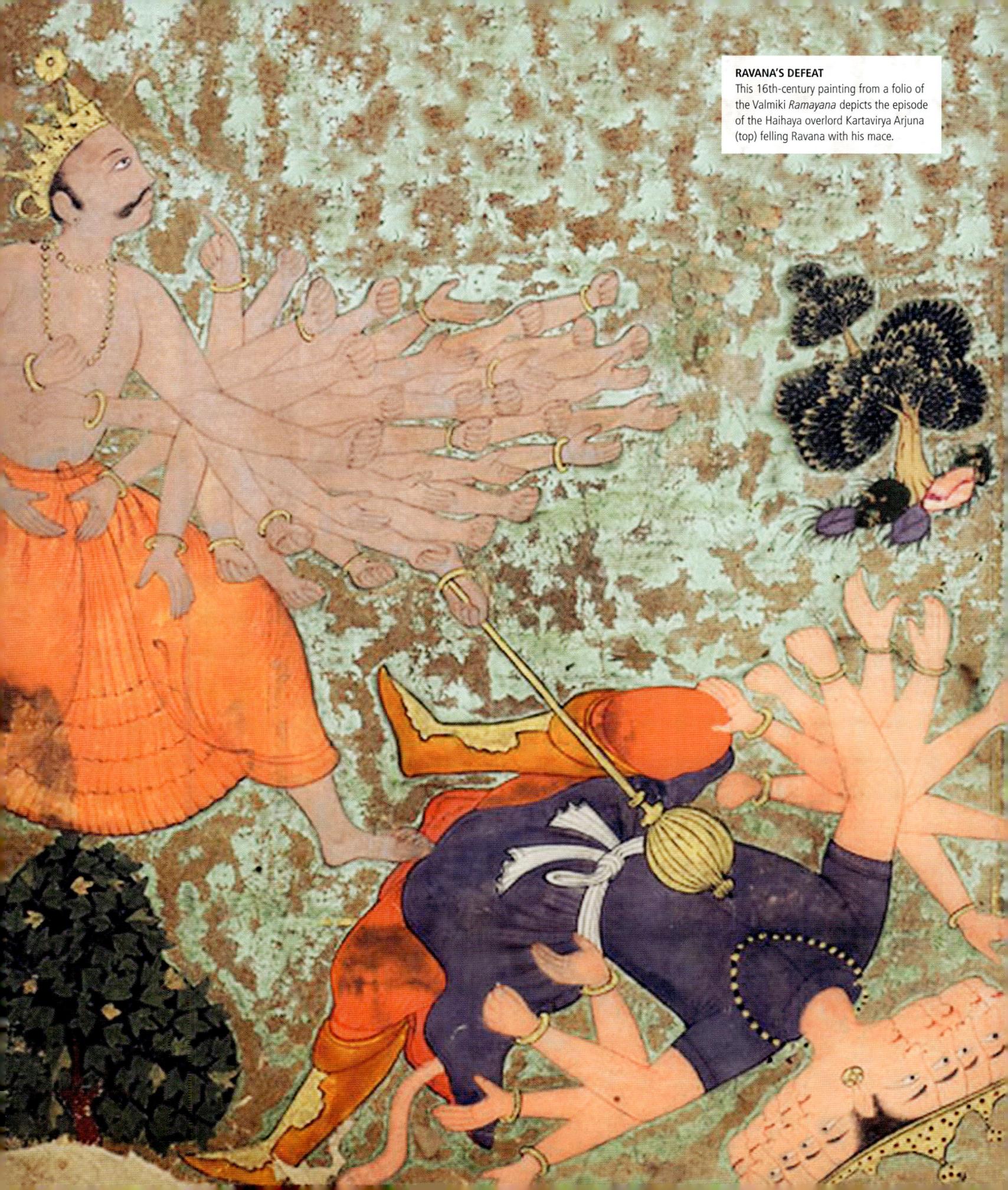

STORY FROM THE *RAMAYANA*

Vayu's Son, **Hanuman**

Vali and Ravana were unmatched in their strength, Rama told Agastya, but they were not as strong as Hanuman. He recounted the Vanara's astounding feats and wondered why he had not used them against Vali. Perhaps, Hanuman had not realized the true extent of his power?

> "In this world, there is no one who is superior to **Hanuman** in **valour**, **enterprise**, **intelligence**... and **patience**... In his ability to destroy the worlds, he is like **Death**. Who can stand before Hanuman?"

SAGE AGASTYA TO RAMA, *SARGA* (36), UTTARA KANDA

Agastya agreed with Raghava's words and then told him Hanuman's story. "You are right. Nobody is equal to Hanuman in strength or wisdom. However, a sage's curse made him forget this," the sage said.

Kesari ruled over Mount Meru and his wife Anjana bore Hanuman, the son of the wind god, Vayu. Once, she went into the forest to bring some fruits. Hungry and anxious in his mother's absence, little Hanuman began to cry.

The delicious red fruit

He suddenly saw the rising sun, which looked like a delicious red fruit. He leapt up to grab it, and celestial beings marvelled at his strength. They exclaimed, "If he can do this while he is still a child, imagine his might as a young man!" Vayu protected him from the sun's heat as he rose, and the sun himself did not burn him because he was just a young child."

At that moment, the celestial Rahu approached the sun. He saw Hanuman trying to grasp the sun as well and went to Indra, the king of gods, to complain.

"How is it that after giving the sun and moon to me to consume you have now granted them to another?" he said. "It is the day of the new moon and I went to eat the sun when I saw another person there!" Indra mounted Airavata, his elephant, and approached the place where Hanuman was. The little Vanara saw them and let go of the sun. Rahu lunged towards the sun and Hanuman towards him.

The former turned to Indra, shrieking, "Save me! Save me!"

Indra's weapon

Hanuman saw Indra's mount and mistook it for larger, more interesting fruit, and promptly reached for it. At that moment, his form turned as radiant as Indra's. The god struck the child with his mighty weapon and he fell unconscious on a mountaintop, the fall breaking his jaw.

God's favourite child

Enraged at his son's injury, Vayu stopped blowing and the lives of all beings were in danger. Brahma, the Creator, revived Hanuman and Vayu resumed his functions.

Brahma then said, "There are great deeds that this child shall perform for your sake, gods! Therefore, protect him with your blessings."

Indra spoke first, "This child, whose *hanu* (jaw) I have broken with my weapon, will forever come to be called Hanuman. My weapon will never hurt him again."

The sun god said, "I grant him a hundredth part of my own brilliance, and when he

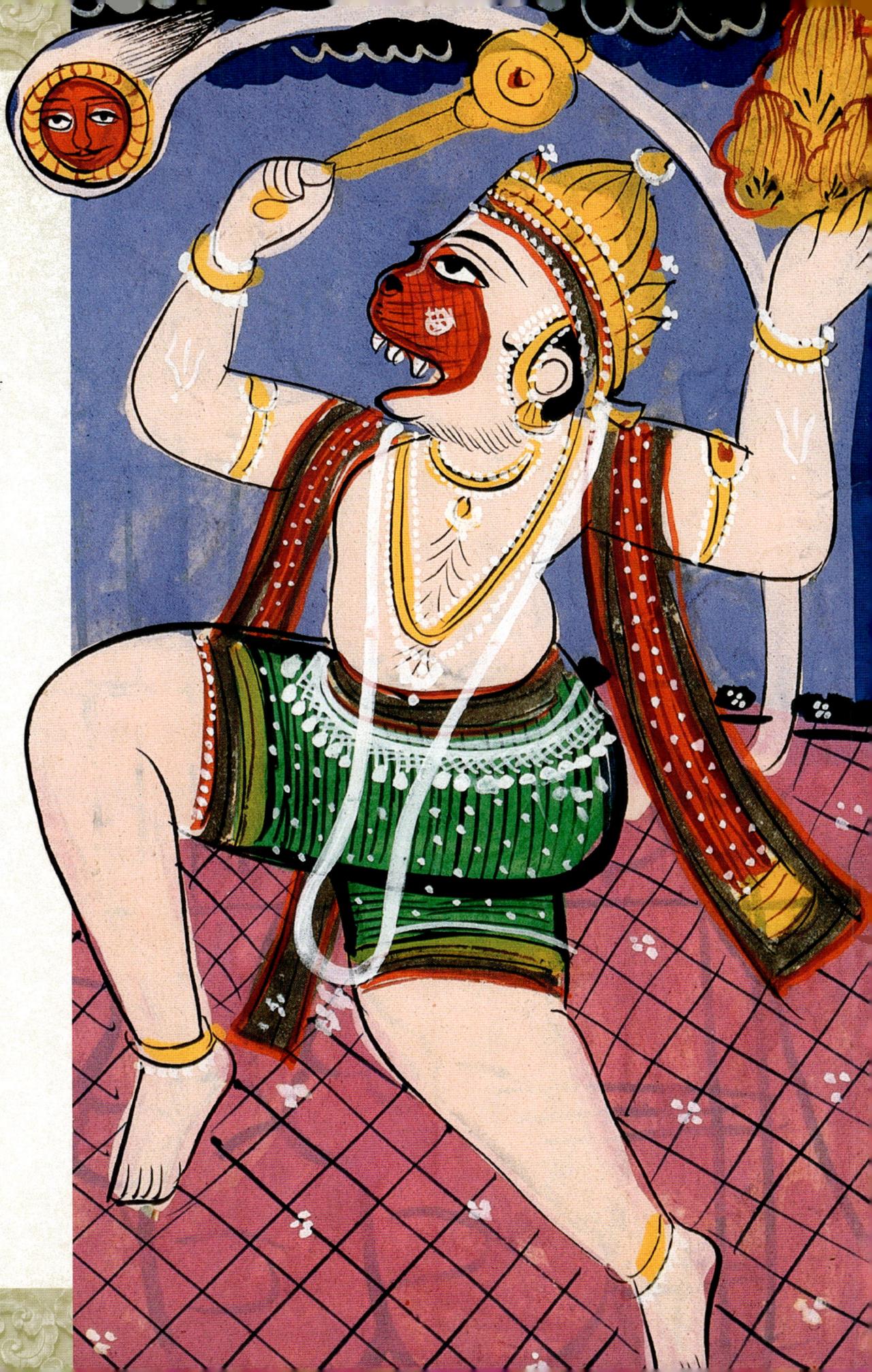

is ready, I shall myself impart knowledge unto him, so that he shall be erudite."

Varuna said, "He shall never die either by my noose or by water." Yama granted him good health and invincibility in battle, and promised that his mace would not kill him. Shiva granted him protection from his weapon and himself. Brahma blessed him, so that he was safe from the Brahmanas and their punishments, while Vishvakarma said that none of the weapons of the gods that he had built would hurt Hanuman.

The mischievous one

Brahma assured Vayu that Hanuman would perform great deeds for Rama's sake, and the wind god returned him to Anjana and Kesari.

However, the young child, now with powers that made him impervious to all forms of discipline, became impossible to manage.

Anjana, Kesari, and Vayu could not together get him to behave. Even the sages were helpless as he tormented them and broke their vessels and ladles used for sacrifices. Finally, some sages cursed him, to simply cause him to forget his powers.

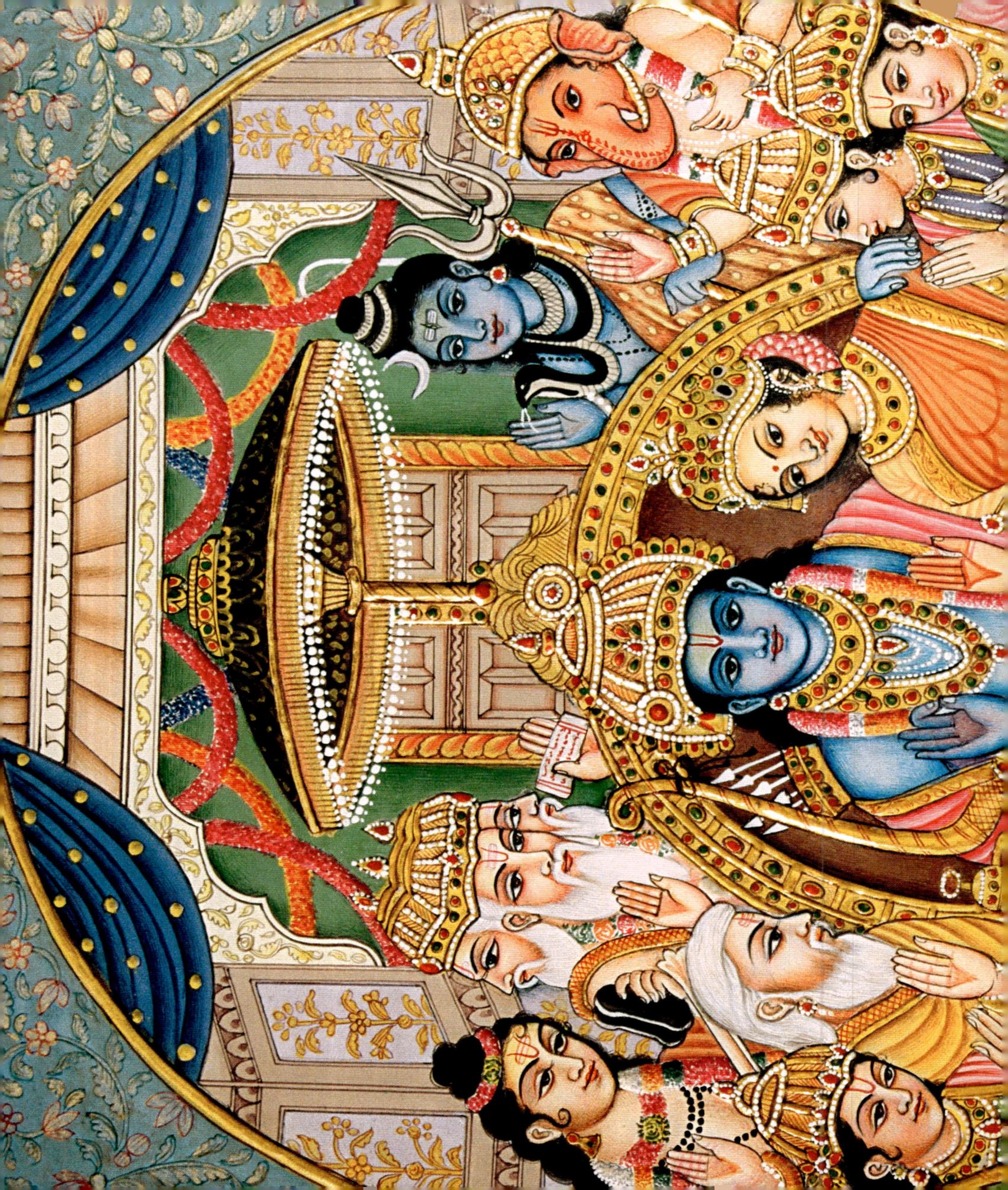

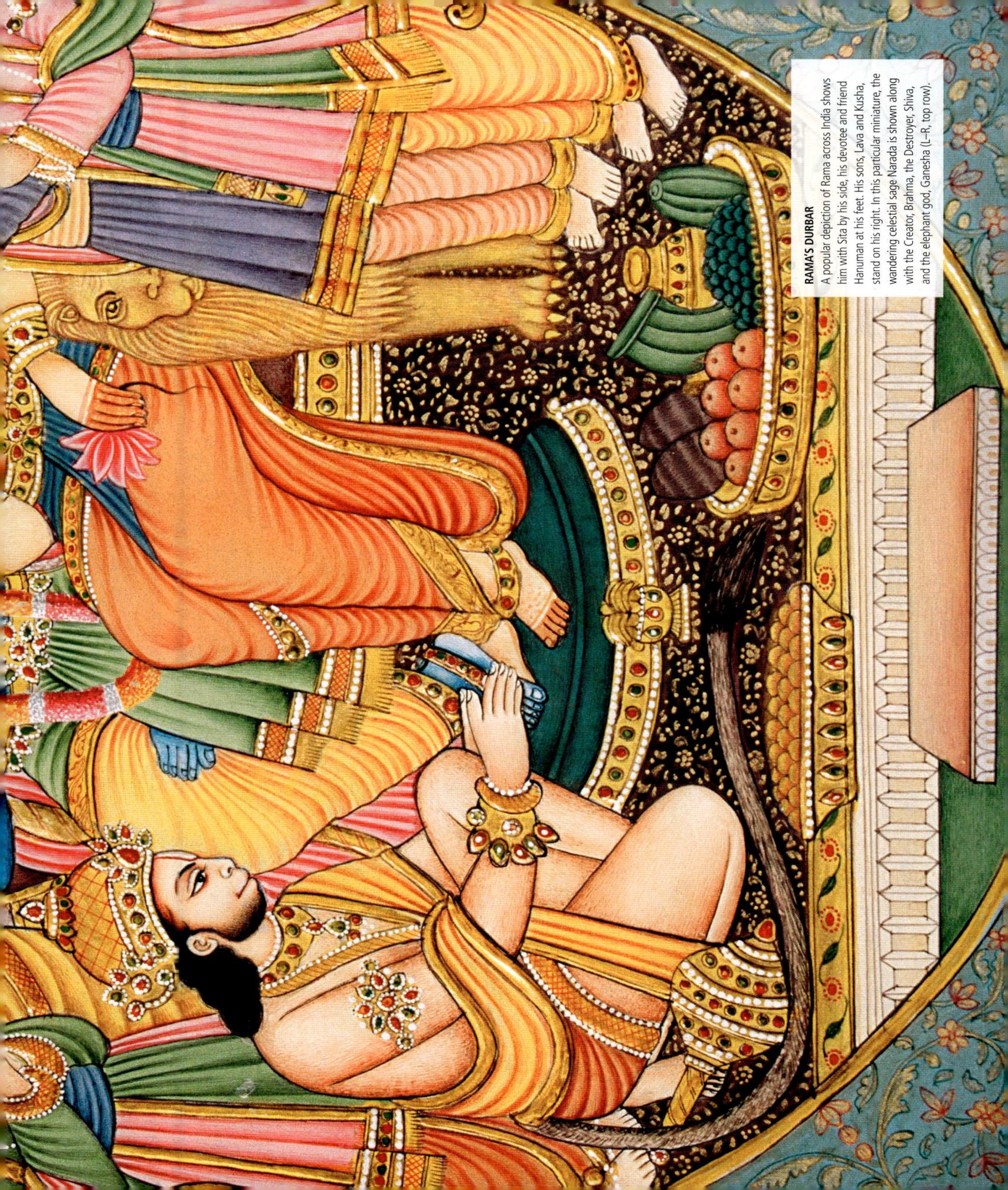

RAMA'S DURBAR
A popular depiction of Rama across India shows him with Sita by his side, his devotee and friend Hanuman at his feet. His sons, Lava and Kusha, stand on his right. In this particular miniature, the wandering celestial sage Narada is shown along with the Creator, Brahma, the Destroyer, Shiva, and the elephant god, Ganesha (L–R, top row).

Aspersions Cast

One by one, Rama bid farewell to the kings and their armies who had come to Ayodhya to see him consecrated. It was time to resume his duties as the king and live out his days happily. Fate, however, had other plans.

The sages left after they told Rama the story of Ravana and then, the might of Hanuman. Soon, the great-souled kings, who had come to witness Rama's coronation, left as well.

Rama wished them well on their journey and they, on their part, expressed their delight at his coronation.

Farewell to friends

The Vanaras, Rakshasas, and bears continued to live in Ayodhya, delighted to be with Rama, who found pleasure in their company as well. A few months later, Rama said to Sugriva, "Return to Kishkindha with Hanuman, Angada, and the others who gave up their lives for me." Turning to Vibhishana, he said, "Rule Lanka in accordance with dharma, and never abandon it. Remember Sugriva and me."

Hanuman bowed before Rama and said, "I have supreme love and firm devotion for you; my mind will not leave you. So long as I shall wander the earth listening to your story, breath shall remain in my body."

Rama embraced him and said, "So it shall be. I have no doubt while the worlds remain, so shall my story, and thus, your breath." With great affection, Rama gave his necklace to Hanuman. As the Vanaras left, they seemed faint at the thought of leaving Rama.

Bharata told Rama, "There has never been a king like you. Even your subjects say this."

Together at last

Rama and Sita spent many days engrossed in each other. They spent time in the grove with its beautiful flowers

RAMA'S DEVOTEE
Hanuman, kneeling before Rama in this gouache painting, proved to be his most beloved devotee and messenger, sworn to roam the earth as long as the world remembered Rama's story.

and delicious fruits. Rama dealt with matters of the kingdom and Sita spent her time in worship and served her mothers-in-law in the morning. They were together in the afternoons.

Soon after she became pregnant. Rama said, "The birth of our child is close. Why don't you ask for something?"

Sita said, "I wish to see the ascetic groves on the banks of the Ganga, and stay there for a single night." Rama granted her this wish.

Kingly duties

Rama left to attend to his advisers and called upon on them, one by one, to assess the mood of his people and the kingdom. He called upon Bhadra, an adviser, and asked, "What is happening in the kingdom? What are my subjects talking about? How do they speak of me?"

At first, Bhadra told him that everyone spoke well of him, but when Rama probed further, he said, "They say that after retrieving Sita, Rama set aside his anger and brought her back into his house. What joy could she bring him, when she was forcibly taken by Ravana? We will have to do this for our wives as well, for people merely follow their king and what he does."

"Hear what the **citizens are saying about me and Sita**... It has **shattered** my inner organs... In the city, they are **conversing about Sita's evil conduct**."

RAMA TO HIS BROTHERS, *SARGA* (44), UTTARA KANDA

Rama's worst nightmare

Rama, with great pain, asked the rest of the advisers, "Is that so? Do they all say this?" They lowered their heads, and said, "So it is." Rama dismissed them and called for his brothers. They rushed to see him and saw him downcast with tears.

He embraced them and said, "You are everything to me. You are wise and well versed in scripture." He told them what he had heard and said, "This is what they say of my Sita. Lakshmana, the bearer of oblations, fire, and the wind stood by Sita's purity, the sun and moon praised her. She is sinless, in the eyes of the sages. My inner self knows that she is blameless. So you see me drown in this new, unsurpassed sorrow – I would abandon you, my life, or indeed, Sita, to avoid disrepute. And yet, what greater pain could there be than to not see her again?"

He told them not to question his decision and then said to Lakshmana, "Take Sita with you. Leave her in an empty space at the hermitage of Sage Valmiki on the far bank of the Ganga, by the River Tamasa." He added, "If you have any respect at all for me, take her from here. She said she wished to see the hermitages on the banks of the Ganga. Let it be so." Overcome by tears, Rama retreated into his quarters.

TOGETHER AGAIN
A wood carving of Rama and Sita shows the divine couple in a loving embrace, enjoying their moment of togetherness.

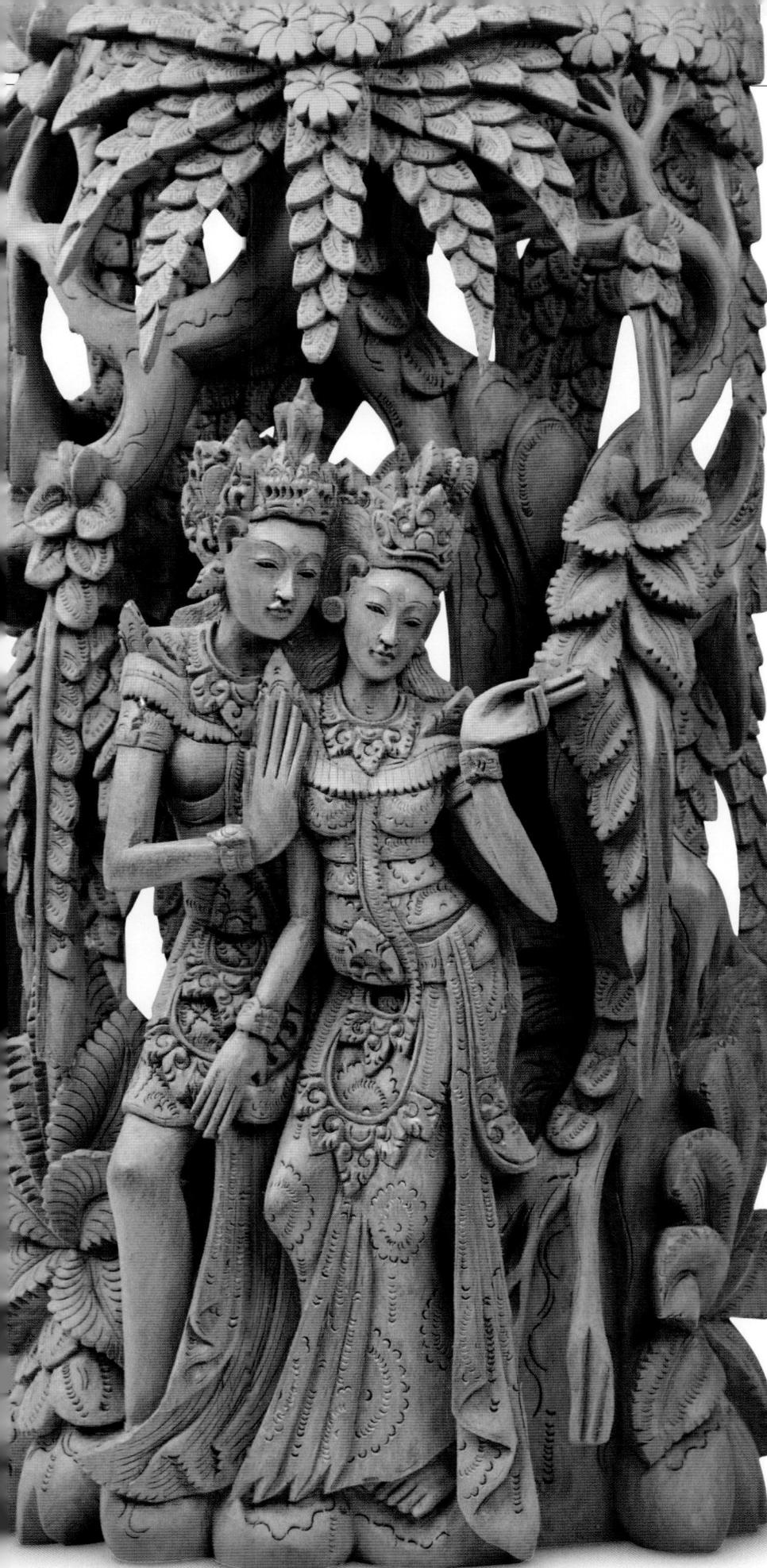

Labels visible within the painting: लक्ष्मण · वरमी · सीता

GRIEVING SITA

This painting from the first quarter of the 19th century and belonging to the Punjab Hills, Kangra, depicts Sita's exile in three parts. The artist shows Lakshmana returning from Valmiki's hermitage, grief-stricken Sita surrounded by animals (top right), and Sita being comforted by Valmiki (bottom right). The artist has also indicated the appropriate colour palette and labels to guide the pupil to colour the line drawing.

Sita **Exiled**

With a heavy heart, Lakshmana did as his brother, Rama, commanded. He prepared to take Sita on another journey, but this time, to leave her behind forever.

The next morning, Lakshmana requested Sumantra to prepare the chariot and went to Sita. He told her that Rama had asked him to take her to the hermitages by the River Ganga. Filled with joy, Sita swiftly boarded the chariot.

As they got closer to the river, Lakshmana began to weep. Sita teased him gently, "Can you not bear separation from Rama for even two nights? I love your brother more than life too, but come, do not be a child. We will be back soon."

Lakshmana wiped his eyes and arranged for a boat. When they reached the far bank, he folded his hands, as his eyes filled with tears, and said in a choked voice, "My brother has given me a terrible command. I would rather die than do this task."

When Sita commanded him to explain, Lakshmana told her what had happened and what was said. "The king has decided to renounce you," he said and told her that Rama had asked him to leave her at the hermitage she wanted to visit during her pregnancy. She would be comfortable at Valmiki's hermitage and under his protection, he said.

Sita fainted and when she regained consciousness said, "Surely this body has only been created to bear pain. I, whose conduct has ever been pure, have been renounced in this way. What should I tell the sages when they ask about the offence for which I have been renounced? I cannot even drown myself in the Ganga, for Rama's progeny would also die.

"Do as you have been commanded and leave me here. Obey the king. Greet my mother-in-law and bow before the king, wishing him well, and say that he must act towards his subjects as he does towards his brothers. That is his supreme dharma." Lakshmana, unable to speak, bowed before her and left.

As Sita wept, Valmiki's sons saw her and called the sage. He said, "Sita, I knew you would come. I know you are blameless through my Sight, and so you will stay here under my protection."

> "What crime have I committed in an earlier life?... I am **pure in conduct.** Nevertheless, the **king has abandoned me.**"
>
> SITA TO LAKSHMANA, *SARGA* (47), UTTARA KANDA

With Brothers **by His Side**

Distressed and overcome with severe torment for abandoning Sita at Sage Valmiki's hermitage, Lakshmana returned to Ayodhya. Rama, however, grieving for his beloved and bereft of all joy, was simply relieved to have his brother by his side again even as urgent matters of state sought his attention.

Lakshmana stared in anguish, as Sita wept at the far bank of the River Ganga. He kept turning back to look at the miserable one until he mounted the chariot, with Sumantra at its reins.

Lakshmana said, "I cannot think of anything more painful for Rama than to have renounced his beloved wife. This separation from Sita seems to be fate. The one who could defeat gods went to the forest to keep his father's word – even more painful than those years is this new sorrow. How has dharma been upheld in this act that shall only lead to disrepute and destroy his glory?"

Durvasa's prophecy

Sumantra replied, "Do not grieve, Lakshmana. This was presaged – Rama will live a life of sorrow with little joy. The revered sage, Durvasa told your father this in my presence, while Vasishtha was there. I would never tell you or Bharata this, but perhaps fate is inevitable.

"Durvasa told the king that Rama would rule for several thousand years before going to Brahma's realm, perform many sacrifices, but would, at some

> **"I am conferring the kingdom of the auspicious city of Madhu on you... You are capable of establishing a prosperous city and an auspicious countryside in Madhu's dominion."**
>
> RAMA TO SHATRUGHNA, *SARGA* (54), UTTARA KANDA

point, renounce Sita, Bharata, Shatrughna, and even you. This is how it shall be."

Finding solace

Lakshmana found some succour in this. When they reached Ayodhya the next afternoon, Lakshmana grew desolate as he wondered what he could possibly say at Rama's feet. He reached the palace, entered Rama's chambers and found his brother sitting there, his eyes filled with tears.

Lakshmana grasped Rama's feet and said, "In accordance with your commands, I have left my revered sister-in-law at Valmiki's hermitage, and returned to serve you. Do not grieve, men such as yourself ought not to fall prey to grief like this.

"All accumulations are subject to dispersion, all that rises is subject to fall,

all unions are subject to separation, and life is subject to death. You have the capacity to vanquish the three worlds, and your own self – then why this sorrow?" Rama replied with supreme love, "I am pleased that you acted as I commanded you to. I am calmed by your sweet, wise words."

A new threat

Sumantra then announced the arrival of Sage Chyavana and some ascetics who sought favours. After the proper honours had been offered, Rama gave them his word that he would fulfil their wishes.

Buoyed by his confidence and assurance, they told him about an Asura called Madhu, who was married to Sumali's daughter, Kumbhinasi. Madhu had received a

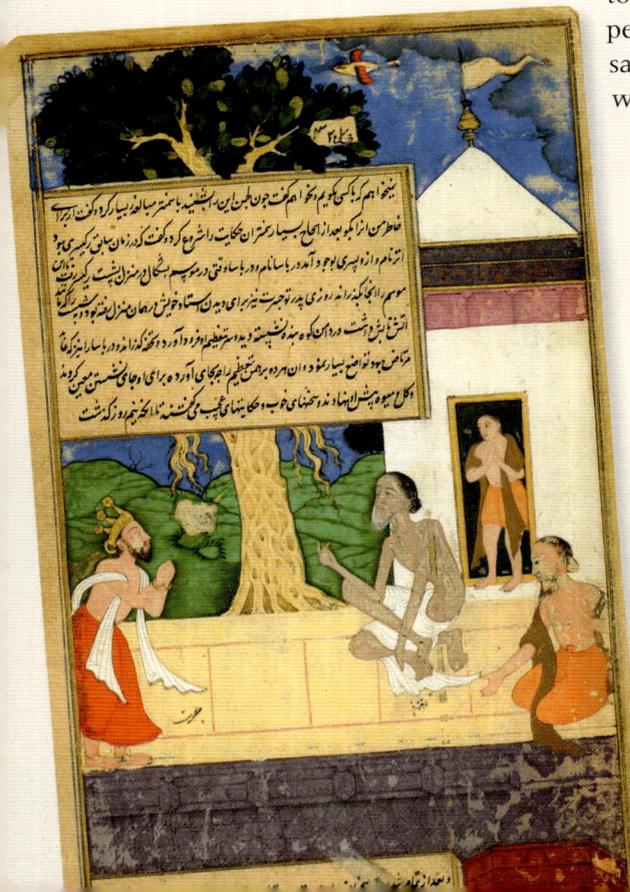

THE SAGE'S PREDICTION
King Dasharatha asked the powerful Sage Durvasa about the destiny of his descendants, only to be told that after ruling for many years, Rama would go to Brahma's realm. This 16th-century painting in opaque watercolour, gold, and ink depicts the episode with Dasharatha on the left.

mighty weapon from Shiva, the Destroyer of the universe, which he could pass on for one generation. His son Lavana possessed the weapon now and was invincible. He lived in Madhupura, on the banks of the River Yamuna, and consumed various creatures. Aware of the power of the mighty weapon, Lavana tormented the sages. The ascetics now sought Rama's protection.

Rama reassured the sages and then wondered which of his brothers would be ideal for the mission. Bharata sensed his dilemma and offered to go, but Shatrughna intervened.

He said, "The revered second brother, Bharata, has suffered a great deal because of his separation from you. He bore the burden of the kingdom for the duration of the exile. It is only right that I should go, for why should he suffer more while I still live?"

Delighted at this words, Rama then consecrated Shatrughna as the ruler of Madhu's city. With great affection, he imparted to Shatrughna the unfailing arrow – produced by Vishnu, the Preserver of the universe to kill Maya.

Rama had not used the arrow in the battle with Ravana as it would have created fearsome circumstances. He told Shatrughna to attack Madhu when the evil one was not bearing Shiva's weapon.

So, with an immense army and adequate resources, Rama sent Shatrughna to vanquish Lavana.

RAMA'S YOUNGEST SIBLING
This 19th-century painting from Patna, Bihar, of Shatrughna depicts him walking along a path holding a bow and arrow. Rama entrusted him to slay the dreadful Rakshasa Lavana.

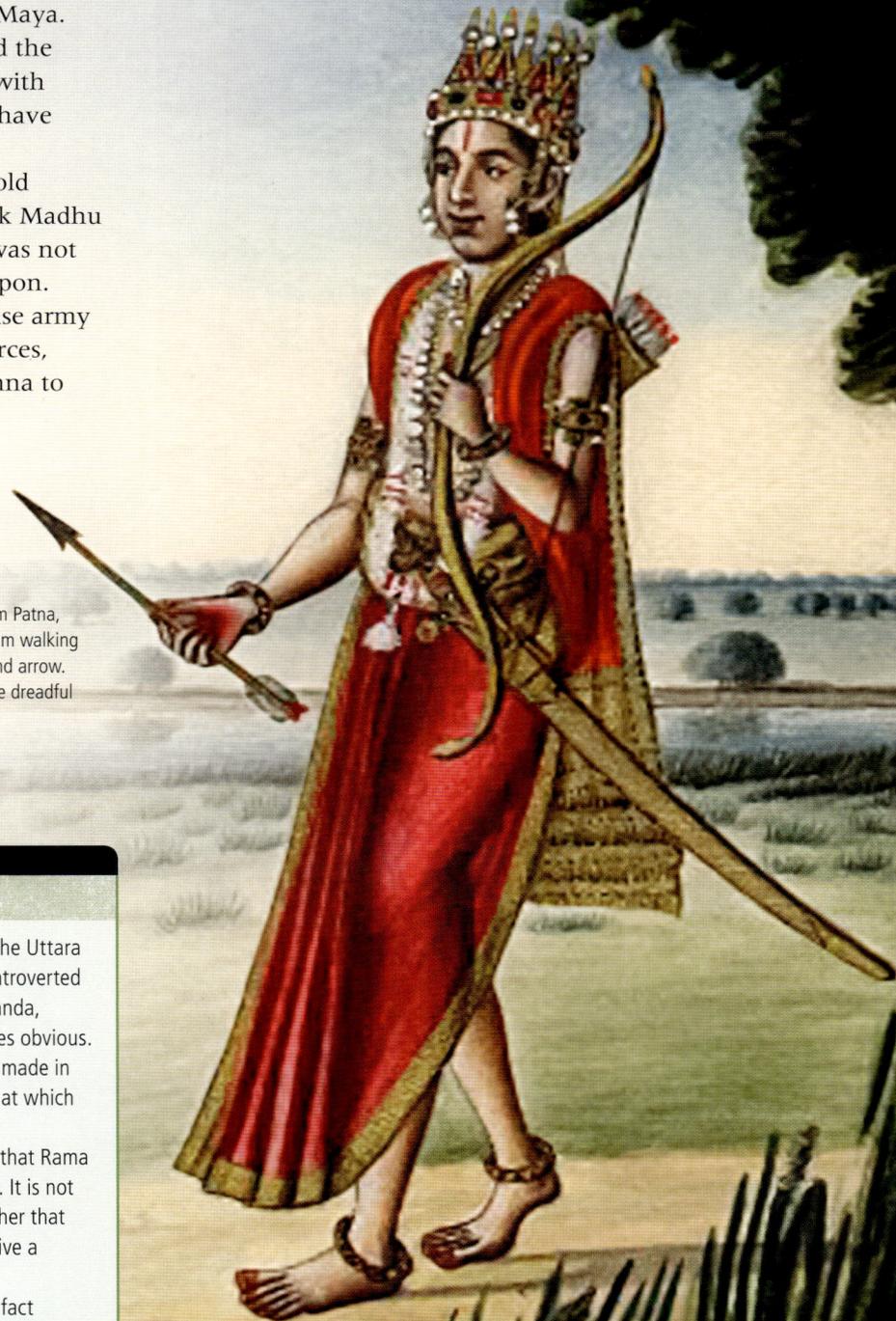

KEY CONCEPT

THE INEVITABILITY OF FATE

Fate plays an interesting role in Valmiki's *Ramayana*, particularly in the Uttara Kanda. It is often mentioned as this mighty thing that cannot be controverted from time to time, especially in the Ayodhya Kanda. In the Uttara Kanda, however, the mechanics of how everything is predetermined becomes obvious. Sita is predestined to be Ravana's end, if only because of a vow she made in an earlier life. Ravana's own actions are determined by the moment at which Kaikasi approached his father (See p 342).

Lakshmana carries out perhaps the most painful and difficult task that Rama assigns him, and after leaving Sita, he is seen wondering about fate. It is not that the intervention of fate absolves Rama of responsibility, but rather that there is no point in brooding over the inevitable. Rama is bound to live a mostly sorrowful life.

The predictability of events in the *Ramayana* is evident in the very fact that Valmiki is able to "see", as Brahma promises, events of the past and future when he is given the task of writing Rama's life-story.

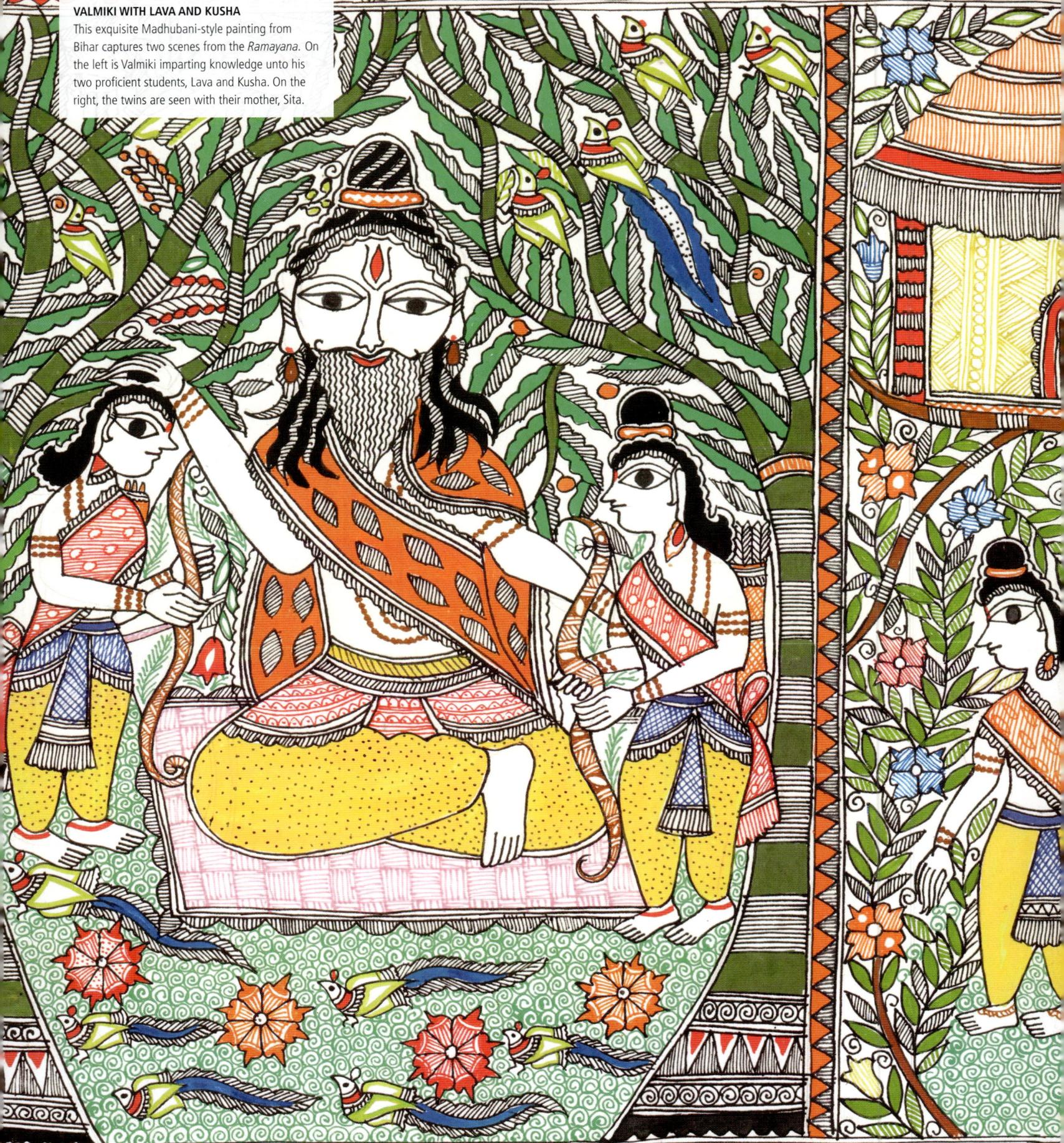

VALMIKI WITH LAVA AND KUSHA
This exquisite Madhubani-style painting from Bihar captures two scenes from the *Ramayana*. On the left is Valmiki imparting knowledge unto his two proficient students, Lava and Kusha. On the right, the twins are seen with their mother, Sita.

Birth of **Lava** and **Kusha**

Shatrughna marched along with his army, with the singular purpose of accomplishing the task Rama had given him. He reached Sage Valmiki's hermitage, and was blessed with good fortune beyond his dreams.

Shatrughna left for Lavana's kingdom alone, while the army marched behind him, for they would take a month to reach. The prince reached Valmiki's hermitage in two nights, where he sought and received the sage's permission to spend the night.

That night, the sage told him the story of Mitrasaha, a great king from the Ikshvaku lineage, who was tricked into feeding the powerful sage Vasishtha, human meat, and was cursed into becoming a consumer of human meat himself. When propitiated, however, the sage set a 12-year limit to the curse. Shatrughna then honoured Valmiki and proceeded towards the cottage for the night.

That night, Sita gave birth to two sons. The ascetic children rushed to tell Valmiki the news in the middle of the night. The sage performed rituals that would destroy the Rakshasas and protect them.

For this, he took *kusha* grass and its stalk, called *lava*, and so the older child was named Kusha, and the younger, Lava.

Shatrughna heard the happy news and rejoiced.

> "**Shatrughna** heard this extremely **pleasant news**. In the night, he went to the cottage of leaves and said, 'This is **good fortune**. It is fortunate.' In this way, the great-souled **Shatrughna rejoiced**…"

AN ACCOUNT OF SHATRUGHNA'S DELIGHT, *SARGA* (58), UTTARA KANDA

Righting **Wrongs**

Entrusted by his brother Rama to kill Lavana, Shatrughna set forth on a journey to find the Rakshasa. Accompanied by a great army and many consorts, he sought shelter with a great sage, gathering insight about his fierce opponent.

SHATRUGHNA SLAYS LAVANA
This 17th-century Mughal painting attributed to painter Qasim, depicts the episode of the killing of Lavana at the hands of Shatrughna.

presuming him dead, did not reach for his weapon. Challenging the Rakshasa for the second time, Shatrughna released the excellent arrow Rama had given him, destroying Lavana, the terror of the three realms.

The gods praised Shatrughna and bestowed upon him a boon for his glorious victory. As per his wishes, they blessed him so that his vision of a well-established city would be realized quickly. Shatrughna spent 12 years building the beautiful city of Madhupura and then resolved to see Rama's feet again.

S hatrughna stayed with the Sage Chyavana when he reached the banks of the River Yamuna. The sage told him about the great Ikshvaku king Mandhata, who had sought to vanquish the three worlds.

Indra, the king of gods, perturbed by Mandhata's successes told him that the Rakshasa Lavana, who was not under his control, still remained in the earthly realm. Mandhata was killed

by Lavana. However, Chyavana assured Shatrughna that he would certainly be able to kill the Rakshasa the next day.

Killing the Rakshasa

Shatrughna reached Lavana's residence and challenged him to battle, introducing himself as Rama's brother.

Lavana recounted Rama's offences against his extended family, including Ravana, and the two battled furiously. At one point, Shatrughna

Service beyond self

Hurrying to Ayodhya, Shatrughna entered Rama's presence and said, "Your majesty, I have done everything you commanded. Lavana has been killed and the city has been settled. I no longer wish to live without you, for I am as bereft as a cow without his mother in

Rama embraced his brother and replied, "Do not be so grief-stricken. Warriors and kings do not despair over living away. Protect your subjects in accordance with dharma. Do visit me, Shatrughna, for I love you more than life itself. However, your duty is to your subjects, and they must be cared for. So spend a few nights here, and

A FATHER'S GRIEF
In this 17th-century artwork from Udaipur, Rajasthan, Rama is shown seeking advice from sages. Lakshmana is first seen before Rama, and then conveying his message to the distraught old man at the door. The son's body is seen later as preserved in an urn.

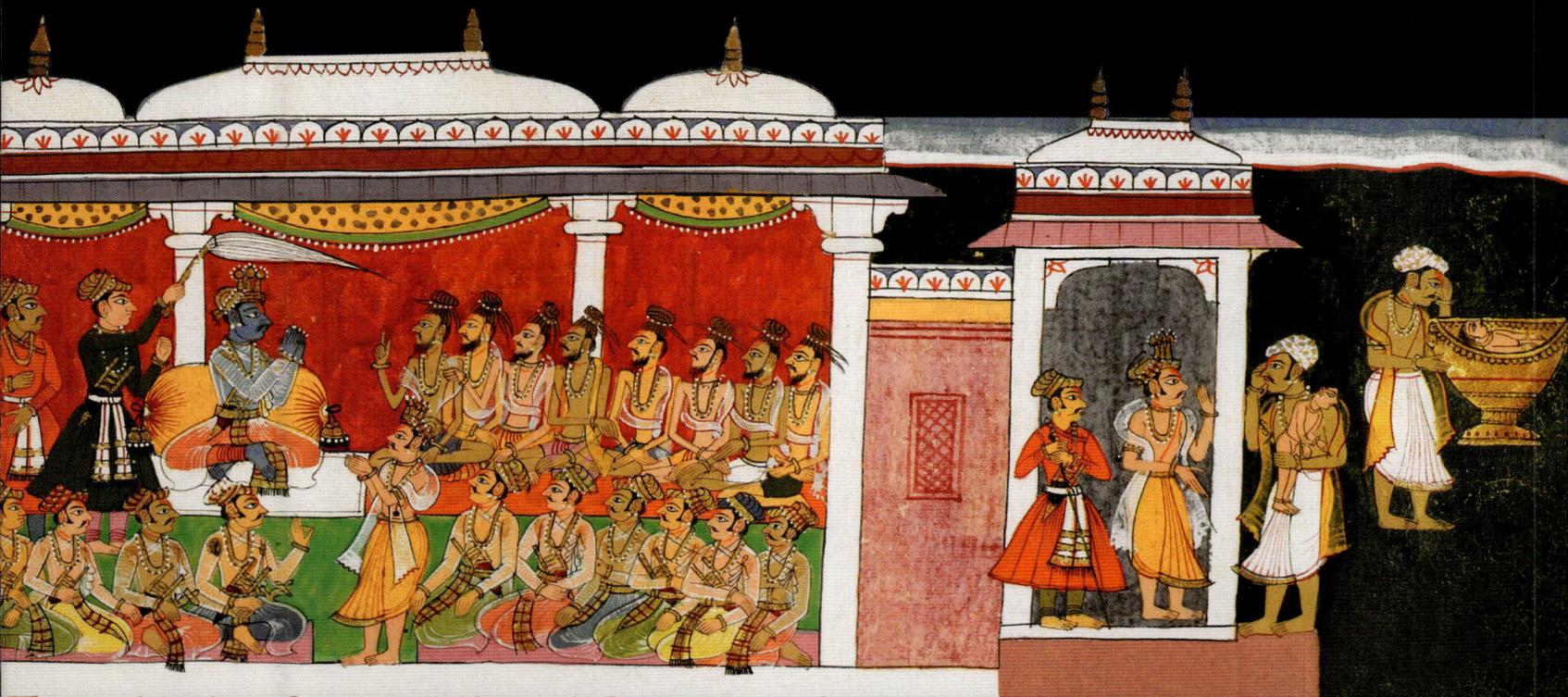

Crestfallen, Shatrughna agreed. After he left, Rama lived in Ayodhya with Bharata and Lakshmana.

The killing of Shambuka

One day, an old man came to the royal gate with a deceased child, and lamented loudly as he wondered why he had to see his young son dead. He proclaimed that it must be the king's fault that such a terrible thing had happened in his realm. When Rama heard of this, he called upon his advisers. It was determined that there were different kinds of restrictions on ascetic practice during different eras.

They determined, that a Shudra, a person from the last varna, must be performing austerities for such a thing to have come about.

Rama left on the Pushpaka Vimana, which had since returned to him, and travelled in all directions but did not find anyone doing such a thing. In the south, he came upon an ascetic hanging upside down. Rama praised him for his practice, and asked him who he was.

The ascetic introduced himself as Shambuka, a Shudra, performing ascesis in pursuit of heaven. As soon as he said this, Rama raised his sword and cut off his head, bringing the old man's child back to life.

> "The **lord of men** searched everywhere in the eastern direction. The descendant of a royal sage then went to the **southern direction**. He saw a great lake on the northern slope of Shaivala. Near that lake, **an ascetic was tormenting himself** through great austerities."
>
> RAMA SEARCHING FOR SHAMBUKA, *SARGA* (66), UTTARA KANDA

OF A TIME PAST

Rama spent the night at Sage Agastya's hermitage who gave him beautiful ornaments. When Rama asked him where they had come from, the sage told him the story of a king who turned to ascetic practices but, when he went to heaven after dying, continued to be tormented by hunger. It was so because the king did not have any progeny to provide food for him after death and was forced to feed off of his own mortal body until liberated by Agastya. His body disappeared when Agastya accepted his gift of ornaments.

The sage also told Rama the story of how the Dandakaranya came to be formed when a sage's daughter, Araja, was raped and he destroyed the realm of the perpetrator. The region that was protected from this, where the sage's daughter, Araja stayed, was called Janasthana.

The **Horse Sacrifice**

Rama decided to perform a horse sacrifice and all his faithful subjects, allies, and devotees were invited to witness the ceremony and delight in the generosity of their beloved king. The sage Valmiki heard of this and thought it an opportune moment.

Rama returned and asked for Bharata and Lakshmana who greeted him with great affection. After they embraced, Rama proposed that he would perform the Rajasuya Yagna, a ritual to establish a king's sovereignty, with them by his side. Bharata, however, said, "O bull among men! Dharma is supreme for you and the entire earth is yours. Your subjects love you as a father and other kings hold you in the same regard as the three of us. Why would you perform a sacrifice that leads to the destruction of the kings and the earth?" Rama took great delight in Bharata's speech, and praised him, and decided not to perform the Rajasuya after all.

A brilliant idea

Lakshmana suggested something different. He said, "The horse sacrifice destroys all sin. It is how the king of gods, Indra got rid of the sin of killing the Brahmana, Vritra. Vishnu, the Preserver of the universe, told the gods to perform a horse sacrifice for him." Acknowledging Lakshmana's sound advice, Rama spoke in praise of the horse sacrifice himself.

Story of Ila

Rama told his brothers the story of a king named Ila who chanced upon a place where Shiva and his consort, Parvati, were together, and since everything that dwelled there had turned feminine for Parvati's pleasure, so did Ila and his companions.

Shocked, Ila sought the favour of Shiva. The latter offered him everything – except a return to masculinity. Shiva's consort, Parvati, however, said that she

THE SACRIFICIAL RITUAL
Ashvamedha was a ritual sacrifice performed by kings in ancient India wherein a strong horse was let loose to wander at will. At the end of one year, the stallion was brought back and sacrificed.

SHIVA AND PARVATI
This 19th-century painting in opaque watercolour, gold, and silver on paper from Himachal Pradesh depicts Shiva sitting with his consort, Parvati, in her garden of pleasures where Ila chances upon them.

> **"For the sake of being consecrated in the sacrifice, let a golden image of my wife be prepared. Let the immensely intelligent Bharata leave in advance."**
>
> RAMA'S PROCLAMATION, *SARGA* (82), UTTARA KANDA

could grant Ila only half of what he wanted, for the other half would have to be completed by Shiva himself.

Ila then elected to spend every alternate month as a man. Known as Ilaa in her feminine form, she fell in love with and bore the child of Budha (Mercury), the son of the moon. It is said that the child was the first king of the Chandravamsha or Lunar dynasty. Budha then brought all the sages together and asked for their advice. They told him that the only way to propitiate Shiva was through the Ashvamedha Yagna.

The sacrifice

After they had heard the story, Rama told Lakshmana to call the sages and plan the sacrifice. Messengers were sent to Sugriva, Vibhishana, and Rama's other allies.

Bharata went to the Naimisha grove by the River Gomati with his retinue, where they built a sacrificial ground, as it was a sacred spot. A golden image of Sita was created as it would be initiated into the sacrifice as Rama's consort. Rama then released the special sacrificial horse with Lakshmana as its protector, and went to the grove in Naimisha. There, Sugriva and Vibhishana, along with the Vanaras and Rakshasas, took on various responsibilities, and Bharata and Shatrughna gave away gifts. Old ascetics, who had seen many sacrifices of various kinds, exclaimed that the gifts in Rama's charity exceeded any that they had ever seen before. This was a sacrifice like no other.

Valmiki's instruction

As the sacrifice was set up, Valmiki arrived as well. He told Lava and Kusha to go to the site and recite the *Ramayana*. He instructed them to only consume fruits and roots, not demonstrate the least desire for money, and recite 20 *sarga*s a day. If Rama were to ask who they were, they should only say that they were Valmiki's disciples.

ANALYSIS

RITUALS OF THE YAGNA

For various Vedic ritual performances, the person for whom it is being done must be accompanied by his wife. This is why Rama has to have a wife for conducting the Ashvamedha sacrifice. However, because he did not wish to marry again, he gets Sita's likeness rendered in gold.

In a fascinating piece, Monika Nowakowska, a scholar of classical Indian philosophy, brings up the treatment of golden Sita in Mimamsa, a system of providing rules for the interpretation of the Vedas. The context of that treatment is the basis of dharma. One of the aspects brought up in this context is that Rama's production of a golden likeness of Sita for the sacrifice serves the purpose of conveying to the reader his affection for Sita. And that she was only abandoned out of fear of gossip, and not because Rama himself thought she was at fault.

A STATUE OF SITA at the Seetha Amman Temple in Sri Lanka, believed to be the site where she was held captive

Sita's **Second Trial**

Lava and Kusha narrated the *Ramayana* to Rama and his courtiers, and in the process revealed their identities. A hopeful Rama asked for Valmiki and Sita to present themselves before him. He, however, had one more request – for Sita to prove her purity once more.

Lava and Kusha followed Valmiki's instructions and reached the sacrificial ground the next morning. Well versed in the musical arts, they performed Valmiki's immortal composition in such an evocative manner that Rama found them exceptional. He gathered everybody to listen to them, and the audience found themselves mesmerized. They wondered at the twins' skills, the exceptional composition, and also how much they seemed to resemble Rama.

When they finished, Rama asked Bharata to reward them with 18,000 gold pieces. The brothers refused and said, "We are forest-dwellers. We live on fruits and roots. What have we to do with gold?"

Rama asked them about the composer and the actual extent of the narrative. The boys replied, "It is 500 sargas from the beginning, and the creator is Sage Valmiki. He has composed this to go up to the extent of the life of the protagonist. If you wish to listen to it, you may all do so during the breaks in the sacrifice."

Rama agreed and he, along with the sages and all the other attendees, listened to the twins and their sweet voices for several days.

LOCATION

NAIMISHA

The Naimisha forest, or the Naimisharanya, often identified with present-day Neemsar in the northern Indian state of Uttar Pradesh, is an important site in Hinduism. It is not only significant as a place where many narratives come to be told, but also as an important location for worshippers of Vishnu, the Preserver. It is also where various figures have performed great penance.

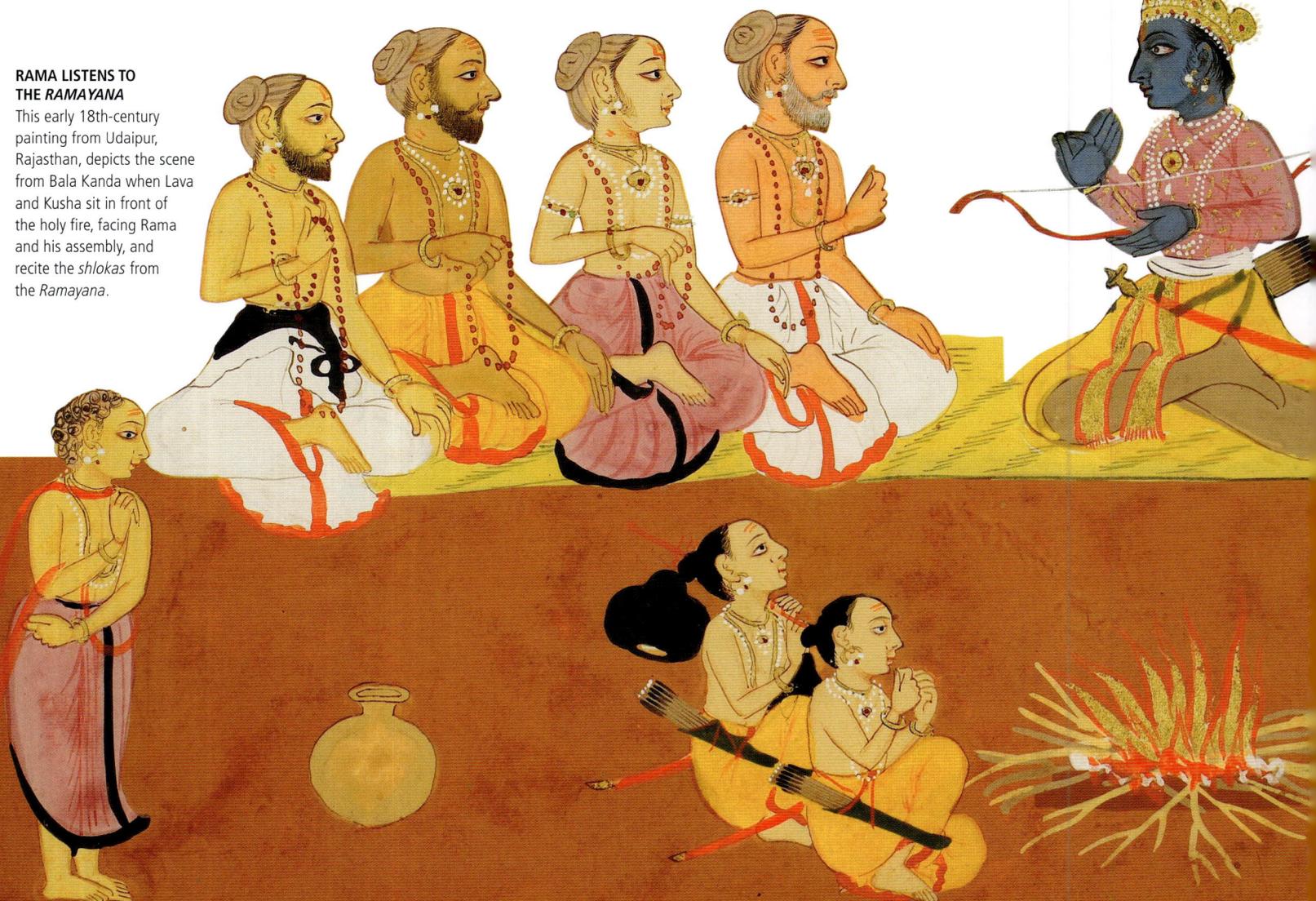

RAMA LISTENS TO THE *RAMAYANA*
This early 18th-century painting from Udaipur, Rajasthan, depicts the scene from Bala Kanda when Lava and Kusha sit in front of the holy fire, facing Rama and his assembly, and recite the *shlokas* from the *Ramayana*.

"O Brahmana! I know that she is innocent. However, scared because of the condemnation... I abandoned Sita. You should pardon me."

RAMA TO VALMIKI, *SARGA* (88), UTTARA KANDA

Sita is summoned

When they described Sita's sons, Kusha and Lava, Rama, surrounded by his courtiers, gently told his messengers, "Go to the sage and to Sita. If her conduct is untainted, then let her come here and prove it. Find out what the sage wants and what Sita would like to do. Let Sita go through an ordeal here and purge me of the aspersions too."

The sage listened to Rama's gentle words and acquiesced.

"I seek forgiveness"

The great sages gathered at the sacrificial ground the next day. Valiant Rakshasas and

When Rama heard this, he announced that Sita would prove her blamelessness the next day. "O sages, come with your disciples. Kings, come with your followers. Let anyone who desires proof from Sita come and bear witness," he said, as the gathering praised him.

the brave Vanaras were there as well, as were the people of Ayodhya. They were there to see Sita take the pledge, and stood there like mountains made of stone.

Sita walked in behind her protector, Valmiki, and those that were gathered praised her, or Rama, or both of them. Valmiki stopped in front of Rama and said, "Son of Dasharatha, here stands before you the blameless Sita, whom you abandoned for fear of disrepute, although she has always conducted herself in accordance with dharma.

"She will give you proof, you have but to command her. These sons are yours. This I tell you honestly; I am the tenth son of Prachetasa (one of the Prajapatis, the creator deity of the Vedic period), Rama, and I have never spoken an untruth. I have performed great austerities

for thousands of years, and I am telling you Sita is blameless. Knowing her to be as brilliant and as pure as the fire, I accepted her.

"That Sita, whose conduct is pure, and who reveres her husband and who is blameless, shall give you, who fear gossip, proof."

Rama, his hands cupped, addressed Valmiki while he looked at Sita, "It is as you say. Your words alone are my proof. Indeed, she herself gave me proof in the presence of the gods and Gandharvas. I seek forgiveness for having abandoned her for fear of what people would say, even when I had no doubts about her. I also know Kusha and Lava to be mine.

"I will be delighted if Maithilee establishes her purity. Let my love for her be known to the world, once she proves her blamelessness here."

ALTERNATIVE ACCOUNT

MEETING LAVA AND KUSHA

Rama's meeting with his sons is not always in such calm settings. In many narratives, Kusha or Lava capture the sacrificial horse and in the battle that follows, they sometimes end up facing Rama. In one narrative, they face one of their cousins (Lakshmana's son), but become friends.

In the 8th-century Sanskrit playwright Bhavabhuti's narration, Kusha is introduced to Rama as his nephew's friend at Valmiki's hermitage. Eventually, Valmiki stages a play where Sita dies after her exile, and at that point, Rama falls unconscious. Lakshmana intervenes, asking if Rama's death was the performance's intent. At this point, the real Sita emerges. Arundhati, the sage Vasishtha's consort, witnesses her blamelessness, and she goes on to chastise Ayodhya's citizens who had cast aspersions on Sita in the first place.

In the **Arms** of the **Goddess**

Sita looked up at the gods gathered in the sky and the people who had gathered to watch her, and folded her hands in salutation. The moment of truth had arrived.

The supreme gods gathered to witness the moment, with Brahma, the Creator, in the lead. Sages, Gandharvas, and the Apsaras were there as well.

A gentle breeze began to blow, as Sita looked at the earth, joined her hands in salutation, and said, "If I have never thought of anybody other than Rama, let the earth give me room." As she said these words, something extraordinary happened.

A divine throne, ornamented with different kinds of jewels, rose from the earth, borne on the hoods of mighty serpents.

The Goddess Earth sat upon the throne. She embraced Sita and greeted her with words of welcome. She honoured Sita and then seated Sita by her side. As Sita entered the earth, flowers rained down from the sky and the gods praised her.

The sages and kings who had gathered at the sacrificial ground were amazed as were all beings of the earth and in the sky. Some rejoiced, others cried, some looked at Sita, and the others at Rama, but nobody was unmoved.

When the sacrifice was over, Rama grew distressed. He found the world empty and without its essence for Sita no longer lived in it. He gave away all his riches and entered Ayodhya with Sita in his heart, vowing never to marry again.

"Some roared in joy. Some were immersed in thought. Some glanced towards Rama. The minds of some were on Sita. For a while, on seeing Sita enter, all those assembled ones from the world were confounded. "

AS SITA ENTERS THE EARTH, *SARGA* (88), UTTARA KANDA

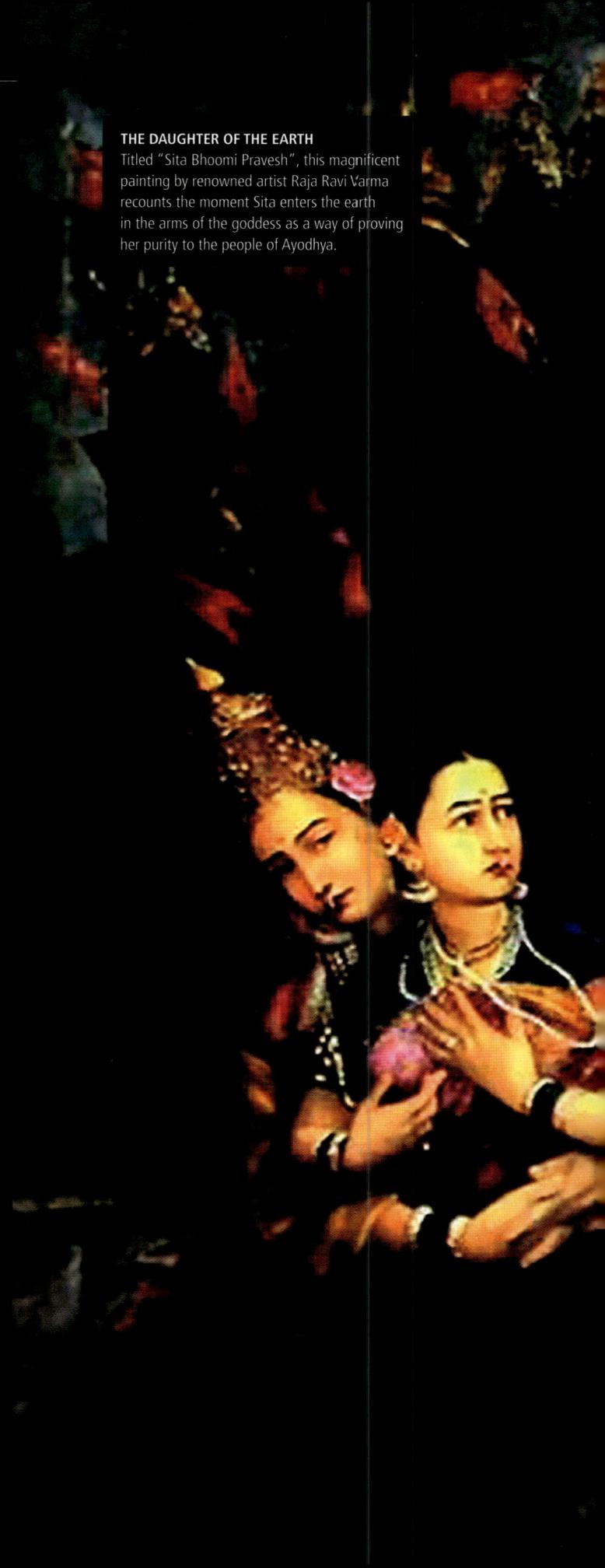

THE DAUGHTER OF THE EARTH
Titled "Sita Bhoomi Pravesh", this magnificent painting by renowned artist Raja Ravi Varma recounts the moment Sita enters the earth in the arms of the goddess as a way of proving her purity to the people of Ayodhya.

The Wheel of **Time**

Rama never recovered from the loss of Sita and focussed all his attention on matters of the kingdom. His reign brought peace and prosperity for all. One day, a guest arrived, for all good things eventually come to an end and destiny had run its course.

> "You have **resided here for eleven thousand years**. Now **destiny** requires you to **return** to your own ancient city."

KALA TO RAMA, *SARGA* (94), UTTARA KANDA

The great-souled Rama ruled over Ayodhya for 10,000 years. The citizens were happy and healthy and there was no adharma. The Vanaras, bears, and Rakshasas lived happily as well under his reign.

After many years, Rama's mother Kaushalya passed into the heavenly realms, and Kaikeyi and Sumitra followed soon after, where they were reunited with Dasharatha.

The next generation

Some time later, Yudhajit, Bharata's uncle and the ruler of Kaikeya, sent word to Rama that the Gandharvas controlled the land on either side of the River Indus and Rama could capture it, should he wish to.

Rama divided the land between Bharata's sons, Taksha and Pushkala, and sent Bharata with them to help settle their realms. The army emerged victorious and Taksha became the ruler of Takshashila and Pushkala of Pushkaravati. Bharata stayed with them for five years before returning to Rama.

On Bharata's suggestion, Rama assigned Lakshmana's sons, Chandraketu and Angada, the areas to the west and the north. Bharata and Lakshmana accompanied them respectively and helped settle them, before returning.

Time arrives

One day, Kala, or Death personified, arrived in Ayodhya, in the form of an ascetic. He told Lakshmana that he had come as the messenger of a sage and wanted to see Rama.

As he approached Rama, he seemed to burn with his own energy. Rama received him and asked about the message. "Raghava," he said, "this message can only be said between the two of us. Anyone who hears or sees these words has to be killed." Rama turned to Lakshmana and said, "Stay by the door, and do not let anyone in. I will slay anyone who sees or hears us while we talk."

Once they were alone, Kala said, "Rama, I come to you as a messenger of Brahma, the Creator. I am your son,

THE CITY OF TAKSHA
The ancient city of Takshashila, now called Taxila, lies in Pakistan. It is traditionally believed that Bharata's son, Taksha established and reigned over the region.

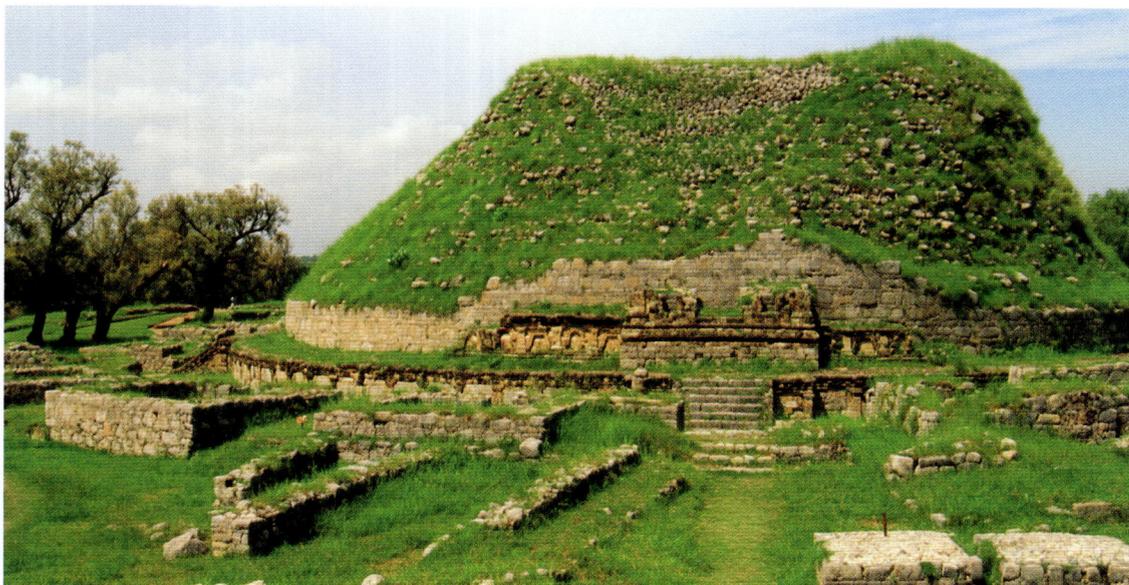

created from your maya. I am the one who causes the destruction of all things. Brahma has said, 'You created me and charged me with the creation of the world. I supplicated and you became Vishnu to protect the worlds. To protect is your vow, and so you took a human form to protect the beings that Ravana tormented. You have ruled here for 11,000 years and now, Kala has come to you. If you wish to stay on, then, of course, it is as you shall do, but should you wish to return, the gods would be delighted.'"

Rama replied, "I have heard the message and I am delighted at your arrival. I shall return. Now everything is at an end, I should certainly stay by the gods who are subject to me, as Brahma has said."

Fate or chance?

As if to set in motion precisely Rama and Kala's discussion, Sage Durvasa arrived and asked for Rama.

Lakshmana asked him if he could help and requested him to wait, in case he wished to see Rama himself. Durvasa's face darkened with anger and he said, in furious tones,

"Show Rama to me this instant, or I shall kill you, him, Bharata, people of this city, and your progeny. My anger is unbearable."

The ultimate sacrifice

Lakshmana thought to himself, "It is better that I die than all these other people," and went in to interrupt Rama. His brother dismissed Kala and received Durvasa with due honour. At his request, the sage told him that 1,000 days had passed since he had last eaten. "I wish to eat," he said. Delighted, Rama offered him whatever had been cooked. Durvasa ate the meal like it was nectar and left soon after.

> "Pure, **supreme Brahman,** Rama!... Located in the station of **eternal bliss, Rama**!"
>
> A POPULAR HYMN

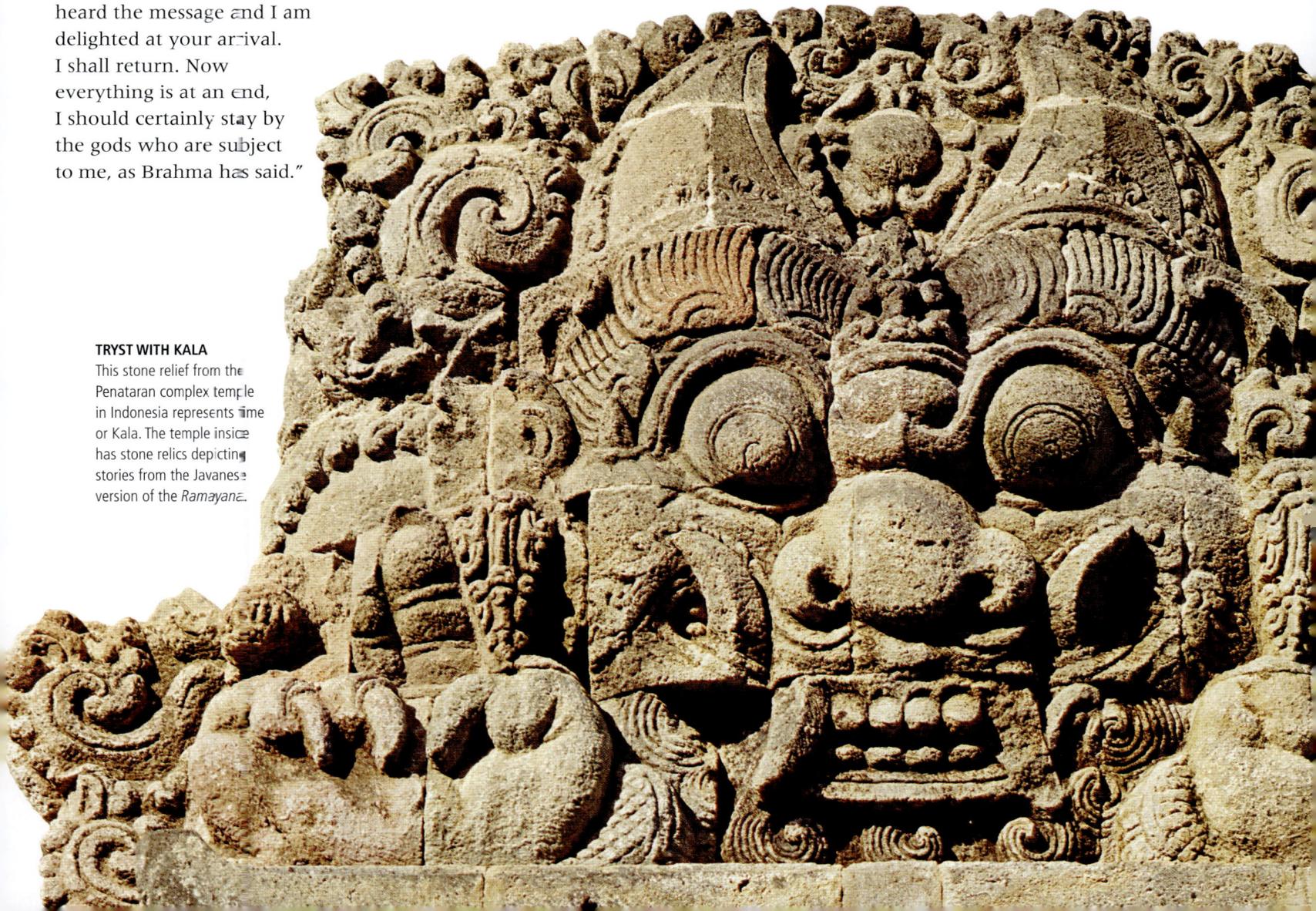

TRYST WITH KALA
This stone relief from the Penataran complex temple in Indonesia represents time or Kala. The temple inside has stone relics depicting stories from the Javanese version of the *Ramayana*.

Lakshmana is Renounced

Rama found himself caught in a dilemma. Would he keep his word and kill his brother, or break his promise? In the end, dharma reigned and destiny had its way.

Rama remembered Kala's words and turned his face away in anguish. Tormented, he said, "There is no other way," and fell silent.

Lakshmana had no qualms and said almost cheerfully, "O Raghava, do not worry on my account. Such is the predestined way of time. Steady one, kill me and keep your vow. Those whose words are made untrue go to hell. If you love me, if you are pleased with me, then kill me and augment dharma."

Rama, shaken, called his priests and ministers and told them the situation. Vasishtha said, "I have foreseen this. You will be separated from Lakshmana. Renounce him. Do not break your word, for that ends in the destruction of dharma, and so of existence. Tiger among men, keep the world order in place by killing your brother."

Rama turned to Lakshmana and said, as he wept, "I renounce you. Let dharma not be transgressed. Death and abandonment are the same for the honourable." Lakshmana, his eyes filled with tears, left and walked to the River Sarayu.

He folded his hands in salutation, touched the water, and entered it. He controlled his breath and did not release it.

When his breath stopped, flowers rained down from the heavens, and, unseen by all, Indra, arrived and took Lakshmana, in his physical body, to heaven. The gods rejoiced at his arrival, for one quarter of Vishnu had returned.

> "… You will **be separated** from the immensely illustrious **Lakshmana**… Do not make your **pledge false**. If pledges are destroyed, **dharma** also heads towards destruction."

VASISHTHA TO RAMA, *SARGA* (96), UTTARA KANDA

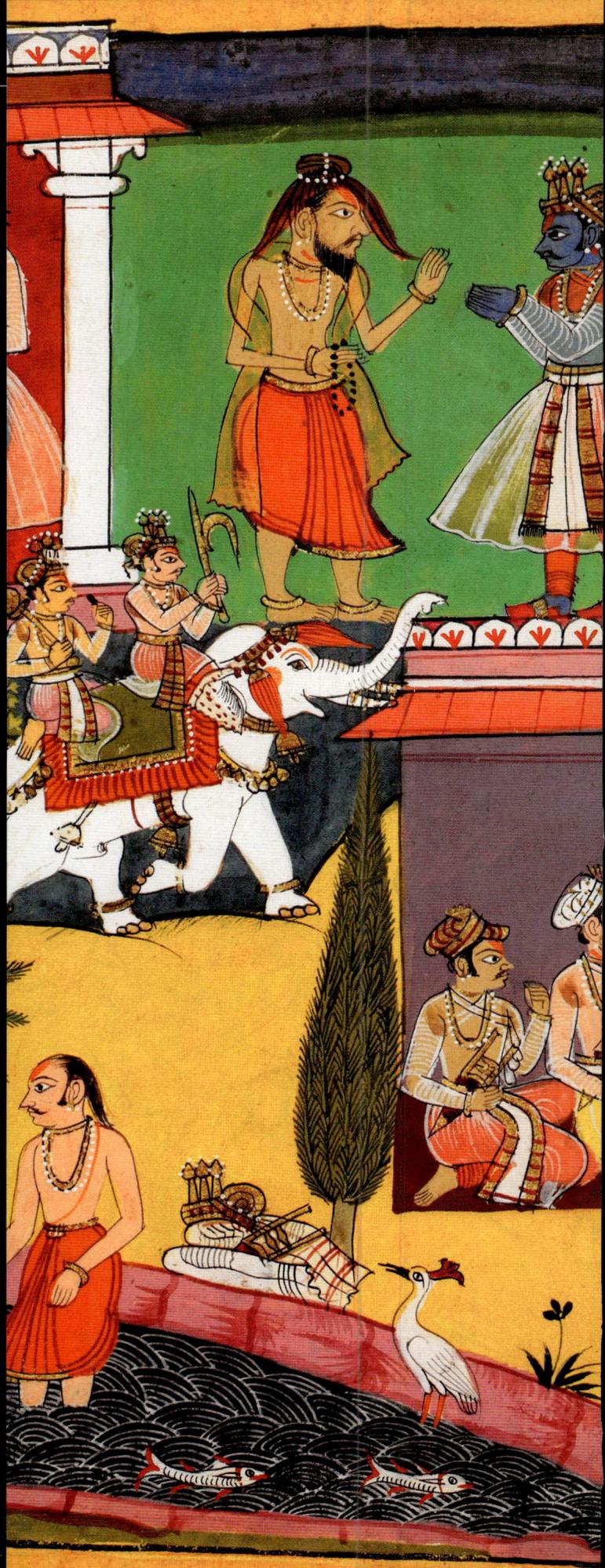

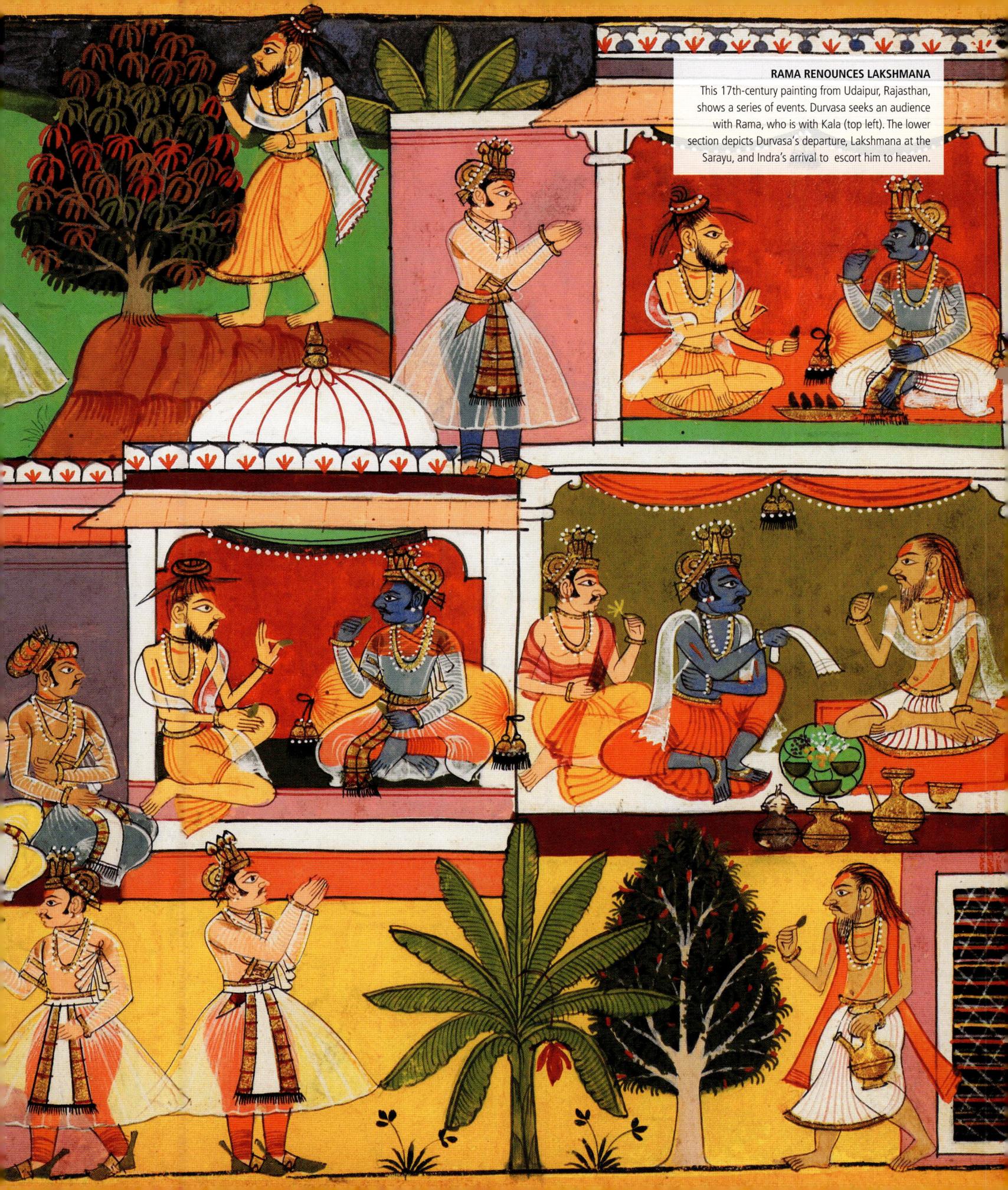

THE STEADFAST BROTHER

Lakshmana

"His brother is... **his equal** in qualities and valour. He is always like **Rama's right arm,** as is **his breath of life**."

SHURPANAKHA TO RAVANA, *SARGA* (32), ARANYA KANDA

A PORCELAIN SCULPTURE
of Lakshmana from Spain

Of all the characters in the *Ramayana,* it is Lakshmana who almost never leaves Rama's side. As one-quarter of Vishnu (sometimes an incarnation of Shesha, the serpent upon whom Vishnu reposes, and who bears the worlds on its hood), and as Rama's younger brother, Lakshmana, in Valmiki's *Ramayana,* offers a glimpse into a tender relationship that serves as a model, not only for brothers but also devotees who seek to serve Rama.

By his side

Rama reveals his inner life, and relies on Lakshmana the most. He turns to him both when he is incapacitated by sorrow and also when he needs a counterbalance for his anger. In either case, Lakshmana is always by Rama's side to complement him perfectly – indeed like his second breath, non-different from his own self.

It is remarkable to note, however, that for all of his reverence for Rama, Lakshmana is not always in complete agreement with him. On the contrary, he disagrees with what are perhaps the two defining decisions that Rama takes – his determination to accept the decision of exile (See pp 90–91) and his renunciation of Sita (See pp 356–57).

In service to Rama

It is not that Lakshmana does not make his differences known or blindly follows Rama; it is the higher ideal of unconditionality that he observes. He may express his dissent, but never leaves Rama to face anything alone.

In the Ayodhya Kanda, Lakshmana is prepared to burn the city and kill his father, but when Rama

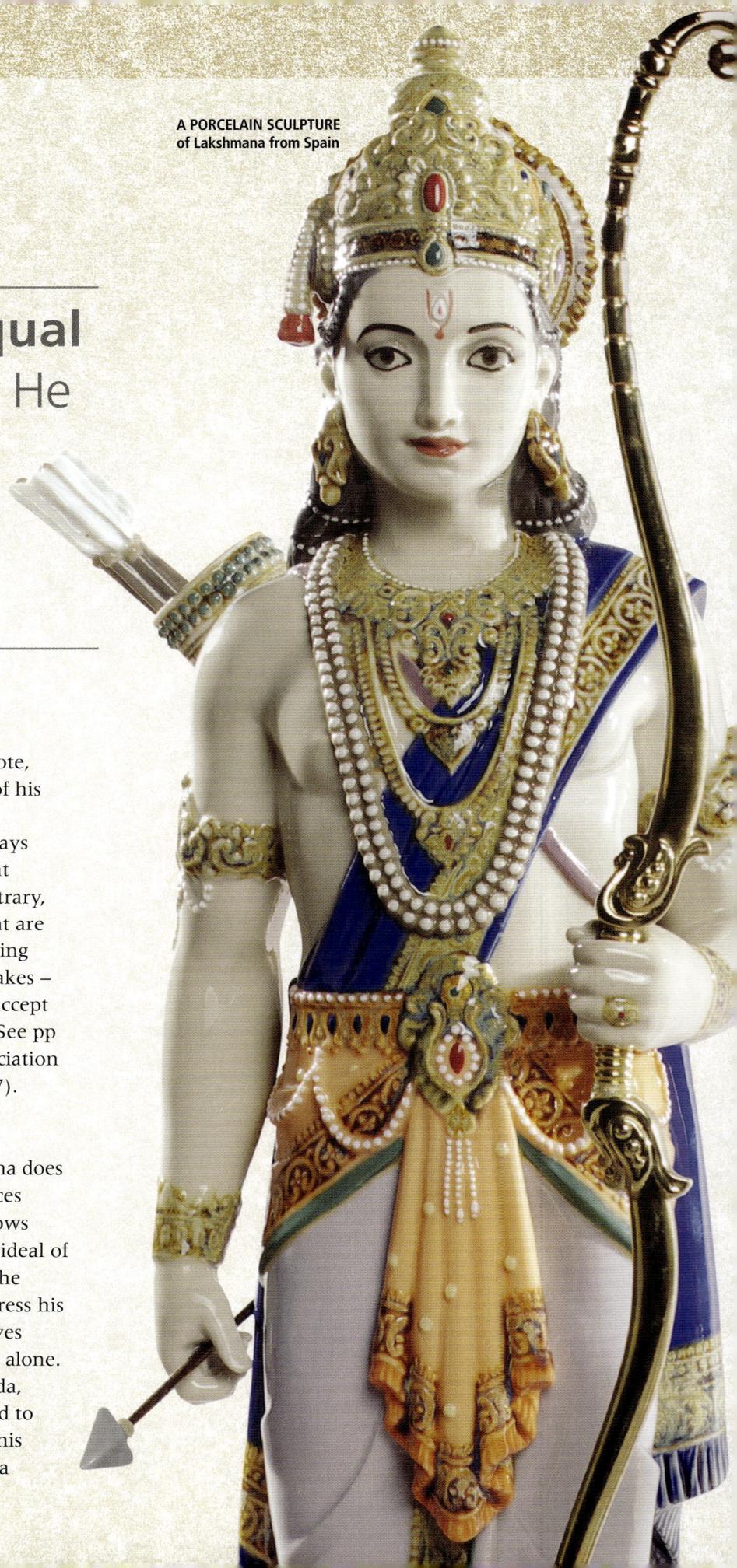

does not want him to do so, he stays by his brother's side for 14 years of exile. While Rama's exile was in the service of truth and glory, Lakshmana's only purpose was service to Rama.

On one of those early nights in the forest, it is to Lakshmana that Rama turns and, speaking movingly, his eyes filled with tears, urges him to return to Ayodhya. His own mother, he says, was afflicted by misfortune, but there was no reason for Sumitra to suffer on his account. Seeing Rama giving in to his sorrow, Lakshmana consoles him and says, "Neither Sita nor I would live without you for even a moment, as fish cannot live when removed from water."

Lakshmana is also quick to express his anger when he feels Rama is wronged. This is true not only when he learns of Rama's exile, but also at the time when Bharata comes to see Rama in Chitrakoot – Lakshmana gets set for battle upon seeing his procession approach.

Steadfast amidst grief

After Sita's abduction, Lakshmana is everything to Rama. It is certain that Lakshmana, too, was deeply anguished by Sita's abduction and yet, his sorrow is set aside so that he can bear Rama's for him. If he is the fire to Rama's moon-like demeanour, and the balm for his anguish, Lakshmana can also be the one who calms him down when his frustration turns into anger.

For instance, on learning of Sita's abduction Rama resolves to destroy all of creation. It is Lakshmana who reminds him of his compassion (See pp 158–59). When Rama begins to feel depressed as he waits for Sugriva through the monsoon months, it is Lakshmana who speaks to him and calms him (See pp 182–83).

His commitment to be whatever Rama needs him to be is so complete that in the final battle, when he is wounded and Rama, who has lost all hope, laments as he embraces Lakshmana, it is still the latter who encourages him to return to battle and defeat Ravana once and for all (See pp 310–11).

Brotherly affection

Rama, too, perfectly reflects Lakshmana's tenderness, afflicted by a lack of will to go on when Lakshmana is seriously injured. It is significant that the decision for Rama to end his earthly existence coincides with Lakshmana's departure (See pp 372–73).

In the Uttara Kanda, there is a shift in the way Rama's inner life is portrayed. Unlike the Aranya Kanda, where Rama's sorrow is "on-screen", so to speak, in the final cantos, it is described rather than shown. Here we find Lakshmana, pained to the point of seeking death when he has to drop Sita off near Valmiki's hermitage at Rama's orders. He is moved by Sita's pain, yet unable to transgress his older brother and king's command, and equally unable to abandon

his beloved brother in his time of greatest need. He recognizes, too, that Rama's life, as Sumantra said, is to be one of little joy and much sorrow (See p 358).

He returns, and knowing that Rama would be in pain and grieving at what he had done, speaks gently to him, encouraging him to take heart.

Unconditional devotion

Lakshmana's relationship with Sita and Rama has been portrayed beautifully. The broad contours of this relationship remain the same for devotees, who hold Lakshmana up as the perfect servant of Rama. In such contexts, Lakshmana's time in the forest is a time for the perfection of his pursuit of the divine as well as his servitude.

In many narratives, Lakshmana does not sleep for 14 years, Chitrakoot and Panchavati, are his loci of austerities. It is thus that, with a final push from Hanuman, Rama's eternal intermediary, he is able to kill the darkness that is Indrajit. Lakshmana is also often in the position of receiving instructions from Rama in the pursuit of the divine.

On occasion – such as in the "Lakshmana Gita" in the medieval Sanskrit

text *Adhyatma Ramayana* and Tulsidas's *Ramcharitmanas* – imparts knowledge as well.

For devotees of Rama, Lakshmana is somebody who can act as an intermediary; he is beloved to Rama as his own breath, and yet more accessible than the Supreme Lord himself.

This is not to say that Lakshmana is always sombre; there is often an element of levity, for example in some renditions of his war of words with the sage Parashurama after Rama's wedding. The dynamic of Lakshmana, as someone quick to anger, injects not only the heroic mood, but also Rama's indulgent amusement as the long-suffering older brother calming him down, making known another aspect of Rama himself.

> " … Rama is an object of **obeisance**, Rama is the lord/ Lakshmana, the immaculate reservoir of **affection**/ more beautiful even than the **ocean of mercy**…"
>
> ABOUT RAMA AND LAKSHMANA, "LAKSHMAN" BY SUMITRANANDAN PANT

CHARACTER PROFILE

URMILA

In Valmiki's *Ramayana*, we hear of Lakshmana's wife Urmila at the time of the princes' weddings, but we almost never hear from her after. There is also a view that Lakshmana was able to stay awake for 14 years because Urmila was sleeping on his behalf. Various 20th- and 21st-century authors have chosen to portray Urmila movingly, describing their mutual love in separation, it being even longer than Rama and Sita's.

The Final **Decision**

Rama realized it was time to make his way to heaven, but how could he abandon those he loved?
How could he leave behind his brothers, the Vanaras, the bears, the Rakshasas, and the people
of Ayodhya, for they had sworn to follow him to the very ends of the earth, if necessary?

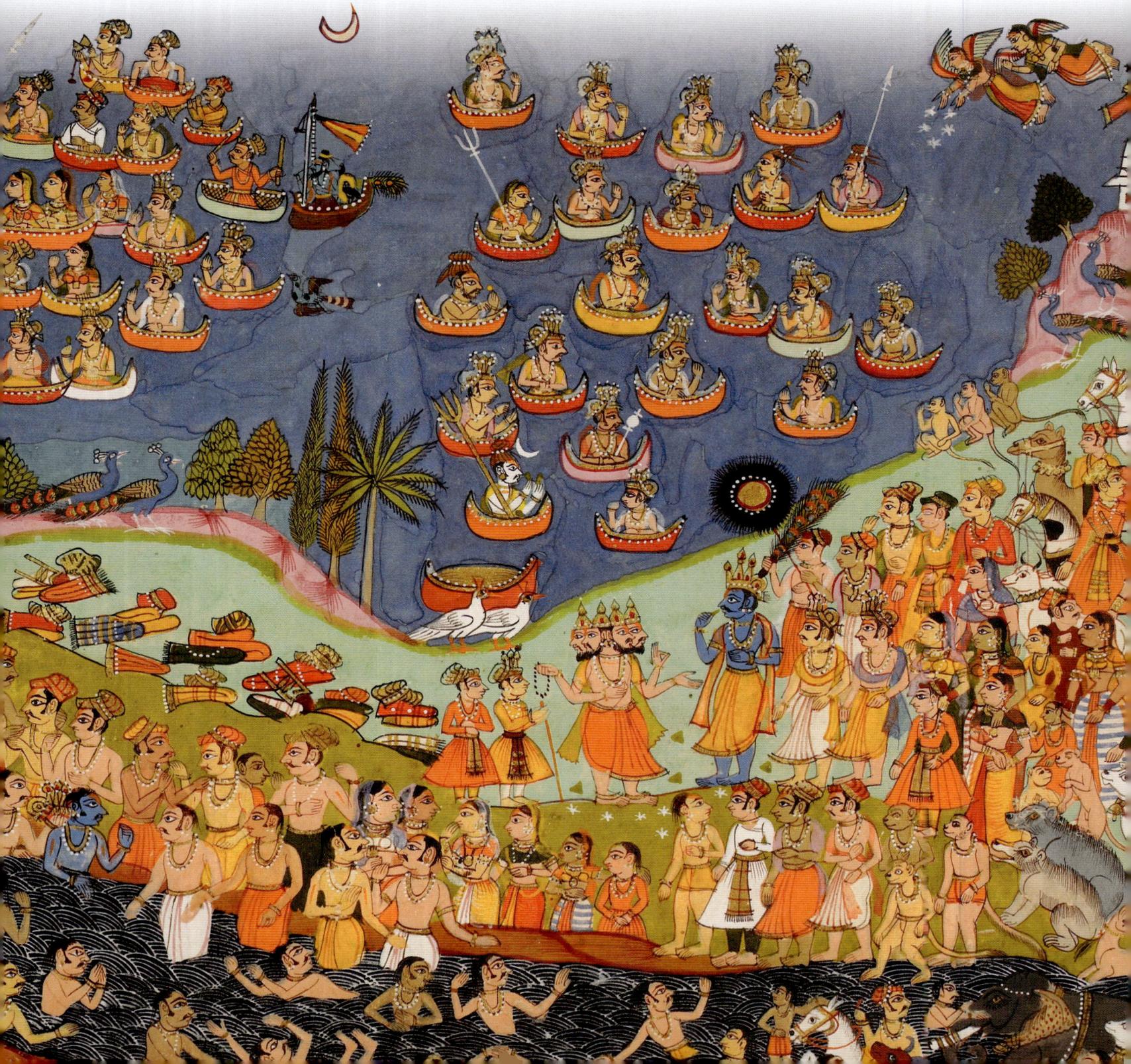

Lakshmana's departure left Rama in despair. He told the ministers of his plan to consecrate Bharata as the king and leave the same way as Lakshmana.

The subjects placed their heads on the ground as though they had lost what was most precious to them. Bharata fainted, and when he regained consciousness, rejected the kingdom. "I do not desire the kingdom without you, joy of the Raghus," he said. Instead, he asked Rama to consecrate Kusha as the king of Kosala and instate Lava in the north, and send word to Shatrughna about their ascent to heaven.

Rama's devoted followers

Vasishtha saw the citizens in deep sorrow and told Rama, "Look at them, fallen to the ground at your words. Ask them what they want, and do not go against their wishes."

When he asked them, they cried, "We will go where you go, Rama! This is our supreme dharma and greatest happiness. If you have any love for us, let us come with you, with our families, wherever you go, to the forest or to the depths of the ocean. Do not renounce us."

Seeing their devotion, Rama realized that they were determined and allowed

RAMA ENTERS THE HEAVENS
This 17th-century painting from Udaipur, Rajasthan, depicts Rama entering the sacred waters of the River Sarayu accompanied by his the Vanaras, bears, Rakshasas, and people, as the gods look on and rejoice.

them to accompany him. He consecrated Lava and Kusha and sent a messenger, in haste, to Shatrughna who was in Madhura.

The messenger did not stop for rest and reached Madhura in three days and nights. He told Shatrughna of Rama's decision and the consecration of Lava and Kusha, and urged him to hurry.

A brother's request

Shatrughna divided the kingdom between his sons, Mahabali, who inherited Madhura, and Shatrughati, who inherited Vaidisha, and hurried to Ayodhya.

> "O Rama! We will go wherever you go. This is our supreme delight. In our view, this is our supreme dharma. We are firm in following you. Our hearts will always be satisfied at that... O lord! If you do not wish to abandon us, take us with you, to the forest for asceticism, to impenetrable places, to rivers and to oceans."
>
> RAMA'S SUBJECTS TO RAMA, *SARGA* (97), UTTARA KANDA

Rama stood alone on a single chariot, in a thin silken garment, blazing like fire. The great sages surrounded him. Shatrughna walked up to him and told him that he had consecrated his sons and said, "Permit me to follow you, for I am determined. There is not much for me to say, for your commands cannot be transgressed, but you should not abandon me." Seeing that he was firm on his decision, Rama agreed to his request.

Rama's final word

The Vanaras and Rakshasas, who were descendants of gods, the Gandharvas, and the sages assembled for they knew Rama was leaving. They said, "If you are going to abandon us, it will be as if you have struck us with the sceptre of Death."

Rama turned to Vibhishana, and said with great love, "So long as your subjects remain, you shall rule over Lanka. Protect and rule over your subjects with dharma, and do not say another word on the matter." To Hanuman, he said, "You determined that you would live, and so,

do not violate your vow. As long as my account is spoken in the world, till then, remain alive and keep your pledge." He allowed the rest of the Vanaras and Rakshasas to accompany him.

The departure

The next morning, Rama, resplendent, his shoulders as broad as ever, his eyes resembling lotus petals, asked Sage Vasishtha to make all preparations for their departure.

Rama walked out of the house, silent, with no desire or impulse, radiant, as though he were a second sun. Glory, dharma's consort, Modesty, and Resolve personified walked by his side and in front. The Vedas, Gayatri (the personified form of the Gayatri Mantra, a Vedic hymn), and sacred formulae embodied themselves to accompany him, as did his weapons.

The sages followed him, as did his advisers, servants, priests, everybody from the inner quarters, and Bharata and Shatrughna.

There were sounds of delight as they followed Rama. No one was miserable, or ashamed, or sad. The people from the countryside came only to look, but joined him. The bears, the Vanaras, the Rakshasas, and the people of Ayodhya followed, each filled with devotion to their beloved Rama.

Everyone stopped when they reached the sacred river, the Sarayu, for this was where Raghava would present himself before heaven.

ALTERNATIVE ACCOUNT
SEPARATION FROM LAKSHMANA

In some Jain narratives, the gods trick Lakshmana by giving him the impression that Rama has died, and in turn, he dies. When Rama finds out, he is devastated, and there are some moving descriptions of how he refuses to allow Lakshmana's last rites to be performed for he does not accept that his beloved brother has passed.

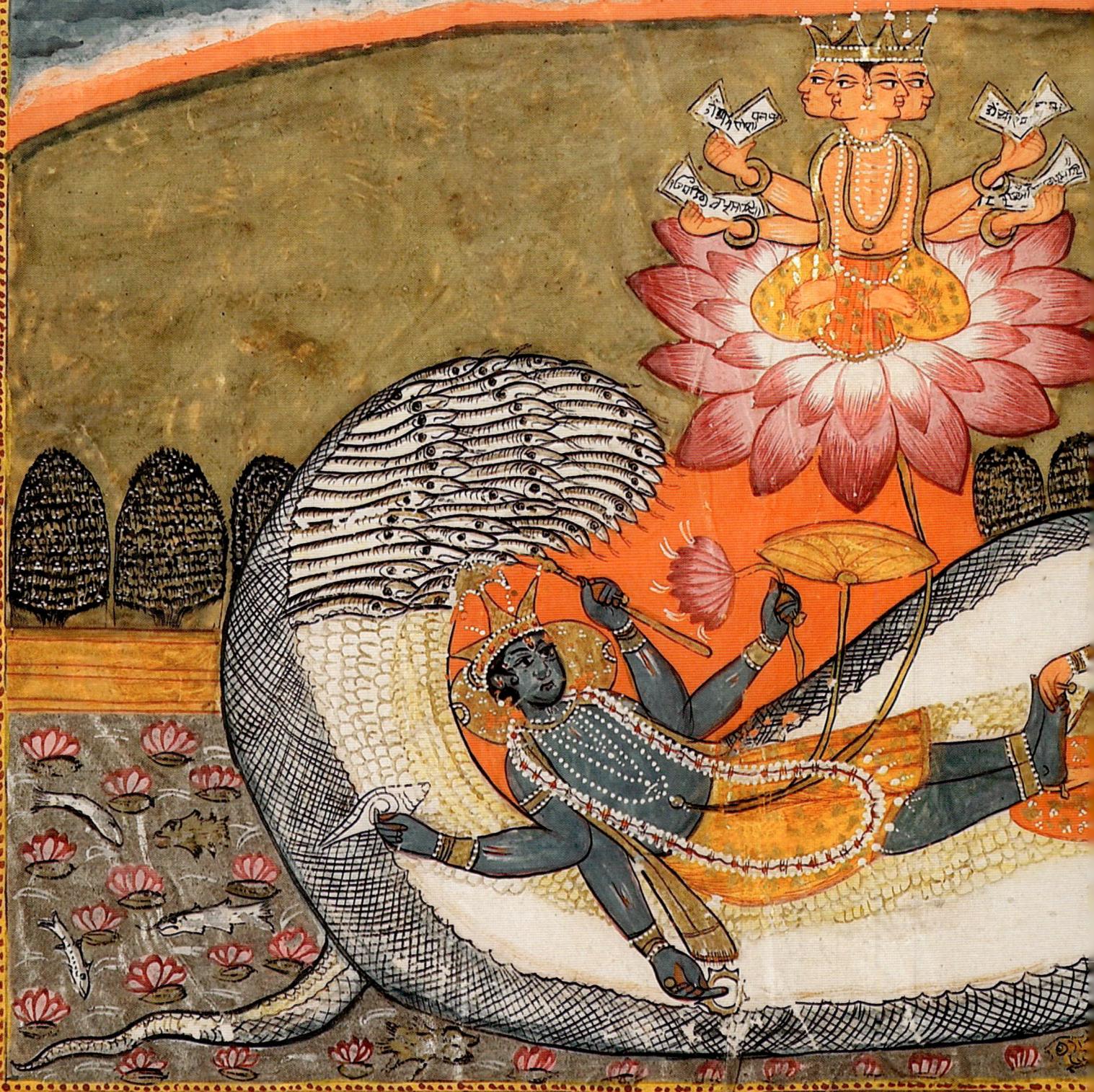

Order is Restored

As Rama entered the waters of the sacred river Sarayu, a strong wind started blowing and the gods gathered, waiting for the moment Vishnu, their lord, would take his rightful place.

Brahma, the Creator of the universe, arrived at that very moment surrounded by gods and sages on their vimanas (celestial chariots). Flowers showered from the sky and trumpets blared.

Rama walked to the waters of the Sarayu, and Brahma said, "Come, Vishnu, bless you, and blessed are we at your arrival. With your brothers, enter your Vishnu-body. You are the refuge of the world – nobody truly knows you, except for your own maya, your eternal companion."

Rama and his brothers entered their Vaishnava splendour, and the gods worshipped him in that form. The sages, Gandharvas, apsaras, Rakshasas, birds, and serpents were delighted for all their wishes had come true. Vishnu asked Brahma to grant the best of realms to his companions, who were devoted to him, had given up their lives, and followed him out of love.

And so, Brahma granted them great realms, and declared that any being, who died with Rama on their minds, would attain the best of realms.

The Vanaras took on the bodies of their fathers, turning into gods, Gandharvas, sages, Yakshas, and so on. Whoever took a dip in the Sarayu was delighted, abandoned their mortal body, and ascended a divine chariot.

All beings, moving and unmoving, descended into the waters, where Rama had cast his body and ascended the heavens.

> **"O god**! You are the **refuge of the world**... You are without decay and accumulate **everything**. O immensely energetic one! As you wish, enter **your own body**."
>
> BRAHMA TO VISHNU, *SARGA* (100), UTTARA KANDA

Glossary

adharma
Literally meaning unrighteousness, adharma is anything that goes against dharma – the moral law that governs conduct. It is anything that upsets the natural order of life or results in disorder in the universe.

amrita
The elixir or nectar of immortality, which the gods attained after the churning of the ocean.

anushtubh
A metrical form consisting of four *pada*s, or "quarter-verses" that consist of eight syllables each. It became common in the later hymns of the *Rigveda*, and ultimately became the *shloka*, which is the principal epic metre.

apsara
Etymologically meaning someone who has been created from water, apsaras are water nymphs. They are young women of great grace and beauty, who reside in *svarga*, and serve in the court of Indra, the king of the gods. They are excellent dancers and are often companions to the Gandharvas, or celestial musicians.

Ashwamedha
The sacrifice of a royal horse. It is a Vedic rite of grand proportions that ancient Indian kings often performed to prove their sovereignty, and to ensure the prosperity and fertility of their kingdoms.

astra
A weapon that is hurled. *Astra* is a term also used for a divine weapon, such as one invoked on an arrow.

astrology (in India)
A study that involves the forecast of events and the prediction of good or bad times through an observation of celestial bodies. The system has been vastly referred to by people to assess or forecast favourable omens for or before starting an auspicious ritual.

Asura
These are beings who reside in a world under the surface of the earth. The Asuras and the Devas, or gods, are engaged in an eternal struggle for power and supremacy over the other. Varuni, the goddess of liquor, emerged during the churning of the ocean, and liquor was claimed by the gods. Hence, according to one story, the gods came to

be called Suras (with liquor) and the Daityas as Asuras (those without liquor).

Brahmana
The highest ranking class in the Hindu class system, or varnas. Brahmanas are members of the priestly class and are believed to be the repositories of knowledge. They are the only ones who can perform *yagna*s and rituals to propitiate the gods.

Brahmarshi
A sage with knowledge of the Supreme Being.

Brahmavidya
The science or knowledge obtained through the study of the divine.

Chandravamshi
The descendants of Chandra, lord of the moon. Influenced by the emotional, passionate nature of their ancestor, the moon, kings of this line were considered volatile and temperamental. The *Mahabharata* narrates the story of the Chandravamsha, or the lunar dynasty.

Daitya
Descendants of Diti, the granddaughter of Brahma. Daityas were killed by the Suras, or Devas after the churning of the ocean.

dharma
Hindu scriptures lay down dharma as being a way of life that follows the path of righteous conduct in thought, word, and action. However, the meaning of dharma changes depending on the context – what is dharma in one situation may be adharma (unrighteous) in another. The term is also famously multivalent, and can refer to duty, morality, good behaviour, ethics, and governance.

Gandharva
Semi-divine beings of great physical beauty are musicians and singers for the Devas at Indra's court. On the earth, they prefer to dwell in woodlands and forests. They are often described as Kubera's companions and they marry apsaras.

Hindu calendar
One Hindu calendar is based on lunar months, that is, the cycles of the phases of the moon. Each year is made of 12 such months (354 days). The discrepancy between a 365-day solar year and lunar year is bridged by the inclusion of one extra month in the lunar year every 30 months. The 12 months are

named – Chaitra, Vaishakha, Jyeshtha, Ashadha. Shravana, Bhadrapada, Ashvina, Kartika, Margashirsha, Pausha, Magha, and Phalguna. The four months, beginning in Ashadha to Kartika, are known as Chaturmasa (four months). This period is considered holy by many religions, including Hindus, Jains, and Buddhists, and people immerse themselves in penance, fasting, austerities, and religious observances.

kanda
Valmiki's *Ramayana* is divided into seven parts, called *kanda* – Bala Kanda, Ayodhya Kanda, Aranya Kanda, Kishkindha Kanda, Sundara Kanda, Yuddha Kanda, and Uttara Kanda. Each of these are further divided into sections called *sarga*s.

Kshatriya
One of the four vocation-based divisions (varnas) of the Hindu caste system, Kshatriyas were the rulers and warriors, responsible for keeping the peace, dispensing justice, and protecting the rest of society. It is believed that the dharma of a Kshatriya was to enforce dharma, protect those who sought protection, and

maintain peace and order in the realm.

lila
A Sanskrit word meaning "play", "sport", "spontaneity", or "drama". This term has many different meanings in Hinduism but most, in one way or another, focus on the effortless or playful relation between the "Absolute", or Brahman, and the dependent world.

Marut
Wind gods, they are the companions of the king of the gods, Indra. Usually believed to be seven, each sometimes divides itself into further seven, making 49 Maruts.

maya
An illusion or trickery, maya is anything that seems to be that which it is not. In everyday use, maya is fraud, trickery, and magic while spiritually, it is any existence other than the ultimate reality. It also refers to the capacity of the Divine Being whereby the phenomenal world comes into being.

Nagas
Semi-divine, serpent-like beings who can assume

any form at will. They are the protectors of nature, particularly of waterbodies.

Nishada
A hunter tribe that resided in the forests and the mountains. There is mention of several kingdoms that were ruled by this tribe. In the *Mahabharata*, the Nishadas dwell in forests and mountains. They are believed to be the descendants of a king called Veda, who, corrupted by wrath and malice, became unrighteous and was slain by Brahmanas. Some of his descendants became Nishadas while the others were called Mlechchhas, said to be found in the Vindhya mountains.

Patala
One of the seven nether regions of the universe. The other six are – Atala, Vitala, Sutala, Rasatala, Talatala, and Mahatala.

praya
The practice of voluntary fasting to death, it is adopted by someone who has no worldly desires left.

Rajasuya

Rajasuya succeeds the consecration of a king. It is an elaborate ritual sacrifice performed by kings to establish their sovereignty as a public announcement of independence.

Rakshasa

Beings who have the power to change their appearance by will. Brahma created them to protect the waters.

Rasatala

One of the seven nether regions. The other six include Atala, Vitala, Sutala, Talatala, Mahatala, and Patala. Rasatala literally means "That which is below the earth", and is either the fourth or sixth of the Patala or "nether region", believed to be the home of Ananta or Shesha, the thousand-hooded serpent on whom the Hindu god, Vishnu rests.

sarga

Valmiki's *Ramayana* is made of 500 *sarga*s, which are subsections of the book within the *kanda*s.

Shrivaishnava

A member of a Hindu community that worships Vishnu. The community is most widespread in southern India. Some significant figures in this tradition include Nathamuni, Yamunacharya, and Ramanuja.

Shudras

Lowest of the four vocation-based divisions of the Hindu caste system, Shudras are the service providers, traditionally artisans or labourers.

Suryavamshi

The descendants of Manu, believed to be the first human and son of the sun god. They are known for their reason and logic. Many dynasties, including the Ikshvaku, which Rama is from, are from Suryavamsha, or the solar dynasty.

svarga

The celestial abode of the Devas ruled by Indra. Here, there is no unhappiness and every desire can be indulged. It is the transitory place for righteous souls awaiting rebirth.

swayamvara

An ancient Hindu practice where a maiden herself (*swayam*) chooses her husband (*vara*) from a group of eligible suitors.

tirtha

A Sanskrit word that means "ford" – where one may cross over to reach the far shores of heaven. It is a holy place with water that is made sacred by the virtue of being associated with a god or saint. A *tirtha* may typically have a place for devotees to bathe and purge themselves of their sins.

Vaishyas

One of the four varnas from the Hindu class system, Vaishyas are third in hierarchy and are traders or agriculturalists.

Vanara

The word literally translates to "those who roam around in the forest". Although it is sometimes translated to "ape", there is no consensus on the classification of the Vanaras as a species. They are said to have been born as a result of the union between the gods and mortal Vanara women, at the behest of Brahma. Endowed with bodies of monkeys and possessing magical powers, their purpose is to provide Vishnu with inexhaustible armies during his time on the earth.

varna

The Hindu system of social organization based on the division of labour established in ancient India. The four varnas include, Brahmanas, priests or the spiritual class; Kshatriyas, military or the ruling class; Vaishyas or the merchants; and Shudras, servants or the service providers. In accordance with the varna dharma, a son was obliged to follow the same vocation as his father. The first reference to the origin of varnas is found in the *Rigveda*.

Vedas

The oldest scriptures of Hinduism, the Vedas are a collection of hymns or poems making a body of knowledge on a range of subjects. Sage Vyasa is credited with classifying the hymns to create four Vedas: *Rigveda*, *Samaveda*, *Yajurveda*, and *Atharvaveda*.

Vidyadharas

Semi-divine beings that occupy the region between heaven and the earth.

Viryashulka

A ceremony where a suitor who exhibits the most *virya* (valour) is offered to the maiden for whom the ceremony is being conducted. The word *shulka* means price.

yagna

The practice of ritual offering to propitiate the gods and ensure their blessing, as prescribed in the Vedas.

Yaksha

Powerful, but benevolent, and sometimes mischievous forest-spirits who are believed to be guardians of treasures and are fond of riddles. They are often described as the companions of Kubera, the god of wealth.

yuga

According to Hindu beliefs, yuga is an age, or an epoch of humankind.

Ancient Hindu belief dictates that time is cyclic. Each cycle of time comprises four yugas. The first is Krita Yuga, a golden age and an age of prosperity. The two following yugas, Treta and Dwapara, see a gradual deterioration of humanity, the environment, and quality of life. Kali Yuga, the final age, is a time of disorder and darkness, when the relentless exploitation of both humans and nature culminates in the destruction of the universe. The present era is believed to be the Kali Yuga that began around the time of the death of Krishna, one of Lord Vishnu's incarnations.

ALTERNATIVE NAMES

Through Valmiki's *Ramayana*, certain characters have more than one name.

- Sita: Maithilee (princess of Mithila), Vaidehi (daughter of the king of Videha), Janakee (the daughter of Janaka)
- Rama: Raghava (descendant of Raghu; also used for other people from that lineage)
- Hanuman: Maruti (son of Maruta, another name for Vayu)
- Garuda: Suparna (the one with beautiful feathers)
- Ravana: Dashagriva (the one with 10 heads)
- Kubera: Vaishravana (son of Vishrava)
- Lakshmana: Saumitri (son of Sumitra; also applies to Shatrughna)

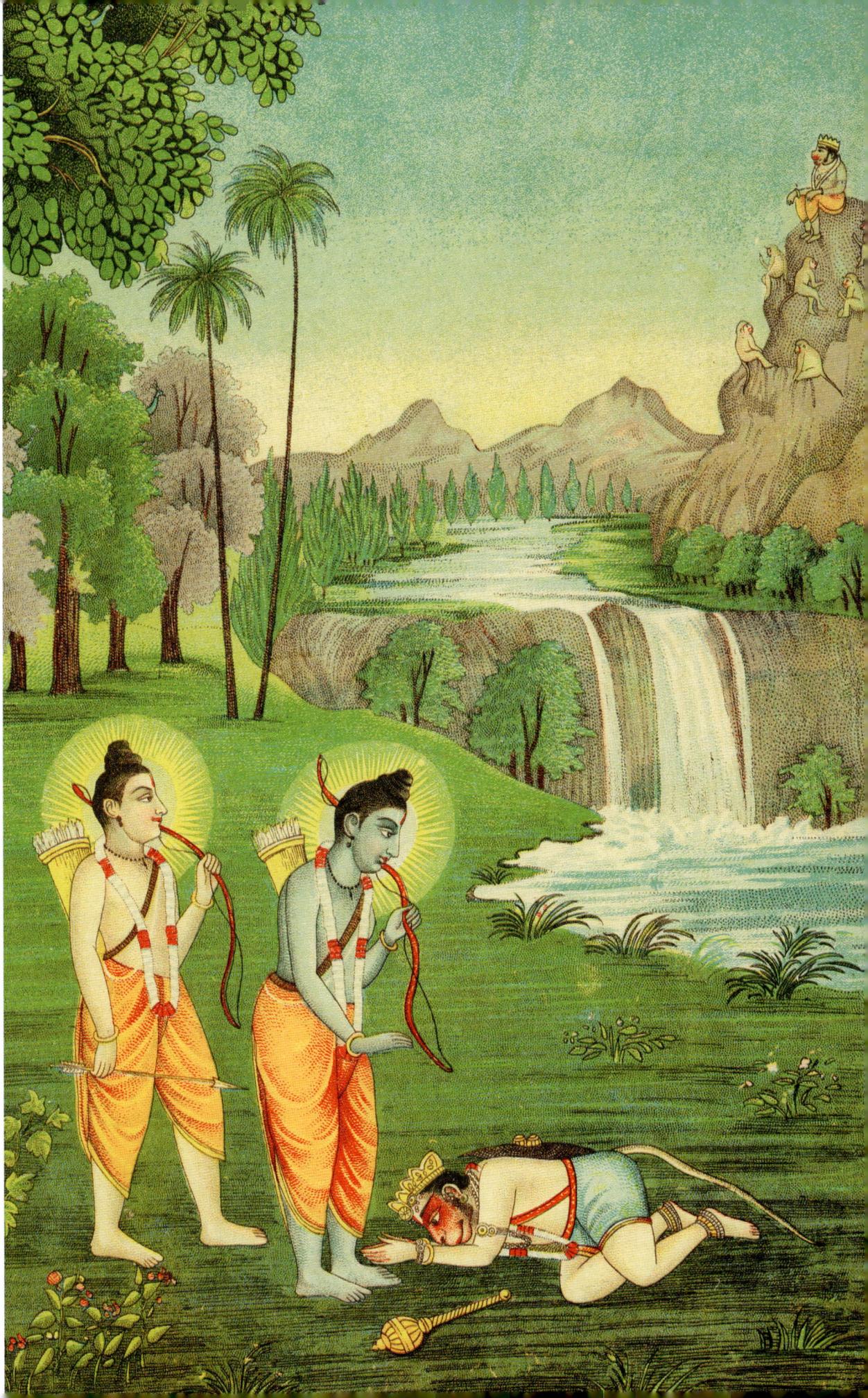

Index

Bibliography

PRIMARY SOURCES: EDITIONS, TRANSLATIONS, AND COMMENTARIES

Adhyātmarāmāyaṇa: Hindi-Anuvadasahita. Trans. Gupt, Shrimunilal. Gorakhpur: Gitapress, 2016.

Aiyar, TR Ratnam, S Rangachariar, and Kasinath Pandurang Parab, eds. *The Mahaviracharita of Bhavabhuti with The Commentary of Viraraghava.* Bombay: Tukaram Javaji (Proprietor of Javaji Dadaji's "Nirnaya Sagara" Press.), 1892.

"Ananda Ramayana (Pothi or Oblong).Pdf." Accessed July 9, 2020. https://ia802904.us.archive.org/7/items/anandaramayanapothioroblong_202003_148_w/Ananda%20Ramayana%20%28Pothi%20or%20Oblong%29.pdf.

Bhavabhūti. *Bhavabhūtipraṇītaṃ Uttararāmacaritam.* 1. saṃskaraṇa. Vārāṇasī: Caukhambā Paõliśarsa, 2001.

Diṅnāga. *Kundamālā.* 1. saṃskaraṇa. Vārāṇasī: Caukhambā Surabhāratī Prakāśana, 1992. https://catalog.hathitrust.org/Record/002886212?signon=swle:https://shibidp.cit.cornell.edu/idp/shibboleth.

Durgaprasad, Pandit, and Kasinath Pandurang Parab, eds. *The Anargharaghava of Murari with The Commentary of Ruchipati.* Kavyamala 5. Bombay: Tukaram Javaji (Propreitor of Javaji Dadaji's "Nirnaya Sagara" Press.), 1887.

"Indic Manuscripts Collection: Ms. Coll. 390, Item 2532 - Śivatāṇḍavastava." Accessed July 7, 2020. http://dla.library.upenn.edu/dla/medren/pageturn.html?id=MEDREN_9958038363503681&doubleside=0&rotation=0¤tpage=3.

Indra, Indrapāla Siṃha. *Saṭ Ahalyā :Khaṇḍa Kāvya /.* Āgarā :, 1996. http://hdl.handle.net/2027/uc1.b4562103.

Jagannathan, NS, ed. *Kamba Ramayana.* Translated by PS Sundaram. Penguin Books, 2002.

Kālidāsa. *Kumārasambhavam.* 7. saṃskaraṇa. Vārāṇasī: Caukhambā Vidyābhavana, 1998.

———. *The Raghuvaṃśa of Kālidāsa*: With the Commentary of Mallinātha. Edited by Gopal Raghunath Nandargikar, Mallinātha., and Hemādri. [4th ed.]. Delhi: Motilal Banarsidass, 1971. https://catalog.hathitrust.org/Record/000344227?signon=swle:https://shibidp.cit.cornell.edu/idp/shibboleth.

"Kalidasa: Raghuvamsa." Accessed June 30, 2020. http://gretil.sub.uni-goettingen.de/gretil/1_sanskr/5_poetry/2_kavya/kragh_pu.htm.

Kṛttibāsa. *Kṛttivāsa Rāmāyaṇa.* Delhi, India: Eastern Book Linkers, 1997.

Lefeber, Rosalind. *The Rāmāyaṇa of Vālmīki: An Epic of Ancient India, Volume IV: Kiskindhakāṇḍa.* Princeton University Press, 2016. http://muse.jhu.edu/book/49123/.

Miśra, Bhagavatīśaraṇa. *Eka Aura Ahalyā /.* Dillī :, 1991. http://hdl.handle.net/2027/uc1.b3834305.

Murāri Miśra. *Anargharāghavam: Kavivaramurāriviracitam, prakāśa saṃskṛta-Hindīvyākhyopetam, Vyākhyākāraḥ Śrīrāmacandramiśraḥ. 1. Saṃskaraṇa.* Vārāṇasī: Caukhambā Vidyābhavana, 1960. https://hdl.handle.net/2027/mdp.39015061129535?urlappend=%3Bsignon=swle:https://shibidp.cit.cornell.edu/idp/shibboleth.

Raviṣeṇa. *Padmapurāṇam =: Padmacaritam: Hindī anuvāda, prastāvanā, tathā ślokānukramaṇikā sahita.* 2. saṃskaraṇa. Nayī Dillī: Bhāratīya Jñānapīṭha Prakāśana, 1977. https://catalog.hathitrust.org/Record/000951120?signon=swle:https://shibidp.cit.cornell.edu/idp/shibboleth.

Shastri, Shrinivasa Katti Mudholakara, ed. *Rāmāyaṇa of Vālmīki with the Commentaries Tilaka of Rāma, Rāmāyaṇaśiromaṇi of Śivasahāya and Bhūṣaṇa of Govindarāja.* Vol. 1–7. Parimal Sanskrit Series. Delhi: Parimal Publications, 1983.

"Shivatandavastotra by Ravana." Accessed July 7, 2020. https://sanskritdocuments.org/doc_shiva/shivtAND.html.

Shyama Kaimal. *Ramayana Tatparya Sangraha Appayya Dikshit Vani Vilas Press.* Accessed June 22, 2020. http://archive.org/details/ramayanatatparyasangrahaappayyadikshitvanivilaspress_202002

Śrīmadgosvāmī Tulasīdāsajīviracita Śrīramacaritamānasa. Gorakhpur: Gitapress, 2004.

The Rāmāyaṇa of Vālmīki: An Epic of Ancient India, Volume I: Balakāṇḍa. Princeton, NJ: Princeton University Press, 2016. https://doi.org/10.1515/9781400884551.

The Rāmāyaṇa of Vālmīki: An Epic of Ancient India, Volume II: Ayodhyākāṇḍa. Princeton, NJ: Princeton University Press, 2016. https://doi.org/10.1515/9781400883103.

The Rāmāyaṇa of Vālmīki: An Epic of Ancient India, Volume II: Ayodhyākāṇḍa. The Rāmāyaṇa of Vālmīki: An Epic of Ancient India, Volume II. Princeton University Press, 2016. http://princetonup.degruyter.com/view/title/524976.

The Rāmāyaṇa of Vālmīki: An Epic of Ancient India, Volume III: Aranyakāṇḍa. Princeton, NJ: Princeton University Press, 2016. https://doi.org/10.1515/9781400883110.

The Rāmāyaṇa of Vālmīki: An Epic of Ancient India, Volume V: Sundarakāṇḍa. Princeton, NJ: Princeton University Press, 2016. https://doi.org/10.1515/9781400884575.

The Rāmāyaṇa of Vālmīki: An Epic of Ancient India, Volume VI: Yuddhakāṇḍa. Princeton, NJ: Princeton University Press, 2009. https://doi.org/10.1515/9781400833269.

The Rāmāyaṇa of Vālmīki: An Epic of Ancient India, Volume VII: Uttarakāṇḍa. Princeton, NJ: Princeton University Press, 2016. https://doi.org/10.1515/9781400884568.

The Valmiki Ramayana 1. Trans. Bibek Debroy. Penguin Random House. 2017.

The Valmiki Ramayana 2. Trans. Bibek Debroy. Penguin Random House. 2017.

The Valmiki Ramayana 3. Trans. Bibek Debroy. Penguin Random House. 2017.

Veṅkaṭanātha. *Śrīveṅkaṭaraṅganāthadeśika-praṇītaṃ Pādukāsahasram: Śrīnivāsaviracitayā Parīkṣābhidhayā ṭīkayā samuttaṅkitam*. Vārāṇasī, Bhārata: Caukhambhā Saṃskṛta Saṃsthāna, 1984

SECONDARY SOURCES

Bhavabhūti, and Sheldon Pollock. "Introduction." In Rama's Last Act, translated by Sheldon Pollock. New York: New York University Press, 2007.

Bhise, Usha R. "Mahāvīracarita: Design and Purpose." *Annals of the Bhandarkar Oriental Research Institute* 69, no. 1/4 (1988): 255–63.

Brinkhaus, Horst. "Early Developmental Stages of the Viṣṇuprādurbhāva Lists." *Wiener Zeitschrift Für Die Kunde Südasiens / Vienna Journal of South Asian Studies* 36 (1992): 101–10.

Bronner, Yigal. "A Text with a Thesis : The Rāmāyaṇa from Appayya Dīkṣita's Receptive End." In *South Asian Texts in History: Critical Engagements with Sheldon Pollock*, edited by Yigal. Bronner, Whitney. Cox, and Lawrence J. McCrea. Ann Arbor, MI: Association for Asian Studies, 2011.

Chaturvedi, Aditya. "The Passage of Ramā's Lord: An Introduction to the Rameśvaracarit Mithilā Rāmāyaṇa." MA Thesis, School of Historical Studies, Nalanda University, 2018.

Chhikara, Savita. "Paumacariyam Adaptation or Variation." *Proceedings of the Indian History Congress* 68 (2007): 179–84.

Couture, André. "From Viṣṇu's Deeds to Viṣṇu's Play, or Observations on the Word Avatāra as a Designation for the. Manifestations of Viṣṇu." *Journal of Indian Philosophy* 29, no. 3 (2001): 313–26.

Creese, Helen. "Rāmāyaṇa Traditions in Bali." In *From Lanka Eastwards*, edited by Helen Creese, Andrea Acri, and Arlo Griffiths, 93–118. The Ramayana in the Literature and Visual Arts of Indonesia. Brill, 2011. https://www.jstor.org/stable/10.1163/j.ctt1w76w8d.9.

Dvivedī, Śyāmākānta. "Sītā-Śodha Kā Ādhyātmika Rahasya." *Kalyāṇa* 49, no. 1 (Special Issue) (1975).

Erndl, Kathleen M. "The Mutilation of Śūrpaṇakhā." In Many Rāmāyaṇas: *The Diversity of a Narrative Tradition in South Asia*, edited by Paula. Richman, 67–88. Berkeley: University of California Press, 1991. http://publishing.cdlib.org/ucpressebooks/view?docId=ft3j49n8h7;query=;brand=ucpress.

Garg, Surendra Kumar. "Ramakatha - Variations and Negations." *Annals of the Bhandarkar Oriental Research Institute* 77, no. 1/4 (1996): 195–207.

Godakumbura, CE. "Rāmāyaṇa in Śrī Laṅkā and Laṅkā of the Rāmāyaṇa." *Journal of the Royal Asiatic Society of Sri Lanka* 59, no. 2 (2014): 55–83.

Goldman, R, and J Masson. "Who Knows Rāvaṇa? – A Narrative Difficulty in the Vālmīki Rāmāyaṇa." *Annals of the Bhandarkar Oriental Research Institute* 50, no. 1/4 (1969): 95–100.

Goldman, RP. "Rāmaḥ Sahalakṣmaṇaḥ: psychological and literary aspects of the composite hero of Vālmīk's Rāmāyaṇa." *Journal of Indian Philosophy* 8, no. 2 (1980): 149–89.

Goldman, Robert P, and Sally J. Sutherland Goldman. "Historicity and Sovereignty in the Uttarakāṇḍa." In *The Rāmāyaṇa of Vālmīki: An Epic of Ancient India, Volume VII*, 157–68. Uttarakāṇḍa. Princeton University Press, 2017. https://doi.org/10.2307/j.ctt1gsmwj0.14.

Grierson, George A. "On the Adbhuta-Ramayana." *Bulletin of the School of Oriental and African Studies* 4, no. 1 (March 1926): 11–27. https://doi.org/10.1017/S0041977X0010254X.

Grierson, George, and Divâkara Prakâśa Bhaṭṭa. "Sītā Forlorn, a Specimen of the Kāshmīrī Rāmâyana." *Bulletin of the School of Oriental Studies, University of London* 5, no. 2 (1929): 285–301.

Griffiths, Arlo. "Imagine Laṅkapura at Prambanan." In *From Lanka Eastwards*, edited by Arlo Griffiths, Andrea Acri, and Helen Creese, 133–48. The Ramayana in the Literature and Visual Arts of Indonesia. Brill, 2011. https://www.jstor.org/stable/10.1163/j.ctt1w76w8d.11.

Hardy, Friedhelm. *Viraha-Bhakti: The Early History of Kṛṣṇa Devotion in South India*. Delhi: Oxford, 1983.

Henry, Justin W. "Explorations in the Transmission of the Ramayana in Sri Lanka." *South Asia: Journal of South Asian Studies* 42, no. 4 (July 4, 2019): 732–46. https://doi.org/10.1080/00856401.2019.1631739.

Henry, Justin W, and Sree Padma. "Lankapura: The Legacy of the Ramayana in Sri Lanka." *South Asia: Journal of South Asian Studies* 42, no. 4 (July 4, 2019): 726–31. https://doi.org/10.1080/00856401.2019.1626127.

Jordaan, Roy. "The Causeway Episode of the Prambanan Rāmāyaṇa Reexamined." In *From Lanka Eastwards*, edited by Andrea Acri, Helen Creese, and Arlo Griffiths, 179–208. The Ramayana in the Literature and Visual Arts of Indonesia. Brill, 2011. https://www.jstor.org/stable/10.1163/j.ctt1w76w8d.13.

Kane, PV. "The Kundamālā and Bhāsā." *Annals of the Bhandarkar Oriental Research Institute* 10, no. 1/2 (1929): 155–155.

Kieven, Lydia. "Hanuman, the Flying Monkey: The Symbolism of the Rāmāyaṇa Reliefs at the Main Temple of Caṇḍi Panataran." In *From Lanka Eastwards*, edited by Andrea Acri, Helen Creese, and Arlo Griffiths, 209–32. The Ramayana in the Literature and Visual Arts of Indonesia. Brill, 2011. https://www.jstor.org/stable/10.1163/j.ctt1w76w8d.14.

Lutgendorf, Philip. Hanuman's Tale: The Messages of a Divine Monkey. Oxford University Press 2007.

———. The Life of a Text: Performing the Rāmcaritmānas of Tulsidas. Berkeley: University of California Press, 1991.

———. "The Secret Life of Rāmacandra of Ayodhya." In Many Rāmāyaṇas: The Diversity of a Narrative Tradition in South Asia, edited by Paula. Richman, 217–34. Berkeley: University of California Press, 1991. http://publishing.cdlib.org/ucpressebooks/view?docId=ft3j49n8h7;query=;brand=ucpress.

———. "The View from the Ghats: Traditional Exegesis of a Hindu Epic." The Journal of Asian Studies 48, no. 2 (1989): 272–88. https://doi.org/10.2307/2057378.

McCrea, Lawrence J. "The Poetics of Perspective in Rājaśekhara's Young Rāmāyaṇa." In Innovations and Turning Points: Toward a History of Kāvya Literature, edited by Yigal Bronner, David Shulman, and Gary A. Tubb. New Delhi, India: Oxford University Press, 2014.

McDaniel, Justin. "This Hindu Holy Man Is a Thai Buddhist." South East Asia Research 21, no. 2 (2013): 191–209.

Mumme, Patricia Y. "Rāmāyaṇa Exegesis in Tenkalai Śrīvaiṣṇavism." In Many Rāmāyaṇas: The Diversity of a Narrative Tradition in South Asia, edited by Paula. Richman, 202–16. Berkeley: University of California Press, 1991. http://publishing.cdlib.org/ucpressebooks/view?docId=ft3j49n8h7;query=;brand=ucpress.

Padma, Sree. "Borders Crossed: Vibhishana in the Ramayana and Beyond." South Asia: Journal of South Asian Studies 42, no. 4 (July 4, 2019): 747–67. https://doi.org/10.1080/00856401.2019.1631738.

Paul, Meenakshi F. "Ram as Folk Hero in the 'Ramains' of Himachal Pradesh." Indian Literature 51, no. 4 (240) (2007): 178–87.

Pollock, Sheldon. "The Divine King in the Indian Epic." Journal of the American Oriental Society 104, no. 3 (1984): 505–28. https://doi.org/10.2307/601658.

Pou, Saveros. "Indigenization of Rāmāyaṇa in Cambodia." Asian Folklore Studies 51, no. 1 (1992): 89–102. https://doi.org/10.2307/1178423.

Rajendra Prasad. "The Theory of Puruṣārthas: Revaluation and Reconstruction." Journal of Indian Philosophy 9, no. 1 (1981): 49–76.

Radice, William. "The Significance of Madhusudan Dutt and His Epic." India International Centre Quarterly 30, no. 1 (2003): 73–88.

Raman, Srilata. Self-Surrender (Prapatti) to God in Śrīvaiṣṇavism: Tamil Cats and Sanskrit Monkeys. London: Routledge, 2007.

Ramanujan, AK. "Three Hundred Ramayanas: Five Examples and Three Thoughts on Translation." In Many Rāmāyaṇas: The Diversity of a Narrative Tradition in South Asia, edited by Paula. Richman, 22–49. Berkeley: University of California Press, 1991. http://publishing.cdlib.org/ucpressebooks/view?docId=ft3j49n8h7;query=;brand=ucpress.

Rao, Ajay K. Re-Figuring the Rāmāyaṇa as Theology: A History of Reception in Premodern India. Routledge, 2015.

Reynolds, Frank E. "Rāmāyaṇa, Rāma Jātaka, and Ramakien: A Comparative Study of Hindu and Buddhist Traditions." In Many Rāmāyaṇas: The Diversity of a Narrative Tradition in South Asia, edited by Paula. Richman, 50–63. Berkeley: University of California Press, 1991. http://publishing.cdlib.org/ucpressebooks/view?docId=ft3j49n8h7;query=;brand=ucpress.

Richman, Paula. "E.V. Ramasami's Reading of the Rāmāyaṇa." In Many Rāmāyaṇas: The Diversity of a Narrative Tradition in South Asia, edited by Paula. Richman, 175–201. Berkeley: University of California Press, 1991. http://publishing.cdlib.org/ucpressebooks/view?docId=ft3j49n8h7;query=;brand=ucpress.

Richman, Paula., ed. Many Rāmāyaṇas: The Diversity of a Narrative Tradition in South Asia. Berkeley: University of California Press, 1991. http://publishing.cdlib.org/ucpressebooks/view?docId=ft3j49n8h7;query=;brand=ucpress.

Sanmugeswaran, Pathmanesan, Krishantha Fedricks, and Justin W Henry. "Reclaiming Ravana in Sri Lanka: Ravana's Sinhala Buddhist Apotheosis and Tamil Responses." South Asia: Journal of South Asian Studies 42, no. 4 (July 4, 2019): 796–812. https://doi.org/10.1080/00856401.2019.1631900.

Saran, Malini. "The Ramayana in Indonesia: Alternate Tellings." India International Centre Quarterly 31, no. 4 (2005): 66–82.

Shah, Shalini. "Articulation, Dissent and Subversion: Voices of Women's Emancipation in Sanskrit Literature." Social Scientist 45, no. 9/10 (2017): 79–86.

Shulman, David. "Divine Order and Divine Evil in the Tamil Tale of Rama." The Journal of Asian Studies 38, no. 4 (1979): 651–69. https://doi.org/10.2307/2053906.

Shulman, David Dean. "The Phenomenon of Localization." In Tamil Temple Myths, 40–89. Sacrifice and Divine Marriage in the South Indian Saiva Tradition. Princeton University Press, 1980. https://doi.org/10.2307/j.ctt7zv390.9.

Singaravelu, S. "Sītā's Birth and Parentage in the Rāma Story." Asian Folklore Studies 41, no. 2 (1982): 235. https://doi.org/10.2307/1178126.

Witharana, Dileepa. "Ravana's Sri Lanka: Redefining the Sinhala Nation?" South Asia: Journal of South Asian Studies 42, no. 4 (July 4, 2019): 781–95. https://doi.org/10.1080/00856401.2019.1632560.

www.wisdomlib.org. "Story of Paraśurāma," January 28, 2019. https://www.wisdomlib.org/hinduism/compilation/puranic-encyclopaedia/d/doc241820.html.

Young, Jonathan, and Philip Friedrich. "Mapping Lanka's Moral Boundaries: Representations of Socio-Political Difference in the Ravana Rajavaliya." South Asia: Journal of South Asian Studies 42, no. 4 (July 4, 2019): 768–80. https://doi.org/10.1080/00856401.2019.1633114.

Acknowledgments

The publisher would like to thank:
Bibek Debroy for his guidance and permission to use excerpts from his translation of the Critical Edition of *The Valmiki Ramayana*.

Tarinee Awasthi for writing the content of this book.
Tarinee Awasthi is a devotee of Rama, deeply passionate about the *Ramayana* tradition, and reads Sanskrit, Awadhi, and Braj (in addition to Khari Boli Hindi and English). Trained in history at St Stephen's College and Jawaharlal Nehru University, she is currently a doctoral candidate at Cornell University, where she studies Indian religion. This combination of skills and interests made it possible for her to dip into a unique range of material in the original Sanskrit (including, but well beyond Valmiki's *Ramayana*) as well as various north Indian vernaculars, and unattributed translations from those sources are also hers. Her contribution here is not affiliated with any of the institutions above.

Vatsal Verma for content planning, **Priyal Mote** for illustrations, **Suresh Kumar** for cartographic assistance, **Satish Gaur, Umesh Singh Rawat**, and **Tarun Sharma** for technical support, and **Jennifer Ingty** for editorial assistance.

Every effort has been made to acknowledge those individuals, organizations, and corporations that have helped with this book and to trace copyright holders. DK apologizes in advance if any omission has occurred. If an omission does come to light, DK will be pleased to insert the appropriate acknowledgment in the subsequent editions of the book.

The publisher would also like to thank the following for their kind permission to reproduce their photographs:

(Key: a-above; b-below/bottom; c-centre; f-far; l-left; r-right; t-top)

Polsky and Leon B. Polsky Fund, 2002. **110-111 Alamy Stock Photo:** IndiaPicture / Amit Pasricha (b). **111 Alamy Stock Photo:** Album / British Library (tr). **112 Alamy Stock Photo:** Abbus Archive Images (tl). **112-113 akg-images:** (b). **114-115 The Cleveland Museum Of Art:** Purchase and partial gift from the Catherine and Ralph Benkaim Collection; Severance and Greta Millikin Purchase Fund (b). **115 Dreamstime.com:** Ron Amonratanasareegul (cra). **116-117 Freer Gallery of Art, Smithsonian Institution:** Gift of Charles Lang Freer. **113 Dreamstime.com:** Ron Amonratanasareegul (bl). **119 Alamy Stock Photo:** Abbus Archive Images. **120-121 Alamy Stock Photo:** Photonell. **122 National Museum, New Delhi:** (r). **123 Alamy Stock Photo:** Dinodia Photos RM (br). **124 Dreamstime.com:** Srisakorn Wonglakorn (bl). **125 Alamy Stock Photo:** History and Art Collection. **126-127 akg-images. 128 The Metropolitan Museum of Art, New York:** Samuel Eilenberg Collection, Gift of Samuel Eilenberg, 1987 (bc). **129 akg-images:** (t). **130 123RF.com:** prapan Ngawkeaw (b). **Dorling Kindersley:** Geoff Brightling / 95th Rifles and Re-enactment Living History Unit (bc). **Dreamstime.com:** Borya Galperin (bl). **131 Dreamstime.com:** EPhotocorp (br). **Getty Images:** De Agostini / DEA / L. Romano (tl). **132 Dreamstime.com:** Arykoswara (tr). **132-133 Alamy Stock Photo:** Dinodia Photos RM (b). **134-135 Alamy Stock Photo:** Chronicle (c). **135 Getty Images:** AFP / Narinder Nanu (br). **136-137 akg-images. 138-139 Bridgeman Images:** (c). **140 The Metropolitan Museum of Art, New York:** Gift of Steven Kossak, The Kronos Collections in celebration of the Museum's 150th Anniversary, 2020 (r). **141 The Metropolitan Museum of Art, New York:** Gift of Steven Kossak, The Kronos Collections, in celebration of the Museum's 150th Anniversary, 2020 (tl, bc). **143 The Cleveland Museum Of Art:** Purchase and partial gift from the Catherine and Ralph Benkaim Collection; Severance and Greta Millikin Purchase Fund. **144-145 Getty Images:** AFP / Dibyangshu Sarkar. **146 Wellcome Collection:** Ravana, the demon king on his Veeman, a mythological plane or chariot. Gouache painting by an Indian painter./https://creativecommons.org/licenses/by/4.0 (tr). **146-147 The Metropolitan Museum of Art, New York:** Gift of Cynthia Hazen Polsky, 1985. **148 Dreamstime.com:** Klodien (bc). **148-149 Alamy Stock Photo:** TAO Images Limited (c). **150-151 Dreamstime.com:** EPhotocorp. **152-153 Alamy Stock Photo:** Interfoto. **154-155 Wellcome Collection:** Ravana slaughtering Jatayu the vulture, while an abducted Sita looks away in horror. Chromolithograph by R Varma./https://creativecommons.org/licenses/by/4.0. **155 Dorling Kindersley:** Priyal Mote (cr). **156-157 Alamy Stock Photo:** Michelle Enfield. **158 The Metropolitan Museum of Art, New York:** Purchase, T. Roland Berner Fund, 1974 (bl). **159 Dreamstime.com:** Bazruh (r). **160-161 Getty Images:** Herve BRUHAT / Gamma-Rapho. **162-163 Alamy Stock Photo:** The History Collection (c). **163 Getty Images / iStock:** reddees (br). **164-165 Los Angeles County Museum of Art:** Nasli and Alice Heeramaneck Collection, Museum Associates Purchase. **166-167 Alamy Stock Photo:** Margarete Lovison (c). **167 Getty Images:** Chandrasekhar Velayudhan (br). **168-169 The Metropolitan Museum of Art, New York:** Seymour Fund, 1976. **170-171 Wellcome Collection:** Hindi Manuscript 95/https://

creativecommons.org/licenses/by/4.0 (t). **171 Dreamstime.com:** Arun Bhargava (br). **172 akg-images:** Roland and Sabrina Michaud (l). **173 Dreamstime.com:** EPhotocorp (b); Letloose78 (cr). **174-175 Dreamstime.com:** EPhotocorp (b). **174 Alamy Stock Photo:** Art Collection 3 (cr). **176 123RF.com:** dinodia (tr). **176-177 The Metropolitan Museum of Art, New York:** Cynthia Hazen Polsky and Leon B. Polsky Fund, 2004. **178 Alamy Stock Photo:** The Protected Art Archive (tr). **179 123RF.com:** dinodia (bc). **Alamy Stock Photo:** Art Collection 3 (tc). **180 123RF.com:** Dmitry Rukhlenko (bl). **181 The Cleveland Museum Of Art:** Gift of Mr. and Mrs. William E. Ward (br). **183 akg-images:** Erich Lessing. **184-185 Los Angeles County Museum of Art:** Indian Art Special Purpose Fund. **186-187 Alamy Stock Photo:** LGASIASTOCK. **187 Dreamstime.com:** Roop Dey (br). **188 Alamy Stock Photo:** CPA Media Pte Ltd (t). **189 Alamy Stock Photo:** Sabena Jane Blackbird (br). **190-191 Los Angeles County Museum of Art:** Gift of Dr. and Mrs. Pratapaditya Pal in memory of J. J. Klejman. **191 Dreamstime.com:** Yuliya Borodina (cra). **193 akg-images. 194-195 akg-images:** (b). **194 Dorling Kindersley:** Priyal Mote (bl). **196 National Crafts Museum & Hastkala Academy.:** Accession No. 64 / 3181 (l). **197 Dreamstime.com:** Kunchit Jantana (br); Ugeshkumar (tl). **198 Dreamstime.com:** Irabel8 (b). **199 Alamy Stock Photo:** UtCon Collection (br). **200-201 akg-images. 202-203 Getty Images:** This is Captured by Sandeep kphotographys@gmail.com / Moment Open. **204-205 Los Angeles County Museum of Art:** Purchased with funds provided by Christian Humann. **206-207 From The Collection of Academy of Fine Arts and Literature Museum. 208-209 Alamy Stock Photo:** Tim Gainey. **210-211 Alamy Stock Photo:** Granger Historical Picture Archive. **211 Dreamstime.com:** Nila Newsom (tr). **212 Alamy Stock Photo:** The Picture Art Collection. **213 Alamy Stock Photo:** Album / British Library (c). **Dreamstime.com:** Anastasiia Guseva (cra). **214-215 akg-images. 216-217 Getty Images:** Sonu Mehta / Hindustan Times. **218 akg-images. 219 Dorling Kindersley:** Priyal Mote (br). **220-221 Dorling Kindersley:** Priyal Mote. **221 Alamy Stock Photo:** Historic Collection (br). **222 Dreamstime.com:** B R Ramana Reddi (t). **223 The Metropolitan Museum of Art, New York:** Gift of Josef and Brigitte Hatzenbuehler, 2009 (bl). **224-225 Dreamstime.com:** Ilya Shalkov (t). **227 Alamy Stock Photo:** Granger Historical Picture Archive. **228 Alamy Stock Photo:** Album / British Library. **229 Dreamstime.com:** Teodorius2014 (tr). **230-231 akg-images:** Zurich, Rietberg Museum.. **232 Wellcome Collection:** Bas-relief of Ravana, King of the Rakeshas./https://creativecommons.org/licenses/by/4.0. **233 Wellcome Collection:** Two men carrying a captured monkey tied to a pole, possibly Hanuman. Watercolour drawing./https://creativecommons.org/licenses/by/4.0 (tc). **234-235 Getty Images:** Sanjay Kanojia / AFP. **236 Alamy Stock Photo:** imageBROKER. **237 Dreamstime.com:** Prasong Takham. **238-239 Dreamstime.com:** Evan Spiler. **240 Dreamstime.com:** Victorflowerfly (bl). **241 Alamy Stock Photo:** Album / British Library (t); imageBROKER (br). **242-243 Getty Images:** Corbis Historical / Historical Picture Archive. **244-245 Dreamstime.com:** Alexandr Kornienko. **245 National Crafts Museum & Hastkala Academy.:** Accession No. 73 / 5253 (tr). **247 National Crafts Museum & Hastkala Academy.:**